THE JOYS OF WINE

THE JOYS OF

WINE

CLIFTON FADIMAN
SAM AARON

EDITED BY DARLENE GEIS

HARRY N. ABRAMS, INC.

PUBLISHERS · NEW YORK

ULRICH RUCHTI, *Designer*

NAI Y. CHANG, *Vice-President, Design and Production*
JOHN L. HOCHMANN, *Executive Editor*
MARGARET L. KAPLAN, *Managing Editor*
BARBARA LYONS, *Director, Photo Department, Rights and Reproductions*
RUTH EISENSTEIN, *Associate Editor*
DIRK LUYKX, *Production Coordinator*
ROBERT PORTER, *Maps*
ROBERT GRINSTEAD, *Index*

Library of Congress Cataloging in Publication Data

Fadiman, Clifton, 1904-
　　The joys of wine.

　　1. Viticulture.　2. Wine and wine making.
3. Viticulture—California.　I. Aaron, Sam, joint
author.　II. Title.
SB388.F32　　　641.2'2　　　74-14907
ISBN 0-8109-0549-0

Library of Congress Catalogue Card Number:　74-14907
Copyright© by Harry N. Abrams, Incorporated, New York, 1975

Grateful acknowledgment is hereby made to the following for permission to use copyrighted material: The Curtis Publishing Company, for "Brief History of a Love Affair," by Clifton Fadiman from *Holiday Magazine*© 1957. The New York Times Company, for "What You Always Wanted to Ask About Wine," by Russell Baker, from the issue of April 28, 1974 © 1974. Mrs. James Thurber for the cartoon on page 60. © 1945 James Thurber. © 1973 Helen W. Thurber and Rosemary Thurber Sauers. From *The Thurber Carnival* (originally printed in *The New Yorker*). Collins-Knowlton-Wing, Inc., for "The Man Who Made Wine," by J. M. Scott © 1954. Peter Dickinson, for "Maître de Chai: Latour." 1964. John Farquharson Ltd., for "The Growth of Marie-Louise" by John Le Carré © 1969. A. Watkins, Inc., for "The Bibulous Business of a Matter of Taste" by Dorothy Sayers © 1928. Alfred A. Knopf, Inc., for "Taste," from the book *Someone Like You*, by Roald Dahl © 1951. Laurie Lee, for "Corkscrew Carol" 1958. H. S. Mackintosh, for "Ballade Beaune." 1958.

TO
THE WINEMAKERS OF THE WORLD
WHO PLANT
THE LIVING VINE
AND HARVEST
AN ENHANCEMENT OF OUR LIVES

CONTENTS

THE JOYS OF WINE

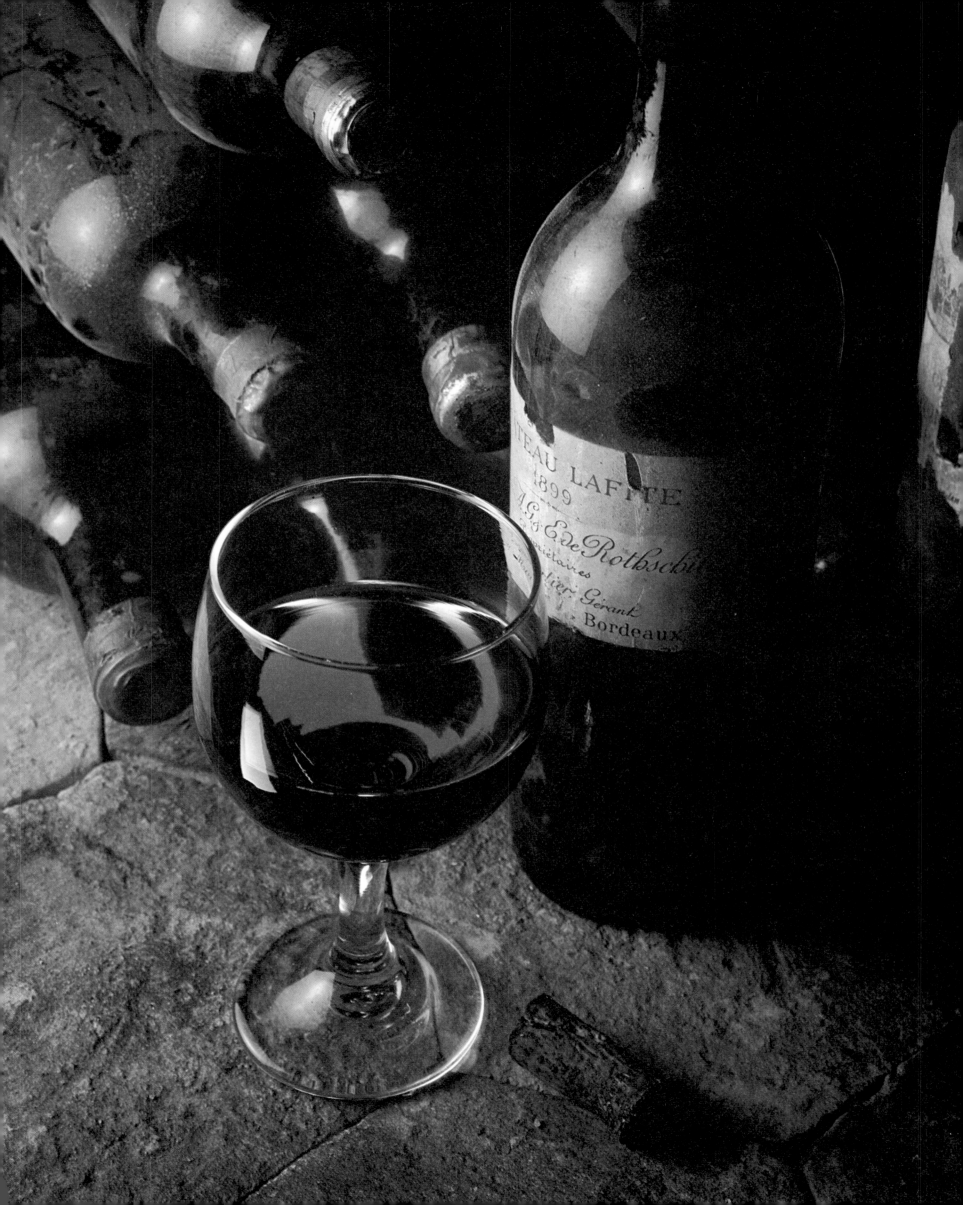

REFLECTIONS IN A WINE GLASS

CLIFTON FADIMAN

The life of wine, like that of a man, is molded by the pressures of the flow of time. As we ourselves alter in form, if not essence, so do the wines in our cellar or on our pantry shelf. So also do our judgments of them. Reflecting on this intimate relation between time, wine, and men, I thought it might be interesting to begin by reprinting unchanged, in all its innocent fervor, my essay "Brief History of a Love Affair," first published in Holiday *in 1957, and then to review it in the light of the passage of the years (see page 34). The words were set down by an amateur. I have retained that status.*

BRIEF HISTORY OF A LOVE AFFAIR

Dead Lucre: burnt Ambition: Wine is best.

—HILAIRE BELLOC, *Heroic Poem in Praise of Wine*

Like most love stories, mine will mean something to lovers; rather less to those merely capable of love; to the incapable, nothing. And, since no love affair's wild heart lets itself be netted in words, this chronicle of a passion may likewise fail of effect. Yet what lover, telling his tale, has ever been put off by the thought of failure? For he speaks not to persuade but to dress his delight in another guise, and, if he cannot command attention, will settle for being overheard. If his defective audience-sense often makes him a bore, it is a risk he runs cheerfully enough.

When I was about eleven I chanced to be left alone of a summer afternoon in the house of a family friend. Researching, I came across a cabinet enclosing many interesting bottles, clearly drinkables. One dwarfish flagon, looking as though it had escaped from a woodcut in a Grimms' fairy tale, was labeled, most gothically, *kümmel*. The bottle, perhaps half-full, played apple to my Eve. Sampling it, I found it good. There was no one to tell me that an ounce of *kümmel* is a better thing than two ounces, and a far, far better thing than twelve ounces. So, in the course of the long, drowsy, solitary afternoon, in sips that grew more and more abstracted, I absorbed the *kümmel.* Perhaps I am the only man alive who at the age of eleven survived a lost weekend based on a flavoring of caraway seeds. I was not even reprimanded. For one thing, I was for some time in no state to grasp the moral force of any reprimand. For another, any impulse my host may have felt to warn me against solitary tippling was lost in awe of my capacity.

Prohibition and my college career, neither of them a suc-

cessful experiment, partly coincided. A lean purse hindered me from becoming even a modest representative of the Fitzgerald era. But from time to time a more worldly companion and I would pay a furtive visit to a speakeasy. There, as a gesture of decadence, we imbibed a pousse-café. Sometimes two. Speakeasy illumination being what it was, I do not believe I ever actually made out the colors of the seven traditional liqueurs that compose this sybaritic concoction. But I had full confidence that, together with the reciting of Swinburne, they made up the iridescent symbol of abandonment.

This brace of anemic encounters with the Demon would seem to have little to do with my love affair. I fish up these memories only to emphasize the fact that I came to wine an enological virgin. For, though I concede the gross chemical kinship binding all alcoholic liquids, the worlds of wine and nonvinous spirituous beverages remain distinct. Thus I was all of twenty-three before being introduced to my first real bottle.

In successful love affairs the most radiant moment often occurs at the outset. Consummation, repetition, recollection: each diffuses its appropriate delight. Incomparable, however, is the moment when, all innocent of experience, knowledge, and judgment, one for the first time meets the object of a future passion and feels chosen, marked, almost *fated*. The narrator in Conrad's *Youth*, sailing at dawn, in stillness and exaltation, through the gateway of the fabled East, the boy Napoleon leading his troops in play battle on the Corsican uplands, feeling in his bones the electric shock: "I am a soldier!"; the awkward beginning angler or duck shooter with his very first cast or shot sensing, amazed, his future vocation—all, long before achieving success or even skill, vibrate to their joyful destiny. Any knowledge is good. But the most exquisite knowledge flows from the sudden insight that you are by a quirk of nature fashioned to acquire still greater knowledge.

Paris in 1927: of all places on the round earth's varied crust the best place in which to try one's first bottle. My wife had by a few weeks preceded me there, so that when I arrived she was already wearing the city like a glove. We met at noon of a brilliant August day, a day like a pearl. We had little money but much youth. For our lunch my wife, shrewdly deciding to start me off modestly, chose the Bon Marché, the Macy's of the Left Bank. She could have saved her pains: I was in Paris: a department store was Aladdin's palace. Was the lunchroom on the fourth floor? Or in Heaven? I have forgotten.

With our lunch my wife, already to me formidably learned

(Overleaf)
Paris! Solace for the spirit, the eye, the palate . . .

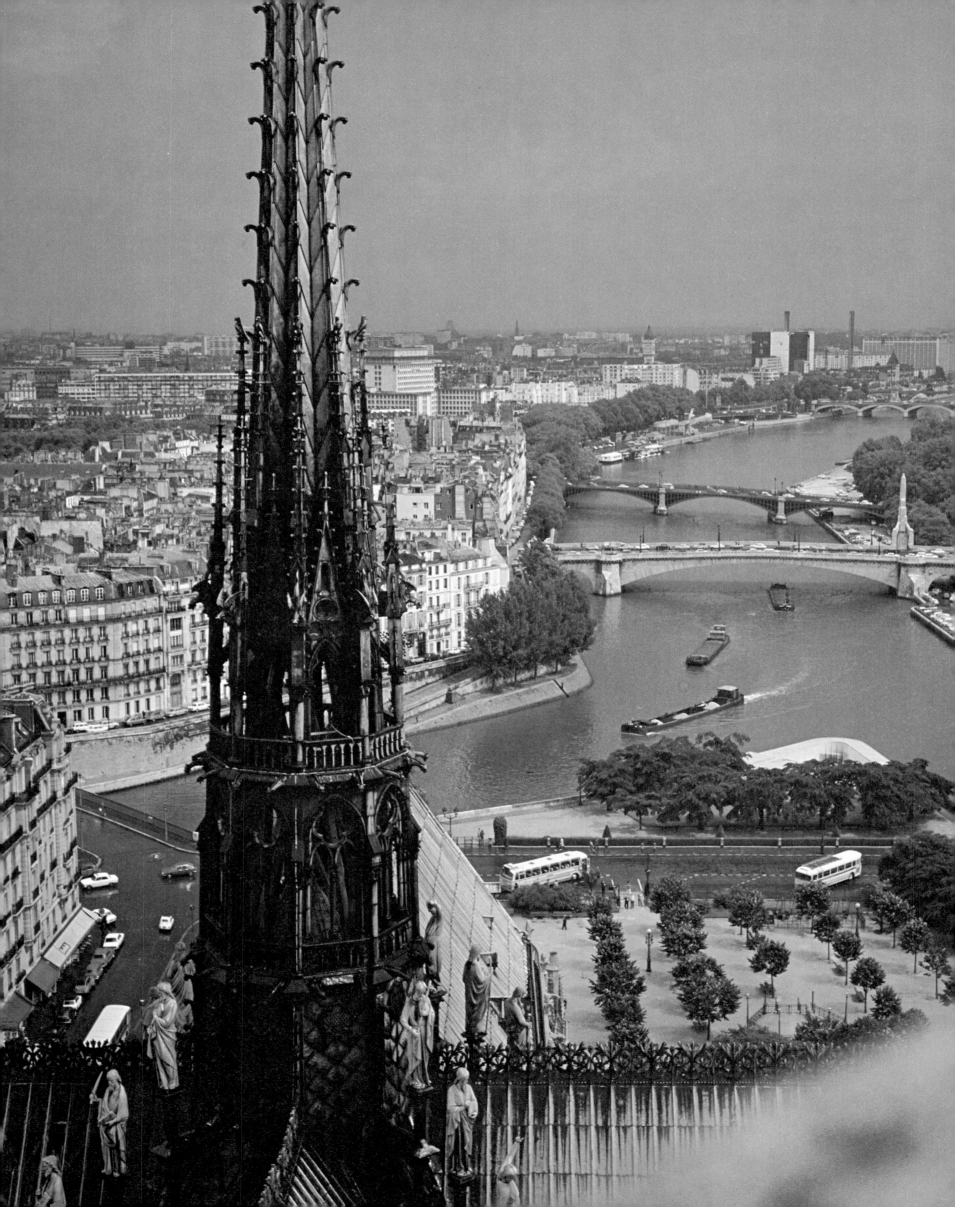

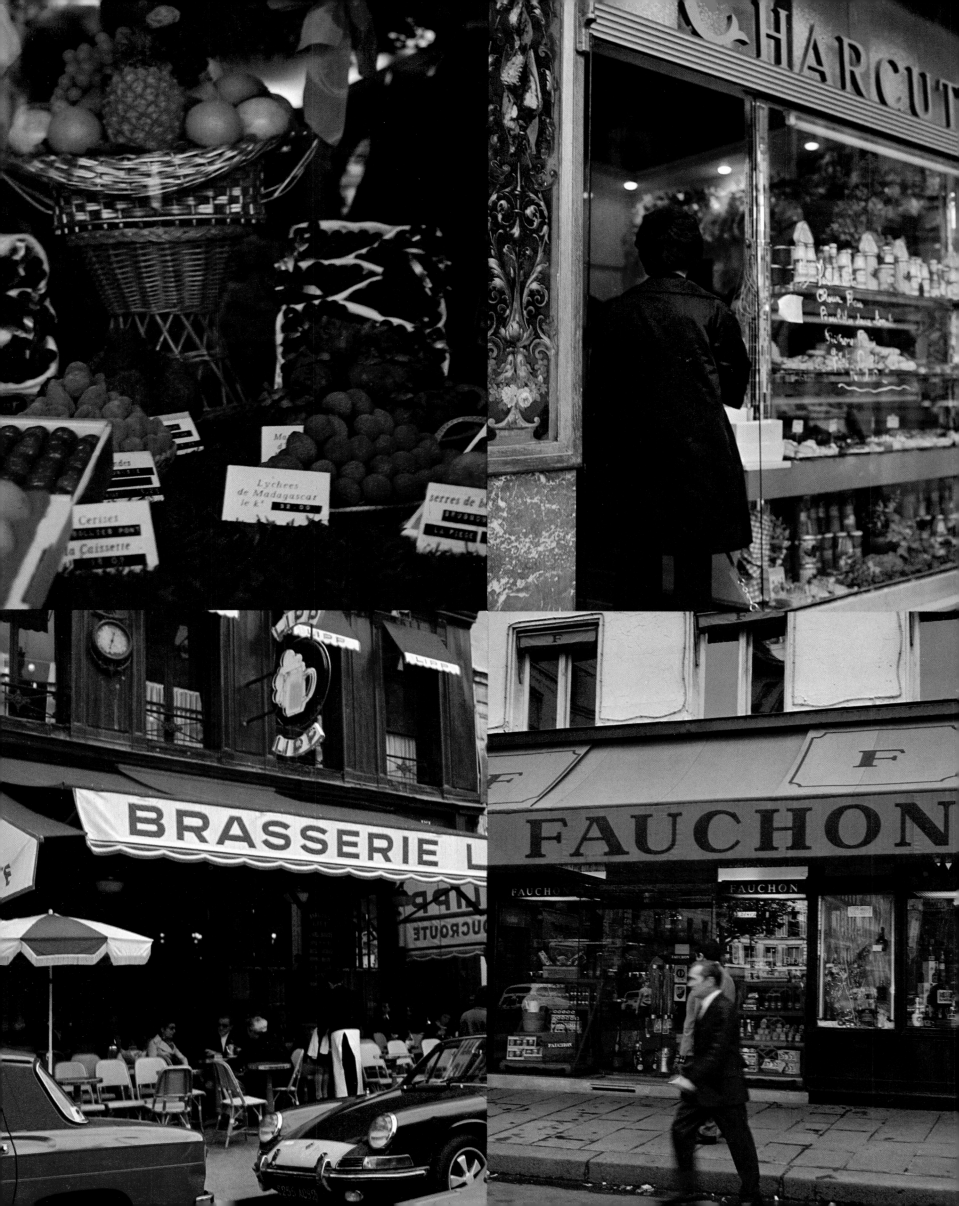

in these matters, ordered a cheap white Graves. Its deep straw color was pleasing to the eye. Even in this busy department store it was served with just a graceful allusion to a flourish. It was properly chilled against the midsummer heat. For the first time I tasted *wine*. It must have sent me into a mild catatonia for it was not until perhaps sixty seconds later that I seemed to hear my wife's voice say from far away, "You have the most peculiar, *foolish* smile on your face." "Do I?" was all I could reply. We may know we are happy when we do not know we are smiling.

And so the die was cast. I felt not so much that here was a new experience as that here was an old experience that had been waiting all my life for me to catch up with it. It was almost enough to make one credit Plato's crazy doctrine of reminiscence.

When one is young and has little money it is prudent to spend that little on the unnecessary, the emotional dividends being higher. We stayed six weeks in Paris and a large part of our budget went on wine that, I am proud to say, we could not afford.

By the time I had finished my tenth bottle in Paris and could tell claret from Burgundy without glancing at the bottle's shoulder slope, I had grasped a fundamental fact: that the pleasures of wine, being both sensory and intellectual, are profound. There are few pleasures of which this can be said.

The appeal to the senses may be simple; one can toss off a glass of a *vin de carafe* with mild pleasure, and so an end. But it *need* not be: there is wine available (nor should one drink too much of it) proffering a whole world of complex stimuli involving taste, color, and fragrance. Add to this the fact that one tastes a wine in several different ways, all involved in a single swallow, for this swallow leads a triple life: one in the mouth, another in the course of slipping down the gullet, still another, a beautiful ghost, the moment afterward.

This much I learned quickly. Nor have I ever tired of

And one wine in its time plays many parts, Its acts being seven stages.

The Christian Brothers Collection

18

learning it again and again. The sensory satisfactions of wine, varying with each sip, each bottle, each occasion, are so ramified that boredom is impossible. I know that T. E. Lawrence, hardly a well-balanced type, despised wine because he felt its gratifications were too simple. He preferred to discriminate, he declared, among varieties of water. For such refinements I lack the necessary sophistication, or perhaps merely the necessary puritanism. Water and milk may be excellent drinks, but their charms are repetitive. God granted them swallowability, and rested.

The intellectual attractions of wine are less quickly understood than the sensory ones. At twenty-three I did not grasp them at all, and thirty years later* am still but a grade school student. The fact is that, like philosophy or law or mathematics, wine is a *subject*, or what Arnold Toynbee would call an intelligible field of study. The easiest way to comprehend this idea is to realize that one can *talk* about wine, and on a dozen planes, from the simple one of an exchange of likes and dislikes, to more complex ones involving the careful analysis of sensations, together with such fields of inquiry as history, geography, topography, physics, chemistry, law, and commerce. Name me any liquid—except our own blood—that flows more intimately and incessantly through the labyrinth of symbols we have conceived to mark our status as human beings, from the rudest peasant festival to the mystery of the Eucharist. To take wine into our mouths is to savor a droplet of the river of human history.

The old-fashioned phrase, at once noble and jocular, "to discuss the wine" glows with meaning, just as no meaning would attach to a "discussion" of ice-cream soda or Coca-Cola, or any of those children's beverages which we grown-up Americans actually *drink*, giving the unsympathetic observer the same queasy feeling one gets from watching an adult playing with a rattle in a lunatic asylum.

*Written in 1957.

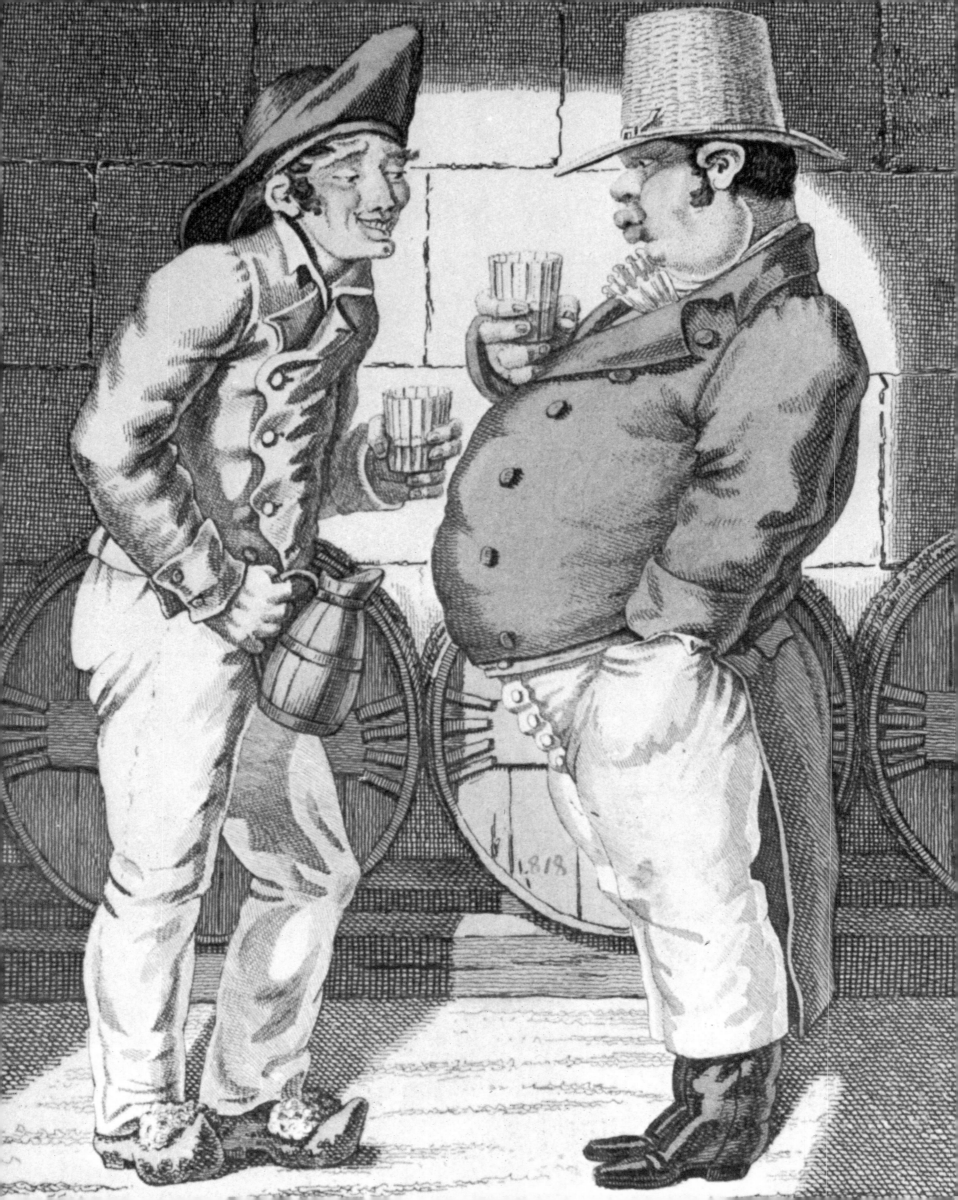

When [the wines] were good they pleased my sense, cheered my spirits, improved my moral and intellectual powers, besides enabling me to confer the same benefits on other people.

—GEORGE SAINTSBURY

Similarly, it is no accident that the subject of wine should have stimulated the thought of so many serious writers, from the greatest, such as Plato and Euripides, down through Peacock, Thackeray, Meredith to such rare spirits of our own day as Samuel Eliot Morison (who has written beautifully on port) and the late Hilaire Belloc.

These writers have done much for wine; but so powerful is wine that it can do as much for writers. Interesting, for example, is the case of George Saintsbury (1845–1933). By general consent his *Notes on a Cellar Book* ranks as the nearest thing in English to a wine classic. Saintsbury was by trade a historian and professor of literature, the author of perhaps half a hundred fat tomes of solid though often crotchety scholarship. He had apparently read everything in half a dozen languages. Yet nothing he wrote will last except a tiny volume that you may read in half an hour and savor for a lifetime. He put together *Notes on a Cellar Book* when he was seventy-five, many years after he had had to abandon serious wine drinking. The wines he discusses are virtually all from the nineteenth century, and you and I will never drink them. Yet, so vast is his knowledge, so accurate his memory, and so delightful his Tory wit, that this little collection of casual notes will be read when all his scholarship is dust. His character was as crusted as the port he prized, and character impinging on a miracle (wine is a miracle) may be one of the keys to the secret of literary survival.

I can think of another piece of wine writing that may, along with Saintsbury's, pass this final test. That is Hilaire Belloc's *Heroic Poem in Praise of Wine*, conceived at a Miltonic elevation. The seven words quoted from it that head this essay enclose more of life's heartbreak than will all this year's novels.

Civilized minds, such as Saintsbury's and Belloc's, turn to wine precisely because they *are* civilized; because wine is a civilizing agent, one of the few dependable ones, one that again and again has proved its life-enhancing properties. When you find a first-rate brain, like Shaw's, rejecting wine, you have probably also found the key to certain weaknesses flawing that first-rate brain. The Founding Fathers, if recollection serves, were all

Vintner to winebibber: "Well, how do you like it?" Early-nineteenth-century print by G. de Cari

The Christian Brothers Collection

21

wine drinkers; some subtle coarsening, a slight lowering of the national tone, made its entrance with Andrew Jackson and his gang of corn-liquor devotees. H. Warner Allen's claim may seem a trifle expansive, but surely not absurd: "Main Street would vanish if all its inhabitants drank half a bottle of wine with each meal."

As a subject one can as easily finish with wine as with Shakespeare. There is always more to be learned and therefore more to be communicated, for wine does not isolate but binds men together. As one drinks more and better bottles many mental processes are called into play—memory, imagination, judgment, comparison are but a few. Even volition is involved, as when one summons the will power not to acquiesce in the opinions of other wine drinkers, or refuses to be bluffed by the prestige of a year or label. At such moments one may even claim to be performing a moral act.

I believe these things deeply, just as, like any sensible person, I discount the abracadabra of wine: the excesses of connoisseurship, the absurdities of finicky service, the ceremonial of a hierarchy of glasses, the supposed ability of the expert to determine from a few sips which side of the hill the original grapes were grown on. One can make excellent love in a meager hall bedroom, the requisite elements being three: two lovers and a means of support. So with wine, the requisite elements being likewise three: a bottle, which may be a country-wench Rhône, surrendering at once its all, or a magisterial Romanée Conti, calling for involved investigation; a glass, preferably thin, clear, and holding at least half a pint; and a lover. (Perhaps I should add a corkscrew.)

But, because wine may be enjoyed without hoopla, that does not mean that care should not be taken in its consideration. Wine is elemental, not elementary.

This said, the time would seem to have come for a short, testy digression on those two opposed figures, the wine snob and the wine *sans-culotte*.

It is easy to make fun of the wine snob. It is also often good fun. Everyone recalls James Thurber's caption to his drawing showing one would-be connoisseur offering his dinner guests a glass of wine: "It's a naive domestic Burgundy without any breeding, but I think you'll be amused by its presumption." Such silliness exists, and should be laughed out of court. On the other hand a "wine snob" may simply be someone who knows more about wine than I do—I meet him frequently—and has not yet learned to convey his information tactfully or clothe

Wine break in the vineyards of Bordeaux

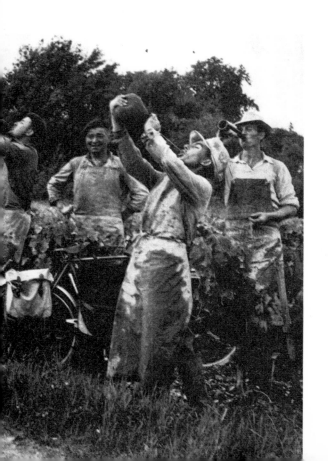

his enthusiasm in quiet English. But we must qualify further. Thurber's popinjay *is* a popinjay—and yet the word "breeding," which may seem affectation, has a fairly definite meaning. It is part of the slang of wine lore. A good Châteauneuf-du-Pape may boast a dozen excellent qualities, including its moderate price. Taste it, however, after a first-rate Latour and it is not difficult to sense that the claret is clothed in a certain unaggressive elegance to which the forthright Rhône makes no claim. The plain fact is that wine has personality. It is not dead matter, like a motorcar, but a live thing, like a human being or a page of fine prose. One must be wary of snob-calling: the inferior man is often known by the number of snobs he complains of meeting. The man who drools his comparative history of the major-league shortstops of the past twenty years is hailed as a fan. But he who knows something about "one of God's greatest gifts to man," in André Simon's phrase, is called a wine snob. A man who tells you in detail about his special-body motorcar is listened to with rapt attention. But one who writes with love about his magnum of Mouton-Rothschild '69 is a suspicious character, even though the car's body cannot compare with the claret's, even though obsolescence is built into the one as longevity is built into the other.

The wine snob at his worst is a bit of a bore and a bit of a fool. But at least he is a learned bore and a learned fool. The wine *sans-culotte* is a complete bore and a complete fool. He is opposed to a hierarchy of taste (even when it is patiently explained to him that this is not a fixed hierarchy) as his kin spirit is opposed to a hierarchy of political competence. So widespread among us is the notion that the only way to discover the right standard is to count the noses of those adhering to it, that even wine dealers, who know better, and writers on wine, who know much better, give lip service to such dogmas as "A wine is good if it tastes good" or "A good wine is the wine you like." Back of these statements probably lies the idea that they will make converts to wine by making wine seem as accessible, as "democratic," as orange pop.

Yet the very wine man who, for what he thinks sound commercial reasons, expounds this nonsense will spend a great deal of his time contradicting it by his actions. For he is constantly offering his friends, not the wine they will "like" or that he thinks they will "like," but simply the best wine he has, in the conviction that the palate is as educable as the mind or the body.

That the mind is educable may be questioned by those

leaders of American education who, having made the profound observation that the majority of children prefer play to study, are led by the iron logic of the count-noses theory to rebuild the curriculum around play. Such play is frequently disguised as "study": visiting pickle factories or learning how to answer the telephone. (In one school of my acquaintance this latter scholarly activity is part of a course known as Communication Skills.) That the body is educable, however, no good American denies. The duffer doesn't boast of his dufferdom. He doesn't say, "Well, I enjoy shooting over 100, therefore shooting over 100 is good golf." He does his best to reduce his score, because he *knows* there is such a thing as better playing than his own.

Perhaps I can make my point clearer by instancing a certain beverage that advertises itself on the car cards and subway posters of New York City as "the wine you can cut with a knife." Now it is highly probable that a great many people (who do not really want to drink wine, but *do* want to drink sugar) actually buy and like this bottled syrup. No one objects to this: the palate is a free agent. But it is not fair to say that because this peculiar concoction "tastes good" it *is* good. It may be a good *drink* (though on what grounds I cannot conceive) but it cannot be a good *wine*. And it cannot be a good wine because the capacity to be "cut with a knife" is simply not one of the qualities of wine. Such a quality is proper for honey or Turkish coffee or for other preparations whose characteristic charm lies in their syrupiness. But it is not proper for wine. You may object that a great Sauternes is sweet, or a fine port. I ask you to taste them and to note how perfectly balanced is the sugar, how lightly it lies on the tongue, to what *other* qualities it is married. I ask you also to remember that "the wine you can cut with a knife" is sold as a table wine, presumably for hearty consumption, whereas no one in his right senses would think of drinking over three ounces of a Château Yquem at a single meal.

The childish palate will *always* at first prefer the excessive or the unbalanced taste. Upon certain primitive African or Melanesian tribes you cannot confer a greater gift than a can of peaches. This does not make canned peaches a delectable food; canned peaches remain exactly what they are, no matter how many savages tell you they are superior to a *soufflé Grand Marnier.*

Few men can afford to drink only the best; and indeed no man should want to, for there is a certain monotony in excellence, as there is in mediocrity. But that need not hinder a man,

Brother Timothy and a gift of God. The cellar master of The Christian Brothers brings his expertise to the tasting of a wine

24

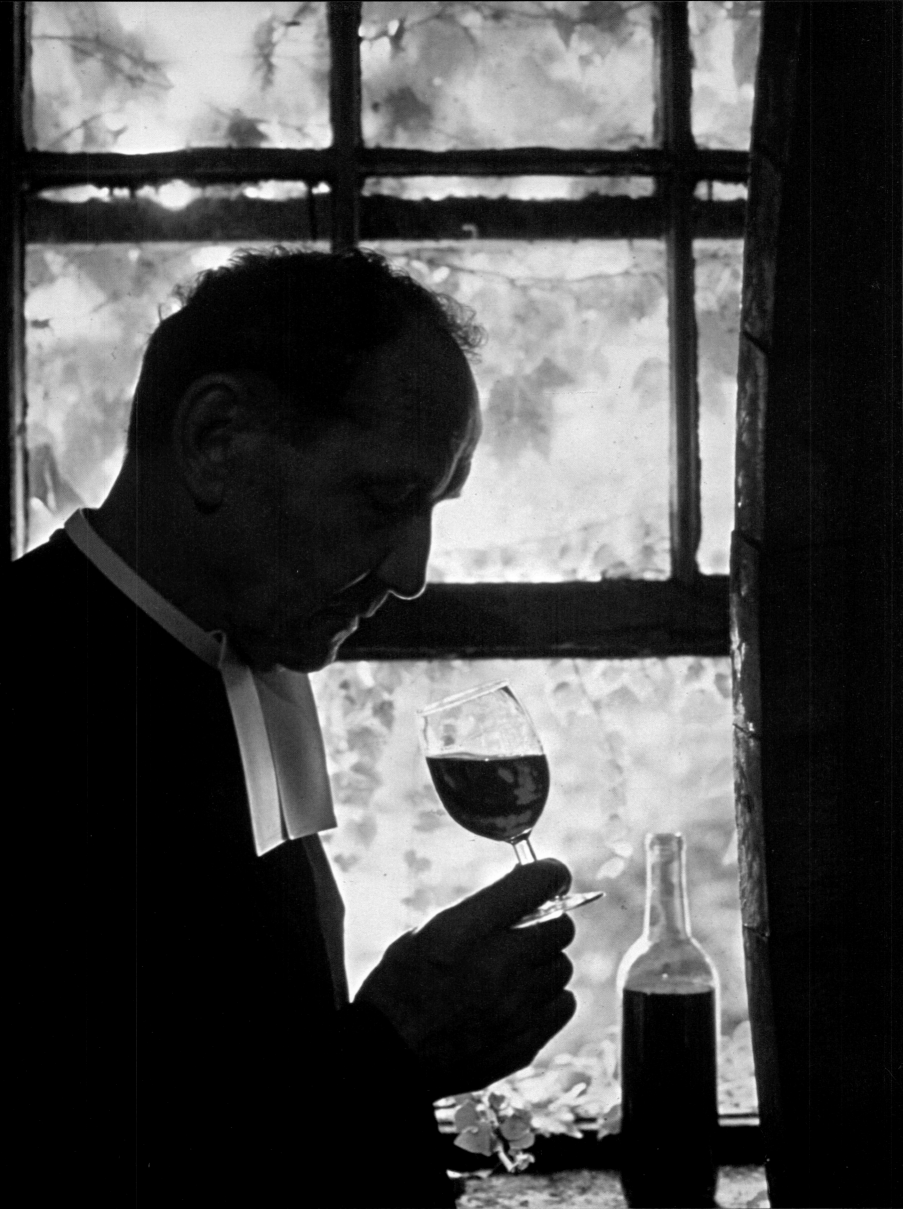

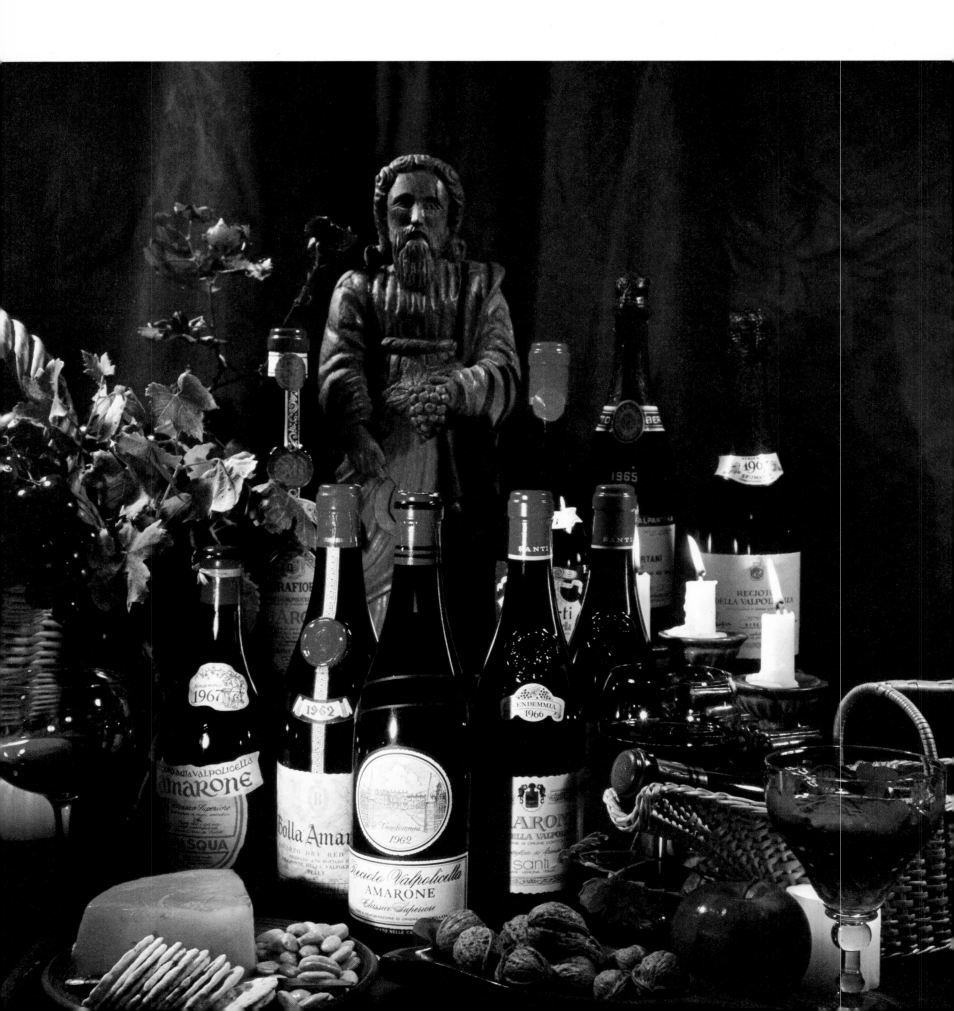

*In after-dinner talk,
 Across the walnuts and the wine.*

—TENNYSON

even as he sips his sound, cheap wine, from knowing that there are other wines capable of giving him, if he has paid any attention to his palate, rarer and finer pleasures. A wine is not good merely because I like it. It is perfectly possible however that I may like it because it is not good; in which case it is pointless for me to change the wine before changing myself.

These intemperate remarks off my chest, I return to the narrative of my small *affaire*. This narrative, as you must already have noticed, will not teach you anything. To learn about wine you must consult the manuals of the learned. I record here, not information, but merely the birth and growth of an emotion. The small store of knowledge I possess I did not begin to accumulate until about seven years after my return from Paris. During those seven lean years Prohibition played out its dismal tragicomedy. In 1933 I made the helpful acquaintance of Frank Schoonmaker, then a youthful amateur, now one of the greatest living experts, particularly in the subtle field of German wines. In a small way I helped to launch *The Complete Wine Book*, by Mr. Schoonmaker and Tom Marvel, one—and by far the best—of the flood of manuals released by Repeal. I even invested the sum of five hundred dollars in a wine-importing concern, lost every cent of it, and have no regrets. A visit to the beautiful Widmer winery at Naples, New York (where the hospitable Mr. Widmer laid out for us twenty-three wines on a broad open-air trestle table), made me aware of the treasures of my own country.

I learned that most of the few simple rules about drinking wine are not chichi but sensible conclusions drawn from hundreds of years of experience of intelligent men. I learned also that these rules are not inflexible. It is standard practice, and good practice, to marry Chablis to shellfish, but the best Chablis I ever tasted was a superchilled bottle drunk in defiant gulps, unaccompanied by any food, on a very hot day when I was very thirsty. One morning at 3 a.m., tired and famished after eight hours at my writing desk, I ravished the kitchen and ate two cans of unheated Vienna sausages on Vermont crackers, together with a whole bottle of Chassagne-Montrachet '45. Barbarous? Not at all—merely an instance controverting Robert Browning, with

> ... *the time and the place*
> *And the loved one all together!*

One can learn, not only from such accidental successes (lit-

Sons of the sun of Italy, blessed by Saint Vincent, patron saint of wine-growers

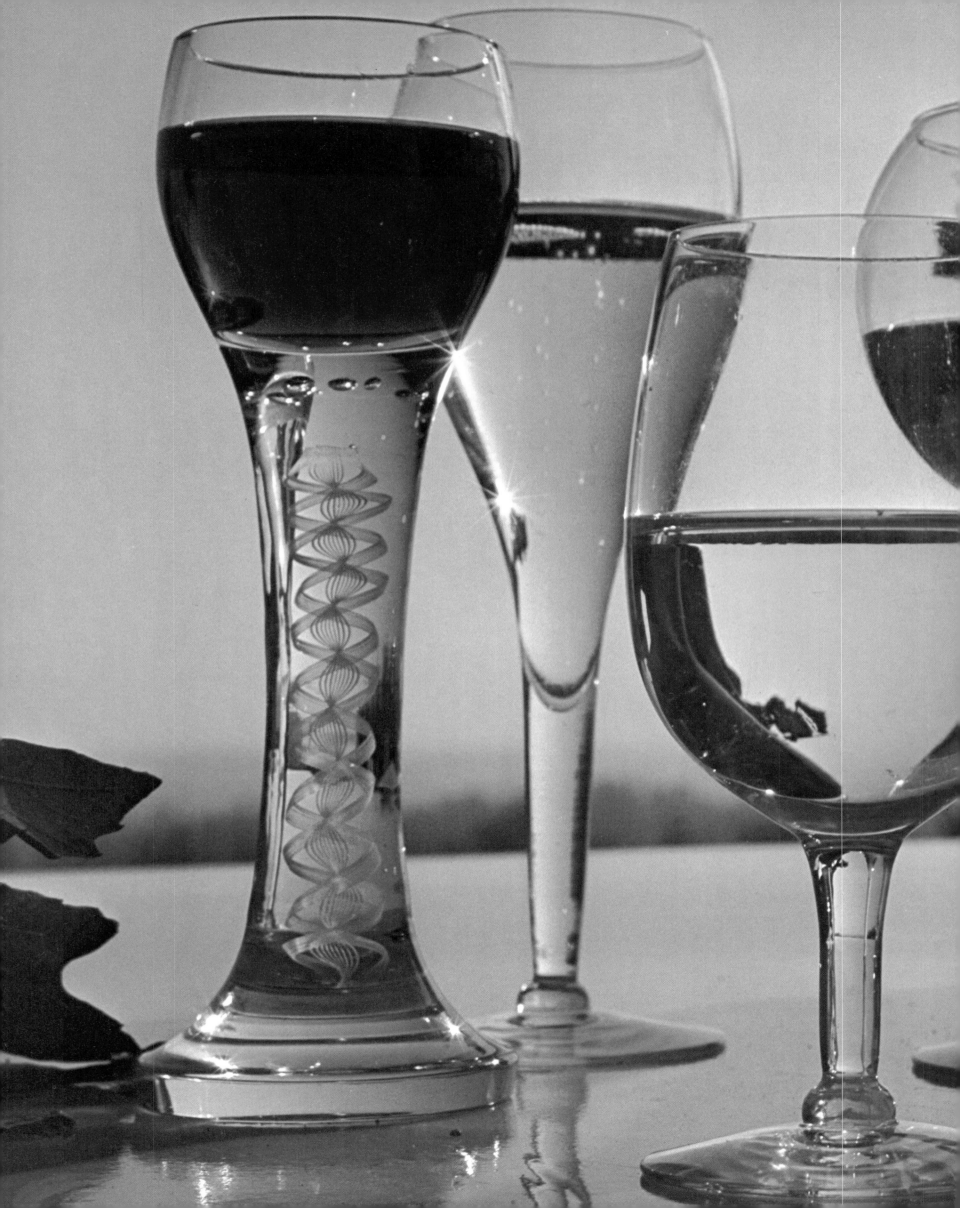

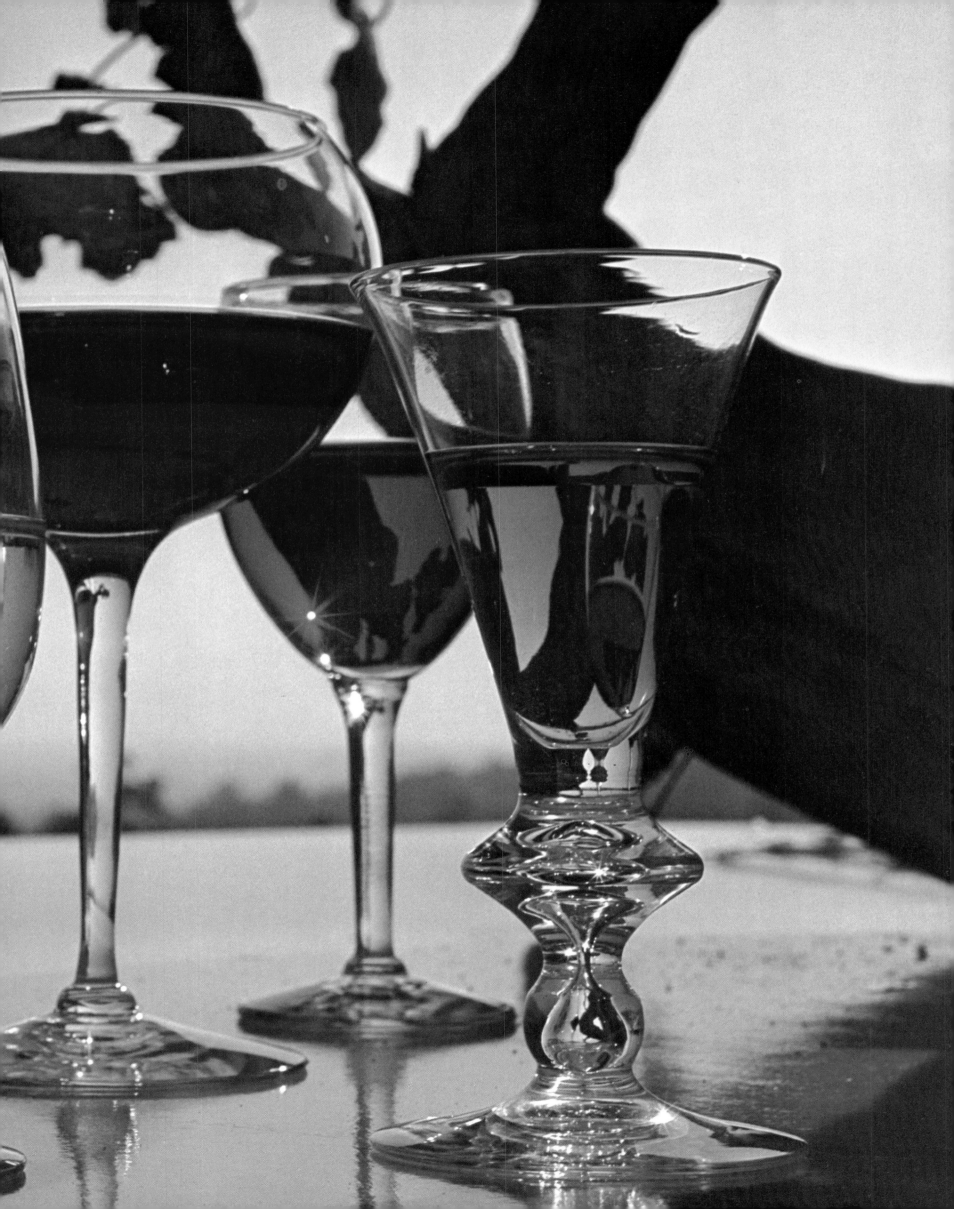

erally, *succès de fiasco*) but even from elaborate failures. I once attended a winetasting given by a gentleman whose reputation had been originally established on the football field, but who had graduated to higher things. With characteristic generosity he had assembled for us a dazzling collection of Rhines and Moselles, the finest labels and the most unbelievable years. The most recent of them belonged to the incomparable 1921 vintage; but others dated from 1915, 1911, and I think even from 1900 and 1893. They had been bought, in a fit of enthusiasm, from a single cellar; and, with one or two exceptions, the entire potentially heavenly collection had faded. They had not turned or decayed; but their hearts had stopped. Yet not one of us said so. We muttered, every cowardly man jack of us, some polite vacuity—and went on drinking these noble ectoplasms, admiring the naked Emperor's new clothes. It may have been that we felt a flood of sympathy for our host in his misfortune, but I cannot help remembering that he stood six feet two in his socks and could have demolished any seven of us poor indoor creatures at a blow. Even at such polite functions as winetastings one learns a good deal about human nature.

I suppose no account of a happy marriage can be, except to the participants, notably interesting. I shall hurry over mine. Repeal came at the end of 1933; hence next year wine and I will celebrate the twenty-fifth anniversary of our legal union. (Don't send silver; glass will do, with the proper enclosures.) The changing embodiments of my spouse have on occasion disappointed me: some, the termagants, developed an acid temper; the reputed charms of others faded upon consummation. Many were not worth the bride-purchase price. With still others, though good of their kind, I found myself, after a decent interval of connubial experiment, temperamentally incompatible. I shall never learn to love the lady known as Vouvray, for example, and I gladly surrender all rosé wines to their admirers. Yes, we have had our ups and downs, wine and I, our misunderstandings and our reconciliations, our delights and our discords. On the whole however I think of ourselves as a model couple: faithful, mutually solicitous, still ardent, and, in the case of the lady, well-preserved.

The record of our union is contained in my Cellar Book, the earliest entry being that of October 17, 1935, at which time I seem to have laid down a dozen Morey, Clos des Lambrays '29 at a price ($28) that today induces wistful dreams. "Quite beautiful" is the notation under "Remarks": vague phrasing, but from the heart. The day before yesterday I binned three

The Vintage, woodcut by Aristide Maillol

The Christian Brothers Collection

cases that for some years had been maturing their charms for my special benefit: Volnay, Clos des Ducs '43; Niersteiner Rehbach '43 (which may be *too* mature—it is such delicate uncertainties that give to wine drinking what hazards give to golf); and Piesporter Goldtröpfchen Schloss Marienlay '47. Between these two entries lies a third of a lifetime of adventures, each one drawn by the twist of a corkscrew from its horizontal torpor in the dim cellar to the vivid life awaiting it within the clear glass.

The drinking of wine seems to me to have a moral edge over many other pleasures and hobbies in that it promotes love of one's neighbor. As a general thing it is not a lone occupation. A bottle of wine begs to be shared; I have never met a miserly wine lover. The social emotions it generates are equidistant from the philatelist's solitary gloating and the football fan's gregarious hysteria. "Wine was not invented," says J. M. Scott. "It was born. Man has done no more than learn to educate it." In other words, wine is alive, and when you offer it to your fellow man you are offering him life. More than that, you are calling out more life in him, you are engaging in what might be called creative flattery, for you are asking him to summon up his powers of discrimination, to exercise his taste, or perhaps merely to evince curiosity or a desire to learn. I know no other liquid that, placed in the mouth, forces one to think.

That is why there are few better gifts to send a newly married couple than a case or two—or a bottle or two—of wine. It is not that, when drinking it, they will recall the donor—if you crave such vulgar satisfactions it is more efficient to send them a chair with a pair of spurs set in the upholstery. It is that, when drinking it, they will become more conscious of *themselves*, of their own capacity for joy. I doubt that you get the same result from a toaster.

It is for this reason that men of a wiser generation than ours left wine to their sons after their death. I cannot leave much, but I have carefully seen to it that I own more wine than I can possibly drink before I die. (This is not hard to do; forgo a suit of clothes—no man needs to buy more than one every five years or so—and you have the wherewithal for three cases.) What good will three thousand dull dollars, which can at best yield five or six percent, do my son as compared with a thousand inherited bottles of wine, guaranteed to generate cheer and laughter and good talk long after my last swallow?

But, if such considerations seem too rarefied, I retreat to my last line of defense, that of enlightened selfishness. I heard

*W*hat though youth gave love and roses,
Age still leaves us friends and wine.

—THOMAS MOORE

once, or perhaps read somewhere, that the palate is among the last of our organs to decay. I do not know whether this is so; I am not so great a fool as to hand over to the Inquisition of science a statement that has all the marks of a self-evident truth. Yes, our muscles give way at last to gravity's quiet, resistless pull; the best, the most joyful of our glands, in the end withers; the eye, the ear lose some of their fine quick power to seize upon the world; the limbs begin to ask What's the hurry? But I know men of eighty whose infirmities for the brief space of a bottle's emptying vanish as they sip their wine, their taste buds as lively as when they were one-and-twenty—nay, livelier. The pleasures of old age are few, but what one is more worthy of cultivation than a pleasure that the body, even in decay, can enjoy without enfeeblement, and judgment and memory still lift to the plane of the nonmaterial?

I turn the pages of my Cellar Book. Two lines, appearing toward the end of *The Waste Land*, slip unbidden into my mind:

London Bridge is falling down falling down falling down
. . .

These fragments I have shored against my ruins
. . .

The Frugal Repast,
etching by Pablo Picasso

32

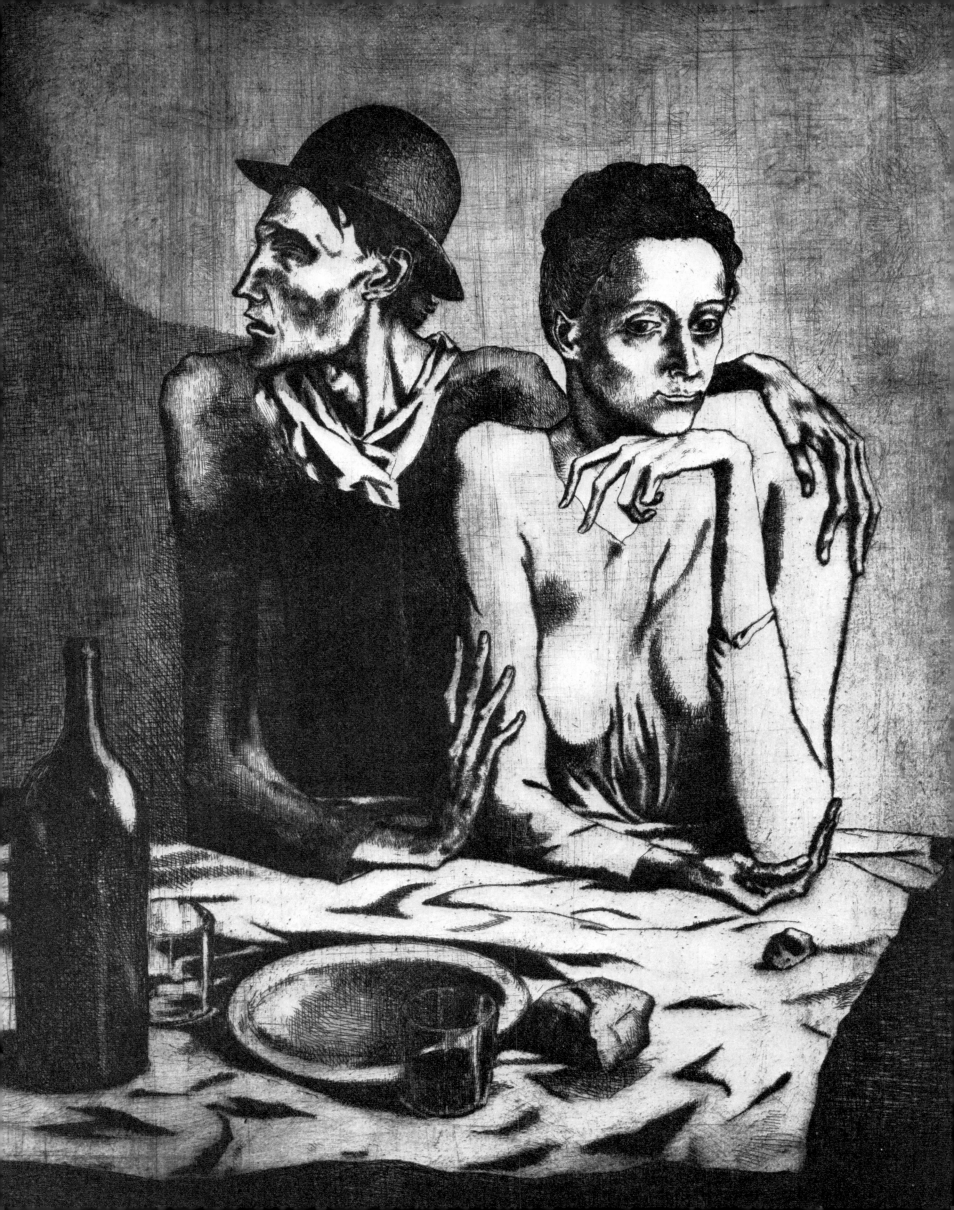

Rereading this love letter today I find its tone flushed and swollen at some points, ungenerous and defensive at others. Like some wines, it lacks balance. For example, in 1957 I seemed quite sure that "the worlds of wine and nonvinous spirituous beverages remain distinct." That sounds like a moralistic judgment. None was intended. I do not necessarily agree with Thomas Jefferson, who in 1818 said in a letter: "[Wine] is, in truth, the only antidote to the bane of whiskey." The issue turns rather on mental attitude. Neither wine nor hard liquor would be drunk unless they produced effects more interesting than those of milk. Generally speaking, we demand something from hard liquor: a punctual reaction. But we expect a wine of quality to demand something from *us*: a slightly intensified exercise of our senses, perhaps the endeavor of comparison, and finally the crystallization of judgment.

I no longer, as I did years ago, think Saintsbury a classic (though he remains a valuable fossil) and I perceive now that I mistook for wit what was at times mere cantankerousness. And while I would not change the enthusiastic reference to New York State wines, it is today clear what was not so apparent two decades ago—that the great potential for American wines lies in California.

The ungallant statement "I shall never learn to love the lady known as Vouvray" is a fair example of the sort of snobbery time and experience may mitigate. Vouvray often leans to sweetness. In 1957, I was conventionally rigid in thinking that, except with dessert, one should stick to dry wines. I now value Vouvray precisely for its touch of the dulcet, as well as for its open-air freshness and that occasional hint of secondary fermentation which gives it its distinctive character.

I am still trying to learn to like rosé wines. But the sweetness of most of them seems somehow superimposed rather than intrinsic. I am thinking particularly of a Portuguese rosé vastly popular in this country, perhaps in part because it comes in pretty bottles. Antique wine bottles possess a legitimate charm for collectors. But slick modern packaging seems an irrelevance. Wine drinking and interior decoration do make contact insofar as it is pleasant, though hardly mandatory, to drink from a clear, thin, well-designed glass or pour from a graceful decanter. Bottles, however, should be functional. Long ago my wife and I

were fortunate enough to be the occasional guests of a hostess properly renowned for her impeccable taste in decorative arts of all kinds, as well as for the exquisiteness of the food served at her table. The wine, however, was invariably the Portuguese rosé above mentioned; and I suspect that her choice was in part determined by the attractiveness of the container.

I would like also to qualify a certain dogmatic tone I detect in my 1957 reflections. I am still, as an amateur, intimidated, even awed, by the rhadamanthine judgment of Henri Murger, who declared that the first duty of a wine is to be red; or by the similar conviction that animates "Burgundy men" or "claret men." Yet today I am a little sorry for them too, as one might be for a citizen proud that he has always voted Republican or Democratic. To have preferences is natural enough, but the last couple of decades have taught me how much more rewarding it is to nurture an open mind and a catholic palate.

In my home town of Santa Barbara there is a Greek provisions shop that surprisingly specializes in exotic wines, moderately priced, from Greece, Yugoslavia, Corsica, Australia, and other places rather off the beaten track. Almost all the labels are unfamiliar to me. It is also true that, after trying certain of these wines, I would have been no less happy had some of the labels and the contents remained unfamiliar. On the other hand, I am grateful for a dozen new experiences, journeys into hitherto unknown wine worlds, little astonishments, minuscule enhancements of life. Chilean whites, for example, represent for me, as for thousands of others, a pleasing discovery; and I have even learned to appreciate the odd sensation that resinated Greek wines confer on the palate. What a charitable provision of God or physiology to design our palates so that they remain, one hopes to the very end, not only educable but eager for education.

As I look back upon 1957, I think, too, I am changing my mind about leaving wine to my heirs and assigns. I have come across an acrid injunction by the Roman poet Martial: "Never think of leaving perfume or wines to your heir. Administer these yourself and let him have the money!" I have no opinion about perfume, but Martial may be right about wine. Besides, as the Internal Revenue Service conveniently sees to it that most of us can leave very little cash in any case, I might as well make a clean sweep, do my best to enjoy what bottles remain, and let the next generation enjoy the satisfaction of starting its own collection.

"One day, Son, a little of this will be yours."

The penultimate paragraph of the essay was written in anticipation, when I was a mere child in my fifties. It sounds as though I were looking forward to becoming a senile toper. Experience has made me notice certain cautionary signals. Therefore I have learned to drink less wine, and in the process learned what I think I did not know then, that a single glass, rather than a half-bottle, can give a sufficient pleasure. Wine can be too easy to drink. That "little extra" may dull the honed edge of enjoyment.

Age brings to the wine drinker a certain increased independence of judgment. I am less awed by labels than I was a score of years ago. I no longer will myself to see qualities in a wine that are not really there. To this end I have been helped by my son and daughter, to whom years and labels mean little, and who assess with candor, even brutality, whatever wine is given them. Such reactions are not only the prerogative of youth but on occasion instructive to their tradition-bound elders.

The fact is, however, that the more wine experience we have the more apt we are to relax our dogmatism and increase our stock of appreciation or simple tolerance. Certain modest wines with which in 1957 I was quite unfamiliar now give me pleasure, such as Quarts de Chaume and other wines of the Loire. At my age discoveries are rare. I came upon Quarts de Chaume only a few months ago, as these words are written, and found its fresh, balanced, reticent sweetness a small delight. We drank it (this will horrify formalists) with roast pork, and they married well enough.

I have learned, while still generally respecting them, that I may on occasion disobey many traditions associating certain

36

wines with certain foods. For example, just recently my son created a fine mess of spaghetti accompanied by his own patented sauce, vaguely resembling Bolognese with a powerful admixture of mustard. Instead of the conventional Italian red we decided to try a fresh Wiltinger. Curiously enough, this cold, light, slightly sweet white wine cut the heaviness of the sauce and indeed went very well with the spaghetti. Elsewhere in this book you will find listed a number of traditional wine and food alliances. But these marriages are made on earth, not in heaven, and may be dissolved without special dispensation.

On the whole, however, I find that the passage of the years has not changed the radical emotion that gives the early essay whatever interest it may still possess. If more decorously, I remain in love, now a Philemon rather than a Romeo, but still convinced that wine is more than a mere beverage, that it is one of the indices of civilization, and therefore worthy of life study.

This book is called *The Joys of Wine*. Thanks to the happy design of our sensory equipment, these joys are partly animal. But they are also of the mind. The tradition, for example, linking wine and sociability has remained unbroken for three millenniums and is recorded in thousands of poems, stories, legends, myths, and historical anecdotes. The conversational level of any culture depends of course on many factors, of which wine is surely one. With the high culture of France we normally associate wine and, with it, conversation. The evolution of the café and the elaborate attention given to restaurant-going among middle-class Frenchmen point to the connection linking food, wine, and talk. Perhaps the Laplanders, who do not drink wine, have developed an art of conversation, but no evidence supports the idea. My own recollections suggest that American conversation assumed its most banal form during the Prohibition period and my hope is that as we become more and more habituated to wine American conversation will begin to revive.

One ponders the old-fashioned phrase "to discuss the wine." One may discuss anything, of course. But wine, when drunk seriously (though it need not be), seems to make a tacit request: Talk about me. Just as fine music, almost between the notes, appears to be forming some tantalizing statement which one feels *ought* to be verbalized, so a fine wine makes statements not to be summed up in simple expressions of pleasure or aversion. There is often a moment in the drinking of a glass of wine (and it need not bear a patrician title) when it suddenly

talks to you. This may not occur on the first few sips; but there is a split second when the wine announces its character or personality or essence (you see, there are no words) and your palate receives, comprehends, and replies to the statement.

It is the baffled effort to explain this statement to others that sometimes produces high-flown, imprecise, or esoteric wine talk. It is charitable not to judge such talk too skeptically. It need not be phony. On the contrary, it is more often sincere—but inadequate. Aware of its inadequacy, we persist in discussing our wine, perhaps because it is in the nature of man to want to communicate to others his sensations of pleasure. To talk about joy is another joy.

In this connection the classic anecdote (it concerns brandy, but no matter) goes back to that wellspring of anecdote, Talleyrand. It is recalled in Robert Balzer's *The Pleasures of Wine*, a book as charming as it is informative.

> The story is told that at the conclusion of one of Talleyrand's feasts, when a fine Champagne brandy of great age and distinction was served, his guest took up his glass and downed the liquid in one gulp. The celebrated host, not unmindful of his position, was startled into perceptible amazement. "Oh! my dear Sir!" "What have I done, Monseigneur?" "Well, Sir, since you ask me, let me tell you that a fine Champagne of that age and quality deserves to be appreciated." "Doubtless, Monseigneur, but I am one of the uninitiated." "Well, Sir, one can learn. . . ." "With pleasure, Monseigneur. Would you vouchsafe to instill the first rudiments?" "Willingly," replied Talleyrand. "Thus, one takes one's glass in the hollow of one's hand, one warms it, one shakes it and gives it at the same time a circular movement, so that the liqueur may liberate its scent. Then one lifts it to one's nose, one breathes it in. . . ." "And then, Monseigneur?" "And then, Sir, one puts one's glass down and one . . . talks about it. . . ."

To love wine is not difficult; and to talk about what we love is but to do what comes naturally. Remembering the phrasing of Thurber's cartoon, however, I am rather amazed than amused by my "presumption" in actually setting down in cold print these thoughts on wine. For what can I say that has not been better said by a vine-wreathed procession of better thinkers and better drinkers?

That procession winds back into prehistory. Perhaps the world's oldest creation myth is the Sumerian epic of Gilgamesh, which may date from the third millennium B.C. Here we meet Enkidu, a "wild man" who is humanized and civilized when a temple harlot gives him wine to drink. Greek mythology has as

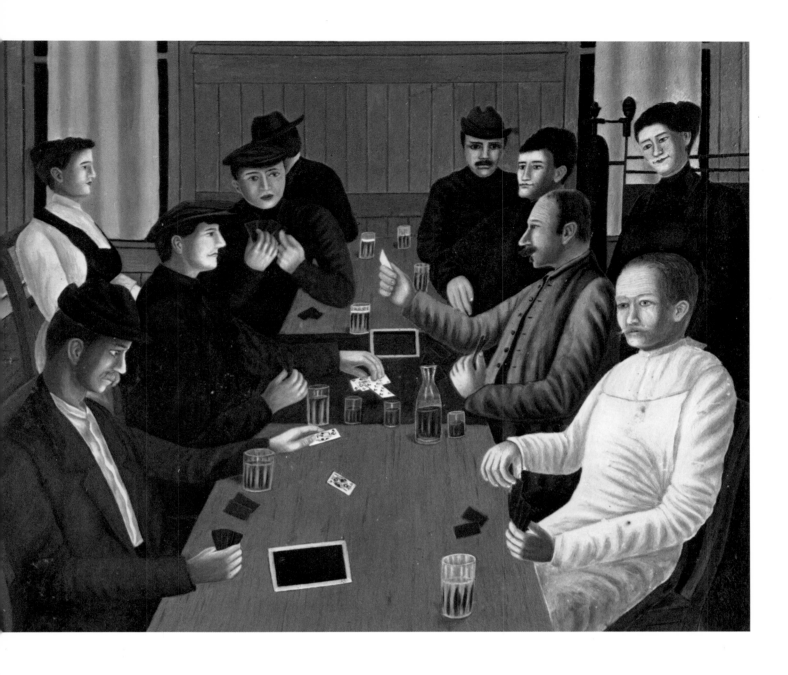

"The tradition linking wine and sociability has remained unbroken for three millenniums." *In the Tavern,* painting by Adolph Dietrich

one of its central figures the god of wine, Dionysus, and out of the rites of Dionysus emerged the drama of the western world. But, in quest of literary pedigrees, it is always safest to start with Homer. We do not know who Homer was, whether a single person or a syndicate. We do not even know whether the author of the *Odyssey* was a man or, as Samuel Butler argues, a woman disguising herself as Nausicaä. But we do know that the Homeric books, at the dawn of our literary tradition, abound (striking an occasional monitory note) in praise of wine. For that other great spring of Western culture, the Bible, the vine is a fundamental symbol. Indeed, from Hebrew legend we may infer that the tree of knowledge was the vine; and the Saviour declared "I am the true vine." One recalls the terrifying image in Revelation, "the great winepress of the wrath of God." But the Bible can descend from such pinnacles of symbolism. It speaks again and again of the very grape itself, and, though caution is expressed in "Look not upon the wine when it is red," the balance comes down decisively on the side of joyful laudation. Indeed one may interpret Noah's planting of the

first vineyard, on Mount Ararat in the Caucasus, as one of the great archetypal myths man has created to emblem the beginnings of civilization.

It is in such giant footsteps that a contemporary praiser of the joys of wine must set his miniature feet as he inscribes his miniature footnotes. His hesitation increases as he recalls a whole literature of wine accumulated since ancient days. It is not a systematic literature, any more than wine drinking is a systematic art. Though vast as the Heidelberg Tun, which held the equivalent of 245,000 bottles of wine, the literature boasts no single imaginative masterpiece devoted entirely to our theme. That theme is diffused, like a vital moisture, through thousands of pages, with certain writers, such as Horace and Anacreon, giving it special prominence. If we alphabetize a mere dozen of those classical writers who have celebrated wine, we come up with Aeschylus, Alcaeus, Anacreon, Aristophanes, Callimachus, Catullus, Euripides, Galen, Horace, Plato, Pliny the Elder, Sappho. Some of their ancient utterances will be found in this book. In Plato's *Symposium* we overhear Socrates discoursing as eloquently on wine as on love. He was among the first to note, as a philosopher, that of all the curious actions of which our bodies are capable, the two that feed the imagination most richly are the making of love and the drinking of wine. Then there is Euripides' last play, *The Bacchae*, mingling sexuality, intoxication, and the sacral: a mystery play about wine. Yes, the literature of antiquity glows and flows with wine.

Pass now to the Christian Era. St. John Chrysostom, not to mention other Church fathers, reminds us that vinous cheerfulness lightened the alleged gloom of the Middle Ages. In one of his *Homilies*, the good father argues well:

I hear many cry when deplorable excesses happen, "Would there were no wine!" Oh, folly! oh, madness! Is it the wine that causes this abuse? No. It is the intemperance of those who take an evil delight in it. Cry rather: "Would to God there were no drunkenness, no luxury." If you say, "Would there were no wine" because of the drunkards, then you must say, going on by degrees, "Would there were no steel," because of the murderers, "Would there were no night," because of the thieves, "Would there were no light," because of the informers, and "Would there were no women," because of adultery.

Equally logic-tight is the medieval German syllogism: "Drink wine, and you will sleep well. Sleep, and you will not sin. Avoid sin, and you will be saved. *Ergo*, drink wine and be saved." Wine also surfaces riotously in the drinking songs of

"And Noah began to be a husbandman, and he planted a vineyard . . ."
Portion of fresco by Benozzo Gozzoli in the Campo Santo, Pisa

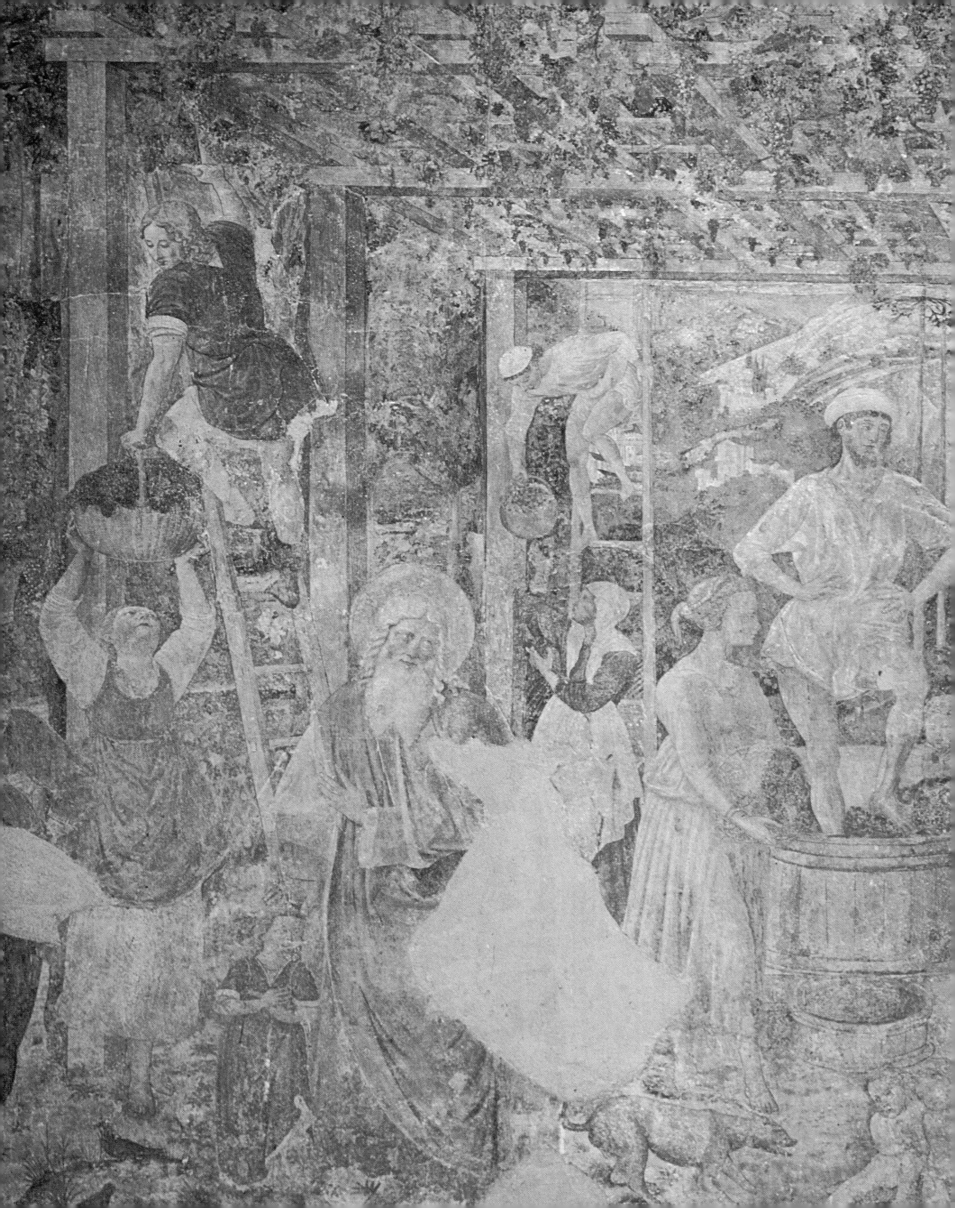

the goliards, those wandering students of the twelfth and thir-teenth centuries whose counterparts exist in our own time.

As we travel onward the writer-celebrants become too nu-merous to mention. Let us nonetheless mention a few: Chaucer (whose father was a vintner), Luther, Shakespeare, Milton, Mar-vell, Rabelais, Herrick, Ben Jonson, Pepys, the earlier Samuel Butler, John Gay (his very first poem was entitled *Wine*), Sam-uel Johnson, Ben Franklin, Peacock, Goethe, Scott, the dyspep-tic Carlyle, Byron, Keats, Tennyson, Matthew Arnold, Dickens, Emerson, Flaubert, Balzac, both Daudets, the elder Dumas, Longfellow, Meredith, Baudelaire, Stevenson, Colette, Chester-ton, Belloc, Hemingway . . . to list a mere scatter of the noble dead.

When we reach our own time the emphasis rests on the lit-erature of knowledge. Perhaps never in the history of the sub-ject have we had so many painstaking and authoritative books *about* wine, many of them listed in our Bibliography, page 436. But the literature of power (to recall De Quincey's familiar distinction) is not unrepresented. Good novelists such as Alec Waugh have written memorable pages. One of the finest of our poets and critics, William Empson, calls his longest poem *Bacchus*. With proper seriousness it considers wine simultane-ously on three levels: the experience of drunkenness, the myth of Bacchus, and the actual processes of fermentation and dis-tillation.

These names are all of the West. My parish-pump illiteracy prevents me from matching them with Eastern names. But we at once recall that *The Rubaiyat* is built in fair part on the wine theme:

> *I often wonder what the Vintners buy*
> *One half so precious as the stuff they sell.*

The *ghazals* of Hafiz, Persia's greatest lyric poet, celebrate wine. His line lingers in the memory: "On turnpikes of wonder wine leads the mind forth." There is a Chinese poet, antedating Homer, one of whose quatrains has survived for thirty-two cen-turies:

> *The dew is heavy on the grass,*
> *At last the sun is set.*
> *Fill up, fill up the cup of jade*
> *The night's before us yet.*

There is Li Po (c. 701–762), generally considered one of the great poets of the classic T'ang Dynasty. We do not know that

he was a connoisseur, but we do know that he was an assiduous wine drinker, drinking perhaps not wisely but too well. There is the fourteenth-century Japanese essayist Kenko Yoshida. And there are doubtless hundreds of Oriental writers whose native vintages may puzzle our Occidental palates but whose enophilia talks to ours.

So: Is there anything more to say? An empty question. For, whether there is or not, men and women will persist in writing about wine, and on planes other than the purely informative. Perhaps the urgency is all the stronger precisely because the pleasures of wine have never generated a dependable rhetoric or vocabulary. In this respect wine drinking is like music or mysticism. All three are in the end inexpressible in words, yet all three have developed considerable literatures. It is perhaps the very difficulty, even impossibility, involved in describing a venerable Latour, or the statement somewhere threaded through one of Beethoven's last quartets, or the sensation of union with the Divine, that has made wine lovers, music lovers, and God lovers try so ardently to communicate the incommunicable.

Thornton Wilder once described literature as the orchestration of platitudes. That circumstance has never deterred serious writers. So is it with the smaller matter of setting down one's meditations on wine. Perhaps we do little more than pour old thoughts into new bottles. But it is not the pursuit of novelty that makes men write about wine. The spring of their action is rather a tribute to wine's power to suggest one more reordering of one's thoughts. The literature of wine is not rich in new insights, but in mutations of reflection and feeling. From Homer to the next wine book you read this impulse is reflected. As long as there are glasses to fill and empty, so long will men persist in ringing changes on a traditional theme.

It would be affected to deny that wine's central attraction lies in the simple drinking of it. Yet inasmuch as Coleridge's "streamy nature of association" is part of the very fabric of our minds, many of our simplest activities are enhanced because we cannot help linking them to often only remotely related feelings and ideas. I own a single bottle of Château Latour 1955. When I drink it, it will taste—as it will taste. Yet even if time has not been kind to it, it will gain in interest by the merest fraction of a fraction when I recall that this very vintage was the favorite red wine of de Gaulle. In the same way I am glad to know that Churchill was insistent as to champagne: it must be Pol Roger.

*burgundy for kings,
champagne for duchesses,
and
claret for gentlemen.*

—FRENCH PROVERB

The claret now called Rausan Ségla was, under a slightly different name, a wine Thomas Jefferson liked to import. This prejudices me somewhat in Rausan Ségla's favor. The well-known expert Cyril Ray, editor of *The Compleat Imbiber*, felt the same way about Bardolino once he discovered that Max Beerbohm drank a daily glass of it at teatime in his villa in Rapallo. Lovers of Orvieto and art will rejoice to learn, also from Mr. Ray, that Signorelli, working on his frescoes in Orvieto cathedral, exacted as part of his contract an unlimited supply of the grapes from which Orvieto is made.

Stories that link wine to famous artists are legion. I submit two from the world of music. The first is from Artur Rubinstein's autobiography, *My Young Years*. He is recalling an anecdote told him by a famous woman pianist who had known Brahms well. A great wine connoisseur once invited Brahms to dinner. " 'This is the Brahms of my cellar,' he said to his guests, producing a dust-covered bottle and pouring some into the master's glass. Brahms looked first at the color of the wine, then sniffed its bouquet, finally took a sip, and put the glass down without saying a word. 'Don't you like it?' asked the host. 'Hmm,' Brahms muttered. 'Better bring your Beethoven!' "

And then there is the pleasant story of Gluck, who was once asked which, of all the good things life could hold out to a man, he most loved. Without hesitation came the reply: "Money, wine, and fame." Asked to explain this puzzling choice, he replied: "Nothing could be more natural. With the money I can choose and buy the wines. The wine awakens my genius. And my genius wins me fame."

For some reason wine is almost as strongly associated with doctors as with artists. Rabelais was a doctor who chose as the central symbol of *Gargantua and Pantagruel* the Divine Bottle. In our own day there flourishes in San Francisco a vigorous Society of the Medical Friends of Wine which regularly holds extraordinary and very well attended banquets. It is true that most doctors are convinced of the medicinal effects of wine, properly used, agreeing with Louis Pasteur's dictum, "Wine is the most healthful and hygienic drink there is"; but the affinity goes beyond this professional interest. There is a deep mystery

here worthy of examination. At the few wine dinners I have attended those who speak most interestingly about wine (omitting the professionals, of course) tend to be doctors. Occasionally medico-vinous enthusiasm is carried to unusual heights—or depths. I have read somewhere of one French physician who advises, for the compounding of an effective enema, a 25 percent infusion of Beaujolais.

Wine need not relate to a historical character. It may be associated with those sometimes realer personages invented by novelists and playwrights. Devotees of Simenon will recall how frequently Inspector Maigret, faced by a puzzling problem in detection, will drop into a café and thoughtfully sip a glass of cheap white wine. One somehow feels it will do him good, it will help toward the solution of the crime, it is a gesture reassuring to both Maigret and the reader. For me a white French *ordinaire* is Maigret-flavored. More generally, French literature as a whole is wine-flavored, reflecting one of the basics of ordinary French life.

In 1957 I wrote: "To take wine into our mouths is to savor a droplet of the river of human history." The phrase is a shade orotund. Yet it embraces a truth. As one ages and the past looms larger in the imagination, that truth is touched with an added emotion. If one is lucky enough to be able to taste an old Madeira (only recently some 1830 Sercials were still purchasable), memory may relay a message to the palate recalling that Madeira was for a time almost our national wine, favored by the great pre-Revolutionary families of our seaport cities, by our Founding Fathers, and indeed by the gentility well into the late 1800s. A sip of Ausone can send the mind roving back a millennium and a half to the Roman consul-poet Ausonius, who recalled, as he looked up at the Moselle vineyards where he was then stationed, his dear "native land, dedicated to Bacchus. . . ." The excellent dry Graves called Château de la Brède may remind us that in this château Montesquieu, of a family of wine-growers, wrote his influential *De l'Esprit des lois,* one of the roots of our own Constitution. The wine is still produced by his descendants, who own the moated château. (From report, however, Montesquieu was a dull and stingy host.) For lovers of literature sherry has a Ruskinian flavor; it was the elder Ruskin's success as a wine merchant that subsidized his genius-son's entire career. The classic anecdotes recur almost automatically: our glass of Clos de Vougeot announces, as we raise it to our lips, that when Napoleon's army passed this great vineyard, the

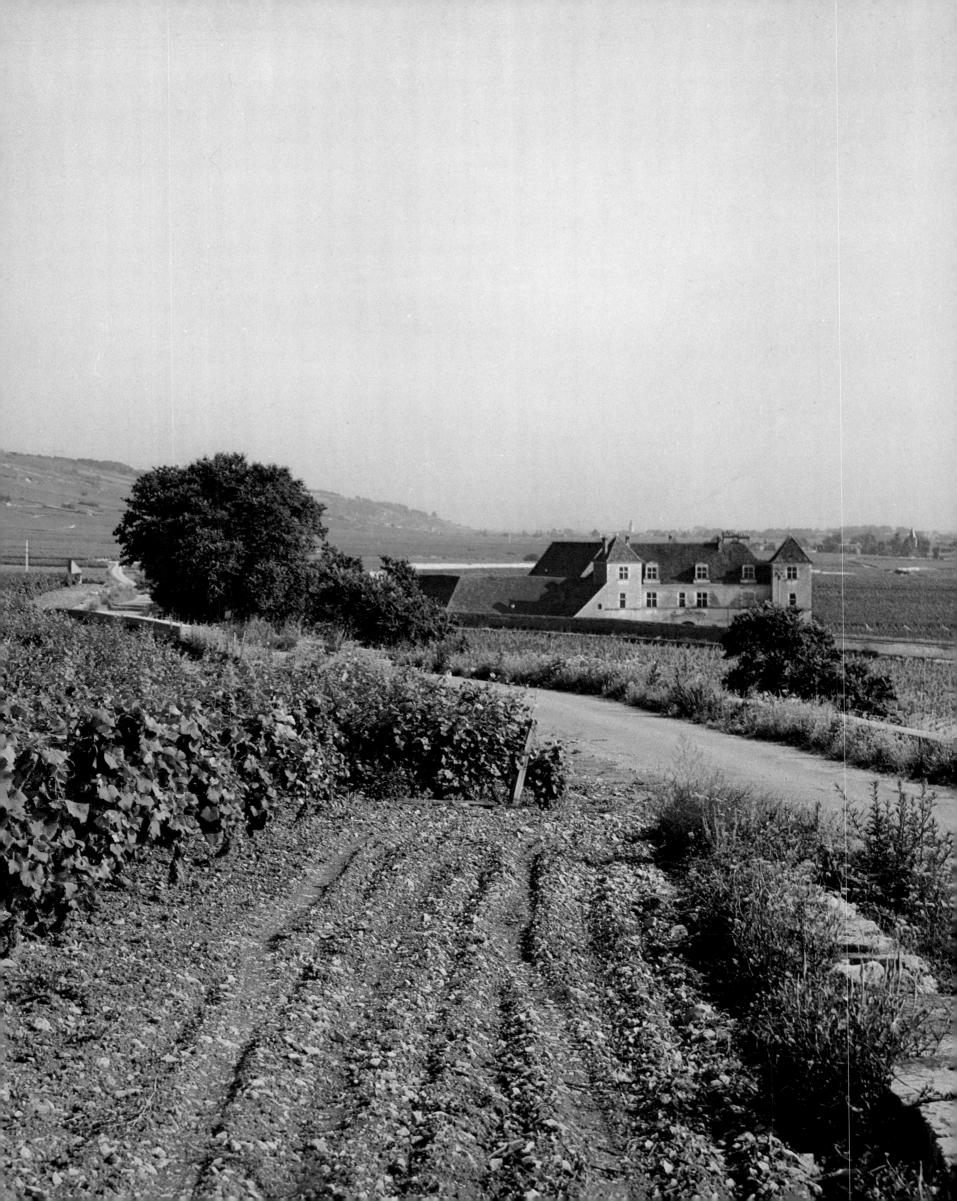

commanding officer ordered the men to present arms, adding, "My children, it is to protect these beauties that you go to fight." There have been more idiotic defenses of man's supreme idiocy.

We shall never be quite sure how much our present appreciation of claret owes to the simple historical fact that the Scottish Jacobites, to show their sympathy with "the King over the water," drank claret partly as a gesture of loyalty. Scotland ever since has been claret-land par excellence; just as (perhaps reflecting the brilliant centuries under the Dukes of Burgundy's rule) Belgium seems to have the most enthusiastic palate for fine Burgundy.

In London there is a colossal building which at one time housed the Board of Trade and the Air Ministry. Set deep in its foundations is the vaulted wine cellar of Henry VIII. To preserve this cellar the whole substructure, weighing one thousand tons, was moved. Part of this piety is a bow to conventional history, for Henry VIII is a great name. But I wonder whether the English would have used their engineering skill in the interests of historical preservation if the cellar of Henry VIII had been employed for purposes other than the storage of wine.

These are but relatively modern instances of wine's power to connect with history, and thus to give us that quiet joy which comes of the sense of continuity. When we drink wine we are bonded with our ancestors of untold ages ago, with our fellow drinkers of ancient China, India, Egypt, and Persia. (Shiraz, in the mountains of Farsistan, is thought by some to be wine's original homeland.) We may recall that in the thirteenth century B.C. the Chinese knew how to distill their special brandy from rice wine. To traverse Portugal's Douro region is to tread ground on which wine has been made for two thousand years. Drinking, we toast men and women who lived and slaved in Memphis four thousand years before Christ. Wine means the ritual four cups drunk to this day by those Jews who annually celebrate the Passover, commemorating the Exodus. Wine means ancient Phoenicia, the rites of Dionysus, the bacchanals of Rome, wooded antique Gaul, and the Rhine and Moselle valleys of long ago. If we are sharing a bottle with a beloved, long-dead Martial may come to mind, with his desire "to kiss lips moist with old Falernian."

And, with the rise of Christendom, wine and the Church are linked, not only in ritual and mystery, but in the most practical way. The monks and abbots of the Middle Ages helped to preserve not only the learning of the classic age but the similar-

Clos de Vougeot,
château and vineyard in Burgundy

47

ly civilizing culture of the vine, a tradition that has not died out in the Church of our own day. Thus I am grateful, when I drink the wine of my state, California, that in its career the Jesuit missionaries play a noble part, especially the great eighteenth-century pioneer Father Junípero Serra, who built a chain of missions of which vineyards were an essential constituent.

The mind monopolized by Now is arid, wanting irrigation. Wine, impalpably binding us to history, acts as a countervailing force. Wine de-provincializes us not only in time but also in space. True, there is a special satisfaction in drinking, close to the vineyard, those stay-at-home wines that refuse to travel, just as corn fresh-picked from the field has its own unrivaled savor. But there is another, equally valid satisfaction that comes of drinking wine associated with another country, another culture, than one's own. The standard example, perhaps, is port.

Whenever I drink port I feel a slight vibration of guilty pleasure, as of an invisible man trespassing unchallenged on territory not his own. It is a little akin to the private joy of poaching. For to taste port is to taste a tiny atom of England and her past. Though a Portuguese wine, now happily spread throughout much of the civilized world, port remains an English drink. It sheds its ruby or mahogany glow over much of England's literature, history, converse, and manners. It has become a symbol of a certain British cast of mind. When I drink it, whether it be a modest table port or, rarely, a true vintage port, I am for a split second a small fraction of an Englishman.

Vintage port is an Anglo-Portuguese invention, and famous English names to this day appear among the membership of the Guild of Exporters of Port Wine. Indeed, to a fortunate collusion between Portugal and Britain we owe the rediscovery of a long-lost secret, or rather mystery: the mystery of aging ageable wine in glass, just as the ancient Romans seem to have matured it in air-sealed earthenware pots. Ever since the Methuen Treaty of 1703 England has been involved in the creation, distribution, and, most of all, the ingestion of port. No slight is intended to the genius of the native growers and shippers. It is merely a fact that history and English taste have combined to make port, of many levels of excellence, bound up with England, notably throughout the nineteenth century.

Readers of Huysmans' *A Rebours* will recall the passage in which Des Esseintes, a *fin de siècle* devotee of the enhancement and derangement of the senses, prepares for a visit to England. In Paris, he enters the "Bodega," a wine cellar fre-

"The rites of Dionysus, the bacchanals of Rome . . ." *A Young Bacchant*, bronze by Jean-Baptiste Carpeaux

48

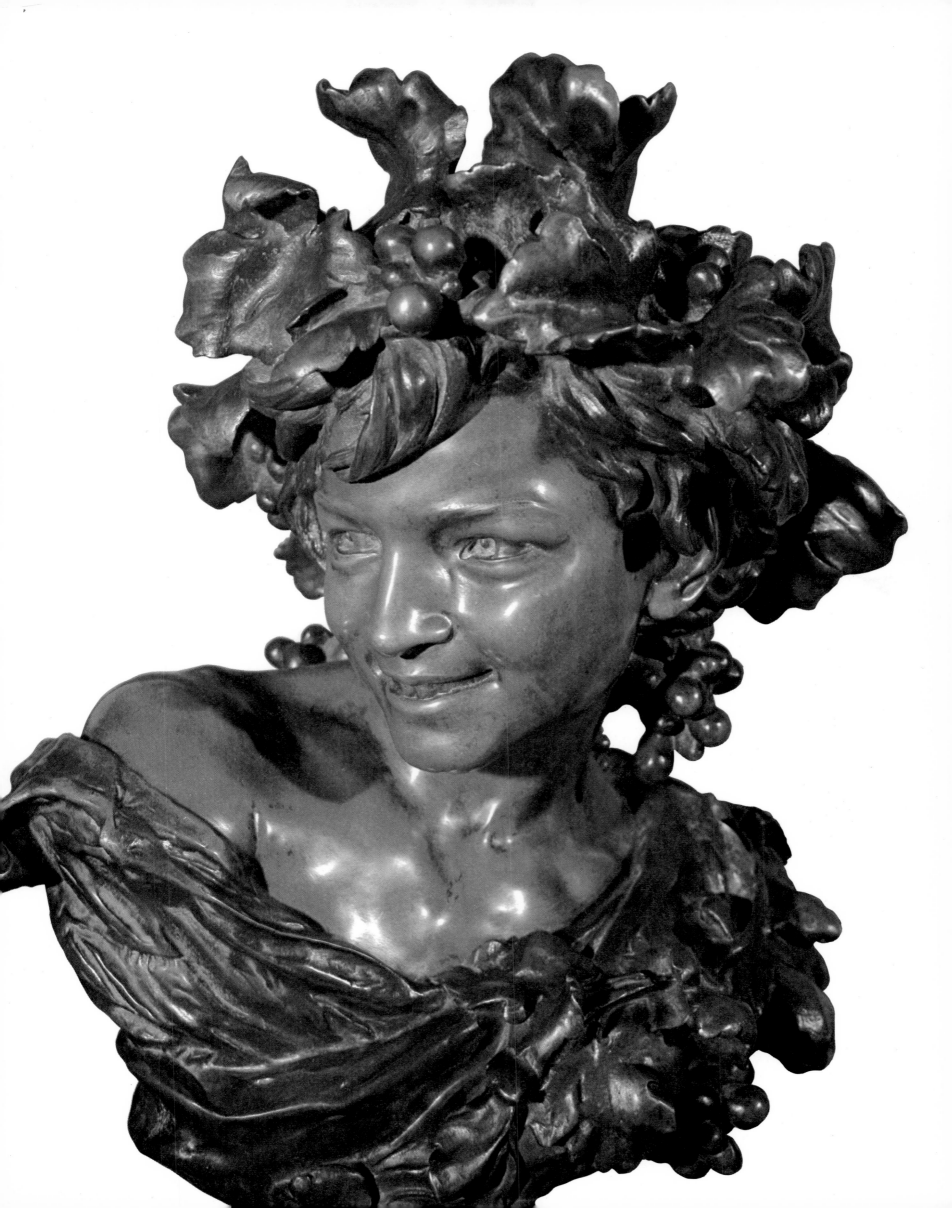

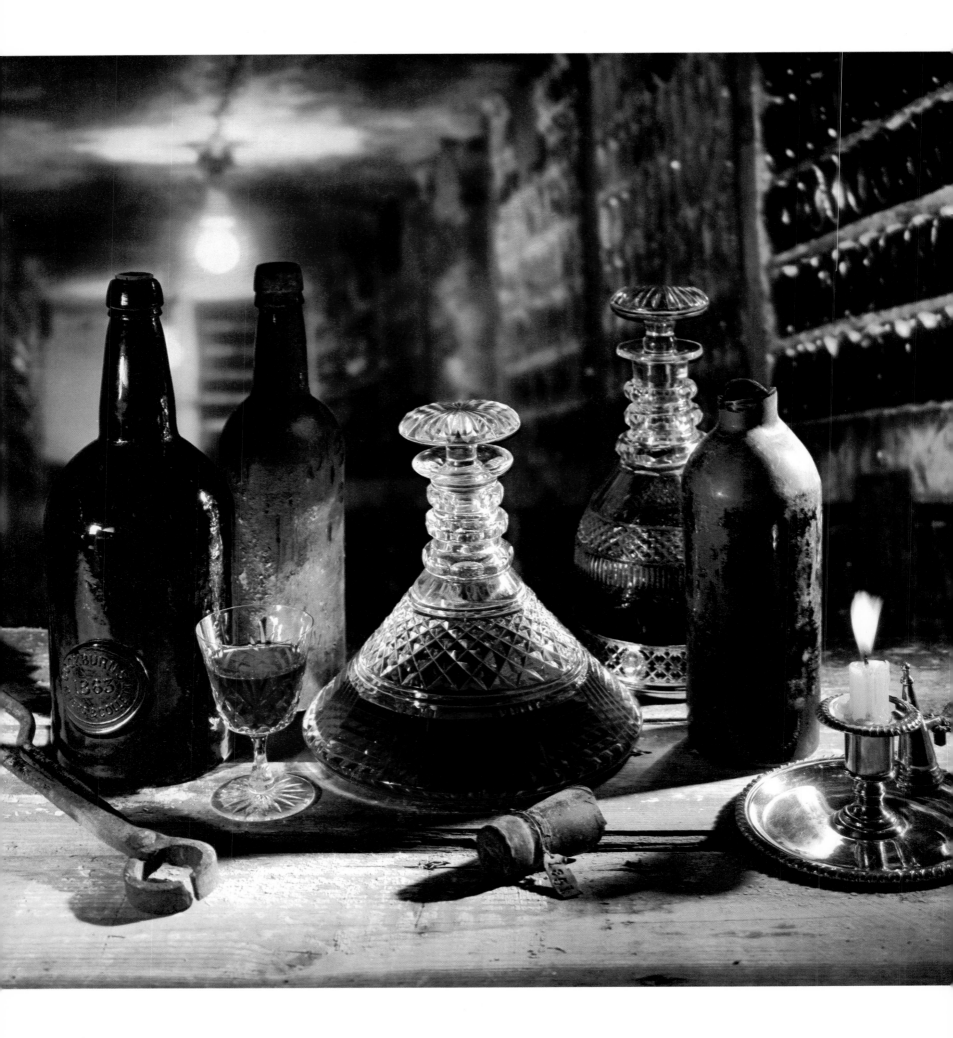

quented by English visitors. His nostrils are assailed by the effluence of a row of great casks, "their labels announcing a whole series of ports, strong, fruity wines, mahogany or amaranth colored, distinguished by laudatory titles, such as 'Old Port,' 'Light Delicate,' 'Cockburn's Very Fine,' 'Magnificent Old Regina.' . . ." Dreamily watching the English types contemplating their port-filled glasses, he evokes in his mind a procession of Dickens's characters, quintessentially English, all drinkers of port. The experience is one of several in Paris that so vividly recreate in him certain images of England that he at last decides it would be a waste of time actually to go there. So he returns home.

It is pleasant but perhaps needless to dwell on the Englishness of port. The Loyal Toast is drunk in port. Paradoxically, there is some slight evidence that the regicide Oliver Cromwell may have introduced the port habit (though it was a different wine from the one we think of today) into his native land. Port flows through the pages of English literature, but not those of other countries. From a hundred poetical apostrophes one selects, almost at random, Tennyson's often-quoted lines:

> Go and fetch a pint of Port
> But let it not be such as that
> You set before chance-comers,
> But such whose father-grape grew fat
> On Lusitanian summers.

From hundreds of prose passages, I like to recall the opinion of the redoubtable Miss Stanbury in Trollope's *He Knew He Was Right:* ". . . she thought that a glass of port after dinner was good for everybody. Indeed, she had a thorough belief in port wine, thinking that it would go far to cure most miseries." Thackeray agrees with her: "Sip your spirits and cure your cold, but I will take port that will cure all things, even a bad character. For there was never a port drinker who lacked friends to speak for him."

Port has its own small English rituals, such as the ceremonial clockwise passage around the table, rituals requiring the cooperation of all those present. English social history is rich in evidence of this wholehearted cooperation. The results were often striking. Allowing for the smaller bottle-size, we still marvel at stories of the three-bottle Regency Englishmen who at the gray dawn's beginning would be found slumbering, quietly or stertorously, beneath the table. Hugh Johnson tells the classic

"To taste port is to taste a tiny atom of England and her past." Left to right: bottle irons; magnum of Cockburn 1863; bottle of Cockburn 1812; glass, ship's decanter (c. 1800), and another decanter containing Cockburn 1908; bottle of 1851 Cockburn, neck and cork removed by the bottle irons; Sheffield candlestick that belonged to Prime Minister Gladstone

anecdote of the English lord who, having done away with three bottles of port and being asked if he had drunk them all without assistance, replied, "Not quite. I had the assistance of a bottle of Madeira."

"Port for men," said that quintessence of Englishness Samuel Johnson—even though one feels his true allegiance was to tea. The equally quintessential Saintsbury said of it that it "strengthens while it gladdens as no other wine can do." Yet, much as I love port, I cannot agree with the classical scholar Richard Bentley, who is believed to have said of claret that "it would be port if it could." No wine should try to be other than it is, but only the best of its kind that it may be.

In England port seems to have been, even more than other wines, a convivial potation. Yet it can also be a meditative wine, harmonizing with the joys of solitude. One cannot quite so suitably brood over champagne or Burgundy. But port seems, in the course of a long evening's reading or reflection, to slip down with insidious ease. It is good company, with something of the therapeutic quality Miss Stanbury ascribed to it.

Sometimes wine lovers pass through periods in which, for obscure reasons, they are mesmerically attracted to some particular wine. Once, long ago, I, like most of us, had my dark night of the soul. It was during this time that I discovered the virtues of port, its willingness to be a companion, its soothing and yet enlivening genius, its consolatory powers. I drank no other wine, but almost every evening resorted to my drug: two or three glasses of an inexpensive port. I did not ask of my liver what the consequences would be. I merely felt that somehow port was emollient to my bruised ego. I drink very little of it today, but I notice that when I do so, I am alone and in a mood which, had I any philosophy, I would call philosophical. If there be such a thing as a philosopher's wine, I think it may well be port. It has weight and dignity, calling for the concentrated mind. It is an evening, even a midnight, wine.

If port recalls England, champagne—despite some excellent near-equivalents made in our own country—inevitably brings France to mind, or at least certain standard images of France, those of gaiety, hedonism, lightness of style. Unlike port, champagne is a wine suited to celebrate a sudden happy meeting. If port is the wine of reflection, champagne is the wine of whim and spontaneity. It is what Dickens called it, "one of the elegant extras of life." Champagne is best drunk (alas! if one could only afford it) to celebrate a cheerful chance encounter

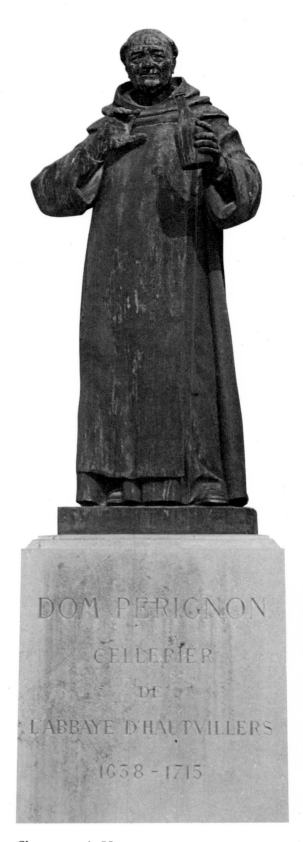

Champagne's Homer:
statue in the court of Moët et Chandon, Epernay

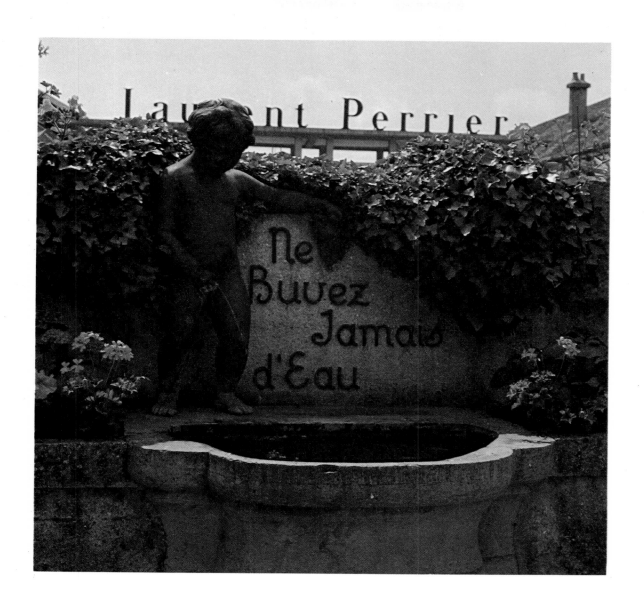

A replica at the Laurent-Perrier champagne winery, Tours-sur-Marne, of Brussels' famous *Manneken Pis,* the most inexhaustible argument against Prohibition ever produced by any artist

with a friend, or the receipt of good news. Its evanescent sparkle symbolizes those bubbles of exaltation of the social mood that come to us all, quickly break, and pass away. Its inner life manifests itself in visible ebullience and justifies Byron's florid phrasing:

> *. . . champagne with foaming whirls,*
> *As white as Cleopatra's melted pearls.*

The bubbles are the gift of the god of chemistry, working with a little sugar to induce a second fermentation. They are not, as is sometimes thought, the discovery of champagne's saint, the old cellar master of the Benedictine Abbey of Hautvillers, Dom Pérignon. Dom Pérignon (who was blind, a very Homer of wine) is credited with the creative idea of blending. It is to him we owe much of the care and processing that make champagne the preeminent beverage of conviviality. For one thing, we are told, he introduced the use of the cork that keeps the carbon dioxide gas from escaping.

The cork! Odes, even epics, should be devoted to the cork.

It is one of those few inventions, like Kleenex or—just barely possibly—the wheel, that are beneficial without qualification. The wheel makes life easier, but the cork actually makes life—the life of a maturable wine—possible. Modern connoisseurship begins with the cork.

Kipling once wrote a "Tree Song" beginning:

> *Of all the trees that grow so fair,*
> *Old England to adorn,*
> *Greater are none beneath the Sun,*
> *Than Oak and Ash and Thorn.*

This is an estimable English sentiment with which no one can quarrel. But if I could write verse as good as Kipling's I would celebrate *Quercus suber,* the cork tree, whose inner bark yields us those air-filled cells that are impermeable (usually) to liquids. And one cannot praise the cork without praising that heaven-made marriage, the union of cork and corkscrew. If you ever visit Brother Timothy at the Christian Brothers vineyards in California, try to see his corkscrew collection—I believe he has 2,000 examples, some of them on view at the Wine Museum of San Francisco. The action of a good corkscrew on a sound cork that has kept life within a sound bottle of wine furnishes real and constantly repeatable pleasure to those who care for such small matters. On the whole I would prefer to experience such a pleasure as against that of a journey to the moon, which is of doubtful benefit to the human race.

That wine connects with religion, history, legend, myth, literature, and the arts, with space and time—all this is true, and all constitutes part of the joys of wine. But one need not be interested in any of these linkages to love and enjoy wine. For most of us its satisfactions lie squarely (or roundly) within the bottle itself. But what rests in that bottle represents a broad range of possible sensations. It is the unique diversity of wine that is one of its principal charms.

"One of the elegant extras of life . . ."

We tend to think of our modern world as offering a tremendous variety of goods. But that is only a half-truth. The supermarket may offer a choice of twenty kinds of bread. Yet they hardly differ from each other, and not one equals the ordinary loaf you will pick up at a bakery in Paris. But wine is truly various. There is first the simplest of all distinctions, that between a table wine for habitual, casual consumption—and something better. In his excellent *The Wonder of Wine* Edouard Kressmann quotes Professor Maynard Amerine, the distinguished enologist of the University of California, who neatly defines these two fundamental categories: "The fine wine leaves you with something pleasant; the ordinary wine just leaves." But think for a moment of other variations. Wines, for example, are divided by occasion: aperitifs, dinner wines, after-dinner wines. They may be fortified or natural, sparkling or still. They may be blended or single vineyard products. They may be red, white, or rosé—but how wide is the chromatic spectrum concealed within these simple words.

They vary in alcoholic content, in sugar, in iron, in tannin. The same wine may not be quite the same if poured from a magnum (especially true of champagnes of some age). There is a fantastic difference in ageability, from the Viennese *heuriger* or Beaujolais *primeur* to the near-immortality of a Madeira or some Tokays.

And wines come, granted certain limits of latitude, seemingly from everywhere—even England, which is now producing "Hambledon white," described as having some of the virtues of a good Moselle. The People's Republic of China is sending us wines grown mostly in Chinese Turkestan and in Shansi and Kansu provinces. (In Marco Polo's day fifty-four varieties of Chinese rice wine are recorded.) Israel, whose wines have not hitherto been distinguished, is now producing one approved by experts, from the Cabernet Sauvignon grape.

The variety of flavors, fragrances, bouquets is equally astonishing, especially when one considers that the bouquet of a single glass may itself change slightly in the course of drinking. And that single glass is itself a small world of sensations. In addition to the bouquet, there is the taste in the mouth, then on the palate, then finally the aftertaste. The temperature at which a wine is best drunk reflects still another scale of variations. Wine that seems lifeless when poured directly from the bottle may improve if left to breathe for a time—or it may not. Naturally, most wines are (and should be) dependable. Blended to

Two good men of Jerez. The ingenious "wine thief" is called a *venencia*. A whalebone wand affixed to a long silver cup, it is inserted in the bunghole of a sherry cask and deftly used here to fill a bouquet of glasses

a fixed formula, they are made so as to present no variations. But there is, in any wine of breeding, plenty of surprisability, not only as between the years, but within any given year, that variation depending on a host of factors, including some that we simply know nothing about.

The diversity of wine, while intriguing, is at least partly understandable in terms of certain givens: grape variety, weather, soil, modes of handling, and so forth. But there also clings to wine an aura of mystery. This penumbra of the inexplicable adds another element of fascination. For example, speaking of sherry, Hugh Johnson tells us that a Fino made in Sanlúcar de Barrameda, then transferred to Jerez, and there stored will take on quite another personality. Sherry seems peculiarly mysterious, because the yeast called *flor* does not act as it should—that is, it works when *exposed* to the air, thus breaking all the rules. (Madeira is also so exposed.) While the chemists can throw some light on the matter, the survival power of certain wines—Tokay, Madeira, Château-Chalon (which also develops the sherry *flor*)—remains in the end a mystery.

Quasi-magical powers are often ascribed to wines. The late Raymond Postgate, a hardheaded no-nonsense expert, once noted that Tokay, with its odd chemical makeup—its high phosphorus content, for example—has been thought useful in cases of infertility. But there is probably no truth to the stubborn tradition that Tokay is an aphrodisiac, except to the degree that all wines (unless they make you sleepy, as is true for some of us) have a releasing and so a joyous effect on the libido. Still we like to remember the story, carefully nurtured by the owners of Château Lafite, about the Duc de Richelieu, grand-nephew of the great Cardinal. At eighty-four he admitted to his bosom his fourth wife, a charming young widow. At ninety-two he died, in the full bloom of sexual vigor, crediting his powers to the habitual consumption of Château Lafite.

Which somehow recalls the familiar tale of the head of an Oxford college who was entertaining a teetotaler guest at a formal dinner. The teetotaler, offered a glass of port, proclaimed loudly: "I would rather commit adultery than drink a glass of liquor." A short, embarrassed silence was broken by the venerated head of the college remarking quietly, "Who wouldn't?"

On the other hand, in his delightful *In Praise of Wine,* the novelist Alec Waugh recalls a Saintsbury Club dinner which featured one of the great bottles of the century, Chambertin 1911. Hilaire Belloc, in an eloquent apostrophe, spoke at the

Minotaur with Artist and Two Girls,
etching (mixed mediums) by Pablo Picasso

58

C orn shall make the young men cheerful,
and new wine the maids.

<div align="right">—ZECHARIAH</div>

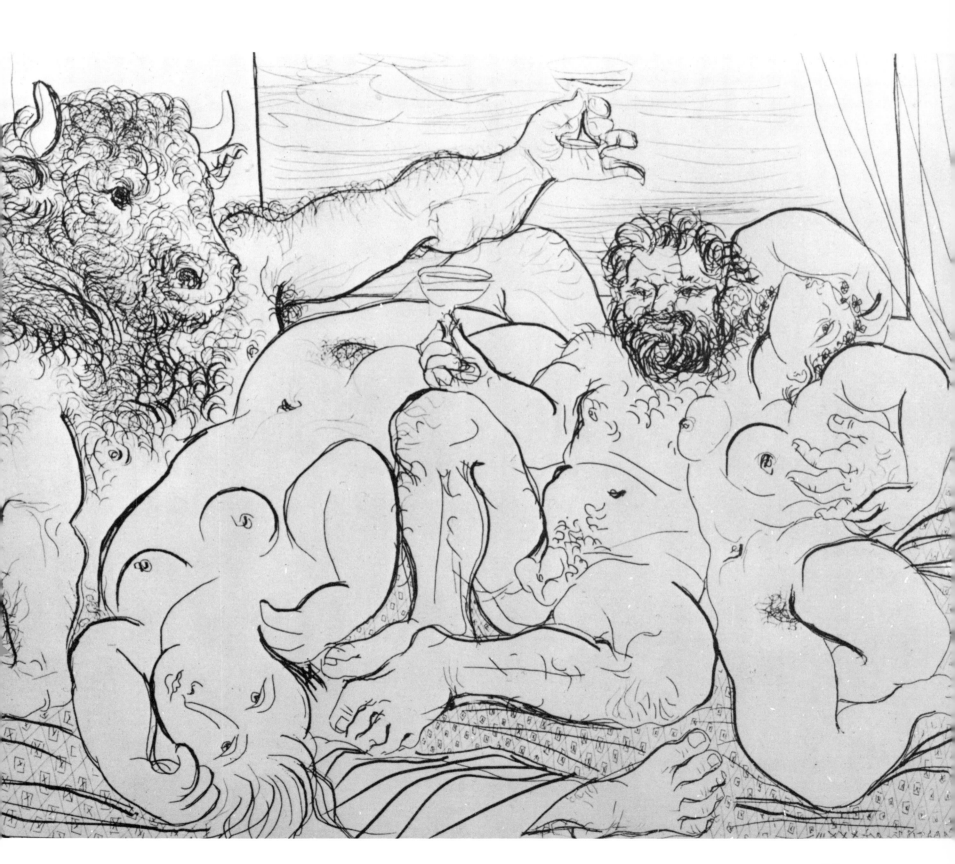

dinner, ending his speech thus: "And when I depart from the earth to appear before my beloved Lord to account for my sins, which have been scarlet, I shall say to Him: 'I cannot remember the name of the village; I do not even recollect the name of the girl, but the wine, my God, was Chambertin!' "

It is probably the close association of wine with at least two of our most powerful human drives—sex and religion—that lies at the base of what is often smiled at as the mystique of wine. It is possible, I suppose, to weave a mystique around anything that interests us intensely. To it is assigned a cluster of emotional or esthetic values that enthusiasts feel are there but to which nonenthusiasts are blind. In that sense there exists a sports mystique, a motorcar mystique—perhaps, for all one knows, a mystique of double-entry bookkeeping.

Mystique makers tend to excess. They often develop a special language, opaque to the rest of us. This is not untrue of wine, about which a considerable amount of nebulous nonsense has been spoken and written. And yet . . . and yet. . . . There *is* something, for the confirmed wine drinker, the true believer, that lies beyond and below the simple satisfaction of quenching one's thirst with an agreeable beverage.

Perhaps all arts that produce a few inexplicable super-artists tend to evoke the kind of reverence which translates into mystique. Just as we are dazzled by the fact that literature, music, and painting have produced only a handful of supreme geniuses, so we are fascinated by the rarity of truly great wines. There is no use discussing a classic claret or an absolutely achieved vintage port as if it were no more than an excellent wine. Such rare bottles move us to a new level of almost puzzled admiration.

This special emotion, we should keep in mind, is relatively modern. It depends on a culture of connoisseurship that, strictly speaking, hardly goes back more than two centuries, if that. We had to have the cork first, and then viniculture of a sophisticated sort that has come into being only over the last 150 years. In classical writings we find literary tributes filled with fervor, even ecstasy. Yet it is doubtful that the famous Opimians and Falernians of the Roman plutocracy would rank as what we consider fine wines; and of course they were often altered by additives such as honey.

It is all too easy for wine lovers to go overboard in their enthusiasm. Wine is a very good thing; but it is a very good thing of this our common earth. It is not transcendental.

"It's a naive domestic Burgundy without any breeding, but I think you'll be amused by its presumption"

Though it shares certain properties with the arts it is not, like them, a creature of the imagination. It cannot, like great music or verse, transport us. Hence one should beware of spurious or affected attitudes toward wine. One should indulge in wine's traditional rituals for their intrinsic meaning and beauty, not for their power to exclude others, the Outsiders. Professionals who know too much about wine may, in conversation with us ordinary men, lose the common touch and overwhelm us with their technical knowledge, their talent for discrimination, their exotic terminology.

Which brings us to the question of wine snobbery. Thurber's famous cartoon of 1937 is perhaps ancestral to our modern satire on the wine snob. But such satire goes back a long way. Ambrose Bierce tells us about an old connoisseur who was smashed up in a railway collision. "Some wine was poured on his lips to revive him. 'Pauillac, 1873,' he murmured and died." The wine snob was a familiar figure in Victorian times, as we can observe from the languid remark of Mr. Mountchesney in Benjamin Disraeli's *Sybil*: "I rather like bad wine; one gets so bored with good wine."

A certain amount of such chichi is after all only human. Ritual is one of man's many safety devices. Through ritual he is for a few moments able to neutralize his suspicion that life is chaos. Convivial drinking softens life's rough edges. It is a way of escaping from our essential solitude as well as from the boredom of brute fact. To surround the drinking of an interesting wine with a bit of protocol or even formalized discussion seems to me in this sense forgivable, if not indeed salutary.

In Dickens there is a scene in which Dick Swiveller calls out, "Some wine here, ho!," then elaborately, as waiter, hands himself the flagon, then even more elaborately, as guest, accepts it from himself. This parody of wine ritual merely points to the need we have for weaving around some of our pleasures a web of ceremony whose utility is spiritual, not practical. The port will taste the same in whatever order the drinkers consume it. But by deferring to the traditional clockwise movement of the decanter we create the most ephemeral of links with all past drinkers of port and at the same time mark, by a ritual gesture, our respect for the wine and perhaps our hope that it will turn out to be sound and good. Such rituals as wine drinking has engendered are part of the creativity of man. They are minor arts. The toast, whether a mere nod of the head or the formal diplomatic mini-speech, is one of the thousands of ges-

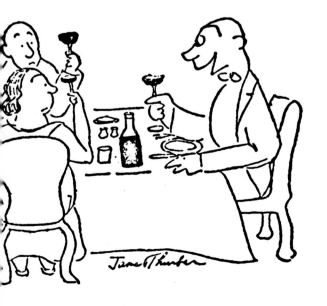

tures we have evolved to remind us of what we are constantly forgetting—our common humanity. The etiquette of wine is a matter of a few easily learned simplicities. Once we have internalized it, it can add to our enjoyment without creating undue self-consciousness.

Whatever mystique may lie in wine does not, however, rest on such ritual. It rests on simpler matters. There is something special about wine's history, for example, and the mode of life it generates. It is no accident that, as we have noted, wine from earliest times has been associated with our deepest religious impulses, serving not merely as a drink but as a symbol. Nor is it an accident, as this book shows, that wine and its rituals are diffused through the literary, pictorial, and plastic arts.

I have met only a few men whose lives were dominated by the making and selling of wine, or by a passion for explaining the world of wine to others. But all of them had a common rare distinction: they were civilized. One felt that they were somehow strengthened and refined by their long association with a traditional product that had more to offer than the potentiality of profit. Wine men are engaged in something that is not quite a vocation but yet is more than a trade, something that requires of them a knowledge of the past, good manners, a hospitality of the heart. Doubtless in the wine establishment there are vulgarians, but I have not encountered them. Wine men generally seem to have a serenity that must be rooted in the conviction that they are dispensing a product of whose life-enhancing qualities there can simply be no question. One feels they would agree with Ernest Hemingway's summary statement: "Wine is one of the most civilized things in the world and one of the natural things of the world that has been brought to the greatest perfection, and it offers a greater range for enjoyment and appreciation than possibly any other purely sensory thing which may be purchased."

Without impugning the dignity of other walks of life, one can say that the wine trade is one of the few to which one might dedicate one's self with a fraction, at least, of the purity of a true vocation such as philosophy, religion, or teaching. I think of the long life of the late André Simon. In its public and professional aspects it was devoted entirely to wine. He made a living by writing about it and publicizing it. But in so doing he lifted the level of civilization by a tiny degree. Think of what we owe to such a man as Count Agoston Haraszthy, that eccentric adventurer who, it is thought, departed this life in the jaws

"The etiquette of wine is a matter of a few easily learned simplicities."

of an alligator but who before this bizarre end had become in essence the father of California winemaking. Such men add to the sum total of the joy of living.

Even when we descend precipitously from the high plane of an Edouard Kressmann or an André Simon, down, down, down to the world of TV commercials, there is a difference, hard to pinpoint, between an inflated pitch for a mass-produced, mass-sold table wine and a similar pitch for a used-car lot. No matter how fanciful may be the wine commercial's claims, we know that the product itself does offer the possibility of a small but real increment of happiness. It is hard to be totally dishonest when offering a wine that is at least palatable.

What *does* place in jeopardy wine's integrity as a civilization index is not conventional commercialization but something rather the opposite: the juxtaposition of wine and the power of extraordinary wealth. Of late there have been reports of incredible prices paid for rare wines. We are told, for example, that a wealthy housewife recently bought a jeroboam of 1929 Château Mouton-Rothschild* for $9,600, planning to give the bottle to her husband for a Christmas present. When such gestures are exercised with respect to wine, one feels troubled. Instead of wine becoming a greater, it becomes a lesser thing, for the housewife's purchase had nothing to do with a love for wine. Such exhibitionism de-civilizes wine.

But, though there are many millionaires, they are still too few in number to sully wine's fair name. The tradition of wine drinking cannot, should not, and will not rest on the ingestion of high-priced rarities by a rich minority. The tradition rests on the drinking of sound and often quite ordinary wine by us the people.

This is not to deny that there is an aristocratic element, based on the faculty of discrimination, involved in the art of wine drinking. But that element is not its living core, nor should it ever be.

*Now, at long last, upgraded to its proper position of First Growth—although that means we can no longer enjoy the fine arrogance of its motto:

Premier ne puis
Second ne daigne
Mouton suis.

(First I cannot be; second I do not deign to be; I am Mouton.)

I recall a line of Matthew Arnold, remarkable mainly for its unmelodiousness. He once began a sonnet with a question:

Who prop, thou ask'st, in these bad days my mind?

He answers: Homer, Epictetus, Sophocles. Most of us, asking ourselves the same question, would reply in terms rather less culturally elevated. Yet each of us has his own little collection of escape hatches of some kind.

One of mine is shared by hundreds of millions of my fellow beings and has been so shared for thousands of years. I cherish the fact that a large part of mankind continues to vote overwhelmingly in favor of wine, seeking at times to enhance and sharpen the savor of life, at times to blunt its edge, more often simply to drink it because it tastes pleasant. As long as wine drinking flourishes (and today happens to be one of its peak periods), we should make every effort to prevent the human race from abandoning this planet to the insects, or any other takeover conglomerate.

Yes, wine, among other good things, remains, to use Arnold's word, a prop—to the mind, to the body, and, even though we are told no such thing exists, to the soul. It is associated not only with a pure pleasure but with the mysteries of growth and the rich fabric of our human past. It contains an inexplicable *élan vital*. When we drink a fine wine at its best, or a daily wine at its soundest, we somehow absorb a tiny part of this *élan*. There, for me, lies wine's final seduction, crowning its joys. C.F.

PRINCIPAL WINE GRAPES OF THE WORLD

FOLLE BLANCHE

CABERNET SAUVIGNON

GAMAY BEAUJOLAIS

GEWÜRZTRAMINER

RED WINES

Variety	*Quality*	*In Europe*
CABERNET SAUVIGNON	Excellent	Dominates in all the better Bordeaux vineyards.
PINOT NOIR	Very good	No wine in France is entitled to the name Burgundy unless it is made from 100 percent Pinot Noir—the noblest of red-wine grapes, along with Cabernet Sauvignon.
GAMAY BEAUJOLAIS	Very good	Not to be confused with Gamay (listed below), which is the grape of Beaujolais. The Gamay Beaujolais is unique to California.
GAMAY	Fair	There are many subvarieties. The best grows in Beaujolais. Also the basic grape of many other European vineyards.
BARBERA	Good	Grows in North Italy.
ZINFANDEL	Good	European origin unknown. Probably brought to California by Count Haraszthy. Now unique to California.
GRENACHE	Good	The grape of Tavel Rosé, most of the Côtes du Rhône, and some of Châteauneuf-du-Pape. Widely planted in the Rioja of Spain.

WHITE WINES

Variety		
CHARDONNAY (also, improperly, Pinot Chardonnay)	Excellent	Grows in Burgundy, Chablis, Champagne, and parts of Italy.
JOHANNISBERG RIESLING	Excellent	Grows in the Rhine and Moselle valleys of Germany and in Alsace, Austria, Luxembourg, and North Italy.
CHENIN BLANC	Very good	Grows in the Loire Valley, particularly in Vouvray and Saumur
SAUVIGNON BLANC	Very good	Grows in Sauternes, Graves, and the Loire Valley.
TRAMINER (also called Gewürztraminer)	Very good	Grows in Germany, Alsace, and Italian Tyrol.
COLOMBARD	Fair	Grows in the French commune of Cognac—used for brandy.
FOLLE BLANCHE	Good	Formerly widespread in the commune of Cognac, but is now replaced there by the Ugni Blanc. Does well in the Loire Valley around Nantes as Gros Plant. Called Picpoul in the French Midi, and yields light wine.

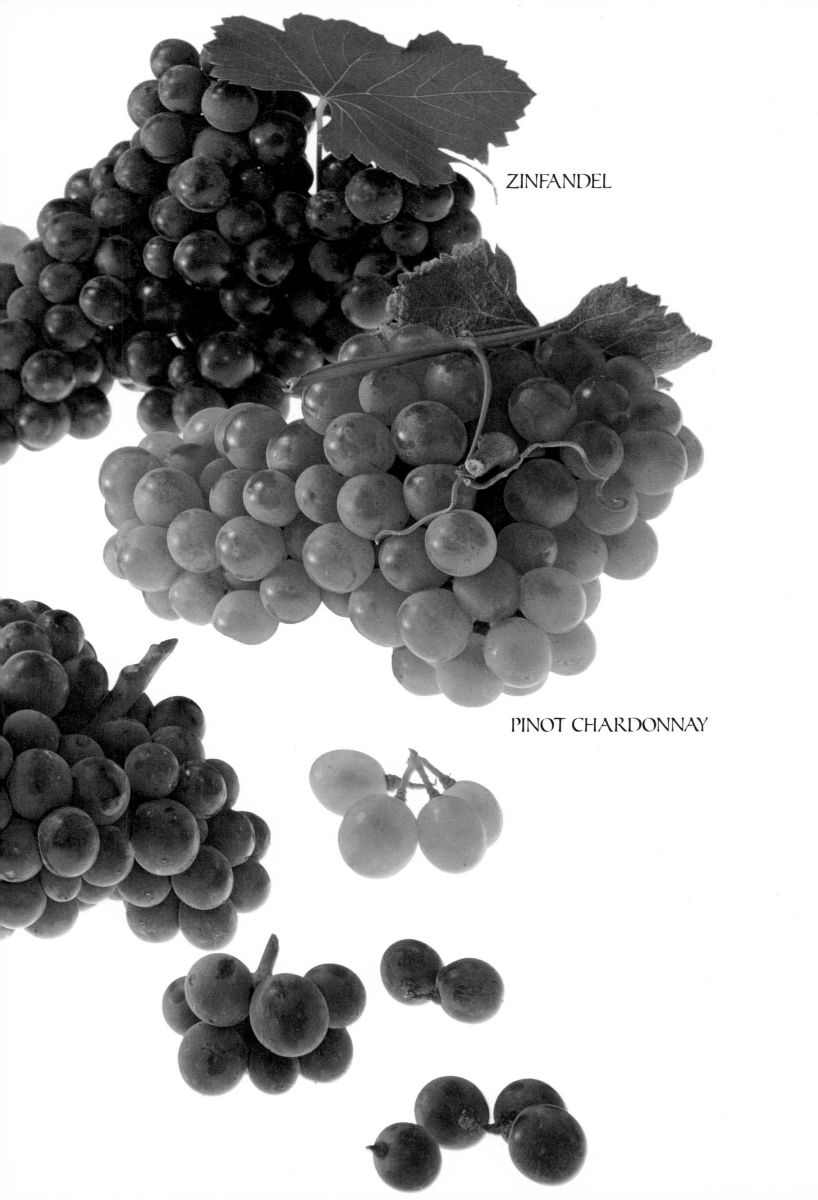

ZINFANDEL

PINOT CHARDONNAY

JOHANNISBERG RIESLING

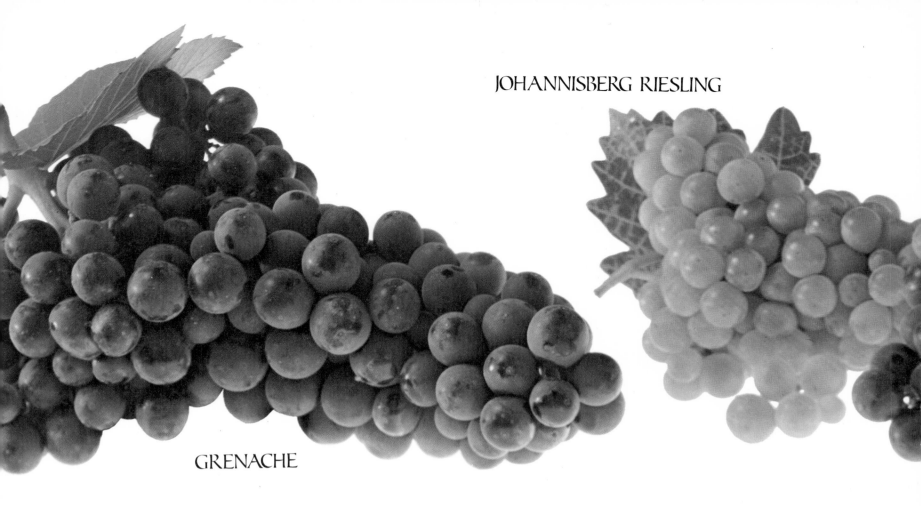

GRENACHE

CHENIN BLANC

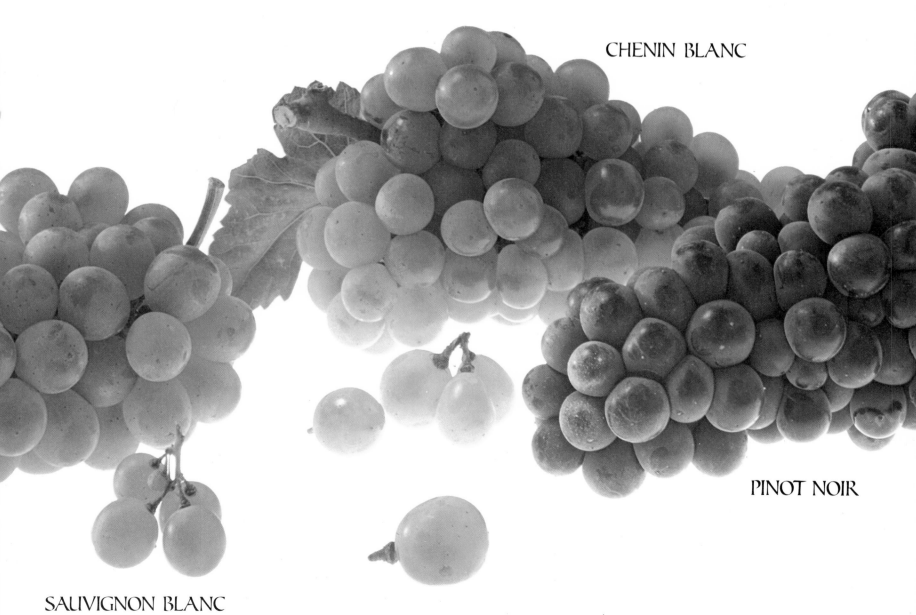

PINOT NOIR

SAUVIGNON BLANC

In California	Comments
The pride of the finest North Coast plantings.	The basic grape of Lafite, Mouton, and Haut-Brion, as well as of most of the other great red Bordeaux. Its wine is long-lived, beautifully balanced, with much power and class—certainly the best red wine of California, especially in the north.
Limited production, owing to low yields and rather high costs. Particularly successful in the vineyards of Napa, Sonoma, and Mendocino counties, and south of the Bay Area.	Has not yet achieved the heights of the Cabernet Sauvignon in California, but is on the way. Its wine is similar to the French red Burgundies but lighter, drier, and with less depth.
Ever-increasing plantings from northern Mendocino to southern Monterey County.	Despite its name, which may tend to confuse, Gamay Beaujolais is actually an offshoot of the Pinot Noir grape. Yields a wine that is fruity, fresh, and quick to mature.
Called Napa Gamay in California. Grows in the North Coast counties and the warmer Central Valley.	Although often confused with the Gamay Beaujolais (above), not in the same class. An economical grape because the yield per acre is high. Provides only modest depth and character, but resulting wine, never outstanding, can be light and agreeable.
A good basic grape of Napa and Sonoma counties, now being planted profusely in the warmer Central Valley.	If it comes from Napa or Sonoma County, you will usually find the wine excellent: deep-colored and full-bodied. Satisfactory but not nearly so good when the source is the Central Valley. Often better than its Italian counterpart.
Grows best in the North Coast counties, but is planted all over the state.	America's basic wine grape—fruity, quick to mature, generally very delicious. Provides the varietal foundation for the best of the jug wines.
Responsible for the excellent vins rosés of the North Coast counties. Also used for jug wine in Central Valley and in making the best port of California.	The best California rosé and red jug wines owe their origin to this grape, which yields a fresh, pleasant, well-balanced wine. Used for jug wine in the San Joaquin Valley.
Planted almost exclusively in northern California, where the wine is called Pinot Chardonnay.	High quality, but the yield per acre very low. The wine is not as fruity and a bit drier than the French white Burgundies. Topflight examples can hold their own against Chassagne-Montrachet, Meursault, and Pouilly-Fuissé.
Thrives only in the cooler sections of the northern counties.	Only the true Riesling grape in California bears the prefix "Johannisberg." This distinguishes it from the many imitators that bear the word "Riesling" but not "Johannisberg." Fruit and bouquet are less pronounced than in Germany or Alsace, but there will be fine harmony and breed among the better examples.
At its best in Sonoma, Napa, Santa Clara, San Benito, and Monterey counties.	Generally pale in color and on the dry side (with a few exceptions), superb bouquet—hence often used in California champagne blends.
Grows in the North Coast counties and upper Central Valley.	Generally yields a wine similar to the French dry Graves. Often sold under such California names as Dry Sauterne and Blanc-Fumé.
Generally is limited to the North Coast counties.	Whether European or Californian, Traminer wines are generally soft, showing a bit of sweetness, and with pronounced flowery bouquet. For the best of the harvest the growers often substitute the legally permitted alternative name "Gewürztraminer."
Grows in North Coast area and upper Central Valley.	In France, provides a wine high in acid, excellent for making cognac. Happily, in California it yields a pale, very dry light white that can be delightful. Often bears the label "Chablis" or "French Colombard" when source is California. Sometimes it makes a slightly sweet wine.
Grows in the North Coast counties and Central Valley.	Gros Plant du Nantais is well known and similar to Muscadet. The wine Folle Blanche makes in California is tart and refreshing; sometimes bottled as a varietal.

THE
WINES
OF
NORTH
AMERICA

When future observers survey the history and development of wine in the United States, I believe they will label the latter half of the twentieth century the dawn of the golden age of American wine. Europe has had two thousand years of experience in the art of making and imbibing wine. The United States, in less than three hundred years, has progressed to the point where it stands on the threshold of a most promising future for both wine production and wine consumption.

Significantly, the annual rate of consumption has tripled since the end of World War II, reaching 2.6 gallons, or 13 bottles, per adult. A conservative estimate has it that by 1980 the average American will consume 14 bottles of table wine per year. This is still far less than the 190 bottles the average Frenchman drinks, or the 205 bottles an Italian consumes each year. But the present tremendous growth rate here signals an ever-developing interest, both in imported wines and, increasingly, in our own American wines.

American winemakers have shown an indomitable capacity for facing adversities. They conquered their own inexperience and solved many of the problems of the mysterious soil; they bravely withstood natural calamities, such as the phylloxera epidemic that between 1860 and 1900 ravaged many of the European vines planted in California, and the great San Francisco earthquake of 1906 that brought down the walls of many wineries.

But on January 16, 1919, American winemakers were felled by a blow that would not have entered even the worst nightmares of the European *vignerons*. It was the most punishing disaster that could have befallen them—Prohibition.

Today, especially to young people, Prohibition conjures up a picture of wild speakeasies where the Lost Generation gaily swigged rotgut, bad rye, and bathtub gin. But for those in the wine trade it meant catastrophe. Only about two dozen wineries were able to stay in business, producing small quantities of medicinal, sacramental, and cooking wines. For scores of dedicated winemakers Prohibition meant thousands of vineyard acres lying fallow or replanted with coarse-skinned grape varieties that could be shipped for the table but usually found their

way into homemade wine. Failing that, the acreage was sold quickly and cheaply for other uses. It was the collapse not merely of an industry but of a way of life. Hundreds of skilled professionals were forced to seek their livelihood elsewhere, and at the American dinner table the gracious habit of a bottle of wine to accompany the meal was forgotten.

It is ironic that this man-made disaster occurred in the country whose borders encompass some of the best natural grape-producing land in the world. The wild grapes that still grow here abundantly so impressed Leif Ericson when he came ashore in North America about nine hundred years ago that he named the new country "Vinland."

Up to now, a relatively modest portion of our generous soil has been allocated to the production of wine. So far twenty-six of our states produce wine commercially (though grapes grow in all fifty), with California far in the lead. But I am sure that the industry's fantastic rate of growth will encourage other states where the climate is propitious to join the ranks of the wine producers.

A hundred years ago, when good vineyards grew close by, not only Los Angeles but Pittsburgh, St. Louis, and Cincinnati were important winemaking cities. Four hundred years ago settlers from France made some of the earliest American wine from wild scuppernong grapes that grew near what is now Jacksonville, Florida.

The colonists fermented wild grapes from the hardy *Vitis labrusca* vines native to the East Coast. Many, however, preferring the taste of European wines, tried to plant the European *Vitis vinifera* here instead. Lord Delaware, Lord Baltimore, Governor John Winthrop of Massachusetts, William Penn, and even the ingenious Thomas Jefferson all failed in their attempts, defeated by the rigorous climate and by diseases and pests to which the more delicate European plants were not immune.

But in California, where the climate was milder, Padre Junípero Serra, the Franciscan friar who founded Mission San Diego de Alcalá, successfully planted vinifera vines shortly before the American Revolution. Because wine was essential for the Eucharist, the religious orders had a long tradition in Europe of excellent winemaking, and they brought their skills and knowledge to the New World.

Our Eastern labrusca hybrid grapes such as Concord, Delaware, and Catawba produce wine with a distinctive grapy, or "foxy," taste that, though favored by many, is different from the traditional taste of fine European wine. Recently these

One hundred years ago European vintners brought their skills to California. The Nouveau Médoc Winery was founded in Oakville in 1877 by two French winegrowers

labrusca varieties have been blended with the viniferas of the West to produce the popular Cold Duck, as well as kosher wines.

Today only 17 percent of the wine consumed in the United States is imported. California produces 70 percent of the wines we drink, the remainder coming from other states, principally New York.

Perhaps the greatest obstacle in the path of the American winemaker has been his own countrymen's attitude toward his product. Although American wineries now rival all but the very greatest of Europe, native American wines until this past decade lacked status and were looked upon with disdain by many wine drinkers, especially in the East.

This lack of appreciation was perhaps justified by the fact that just after the Repeal of Prohibition, in 1933, American wineries produced relatively little table wine, concentrating instead on fortified wines. Also called dessert wines, these include such beverages as port, Muscatel, sherry, and Tokay. Until as recently as 1968, when this trend at last happily reversed itself, the United States and Australia had the dubious distinction of being the only two nations to consume more dessert wine than table wine. It must be remembered that dessert wines contain 20 percent alcohol by volume and many sell for



scarcely more than $1 a bottle. This fact explains much of the popularity of dessert wines among those in search of inexpensive intoxication.

After Repeal, the only native table wines available were generics of a very low quality. (A generic wine is essentially a combination of a number of different grape varieties, often grown in various localities.) These blended wines were, and still are, usually given the names of the famed winemaking areas of Europe (Burgundy, Chablis, Rhine, Sauternes, etc.). Vineyards born overnight hurriedly placed on the market wines made from combinations of grape varieties whose chief virtue lay in their capacity for quick and high yield. These wines, which bore little or no resemblance to those of the areas from which they took their names, had a crude, grapy flavor and were of course no match for the least of the traditional refined European wines, which could now once again be imported.

Then, about 1938, winemakers chose to use basic European grape varieties and attempted to produce less plentiful but better-quality varietals. An American varietal wine such as Pinot Noir or Johannisberg Riesling is named after the specific grape variety employed in its production. A varietal wine is required by law to contain at least 51 percent of the product of

Hand-colored lithograph by Currier and Ives, New York, 1872

The Christian Brothers Collection

76

the grape from which it takes its name. In order to impart recognizable varietal flavor, good growers generally insist on a higher proportion.

In the 1930s, in their eagerness to provide the budding American market with a number of different wines, some vineyard owners greatly diversified their grape plantings, exceeding the possibilities of their own vineyard soil and climate and often putting on the market dozens of generics and varietals when only a few were suited to their particular soil. Because these grapes had been transplanted to what were sometimes the most inappropriate settings, the wines yielded by the noble grape varieties bore no more relation to their illustrious namesakes than a lump of coal bears to a diamond.

Since World War II, however, much progress has been made. Generic wines are now produced in staggering quantities. They have improved with trial and error and, more important, through scientific experimentation. Such revolutionary and, for us, crucial techniques as scientific harvesting and low-temperature fermentation make our generic wines better than ever before. The United States now produces good, uncomplicated, and sturdy everyday wine, often bottled in half-gallon or gallon jugs. In terms of a quantity market, the California winemaker has learned to make the rich soil and bountiful climate work for him.

Jug wines have attained a great and well-deserved popularity in this country. Gallo, which supplies an astonishing one out of every seven bottles of wine consumed in the United States, markets a Hearty Burgundy and a Chablis Blanc, each made of a blend of grape varieties. These cost hardly more, and are certainly better, than the table wine the average Frenchman in Paris or Marseilles drinks every day. Other companies, among them Paul Masson, Inglenook, Christian Brothers, and Almadén, are making laudable contributions to American large-scale wine production.

In the area of varietals, too, we have made substantial progress, with specialization now becoming the norm. A vast amount of research has been done in the last forty years to find the best soil and climate conditions for particular grape varieties. Professor Maynard Amerine, who succeeded the noted Dr. Albert Winkler as chairman of the Department of Viticulture and Enology of the University of California at Davis, has perhaps contributed more than anyone else to the refinement of techniques and to the elevation of our standards of excellence.

One could devote many pages to a description of the dedicated efforts and successes of such men as Frederic Bioletti, Maynard Joslyn, and the eminent geneticist Harold Olmo, to name but a few of the men who spearheaded the viticultural revolution after Repeal. Davis and, more recently and on a somewhat smaller scale, the Department of Viticulture and Enology at Fresno State College have become important centers of research. Their graduates are much sought after throughout the world, and many of our winemakers have either attended their classes or profited from their work.

In recent years similar efforts have been made in New York State under the direction of Cornell University and the New York State Department of Agriculture. Research is now being carried on at the State Experimental Station at Geneva, in the heart of the Finger Lakes region. Guidance has been given to growers, particularly in the field of the French-American hybrids, thus enabling them to reduce the foxy taste that many sophisticated wine drinkers find objectionable. California and New York vineyard owners are learning the advantages of specialization, the use of fewer, better-adapted varietals, more accurate and better labeling, and, when necessary, higher prices for their wines. All this has done much to upgrade and dignify American wine.

It was Frank Schoonmaker, one of America's leading wine authorities, who taught the California growers that it is not necessary to limit the price of a California wine to $1.25 the bottle or to call it merely "Burgundy" or "Chablis." Thanks to his tutelage and encouragement, vineyards such as Almadén, Wente, and Louis M. Martini had learned even before World War II to give their wines added importance by including valley names or vintage dates and to indicate better quality by proudly showing on the label a superior grape variety such as Pinot Noir. An acceptable higher price, justified by the finer wine in the bottle, followed naturally.

Today, vineyards tend to specialize, abandoning earlier attempts to market a full range of wines. Because of this, because of the higher standards now set, and because many American winemakers have been willing to forgo quick profits from high-yielding grape varieties, they are producing some exceptionally fine wines. The Cabernet Sauvignon grape, for example, has, when lovingly tended, thrived extremely well on California soil. Furthermore, we are developing our own varietals, such as Zinfandel, which produce uniquely American wines.

if God forbade drinking
would He have made wine so good?

—ARMAND CARDINAL RICHELIEU

In New York State and Ohio, a great breakthrough has occurred in the area of hybrids. When in the nineteenth century the phylloxera pest, originally brought to France in the roots of American vines, ravaged the European vines and destroyed most of their vineyards, the French imported American vines that were phylloxera-resistant, grafted their own vines to these healthy roots, and thus saved their vineyards. Later they cross-bred the American and European vines, eventually developing a number of hybrids that produced good wines. French-American hybrids are now being used successfully east of the Rockies.

The American consumer's greatest error, once he has taken the step of buying one of these fine native wines, has been his hurry to drink it. No one would dream of purchasing a two-year-old Château Petrus and serving it the same night. Yet many of our best native wines are heedlessly consumed in their infancy, before they have had a chance to develop into what can in many cases be a glorious adulthood. Until 1970, when the California legislature changed the law, even the California vine-yard owner was discouraged from aging his wines in his own cellars (thereby doing our job for us) by a yearly inventory tax on all wines held by him on his estate. Luckily, the vintners now will be able to age portions of their vintages without paying tax on the same wine year after year. But let us, the consumers, take the responsibility for giving the better American wines their due by properly aging them in our own cellars or wine racks. A mature Heitz Cellars Cabernet Sauvignon or a Georges de Latour Reserve Cabernet Sauvignon (two of California's finest) can stand up very well to its French cousins.

Note that I say cousins—not brothers. It is a sad fact that American wines are constantly compared unfavorably to their European counterparts. In a sense it seems a natural comparison, because the better American wines are made for the most part from European grape varieties and do bear some taste similarities to those of the Continent. But when we take into consideration the enormous differences in soil and climate, the comparison seems pointless and probably invalid. Let us not forget that only a tiny proportion of France's vineyards (perhaps 5 to 10 percent) produces the aristocratic wines. We Americans rarely taste the

79

vins ordinaires in the plastic bottles (yes, plastic!) which many Frenchmen imbibe with their meals. Although only a few American products have achieved the subtlety and finesse of their European relatives, our wines have their own charm. And certainly we, too, have our own superb 10 percent.

The proof is in the tasting. A dramatic demonstration of this took place in early 1974 on the NBC-TV evening news program. The anchorman presented me with a bottle of Lafite Rothschild 1966 and a bottle of Mondavi Cabernet Sauvignon 1970, asking that I describe the wines and state the price. I told the audience that the Lafite commanded $45 and the Mondavi $6. One of the newscasters stated, "I suppose anybody could pick out the $45 wine." I replied that it would not be easy. He unexpectedly asked if he could be put to the test. While he closed his eyes, I poured the two wines for all two million television viewers to observe clearly. Eyes open, the newscaster tasted and then smiled as he announced, "This one—to the left—is the $45 Lafite." My response was, "I am afraid you are wrong—but I can understand why. The Lafite, still rich in tannin, is hardly ready to drink, is not now attractive, but will be glorious ten years from now. The Mondavi Cabernet Sauvignon, light and graceful, with much less tannin, can win hands down in any blind tasting held *at this point* in the development of the two wines."

Many of California's finest products are, unfortunately, still too scarce to be available in most parts of the country, but there is hope that this situation may improve in time. Then, too, while in some states, such as California and Illinois, wine may be purchased, as in France, at the grocery store or at the supermarket, in other states, such as Pennsylvania, the sale of all liquor, including wine, is restricted to state-controlled stores. At the present time, although none of our states are totally dry, many townships or counties still are, and in twenty states, including New York, wine may be sold only in private, licensed retail liquor stores.

The men who operate these retail stores have affected and reflected the American wine revolution. Once upon a time, wine was bought in a liquor store from a liquor salesman who happened also to carry some wines, about which he knew little or nothing. Today, wine merchants are students of the subject. The second generation especially—the sons of the men who began or resumed their businesses after Repeal—are becoming more and more knowledgeable about both European and Ameri-

Wine merchants, wholesalers, and importers are knowledgeable about wines, and their expertise has stimulated America's growing interest. Peter Sichel, president of H. Sichel and Sons, is considered one of the world's leading wine authorities

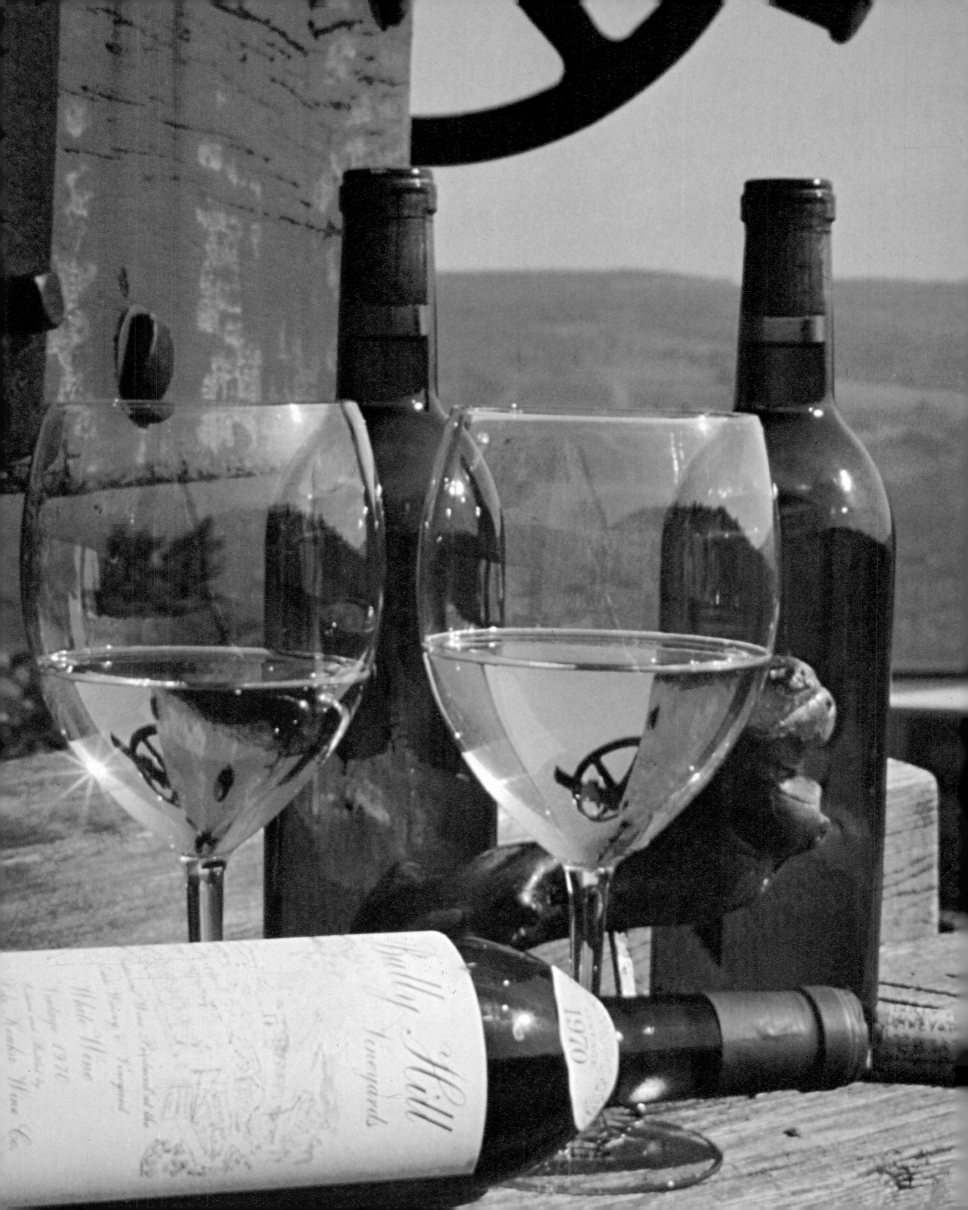

can wines, and many now possess the expertise required to guide their customers.

This is just one more reflection of the tremendous current surge of interest in wine. Our life-style has changed greatly since World War II. For many, wine has joined hi-fi equipment, world travel, and art collecting as a status symbol, as the "in" thing. Our increased affluence, leisure, interest in gourmet cooking, and vacations abroad have contributed greatly to our growing interest in vineyards and wines.

Many books on the subject have had wide distribution in the United States in recent years. Whether writing about European or American wine, such men as Leon Adams, Professor Maynard Amerine, Gerald Asher, Robert Lawrence Balzer, Alexis Bespaloff, Michael Broadbent, Nathaniel Chroman, Creighton Churchill, Hugh Johnson, Alexis Lichine, William Massee, Robert Jay Misch, Edmund Penning-Rowsell, Cyril Ray, Frank Schoonmaker, Peter Sichel, André Simon, Alec Waugh, and Harry Waugh have made a great contribution to the American wine trade through their books and articles. Today almost every magazine carries occasional articles on wine. Fine specialized magazines are also available, and some are very popular: *Vintage Magazine, Wine, Gourmet, Revue du Vin de France, Wine World, Wines & Vines,* to name but a few. Major metropolitan newspapers across the country are covering the wine scene. Frank J. Prial has a following in the *New York Times,* Paul Zimmerman in the *New York Post.* Ruth Ellen Church writes on wines for the *Chicago Tribune,* Henry Rubin is in the *San Francisco Chronicle,* Robert Lawrence Balzer appears in the *Los Angeles Times*—and even *Women's Wear Daily* carries a weekly wine column. Radio and television, as well, present programs on wine to a growing audience.

Americans have in recent years become more and more interested in the preparation of good food, and some food writers and cookbook authors have also been helpful and influential in the area of wine: James Beard, Craig Claiborne, Julia Child, Jacques Pepin, Helen McCully, Richard Olney, José Wilson, Pierre Franey, Robert Courtine, Waverley Root, Nika Hazelton, and many others have promoted the idea that good drinking is a necessary adjunct to good eating.

Another phenomenon reflecting our increasing involvement with wine in all its aspects is home winemaking. This has grown to the point where we now see home winemaking kits advertised on television. Dozens of books and magazines are

Vintage white wines made from French-American hybrids grown in the Finger Lakes region of New York State

available on do-it-yourself winemaking. Not every adventurous hobbyist is making great wine, but doubtless some of the homemade products are quite acceptable. It is interesting that this represents, in a sense, the carrying on of a native tradition: there was a time when it was as natural for many American households to produce their own wine as it was for them to bake their own bread. In fact, many of the now renowned American wineries started out as family-owned and -operated enterprises. The Gallo brothers, for example, still retain total control of their vast operation. At the other end of the scale is the small, excellent Boordy Vineyard in Maryland, which is owned and operated by Philip Wagner and his wife.

There is also a growing interest in wines made from fruits other than the grape. In Vermont, Frank Jedlicka of Vermont Wineries produces and markets a Vermont Apple Wine (made from apples but fermented in the manner used for grapes), which should interest those looking for new taste experiences.

These are some of the signs of the wine boom in the United States. But, more important, our attitudes are changing and our prejudices are vanishing.

Because there is a tremendous and ever-increasing world demand for them, European wines will remain high-priced. After all, how many of us are willing and able to pay over $300 for a case of Château Latour 1971—a wine that should not even be opened for a decade?

As more and more Americans are forced by the prohibitively high prices of their favorite French wines to try the American wines, the chances are that they will be delighted with what they discover. Americans are beginning to realize that they have a fine native product, much of it suitable for quality everyday drinking. As for our more exalted labels, I predict that there will soon come a day when fine American wine, no longer a poor cousin, will adorn an elegant dinner table anywhere in the world as proudly as any of its distant relatives. S.A.

An unusual wine made from pomegranates in the southern Santa Clara Valley

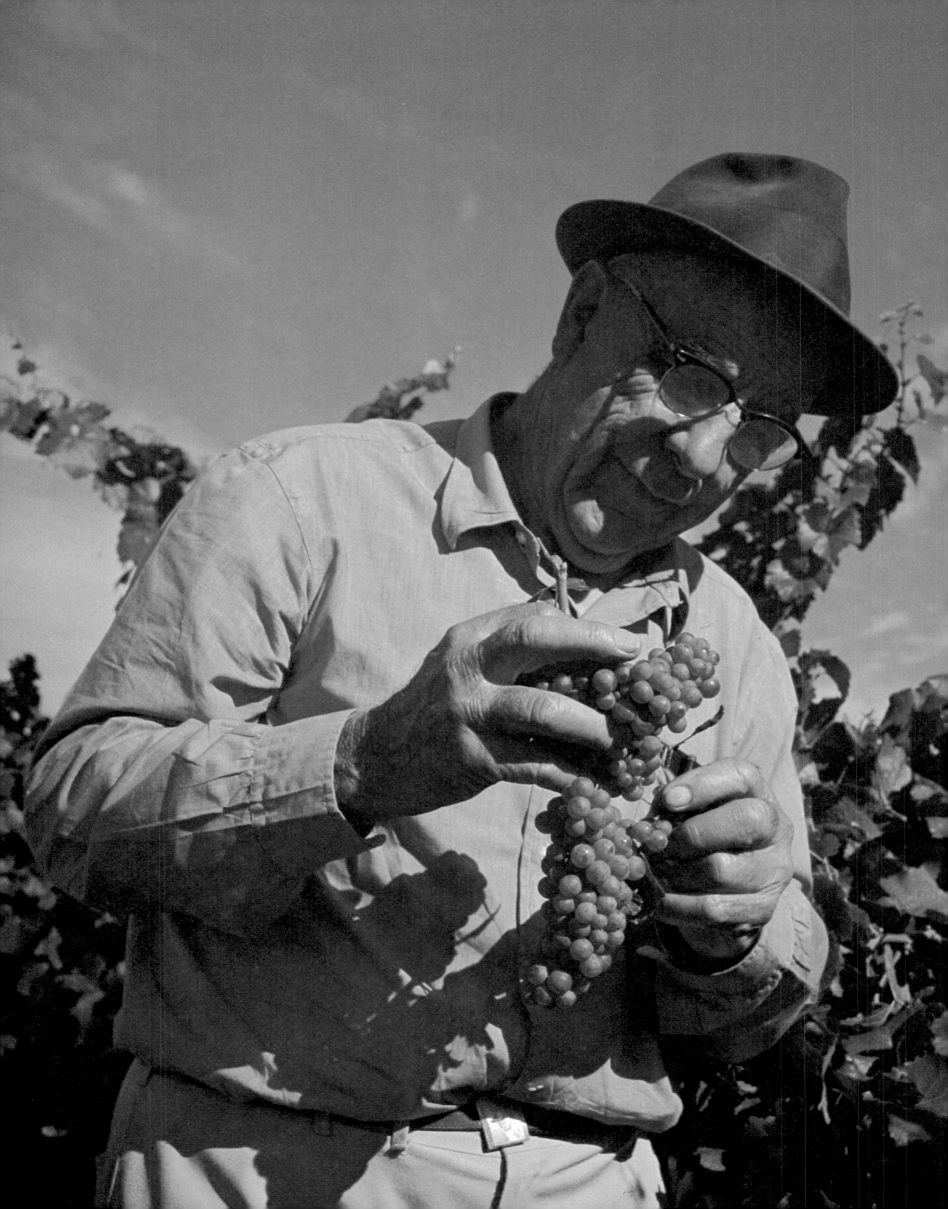

THE WINES OF CALIFORNIA

AN APPRECIATION

ROBERT LAWRENCE BALZER

In 1662, in the merry days of good King Charles, the court historian issued a description of wine in which he called it "but Water sublim'd."

Fine wine is indeed a kind of "sublime water." In considering the sublime waters of California we shall focus on fine wine as opposed to that good but simple ferment of the grape made and consumed without special regard for its potentially superlative merit. One eats to satisfy a natural animal hunger, but one dines with particular regard for and thought to fine foods, with curiosity as to their origins, their ingredients, and the artists who prepared them. So it is with fine wines. They are the issue of a magnificent trinity: Soil, Vine, Skill. To produce fine wine, one begins with appropriate land and select vines, progressing to particular techniques of winemaking. The vine will thrive in all manner of soils, in some where nothing else can survive, soils that seem nothing but schistic rock. My Burgundian friend Robert J. Drouhin says, "Man cannot add qualities to what nature produces but he can have as an ideal the extraction of 100 percent of the potential qualities of the grape. No one has as yet accomplished this." Accepting the Drouhin pronouncement, California vintner Robert Mondavi of the Napa Valley is animated by an almost feverish drive to extract more and more from the grape. Though a jury of his peers has acclaimed it one of the state's finest red wines, he is not altogether satisfied with his California Napa Valley Cabernet Sauvignon. Mondavi's aim is to rival the best from that grape's own homeland, Bordeaux. Neither he nor I would describe the contest as an attempt to "match" French claret. In Olympian competition there is a nobility in all contenders for the laurels but no two performances are identical.

Far-roving pioneer vintners from Europe carried with them the desire to create a vinous echo of their homelands. For two hundred years of winemaking in California they have pursued this aim studiously, patiently, wisely. The result? As the dean of the world's enologists, Professor Maynard Amerine of the University of California at Davis, recently said, "The best French wines are made in France. The best California wines are made in California . . . and we intend to make them better!"

That great wines are made in California is no longer a controversial

Ernest Wente, a second-generation California vintner, examines a cluster of Chardonnay grapes

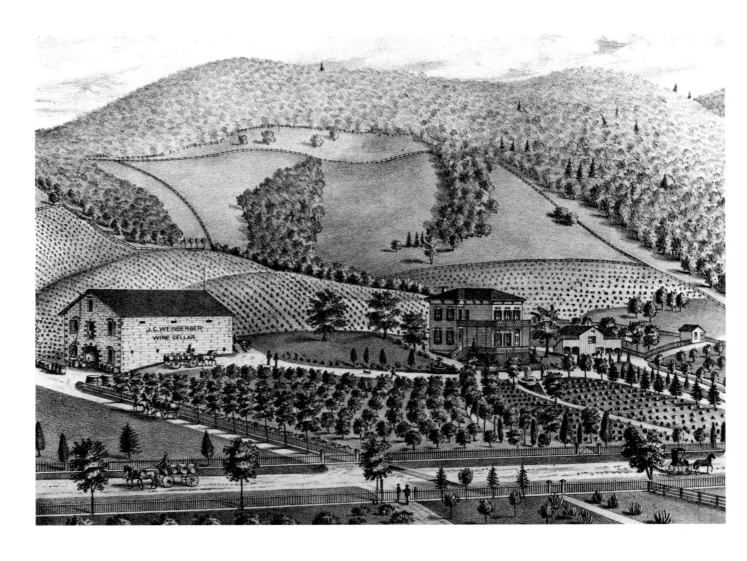

statement. It becomes a futile argument when an ill-positioned advocate attempts to compare their merits too narrowly with wines of other lands. Every wine draws its indigenous character from the individual attributes of its own soil and vines, and from the winemaker's philosophy and skill. A divine ordering in those great geological upheavals when the seas retreated, leaving the land masses, ridges, mountains, alluvial slopes, and rocky canyons—this composed the soil. Men carried the vine and its clonal cousins all over the world. Men made wine according to their knowledge, skill, and dreams. Nowhere have two identical wines been made. Great wines come into being where the right vine is growing in the right soil and the nectar is transformed through fermentation under the watchful eye of a knowing, sensitive, creative vintner. When all three points—Soil, Vine, Skill—are struck, like the three notes of a major chord, with equal and ultimate finesse, great wine is produced. Any diminution of any one of these factors will correspondingly lessen the quality of the wine. All wine-makers know this to be so. All visionary winemakers, through recorded time, have followed their own paths to make this difficult dream come true.

The first vines in California, which were planted at Mission San Diego in 1769 by Padre Junípero Serra, had but one main grape variety. It is still known as the "Mission grape" because it dominated the vine-yards of the twenty-one missions established along El Camino Real, the

This pleasant vineyard on the Silverado Trail in Napa Valley produced some of the early California wines

An old handpress for crushing grapes has been memorialized in this sculpture in Golden Gate Park, San Francisco

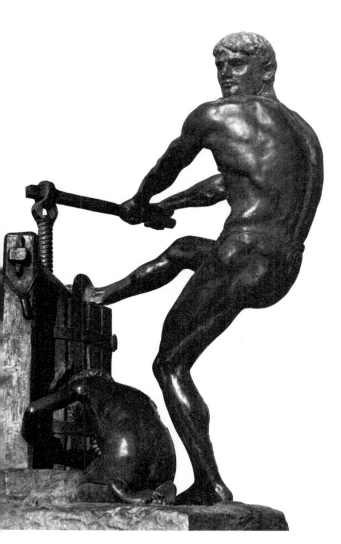

colonial highway leading north to San Francisco and Sonoma. Until the 1830s this heavy-yielding vine, with grapes "bluish-black and the size of a musket ball," as an English sea captain described them, was the only wine-producing vine growing in California. There are still more than 6,000 acres of Mission grapes, yielding a high annual tonnage for winemaking, but the blood of these grapes seldom finds its way into premium bottlings.

In 1831, Jean Louis Vignes, who came from a Bordeaux wine family, settled in the pueblo of Los Angeles and immediately established a vine-yard with cuttings of vines sent to him from his homeland. Dissatisfied with the wine produced locally from Mission grapes, he dreamed of making the claret he remembered from his homeland. The same dream of the wines of home stirred subsequent winemaking immigrants from France, Germany, Italy, and Hungary. To achieve this seemingly simple but in fact complex goal, they endured every kind of hardship. When Pierre Mirassou, who had come to San Jose from France, returned to obtain select vine cuttings for his California vineyard, the clipper ship carrying him and his precious cargo was becalmed after rounding Cape Horn. The ship's captain refused him any more water for sustaining life in his vine shoots, so Mirassou made a deal to buy all the potatoes on board and stuck the vine ends into the moisture-filled spuds! Descendants of those vines still green the rolling hills of the Mirassou Vineyards.

California's most heroic and tragic history of vineyard and wine-making has a Hungarian nobleman as its protagonist. In 1861, carrying a letter of introduction from William H. Seward, Abraham Lincoln's Secretary of State, Count Agoston Haraszthy journeyed through all the wine lands of the Continent, obtaining 100,000 cuttings of vines from every principal winegrowing region. Each was tagged, labeled, and brought by ship to California. He wrote an exciting book about his visits, noting all the viticultural and winemaking procedures of each country of his pilgrimage so that his studies might be implemented in California on his return. The book, *Grape Culture, Wines, and Wine-Making,* was published by Harper's in 1862, but the distribution of the vines to the intended suitable areas was never achieved. The California legislature, which had authorized his journey, refused payment of his $12,000 bill when it was submitted. He was left to peddle the vines as best he could. They were sold off in small lots, tags often being lost, titles smudged or rendered illegible. But one of the vines Haraszthy imported was to become California's great pride, the Zinfandel, still of unknown origin. (Recent studies by Professor H. P. Olmo of Davis suggest that Zinfandel is a clonal descendant of the Italian Sangiovese of Chianti, which through the centuries made its way across the Adriatic and ultimately to Hungary, where it was obtained by Haraszthy. Tastings in which I have participated recently comparing aged Chianti with equally aged Zinfandel suggest that there is indeed some relationship here. But years will be needed to determine the certainty of this vine evolution.)

California Zinfandel vineyards exist in every winegrowing region of the state, producing every quality of wine, from the most ordinary red to the most distinguished complex ruby of true finesse and character. As of 1973 the plantings exceeded 27,000 acres, almost double the acreage of

CALIFORNIA

MORRIS-BURG
VINTAGE
RARE OLD
SAUTERNE

Some souvenirs of the thriving
California wine industry in the "good
old days" before Prohibition

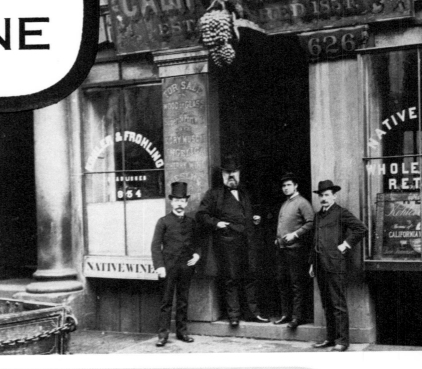

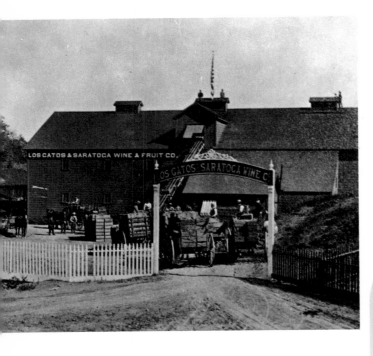

WIDOW FINKE
REG. U.S. PAT. OFF
EXTRA DRY
ESTABLISHED 1864
CALIFORNIA
BURGUNDY
CARBONATED

A. FINKE'S WIDOW
·SAN FRANCISCO·CALIFORNIA·U·S·A·

90

California's most sought-after grape, Cabernet Sauvignon. With patient aging in both oak cask and bottle, a California Zinfandel from one of the cooler viticultural regions of the North Coast, harvested at the right moment of sugar content, fermented with intense care, is inevitably one of the world's great wines. It pours out, when young, with an almost raspberry fragrance, a buoyant flavor of freshness and zing. It has sometimes been called "the Beaujolais of California." But aged reserve-bottlings, after long resting, suggest the nobility of bouquet and lingering aftertaste of the finest Burgundies. Late-harvested Zinfandels, sometimes reaching an incredible 17 percent alcohol by reason of high grape-sugar content, are arousing new excitement among wine lovers. The first Late Harvest Zinfandel was created almost by accident at Bob Travers's Mayacamas Vineyard in 1968. With grapes from the Sierra foothills he was able to reproduce the phenomenon in 1972. Such wines can last a century!

California's greatest success with European vines has come with Cabernet Sauvignon and Chardonnay. Both are runaway favorites among enthusiastic connoisseurs of California wines. The eminence of these two *Vitis vinifera* varieties, from Bordeaux and Burgundy respectively, was attained only in the last quarter century as winemakers acquired greater understanding of the California environment and learned to adapt traditional techniques to it.

While "claret" is the common term for the red wine of Bordeaux made from Cabernet Sauvignon grapes (with optional admixtures of Merlot, Malbec, Cabernet Franc, Petit Verdot, and Carmenere), one seldom hears that wine name in California. The whole system of wine nomenclature in California emerged from the recognition of the superior quality of table wines made from superior breed stock of choice vines, such as the Cabernet Sauvignon. The palate of American wine drinkers became accustomed to the richness of Cabernet Sauvignon, and it is now the California red wine in greatest demand.

The most successful California white wines are made from the noble white grape of Burgundy, Chablis, and Champagne—the Chardonnay grape (sometimes improperly dubbed "Pinot Chardonnay" after the wine; it is not a member of the Pinot family). With the general acceptance of using proved yeast cultures in place of wild yeasts from the bloom of the grape skin (as practiced in Burgundy), plus cool, controlled fermentation, California vintners are producing brilliantly clean, dry, appetizingly intriguing wines of enormous appeal. Several tasting juries of acknowledged experts have judged California Chardonnay wines as surpassing the quality of some of the most famous white Burgundies. More and more I have noticed that in restaurants and private homes a glass of well-chilled Chardonnay is replacing the martini as an aperitif. Its time has arrived, but, alas, the plantings have not been able to keep up with the demand. Even during the wine slump of the spring of 1974, when sales of imported wines languished, such fine examples of California Chardonnay as those of Freemark Abbey, Chalone, Christian Brothers, Sonoma Vineyards, Sterling, Robert Mondavi, and Spring Mountain disappeared like dew before the sun.

As a consequence of the combined talents of enologist André Tchelistcheff and Davis-graduate enologist Mary Ann Graf at the Simi Winery in

the Sonoma Valley, two more European grapes have emerged as California standouts, the Alsatian Gewürztraminer and Johannisberg Riesling. Neither begins to suggest the wine of Alsace or Germany, but each is dramatic in its own way, carrying the haunting incense of oak from the aging barrel, mingled with the varietal characteristics of the vine.

Even the best of California's winemakers have had only sporadic success with the Burgundian Pinot Noir. Like an unruly child, it has generally failed to respond to the most meticulous attention. Low-yielding, it offers challenge without too much hope of reward. The White Riesling of the Rhine, dubbed Johannisberg, makes a fine white wine in California, but it bears little resemblance to the silky, aristocratic vintages of the Rheingau or Moselle. But the bright grape-child of the Loire, Chenin Blanc, is demonstrating to California growers how much it adores the environment of the Sunshine State's coastal areas. Fragrant and fruity in young bottlings, it has a perfume that is a souvenir of some of the finest vintages of the Loire Valley. Its robe, or color, suggests the lightness of chiffon, whereas its across-the-ocean relative has the crisper luster of taffeta. Both are gay and bright wines. There is no reason not to enjoy them both. But there is also no reason to denigrate one because it is not twin to the other. The undeniable charm of Gallo's Chablis Blanc relies upon its body of 60 percent Chenin Blanc.

California has developed revolutionary concepts in winemaking, some of which have been exported to the Old World, where the grape has been no stranger for two thousand years. Temperature control, stainless-steel fermenters, and computers that fractionate every microelement of the compound nectar—these are now the subject of serious study by vintners everywhere. And in Australia new systems of extracting the color from grape skins have been developed, to be shared with winemakers in California as well as winemakers from France, Italy, and Germany.

With all the time that has elapsed since Noah first crushed a grape and made wine, and with all the technological advances of our age, winemaking is not yet an exact science. Beyond the laboratory lie the whims of nature and the creative drives of man, whose dreams reach toward an elusive perfection such as that described in a Grecian ode of Bacchylides composed five hundred years before Christ:

"Sweet compulsion flowing from the wine cups warms the heart
. . . all mingled with the gifts of Dionysus, it darts through the
brain, sending the thoughts of men to heights supreme."

Great wines are made by great men adventuring with one of earth's greatest gifts, the nectar of the grape, until it becomes "Water sublim'd." To catch the passion of the winemaker you have but to spend moments in sharing a wine with its creator: Château Margaux with Bernard Ginestet, Mouton-Rothschild with Baron Philippe, Muscat d'Alsace with Hubert Trimbach, Chianti Classico with Baron Bettino Ricasoli, Fiano with Antonio Mastroberardino of Campania, Recioto della Valpolicella Amarone with Giovanni Bertani of Verona. Or swirl a glass of ruby Bardolino on the shores of Lago di Garda with Dottore Lamberto Paronetto. Such men live for the *education* of their wines, to bring them forward into the arena of perfection.

The Gallo brothers, Ernest and Julio, enjoy the daily ritual of tasting their wines

It is no different with California's winemakers. Brother Timothy has spent more than thirty years of his life among his vines and wines at Mont La Salle in the Napa Valley. Grape growers and winemakers revere the names of the late Herman Wente and Louis M. Martini, as they admire the active and dynamic descendants of those two dynasty founders. Through the efforts of Ernest Gallo millions enjoy his ever-improving wines. Young Dick Graff of Chalone endures a severe monastic separation from the world at his remote vineyard high in the Gavilan benchlands of Monterey County, trucking every ounce of water up the mountain to make possible the survival of his thirsty vines. But the golden brilliance of his Chardonnay is so superb that I can only borrow the phrase of Dumas, "Drink it bareheaded and kneeling." A list of great winemakers and great wines of the world, the New as well as the Old, would fill a whole book . . . and name no one wine that matched another.

"We like that best to which we are accustomed," Louis M. Martini once told me. Every man is his own czar in the empire of taste. You have only to try the next unknown bottle to expand the borders of your wine-drinking pleasure. But first measure the wine's potential in terms of our trinity: Soil, Vine, Skill. It is the way of the connoisseur, demanding the discipline of discrimination and, together with sensory awareness, leading you directly to the heart of the grape.

THE VINEYARDS OF CALIFORNIA

NORTH OF SAN FRANCISCO BAY

NAPA, SONOMA, AND MENDOCINO COUNTIES

As if the little plots of Bordeaux and Burgundy and Champagne had been transported to California, the counties of Napa, Sonoma, and Mendocino constitute some of the finest wine-growing regions in the United States, potentially on a par with any of the best vineyard lands of France or Germany. Fine wines grow here for a hundred miles north of the city of San Francisco, on flat valley floors, by swift rivers, on gentle rolling hills, and even on the steep slopes of mountains.

First in importance is the Napa Valley, stretching in a lazy crescent northwest of the tidelands on San Pablo Bay. Though its fame has brought hundreds of thousands of visitors to the vineyards and wineries, especially in the summer months, parts of the valley in Napa County still retain some of the simple, quiet beauty that attracted the first winemakers a century ago. On either side, hills rise to 1,000 feet. At the head of the 35-mile-long trough stands majestic Mt. St. Helena, at 3,000 feet offering a vista ranging over the valley vineyards and those in neighboring Sonoma County as well. Below the peak, strung out on the thread of Highway 29, the "Wine Way" of Napa, are the important wine towns: Calistoga, St. Helena, Rutherford, Oakville, Napa—names that now ring with some of the same authority as those of the famous French wine communes.

The ridge of the Mayacamas Mountains separates Napa from Sonoma County, which in turn runs from the Russian River Valley across to the bleak headlands of the Pacific. There, stately redwoods stand where vines will rarely grow, for the rugged coastal strip is too foggy and cool to support wine grapes. Most of the 13,000 vineyard acres in Sonoma cover the broad,

fertile center of the county, from Santa Rosa north through Guerneville, Healdsburg, Asti, and Cloverdale.

Beyond Cloverdale the landscape changes little, even after one enters Mendocino County. The Russian River Valley remains the axis for the important vineyards which follow it to its source north of Ukiah, where the scenery becomes more dramatic but the acres that can welcome the vine fewer and fewer. Mendocino is the northernmost of the great North Coast wine districts, but for many years the inland climate there was thought to be too warm for growing the best wine grapes. Now many of the vineyards on cooler hillsides have dramatically proved that Mendocino soil can yield fine fruit from the noble grape varieties; vineyard acreage has increased, and several top-quality wineries have been constructed or enlarged. The future for Mendocino wines is bright indeed.

The tradition of sampling wines at the vineyard is an old one. The "Wine Way" of Napa Valley offers many pleasant opportunities

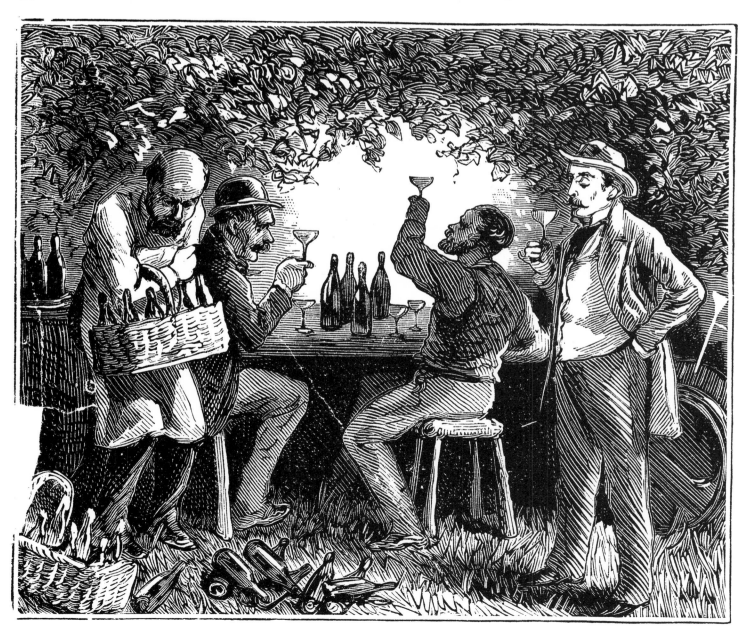

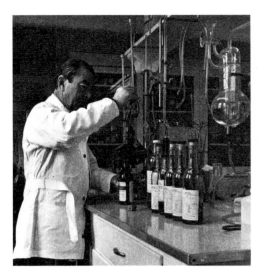
André Tchelistcheff in the Beaulieu laboratory

BEAULIEU VINEYARDS, Rutherford, Napa County. Fine traditions stand behind many of the important Napa Valley wineries. Of these traditions, some are longer but none grander than the story of the great men and remarkable wines associated with the handsome place that is Beaulieu. The buildings, vineyards, and classic gardens resemble those of a French wine château in the Médoc or Graves. So it is not too surprising to learn that the finest Beaulieu bottlings are of the greatest Bordeaux wine grape—Cabernet Sauvignon. First among these giants are the "Private Reserve" Cabernets—regal, rare, and rationed wines that for thirty-five years have been at the heart of Beaulieu's enviable reputation.

Until 1973 the man who made the Cabernet Sauvignons and Pinot Noirs and all the other Beaulieu wines was the dedicated, wonderfully sensitive André Tchelistcheff, brought to the vineyard in 1938 by its founder, Georges de Latour. Tchelistcheff's European vinicultural training and de Latour's ties to Bordeaux and Burgundy ensured the traditionally high quality of the wines, which continued even after de Latour's death, in 1940. Neither the sale of the property to Heublein, Inc., nor Tchelistcheff's recent retirement seem to have had any adverse effect on the wines. His successors do their work well.

Beringer's Johannisberger Riesling

BERINGER, St. Helena, Napa County. The Beringer brothers came from Germany and in 1876 built a homestead at St. Helena, with vineyards, aging tunnels dug 1,000 feet into the hills (by Chinese laborers), and a handsome mansion that makes one think of an estate on the Rhine. Four generations of Beringers made great wines here, at the oldest family-owned winery in the Napa Valley. But in recent years the wines were not as good, and it became clear that an infusion of fresh capital was needed to replace the antiquated equipment and renew the vineyards. The president of the Swiss Nestlé Corporation was sufficiently interested to leave Lausanne and journey to America to acquire the 700-acre vineyard in 1970.

Can this giant corporation infuse life into a tired winery and bring their wines back to their historically high standards? Wine lovers across the country are asking this question of Beringer and Nestlé. The new owners have installed the best modern winery equipment and hired an enthusiastic, skilled winemaker and enologist— Myron Nightingale—to take charge of the vintages. Their efforts and hopes are geared to placing Beringer wines once again among the best in the valley.

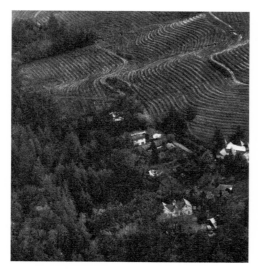

Château Chevalier and terraced vineyards

Buena Vista's wine cellar

CHATEAU CHEVALIER, St. Helena,
Napa County. In the nineteenth century the Beringer family grew grapes in Napa Valley; their summer retreat was an hour's wagon ride up the mountains to the west, where the grapevine also flourished.

Recently Greg Bissonette bought the old Beringer summer property and reclaimed the extensive vineyards from what in time had become a dense pine forest. When enough of the trees were removed, he discovered some of the century-old vinestocks still protruding from the rich earth. Now cleared, this land has been replanted with Cabernet Sauvignon, Zinfandel, Chardonnay, and Riesling, all growing not far from the wonderfully restored house, with its dramatic view. Vineyard watchers report that by 1978 the Château Chevalier will be making some of the best wines in California. If the Bissonettes can capture even a tiny bit of the beauty and character of the mountainside estate, the wines will be well worth the wait.

BUENA VISTA, Sonoma, Sonoma
County. Count Agoston Haraszthy, a political exile from Hungary, founded the Buena Vista vineyard in 1856, and became known as the father of modern California winemaking. Accustomed to living in the grand manner, the Count built a replica of a Pompeian villa on a commanding knoll, surrounded it with formal gardens, and planted a sizable vineyard. He made a trip to Europe in 1861 and brought back 100,000 vines of almost 300 varieties. After his death, the phylloxera pestilence invaded Buena Vista and destroyed the vines. To compound the disaster, the picturesque underground tunnels of Buena Vista collapsed during the earthquake of 1906.

But life has a way of building on the ruins of the past. In 1943, Frank Bartholomew, then the Chairman of the Board of United Press International, acquired a 400-acre tract of Sonoma land that included the long-neglected Buena Vista vineyard. It became the rewarding challenge of Bartholomew and his wife, Antonia, to bring back the golden days of the nineteenth century. They repaired the tunnels, replanted the vineyards, and put the winery under the direction of Albert Brett, who produced some of Sonoma's best wines—a fitting tribute to the heritage of Count Haraszthy.

During the 1960s, wine connoisseurs sought out Bartholomew's cask-numbered Cabernet Sauvignon, Chardonnay, Green Hungarian, and his remarkable Zinfandel. Buena Vista was sold in 1968 to Vernon Underwood of Young's Market Company of Los Angeles, the Bartholomews retaining their home and a small adjoining vineyard, where fine wine is still made.

Vernon Underwood and his associates have retained Albert Brett as their winemaker and have recently planted 600 acres of vines nearby on the Napa–Sonoma County line. Local experts believe that the quality of Buena Vista's wines will continue to improve during the years ahead. I recommend that you now try the Buena Vista Chardonnay, Cabernet Rosé, Pinot Noir Cask-Bottling, Cabernet Sauvignon, and above all, their delightful Zinfandel.

FREEMARK ABBEY, St. Helena,
Napa County. Even the young who may not yet be interested in wine love to visit Freemark Abbey because upstairs in the stone winery building are a candle factory and a gourmet shop. Wine lovers, whether young or mature, visit the rest of the structure as if it were a shrine dedicated to Bacchus. At this vineyard was born the fabulous Pinot Chardonnay that outclassed the best of the Corton Charlemagnes and Montrachets offered in a blind tasting held with European and American wine experts.

I was one of the judges on that important day. Incredulous, wine authorities present asked, "How could it happen?" Perhaps the answer lies in the region's superior soil and the careful attention paid to the vines and the winery, along with dedicated teamwork on the part of the four major partners. These men keep close watch over the progress of the grapes and wine, from the first spring flowering, through the barrel and bottle life, and on through distribution across the country. Larry Woods tends the vineyards, Bill Jaeger handles the finances, Chuck Carpy runs the day-to-day life of the winery, and the skillful Brad Webb and Jerry Luper make the wines—perhaps the most remarkable winemaking team in the state.

Not long ago Freemark Abbey was one of the tiny "boutique" producers. Now it boasts an annual production of 20,000 cases—the size of Lafite-Roth-

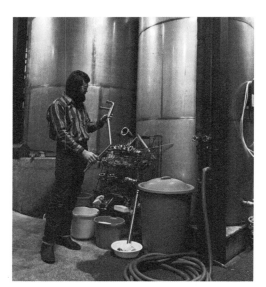

Barrel-cleaning tools, Freemark Abbey

schild. The reds are fine, with Cabernet Sauvignon and Pinot Noir being made in the great French tradition, and their Petite Sirah, even to a trained palate, tastes not one whit inferior to a good Châteauneuf-du-Pape.

CRESTA BLANCA, Ukiah, Mendocino County. Cresta Blanca has been a famed name in California wine history since 1882. In the late 1950s the firm marketed one of the finest wines ever produced in the state—a Premier Sémillon with some of the great richness of a French Sauternes. When acquired by the Guild Wine Company in 1970, Cresta Blanca moved from its original vineyards in the Livermore Valley to Mendocino County. As a member of the large Guild Co-operative, Cresta Blanca blends wines made from grapes grown in several parts of the state, with emphasis on the good wines of Mendocino. In general, the reds are better than the whites: Zinfandel and Petite Sirah are two of the best.

CUVAISON, Calistoga, Napa County. Interesting small innovative vineyards now dot the best vine-growing region of northern California, and they are reminiscent of the little vine patches one finds in Burgundy and Bordeaux, homes of some of the finest wines in the world. Our own small versions of Château Petrus or La Tâche will help American wines develop the distinctive personality that has been lacking for so many years. One of the tiny "boutique" vineyards is Cuvaison, started by Thomas Cottrell and Thomas Parkhill—a scientist and an electrical engineer. Their capital may have been small, but their ingrained strength and sense of purpose were great. Cuvaison is one of the first wineries to use quasi-carbonic maceration, a fermenting style common in France and now adopted in California for making such charming wines as Beaujolais Nouveau.

If you like fruity Beaujolais, by all means try the Cuvaison Gamay. For the sprightliness of a young Loire Valley white, you will do well with their Chenin Blanc. The wines are pleasant and authentic and can be excellent values. Cuvaison has been acquired by the Commerce Clearing House of Chicago, and it is fervently to be hoped that the projected expansion will not dim the winery's present jewel-like excellence.

CHAPPELLET, St. Helena, Napa County. Donn Chappellet, heir to part of the Lockheed fortune, was a successful executive for a large Los Angeles food-vending company, and, more important, a man who loved wine. In 1967 he turned to his wife and children one day, saying, "Let's take to the hills and grow wine." Though this meant abandoning an enviable business career to take on the exhausting but exhilarating work of carving out a vineyard on Pritchard Hill, high above the floor of the Napa Valley, the prospect was irresistible.

In 1969 the Chappellets left their luxurious home in Beverly Hills for the rugged life of mountain climbing and winegrowing. In a few short years they have extracted from the soil a Cabernet Sauvignon that is sought after, is rationed, and commands $10 the bottle. There is also a Chenin Blanc that some consider the best of its kind in California, as well as a quite remarkable Johannisberg Riesling grown on Prit-

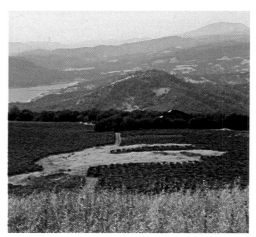

Chappellet vineyard overlooking Napa Valley

chard Hill. This is not the kind of vineyard to visit without appointment, because the Chappellets are always working, hardly stop for lunch, and have little time to chat with the chance passerby.

CHRISTIAN BROTHERS, Napa County. Who are the Christian Brothers? They are a Catholic teaching order with headquarters in Rome. The order was founded in 1680 in the Champagne district of France by Saint Jean Baptiste de la Salle. The proceeds of their wine-making help support nearly two hundred schools and colleges, including St. Mary's College in the San Francisco East Bay and Manhattan College in New York City.

In 1882 the Christian Brothers started to make sacramental wine in California for their own use; their wines became available to the public in the 1930s and are now distributed by Fromm and Sichel. The original winery and novitiate, called Mont La Salle, are nestled amid their vineyards in the hills outside the town of Napa. Not indifferent to technological innovations, the Christian Brothers have built a new model winery and crushing station augmenting the champagne cellar at St. Helena. Wine, like bread, is for the Brotherhood a gift of nature, something to be thankful for and to enjoy without pretension. It is important to know that they make their wine in such a way that it is ready to drink when it reaches the

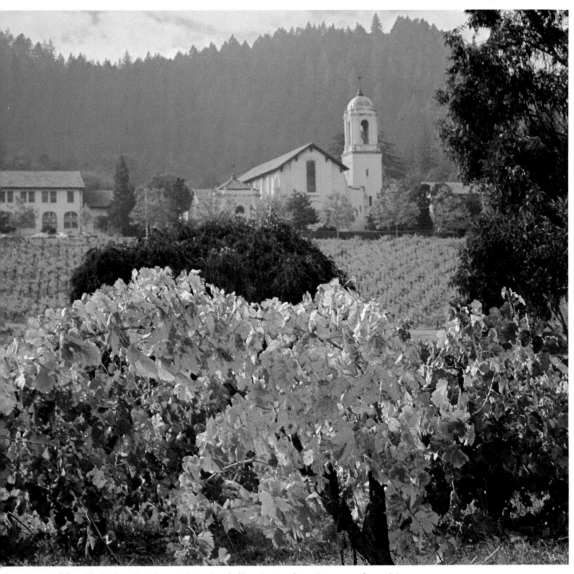

The Christian Brothers Mont La Salle vineyards, winery, and novitiate

wine merchant's shelf. The Christian Brothers generics—Rhine and Chablis among the whites, Burgundy among the reds, and Napa Rosé among the pinks—offer excellent values as simple table wines. Their varietals, including Cabernet Sauvignon, Pinot Noir, Gamay Noir, Zinfandel, and Chardonnay, are astonishingly low-priced. Good bottles can be obtained for about $3 to $4, a far cry from the products of some of the "boutique" vineyards—the small, personally operated wineries—which command triple the price.

CLOS DUVAL, Yountville, Napa County. The noblest of Bordeaux wine-making traditions were transferred not too long ago to the Napa Valley. The *régisseur*, or manager, of the wines at Château Lafite-Rothschild has a son who was graduated from the enological school in Bordeaux. Though brought up in a house on the Lafite grounds, young Bernard Portet chose not to work with his father for Baron Elie de Rothschild. He now seeks his fortune along the Silverado Trail.

Lafite-Rothschild stresses the Cabernet Sauvignon combined with the Merlot grape. Clos Duval does the same in Napa—the American Portet knows no other way. Merlot contributes softness and light elegance, while Cabernet Sauvignon offers depth and long life. The first of the Clos Duval wines, which strove to capture the essence of the Haut-Médoc, reached the American market early in 1975. Since fine red wines like these need five to ten years in the bottle, we will not know for certain until the next decade if this vineyard—soon to produce 13,000 cases a year—has brought the qualities of Pauillac to Napa. Clos Duval certainly bears watching.

FOPPIANO, Healdsburg, Sonoma County. Since 1896 the Foppiano family has been growing grapes and making wine not far from the Russian River in central Sonoma County, with the emphasis on rich, barrel-wood character for its hearty reds. Much of the vineyard acreage has recently been replanted to bring the selection of vines into line with contemporary viticultural ideas. However, the huge, old-fashioned redwood aging tanks remain an integral part of the Foppiano operation.

Based on my tasting notes, the best selections are the red wines—Pinot Noir, Zinfandel, and Petite Sirah—good examples of the long Foppiano tradition of California wines.

GRAND CRU, Glen Ellen, Sonoma County. A phoenix has risen just north of the town of Sonoma. After years of dormancy, in 1971 the pleasant stone winery (formerly called Sonoma County Winery) sprang to life again under the new name Grand Cru. Allen Ferrara and Robert Magnani are the pair responsible for the magical comeback, and they happily and proudly make visitors welcome on weekends and holidays, when the winery is open to the public.

The wines to try are the three Zinfandels. The reds are typically rich and full, the equal of any in the state; the rosé is darker and deeper in flavor than the pink wines made by the other important California wineries; most interesting of the distinguished output is the white called Zinfandel Blanc de Noir, a light, fresh, fruity wine, expensive but well worth searching out. Scarcely half a dozen wineries in the state make a white Zinfandel, and the one from Grand Cru is probably the best.

99

INGLENOOK, Rutherford, Napa County. A young Finnish sea captain, Gustave Niebaum, left the sea to start his vineyard back in 1879. For decades the reserve old bottles of Inglenook commanded high premiums, and even today a forty-year-old Inglenook can fetch $100 the bottle from a California enthusiast.

With a hundred years of tradition and many fine wines behind it, Inglenook commands respect and admiration from the other major vintners in the valley. There have been good times and bad times, but with some of the best vineyard land in northern California, Inglenook is always capable of giving us some memorable bottles which retain much of the flavor that made the old wines famous. Now owned by the large Heublein Corporation through their subsidiary United Vintners, Inglenook is able to distribute widely its extensive range of wines. Such classics as Cabernet Sauvignon, Pinot Noir, and Zinfandel always do well at Inglenook. Also good are a number of less well known wines: White Pinot, Red Pinot, and Charbono. For excellent wines midway between modest jug wines and expensive premium bottlings, try the Inglenook Navalle label (gallons, half gallons, and bottles), which includes Burgundy and claret, Chablis and Rhine, and a vin rosé.

The currently produced numbered cask wines of Inglenook command over $7 the bottle, most shops allocating it on the basis of one bottle per customer. As with other vineyards, the question is: Is it scarcity or excellence that determines the rationing and the price? I leave it to your palate.

HEITZ CELLARS, St. Helena, Napa County. One of the most idealistic of winemakers is Joe Heitz, a former schoolteacher who became a legend not long after his 1960 graduation from Davis. Unlike other members of his class, Heitz worked for someone else only briefly before acquiring his own winery. However, since it takes about

Barrels of wine aging in Heitz Cellars

five years for new vines to bear the fruit that makes the wine, he bought grapes from his neighbors. The wine he made surprised the skeptics who thought that superior wine could come only from grapes grown by the vintner himself. The Heitz magic touch still turns good purchased grapes into great wines, but now Heitz also has vines of his own, and he often gives his bottles specific location designations indicating which part of the vineyard the grapes come from.

Heitz wines typically have much richness and depth, especially the Pinot Chardonnays and Cabernet Sauvignons (which sometimes cost over $10 the bottle). He makes some of the finest generic bottlings in California, and these are less expensive than his varietals.

ITALIAN SWISS COLONY, Asti, Sonoma County. The two best-known nationally advertised brands in California jug wines are Gallo and Italian Swiss Colony. Gallo's headquarters are in the Central Valley, but Italian Swiss clings to its historic roots in Asti, far up in Sonoma County. Gallo remains family-owned, but Italian Swiss Colony is part of United Vintners, the same company that owns the Beaulieu and Inglenook vineyards.

The European roots in Asti are deep, laid down in 1850 by a San Francisco grocer who wanted to be of help

to impoverished Italian and Swiss immigrant farmers. Even the town's name was selected to make the immigrant workers feel at home. When Pietro Rossi, a knowledgeable winemaker, came to Italian Swiss Colony, the cooperative began to flourish, and it made great progress under the guidance of his two sons, both trained at Davis just after the turn of the century. In the years before World War II the Rossis made Italian Swiss Colony one of the great powers in the California wine trade.

During the war Italian Swiss Colony began to produce the very popular Lejon brand of vermouths, brandies, and champagnes. Current emphasis is on good low-cost table wine and on "pop" wines such as Annie Green Springs and Bali Hai.

The fact that Italian Swiss Colony is in Sonoma does not mean that all their grapes are grown there. Many come from the Central Valley, where yields are higher and costs considerably lower. The firm now owns several large wineries in the valley. Though Italian Swiss Colony does not set out to make wine of the distinction of many of its Sonoma neighbors', one cannot deny the important contribution to American wines of this giant organization.

KORBEL, Guerneville, Sonoma County. For nearly a century Korbel champagnes have been made on the banks of the Russian River in the center of Sonoma County. True fame came only with a consumers' report that pronounced Korbel the best United States champagne. Volume tripled virtually overnight and Korbel Brut became so desirable that it had to be rationed.

Korbel Natural, a wine born in much uncertainty, has become one of the firm's most famous products. It gets its name from the fact that practically no sugar is added to the wine after the sediment is disgorged. Though the owners and the winemakers at Korbel first thought it too severely dry, many who were lucky enough to taste it found

Tasting room at Inglenook, built in 1887

Pruning vines on a frosty morning, Korbel's vineyard

it a tart, refreshing cousin of expensive French champagnes. The chances are against your acquiring Korbel Natural. Keep looking, but meanwhile try the Korbel Brut. There is plenty of enjoyment in it, too. Since 1965, Korbel has produced still table wines, including Grey Riesling, Chenin Blanc, Pinot Noir, and Cabernet Sauvignon. Though good, none of these approaches the excellence of Korbel sparkling wines.

ROBERT MONDAVI, Oakville, Napa County. Robert Mondavi's Cabernet Sauvignon is often served at the White House and at dinners given by the State Department. This stamp of approval and the accompanying publicity have made it the single most sought-after red wine of the Western Hemisphere. Perhaps within another generation the equivalent of a Lafite-Rothschild will be born at the Mondavi winery.

Robert Mondavi and his skilled son Michael share an unbridled enthusiasm for good wine. The elder Mondavi did not come by success easily. His wines represent a lifetime of hard work, long hours, and constant dedication. The winery itself, designed in the authentic style of an early Spanish mission by Cliff May, distinguished California builder, reflects Mondavi's love of California and its traditions.

Wines fermenting in refrigerated tanks at Robert Mondavi

The Mondavi Cabernet Sauvignon is supreme; also excellent are the Gamay and Pinot Noir wines. He has also made a great contribution with his whites: Fumé Blanc (like a topflight Loire), Chardonnay (similar to a fine Meursault), and Johannisberg Riesling (with the flower and fruit of a typical German white).

Mondavi is a vineyard to delight visitors. Friendliness, beauty, and wonderful wines merge in the pleasantest of tasting rooms. Delightful outdoor concerts brighten summer weekends, luring the music lovers of San Francisco.

SONOMA VINEYARDS, Windsor, Sonoma County. Rodney D. Strong gave up a drama and dance career in 1960 and now rules one of the largest domains of estate-bottled superior-grade varieties in all California. Perhaps his unfaltering resolve was conditioned by the fact that his grandparents were winemakers in Germany; perhaps wine became a passion with him while he was on a dance tour of European capitals.

It all began in a small Victorian house in Tiburon, on the shore of San Francisco Bay. Peter Friedman, now the president of Sonoma Vineyards, developed the concept of personalized labels on their wine bottles, with such custom-printed inscriptions as "Bottled Expressly for John & Mary Laird." It was a profitable venture but hardly generated enough capital to achieve Strong's

The San Francisco Ballet performing at Sonoma Vineyards

goals. To accomplish his ambition, Strong directed the firm to go public in 1970.

In searching for the best lands and for microclimates that would encourage the noblest grapes to thrive, Strong found his ideal places in Sonoma and Mendocino counties. There are now twenty-eight vineyards and over 5,000 acres providing the stage for his greatest role—that of a successful winemaker.

Sonoma's plantings are limited to the leading four grape varieties: Cabernet Sauvignon, Chardonnay, Johannisberg Riesling, and Pinot Noir. At some point Merlot will be added to provide softness, as is done in Bordeaux.

Perhaps Strong's most creative contribution is his concept of a specific vineyard label rather than one simply bearing the valley name of Sonoma. Only his choicest land will be used for the estate-bottled vineyard appellation. The label will read "Sonoma County, Iron Horse Vineyard, Pinot Noir 1975, estate-bottled by Sonoma Vineyards." And, like the great La Tâche in Burgundy, the Iron Horse Vineyard may be only 20 acres in size. This exalted category will be the highest-priced of the Rodney Strong wines.

Below this level, but still estate-bottled, will be the same varietals. However, the specific vineyard name will not be mentioned and the cost will be somewhat lower.

The most exciting wines in the current production are the Chardonnay 1971 and Johannisberg Riesling Spätlese (late-picking) 1971. As for the reds, one will be rewarded with the Cabernet Sauvignon 1970 and Zinfandel 1970 in magnum.

HANNS KORNELL, St. Helena, Napa County. In the few short years since 1958, when he bought the old Larkmead winery from Italian Swiss Colony, Hanns Kornell has established his name as one of the greatest champagne makers in America. His expertise did not develop overnight. After arriving from Germany, he spent nearly two anxious decades traveling back and forth across the country, making sparkling wines in more states and for more wineries than he now cares to recount. When the opportunity came to start his own cellar, he was able to continue a family tradition of proud and independent champagne making that dates from the middle of the last century.

Kornell makes wine under his own label as well as for many vintners in Napa who have neither the facilities nor the patience to make their own. His raw materials—the still wines he blesses with bubbles—are purchased from friends throughout the valley. All Kornell wines are fermented in the bottle and disgorged in the traditional manner. Two of the best are the Sehr Trocken and the Brut, both containing a high proportion of Riesling and Sémillon grapes. The Sehr Trocken has practically no sugar added after the sediment is removed, so it is even drier than the very dry Brut. Each is remarkable, and the production of only 25,000 cases a year scarcely meets the growing demand.

CHARLES KRUG, St. Helena, Napa County. Newcomers to winemaking in the Napa Valley may be eager and earnest, but for the most part they lack an ingredient found in all the great vintners of the world—an ingrained appreciation of the grape handed down in the family from generation to generation. A half dozen wineries in the valley have this heritage, but nearly all the family firms have been sold to giant corporations. Thus is eliminated their sense of pride in a personal dynasty. Two great families remain active in Napa: one at Louis M. Martini, the other at Charles Krug.

Cesare Mondavi came to Napa years ago to buy grapes for Italian winemaking friends in Minnesota. He fell in love with the land and wine of northern California, stayed on to found a fruit-shipping business, and eventually bought the Charles Krug estate as a place to make wine and to bring up his children. One son, Robert, left the fold to found his own business not far away, in Oakville. The other son, Peter, now manages Charles Krug. The joyous spirit of the place is reflected in the handsome buildings and personified by the amazingly youthful mother of the clan, Rosa Mondavi, a beautiful, bustling woman still very much involved in the day-to-day life of the vineyards. Peter's conscientious attention has given us some of the most consistently good wines in the state.

Charles Krug makes an especially fine Cabernet Sauvignon, some of the greatest vintages dating from the 1950s. The more recent bottles will generously repay a decade of cool rest in a dark cellar. Charles Krug white wines may not require the same at-home aging, but the rewards are just as great. Try the Chardonnay, Chenin Blanc, and Johannisberg Riesling.

OAKVILLE VINEYARDS, Oakville, Napa County. The partners at Oakville Vineyards have accomplished the seemingly impossible: working with a combination of new vineyards, old plantings, experienced vintners, recent Davis graduates, a fine house, and a refur-

bished old winery, they have produced some remarkable wines. Under the guidance of W. E. van Löben Sels and his son Kenneth, Donald Brown, and Peter Becker, the old Bartolucci vineyards were revived.

Though the wines have only a short history, one can already detect those worth buying now and those worth watching in the future. First the Oakville Cabernet Sauvignon: big, full, and rich, it needs even more time in bottle than many of its California counterparts. Unfortunately, there is very little of it, but supplies should grow in the next few years. While waiting for the Cabernet, look for the Our House Red and Our House White, which fill the glasses of happy enophiles all over northern California. Also impressive is the balanced sweetness of the French Colombard—useful as a dessert wine or for summer-afternoon drinking.

HANZELL, Sonoma, Sonoma County. The late J. D. Zellerbach, former United States Ambassador to Italy, and chief of our Marshall Plan special mission to Rome, was a lover of great Burgundy wines. His dream was to reproduce on a smaller scale, in the Sonoma hills of California, the great château of the Clos de Vougeot in Burgundy, and to make there a Pinot Chardonnay rivaling Montrachet and a Pinot Noir approaching the quality of Clos de Vougeot. In 1952, when he planted the grapes and began construction of the remarkable and well-detailed château, the ambitious project was launched. The name of the vineyard derives from his wife's name, Hana, and the family name.

Whether or not his noble red and superb white match their French counterparts is a matter of much discussion. Tasters agree that the white wine stands up to a big white Burgundy, but most would say that the Pinot Noir has not yet fulfilled the dream.

When Ambassador Zellerbach died, in 1963, this valuable and beautiful wine property was acquired by Douglas and Mary Day. They shared the vision of the founder, and under their aegis

quality continued to improve. Hanzell is now managed with equal care by their daughter and son-in-law. Only two wines (Pinot Noir and Chardonnay) are produced here, both noble and both rationed even in California and selling at well over $10 the bottle. With each passing year the taste approaches closer and closer to Montrachet and Clos de Vougeot. It is hoped that these wines will ultimately become classics in the annals of California winegrowing.

SOUVERAIN, Calistoga, Napa County. Frank Schoonmaker, whose understanding of all aspects of European viniculture is phenomenal, is no less competent when it comes to California. For two decades, up to 1973, he was largely responsible for the fame of Almadén, so popular in America. The wine letter he edited, *News from the Wine Country*, gave information and pleasure to those who wanted to know more about the grape. His association with Almadén now severed, he has started on the long, hard road toward good quality at the Souverain vineyards.

Until recently Souverain was owned by Lee Stewart, a capable wine man. Now the vineyards are being expanded under the new owners, the Pillsbury Company. Stewart is still there with Schoonmaker, helping Pillsbury achieve its goal of large production and outstanding excellence. Their varietal wines will bear the name of Souverain. Some of the wines to be bottled at a separate winery nearby in Sonoma County will be known as Château Souverain.

STONY HILL, Napa, Napa County. Obtaining a case of Pinot Chardonnay from Frank and Eleanor McCrea is one of the great West Coast adventures, rather like the East Coast thrill of getting third-row-center seats for a Broadway hit. For those who care, each is worth whatever effort or cost is entailed. The following plan should reward you with twelve bottles of the famous Stony Hill wine: (1) Live in California; (2) be on the McCrea mailing list; (3) once

notified that the wine is ready, get up to the vineyard within two weeks (or your reservation will expire and some other eager wine lover will have carted off your Chardonnay or Johannisberg Riesling).

Stony Hill Chardonnay, Johannisberg Riesling, and Gewürztraminer are California classics benefiting from an experience that few other very small winemakers can muster. The McCreas have been doing for twenty-five years what has just recently become popular. Their wines are big, round, and with an amazing depth that even the other great Napa vintners envy. More than one happy San Franciscan family races wildly over the Bay Bridge every year to find liquid gold far up the Napa Valley at Stony Hill. With only 2,000 cases produced, appreciative Californians do not permit a drop to find its way to wineshops.

SPRING MOUNTAIN, St. Helena, Napa County. There is a handsome hundred-year-old Victorian house near St. Helena with vines in front and a winery in its cellar.

Michael Robbins, a lawyer and engineer from Iowa, went on a business trip to Napa Valley in 1963, saw the charming structure, and could not resist acquiring it; shortly thereafter he moved in with his wife and two young sons. Given his engineering background, it did not take him long to learn how to construct a winery and make wine.

In 1970 Robbins let the world taste his Cabernet Sauvignon, Chardonnay, and Sauvignon Blanc. His 85 acres have been saluted by the San Francisco wine community as utterly remarkable and their wines as equal to the best of these three varietals produced by any other Napa Valley vineyard. Off to an auspicious start, Robbins may in time make wine history.

STERLING, Calistoga, Napa County. Few California wineries have come to life with the dramatic graciousness of Sterling. Perched on a ridge high over

northern Napa Valley, the winery is a sun-washed white fortress in the style of a Greek monastery. It is reached by an aerial tramway. Under the direction of Richard Forman from Davis, with the assistance of owners Michael Stone and Richard Newton, Sterling plans ultimately to produce 100,000 cases a year.

I have tasted many of their wines, and some have already proved astonishing. Both the Pinot Chardonnay and the Sauvignon Blanc are excellent, but the true glories from Sterling are the reds. Seventy percent of the vineyard is planted in Cabernet Sauvignon and Merlot, the two grapes basic to great red Bordeaux. Though understandably less elegant, the Zinfandel, too, shows fine bouquet and body.

The handsome winery attracts many tourists. Since nearly all are tempted by the salesroom, Sterling wines will be sold mainly right at the source. Their interesting Merlot Primeur is a soft and elegant wine that gives as much pleasure to Californians as the new Beaujolais gives to happy wine drinkers in Lyons and Paris.

MAYACAMAS, Napa, Napa County. Bob Travers had done well at the Stanford University Graduate School of Business, and his path then led to a brokerage house on Montgomery Street in San Francisco. But the Travers family had always dreamed of the country and of living a new life in the Napa Valley as winegrowers. Travers studied with and was inspired by Joe Heitz of Napa. In 1968 the family moved to a 2,400-foot-high slope in the Mayacamas Mountains on the site of an extinct volcano. To these fledgling *vignerons*, living at a vineyard accessible only by jeep, busy San Francisco seemed a century away—even though the trip in fact takes but an hour.

The 40 acres of land were planted exclusively with superior varieties— Chardonnay and Cabernet Sauvignon. Plans include eventually doubling the acreage. The total present production is about 7,000 cases, much of it allocated

to friends in the San Francisco area, leaving only a token quantity for sale in prestigious shops across the rest of the country. The most talked-about of all the Mayacamas wines is the Late Harvest Zinfandel of 1968, one of the most concentrated wines ever produced in California. The natural alcohol in this wine reaches an astonishing 17 percent, and the power is reflected on the palate.

The vineyard is well on its way to being a twentieth-century phenomenon. High mountains result in low-yield grapes and high labor costs, so the wine commands high prices. The Mayacamas Pinot Chardonnay and Cabernet cost about $10 the bottle even in California.

PARDUCCI, Ukiah, Mendocino County. At the close of World War I, Adolph Parducci began making wine in Sonoma County in the style of his Italian forebears. Adolph's son John moved north to Ukiah in Mendocino County in 1931. He had a feeling that prospects were good for winemaking in Mendocino, and he was obviously right, for many shrewd young vintners have followed since.

As there is a style to the Parducci family, so there is to their wines. The reds are truly excellent. Some are unfiltered and unfined (an unfined wine has not had mineral or organic substances added to clarify and stabilize it), and you will find depth and sturdiness in their remarkable Cabernet Sauvignon and Zinfandel. As with great European wines, many of them will throw a deposit with the passage of time, thus evidencing vitality even after a decade in bottle.

But John Parducci was not content with the status quo. In 1972, after he had set the tone for all the big Mendocino reds, he became fascinated by the possibilities of long fermentation at low temperatures. This method, in California as well as in Europe, results in wines that are fresh, fruity, well-mannered (smooth and with no rough edges), and quick to mature. It is now the style of a great many vineyards in

Bordeaux and Burgundy for making wine that requires less bottle aging before it is ready to drink.

If you find one of the "old" Parducci wines, you will enjoy a big, fat red in the tradition of Hermitage Rouge. If you run across the reds being produced now, you will be delighted with the fruity elegance. In either event, a good bottle. The Parduccis are now as successful with their white wines. These lacked excitement but have improved with constant experimentation.

SUTTER HOME, St. Helena, Napa County. The Sutter Home Winery, not well known even in the Napa Valley, was built in 1874 by John Sutter, of gold discovery fame. Since World War II the property has been the pride of the Trinchero family. Though they produce several wines, the Trincheros concentrate on Zinfandel. Their Zinfandel 1968 is fondly remembered, as are some of its worthy successors.

Most of Sutter Home Zinfandel grapes grow in the Sierra foothills of Amador County, east of Sacramento. They yield a wine that is tannic, rich, and long-lived. Look for labels with specific designations such as Deaver Vineyard Zinfandel. Extended bottle life is one of the great attributes of Sutter Home Zinfandel; longevity is unusual for wines made from that grape. But will the fruit remain when the tannin softens? Time alone can give us the answer.

YVERDON, Spring Mountain, Napa County. Fred and Russell Aves have created, literally with their own hands, a handsome winery high on Spring Mountain. From the lofty vineyards, visitors have a splendid view of the tall trees stretching to the floor of Napa Valley far below. The 90 acres of vineyards are planted exclusively with very good grape varieties: Chardonnay, Pinot Noir, and Johannisberg Riesling. The first vintage (1971) and the harvests which followed produced some lovely wines that should grow and improve in the future.

LOUIS M. MARTINI, St. Helena, Napa County. By latest count, twenty-two large corporations have attempted to buy this great vineyard, making recklessly high offers. The late Louis M. ("Papa") Martini (who was active until his death at eighty-seven) simply would not sell, nor will his son, Louis P. Martini. It must be remembered that the elder Martini was born in Italy, studied enology at the University of Genoa, and was working as a young man in San Francisco back in 1906, the year of the great earthquake. One does not readily cut ties so firmly bound to California winemaking.

The wines from the family's thousand acres in Napa and Sonoma have long set a standard of reliability and excellence. "Papa" Martini's son and now his grandchildren, too, carry on in his uncompromising fashion. Some say the Pinot Noir does not thrive in California, but upon tasting the Louis Martini version, many wine experts have shown new respect. The Cabernet Sauvignon and Gewürztraminer are models of their types. The Italian-style Zinfandel and Barbera can challenge and even surpass their counterparts from Italy—Chianti and the Barberas.

SCHRAMSBERG, Calistoga, Napa County. The glorious uniqueness of the Schramsberg sparkling wines was well known even before February 1972, when twenty-five cases accompanied the presidential party to the People's Republic of China for the banquet attended by Mao Tse-tung. Since those toasts in Peking the tiny rationings sent to cities around the nation disappear even more quickly than before.

Jack Davies, Schramsberg's owner, is a remarkable man. In ten years he has revived a historic old cellar, and he produces what are unquestionably the best sparkling wines in the United States. Schramsberg makes nothing else and spares no cost in the process, right up to closing the precious bottles with big, expensive corks. Production is slowly increasing, but since it takes

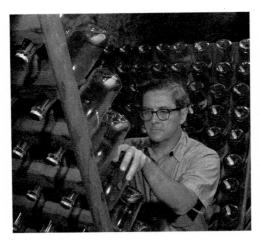

Jack Davies turning champagne bottles at Schramsberg

time to make fully aged superb wine, Schramsberg's sparkling wines will remain dear and scarce for at least another decade. The lovely, light Blanc de Blancs is brut, or quite dry, in the French style. Made from a blend of Chardonnay and white Pinot grapes, it improves after several years in bottle. Schramsberg Cuvée de Gamay, made from the Napa Gamay and Pinot Noir grapes, is also dry, but delicately salmon-colored. For dessert champagne, the Crémant is unsurpassed: less sparkling and noticeably sweeter than the other wines, luscious and rich. Each is a wonderful, effervescent example of what a dedicated, talented man and his family can do in one of the great winegrowing regions of the world.

Robert Louis Stevenson visited the vineyard in the late nineteenth century on his honeymoon with his bride, Fanny. It was then that he described the beauty of the mansion and vineyard, and predicted a brilliant future for the grapes grown there, adding ". . . and the wine is bottled poetry."

SIMI WINERY, Healdsburg, Sonoma County. At the famous Four Seasons restaurant in New York City, American wines are featured. At the top of the distinguished selection of fine California wines is a Simi Cabernet Sauvignon of 1935. Besides being rare, the wine is alive, well-balanced, and in its way reminiscent of old claret. It bears testimony to the greatness and long life

of which California wines are capable.

Forty years ago, when the Simi wine now featured at the Four Seasons was nothing more than noble grapes on the vine, the Simi Winery stood out as one of the few quality producers in Sonoma County. After those good days the property and the wines fell into decline and languished for some years. But since Russ and Betty Green acquired Simi the place has flourished and the wines improve with every passing harvest. An English distilling group, Scottish and Newcastle, has recently purchased the winery.

Russ Green, enologist Mary Ann Graf, and consultant André Tchelistcheff make a great deal of wine in a variety of styles. If you do not know which Simi to sample first or cannot get to New York to try the Cabernet Sauvignon 1935, start by tasting their more recent Cabernet Sauvignon, Carignane, or Zinfandel. Some excellent whites have recently been harvested.

SEBASTIANI, Sonoma County. Like Louis P. Martini and the Mirassou brothers, August and Sam Sebastiani will not sell their vineyards and winery despite dramatic and tempting offers from corporations across the country. August says, "I would as soon sell my children as my vineyard."

The dedication and commitment all the Sebastianis feel to their homestead in Sonoma County are reflected in their big, honest, sturdy wines. Not the least of these is the robust, Italian-style Barbera, long the pride of the family and certainly one of the most pleasant varietal wines in all California. Try it with some substantial food; the combination is perfect. At the other end of the heartiness scale is a rather recent offering, a Beaujolais Nouveau that captures much of the light freshness which has made French wine of the same name so popular. The wine comes from the fine Gamay grape and is sometimes bottled within two months after the harvest, an ideal wine to be served slightly chilled. S.A.

Sebastiani Vineyards' tasting room

THE WINE MUSEUM OF SAN FRANCISCO

Not far from Fisherman's Wharf on San Francisco's waterfront, an elegant small museum opened in January 1974. It is unique in the Western Hemisphere, the first museum in America to celebrate wine "as a symbol of joy in life" and as an inspiration to artists and craftsmen throughout history.

About thirty-five years ago the Fromm and Sichel families, who distribute the wines and brandy of The Christian Brothers, began to assemble with them a collection of art and artifacts devoted to wine and the grape. The cream of the collection has toured leading art museums in the United States and Canada during the past ten years. Now at last the collection has a home of its own. The Wine Museum of San Francisco, which is open to the public with no charge for admission, realizes the vision of Alfred Fromm, Chairman of the Board of Fromm and Sichel; an émigré from Germany, he has said that he and his family "have received nothing but good from this country, and we felt that in some way we had to make a small repayment."

The Museum, which is under the direction of Ernest G. Mittelberger, was

designed by Gordon Ashby. It is a handsome contemporary structure built in a modified California mission style. Natural woods, brick, tile, and wrought iron have been used in its construction, and the collection is displayed in a bright and spacious setting. "I want the Museum visitor to sense the creative spirit, the joy in life, found in these inspired works which glorify the grape, the wine," Ashby says.

The Museum's collection is a richly varied assemblage of the art of many periods, in many mediums. In the pictorial arts, drawings and graphics (lithographs, woodcuts, etchings) predominate, and the artists represented include some of first rank: Chagall, Kokoschka, Picasso, Renoir, Daumier, Maillol, Rowlandson, Currier and Ives.

There are masterpieces of craftsmanship in many materials: glass, porcelain, marble, bronze, and precious metals. The drinking vessels range from Eucharistic chalices to Kiddush cups and include many elaborately wrought tankards for secular use. Perhaps the Museum's most dazzling treasure is the Franz Sichel collection of glass drinking vessels. One of the most important glass collections in the world, its fragile pieces span a two-thousand-year history of man's involvement with the juice of the grape.

The collection, because it is arranged on historical and thematic principles, is a moving educational experience, a dramatic lesson in one delightful area of our culture. The scholar's needs are met through an unusual library of enological literature, containing many rare items in several languages.

The Museum is a living thing, changing its displays from time to time, an invitation to the wine lover to be drawn by the magnetism of art to the tradition that binds him to the ancient and continuing joys of wine.

A few of the Museum's treasures are shown in the following pages.

C.F.

108

Top: Carved wood and silver vintagers, German (Nuremberg), seventeenth century
Right: *The Dinner After the Hunt,* hand-colored etching by Thomas Rowlandson, English, 1787

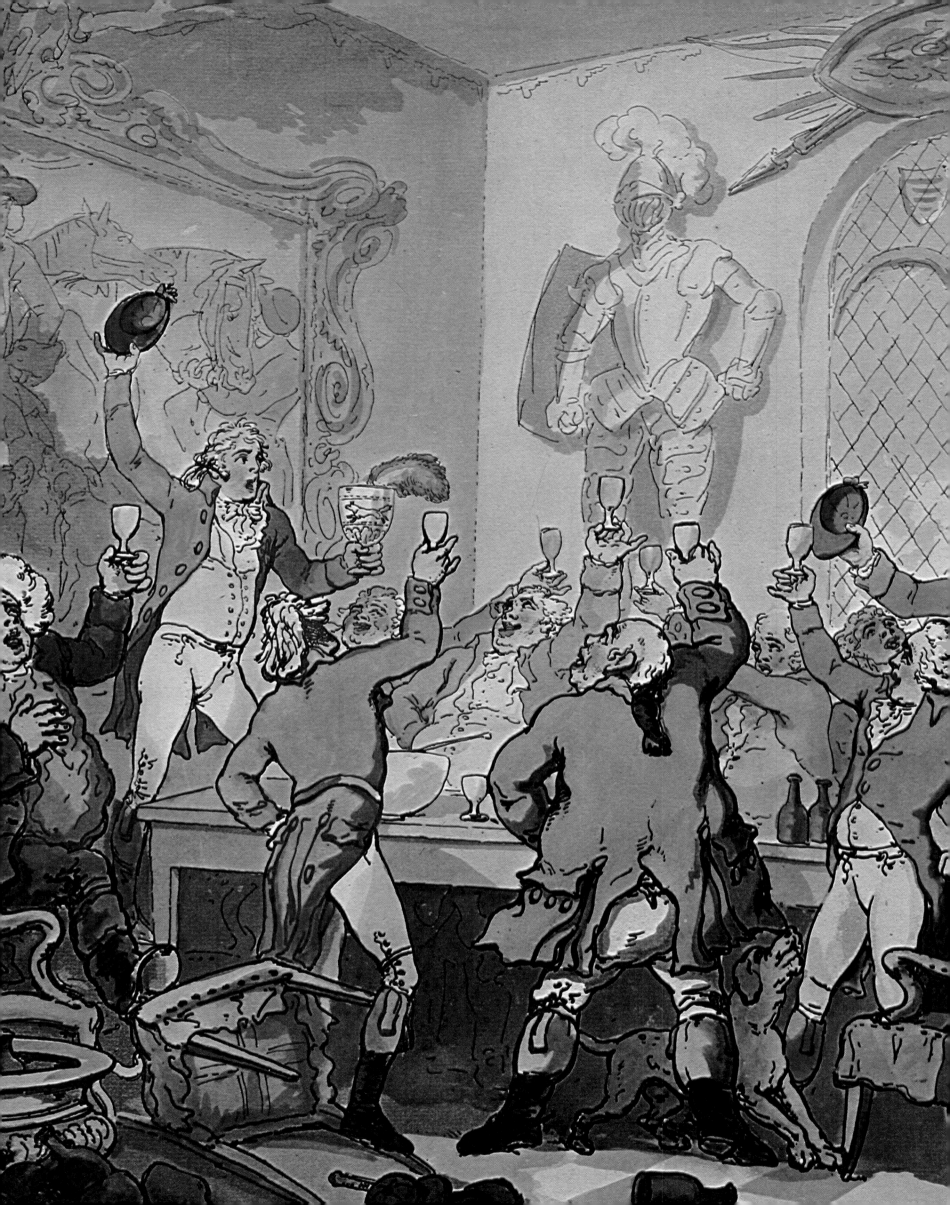

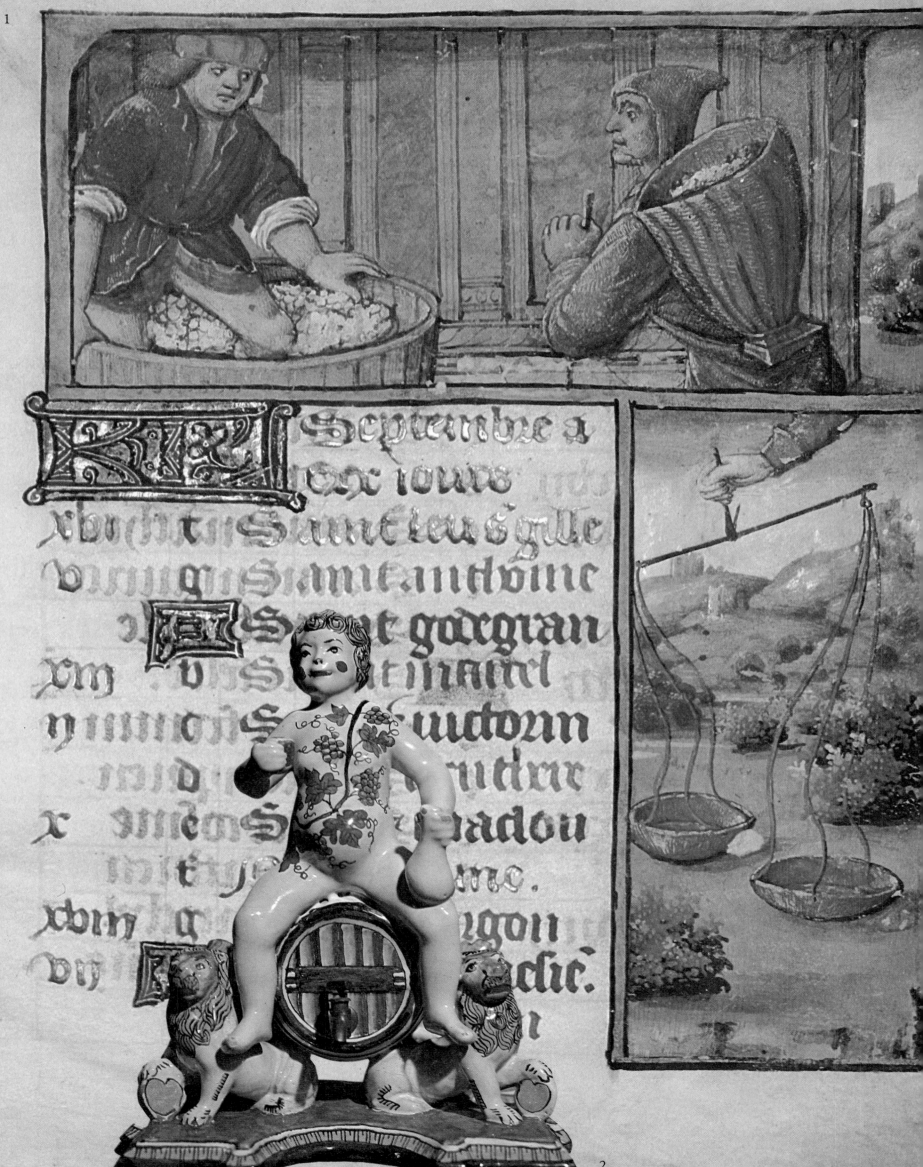

1

Septembre a
xxx iours

xviii f Sainct esgille
vii g Sainct antoine
f Sainct gorgran
xv g Sainct [...]
[...] [...]
[...]
x [...]
xviii [...]
vii [...]

2

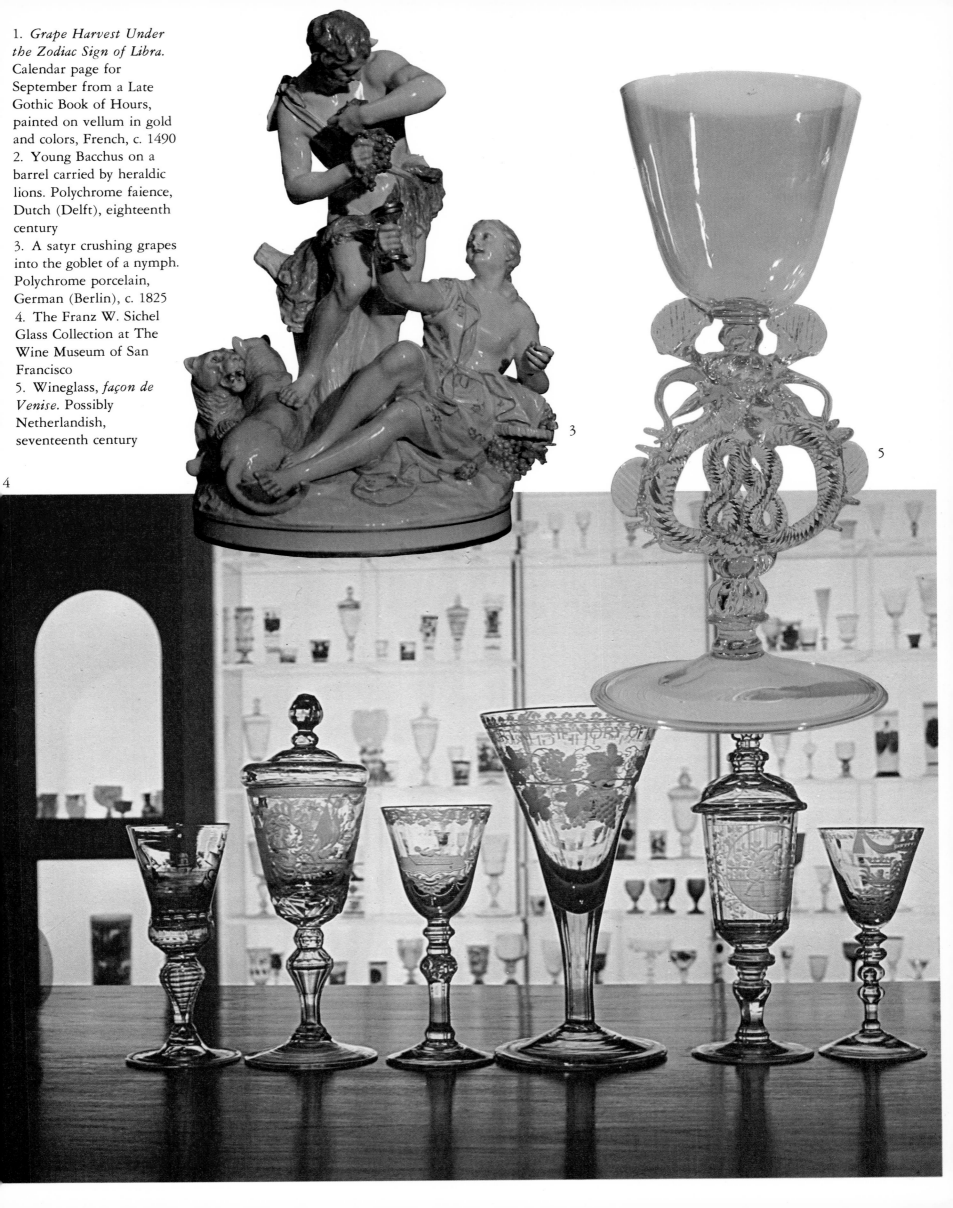

1. *Grape Harvest Under the Zodiac Sign of Libra.* Calendar page for September from a Late Gothic Book of Hours, painted on vellum in gold and colors, French, c. 1490
2. Young Bacchus on a barrel carried by heraldic lions. Polychrome faience, Dutch (Delft), eighteenth century
3. A satyr crushing grapes into the goblet of a nymph. Polychrome porcelain, German (Berlin), c. 1825
4. The Franz W. Sichel Glass Collection at The Wine Museum of San Francisco
5. Wineglass, *façon de Venise.* Possibly Netherlandish, seventeenth century

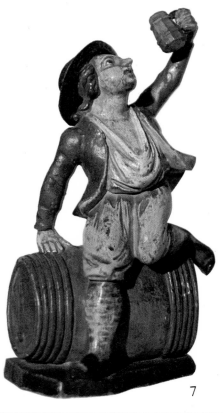

6

7

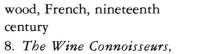
6. Two card players and a wine drinker. Pinprick picture with gouache, Italian, c. 1800

7. Drinking boy perched on a barrel. Carved and painted wood, French, nineteenth century

8. *The Wine Connoisseurs*, hand-colored lithograph by Claude Thielly (after a painting by Hasenclever), French, nineteenth century

8

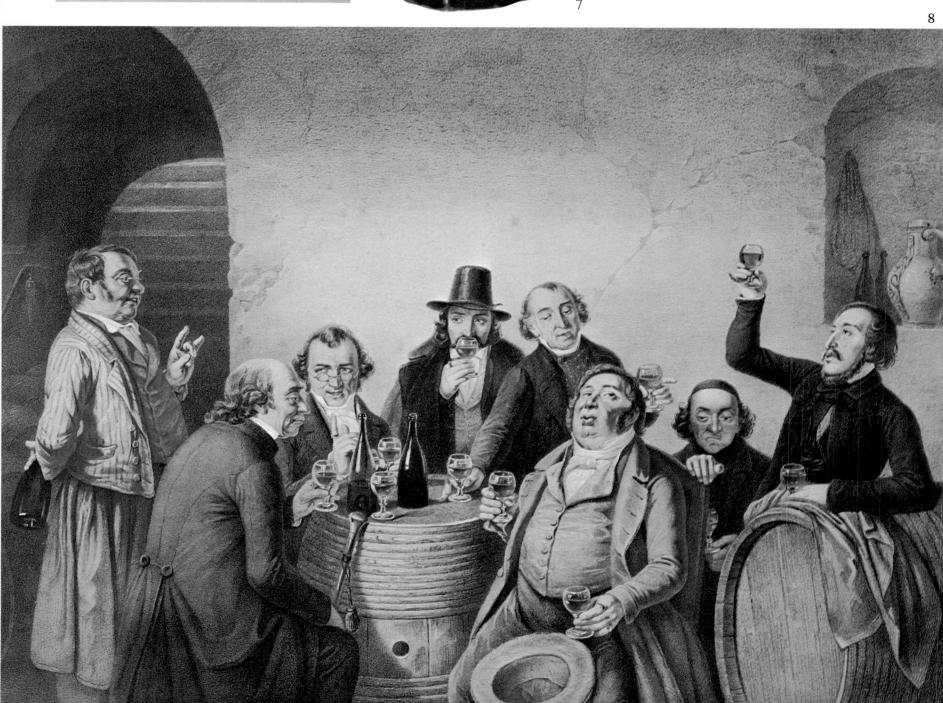

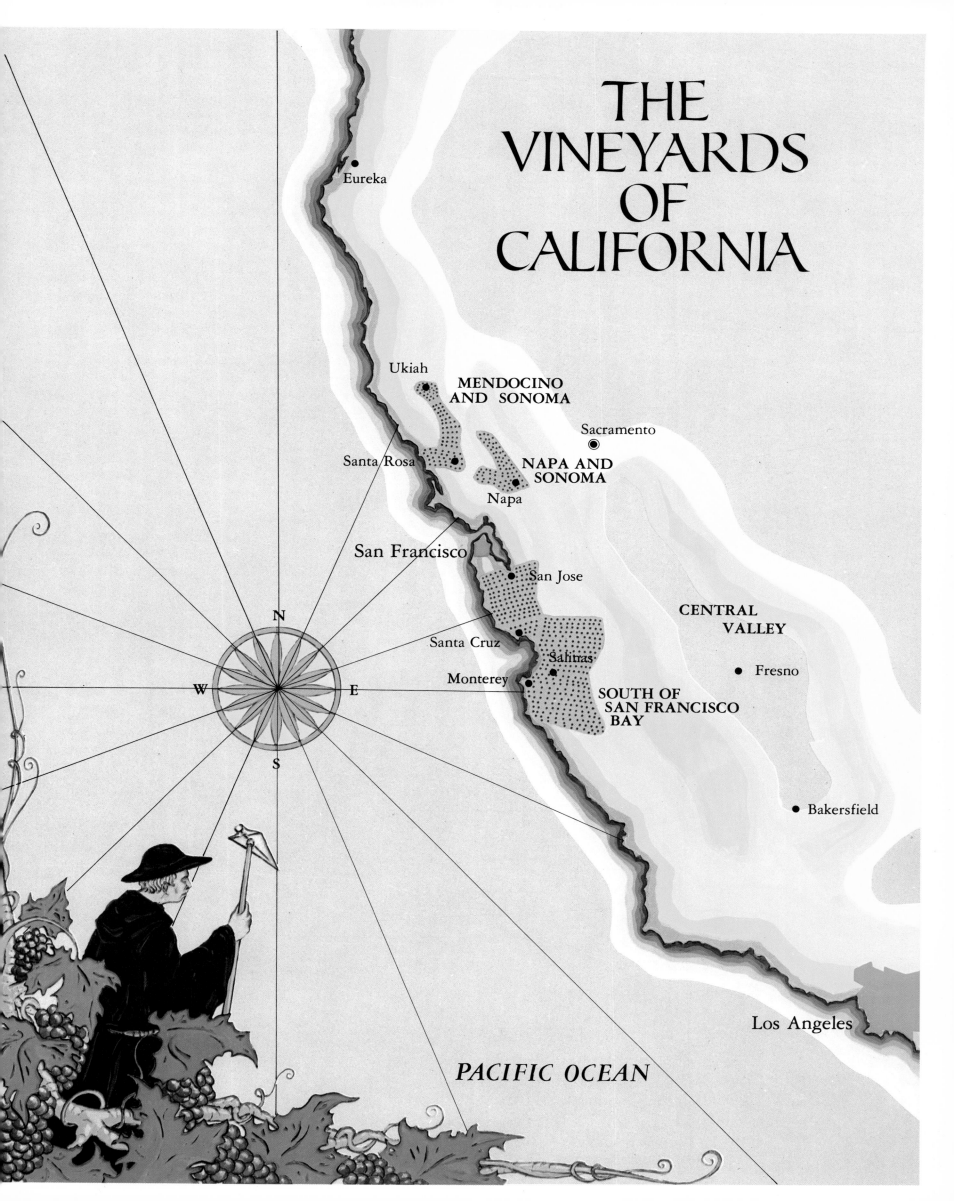

MENDOCINO AND SONOMA

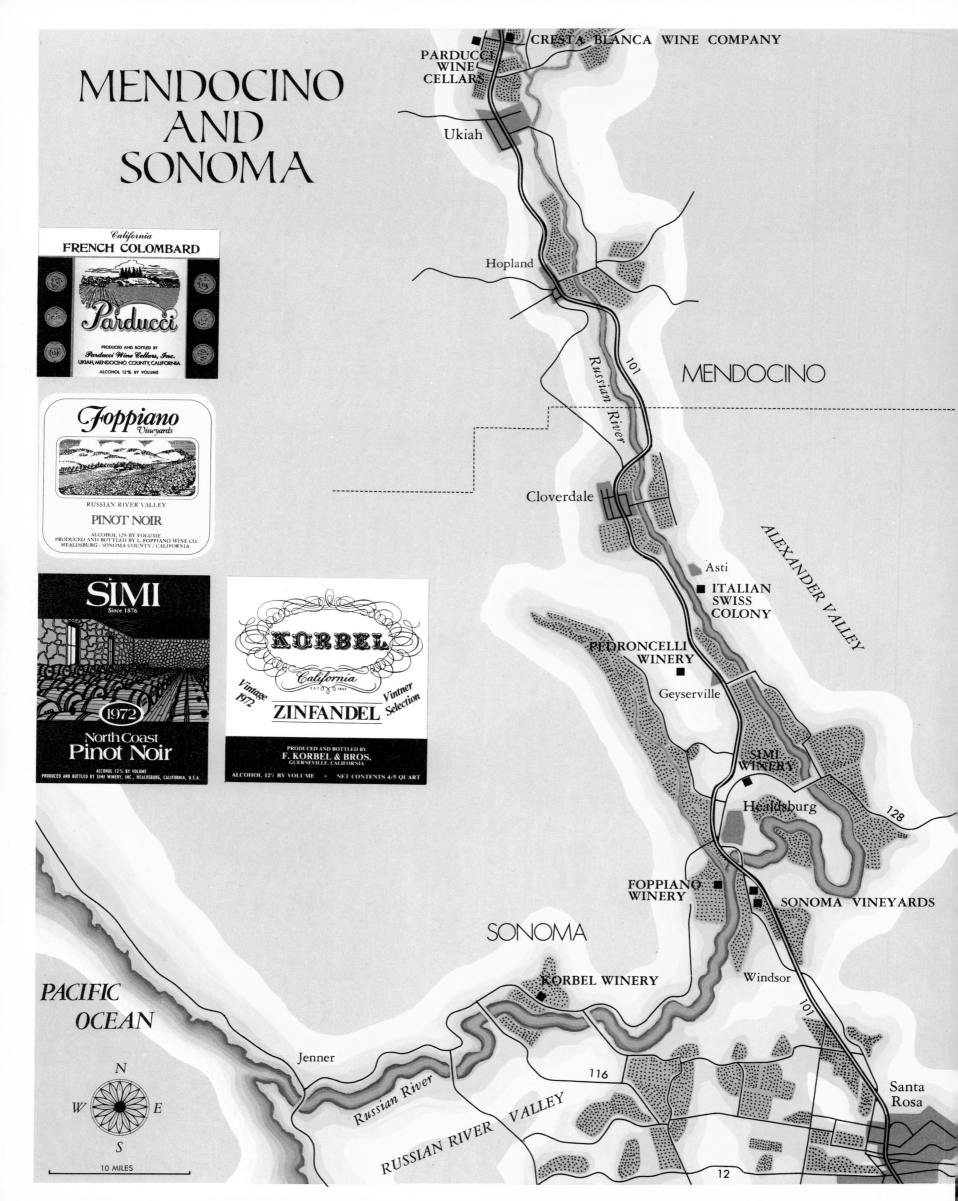

California
FRENCH COLOMBARD

Parducci

PRODUCED AND BOTTLED BY
Parducci Wine Cellars, Inc.
UKIAH, MENDOCINO COUNTY, CALIFORNIA
ALCOHOL 12% BY VOLUME

Foppiano
Vineyards

RUSSIAN RIVER VALLEY
PINOT NOIR

ALCOHOL 12% BY VOLUME
PRODUCED AND BOTTLED BY L. FOPPIANO WINE CO.
HEALDSBURG / SONOMA COUNTY / CALIFORNIA

SIMI
Since 1876

1972

North Coast
Pinot Noir

ALCOHOL 12% BY VOLUME
PRODUCED AND BOTTLED BY SIMI WINERY, INC., HEALDSBURG, CALIFORNIA, U.S.A.

KORBEL
California
EST 1862

Vintage
1972

ZINFANDEL

Vintner
Selection

PRODUCED AND BOTTLED BY
F. KORBEL & BROS.
GUERNEVILLE, CALIFORNIA

ALCOHOL 12% BY VOLUME · NET CONTENTS 4/5 QUART

CRESTA BLANCA WINE COMPANY

PARDUCCI
WINE
CELLARS

Ukiah

Hopland

Russian River

101

MENDOCINO

Cloverdale

Asti

ITALIAN
SWISS
COLONY

ALEXANDER VALLEY

PEDRONCELLI
WINERY

Geyserville

SIMI
WINERY

Healdsburg

128

FOPPIANO
WINERY

SONOMA VINEYARDS

SONOMA

Windsor

KORBEL WINERY

101

PACIFIC
OCEAN

Jenner

116

Russian River

RUSSIAN RIVER VALLEY

Santa
Rosa

N
W E
S

10 MILES

12

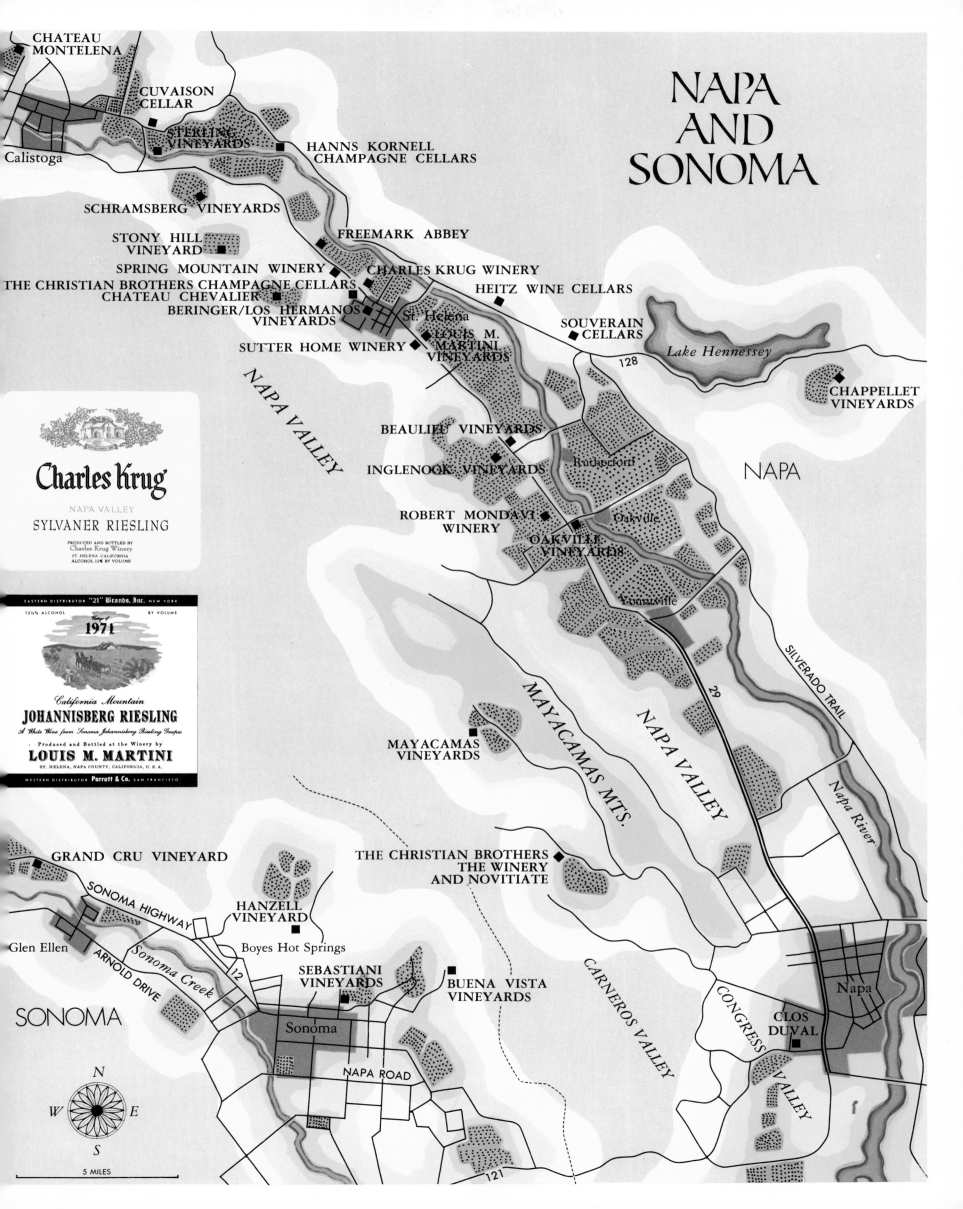

NAPA AND SONOMA

CHATEAU MONTELENA

CUVAISON CELLAR

Calistoga

STERLING VINEYARDS

HANNS KORNELL CHAMPAGNE CELLARS

SCHRAMSBERG VINEYARDS

STONY HILL VINEYARD

FREEMARK ABBEY

SPRING MOUNTAIN WINERY

CHARLES KRUG WINERY

THE CHRISTIAN BROTHERS CHAMPAGNE CELLARS

CHATEAU CHEVALIER

HEITZ WINE CELLARS

BERINGER/LOS HERMANOS VINEYARDS

St. Helena

SUTTER HOME WINERY

LOUIS M. MARTINI VINEYARDS

SOUVERAIN CELLARS

NAPA VALLEY

Lake Hennessey

128

CHAPPELLET VINEYARDS

BEAULIEU VINEYARDS

INGLENOOK VINEYARDS

Rutherford

NAPA

ROBERT MONDAVI WINERY

Oakville

OAKVILLE VINEYARDS

Yountville

Charles Krug

NAPA VALLEY

SYLVANER RIESLING

PRODUCED AND BOTTLED BY
Charles Krug Winery
ST. HELENA · CALIFORNIA
ALCOHOL 12% BY VOLUME

EASTERN DISTRIBUTOR "21" Brands, Inc. NEW YORK

12½% ALCOHOL BY VOLUME

Vintage of
1971

California Mountain
JOHANNISBERG RIESLING
A White Wine from Sonoma Johannisberg Riesling Grapes

Produced and Bottled at the Winery by
LOUIS M. MARTINI
ST. HELENA, NAPA COUNTY, CALIFORNIA, U.S.A.

WESTERN DISTRIBUTOR Parrott & Co. SAN FRANCISCO

MAYACAMAS MTS.

MAYACAMAS VINEYARDS

NAPA VALLEY

29

SILVERADO TRAIL

Napa River

GRAND CRU VINEYARD

THE CHRISTIAN BROTHERS
THE WINERY
AND NOVITIATE

SONOMA HIGHWAY

HANZELL VINEYARD

Glen Ellen

ARNOLD DRIVE

Sonoma Creek

Boyes Hot Springs

12

SEBASTIANI VINEYARDS

BUENA VISTA VINEYARDS

CARNEROS VALLEY

Napa

SONOMA

Sonoma

NAPA ROAD

CONGRESS VALLEY

CLOS DUVAL

N
W E
S

5 MILES

121

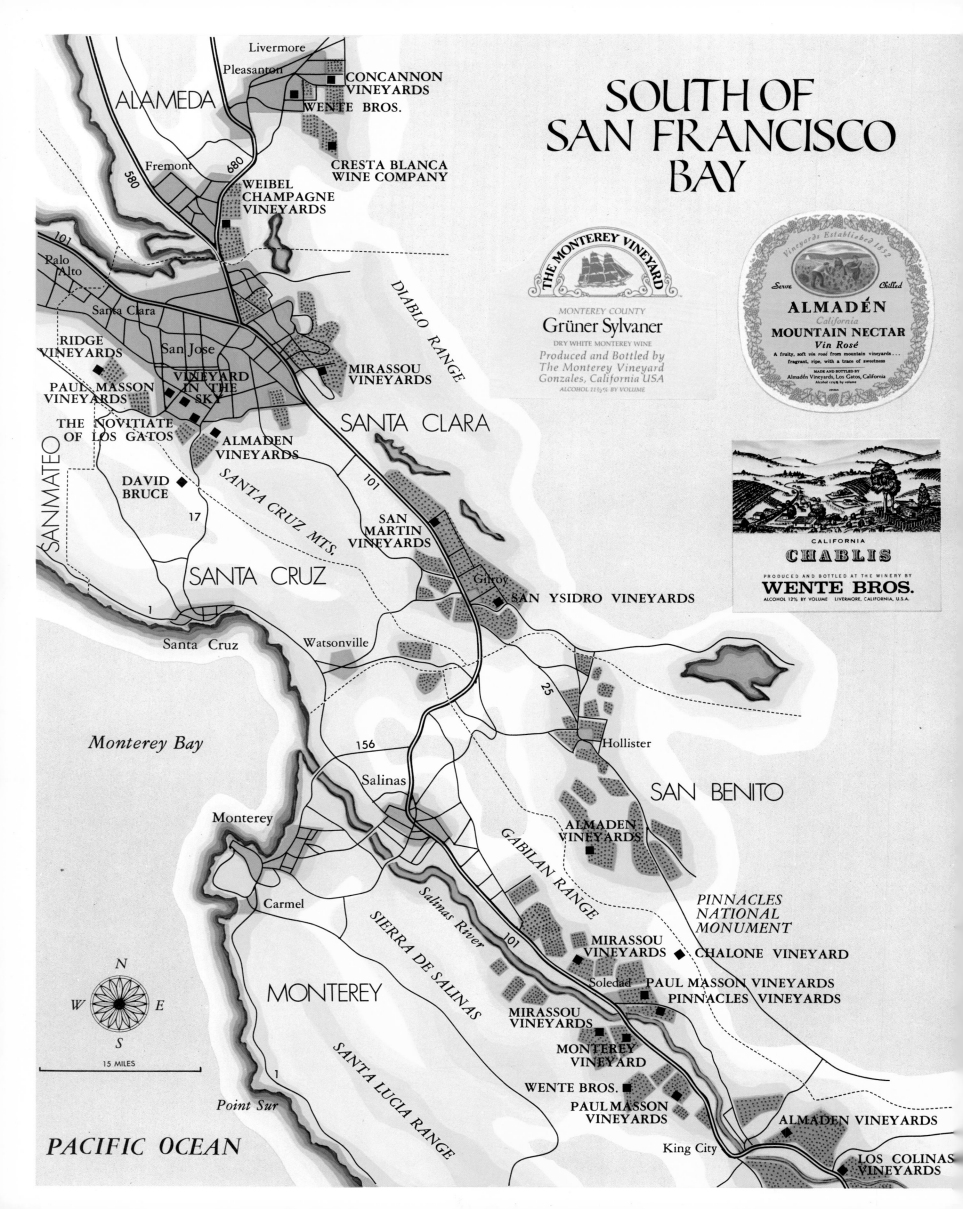

SOUTH OF SAN FRANCISCO BAY

Livermore

Pleasanton

ALAMEDA

Fremont

580

680

CONCANNON VINEYARDS

WENTE BROS.

CRESTA BLANCA WINE COMPANY

WEIBEL CHAMPAGNE VINEYARDS

101

Palo Alto

Santa Clara

San Jose

RIDGE VINEYARDS

PAUL MASSON VINEYARDS

VINEYARD IN THE SKY

THE NOVITIATE OF LOS GATOS

ALMADEN VINEYARDS

DAVID BRUCE

17

SANTA CRUZ MTS.

SANTA CRUZ

Santa Cruz

Watsonville

MIRASSOU VINEYARDS

DIABLO RANGE

SANTA CLARA

101

SAN MARTIN VINEYARDS

Gilroy

SAN YSIDRO VINEYARDS

25

SAN MATEO

Monterey Bay

156

Salinas

Monterey

Carmel

SIERRA DE SALINAS

Salinas River

SANTA LUCIA RANGE

Point Sur

PACIFIC OCEAN

GABILAN RANGE

Hollister

SAN BENITO

PINNACLES NATIONAL MONUMENT

MIRASSOU VINEYARDS

CHALONE VINEYARD

ALMADEN VINEYARDS

101

Soledad

PAUL MASSON VINEYARDS

PINNACLES VINEYARDS

MIRASSOU VINEYARDS

MONTEREY VINEYARD

WENTE BROS.

PAUL MASSON VINEYARDS

King City

ALMADEN VINEYARDS

LOS COLINAS VINEYARDS

MONTEREY

N
W E
S

15 MILES

THE MONTEREY VINEYARD

MONTEREY COUNTY
Gründer Sylvaner
DRY WHITE MONTEREY WINE
Produced and Bottled by
The Monterey Vineyard
Gonzales, California USA
ALCOHOL 11½% BY VOLUME

Vineyards Established 1852
Serve Chilled
ALMADÉN
California
MOUNTAIN NECTAR
Vin Rosé
A fruity, soft vin rosé from mountain vineyards...
fragrant, ripe, with a trace of sweetness
MADE AND BOTTLED BY
Almadén Vineyards, Los Gatos, California
Alcohol 12½% by volume

CALIFORNIA
CHABLIS
PRODUCED AND BOTTLED AT THE WINERY BY
WENTE BROS.
ALCOHOL 12% BY VOLUME LIVERMORE, CALIFORNIA, U.S.A.

SOUTH OF SAN FRANCISCO BAY

ALAMEDA, SANTA CLARA, SANTA CRUZ, SAN BENITO,
AND MONTEREY COUNTIES

The wine lover who visits San Francisco usually drives north to the Napa and Sonoma valleys. Yet there is as much reward should he choose to head his car southeast to Livermore Valley or due south in the direction of the Santa Clara and Monterey valleys. The important difference is that far south of San Francisco the winegrowing areas are not choked by population expansion but still have room to grow.

The Livermore Valley, an hour's drive from San Francisco, has gained renown for its white wines and boasts two famed wineries: Concannon and Wente Bros. Concannon is still expanding its vineyards in Livermore, while Wente Bros. has planted several hundred acres in Monterey County.

Under the guidance of Franciscan fathers, who cultivated grapes there as far back as 1777, Santa Clara was the first of the northern California districts to be planted with the vine. This valley is where the original Paul Masson and Almadén vineyards started, in the mid-nineteenth century. Both Paul Masson and Almadén retain their historic homes and central winery operations here, while planting vast acreages of vines farther to the south, in Monterey and San Benito counties. Much of the movement southward was inspired by research at Davis; Professors Amerine and Winkler proved that the proximity of the sea and the movement of cool air between the mountains in this neglected area can produce a temperature that will permit superior varietal grapes to flourish. Also, underground rivers can, through efficient sprinkler irrigation, supply enough water to meet the vines' requirements. Although wine consumption in the United States is increasing, enough good vineyard land remains in Monterey to meet future demands.

Dr. David Bruce in his hilltop home

DAVID BRUCE, Los Gatos, Santa Clara County. David Bruce, a busy dermatologist practicing in San Jose and living close to the vineyards, developed a great interest in enology. The result was predictable. In 1961 with the help of his family he built his home and winery at a 2,000-foot altitude in the hills above Los Gatos. Until recently Dr. Bruce sold his wines only by mail order. Now the repute of the vineyard is such that he is beginning to introduce his wines in various retail outlets. Convinced that his 1969 Chardonnay is as good as the best of the Montrachets, he charged the Montrachet price of $22 a bottle and sold out promptly. Being a man of inquiring mind, he has conducted such experiments as making a white wine from the Zinfandel grape and vinifying the Grenache grape as though he were making a white wine and not a red or a rosé. His experiments are interesting, but my advice is to limit your selection to his wonderful Chardonnay.

ALMADÉN VINEYARDS, Los Gatos, Santa Clara County. Almadén and Paul Masson owe their origins to the same family wine business, which started in 1852 but later split. With the passage of time, Paul Masson has become part of the international Seagram empire. In 1967 the Almadén Vineyards became the property of another large wine-oriented corporation, National Distillers.

In the first part of the century

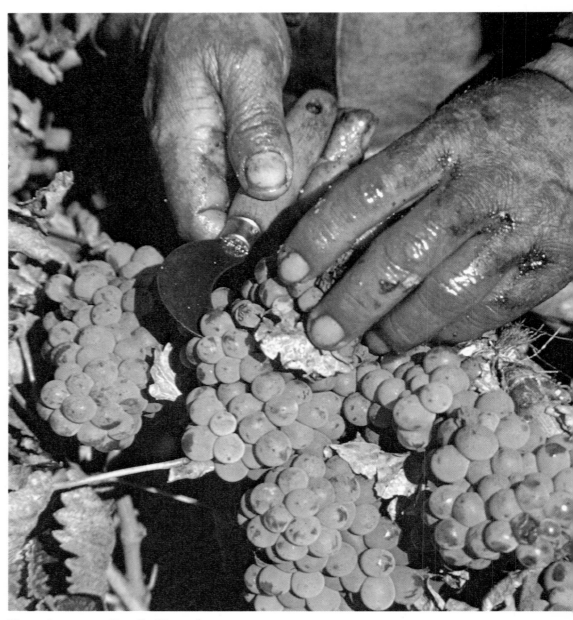
Harvesting grapes, Almadén Vineyards

Almadén (so called since 1941) suffered a number of vicissitudes. But the imaginative Louis Benoist, who reestablished the vineyard in 1941, made the name significant on the American wine scene. It was Benoist who wisely employed wine authority Frank Schoonmaker to advise on matters of taste, quality, and public relations. One of Schoonmaker's great contributions was introducing Grenache, the grape of Tavel, for the making of American rosé wine.

Today Almadén is a giant, cultivating more than 8,000 acres of vineyard land in Santa Clara, Alameda, San Benito, and Monterey counties. Each year 6 million cases of wine are moved out their doors. Their range of wines is vast—over fifty Almadén labels are dispatched, including generics, varietals, champagnes, vermouths, sherries, and ports. It is a rare college student indeed who is not familiar with the large, graceful half-gallon and gallon bottles of Almadén Mountain Red and White.

These Almadén preferences may be reported: Pinot Chardonnay, Gewürztraminer, Blanc Fumé, Grenache Rosé, and Gamay Beaujolais. The economy-minded will do well with Almadén half gallons and gallons, red or white, as satisfying everyday table wines.

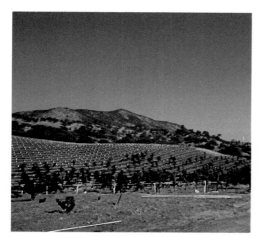

Chalone vineyards high in the Gavilán mountains

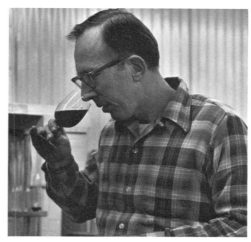

Jim Concannon, grandson of the founder, is Concannon's winemaker

CHALONE, Soledad, Monterey County. This is a unique vineyard situated on the mountain crests 2,000 feet above the Salinas Valley. In spite of the real difficulties posed by its lofty location, Chalone makes great wines.

Producing the wine by hand, winemaker Dick Graff uses traditional and painstaking techniques. His wines have astonished the experts. Rainfall is very scarce in Monterey County, and especially at this elevation moisture is nearly nonexistent. So Chalone actually has brought water up the mountain road by truck from the town of Soledad. Obviously, quantity is limited. Here is a study in contrasts: while tiny Chalone is miles away from any important evidence of our technological age, the winegrowers can look down from their vineyard perch and see the huge Monterey and San Benito wine acreage harvested by the most modern machines.

Chalone whites are some of the most intense, powerful, and rich wines in the state. Try a bottle of their amazing Chenin Blanc or Pinot Blanc, and Chardonnay if you find it.

CONCANNON VINEYARDS, Livermore, Alameda County. This vineyard was saved from the disaster of Prohibition because it had long been skilled in the production of sacramental wines. Even during the heyday of the Drys, production of sacramental wines was permitted. The vineyard was founded in 1883 by James Concannon, an im-

migrant from Ireland and a religious man. When the Archbishop of San Francisco needed altar wines, Concannon's wines filled that need. Today Concannon's grandsons own and operate the business. Although the old sacramental wines still constitute one-fourth of their production, Concannon is more famous now for their fine white table wines.

The gravelly and sometimes downright rocky soil of Livermore Valley seems ideally suited for growing white-wine grapes; Concannon's Sauvignon Blanc is proof of the valley's worth. Cabernet Sauvignon and Petite Sirah are the two best reds from this vineyard.

PAUL MASSON VINEYARDS, Saratoga, Santa Clara County. Of all the picturesque and beautiful vineyards in northern California, perhaps the most delightful is Paul Masson's famed Vineyard in the Sky, 2,300 feet above the Santa Clara Valley. On its steep slopes the original plantings of Pinot Noir, Cabernet Sauvignon, and Riesling vines are still maintained in beautiful fashion.

Paul Masson has successfully joined wine to music. "Music at the Vineyards" concerts take place most summer weekends, and San Franciscans flock there to listen and sip. The summer attendance exceeds 20,000 persons at the concerts and 300,000 at the tasting room.

The origins of the Paul Masson and Almadén vineyards are interlocked. In 1852, Etienne Thée, a winemaker from Bordeaux, planted his vineyard in Santa Clara County. His son-in-law, Charles Lefranc, succeeded him and was later joined by *his* son-in-law, Paul Masson, a Burgundian whose family had been *vignerons* for three hundred years. Eventually Masson started his own company, and later the original Lefranc-Masson winery and villa were bought by Almadén. Both Masson and Almadén can lay claim to being California's oldest commercial winegrowers, since both stem from Etienne Thée's original vineyard, where grapes have been grown continuously since 1852.

Paul Masson planted his Vineyard in the Sky in 1896 and a decade later built the Mountain Winery. It was Masson, the epicurean Burgundian, who entertained San Francisco society and such stars of the entertainment world as Charlie Chaplin and Anna Held (whose champagne bath is said to have taken place at a Masson party). Though not on the same scale, warm hospitality still prevails at the Mountain Winery.

With financial support from Seagram, Paul Masson has become a wine giant and now produces and sells annually over 3 million cases of California wine, some of it going to Europe and Asia. The source of most of the varietal table wine is their vast 7,000-acre Pinnacles Vineyard in Monterey. They do not vintage their wine but prefer blending two or more vintage years to achieve roundness, balance, and readiness for consumption soon after bottling. Among their red wines, in addition to the familiar Burgundy, Pinot Noir, Cabernet Sauvignon, and Gamay Beaujolais, they have developed two proprietary names, Rubion and Baroque, which represent excellent quality and have become especially popular. Along with these, my personal favorites are the Gamay Beaujolais and the Cabernet Sauvignon.

Among the whites there are generics such as Dry Sauterne, Chablis,

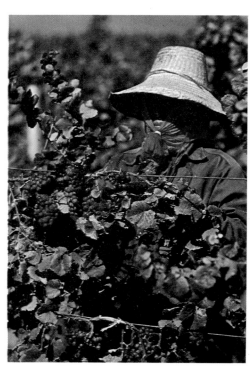
Grape picker, Paul Masson Vineyards

and Rhine. There are also varietals, including Pinot Chardonnay, Pinot Blanc, Johannisberg Riesling, and Chenin Blanc. In the popular proprietary brands there are the Emerald Dry and the Rhine Castle. Those that I particularly enjoy are the Emerald Dry and the Pinot Chardonnay.

Sparkling wines are not ignored here. (It should be remembered that the original name was Paul Masson Champagne Cellars.) All are bottle-fermented. The one worth seeking out is Masson's Brut.

MIRASSOU VINEYARDS, San Jose, Santa Clara County. In the mid-nineteenth century, two French immigrants founded neighboring vineyards in the Santa Clara Valley within the space of seven years. One was Pierre Mirassou, who started his winery in 1854. The other was Pierre Pellier, who in 1861 planted his vineyard with vines brought from France. Shortly after Pellier had established the winery, his daughter married Pierre Mirassou, and the Mirassou branch of the family eventually assumed control of all the winemaking operations. Today Mirassou's great-grandchildren own and manage the

important vineyard that still bears the family name.

A few years ago, pressured by crowded Santa Clara, the Mirassous, along with Paul Masson, planted vineyards in Monterey County. There, using the latest technology, combined with their five generations of experience, they are making exceptional wines.

Typical Mirassou wines are clean, fresh, and fruity, with a distinctive California personality. Some may occasionally disappoint, but the average is very high. Perhaps their best wines are the Chenin Blanc and the vintage Red Burgundy.

THE NOVITIATE OF LOS GATOS, Los Gatos, Santa Clara County. The age-old monastic tradition of winegrowing is carried on in the United States only by the Christian Brothers in the Napa Valley, O-Neh-Da in upstate New York, and the Novitiate of Los Gatos in the Santa Clara Valley. As with the Christian Brothers, making wine and supporting a number of schools go hand in hand for the brothers in Los Gatos.

The Novitiate has been making altar wines since 1888. Only about one-third of their production reaches the general public, but they have plans for expansion. Ultimately, distribution should reach all the large cities in the United States. All their wines are sound, pleasant, and moderately priced. None bears a vintage, but all are fully matured when offered for sale. Their Muscat de Frontignan is rich, sweet, full, and remarkable. Also worthy of attention are their Cabernet Sauvignon, Grenache Rosé, and Riesling.

RIDGE VINEYARDS, Cupertino, Santa Clara County. Three miles of slow, treacherous driving along Montebello Road will bring you to an altitude of 2,600 feet and the Ridge Vineyard, owned by six wine-loving families. It was started in 1960, when David Bennion persuaded three of his fellow scientists at the Stanford Research Institute to join him in making wine for

the sheer joy of it, selling the surplus to friends. The hobby took over, and soon Bennion left his professor's chair to become a full-time winemaker.

The 45-acre vineyard is predominantly planted with Zinfandel, supplemented by Cabernet Sauvignon, Chardonnay, and Merlot. Ridge has set out to prove that Zinfandel can be as bold, deep-colored, complex, and long-lived as the best of California Cabernet Sauvignons. Tasting their Zinfandel is an astonishing experience. The wine is almost unbelievable, full of sheer intensity and power. All the wines produced here are vintage-labeled and unfiltered. Some connoisseurs claim that elegance is sacrificed for the sake of bigness, but no one interested in experiencing the drama of good California wine should fail to acquire at least one bottle of Ridge's Zinfandel.

SAN MARTIN VINEYARDS, San Martin, Santa Clara County. The expanding suburbs of the 1960s forced Paul Masson and Almadén to move south from Santa Clara to the Monterey area for more vineyard land. Southdowns, a Texas conglomerate, bought San Martin from the Felice family and has joined the exodus south to Monterey with new plantings of many thousands of acres. San Martin still has a large vineyard in the south Santa Clara Valley. San Martin's winemaker is Fred Friedrick, formerly in charge of the wines at Paul Masson.

Driving from San Francisco to Los Angeles you will see signs for miles along busy Highway 101 inviting you to stop and taste. The ten-minute wine-tasting session is rather hectic and is hardly recommended if you like to linger over your glass. However, this does not mean that you cannot obtain eminently satisfactory medium-priced wines from San Martin. The range is vast, and though many wines may be ignored, you will be amply rewarded with their Cabernet Ruby, their sweet and excellent Malvasia Bianca, and their generic Red Burgundy.

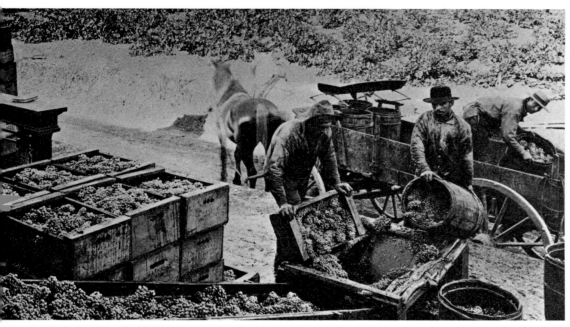
Leland Stanford's old Warm Springs Winery, now Weibel's

WENTE BROS., Livermore, Alameda County. Just up the road from Concannon is the winery of Wente Bros., the second-oldest family-owned vineyard in the Livermore Valley. White wines are the most popular product of the valley, and they have been the specialty of Wente Bros. since Carl H. Wente, grandfather of the present head of the company, came from Germany nearly a century ago. Wente white wines have an impressive pedigree: many of their vine cuttings came, at the turn of the century, from the Count de Lur-Saluces' famous Château d'Yquem vineyard of Bordeaux.

If there is a grape that gives white wine, chances are the Wentes grow it. They were among the first in California to produce top-quality Pinot Chardonnay in any quantity. One of the fine California selections Frank Schoonmaker brought to national attention about thirty years ago was Wente Chardonnay. Another was their Sauvignon Blanc, still a smooth, elegant wine with a slightly sweet edge betraying its Sauternes heritage. Pinot Blanc, a Burgundy wine grape that most experts think less good than the noble Pinot Chardonnay, has never been a true star in the galaxy of California

wines, but the talent of the Wentes and the soil of the Livermore Valley join to make an excellent vintage Pinot Blanc.

The Wente's flair for white wines is not limited to varietals. Astute, artistic blenders, they have combined Chenin Blanc from the Loire with Ugni Blanc from Cognac, creating a charming wine called Blanc de Blancs. Now a favorite in all fifty states, Wente Blanc de Blancs makes enjoyable inexpensive drinking.

WEIBEL CHAMPAGNE VINEYARDS, Mission San Jose, Santa Clara County. The Weibel winery stands on the site of the old Warm Springs Hotel, the most important spa in the San Francisco area until it was destroyed by an earthquake in 1868. Only a year later, Leland Stanford, California Governor and Senator, as well as railroad magnate, bought the large tract of land where the hotel had stood and planted about 100 acres of vines. Later he gave his brother Josiah the vineyard as a gift. The dread phylloxera destroyed the vineyard at the end of the century, and it lay dormant until 1945, when Rudolph Weibel, a recent arrival from Switzerland, bought the land and planted vines, naming his establishment

the Weibel Champagne Vineyards. The Chardonnay Brut Champagne bearing the Weibel label is bottle-fermented, fresh, well-balanced, and truly excellent. You will discover Weibel's champagne bearing many different labels because his vineyards also make private-label champagnes for many hotels and stores across the country. In addition to the champagnes, the wines worth seeking out are estate-bottled Pinot Noir, Pinot Chardonnay, Green Hungarian, and the very good Dry Bin Sherry. These, and indeed most of the Weibel table wines, are made at the handsome new winery in Mendocino County.

THE MONTEREY VINEYARD, Gonzales, Monterey County. This well-financed group of limited partners, headed by Gerald and Myron McFarland, have undertaken one of the most daring and important wine ventures in California history. They have acquired 10,000 acres, probably the largest single vineyard in the world, and are planting it with superior varietals. Their zeal for excellence has led them to Dr. Richard Peterson, formerly the winemaker for Beaulieu, who will have the tremendous job of fusing the potential of Monterey soil with the character of established varietals. Having formed a distribution company and partnership with the Foremost-McKesson Corporation, Monterey plans an ambitious marketing program to make its wines easily accessible. The president of the marketing enterprise is the internationally known wine authority Gerald Asher, who adds his own European training and tradition to the skill of the California professionals at work in the vineyard and the winery.

The first vintage from this exciting new vineyard was the 1974 harvest of Chenin Blanc and Grüner Sylvaner, Gamay-Beaujolais, Chardonnay, and Johannisberg Riesling. The dedication is there and the management is capable. The unknown factors are the soil and the climate. We must wait until 1980 before judging this new vineyard with any perspective. S.A.

THE CENTRAL VALLEY

FROM KERN TO TEHAMA

California's midsection is a remarkably fertile trough lying between the coastal mountains and the higher Sierra ranges to the east. The central valleys, the Sacramento in the north and the San Joaquin in the south, join to create one of the most productive agricultural areas on earth, where water transported from mountain reservoirs greens thousands of previously parched areas. Now, virtually no part of this 30-to-50-mile-wide trough—the Central Valley—lies uncultivated. The freeways connecting Los Angeles and San Francisco meet the first signs of the burgeoning agribusiness in Kern County, following the farms north through Kings, Tulare, Fresno, Madera, Merced, Stanislaus, and San Joaquin counties. North of the Bay Area the Sacramento Valley continues in Sacramento, Butte, Yolo, Sutter, Yuba, Colusa, Glenn, and Tehama counties.

In a district where nearly every major crop does well, grapes play a large role. The San Joaquin Valley alone counts more than 700 square miles under vine, but of course not all of this immense vineyard is devoted exclusively to table-wine grapes; San Joaquin supplies the nation with all its raisins and nearly all its domestic brandy. For us, the important fact is that fully two-thirds of the wine made in California comes from San Joaquin. Or, to look at the volume another way, the valley grows half of all the wine made in the United States.

The fertile flatland, high temperatures, and controlled irrigation result in yields of staggering size. Production per acre three or four times that of the North Coast counties is not uncommon. Yet here, as elsewhere, tremendous yields mean wines of less than exceptional quality. Vines of the Central Valley bear second-rate grapes for table wines but first-rate grapes for fortified wines and brandies. A minimum level of warmth and sunshine is required, or the grapes will have insufficient sugar and the wines will be low in alcohol. Yet with too

much heat and sunlight, the grapes have too much sugar and retain little of the acidity that makes wine fresh and attractive. A poorly made wine from San Joaquin is often powerfully alcoholic but dull, flat, and bland.

The seemingly ideal climate in the central valleys of California adversely affects the quality of the wine in another way. Cabernet Sauvignon, Pinot Noir, Pinot Chardonnay, Johannisberg Riesling, and the other superior wine grapes will not thrive in the scorching heat. Under these conditions the central valleys produce grapes with none of the qualities that have made these noble vines the favorites of winemakers and wine drinkers for centuries. Adversity develops character in wines just as it does in human beings. Only vines that give much inferior wine flourish in the very high temperatures at the farms at Bakersfield and north. In the Napa Valley, Cabernet and Chardonnay may rule, but in the Central Valley the Carignane grape and others of its rank are supreme. While Zinfandel, Barbera, and French Colombard cover considerable acreage, so does the characterless Thompson Seedless. The Thompson is a dependably productive strain whose fruit is suited to the table but not recommended for the wine vat. Yet as recently as 1971 the Thompson Seedless accounted for half of the grapes crushed into wine in California. To change this unhappy situation, plant biologists at Davis have developed hybrid grapes that produce satisfactory wine when grown in climates like the Central Valley's. The Ruby Cabernet, a crossing of the fine Cabernet Sauvignon and the common Carignane, will nowhere give great wine but makes a pleasant enough red in especially hot regions. A successful hybrid of the true Riesling and the old French Muscadelle vine is called Emerald Riesling; it makes a wine much tarter and more vivacious than the average dull Central Valley white. Both these grapes are ideal, and are widely used, for blending into jug wines.

Though the grapes may not be the best for making great wines, the standards of Gallo, Franzia, Italian Swiss, Guild, and the other giant wineries are as high and exacting as any in the state. The goals are, of course, different at the high-volume producers, yet their expertise and awareness of the most modern viticultural techniques are second to none.

Almost unbelievable quantities of jug wine, or *vin ordinaire*, tell the story of wine in the Central Valley. The wineries that make it are among the largest in the world. The biggest and most famous is Gallo in Modesto, east of Oakland.

Fermentation facility at a modern winery

Thanks to a thorough advertising campaign, Gallo wines are known across the country. Because of quality control by a large and creative staff of enologists and technicians, Gallo wines are noticeably better than the typical French, Italian, or Spanish *vins ordinaires*. The men who blend the wines for Ernest and Julio Gallo have found the style that pleases the majority of American wine drinkers. All the wines are slightly sweet. Gallo uses very ripe grapes and stops the fermentation at the proper moment so that a slight trace of unconverted sugar remains. Most Americans prefer wines with a slight trace of sweetness, but as tastes change, Gallo wines will certainly become drier. We must remember that Americans, by and large, are products of the Coca-Cola culture, and it is an easy transition from that beverage to a wine that bears it at least some resemblance.

Among those who have followed in Gallo's pioneering footsteps are Franzia and the various wineries owned by United Vintners. Best known of the United Vintners group is Italian Swiss Colony. Though none may claim so large a share of the market as Gallo, the grapes, the winemaking techniques, and the wines of all the huge wineries seem practically indistinguishable. Some of the companies are joined by ties stronger than mere similarity: Ernest Gallo is married to the daughter of

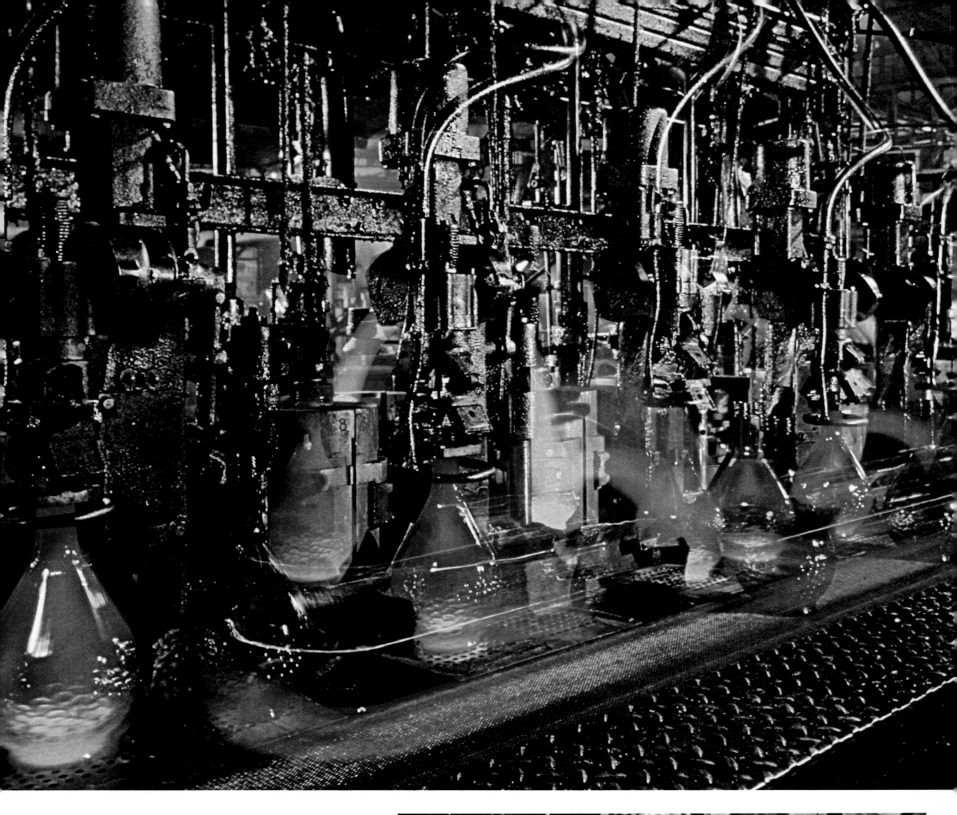

Molten glass is transformed into
jugs for a popular Gallo wine

A grape design is etched by hand on
the bottom of a jug

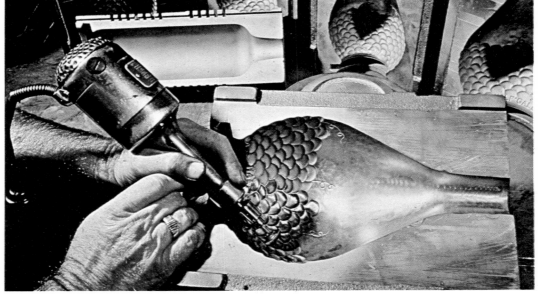

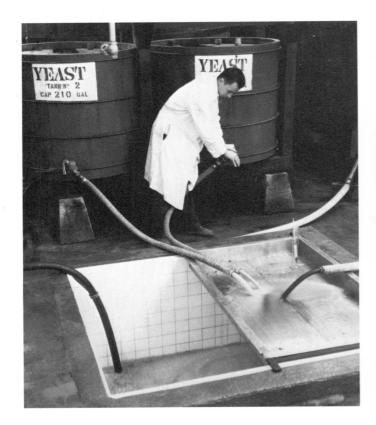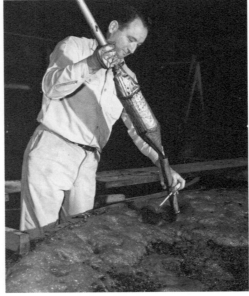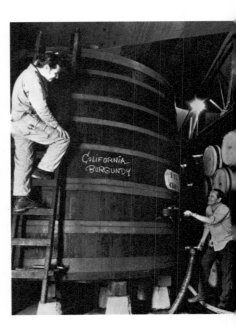

Lester Franzia. Now the property of the Coca-Cola Bottling Company of New York, Franzia aims for the same consumers who seem so happy with Gallo wines. Like Gallo, Franzia buys grapes from all over the state. Expensive select varieties are also purchased from large vineyards in Napa and Sonoma to add character and complexity.

Gallo Hearty Burgundy and Chablis Blanc are perhaps the two best-known wines from the Central Valley. Both are smooth and satisfactory. With its label resembling a red-and-white checkered tablecloth, the Guild Vino da Tavola brand is another of the widely recognized wines from the Central Valley. As the name and label hint, the red resembles a robust and rich Italian wine such as Chianti. But unlike common red Italian wines, Vino da Tavola has the requisite sweet finish, that hallmark of acceptable American jug wines. As with any successful jug bottling, the predictable, never-failing quality of the wine is one of its strong appeals. Such wines are intended to be joyously consumed, not critically tasted. *Vin ordinaire* needs no further defense here.

Besides the ubiquitous gallons and half gallons of red and white everyday table wine, fortified wines are an important part of the wine trade in the Central Valley. In fact, not too many years ago sherries, ports, and other sweet dessert wines made up the great majority of wines from the San Joaquin and Sacramento valleys. That was during the period when fortified wines outsold

Special wine yeasts are being mixed with wine. This mixture will be added to freshly crushed grapes to start fermentation

Measuring the sugar content of fermenting red wine with a hydrometer. The yeast converts the natural grape sugar into approximately equal parts of alcohol and carbon dioxide

Winery workers racking a tank of young California Burgundy into smaller casks. The clear wine is drawn off the lees, leaving the heavy sediment behind

 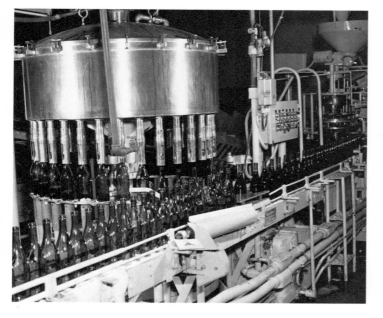 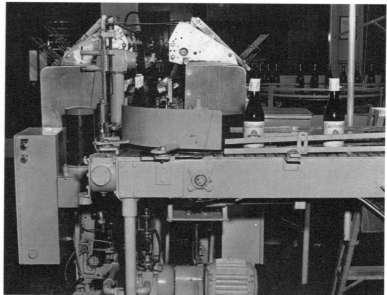

At a modern California winery a vacuum filling machine automatically fills bottles with wine

On the bottling line newly labeled bottles move along the conveyor on their way to the ultimate consumer

(Overleaf)

The Vintage in California—At Work at the Wine Presses. Hand-colored wood engraving after a drawing by Paul Frenzeny, *Harper's Weekly,* October, 1878

table wines throughout the United States. Most of the ports and sherries here were blends of either sweet or dry neutral wines with the brandy distilled widely in San Joaquin. As such, they were often typical of mass-produced wines, bearing little resemblance to their European counterparts. The men of science who studied ways to improve California table wines over the past decades did not neglect fortified wines, however, A few have become quite good, and one in particular quite remarkable.

The best dessert wine made in the United States is the port that comes from Walter Ficklin's little vineyard in Madera, deep in the San Joaquin Valley. Only the grapes that go into the original Portuguese wine make up Ficklin port: Tinta Cao, Tinta Madera, and Touriga. Because the Ficklins are skillful experimenters and experienced blenders of old and new wines, the quality of their wines is always high. Unfortunately, Ficklin port is so well known and appreciated by a small circle of lucky Californians that little finds its way outside the state.

Wine drinkers are grateful for the existence of the Central Valley, just as people in France are happy about the fact that there is a Midi, the source of much of the everyday wine of that country.

S.A.

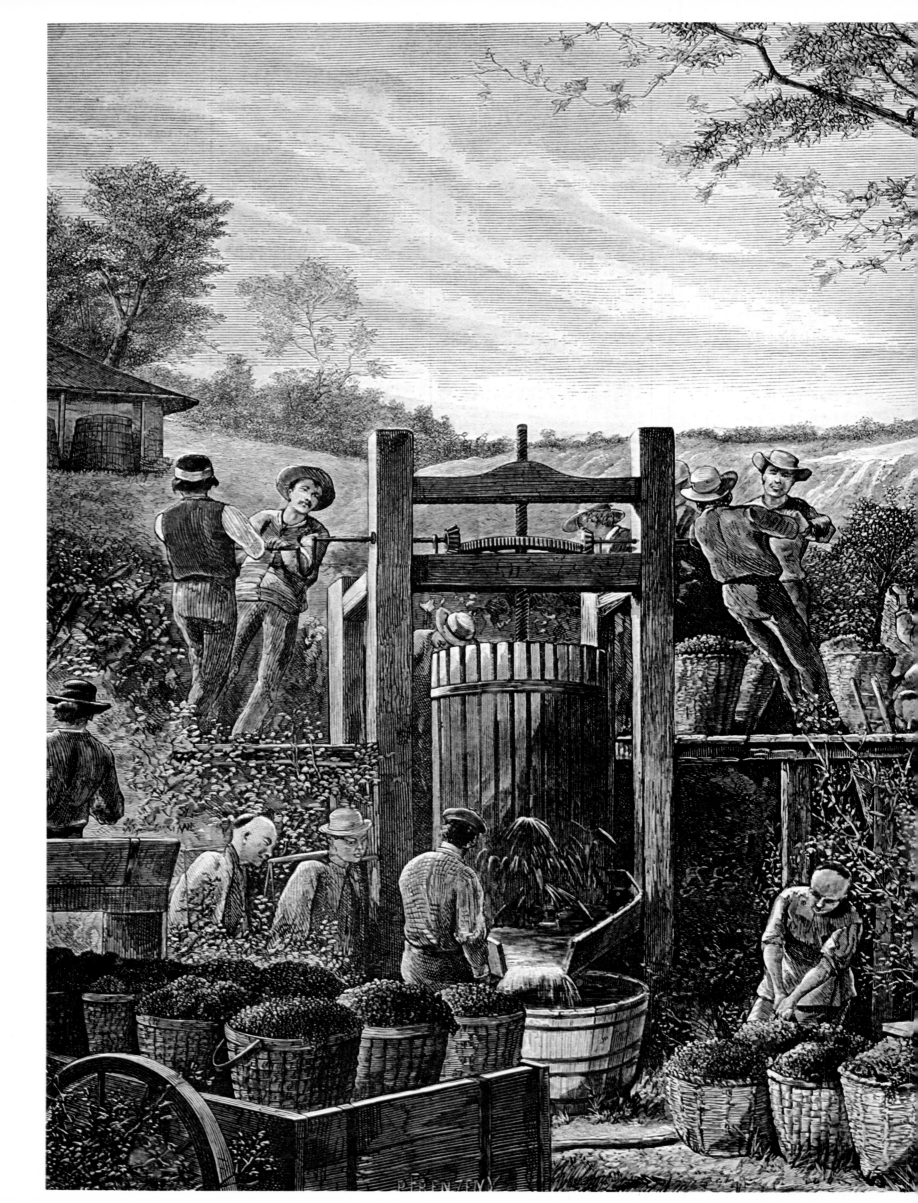

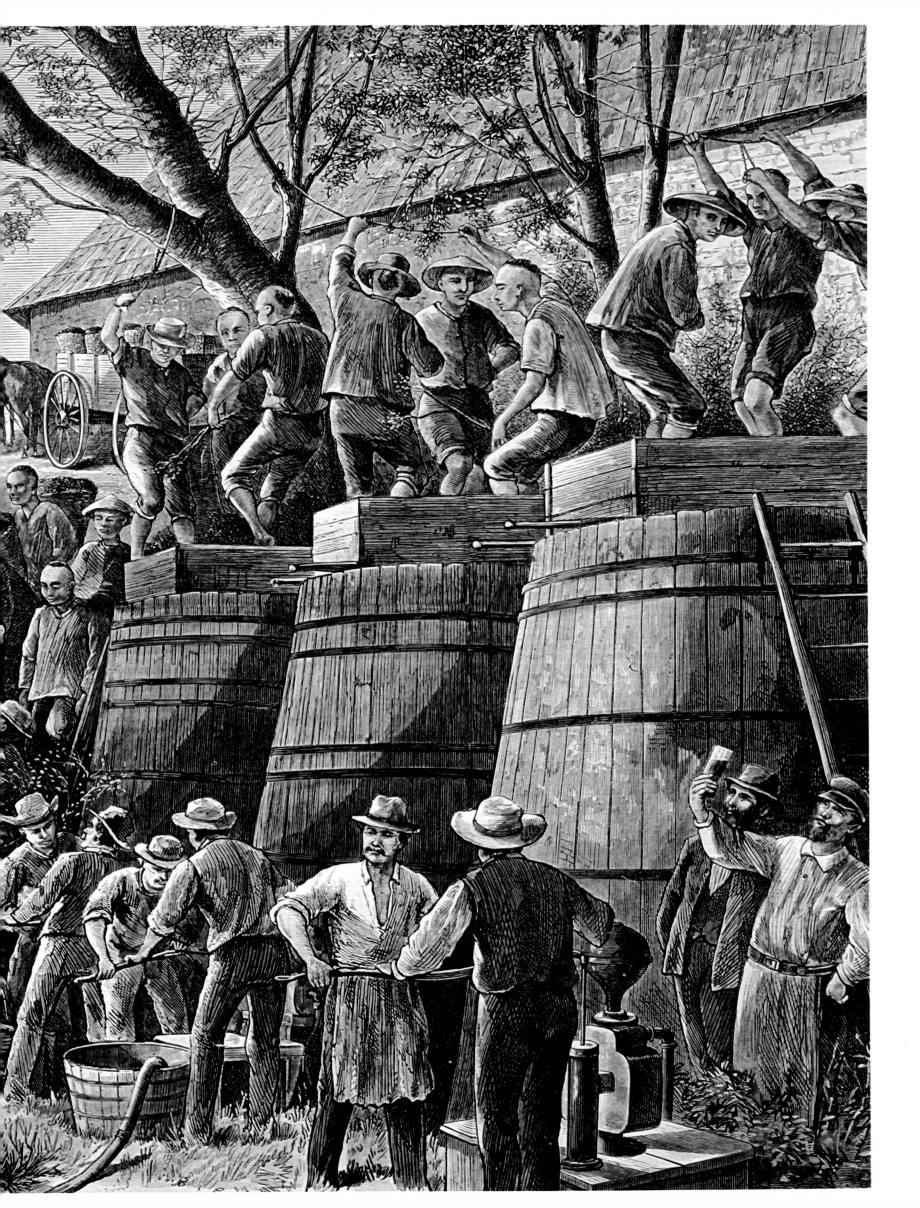

SOUTHERN CALIFORNIA

FROM SAN DIEGO TO SAN LUIS OBISPO

San Diego is where the Franciscan missionaries planted their first vines at the end of the 1760s. And in what has since become downtown Los Angeles, in the first half of the nineteenth century the Frenchman Jean Lous Vignes imported large quantities of European vines to start California's first commercial winery, El Aliso Vineyard. Once the biggest and best winemaking region in the state, the Los Angeles area has seen its wine industry suffer since the beginning of World War II. The decline has been in more or less direct ratio to the region's population explosion.

Drawn by the prospect of jobs in the wartime defense industries, many thousands of Americans migrated to southern California, and the resulting course of urban development took a heavy toll of agriculture in the area. Scores of vineyards were sacrificed to satisfy the urban needs of the increasingly dense population. Now there are hotels, highways, energy plants, and airports where there were thousands of acres of vines and where lovely old wineries once stood. Winemakers who had managed to survive the expansion of cities are being driven out as effectively by pollution—smog not only lowers yield but affects sugar content in mature grapes, and it permanently damages the vines by burning both grapes and leaves.

The Cucamonga area retains a mere vestige of its former glory. Forty miles east of Los Angeles, and often referred to as that city's local vineyard, Cucamonga was from the 1890s to the 1940s the most important wine region in the state. Since then, tens of thousands of acres of vineyard land have been taken over for urban development. Today, only a few remnants of the old wine-trade prosperity remain. The very hot climate in Cucamonga is more conducive to dessert wines than fine table wines, so the area has been hard hit by the foundering of the dessert-wine industry. Often grapes grown in other localities are brought

to the wineries to be blended into generics or pop wines. Most of the few surviving wineries are considering pulling up stakes too, and trying their luck elsewhere.

San Bernardino, the largest county in the United States, has the greatest area under vine in southern California. Yet its 13,000 acres are but a fraction of the former vineyards. Much the same situation exists in Ventura County, once well known for its wines. In San Diego County, the famous Escondido region is now reduced to a few hundred acres of vines. There is, however, a certain amount of planting going on in the center of San Diego County, around the town of Alpine.

At present, hope for the future of winemaking in southern California lies principally in three other counties well away from densely populated centers: Riverside, just below San Bernardino, and Santa Barbara and San Luis Obispo on the coast.

In the southwestern part of Riverside County, at Temecula, a community of vineyard-ranches grouped under the name of Rancho California have, since the 1960s, planted thousands of acres of new vines. A number of the old Cucamonga winemakers have moved to this district. The new plantings, aided by an excellent climate, show great promise for producing large, high-quality yields. Here a new concept in the wine industry has been inaugurated. Vineyards are being offered in lots starting at 40 acres, along with the skilled assistance needed to manage them. Various companies and individuals have already acquired holdings on this basis. Some of them ship their grapes to wineries in other parts of the state.

A healthy amount of activity has taken place in recent years in Santa Barbara County, around the town of Santa Maria, and only twenty miles away at Templeton in San Luis Obispo County. With its long tradition of local winemaking, this region is particularly suited to the production of fine table wines. Its climate, unlike that of the Los Angeles area, is quite moderate, so that grapevines do well. At present a number of wineries in the northern part of the state maintain acreage here or purchase grapes grown in the area.

A number of wineries dating from the nineteenth century still exist in southern California and at a few of them in Los Angeles one can still see equipment used by the Spanish missionaries and their Indian assistants. These wineries are fascinating, and often beautiful, landmarks. Most of them have tasting rooms that welcome the public. Here the wine enthusiast can experiment, and at generally excellent prices (as low as $1 the bottle).

POP WINES

THE NEW PHENOMENON

For a generation raised on Coca-Cola and Frosted Flakes, a bottle of Boone's Strawberry Hill or Annie Green Springs is often the first step toward the pleasures of wine. Since the popularity curve for these wines seems to be descending, it can be presumed that many drinkers have graduated into American jug wines or low-cost imports.

Pop wines (slightly carbonated, so that they "pop" when the bottle is opened) have been on the American scene since the 1960s. Bali-Hai, the first to appear, is actually something of a technological accomplishment. With it the Heublein winemakers hit upon a way to make a stable, flavored wine with an alcohol content nearer that of table wines (12 percent) than that of vermouths (18–20 percent). Europe, sensitive to this new development, has shipped us copious quantities of sangria, which is nothing more than a pop wine with a Spanish accent.

The appeal of pop wines to the young was immediate. With names more reminiscent of a rock band than a drink—Jug Strawberry Glen, Boone's Farm Apple, Cold Bear, Ripple, Spanada—these wines are the young people's alternative to the strong cocktails of the older generation. That formal etiquette which can too often obscure the pleasure of good wine does not get in the way of the plain enjoyment of pop wines. Today's strawberry- and apple-scented concoctions have come full circle, back to a past as long as the heritage of conventional grape wines. The Greeks and Romans were fond of flavoring many of their wines. Vessels in which wine was mixed with water were just as often used for scenting the wine with spices, perfumes, and flower petals. As with our own flavored wines, the ancients probably combined a pragmatic desire for disguising a mediocre product with their blasé search for a new taste experience.

For the moment at least, the dazzling variety of pop wines is here to stay as a part of the youth culture.

Pop Art: *Still Life with Red Wine* by Roy Lichtenstein, 1972

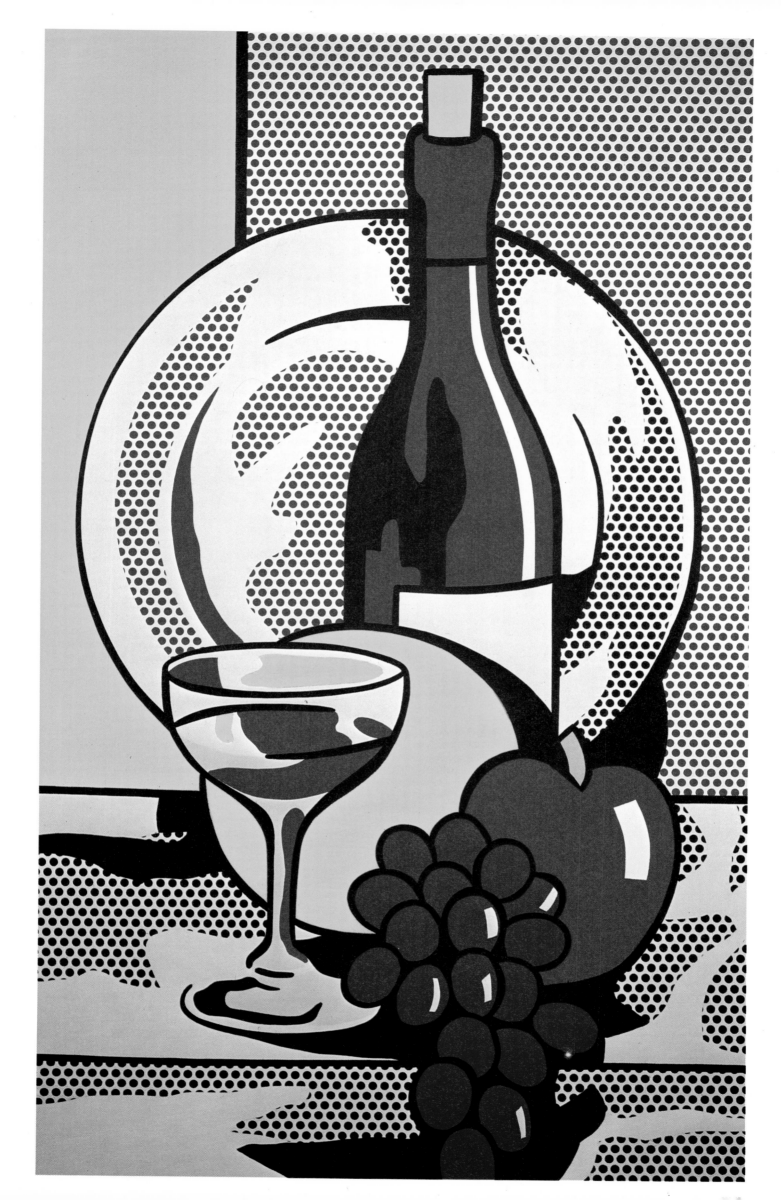

WHAT YOU ALWAYS WANTED TO ASK ABOUT WINE*

* BUT WERE AFRAID BAKER WOULD TELL YOU

RUSSELL BAKER

Russell Baker fans are surely identical with all readers of the New York Times *Op-Ed page and the* New York Times *Magazine. In his good-natured, well-mannered satirical mini-essays he succeeds in being amusing without wielding either the bludgeon or the stiletto. Mr. Baker can also be useful: all patrons of restaurants that specialize in outsize wine lists should carry his cautionary guide firmly clipped to their wad of credit cards. Also, those baffled by French wine jargon will find that Mr. Baker throws an unusual linguistic light on the problem.* C.F.

Many readers have urged me to divulge my wisdom about wine, and I do so gladly, for wine is a noble thing, being much slower than the martini (known in bibulous circles as the quick blow to the back of the head) and much harder than differential calculus.

The most common wines are Chablis (rhymes with "wobbly") and Beaujolais (bo-joe-lay). These are excellent wines for beginners because they are easy to pronounce. Neither should be drunk, of course, unless the label bears the words "*appelation controlée*" (meaning "apples under control") and "*mis au domaine,*" which means "put at the domain."

These phrases are the buyer's guarantee that the wine has been made from grapes, with no apples mixed in, and sent to a good domain to acquire breeding, bouquet, good nose, smooth finish and skill at equitation.

Bottles whose labels bear these phrases are, unfortunately, so expensive that no one can afford to drink them except on a 25th anniversary, and since neither wine will keep for 25 years there is really no point in buying either, especially since, if you are right up on top of a 25th anniversary you would probably rather have three martinis and go to sleep.

Some labels will bear the words "*mis en bouteille dans nos caves,*"

©Punch

which means "bottled in our caves." This wine is made from fermented moss and must always be served at cave temperature. It is the perfect complement to ferns *en brochette*.

In ordering wine at a restaurant, a knowledgeable banter with the wine waiter helps establish one's *savoir-faire*. To avoid humiliation at the outset, the best wine to order is Chateauneuf-du-Pape, since it is relatively easy to pronounce (shot-oh-nuf-dew-pop).

An authoritative question or two creates a forceful impression. "This shot-oh-nuf-dew-pop," you might say, "has it been put at the domain?" or, "Whose caves was it bottled in?"

When the waiter hands you the cork, pass it to your dinner partner and ask him, or her, to squeeze it, then return it to the waiter and ask him to have it chopped very fine and put in the salad. In tasting the wine, roll a small quantity across the palate, then let it settle in the bottom of the mouth and gargle a quantity of air across it and into the lungs, while making loud snoring sounds. Tell the waiter to taste some after objecting that in this particular wine the apples have not been very well controlled.

Having mastered French wines, drinkers will find German wine even more expensive. This is because there is so little of it. The persistent story that Hermann Göring drank it all after the collapse of the Russian front is probably a canard, but it has gone someplace and will not come back for less than $40 or $50 a bottle. It goes beautifully with red cabbage and a Swiss bank account.

For value, the best buys are California and New York wines, but many uninformed sophisticates view them with contempt because they can understand the labels. I have solved this problem with a supply of empty French wine bottles and a funnel. Now my California Cabernet always comes to the table as a *"premier cru"* ("first crew") from Bordeaux.

In the East, unfortunately, the beginner will have to struggle with the wine dealer to get California wine, and this brings us to the crucial subject. Getting one's way at the wine shop.

There are in France huge, underground factories which make a drink compounded of banana skins, random acids, brown sugar and broken shoe strings. Dyed red and bottled, this is shipped to gullible American wine dealers, who sell it as "French country wine."

Merchants with crates of it threatening to eat their way through the cellar floor stalk wine shops on the lookout for innocents, who are always recognizable by the dismay on their faces as they gaze at the price of German wine or wrestle with the distinction between a Côte de Beaune ("Side of bone") and a Côtes du Rhone ("Sides of Rona Barrett").

When the merchant pounces, offering his irresistible bargain in rare French country wine, do not blanch, tremble, yield or buy. Tell him firmly, "Get me a jug of American wine and a half-dozen French empties." It should come to no more than about $4, and, best of all, it will be made from grapes.

"What do you suggest to educate his palate?"

HOW TO READ A CALIFORNIA WINE LABEL

Wherever a wine comes from, the label on the bottle presents a great deal of information that is both useful and instructive. In the case of California wines, state and federal laws require that the label state a number of facts about the contents of the bottle. These are denoted in some cases by specific phrases that have definite meanings under the law. The labels on two bottles can look identical, but a wealth of difference between the two may be expressed in the small type. Listed below are some of the elements to look for on a California wine label.

Produced and bottled by

To earn the right to use the word "produced" the winery must by law ferment and mature at least 75 percent of the wine in the bottle.

Made and bottled by

A much less exact phrase, meaning that at least 10 percent (a small fraction indeed) of the wine in the bottle was vinified and aged at the winery.

Cellared and bottled by, Prepared and bottled by, Blended and bottled by

Vague and loosely applied phrases. It can be assumed that wine so labeled was *produced* by someone other than the bottler. Certain cellar operations might be involved, but the quality of the wine is dependent on the unnamed vintner who shipped the wine to the bottler.

Selected and bottled by

Same as above, but no added cellar operations were performed.

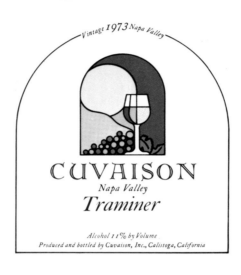

Bottled at the winery

The wine was bottled on the premises where it was produced or where it was blended and finished.

Vintage date

No less than 95 percent of the wine contained in the bottle was fermented from grapes grown and harvested in the year stated. In addition, the grapes must have been grown exclusively in the district mentioned on the bottle. The remaining 5 percent of the contents is legally permitted to be wine from another year. (This is a wise and practical measure allowing for the "topping" of casks to replace wine lost through normal evaporation or leakage.) The date alone, not preceded by the word "vintage," means only that the wine was bottled in the year stated.

The appellation "California"

The wine is made entirely from grapes grown, and their juice fermented, in California. If any part of the finished product contains any wine from grapes grown outside the state, it may not be labeled "California." (This rigid regulation is not true in New York or Ohio.) Nor can sugar be added unless it is exclusively derived from the grape.

District appellation

If the wine label gives a county or district name, 75 percent of the grapes must have been grown in the region specified. Thus a "Napa Valley" wine is legally required to contain 75 percent of Napa grapes.

Estate-bottled

Only wine bottled on the estate where

136

the grapes were grown and in a winery under the same ownership is entitled to be labeled "estate-bottled." Like château bottling in Bordeaux, this guarantees authenticity but not necessarily high quality.

Varietal wines

A varietal wine is one named after the grape variety from which it is produced and having the predominant taste and aroma characteristic of the variety. At least 51 percent of its volume must be derived from that grape—for example, Pinot Noir, Zinfandel, Chardonnay, etc. In practice, the better vineyards use a much higher percentage of the grape than is required by law in order to give the wine more of the characteristic of the grape variety specified on the label.

Generic wines

A generic wine is a blend of many different grape varieties and usually carries a name such as Burgundy, Sauterne, or Chablis. The practice of using European place names for generic wines started in the United States in the nineteenth century and still

persists. But it is hoped that we will develop our own place names for generic wines in the future.

Proprietary wines

A proprietary wine is a blended wine for which the winery has created an attractive fantasy name (Emerald Dry, for example) which will help sell the product. Usually the proprietary wines are secret blends with their own distinctive characteristics; they may range from average to very high quality.

Bottle-fermented champagne

The sparkle is the result of a natural process of fermentation acting on the wine within a closed container.

Charmat-process (or bulk-process) champagne

The sparkle is the result of a secondary fermentation that took place in a glass-lined tank or vat instead of a bottle. In either case the container is tightly sealed during the secondary fermentation to prevent the carbon dioxide bubbles from escaping.

S.A.

NAPA VALLEY GAMAY 1972

The words "Napa Valley" mean that at least 75 percent of the grapes come from that region; the name of the grape indicates that at least 51 percent of the wine was produced from the Gamay. This vintage Mondavi wine is closer to 100 percent on both counts. "Produced and bottled by" is a more exact phrase than "Made and bottled by," as it guarantees that at least 75 percent of the contents was fermented and matured at the Mondavi winery.

1972
Napa Valley
GAMAY
ALCOHOL 12% BY VOLUME
PRODUCED AND BOTTLED BY
ROBERT MONDAVI WINERY
OAKVILLE, CALIFORNIA

the
Christian Brothers ®
VINTNERS SINCE 1882

SELECT NAPA VALLEY
CABERNET SAUVIGNON

A dry red wine of great character and finesse
PRODUCED AND BOTTLED BY
THE CHRISTIAN BROTHERS • NAPA, CALIFORNIA
Alcohol 12% by volume

CABERNET SAUVIGNON—THE BEST RED WINE GRAPE OF CALIFORNIA

Since no vintage year appears, it can be assumed that the wine is a blend of vintages. At least 75 percent of the contents comes from the Napa Valley. The absence of a vintage date also indicates that the wine is probably ready for drinking now, not for laying down.

A WINE FROM ONE SPECIFIC PLOT

Many fine vintners carry the classic California label, shown below, one step further: they add the name of the section of vines which produced the wine. Here the key phrase is "York Creek," a vineyard plot on Spring Mountain in the Napa Valley.

Vineyards Established 1852

Serve *Chilled*

ALMADÉN
California Mountain
GRENACHE ROSÉ
A fresh, appetizing fragrant rosé wine made from the famous Grenache grape of France grown in California vineyards

MADE AND BOTTLED BY
Almadén Vineyards, Los Gatos, California
22556A Alcohol 12½% by volume

RIDGE
CALIFORNIA
PETITE SIRAH
YORK CREEK
1971

GRAPES FROM SPRING MOUNTAIN, NAPA COUNTY
BOTTLED APR 1973 ALCOHOL 13.4% BY VOLUME
PRODUCED AND BOTTLED BY RIDGE VINEYARDS
17100 MONTE BELLO RD, CUPERTINO, CALIFORNIA

OUR LEADING VIN ROSÉ

The varietal grape Grenache, which makes the celebrated pink wine of Tavel in France, also flourishes in California. Under California law, at least 51 percent of the wine must come from the Grenache grape. The word "mountain" is not significant, but lends romantic appeal.

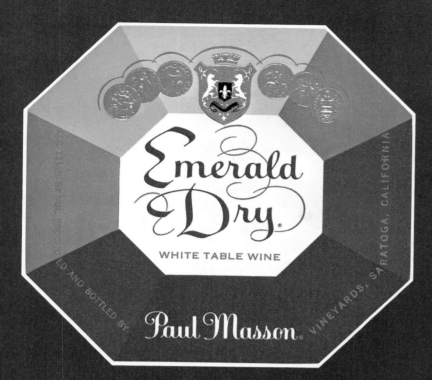

POPULAR PROPRIETARY NAMES

Viticulturalists at the Davis campus of the University of California have developed the Emerald Riesling grape, a hybrid of the famed Johannisberg Riesling of Germany. Employing this grape, Paul Masson, one of California's largest and most prestigious vineyards, has produced a wine for which it has created its own registered proprietary name.

AMERICA'S MOST POPULAR RED WINE

"California" tells us that all the wine was grown in that state. "Made and bottled at" attests that at least 10 percent of the wine was vinified at the winery (here the percentage is undoubtedly higher, because of Gallo's standards). "Hearty" is not a legally defined term; it indicates relatively high alcohol content (13.5 percent). "Burgundy" is a popular term for a blend of red-wine grapes.

HEARTY BURGUNDY.
OF CALIFORNIA

We are often told by knowledgeable people that they are delighted in having discovered a great wine in Hearty Burgundy. Its rich, full-bodied flavor—from extremely fine varietal grapes—will surprise you. Made and bottled at the Gallo Vineyards in Modesto, Ca. Alc. 13.5% by vol.

WHAT DOES CHÂTEAU MEAN IN CALIFORNIA?

"Château" is an elegant word with no technical meaning. Here Wente has blended two superior varietals, Sémillon and Sauvignon Blanc, the grapes that give us the Sauternes of France. This is a good wine, but often "château" is used to make a mediocre wine seem more attractive. "Estate-bottled" means that Wente grew the grapes and made and bottled the wine. "Vintage 1972" attests that 95 percent of the wine is of that year.

1972 VINTAGE

CALIFORNIA
CHATEAU WENTE
A RICH WHITE WINE OF SAUVIGNON BLANC GRAPES

PRODUCED AND BOTTLED AT THE WINERY BY
WENTE BROS.
ALCOHOL 12½% BY VOLUME LIVERMORE, CALIFORNIA, U.S.A.

FREEMARK ABBEY

1971
NAPA VALLEY

PINOT CHARDONNAY

Produced and Bottled by
FREEMARK ABBEY WINERY, ST. HELENA, CALIFORNIA
Alcohol 12.5% by volume

THE GREAT GRAPE OF WHITE BURGUNDY WINE

The Chardonnay grape produces the incomparable French Montrachet and the finest dry white wines of California. Not only the first-rate grape but the simple, precise phrases on the label speak well for the quality of the wine. The combination of vineyard name, vintage date, valley name, and varietal grape name is the classic labeling formula for all great California wines.

THE
VINEYARDS
OF
NEW YORK STATE

Though New York State is second only to California in total wine production, to compare them would be like comparing the Catskills to Yosemite. California has some 600,000 acres of vineyards yielding about 300 million gallons of wine annually—enough to supply every man, woman, and child in our country with more than six bottles. The 40,000 acres of vines in New York State produce only about 15 million gallons each harvest, or well under half a bottle of wine per person in the United States.

Size is not the only difference between our two major winegrowing regions. Nature is kinder in California; the hours of bright sunshine are long, and the growing season is seldom shortened by a killing frost in autumn. There the *Vitis vinifera*, with its sensitivity to cold, can reach maturity in almost carefree fashion. This gentle weather is not found in New York State, and it is only recently that any vines save the hardy *Vitis labrusca* native to the East could survive the sub-zero temperatures of January and February. The Catawbas, Concords, and Delawares had their vogue, but today most experts think we pay a price in flavor for American wines made from American grapes. Catawba and the other labruscas give a heavy taste, an overpowering aroma, and only simple character to their wines—the composite effect called "foxy." Those who have grown up with wines having this peculiar combination of flavor and aroma like and vigorously defend it. But it is unfair to judge these wines seriously alongside the fine table wines of California.

Just as alchemists tried to turn lead into gold, winemakers in the Eastern states have tried to make their wines more like classic European ones. California wineries have had the considerable advantage of being able to work easily with the standard European grapes.

In the East winemakers now have a new friend—a large

140

family of vines known as the French-American hybrids. The new strains may not give us all the breed, depth, and finesse found in wines made of vinifera grapes, but they combine some of the best vinifera traits with a constitution hearty enough for the rigors of a New York State winter. The new vines are developed by grape scientists at experimental vineyards in Europe and America through a painstaking and lengthy process of crossing two or more compatible stocks and then grafting the new shoot onto disease-resistant American roots. Yet even after the successful birth of a hybrid, the eager scientist parent often must wait years for an answer to the most important question about the new vine: Does it make good wine? Many of these hybrids we know today do give us good honest wine. But even the ones now praised had rough going when they first vied for acceptance in the aristocratic circles of the vinifera.

More recent than the hybrid revolution is a trend that may eventually help Eastern winemakers produce more and even better wines in the European style. Dr. Konstantin Frank, a true pioneer, has jumped the hybrid hurdle and has managed to grow the delicate *Vitis vinifera* vines themselves in New York State.

Wine drinkers often refer to "New York State" wines. In truth we should perhaps call them "Finger Lakes" wines, since this relatively small delimited area in the northern counties of the state, between Canada and Pennsylvania, is responsible for most "New York State" wines. Actually, only the shores of two of the lakes, Keuka and Canandaigua, are important wine-growing areas. However, the Chautauqua-Erie grape belt, stretching sixty miles along the Lake Erie shore, also produces vast quantities of wine grapes, most of which are shipped to wineries in the Finger Lakes area. Vines were first planted in this region south of Rochester in 1829, but not until the post–Civil War years did the vineyards and wineries that accompanied them attain real commercial prominence. Their success grew with the taste for wines made from the native American labrusca grapes. Today, as tastes have changed, the future of nearly every winery in the Finger Lakes area depends upon the fine French-American hybrid vines planted only in the last three decades. It is well worth a trip for the wine lover to visit the important vineyards: Gold Seal, Great Western, Taylor, Bully Hill, Widmer's, Boordy, and the famed Dr. Frank's Vinifera Vineyards. They are all fairly near one another, and everyone is made welcome.

At some of the larger producers it is particularly interest-

Native American Concord grapes. A labrusca variety used in many New York State red wines, Concords have the foxy taste not found in French-American hybrids or vinifera grapes

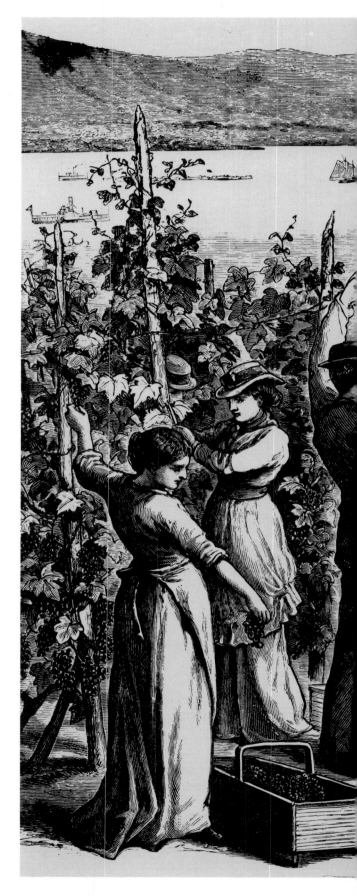

ing to note the tremendous quantities of champagne and other sparkling wines; half of the total United States consumption is supplied by New York State. Fortified wines also play a big part at the wineries; few spirits stores in America do not carry a New York State sherry or port. These fortified wines are usually blended with neutral wines and brandy from California.

Before leaving New York State we should detour to the Hudson River Valley, lately growing in importance. Only recently I attended a conference at the State University of New Paltz in the company of the Marquis de Roussy de Sales, proprietor of the great Château de La Chaize vineyard in the Beaujolais; Alexis Lichine, renowned wine authority and owner of the fine Prieuré-Lichine estate in Bordeaux; and Burgess Meredith, actor, director, vineyard owner, wine lover. With two hundred Hudson Valley farmers in the audience, the subject discussed was viticulture along the banks of the great river. The talk went on far into the night. It is to be hoped that as a result many of the apple growers for whom Eve's fruit is now economically unrewarding will fell a few of their trees and plant instead some of the French-American hybrid vines so ideally suited to the soil and climate of the valley.

Within the reasonably near future the Hudson Valley may become one of the truly great wine regions of the United States. Now only Benmarl and High Tor, a bit farther downstream, give us wines of real excellence, but both will soon be joined by new neighbors making wine of which the country will be proud.

142

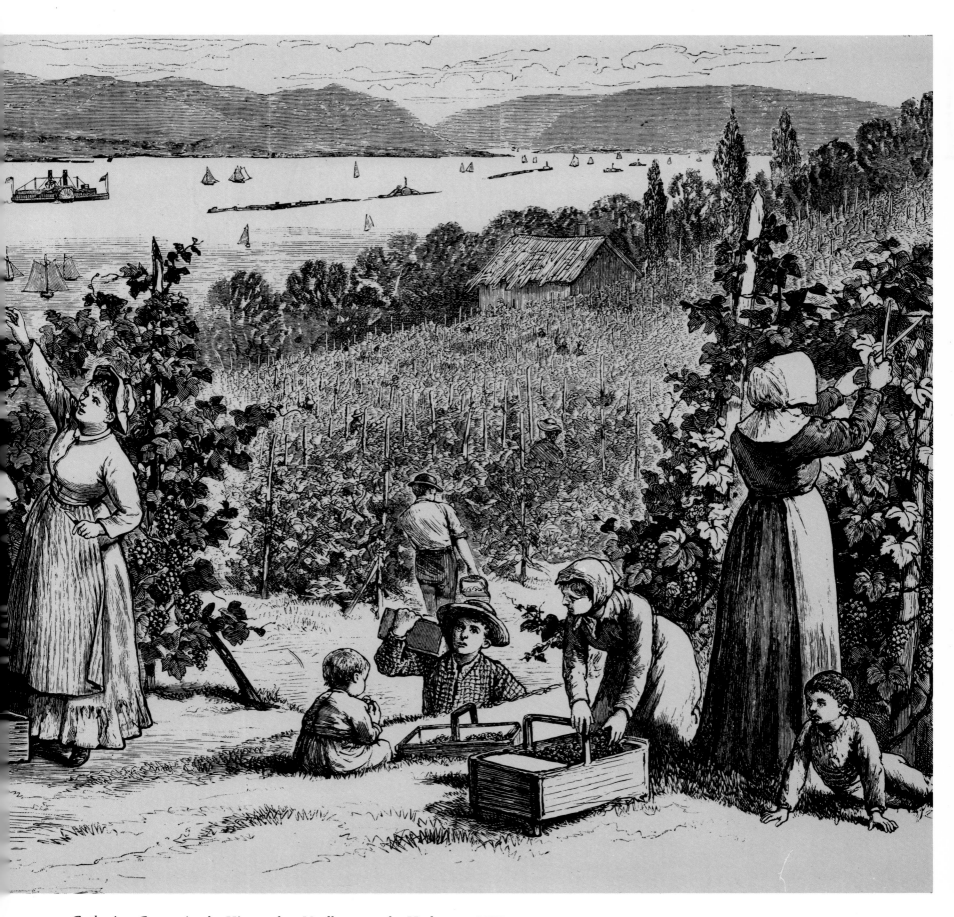

Gathering Grapes in the Vineyard at Marlboro-on-the-Hudson, c. 1890

HIGH TOR, New City, Hudson Valley. High Tor is an impressive outcropping of rock commanding the west bank of the Hudson twenty-eight miles north of New York City. It is also the name of the vineyard near the top of the hill planted by Everett Crosby more than twenty years ago. Crosby came to High Tor after a successful career in New York as a radio writer. Even while still in the city he had tried his hand at viticulture, with a potted Concord vine on his penthouse terrace.

The first years in Rockland County saw much hard work for Crosby and his family, with friends from the city coming out to help with the vintage and to join in the harvest celebration. Although the gala held at the end of picking was canceled when it became unmanageable because it attracted too many people, a few things remained unaltered throughout the Crosbys' years at the vineyard. One was their constant dedication to the high quality of the wine. Another was the unending battle with the flocks of birds that threatened every year to eat all the ripe grapes before a single one could see the inside of a wine vat.

Today High Tor is owned by Richard Voigt. His winemaker is an Episcopal priest named Thomas Hayes. Together they make wines from French-American hybrids, much as the Crosbys did. The Rockland red, white, and rosé are still the light, cheerful wines they have always been, and some of the hybrid varietal wines can challenge any in the state.

BENMARL VINEYARDS, Marlboro, Hudson Valley. Benmarl has helped to speed the revival of an important New York State winegrowing region, the Hudson Valley. Many vines grew along the river north of New York City in the last century. Yet only in the past two decades have vintners come again to cultivate the land and make wine. Benmarl is perhaps the prettiest of the wineries to come to life during the first years of the Hudson's wine renaissance.

Mark Miller and his family are the heart of Benmarl. While working as an illustrator in the Burgundy region of France, Miller came to know and love good wine. On his return to the United States some twenty years ago, he set out to find a Hudson Valley vineyard where he could bring up his family and make wine. He found the perfect site on a bluff in Ulster County overlooking the little village of Marlboro. From the start, all members of the family shared in the work, which included planting the vines and designing the winery. The charm and quality of the wines and the property have not diminished as Benmarl has grown. The vineyard is run with a happy combination of skill, enthusiasm, and business sense that should guarantee a good supply of Benmarl wines in the next few years.

Benmarl means "slate hill" in Gaelic. The word is an apt description of the earth Miller chose for his vines. He grows French-American hybrids and a little Chardonnay. Here, as at the other New York State vineyards planted in hybrid vines, white wines seem to do better than reds. The Benmarl red Baco Noir (like a Rhône red) is pleasant enough but not nearly so fine as the Seyval-Blanc (like a good dry Loire). A wine praised by French and American experts, the Seyval-Blanc of Benmarl is a charming country wine of which New York Staters can be proud.

BOORDY VINEYARD, Penn Yan, Finger Lakes. In 1968 the president of a big grape juice and applesauce concern approached Philip Wagner with the idea of making his popular Boordy wines in New York and Washington State instead of only at Wagner's little homestead in Maryland. Soon two giant plants of the Seneca Foods Corporation were making wine under Wagner's supervision. Now each of the Boordy bottles states its origin—Maryland, New York, or Washington. It is

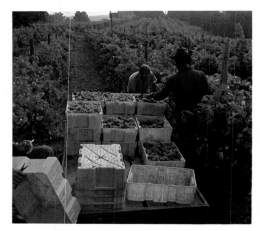
Boordy Vineyard's harvest at the original Maryland winery

Wagner's goal for each of the far-flung Boordy wineries to make a distinctive regional wine to be known, as wines are in Europe, by the name of the area where the grapes were grown and vinified.

All the Boordy wines are light and simple, ideal everyday table wines. The original red, white, and rosé and some of the other blends are made from the French-American hybrids that Wagner insists are the hope for high-quality, inexpensive Eastern wine. Vinifera vines, too, now grow in the Boordy New York vineyards. A limited amount of fine Chardonnay and Chenin Blanc is available.

BULLY HILL VINEYARDS, Hammondsport, Finger Lakes. Walter Taylor is a very talented man. He draws and paints, has written a biography of Glenn H. Curtiss, whose aeronautical museum is nearby, oversees the only wine museum in the East, champions honest Eastern wines, and, most important, he proudly produces some of the best wine in our land. His home base is the lovely Bully Hill Vineyards on a rolling slope overlooking Lake Keuka. At these vineyards, once owned by his grandfather, who founded the Taylor Wine Company in 1880, Walter devotes himself to making natural wines. Even though it is legal in New York State under certain circumstances to add up to 35 percent water and sugar, he shuns the addition of

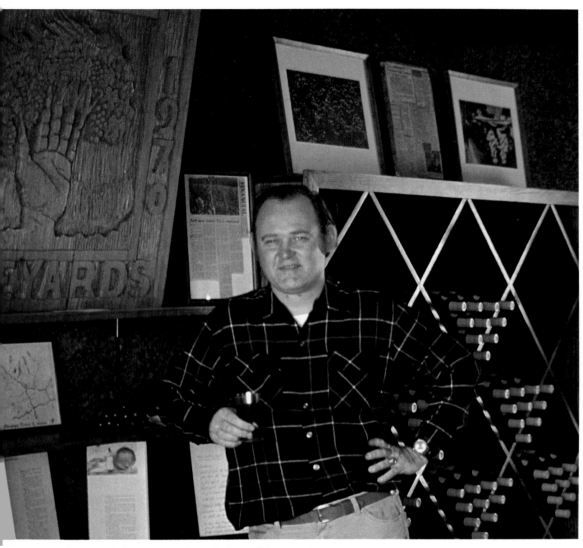

Walter Taylor, owner of the Bully Hill Vineyards

At Great Western, staves are used to separate the champagne bottles

ingredients often used to raise the alcohol level and balance the wine. "Wine without water" is his slogan.

Bully Hill Vineyards started in modest fashion, but now the production exceeds 20,000 cases annually and enjoys distribution in thirty states. At his vineyard Taylor is helped by the able Dr. Herman Wiemer, a capable winemaker who was trained in the Bernkastel vineyards of the Moselle.

Taylor now concentrates on the best of the French-American hybrids. His bottles proudly bear both the vintage date and the varietal name. "A wine label is like a person's face," says Taylor. "It should tell you what you want to know about him." Chancellor Noir and Baco Noir are his two best hybrid red wines. Though I admire his

Aurora Blanc, it is too sweet for my palate and I prefer the refreshing dryness of his Seyval Blanc. The most popular of the excellent wines of this vineyard are the blends of the hybrids, which bear the modest names of Bully Hill Red and Bully Hill White.

GREAT WESTERN, Hammondsport, Finger Lakes. To New Englanders in 1860 the Finger Lakes region must have seemed very far west: this is one possible explanation of the name "Great Western." As has been indicated, Great Western was merged with the Taylor Wine Company in 1961. Its claim to fame is a champagne that has won awards in European competitions and has been a consistent favorite at wedding parties in this country.

I prefer the drier Brut, but there is still a strong demand for their Extra Dry and the sweeter Special Reserve.

Varietals are not ignored here, and I particularly recommend their Baco Noir and Chelois, and also their white Delaware and Diamond. There is, too, a full range of generic wines such as Chablis and Burgundy, as well as sherry and port.

The company is the oldest in the area, proudly displaying over the front porch an antique sign that reads, "New York Bonded Winery No. 1."

GOLD SEAL VINEYARDS, Hammondsport, Finger Lakes. During the early 1960s two extraordinary winemakers met at the Gold Seal Vineyards, along the shores of Lake Keuka. One came from France, Charles Fournier, formerly the manager of Veuve Clicquot Champagne. The other, Dr. Konstantin Frank, came from Germany and Russia (he had been educated in Odessa). It was a happy meeting, because these two zealous gentlemen experimentally planted Chardonnay, Johannisberg Riesling, and French-American hybrids.

Eventually Dr. Frank left to establish his own vineyard. Fournier, now retired, remains as a vineyard consultant. I have shared the platform with him as an instructor in the wine appreciation course given at Cornell University. Mr. Fournier is a highly civilized man, wise in wine lore, and has made great contributions to viniculture in the East.

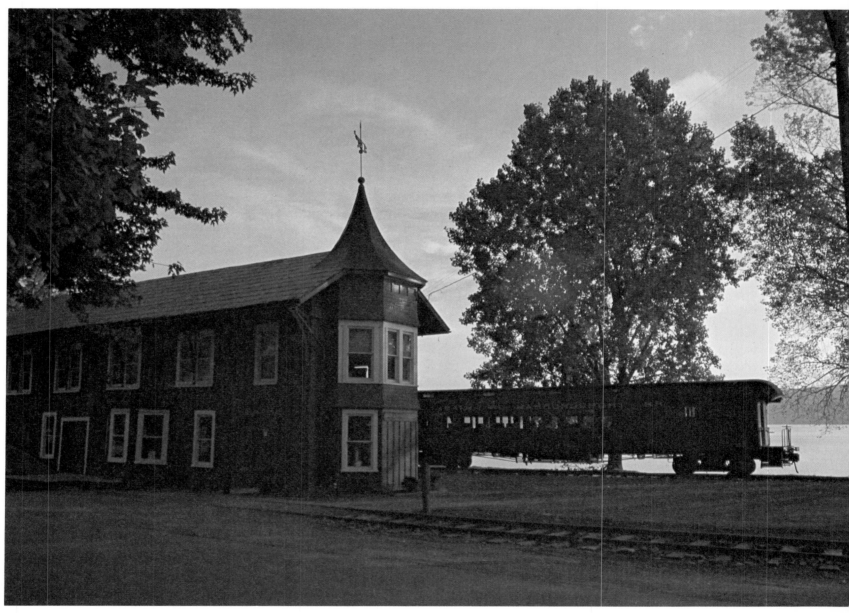

The Hammondsport depot serves the single-track railroad nicknamed "The Champagne Trail"

Founded in 1865 as the Urbana Wine Co., Gold Seal still sits gracefully on the shores of Keuka, a few miles north of Hammondsport. While the management shows no sign of abandoning the dependable and profitable pursuit of making champagne and rather sweet wines from a variety of native labrusca grapes, I am happy to report they are moving more and more in the direction of the superior French-American hybrids as well as Chardonnay and Pinot Noir.

There are 500 acres under cultivation, but they supply only a small percentage of the grapes required by this giant winery. The balance comes from almost 200 hundred independent growers in the area. Pleasant enough, but not to my taste because of sweetness and excessive fruit, are the labrusca wines that bear such names as Sauterne, Burgundy, Concord, Catawba, and Labrusca. You will be happiest with Gold Seal Chablis Nature and Pinot Chardonnay.

TAYLOR WINE COMPANY, Hammondsport, Finger Lakes. Despite its humble origins as a 7-acre vineyard established in 1880 by Walter Taylor, the company that bears the name is now

a large, successful public corporation that annually sells over 3 million cases of wine. Taylor acquired the famed Great Western brand and winery in 1961, making the new combine one of the largest wine producers in the East.

When speaking of Taylor and Great Western, we are talking essentially about New York State champagne. Their well-advertised brands of sparkling wines sell in vast quantities throughout the United States. The best of the Taylor champagnes is the Brut, with a good medium-dry flavor and the "foxy" taste of the Eastern grape that differentiates it from French cham-

Taylor Wine Company's original Delaware-grape vineyard

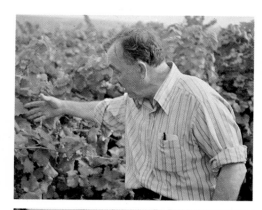

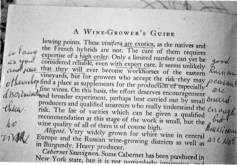

Konstantin Frank with his vinifera grapes and winegrowing notes

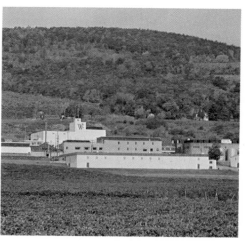

Widmer ages its casks of sherry on these flat roofs

pagne. Taylor also produces Cold Duck, that blend of sparkling Burgundy and champagne which took Americans by storm but is now losing its popularity.

At this winery, table wines are not ignored. There are Taylor Lake Country White, Pink, and Red—fruity and sweet wines not to my rather austere taste, though they are a popular offering on many airline flights and in thousands of homes. The familiar sauterne, Burgundy, claret, and rosé are supplemented by sangria and such fortified wines as sherry, port, white Tokay, and muscatel. Much of what is blended into Taylor wines, particularly the fortified ones, is shipped from wineries in California.

The Taylor Wine Company is serious and dedicated, as the thousands of visitors to the large winery in Hammondsport observe each year. As the winemakers add more and more French-American hybrids to the wines bearing the Taylor label, the quality will continue to improve.

VINIFERA VINEYARDS, Finger

Lakes. Dr. Konstantin Frank owns scarcely 60 acres of vineyards. His winery is barely more than a shed. Few wineshops sell his wines. Yet as the sun now rising on the golden age of American wines sheds more light and touches more lives, his name may become one of the most famous in the East. Dr. Frank's contribution to winemaking in

eastern America is at once simple and overwhelming: he has grown and made wonderful wines from *Vitis vinifera* grapes. With this achievement Frank bucked the long-held prejudices of other local vintners, who thought the vinifera ("wine-giving") grape could never thrive here. His Rieslings, Gewürztraminers, and Pinot Chardonnay vines are the first links joining the relatively backward vineyards of the eastern United States with the mainstream of viticulture around the world.

A remarkable old gentleman, Dr. Frank promotes the cause of vinifera as fervently as he touts his own wines. His wines are good, and worthy of their place in American wine history. The Riesling is rich and fruity, quite like some of the German wines on which it is styled. Both the Chardonnay and the Pinot Noir are big and full in the best Burgundy tradition, and with more solid character than many of their California counterparts. There are also Gewürztraminer, Cabernet Sauvignon, Gamay Beaujolais, Pinot Gris, and Aligoté, as well as two dessert wines, called Sereskia and Muscat Ottonel.

WIDMER'S WINE CELLARS,

Naples, Finger Lakes. Widmer's occupies several plain, functional buildings that would be difficult to distinguish from an industrial plant except for one important difference: 12,000 wooden barrels sitting on the roofs. The casks are Widmer's well-publicized method of aging its sherries. Piled four deep and a delight to view, they hold the young wine as it is matured under the hot summer sun and the deep winter snow.

Sherries make up only a small part of the Widmer production. Here one can discover the familiar listings of labrusca-flavored generics and fortified dessert wines. The best wines bear the simple, honest American names—such varietals as Lake Niagara, Delaware, and Elvira.

Like many of its New York State brethren, Widmer is firmly allied with the native labrusca and the French-American hybrids. Unlike its neighbors, this ambitious winery has made the cross-country leap and expanded into one of the best winegrowing regions of California, the Alexander Valley of Sonoma County. There they have planted a sizable vineyard with European grape varieties. Departing from their past practices, they will be bottling Cabernet Sauvignon, Pinot Noir, and Chardonnay. The Widmer family is gone, and the vineyards are owned by a giant food processor, the R. T. French Company of Rochester.

147

HOW TO READ A NEW YORK STATE WINE LABEL

Many of the wines made in New York State contain only New York grapes, with little or no added sugar or water; in many instances they represent 100 percent of the European varietal or French-American hybrid grape named on the label. However, because New York State is not blessed with the sunshine of California, its grapes may lack the natural sugar of those grown in the West, and it often becomes a matter of practical necessity to raise the alcohol content of the wine by adding an appropriate amount of sugar and water to the fermenting must. Such additions are not intended to adulterate but rather to impart to wines a balance and pleasing taste. By law, no more than 35 percent of the total sugar content may be artificially supplied by the vintner.

Since many of the grapes grown in New York are the strongly flavored *Vitis labrusca*, the resulting overpoweringly foxy taste is often neutralized by the addition of bland wines from California or elsewhere. By state law, no more than 25 percent of the grapes used to make a particular wine can come from another state or country.

Vintage date
At least 95 percent of the grape named on the bottle was grown, harvested, and fermented in the year stated.

The appellation "New York State"
At least 75 percent of the wine in the bottle was produced from grapes grown in the region stated (i.e., New York State).

The appellation "American"
The vintner crushed, fermented, matured, and bottled at least 75 percent of the wine in the bottle.

Estate-bottled
All the grapes that went into the wine were grown by the vintner; he made all the wine and bottled it himself.

Varietal name
As in California, at least 51 percent of the wine must come from the grape named on the label. (Some of the most commonly seen French-American hybrid varietal names are Seyval-Blanc, Baco Noir, and Chelois. Vinifera names to look for are Johannisberg Riesling and Pinot Chardonnay.)

S.A.

"LAKE COUNTRY" WINE

Here all we have to go on is the phrase "Lake Country Red," a pretty but vague expression that has no legal definition. Under state law, a combination of wines from outside the state, plus a limited dosage of sugar and water, can be added to any New York wine. The ultimate excellence depends on the integrity of the winery.

ESTATE-BOTTLING IN THE EAST

The back label tells all—the facts of the vintage, the various grapes that went into the wine, and the fact that it was estate-bottled. One hundred percent of the grapes were grown, vinified, and bottled on the property of the owner. Note that the grape varieties are all French-American hybrids.

TAYLOR

NEW YORK STATE

Lake Country Red

A SOFT, LIGHT, DINNER WINE

PRODUCED AND BOTTLED BY THE TAYLOR WINE COMPANY, INC.
HAMMONDSPORT, N.Y., U.S.A. EST. 1880. ALCOHOL 12% BY VOL. 4/5 QT.

Bully Hill Vineyards
Estate-Bottled Vintage
Chancellor Noir

This rare natural varietal dry red wine was produced by Hermann Wiemer, our winemaker, from 55% Chancellor Noir, 40% Cascade Noir, 5% '72 Rougeon Noir grapes grown in the midst of our Taylor Family Mountain Vineyards.

Our vineyards, 1,000 feet above Lake Keuka heavy with native stones and shallow soils, have been producing fine grapes since 1835.

This wine is produced by age old methods to insure its peerless quality - because of this, the wine can be decanted if there are any natural sediment crystals.

This is an Estate Bottled Wine. 100% of the grapes used have been grown and bottled on the property of the vintner.

This wine has a fine European taste. It is made without the addition of water. For complete information about what is in this wine write for our free brochure.

SERIAL NO. 045559

Walter S Taylor

Wine Maker, Grape Grower
and Owner of the Estate

A KOSHER SACRAMENTAL WINE

Despite the religious cast of the label, with its Hebrew words, most of this wine is consumed as a table wine by the general public. The appeal of Concord fruit and sweetness surmounts religious boundaries. Since "New York State" does not appear on the label, the wine can come from any-where—literally. The one certainty is that it was bottled in New York City.

KOSHER FOR PASSOVER כשר לפסח

MANISCHEWITZ

DRY CONCORD

ALCOHOL 12.5% BY VOLUME

MADE AND BOTTLED BY
MANISCHEWITZ WINE CO., NEW YORK, N.Y. • B.W. 21

A DRY CONCORD GRAPE WINE

כשר לפסח כשר לפסח

UNDER STRICT RABBINICAL SUPERVISION

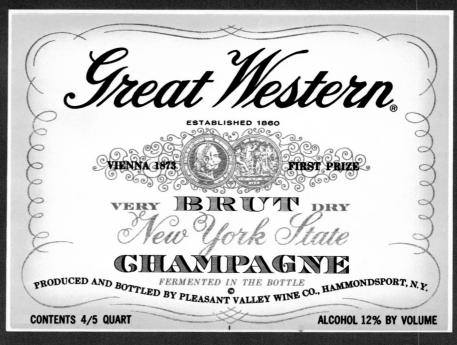

Great Western.

ESTABLISHED 1860

VIENNA 1873 FIRST PRIZE

VERY **BRUT** DRY

New York State

CHAMPAGNE

FERMENTED IN THE BOTTLE
©
PRODUCED AND BOTTLED BY PLEASANT VALLEY WINE CO., HAMMONDSPORT, N.Y.

CONTENTS 4/5 QUART ALCOHOL 12% BY VOLUME

AMERICA'S BEST-SELLING CHAMPAGNE

"Brut" means that this is the driest champagne made by Great Western, but the wine is not necessarily as dry as a French brut. The wine was fermented in the bottle by the classic French method. Some of the wine's pedigree is indicated by the founding date and the awards it has won.

OHIO

Back in the mid-nineteenth century, when Cincinnati was the Queen City of the West, Ohio Sparkling Catawba was the king of American wines. With international honors, and praise at home from Henry Wadsworth Longfellow, Cincinnati wines helped make Ohio the largest wine-producing state in the nation.

An eccentric but remarkable Ohioan named Nicholas Longworth stood behind the amazing story of Sparkling Catawba. When he tasted the first Catawba wine made as a hobby at his vineyard on a hill overlooking the river town, he decided to give up law and real estate and to cast in his lot with the grape. His choice was a wise one. The broad Ohio became the Rhine of America as hills for miles upstream from Cincinnati sprouted vineyards growing the golden Catawba grape, from which the sparkling wine was made. Stately paddle-wheelers loaded with the bubbly cargo called at Pittsburgh and St. Louis, where the wine was sent to the rest of the country, some eventually being shipped abroad.

The triumph of Longworth's wine seemed complete until his vineyards, and those of all the other growers in the pretty valley, succumbed to the double blight of black rot and powdery mildew. In the years before the Civil War the two diseases scourged nearly 10,000 acres of vineyards along the river—a grim prelude to the destruction caused by the phylloxera a few decades later. But by the time of the unhappy demise of the vineyards of southern Ohio, plantings in the northern part of the state were well established in a setting at least as picturesque as the great river valley. Along the shore of Lake Erie between Cleveland and Toledo and on the chain of low islands off Sandusky, vines throve in a friendly climate tempered by the water and remained free of disease thanks to the steady lake breezes. To this day the

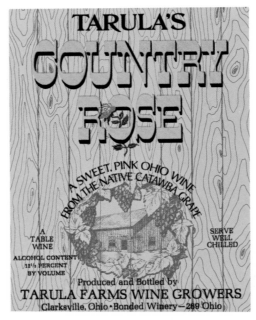

Tarula Farms makes wines from hybrids as well as native Catawba grapes

area remains the most important grape-growing section of the state. It is, in effect, the last stretch of the great Erie fruit belt that follows part of the southern shore of the lake from Buffalo west. The wineries that grew up on North, South, and Middle Bass islands and in Sandusky reestablished an important wine trade in Ohio. Several still operate today, doing a brisk summer business with Lake Erie's boating enthusiasts.

Meier is Ohio's leading winemaker. The firm grows and purchases grapes in the lake district and makes most of its wine at a large winery in a suburb of Cincinnati—an effective marriage of the state's two wine regions. Most of Meier's wines are made from labrusca grapes, like the Catawba, but increasingly the better wine of the French-American hybrids is being produced. Sweetness seems to pervade nearly all Meier's wines; none of the typically native wines is very inspiring, though the dessert wine from the Isle St. George (North Bass Island) vineyard should not be overlooked.

Other vintners in the Sandusky area make wine in a style similar to Meier's. William Steuk grows Catawba and makes many sweetish wines at one of the oldest wineries in the state.

Clermont Vineyards participates in the recent revival of Ohio River wines

Heineman and Lonz have great old cellars on the Erie islands, and there, too, Norman Mantey operates his newer Mon Ami Winery and restaurant.

The future of Ohio wines lies in the southern counties where they first gained fame a century and a half ago. Modern chemicals have conquered the diseases that destroyed Longworth's Catawba vines, so the hills by the river may again welcome the winegrower. But Catawba is not the grape that will make the great Ohio wines of the years ahead. French-American hybrids are the stars of tomorrow. One of the two important plantings of these vines is owned by Meier. Called the Jac-Jan Vineyard, it is situated on a bluff overlooking the river near the handsome town of New Richmond, east of Cincinnati, an area once the heart of the Catawba belt. The wines labeled Château Jac-Jan are good. The Ohio Valley Chablis seems better than the red.

Not too far away, at Clarksville, is the other vineyard that heralds the return of Ohio River wines. Wistar and Ursula Marting own the Tarula Farms, where the vineyards started as one of the experimental plots encouraged by the state. Hybrids have supplanted most of the old Catawbas and Niagaras, to the vast betterment of the wine— red, white, or rosé.

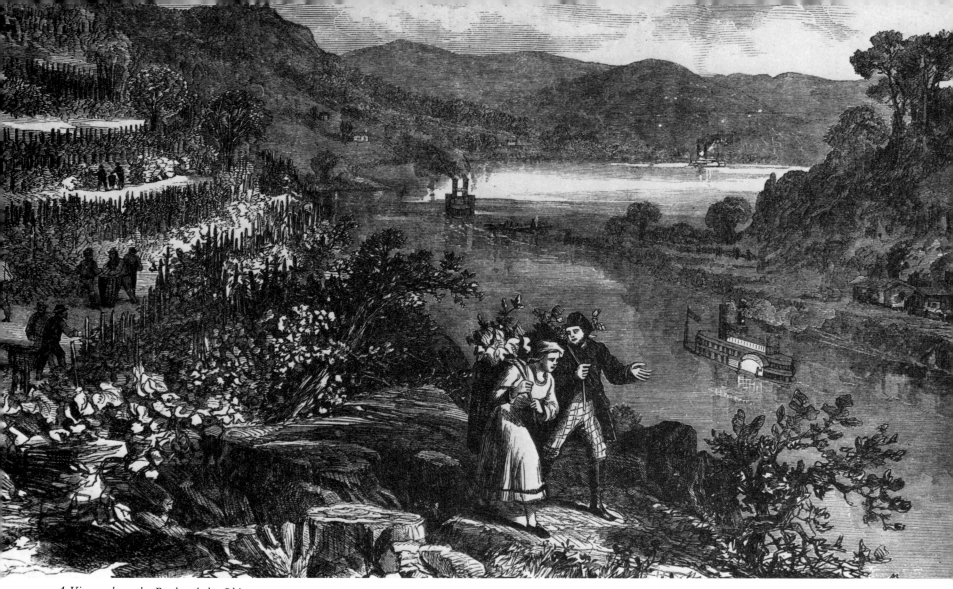

A Vineyard on the Banks of the Ohio, anonymous woodcut illustration from a mid-nineteenth-century pamphlet The Christian Brothers collection

CATAWBA WINE

This song of mine
Is a Song of the Vine,
To be sung by the glowing embers
Of wayside inns,
When the rain begins
To darken the drear Novembers.

It is not a song
Of the Scuppernong,
From warm Carolinian valleys,
Nor the Isabel
And the Muscadel
That bask in our garden alleys.

Nor the red Mustang,
Whose clusters hang
O'er the waves of the Colorado,
And the fiery flood
Of whose purple blood
Has a dash of Spanish bravado.

For richest and best
Is the wine of the West,
That grows by the Beautiful River;

Whose sweet perfume
Fills all the room
With a benison on the giver.

And as hollow trees
Are the haunts of bees,
For ever going and coming;
So this crystal hive
Is all alive
With a swarming and
 buzzing and humming.

Very good in its way
Is the Verzenay,
Or the Sillery soft and creamy;
But Catawba wine
Has a taste more divine,
More dulcet, delicious, and dreamy.

There grows no vine
By the haunted Rhine,
By Danube or Guadalquivir,
Nor an island or cape,
That bears such a grape
As grows by the Beautiful River.

Drugged is their juice
For foreign use,

When shipped o'er the reeling Atlantic,
To rack our brains
With the fever pains,
That have driven the Old World frantic.

To the sewers and sinks
With all such drinks,
And after them tumble the mixer;
For a poison malign
Is such Borgia wine,
Or at best but a Devil's Elixir.

While pure as a spring
Is the wine I sing,
And to praise it, one needs but name it;
For Catawba wine
Has need of no sign,
No tavern-bush to proclaim it.

And this Song of the Vine,
This greeting of mine,
The winds and the birds shall deliver
To the Queen of the West,
In her garlands dressed,
On the banks of the Beautiful River.

—Henry Wadsworth Longfellow

THE VINEYARDS OF
MARYLAND

The story of recent Maryland wines is the happy tale of Philip Wagner and his wife, Jocelyn. Having grown up with a love for good honest wines, the Wagners tried to grow vinifera grapes at their home outside Baltimore. The viniferas did not do well, and they switched to hybrid vines which had just recently been developed in France. Wagner began writing books on the French-American hybrids for the American home winemaker and even turned part of his property into a nursery for propagating the newly popular vines, selling them to other vintners across the country.

As the number of the Wagners' vines increased, so did the quantity of their wine. By 1945, they had their own winery, Boordy Vineyard, and soon were delivering their wines to local restaurants and hotels. The wines gained immense popularity in the Baltimore and Washington, D.C., areas. Wagner eventually quit his post as editor of the *Baltimore Sun* to devote all his time to the vineyard and nursery. For him, the joy of spreading the gospel of the hybrids is at least as important as making his own wine. He and his vine cuttings have made possible many of the little vineyards that have started throughout the eastern United States in the past decades. A true pioneer in the spirit of Johnny Appleseed, Wagner has done more practical good than almost anyone else for the winemaker and the wine drinker.

The Wagners' Boordy wines still are going strong. With Seneca Foods, they have started to make red, white, rosé, and a few varietal wines in Upper New York State and the Yakima Valley of Washington. The good simple wines first made some thirty-five years ago remain virtually the same; if anything, they have improved as the Wagners' skill and knowledge have increased.

TABOR HILL
VINEYARD

1973
BACO NOIR

GROWN AND BOTTLED BY TABOR HILL VINEYARD AND
WINECELLAR, INC., BERRIEN COUNTY, MICHIGAN
ALCOHOL 12% BY VOLUME

The first new Michigan winery in 25 years, Tabor Hill makes vintage estate-bottled wines from French-American hybrids and vinifera grapes

MICHIGAN

Southwest of Kalamazoo is the great fruit-growing region of Michigan, in its own way comparable to the Chautauqua area of New York State. Winemaking has come naturally to the region, and especially in the last few years Michigan wines have shared in the general wine renaissance.

Concords, French-American hybrids, and a few viniferas grow here, the latter at only a few small-scale experimental vineyards. The largest producer is Michigan Wineries, with a plant in Paw Paw (the unofficial grape capital) and another not far away in the town of Lawton. They make a wide variety of rather common wines, grape drinks, and concentrates. Bronte Winery is halfway between Paw Paw and Lake Michigan, whose waters moderate the winter cold just as the Finger Lakes do in New York State. Not the least of Bronte's achievements is that (if its claim is justified) it was the first in the United States to bottle Cold Duck, a drink whose remarkable popularity of a few years ago is now waning.

Tabor Hill is the finest of the "boutique" vineyards in the state. The wines come from French-American hybrids and a few acres of Riesling and Chardonnay. They are as good as any wines from the Midwest I have tasted, and they owe a large debt to Dr. Konstantin Frank, who offered much encouragement when the winery started out, only a few years ago.

MID-AMERICA

Vineyards follow much of the course of the great rivers of Mid-America. We have seen them on the historic banks of the Ohio in that state, but the vine grows along the banks of the "Beautiful River" in Kentucky, Indiana, and Illinois as well. Missouri was once one of the great wine-producing states of the nation, reaching its height soon after Ohio's vineyards declined. To the south, in Arkansas, quite a tradition of winemaking survives and is surprisingly active. Toward the north, in Iowa and a few of the other corn-belt states, vines have to struggle in the midst of devastating insecticides.

Indiana has a new law reducing the commercial wineries' license fees, which finally gives a long-awaited boost to the eager vintners in that state. The first vineyards there grew in the town of Vevay on the Ohio and flourished during the time when Longworth's Sparkling Catawba was so popular. Every summer a Swiss Wine Festival (Vevey was the name of the village in Switzerland from which the town's founders came) still exuberantly celebrates the local wines. Vines are spreading north in Indiana, too. Near the Ohio border is the Treaty Line Cellar, and just south of the Michigan state line and near Lake Michigan several new wine projects are under way. As is the case elsewhere, French-American hybrids form the most important plantings and make the best wines.

Illinois supplies tremendous quantities of kosher wines and, largely because of the Mogen David Wine Company in Chicago, is the third-largest wine-producing state. The grapes and

The largest winery in Arkansas, Wiederkehr, is housed in charming Swiss chalets

Texas' only winery, Val Verde, was started in 1883

juice come mostly from California and New York. But southwest of Chicago, nearer the Mississippi, are a handful of old, traditional producers who continue to grow their own grapes and make wine. Fred Baxter runs the historic winery in Nauvoo, where the Mormons settled briefly in the last century. The Thompson vineyard at Monee has valiantly tried to make champagne in the middle of the lush cornfields. Unfortunately, as is the case in many of the Midwestern vineyards, the pesticides used on adjacent fields often prove too much for the hybrid, labrusca, or vinifera vines.

Missouri is still one of the most interesting winemaking states in the Mississippi Valley. The Stone Hill Winery at Hermann, on the Missouri River, is a picturesque old place that has recently begun to make wines again, most of them from a variety of labrusca grapes. Closer to St. Louis, but still on the banks of the river, is the venerable Mount Pleasant Winery, now reopened and with a new experimental vineyard that should provide a clue as to which grapes will grow best in many Missouri vineyards. An Ozark grape festival highlights the harvest season in the southern part of Missouri. The village of St. James on Beaver Island is the center where the Stoltz Vineyard Winery makes several wines, mostly from labrusca, while the nearby St. James Winery produces sparkling wines. The biggest vintner in the state is Bardenheier's, in St. Louis, who used to blend California wines for sale in the

Midwest. They have now planted their own Missouri vineyards and enlarged the old winemaking facilities—a strong vote of confidence in the future of Missouri wines.

Not too many years ago St. Louis was something of a wine center. The giant Cook's Imperial Champagne Cellar was, a century ago, the home of Missouri sparkling wines. It reopened as the American Wine Company after Prohibition, but suffered from its German connections during World War II and now operates only as a vinegar plant. The man who ran the company for many years was Adolf Heck, the father of the Heck brothers, who continue to make fine sparkling wine in Sonoma County, California.

In Arkansas the ridge of the Ozarks between Altus and Paris in the west and Wynne and Harrisburg in the east supports a surprising number of vineyards and wineries. The largest winery in the state, and indeed in any of the Southwestern states, is the handsome and modern Wiederkehr cellar on the crest of St. Mary's Mountain near Altus. The Swiss and German immigrants who came here a century ago still have their grape festival (no vineyard area of the Midwest would be complete without one), but none of the wines can possibly remind them of those from the home country. Wiederkehr wines come from a wide variety of labruscas and hybrids and for the most part are not unlike the products of many of the other Mid-American

wineries. Not far from them are the Post Winery and the Mount Bethel Cellar, which also rely heavily on labrusca grapes.

THE SOUTHEAST

The southeastern part of the United States may well be our original vineyard. English and French colonists settling in Virginia and the Carolinas found great expanses of the virgin land covered with tangled grapevines that flourished wildly in the warm climate. Some early chroniclers reported that the scent of vines often wafted out over the estuaries and inlets, so that ships approaching the coast were wrapped in the rich, sweet fragrance of ripe grapes.

The vines responsible for the pungent welcome to our shores were unlike any that the immigrants had known in Europe. One vine could cover nearly half an acre with a mass of twisted tendrils, thick green leaves, and individual grapes more than an inch in diameter. The fruit itself did not grow in the conical or shouldered bunches common to the European vines. Instead the giant grapes hung singly or in clusters of two or three. We do not know what the early settlers called them, but the vines of this type are now called scuppernong, or muscadines. They are the species *Vitis rotundifolia,* completely separate from the family *Vitis labrusca* found farther north along the East Coast and even farther removed from the *Vitis vinifera* grapes grown throughout Europe.

It was a scuppernong wine aptly called Virginia Dare that was the most popular wine in the United States just before Prohibition. The original winery group has long since vanished, but scuppernong wine is still made commercially by several companies in Virginia and the Carolinas. It is heavily sweetened to mask some of the more unattractive characteristics of the grape, yet is curiously luscious.

Though the scuppernong will thrive in the humid coastal climate of the lowlands along the Atlantic, the labrusca, hybrids, and vinifera will not. In the cooler and drier Piedmont, bunch grapes and many other tree fruits (most notably peaches) do extremely well. Little table wine is made in the Southeast. Hobbyist vintners in North and South Carolina, Georgia, and Tennessee account for most of the very small production. Wine is not a particularly common drink in many parts of the South. Numerous counties in several states are still legally dry, but the future for wine has been improving over the past few years. Old laws have been changed or new ones enacted. Experimental hybrids resistant to disease may enable more of the hot, humid land to be used for vineyards, especially in Florida. Georgia will still have its peach wine, but some of its rich hill country may prove ideal for grapevines producing classic wines.

THE NORTHWEST

Grapes have long grown in Washington and Oregon, but winemaking is a relatively new pursuit in these states. Plantings of wine grapes have been vastly expanded in the past few years, so that enthusiastic Northwesterners claim their states will soon be making wine as good as California's and in quantities greater than any other state save California produces.

The Yakima Valley in southeastern Washington is that state's main grape-growing region. Before irrigation brought water from the Columbia River watershed, the gently sloping valley and the surrounding area seemed a near-desert, with so little rain that few if any crops could grow. The entire valley is now literally a fruitful place. Vineyards are concentrated in the lower section, around Sunnyside, Benton City,

Guided by André Tchelistcheff, Washington State vinters have produced good varietals from vinifera grapes

and Prosser (where the Seneca Foods–Boordy Vineyards winery that makes the Washington State version of Philip Wagner's popular Maryland wine is located). Hybrids cover most of the acreage, but some Chardonnay, Cabernet, and Pinot Noir grow there too. In fact, true vinifera grapes have for many years thrived in parts of Washington and Oregon. They did not make much of a name for themselves because no one was using them for wine. Some claim that parts of the Yakima Valley should produce as good a varietal wine as can be made in the United States.

Wine is being made in Seattle from grapes grown in the Yakima Valley and in a few other sections of the state. The Ste. Michelle label wines have gained some fame, but for my taste they are odd and unbalanced. The Cabernet Sauvignon seems thin and lacking in good sound vinous character. The Johannisberg Riesling is watery and without varietal flavor. The wines will probably improve as viniculture becomes better understood and more good grapes become available to the vintners.

Washington seems to have more than its share of eager people who make wine as a hobby. One group of professors from the University of Washington in Seattle had such success with

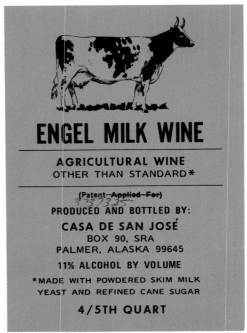

Although grapes grow in Alaska, the state's first winery makes its product by fermenting milk

their homemade vintages that they banded together as the Associated Vintners. Their wines are as popular in the Seattle area as many of the "boutique"

wines from Napa are in San Francisco.

Winegrowing in Oregon is not yet so advanced as it is in neighboring Washington. Although the vinifera, labrusca, and hybrids thrive in a climate very similar to that of Washington, no tradition of making wines from grapes exists. The biggest winery in the state is Honeywood, at Salem, where berry wines and several pop wines are made. Richard Sommer at the Hillcrest Vineyard in Douglas County produces probably the best wines of Oregon. He studied with Professor Maynard Amerine at Davis in California and spent several years searching for the finest spot in Oregon to grow his vines. Sommer and several others have thoroughly infected the state with the wine fever. There already is an Oregon Wine Growers Association, and an Oregon wine festival. Soon there should be plenty of wine to celebrate.

CANADA

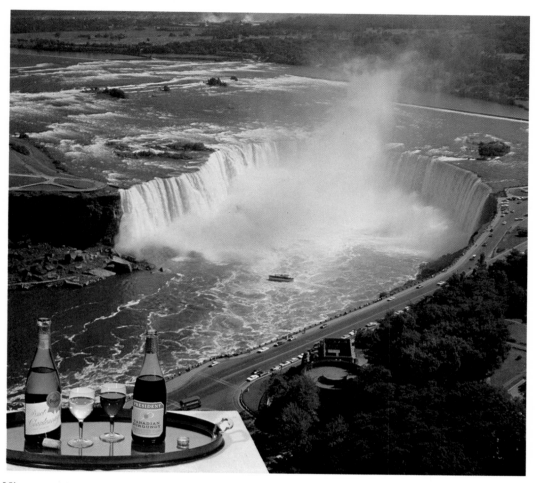

Niagara peninsula, between Lake Erie and Lake Ontario, the site of nine-tenths of Canada's vineyards

Canada has two wine regions. One is the Niagara peninsula in Ontario, a virtual extension of the New York State winegrowing region. The other is several thousand miles west, in the area of Okanagan Lake, just north of the United States border in British Columbia.

Canadians drink less table wine than we in the United States, but to travel through the Niagara peninsula one would hardly think so. Grapes and wine are big business there. The waters of Lake Ontario and Lake Erie moderate what would otherwise be a frigid climate in winter, making the southern shore of Lake Ontario from Niagara to Hamilton a paradise for the vine. Labruscas are by far the most widely grown, but French-American hybrids and even a few true vinifera vines are gaining acceptance. Most of the big wineries date from the middle or end of the last century, about the time when important Finger Lakes producers were

getting started. Eastern Canadian and New York State wines are quite similar, and the same arguments about labrusca versus non-labrusca vines as are heard across the Niagara River rage in Canada.

The biggest winery in Canada is T. G. Bright, outside the city of Niagara Falls. They make some 10 million gallons of wine annually and are especially proud of their champagne and several of the table wines made from Chardonnay and Pinot Noir. Not too far away is the Château-Gai Winery, home of a large selection of table wines, champagne, and fortified wines, some of which are exported to Europe. The Niagara region is also the home of the Ontario Horticulture Experiment Station at Vineland (where else?). The scientists there work with all the fruits that thrive on the peninsula, but some of their greatest successes have been with wine grapes. Among their accom-

plishments are a new hybrid for making fine port wine and a process for making sherry similar to that from Jerez.

The other vineyard district of Canada, in British Columbia, lies near the northern limit of the zone in which wine grapes will grow. River and lake water help temper the winter cold, and the newly planted vineyards marching up the narrow Okanagan Valley seem to be doing well. Even when this pretty land was one large apple orchard, British Columbians were making wine. It was wine made from grapes trucked in from California, however. Laws now state that a wine labeled "British Columbia" must contain at least 65 percent of grapes grown in that province. Calona and Mission Hill are the two wineries that grow grapes and make wine in Okanagan. Several others send crushed grapes to wineries at Vancouver or Victoria, on the coast to the west.

Wineries all across Canada make

wines from grape concentrates. From Nova Scotia to Alberta, giant plants turn out quantities of indifferent wine, often vinified from concentrates produced in California. Grape-juice concentrates are used in a number of smaller Canadian wineries as well. It is said that much of the wine made in the Dominion comes to life in the cellars of thrifty homeowners unwilling to pay the high government-controlled price of wine in retail stores. Wine consumption is on the increase, and that means that Canada will be producing more and better wine to meet the growing demand.

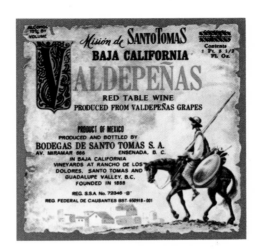

An Italian gold miner founded the Santo Tomás winery in 1888 near the ruins of an old mission

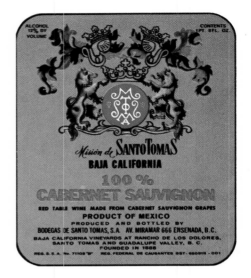

Santo Tomás varietal wines reflect modern improvements made in Mexico's oldest winery

MEXICO

The first American wine was made in Mexico when the Spaniards founded their New World empire in 1521. Wine was a necessary food for the conquistadores, and it was an essential part of the Mass for the missionaries who came later. Cortez saw to it that grapevines were brought from Spain to augment the wild vines and improve the quality of the wine made in Mexico. Later, when Mexico had its own commercial wineries, vintners in Spain felt their trade threatened, and in 1596 King Philip II forbade new or replacement plantings of grapevines in Mexico.

This Spanish prohibition of winegrowing in Mexico lasted nearly three centuries, until the time of Mexican Independence. But during those centuries the cultivation of the grape for winemaking was introduced to South America and the American West by the Spaniards.

Not until the 1930s did the wine trade in Mexico really begin to grow, despite competition from other, more favored beverages. Pulque, the mildly alcoholic drink fermented from cactus juice, is sold in tremendous quantities. Beer is enormously popular, and good

too, and soft drinks are in demand. But the country plainly lacks a winedrinking ethos. So far, the wine boom that the United States is experiencing has not affected our neighbor to the south.

The main vineyard districts are scattered north of Mexico City. In northern Baja California several wineries make good wines. The largest, oldest, and most famous is the Bodegas de Santo Tomás at Ensenada, where Dmitri Tchelistcheff is in charge of the winemaking. He is the son of André Tchelistcheff, who made fine wines for many years at Beaulieu Vineyards in the Napa Valley, California. The Santo Tomás vineyards now grow the best grape varieties, including Cabernet Sauvignon, Pinot Noir, Chardonnay, Johannisberg Riesling, and Chenin Blanc. The Santo Tomás wines are good, and are among the Mexican wines most likely to be found in the United States.

Another important vineyard district is Aguascalientes, lying not too far from the capital on the main north–south highway. Thousands of acres of vines flourish on either side of the road and huge wineries and distilleries (for brandy) stand among the fields. The vineyard closest to Mexico City is San Juan del Rio. The area, though very

far south, is more than a mile above sea level, so the climate is cool and quite suitable for good wine grapes. Farther north, toward the Rio Grande, the Parras Valley is the site of the first vineyard in Mexico. Several of the seventeenth-century wineries still operate here, in greatly expanded form. Among the largest of these is the Bodegas de San Lorenzo, where large quantities of everyday table wine are produced. More vines grow at Torreón and Saltillo in the vicinity of Parras. Hermosillo, in the northwestern state of Sonora, is also a center of wine production.

Few Mexican wines are great. Most are produced as inexpensive, everyday table wines. But some famous European firms make wine in Mexico and bottle it for sale there under their well-known names and for higher prices. These wines are primarily for the wealthier Mexicans with a strong sense of their European ties. The average Mexican, unlike the average Spaniard, Italian, or Frenchman, drinks very little wine, with the result that there is no real demand for a decent *vin ordinaire*. And without this base it is very difficult for a nation to build a tradition of making good wines. S.A.

THE
WINES
OF
FRANCE

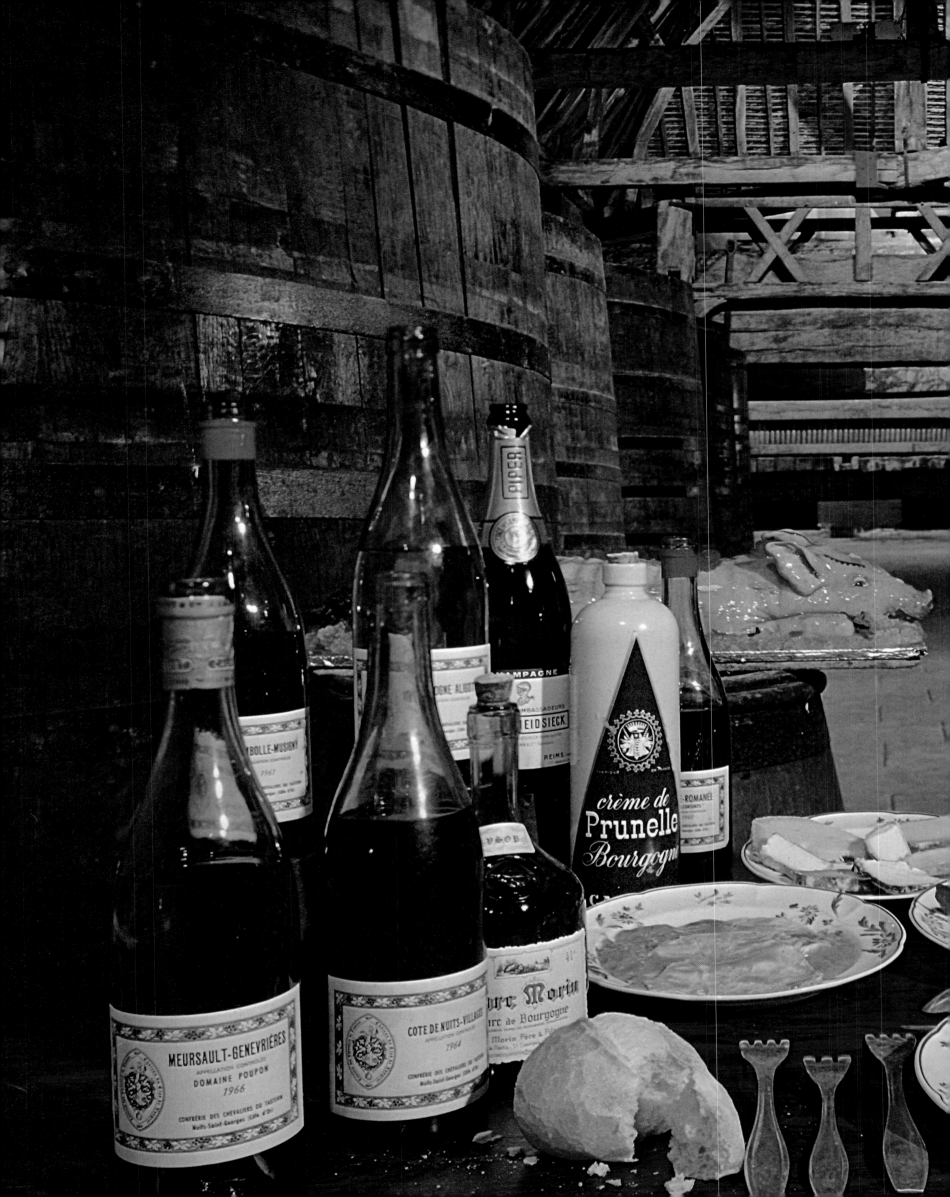

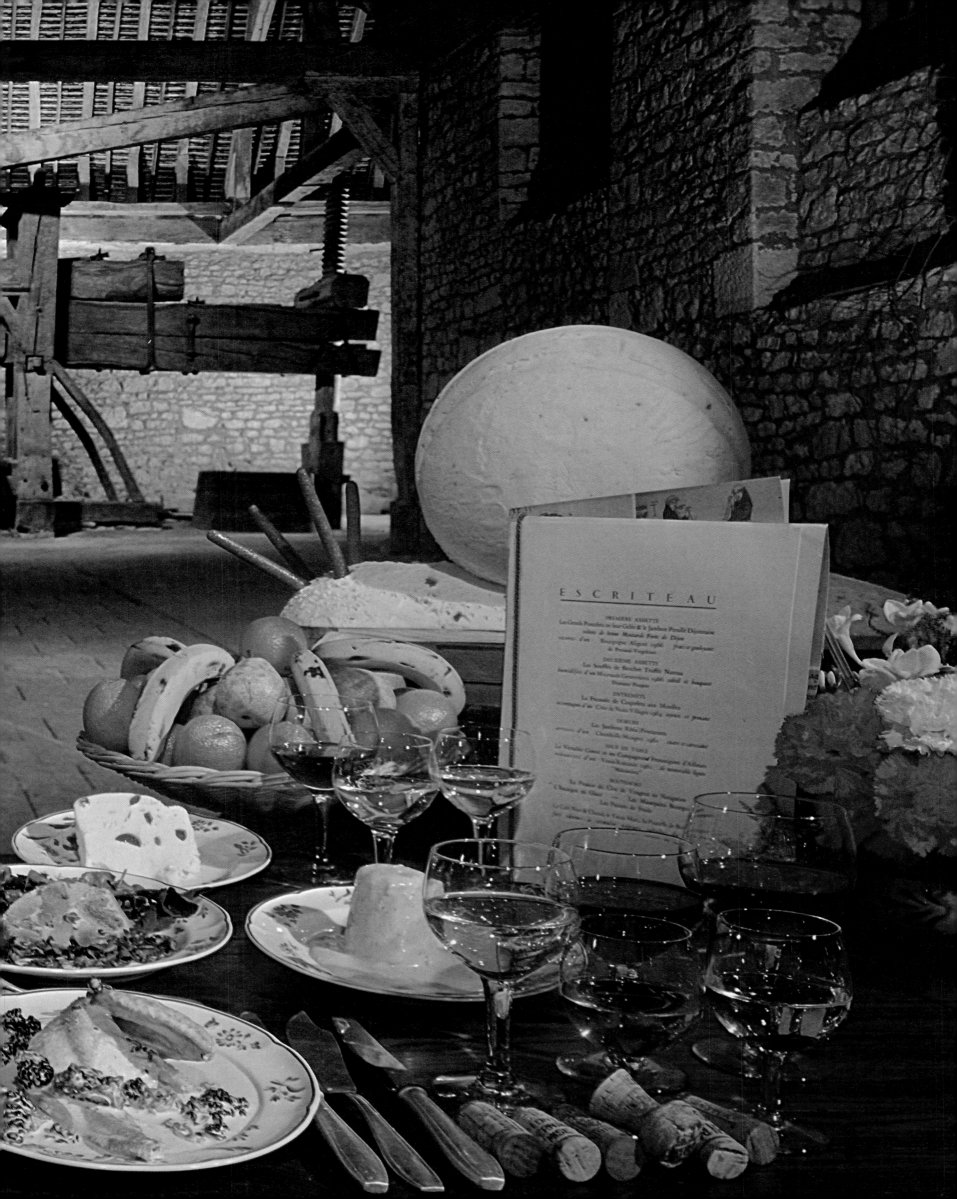

ESCRITEAU

THE MAN WHO MADE WINE

J.M. SCOTT

James Maurice Scott was born in Egypt in 1906 and educated at Fettes College, Edinburgh, and Clare College, Cambridge. He has done a great deal of professional exploring in Labrador and Greenland, and was secretary of the Mount Everest Expedition of 1933. Since 1948 he has devoted the major part of his time to writing. Among his published works, which number more than a score (and include six novels) are several suspense stories of the sea and the mountains—and a book on the vineyards of France. I know few other pieces of writing, factual or fictional, that describe so well as this novella the process of winemaking, the mysteries of vine and grape and bottle, and the spirit of the men who make wine. It seemed the perfect beginning for our section on the wines of France. C. F.

The composite trestle-table—it must have been twenty paces long—was in the night shadow of the big cedar tree. Behind, the white-washed outbuildings had a ghostly brightness. In front and to both sides were vineyards stretching down the gentle slope to the fringe of poplars which marked the *palus* ground and the river Gironde. In the full moonlight the line upon line of vine plants with their shiny leaves gave the effect of a gently rippled sea. The silvery countryside was quiet except for the rhythmical whistle of the grasshoppers.

At one end of the table a single candle was burning. It illuminated a row of bottles, wineglasses and some empty plates. Fifty or sixty people had dined here. But the meal was over and the guests dispersed. From the outbuildings behind there came a sudden burst of concertina music as a door opened; and now and then in the shadows there was the sound of whispering or a girl's gay laugh.

The candle flame, although it rose tall and steady in the still night air, did little more than give each bottle a grotesquely elongated shadow which joined it to the next bottle and the next, but less and less distinctly as the distance from the light increased. At the far end of the table it was so dark that you would scarcely have noticed the old man who sat there. His chin was on his fists, and he was staring out across the sea of vines, motionless as the night.

He was Michel Rachelet, *maître de chai* of the Château La Tour-St.-Vincent for the last twenty-three years, *vigneron* of the estate for more than half a century, and retiring from all work today. It was in his honor

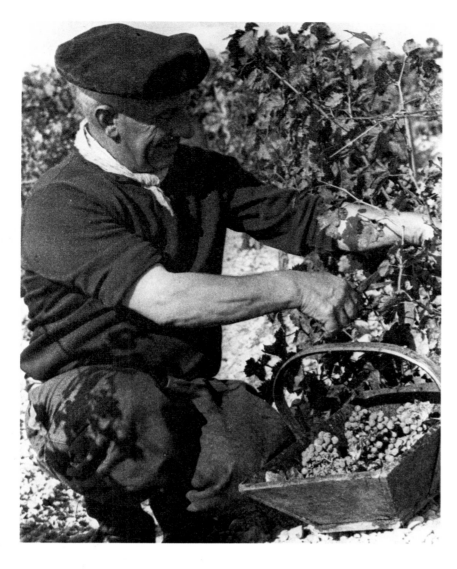

The men who make wine develop their skills during a lifetime of work in the vineyards. Once the harvest begins, the pickers must work quickly—an experienced hand can cut 850 pounds of grapes a day

that the dinner had been given on the eve of this year's vintage. Half an hour ago he, Gros Michel, had been the subject of a flowery recitation entitled, "The Man Who Made Wine," of several speeches and a toast.

The Marquis, who spoke last, had said: "On this September evening we are not only at the close of a vineyard year but at the end of an epoch. The past belongs to the family Rachelet—to Michel here and to his father, who takes us back beyond the turn of the century. Before asking you to drink to our guest of honor, what shall I say of him?

"There are a hundred stories that I could tell of this individualist—ah, I see some of you smiling. But I shall tell no Rachelet story tonight, for although we are proud that he with his good wife beside him could make us laugh as well as work, that could only light one facet of his character. I could speak of his knowledge, his genius with vines and wines. But they are known and appreciated not only here but wherever the wine of this château is drunk. I—I am only the *patron*. I have nothing to do with it. But seriously, when I first came into my inheritance I trembled before every interview with my *maître de chai*—until he took me under his wing and taught me how to be the proprietor of a great estate.

"What then can I say of him tonight? Nothing. No words of mine could do him justice. Instead I shall ask you to drink his health, slowly and in silence, and while you are doing so to look around you at the vineyard and to appreciate the wine.

"This vineyard is as good as any in France because of the loving and patient work of Michel Rachelet. And it was he who assisted at the birth of every wine of this château which is drunk today. . . . What makes one wine better than another? Surely in a word it is character. And is not this wine of ours great because it has in it, perhaps, something of the char-

161

acter of the *maître de chai*—the strength of his arms, the warmth and generosity of his heart, the kindly philosophy of his mind?"

Then everybody had drunk Rachelet's health, standing quite silently, glass in hand, some of them smiling affectionately, some thoughtful, some with tears in their eyes. It had been most moving, their silence and the different expressions of young and old.

But the *patron*, having paid his tribute to his faithful Rachelet, shaken him by the hand and kissed him on both cheeks, had gone back to his château. And then, gradually, as the summer darkness fell, the whole party of estate people had dispersed. Dance music had drawn the young ones and the old ones had gone to bed. They should all have gone to bed, Rachelet thought. Let them sing and caper all night when the vintage was in. But the fortnight of hard work would begin at dawn next day. He himself would never have permitted such behavior, had he still been in charge. But he was no longer responsible. He had nothing more to do. "Oh well," he sighed, "there's time to think a little."

Rachelet sat looking at the vines, which shone like silver in the moonlight. He did not admire them now. He preferred the true daylight colors. They were useful: they told you something. That afternoon he had gone into the vineyards to test the grapes. He had been pleased with the colors then. The leaves were healthy and of a shade which proved that the vines had been nourished on the right proportion of lime, potash, and nitrates. The leaves had finished their job now, so they could turn golden and fall when they liked. They had taken the raw sap from the roots and in the sun heat changed it into the compound substances which the grapes needed. Now, like old machinery, they were rusting. But the grapes were glowing and bulging like buxom girls. When you bit these grapes—Rachelet threw back his head and shut his eyes—they went pop in the mouth, and how sweet they were! They would make a strong wine which should have a long life before it. But what more could one say—at least until the juice fermented? Rachelet shrugged his shoulders and turned up his palms. (Although alone, he still gestured.) There could, for example, be too much tannin which would make the wine hard and bitter, and might not soften completely before the other elements had begun to deteriorate. With the best palate in the world you could not tell that sort of thing before the vintage, any better than you could judge the character of a child to be born of a certain woman. Up in Champagne they had a story of a blind monk named Dom Pérignon who could chew up a handful of the grapes and say exactly what the wine was going to be like. That was the sort of story you expected from Champagne.

If those knobbly old vinestocks with the delicate roots which reached so far down—if they could talk they could say something worth listening to. Vines were so much more sensitive than men. For instance, take a man and woman of Médoc and transplant them to Algeria. Their children would not be black: they would be the same as if they had been born in Médoc. Human organisms were not delicate enough to be affected by differences in water, air, and soil. But a Médoc vine in Algeria would produce Algerian wine because vines always repaid exactly what they had been given. Planted in the Côte d'Or, a vine of Château La Tour-St.-

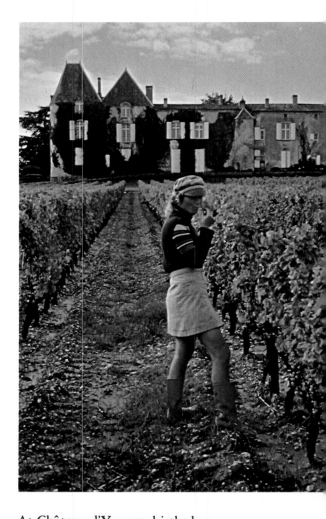

At Château d'Yquem, birthplace of the greatest of all Sauternes, a young worker can't resist sampling the sweet grapes

Vincent would, of course, remain a *cabernet-sauvignon* among the local *pinots,* but it would produce Burgundy, or perish. More than that, plant one of these vines only a stone's throw outside the château boundary—it would no longer produce La Tour-St.-Vincent. It would give artisan wine, peasant wine, *vin ordinaire.* It would at once know the difference in its environment, although the cleverest human chemist would say that the soil, water, and air were exactly the same.

Vines could not be cheated. They were the masters and men the servants. Men could understand only when the fruit had been translated into wine—and then it often took years to appreciate the subtleties.

The subtlety and the true greatness of vines had been made clear to him by the way they had reacted to the phylloxera. After all, it was they, not men with their chemicals, who in the end had offered the only road to salvation.

Rachelet remembered his father talking about the phylloxera. His father's working life had been spent in the shadow of that terrible plague, and he himself had been born—he remembered often being told this—when the evil thing was at its most virulent, when two and a half million acres of French vineyards had already been ravaged by it, and eastward all the way to Australia the same story was being told. There was no cure. The only way of destroying the tiny, louse-like invader was by burning the vines.

Then somebody suggested a method of immunizing the small remaining garrison of French vines. Michel remembered his father exclaiming against this plan. Rachelet *père* had been a big man, as big as his son had grown, but more red-faced, more passionate.

An ancient vinestock, twisted and bare, hangs on the wall like a piece of sculpture. The life of a vine averages forty years, and often the old vines are kept as decorative works of art

"What brought the disease?" he had shouted at his wife and startled children. "Imported American vines! So what do they propose to do?—Import more American vines! What sort of wine do they produce?—*bourgeois* at best. Yet it is said that if we graft our vines on to those stocks we shall still get French wine from them. I ask of you, is that reasonable? What gives our French wine its *finesse* if not the soil, and what draws

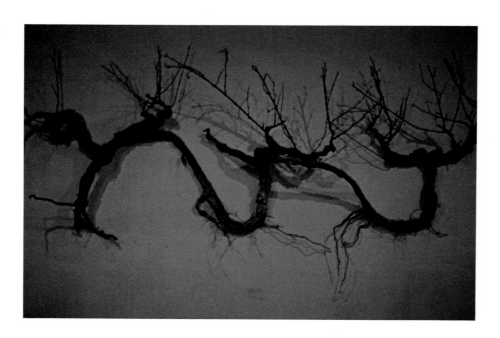

from the soil except the roots?—and the roots will be American. My poor children, you have no future except American wine."

Yet the gamble was tried because nothing else offered any hope at all. Such *vignerons* as could still raise money on credit bought American stocks and grafted on to them the precious French shoots. It was like giving one's children to a foreigner to bring up.

It is three years before a young plant bears grapes from which wine can be made and another year at least before the wine can be good. The *vignerons* had to wait a long time to learn whether they were saved or utterly ruined. You cannot hurry vines. But in the end the plants produced French wine. They knew they were on French soil even though the sap came to them through American roots. So Rachelet *père*, still grumbling, had spent his days grafting and replanting the ravaged vineyards. But to the day of his death he had remained pessimistic about the ultimate result.

"Listen well, Michel," he said often. "This is good for young wine. It is round, it is supple, it has *sève*. But, mark my words, it will not live as long as the wine we made before the phylloxera. Therefore it cannot mature to the same perfection. The great days of wine are past."

Michel did not agree. But although he had been a child at the time and now was an old man, it was still to early to say with certainty whether that gloomy prophecy had been correct.

Nailed above the door of the *chai* was an ancient vinestock. It was without bark, white as the skeleton of some twisted monster. It was said to have lived for one hundred and thirty years. It would be the next century before a post-phylloxera vine could be as old as that, if indeed it were capable of such long life.

Michel Rachelet, sitting at the table, raised his tired gray head and looked thoughtfully at the vineyard sleeping in the moonlight. Vines were mysterious. He had given his life to them, and having learned enough to be modest he would not have dared to say that he knew all about them—although he certainly would not have admitted that any man knew more. Here on the gently sloping ground which faced south-eastward they had the ideal exposure and soil—a soil in which no other crop would have grown well, for it was thick with pebbles as large as a child's fist. That was another aspect of the mystery of vines. But besides a particular soil they needed also good weather and proper care. God attended to the weather, and he, Rachelet, to the care. God had done them well this year—enough rain, then ample sunshine. And Rachelet, although the strain of daily work and constant responsibility had grown almost unbearable, had seen to it that nothing was lacking on his side.

As soon as last year's grapes had been picked and their leaves had fallen, the ground had been plowed up, weeded, and manured. Rachelet did not trust the new composite fertilizers which it was claimed did everything for the minimum of effort. Chemicals were to be used as a doctor uses medicine, but the staple diet was farmyard manure, well dug in. It was a saying of his that land needed a top dressing of human sweat. . . . In his mind's eye, the old man could see the scene in front of him as it

The vinegrowers' tools and techniques have changed little over the centuries. Plate from *L'Encyclopédie,* eighteenth century, Bibliothèque Nationale, Paris

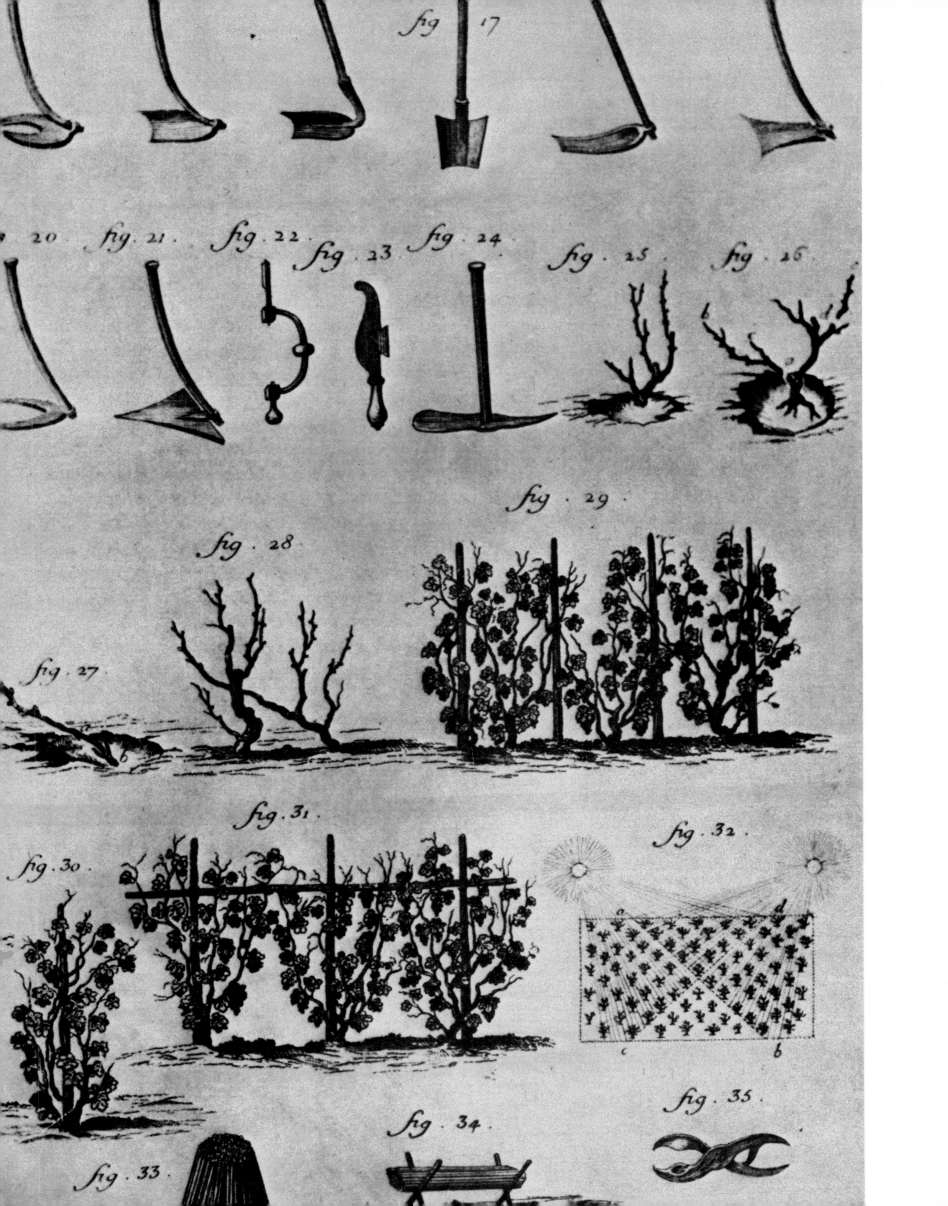

fig. 17

fig. 20 fig. 21 fig. 22 fig. 23 fig. 24 fig. 25 fig. 26

fig. 29

fig. 28

fig. 27

fig. 31

fig. 32

fig. 30

fig. 35

fig. 34

fig. 33

had been in the brisk autumn weather eleven months ago—the well-trained horses with the special plows designed to work along the meter-wide corridors between the rows of vines, the men and women with their hoes and spades piling the soil up in waves to protect the roots from frost. The smell of newly turned earth and of rubbish fires was in the air. The distant poplar trees were like a row of brooms, and a sparkling mist hung over the Gironde.

Then had come the first pruning, *la taille sèche.* His team of horticulturists had worked slowly down the rows, cutting away the unproductive wood. They worked bent almost double so that from the distance they looked like some strange species of animal—except when now and then one rose to his full height to ease his aching back. It was a long pilgrimage, the pruning—many kilometers for each man to travel at a snail's pace.

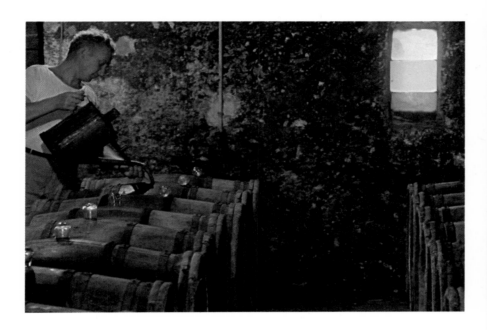

And the fences themselves had often to be renewed. There was enough work for everybody in the wintertime.

As spring approached, Rachelet's problem had been the timing of the first green pruning. If the canes were cut early no sap would be lost, but the quickly growing shoots would be liable to damage by frost. If the pruning were done late the vines would bleed. By a combination of experience and instinct Rachelet had learned to pick his time, and this year had got it exactly right.

The extent of pruning called for imagination. Rachelet had trained his men to look at the almost bare canes and picture the plant as it would be when it was fully grown. Then the quantity of leaves and branches must match the root area, yet this must be adjusted by pruning before an eye had turned into a bud.

The *bourgeonnement* had always fascinated him. It was not only the joy of seeing every morning from one's cottage doorway that the vineyard was painted a stronger shade of green: it was the detail of the change. When one looked closely at a particular cane one noticed that the sprout-

(Left) At Château Greysac an important part of the cellar work is topping—periodic refilling of the casks to make up for evaporation. Too much air is the enemy of wine, and the casks must be kept full

166

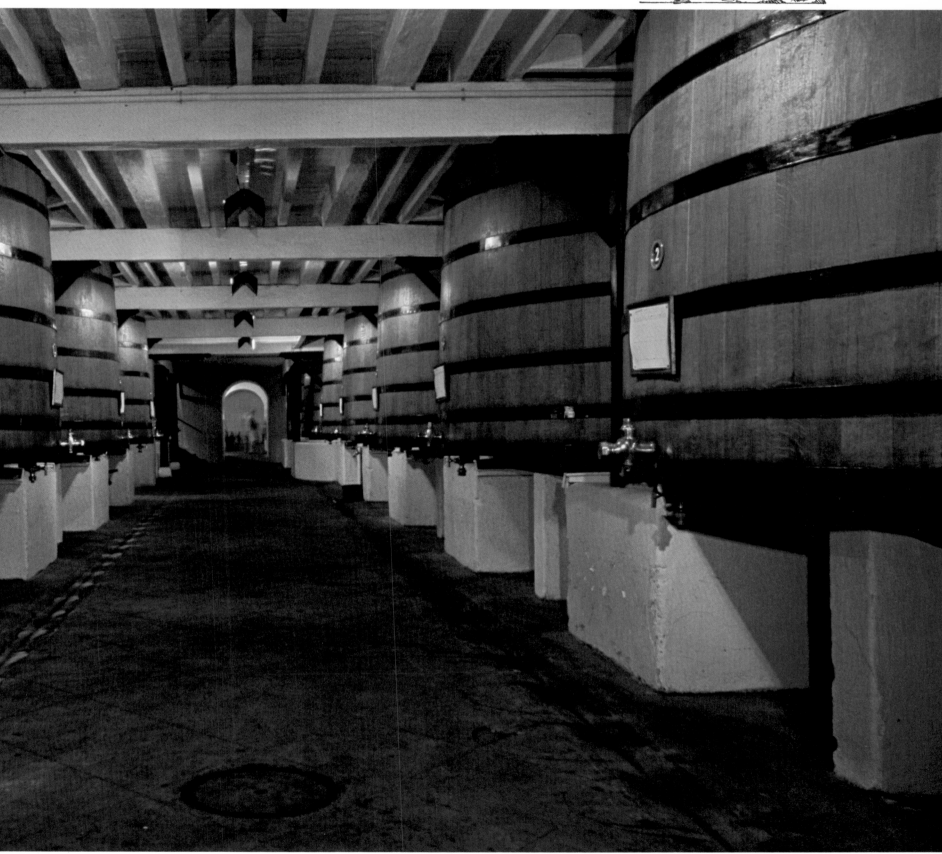

At Mouton-Rothschild, vinification begins in these large oak *cuves,* or vats, where the grapes are left to ferment for about ten days and to macerate for two weeks after that. On each 5,000-gallon vat hangs a temperature chart which records both the temperature and the sugar content of the new wine

ing eyes were larger than when one had seen them last. Soon after this the brown scales fell from the eyes and the woolly buds became visible. Then came the stage which used to excite him so much as a child—and still did. The tiny leaves became separated on their little stalk, even the cluster of minute flower buds was distinguishable. It was a vine branch in miniature.

It would be a real branch soon enough, and meanwhile there was plenty to be done. Each shoot was examined and every one which was imperfect was cut away. And later, when the remaining shoots had grown a little, the ends of some of them were snipped to make them bunch well.

Then the flowering started. This too was a lovely thing to watch in detail. The green hats which the buds wore fell off and the delicate members of the flowers were seen. It was like a conjuring trick. But it was an anxious time for the *vigneron* looking for symptoms of *la coulure,* the disease of barrenness.

The fertilization had gone well this year. When the tiny grapes were forming, the clusters were examined and the least promising removed. And finally, just before the vintage, the old leaves which had done their work were cut away to give more light to the ripening grapes—yet not so much that they would be sunburned.

That covered the plant's development and discipline by pruning. But there had been, besides the active watch for fungoid and insect pests, the passive watch for late frosts and devastating hail. That had been the outdoors round which Rachelet had known for fifty-four years as a qualified *vigneron* and for much of twenty more as a child and apprentice, excluding his years of military service.

But most of his work recently had been in the *chai*. He felt a sudden longing to visit the *chai* before he slept—to walk among the hogsheads of young wine, to go down to the cellar beneath and browse among the thousands upon thousands of bottles which were for him so full of interest and experience.

He thought of all those wines as friends whom he had known since birth. It was his fancy that wine passed through childhood and adolescence in the fermenting vat. That period, which with men lasts fifteen to twenty years, was completed by wine within as many days. But thereafter they lived at much the same rate. The few years which a young fellow spends in settling down to his responsibilities were spent by wine in barrels. It got rid of its wild oats then. When it had cleared its head of clouds and figments it was bottled. But life never stands still: wine, like men, was forever changing, either for better or for worse. Its numerous and complex elements—alcohol, glucose, glycerol, tartrates, acids, salts—were continually readjusting themselves, altering, blending or falling apart, the waste products being excreted as sediment. How well, at what rate, and for how long a wine continued to mature depended principally on what it was born with. For instance, if it were not strong enough it would become bitter with age instead of richer and better balanced. But on the whole it improved. Each bottle became a more valuable member of the cellar—until it reached the peak of what it was capable of some time in middle age. Then the ever-continuing changes began to be for the worse. One element after

another faded—color, *bouquet,* vinosity. Gracefully or suddenly the wine grew old until you could scarcely recognize in it the youth that you had known. At last it died. It went back to water and the things of earth from which in the sunlight its grapes had been made. That was the fascination of a cellar—a whole series of lives in different stages of development.

Rachelet wanted to visit his cellar, but he remembered that it would be dark there, and that he had recently discovered that the steps were steep and slippery. He sighed, and prepared to resign himself—then noticed the candle. He would take that with him. He would manage very well with a candle.

He rose slowly, pressing down with his arms, then moved along beside the table, touching it with one hand, until he reached the candle. Gros Michel was a tall man but a good deal stooped (so much of his work had been done stooping, both in the fields and among the barrels). His limbs and features were large. At the ends of his drooping arms he had big, horny hands. It was a tradition of the Château La Tour-St.-Vincent that he had never been unable to carry between his fingers enough glasses for a winetasting by however many visitors. It was also a tradition that Rachelet's hands could pull out a superannuated vinestock as another man might draw a cork, could cooper a barrel, or make a graft which was certain to flourish. Equally it was said that he had the best palate in Bordeaux, which naturally meant of the whole of France, and therefore of the world. He was not only a character, he was a tradition in his lifetime. But he himself was philosopher enough to realize that to be a tradition is to be as good as dead. They were dancing over there, and making love among the shadows. With no strangers to boast to, they had forgotten him. He had grown outside their real world.

His face, now lit by the candle, was wise and sad. The skin was not rough, yet as full of lines as a sawn tree stump. His deep-sunk eyes were penetrating. They had disconcerted with their steady stare many amateur visitors who had been brought into the *chai* to taste the young vintages. They had swished the wine round their glasses, nosed and sipped it, watching the other tasters out of the corners of their eyes and trying hard to look like connoisseurs in front of the famous *maître de chai.* But—had they known it—Rachelet was not watching them critically. Their knowledge of wine, or the lack of it, mattered little or nothing. He himself knew without question what was excellent, good, or not so good in the barrels and bottles under his care. But he was waiting, like the tutor of some great family, for an appreciative remark on his young geniuses. Compliments warmed from whomever they came. It was only on the rare occasions when criticisms were made that he inquired, politely but firmly, into the authority of the speaker.

As *maître de chai* he had been a man of importance, for La Tour-St.-Vincent was almost a self-contained village with its fine château as a centerpiece. Forty families lived and worked on the estate. Besides the two hundred acres of vineyard there was as much again of farmland. The *patron's* horses were famous, so was the herd of pedigree cattle which produced the necessary manure. (Hundreds of tons of this were needed every year.) There were flocks of geese and ducks and chickens; and the fine

walled garden grew all the vegetables which were eaten the year round. The *chai* itself was a noble structure eighty paces long, its roof supported by two rows of stone pillars. . . .

Next to the *patron*, Rachelet had been the most important man for the past twenty-three years. But now he was of no consequence and alone. Never mind. For old time's sake he would go to his *chai*. There he would still feel somebody, for he had stocked it with most of the wine that it contained. . . . He reached out for the candle which should guide him there. But in doing so his foot caught against something and he sat down, luckily on a chair.

The shock of this little accident made him realize how tired he was. It had been a long, busy, emotional day. When he had returned to his cottage in the afternoon he had found that his efficient niece had got a barber out from Pauillac to shave him, cut his hair, and iron his mustaches. That had been bad enough, but afterward she and her husband had insisted on getting him into his Sunday best, with a new stiff collar which was so high that it almost cut his throat. And after that—well, there had been al! this to-do of chatter and speeches and back-slapping and quantities to eat and drink. It had started in daylight and now it was dark and he was alone. He was not drunk—far from it. For him wine was not a light thing of recreation. It was his work, and this evening with so much to distract him he had scarcely touched anything. Perhaps it would have been better if he had got drunk. Instead he felt flat and lonely. He wanted to visit his *chai*, and he felt too tired and old to get there.

He looked slowly and doubtfully to right and left. He noticed the bottles. Close to the light he could see them individually and clearly. He remembered what they were. They were not what had been provided for drinking. That had been in demijohns which had been carried away by the dancers. These bottles were what the Marquis had caused to be brought up from the *bibliothèque,* or museum, of the cellar, an example of every vintage of the past fifty-four years. They had been nosed, sipped, and applauded at appropriate moments during the speeches, when reference had been made to some particular year. But everybody realized that they had been provided as a gesture and a compliment to the retiring *maître de chai* and had controlled himself from swallowing more than a mouthful even of the greatest wines.

Rachelet nodded his head at the bottles, greeting them like old friends. His good *chai* had come to him. He knew now why he had wanted so much to visit it this night before he slept. The line of bottles stretched down the table from where the candle stood to the dark end where he had been sitting a few minutes ago. They looked something like telegraph poles along a road, linked by shadows instead of wires. He wanted to travel back along that road.

It was too dark for his old eyes to read the labels, even with the candle —he had left his spectacles somewhere. No matter. He half filled a glass from the nearest bottle. He held it to the light and then under his nose. His face became suddenly alert.

Rachelet's eyes were too weak to read labels by candlelight, but they

170

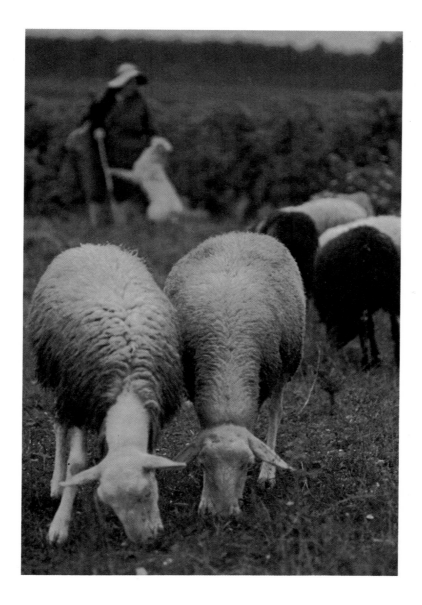

The renowned *agneaux de Pauillac* graze near the vineyards. A specialty of the commune, lamb roasted over a fire of dried vine shoots is the perfect complement to its fine red wines

could distinguish and interpret shades of color; and his well-trained nose was in its way every bit as sensitive as a dog's. That vivid purple with more scarlet than blue in it told him the youth of the wine, and the faint smell, as of flowers in bud, confirmed it. But what told him the year was something thin and hard, an individual sort of unripe fruitiness, in the perfume.

Rachelet threw the wine into the night. He had no wish to taste the 1951 again. He had been sadly disappointed by that vintage, which even at the time he had feared might be the last for which he was responsible. He had done all he could for it—but nothing can make up for lack of sunshine. Human geniuses may make their mark in youth; but not wines. And without original sweetness, no wine can live. What there was of it—some 300 hogs-heads—would be drunk indifferently, almost apologetically, as a light table wine. No one would lay it down for his children or offer it with pride to his friends on great occasions.

This year—it promised so much better! The hot sun had stuffed these grapes with sugar, potential alcohol. Rachelet wished that he might have remained in charge of the vintage instead of retiring on the eve of it. But the *patron* had been right; he was not up to that fortnight of grueling work. Wine in its first, fierce fermentation waits for no man. It has all the selfish impatience of youth. He might have made a mess of things.

He shrugged his shoulders. No matter—he was no longer concerned with the present or the future, only with the past.

Rachelet browsed along the next half-dozen bottles without pausing long over any one of them. They had evidently been set out in sequence, but in any case he would have had little difficulty in recognizing the vintages—in fact, where in one instance two bottles had been transposed he noticed it at once. For him there was nothing at all remarkable in this. Wines, like human beings, have a certain range of qualities. Those on the table were all of the same family, but brothers and sisters have individual characteristics which make each unmistakable to a friend. And was not Rachelet the family tutor who had studied them from birth? The '50 and '49 were the most nearly alike. One might think of them as twins. But they were not identical: one could recognize the older.

The '48, a comparatively poor wine, was none the less individual. Like a plain woman who has a charming smile, it had a lovely *bouquet*. In the mouth, the first thing you noticed was the tannin. The '48 would live a long time whether anybody wanted it to or not. The '47—there was a textbook wine, perfectly balanced, almost too well balanced for its age. The '46— well, one knew it at once because it was so untalented.

Rachelet, in his private analysis, did not employ any of the conventional connoisseur terms to the wines. In the past when he had been responsible for selling them he had given a detailed and most colorful report of each. But he was no longer interested in their marketable qualities. Their scents and flavors only mattered to him now for the memories which they evoked. He hurried through these years because there was nothing worthy to be remembered on this great occasion, either of joy or sorrow. All the vintages belonged to the period when he was merely holding on, with great effort lasting out his promised period of service, looking forward to nothing except rest.

The first wine he paused over was the 1945. For a long time he held its softening purple between him and the candle. He swung the glass in quick circles, then cupped his hands about it and put his long nose down so that it almost touched the wine. He breathed deeply, like a sigh, until his nostrils, his mouth, and all the delicate surfaces which smell and taste and prod the memory were flooded with the subtle vapor which rose from the suddenly warmed and agitated wine.

He held the glass away from him, swinging it slowly in the candlelight. A great wine, the '45—fat and round and full of promise. But he did not want to drink it again. The wine of Château La Tour-St.-Vincent had the reputation of maturing more slowly than any other of the Médoc, and this vintage of '45 was a veritable *corsé*, the slowest in development of any he had known. Although already seven years old, it might be three times that period before it was ready to be drunk. But that was not the reason why he was unwilling to drink it now.

Once more he breathed the wine, then put the glass down on the table. The memories of that year were too vivid, too cruelly contrasting. How well it had promised, in every way! Peace came with the flowering of the vines. The *patron* returned from the army. Together they made a tour of the vineyards and the *chai* while Rachelet reported on the events of the past five years. At last they came to a halt in the shade of this same cedar tree, and the *patron* praised Rachelet for his stewardship.

The aroma of a young wine or the bouquet of a mature one gives the attentive drinker information about the contents of the glass. Even a novice can find pleasure in breathing the wine as a prelude to tasting it

"You have done wonders," he said. "Ever since as a boy you began to work for my father you have done well—better and better. And to maintain the vineyard and *chai* throughout the war so that it all looks as smart as the *École Nationale de Viticulture*—it is nearly miraculous! But I realize the strain it must have been. What is your age, Michel—sixty-eight? A ripe age, but you are not yet on the way out. No, no, you have many useful years in front of you. That is why, being conscious of my debt to you, I have something particular to offer."

The Marquis, although he held himself erect as a soldier, was no taller than the stooping Rachelet. Their heads were level, and Rachelet's eyes searched those of the *patron*, wondering what he meant, feeling pride and joy but fear as well.

"My friend," the Marquis said, "most people of your way of life work on for their masters until they are finished. When they retire they can only sit by their firesides and wait for death. But you deserve something better. Besides hands you have a brain. My father often said that if you had had education you would have been a philosopher as great as Voltaire."

"I am what I am," Rachelet murmured. He wished the *patron* was not so fond of making speeches.

"Listen," the *patron* said. "I have a château also in Anjou. The vineyard is small, but it might, I think, be good if it were well cared for—which it has not been for many years. There is a little house of whitewashed stone for the *vigneron*. It has its own vegetable garden and a well of sweet water. To the left one can see the town of Angers, and to the right over the vineyards is the Loire."

"Yes?" Rachelet said.

"You have only to say the word, and that house and the produce of the vineyard are yours for as long as you shall live and thereafter will belong to any heir you name. You are fortunate in your good wife. Together you could make something of the place, I am sure. Of course, you can remain in your cottage here, if you prefer. But it is smaller, with no vineyard of its own. I will not hurry you for a decision. Think it over and tell me when you have made up your mind."

"I have already made up my mind," Rachelet began.

"Ah, you do not waste time! I only hope you will not leave us too soon." The Marquis sounded a little hurt.

"My father taught me that a man can work usefully until he is seventy-five years old." Rachelet went on slowly. "That means I can assist at the birth of seven more wines. My place is here, *patron*."

The Marquis stared. "But the house and the vineyard in Anjou—"

"*Patron*, I am a man of Médoc."

"So you decline land of your own to work for me?"

"I do not only work for you, *patron*," Rachelet answered in the same slow voice. "I have seen every one of those vines planted. I feel responsible for them and for their wine. Pierre Simon, the husband of my niece, who I suppose will succeed me, does not yet know enough."

At that the Marquis grasped his hand. He, a colonel with the *Croix de Guerre*, had tears in his eyes. But Rachelet remained stiff and unresponsive. He was dissatisfied with himself because he had not been entirely

honest. For a little while he could not express it, and he frowned. Then the words came.

"*Patron*, I must tell you that if you had offered this two years ago, or a little more than two years ago, I would have answered differently. I suppose every man for whom the future matters longs for his own house and land. But now I have no choice."

"I understand you," the Marquis answered in a soft voice. "But will your wife agree?"

Madeleine had agreed completely. In fact, that decision had brought some happiness and self-contentment to two old lovers who held hands and stared into the empty grate.

It kept them quietly happy until the vintage time. This, naturally, is the most busy period of all the busy year—and the most critical. The September weather was exceptionally hot. That meant that the crushed grapes began violently to ferment as soon as they were tipped into the big vats. Too hot a fermentation is dangerous, for under such conditions harmful microbes may flourish at the expense of those that are beneficial. All day long Rachelet was busy as a doctor, watching over the seething, heaving masses in the vats, anxiously taking temperatures. He returned to his cottage late at night, longing for peace and rest.

He found Madeleine tossing and muttering under the blankets, with a high fever. He spent the remainder of the night in a chair by the bedside, and in his broken dozing he confused the fever which was threatening her life with that of the grapes which were in such a hurry to be born as wine.

Next day they took Madeleine to the hospital, and a fortnight later she died. Rachelet was with her at the end. He sat holding her hand while she lay no longer hot and restless but cold and still. He was dazed—he had scarcely slept these last two weeks—and against all reason it came into his mind that the fever which had destroyed her was in some way connected with this year's hot fermentation. Later, when he put the bottles to rest in the cellar, he had been reminded of this thought.

Once more he nosed the glass. The fumes rose into his head. But that was not why tears started to his eyes. Like one listening to a tune of poignantly sad associations, he slowly drank the wine.

Madeleine's death had only confirmed his decision to work on; but it had weakened his physical ability to do so. His young niece Jeanette with her husband, Pierre Simon, had moved into the cottage to look after him. They had done what they could, and he would leave them all he had in recompense. But it had not been the same. In forty-five years of marriage a man forms habits, and a new woman in the house, however willing, causes as much vexation as an unskilled cellar hand. The last seven years had been a terrible struggle. They had broken him.

And yet the feeling of being on the way out—it was the *patron* who had used that expression, the description of a wine which has passed the peak of its second, its adult fermentation and has begun to lose color, *bouquet,* flavor, and strength—this feeling had first come to him two years earlier. It was in 1943.

Rachelet's hand reached along the table. He picked up a bottle and

At Château Lafite a woman wearing time-honored sabots and sunbonnet holds a bundle of *sarments,* the pruned vine shoots that will later be used as fuel

174

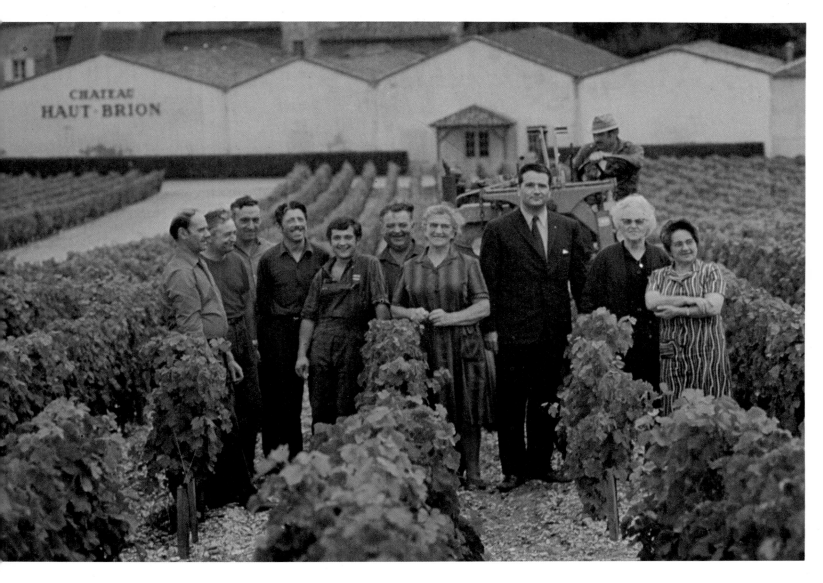

The workers at a wine château are like a large family whose lives are regulated by the seasons and intimately bound up with the growing vines

tested it with his eyes and nose, but it was not the one he wanted. At the next attempt he was successful. He took a mouthful of the wine, and chewed it, thrusting it with tongue and indrawn cheeks into every sensitive crevice. An unusual wine, the '43. Many considered it excellent. That of La Tour-St.-Vincent had matured so rapidly that it had sold better than the other wartime vintages which had preceded it. But to Rachelet there was something false about it. Like a brilliant, charming boy who as a man becomes a nonentity or actively goes to the bad, this wine would not last. He was sure of that.

Why? He shrugged his shoulders. Perhaps the weather had been too mild throughout the previous twelve months and the vines had become soft as people do when their lives are too easy. Or perhaps it depended on some peculiarity in the yeast spores which gathered mysteriously on the skins of the grapes. Or else—was it superstition to imagine that the vines of La Tour-St.-Vincent which he had tended all their lives had been affected by what had happened to him?

All the year, from January to October, Rachelet was happy. Both he and Madeleine were so gay that often in their cottage in the evening they sang the old songs together, as well as they could. For in January they re-

ceived through the underground telegraph system of the Resistance a message from Victor, their son. He had been in England, they knew, and they guessed that he must now be in occupied France. He told them only that he was well, and that he would see them again when France was free. Victor in victory—just that. But it was enough to make proud parents happy.

Never since he was a young man had Rachelet tended the vines with such joyous enthusiasm. There was very little labor to help him—children, women, and old men—but the vineyard was well cared for. There was no disease. His small team, fired by his energy, had harvested the grapes in sixteen days. There was never a cloud in the September sky and the fermentation went perfectly. The new wine calmed and settled and was racked off into hogsheads, full of promise as far as taste and alcoholic content were a guide.

In October, by the same mysterious means, another message arrived. But it was not from Victor. It came from what was described as the Headquarters of the Resistance. It stated: "Victor Rachelet was arrested in February. He was tortured for information but told nothing to the enemy. In September he was executed."

The brave boy had been resisting pain all that fine summer while his parents were laughing. Where had they put the body? Rachelet wondered. Somewhere in France it had fermented and gone back into the soil. Was that all that hopeful youth was born for, to act as manure?

The wine of that cruelly mocking year was still in Rachelet's mouth. He curved back his tongue to spit the stuff violently out. . . . But just in time he realized how wrong and cowardly that would have been. Victor had not put his cup aside. Nor had he, Michel, while Madeleine supported him. He must not do it now just because he was alone.

Slowly he swallowed the mouthful, tasting every drop. He put his glass back on the table, and then—although without thinking why—filled it again, right to the brim, emptying the bottle. There would be dregs in it, of course. But he and Madeleine had drunk their hope to the lees that day and he would do it again, as a festival.

When the glass had been turned upside down over his mouth he felt a new and strong emotion. It puzzled him at first but it was really quite simple. He wanted to lift from his shoulders this weight of sorrow. Was that possible? He had once experienced happiness: otherwise he would not be so capable of feeling sad. . . . Surely the old wine contained something of the spirit in which it had been made. The line of bottles stretched into the shadows toward the place where he had been at the beginning of this strange evening. He got to his feet and, picking up the candle, went a pace or two along the road and dropped down in another seat.

It was fortunate that his hand then closed on the bottle of 1937. If he had picked a lesser vintage, one on the way out, it could have disappointed him out of his new mood. But this wine interested him. It was some time since he had tasted it, but it was evidently in no hurry to mature. It was one of those big, strong, slow growers with which he felt sympathy. He cocked his head and admired the color. He made the rich liquid gyrate and warmed it to bring out the vapors—then breathed them.

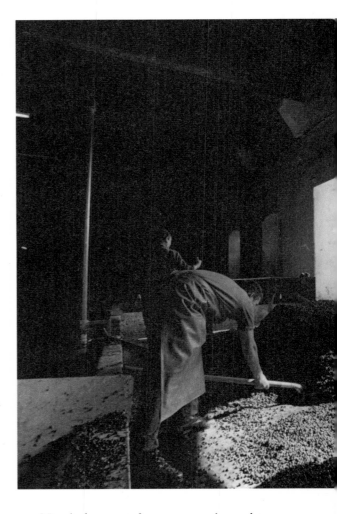

Newly harvested grapes are brought from the fields to the *cuvier* (pressing house), where workers shovel them into the crushers

176

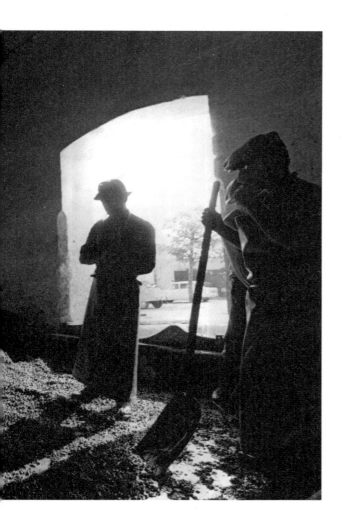

This was what the connoisseur called *bouquet*. It served as a term, but it did not describe what Rachelet's ugly old nose experienced. There were varied odors in wine, certainly, but the result was not like a bunch of flowers, nothing so pretty-pretty. Wine had been born to work for its living. It had struggled as well as enjoyed itself. It had experienced frost and drought and deluge and disease. Its parent plants had been shorn of half their limbs that it might receive more of their blood. It had lived and meant to go on living.

There was the smell of fruit, of course—not only of grapes. There were odors of sweetness, of soft oils and delicate ethers. But there was acid and bitterness as well. Those, and the smell of earth wet or dry, of damp or sun-baked vegetation. There was the tang of young skin heated by hard work. Everything was in the earth, and God created out of it each year a new wine with a new character. Its characteristics were modified as the wine grew older, but they were always recognizable. The *vigneron*, tasting every now and then, could follow its development.

The most important thing was to start it off well in life, in clean vessels so that it was not born infected. If it began life well it needed little besides care and peace. But some wines were like difficult children. This of '37 for instance—unusually soon after it had been transferred into hogshead from the fermenting vat it had needed to be racked—drawn off into another barrel leaving the lees behind. It went on fermenting, casting out impurities. Some of them were so small and light that they would not sink. These had to be netted, dragged to the bottom under a sinking film of white of egg, and the clean wine drawn off. What a lot of wild oats it had had to sow. It was four years before the wine was clear enough for bottling. It had caused a deal of trouble, this wine!

But it was strong! (Rachelet clenched his fist.) He sipped a little of the wine and noticed once more its striking characteristic. It seemed to fill the mouth as some people seem to fill a room. With human beings you called that personality. This wine had been a personality from birth, the difficult boy of the *chai*. Rachelet had not grudged the time and trouble it cost him, because he knew the young wine had in it the possibility of greatness. Already it was proving this. But a few roughnesses remained. It needed further years of contemplation in the cool gloom of the cellar before it would be perfectly balanced.

Rachelet refilled his glass, and sipped it slowly and with enjoyment. It was curious: what the scents and flavors brought to mind was not the work in the *chai*, but a scene in the vineyards. This came to him suddenly and clearly—making him smile for the first time. He saw himself as he had been fifteen years ago, strong and upright, full of the joy of life.

The vintage of 1937 was fine, with a single day of showers. Rachelet's place was in the pressing room, but he liked to walk into the fields on at least one occasion to see how things were going and to encourage the pickers by telling them about the wine. It happened that he chose the day of showers! He reached the distant corner of the vineyards where the harvesting was going on just as the rain came down cats and dogs. The pickers with their half-filled baskets scampered along the narrow lanes between the vines and took shelter under the big umbrellas, pressed tight

together, leaning their heads inward. The girls naturally found themselves being embraced. There was a lot of noise, laughter and mock slapping of faces. It was an unfailing source of merriment when some youth flirted with an old woman. The shouted jokes were coarse but good-humored. Meanwhile the raindrops pattered on the black umbrellas; and the white oxen harnessed to the wagon stood patient and steaming, with their heads lowered and their sad brown eyes looking at nothing in particular. Rachelet could smell the wet leather of their hides. The rain ceased, and the pickers went back to their work, kicking the mud off their boots, trying to hit each other with it.

Rachelet with his wife and son stood watching. The true reason why he had chosen this hour to come out into the fields was that not only would he find Victor in charge but also Madeleine preparing the midday meal. Madeleine's soup was famous: it was said that she put into it everything from the château garden, including the gardener, his daughter, and their cow. As a rule the harvesters returned to the kitchen to eat, but on this occasion lunch had been brought out to them since they were working so far off.

The huge tureen was being heated up over a bonfire which was hissing and spitting from the rain. Madeleine lifted the lid to stir the thick liquor and an odor came out which made the lips wet.

"How long will it be?" Rachelet asked.

"It is ready, greedy one. But your dinner is in the wine house. You men of the *cuvier* are so proud that you eat always alone."

"Not today. I shall eat well today."

Victor called the luncheon hour and the harvesters came elbowing and chattering to receive their bowl of soup and hunk of bread and cheese. Rachelet, with his cavalryman's moustaches and his black, observant eyes, stood watching them. He liked young people and it pleased him that they should so frankly enjoy his wife's soup. But he was impatient for his own share.

"The *patron*—and a visitor," Victor said, looking along the trail which led from the château.

Rachelet could not recognize the distant figures, but he trusted his son's eyes and swore under his breath.

"No soup for you," Madeleine said. "You must take the visitor round."

Little Madeleine, although she had passed her fiftieth birthday, still had a girl's plump figure—in her husband's view at least. Her face glowed. The raindrops on her cheeks looked like tears, but her lips were curving and twitching and her eyes were bright with mischief. Rachelet smacked her hard and affectionately on the behind.

"I shall have my soup, never fear," he said.

The *patron* and the stranger joined them. The *patron* was young. He had only returned permanently to the estate since the old Marquis died the year before, and he was not yet entirely sure of himself.

"This is Mr. Waterford," he said, introducing the stranger, a thin and earnest young man who raised his hat politely. "He is the son of a friend of my father. He is writing a thesis on economics, and he wishes to ask you

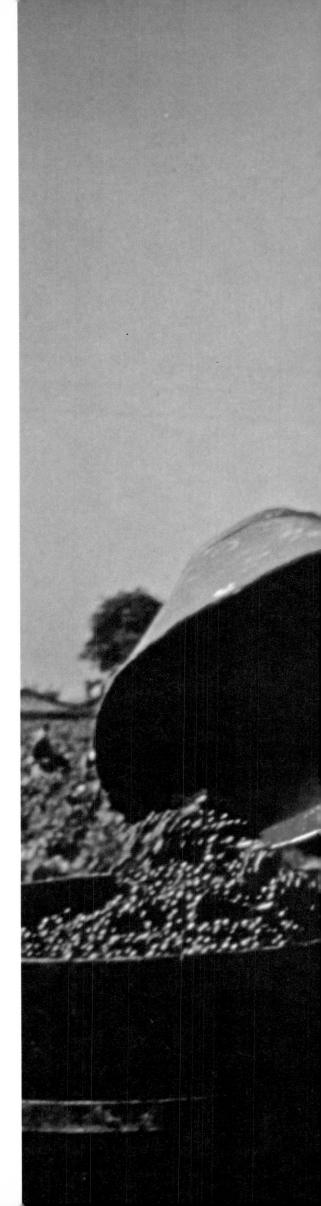

178

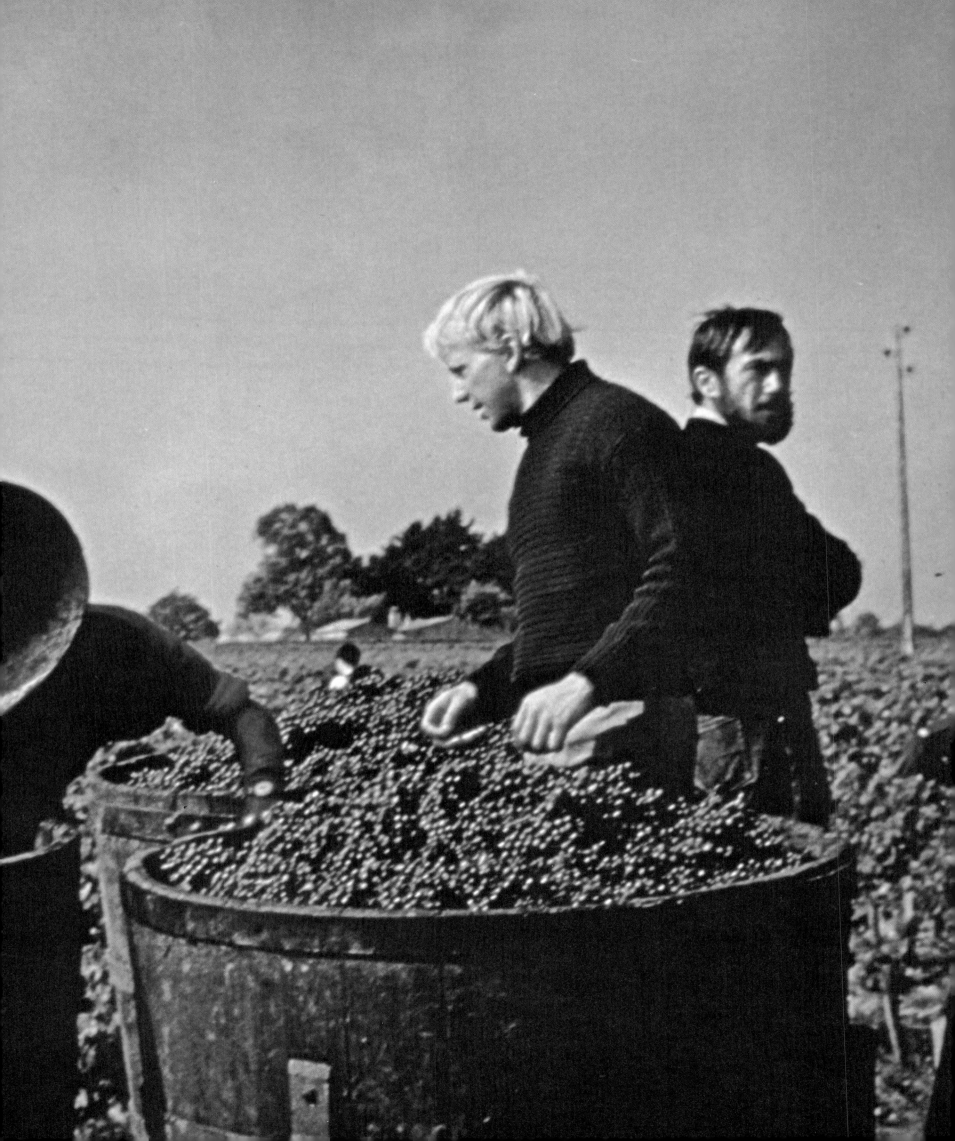

Château de Gruaud Larose

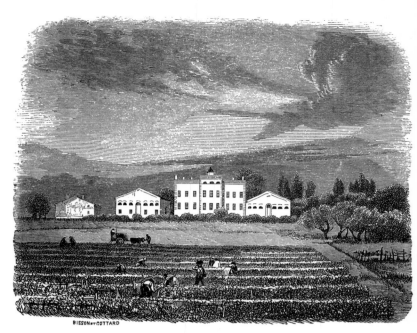

Château de Giscours

certain questions. I expected to find you in the *chai*—"

"It was necessary to come to the vineyards. But I am at the gentleman's disposition," Rachelet answered.

"Then I shall leave you together," the young *patron* said, and excused himself.

"Well, it's like this," Mr. Waterford began diffidently in slow and ill-pronounced French. "I am told that one person in every seven in this country earns his living in the wine industry, so I can't very well ignore it as a part of the economics of the country. But I have never studied wine myself. I do not understand it."

"What is it that Monsieur wishes to understand?" Rachelet asked. Madeleine winked at him while she and her son ostentatiously swallowed their soup, but he ignored them.

"Well, Monsieur Rachelet," Waterford said. "It is like this. Your proprietor was good enough to take me to his *chai*. He gave me half a dozen wines to taste, and he talked about *bouquet* and *velouté* and *finesse* and a lot more that was over my head—"

"Did Monsieur enjoy the wines?"

"They were really wonderful. But the prices varied by fifty percent or more; and, after all, they came from the same grapes and vineyard. Tell me, Monsieur Rachelet, how is it you experts tell that a wine is good?"

"That is very simple, Monsieur. When it tastes good, it is good."

"Tastes—but that's just the mystery. I haven't a palate, you see."

"If Monsieur had no palate he would talk like this." (Rachelet made some guggling noises. Waterford stared—then burst out laughing.) "Would Monsieur like some soup?" Rachelet asked.

"I certainly would. I am due for luncheon at the château in an hour, but this smells too good to miss."

"You have been conscious of the *bouquet*. Do not taste yet, please. Can you tell me what is in the soup?"

Waterford nosed the bowl which Madeleine had handed to him.

"The only thing I can't tell you is what's tasty and isn't there."

"Can Monsieur be more precise?"

"Well, there's onion, and a lot of other vegetables, and a good rich stock, I'd say—and something else."

"Excellent. Now taste, Monsieur. Take a mouthful and chew it well. . . . Now what do you taste?"

180

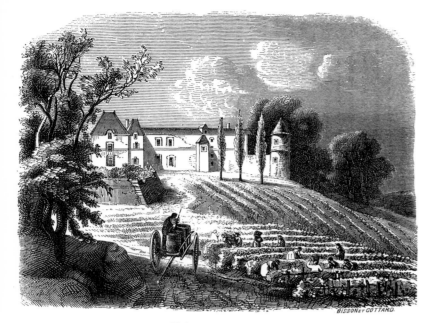

Château d'Yquem

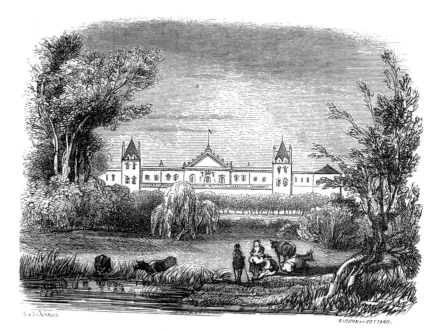

Château de Beychevelle

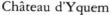

Engravings on this and the following pages from *Les grands Vins de Bordeaux,* Paris, 1849

Waterford swallowed. His eyes were shining behind his spectacles. "I was right about the stock. And the onion too. The other vegetables are too well mixed. But the something else was wine. Now may I eat?"

"Yes indeed, and I will eat with you. You are right to say eat, for good soup like strong wine is to be eaten. Mr. Waterford, you have a palate. Your nose warns you what to expect and your mouth confirms. If the soup had been cooked less you could have tasted all the vegetables, but the result would not have been so satisfactory. If it had been cooked more you would not have distinguished the pleasant tastes you did. It is the same with wine. Wine also draws everything from the earth, but it combines them in the cool and very slowly, not by cooking. And the flavors are far more fine. I am not clever enough to explain more, but you will understand. You like good things. You will soon learn to appreciate wine. The only important thing is to go on studying it affectionately—as one does a woman."

Mr. Waterford was easily persuaded to join the pickers. After two or three rows in the sun which was now blazing from a polished sky he was ready enough to sample the wine from the keg on the ox wagon. A few glasses later he claimed to recognize, with shouts of welcome, all the savors of the earth. After all, he was young and the harvesters encouraged him. He worked until evening, streaming with sweat—and said that he had never enjoyed himself so much.

Rachelet smiled. He had always liked young people, especially when they were modest and polite and had appreciation of the good things which God had given. It pleased him to encourage their appreciation. He himself had enjoyed life so much when this 1937 wine which he was sipping was being harvested—and in the years before. He would not have changed places with an emperor.

After all, he had been something like an emperor, or at least a prime minister, in his *chai*, which was, so to speak, the capital of the estate. What a lot of visitors there had been! But in memory these visits were little more than a procession of almost identical ceremonies not associated with any particular vintage.

The *patron* ushered a party of guests into the coolness of the great pillared building. They paused near the doorway, as if shy to leave the sunlight for the dim and solemn mystery which smelled of wine. Yet they

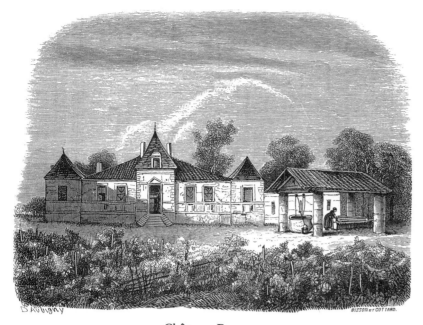

Château Rauzan

Château Pichon de Longueville

were eager—if they were worth anything. Their voices, which had dropped at first, rose in wonder at the size of the place and at the precision of the four rows of barrels of polished oak which stretched away into the shadows. They began to make the round, leaving their tracks on the neatly raked fine gravel of the floor.

At the far end, symmetrically placed beyond the rows of barrels, was a polished walnut table. Just as the visitors reached it, Rachelet would appear with the exact number of glasses suspended bottoms upward between the fingers of his big hands. Without even glancing at the visitors, he placed them on the table and went for his *sonde*.

It was part of the tradition that the *maître de chai* could not only carry so many glasses but also that he knew precisely how many were needed. . . . Rachelet chuckled. That was a little trick which harmed nobody. It was connected with the fact that during the summer the youngest cellar hand was always employed cleaning out empty barrels in the courtyard, shaking a length of chain inside each.

So Rachelet, having placed the glasses on the table, went to a particular barrel. He removed the bung and thrust the *sonde,* a long tube of glass like a pipette, down through the hole. Closing the top of the tube with his thumb he drew out a purple column of wine. Easing up his thumb he dropped an exact measure into each glass. Then he stood back with folded arms to watch while the guests tasted.

He had overheard it said that a visit to the *chai* of Château La Tour-St.-Vincent was like a solemn religious ceremony. That pleased him. It was the right approach to good wine. It made even brokers start tasting in a proper mood. He had often thought what a pity it was that the Church, which knew all about ceremony, no longer owned great vineyards and so could not supply good wine for the Communion. It would have been more polite to the *bon Dieu.* That commercially concocted stuff, and what they told you to believe of it, was . . . Rachelet curled down his lips and shook his head.

There had been plenty of distinguished men among the visitors to the *chai.* One was Marshal Foch. He was in civilian clothes and noticeably older than on the occasion when Rachelet had seen him during the 1914-18 war. But he had recognized him out of the corner of his eye while he was filling the *sonde.* He had muttered with the urgency of a prayer "Little wine, be good. You are about to mix with the blood of a brave man."

182

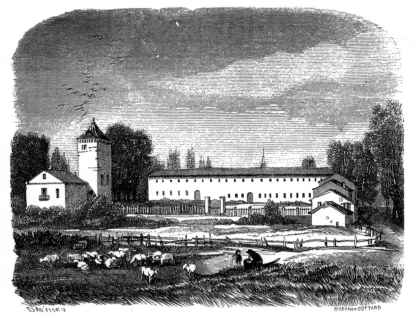

Château de Latour de Cornet

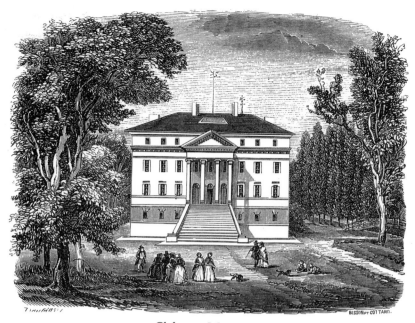

Château Margaux

Afterward the Marshal had shaken him by the hand and thanked him—and had asked him if he were not an old soldier. They had talked for several minutes while the *patron* and his other guests stood round about in silence. . . .

There was a burst of music as a door opened and closed; then singing, a little out of tune, which receded into the night. The first of the revelers were going home. Rachelet hoped the dance would not break up altogether. He was enjoying the sound of it now. . . . He reached for another bottle. He had already remembered so much and he was not yet halfway back along the road.

The next interesting wine he tasted was the 1934. He rubbed his strong hands together and settled down to enjoy the experience. For, as had been mentioned in one of the speeches, the twelve months which preceded the vintage of '34 had been quite remarkably similar to those of this last year. There had been a number of anxious moments this last year, but all had proved well in the end. The grapes were as healthy as one could wish at harvest time, and Rachelet had regretted that he could not live long enough to taste this wine in its maturity. But here it was in its model of eighteen years ago.

Rachelet remembered that year.

Between mild spells there were pricks of sharp cold in the winter, but no late frosts to shrivel the sprouting leaves. The flowering went well. The early summer was cool and rather damp. Then the dry heat came.

Apart from a few isolated cases of apoplexy—vines wilting and dying within a few days, not unexpected in these conditions of sudden change from moisture to dryness—the vineyard continued healthy. Vines with their long roots reaching down into the subsoil can put up with more dry weather than most other plants. But the drought went on too long. Men said to each other that if it would only rain it would rain good wine. The grapes were sound, but they were small. They needed pumping up.

The latter half of July was almost intolerably hot. There was no cloud in the sky and no breath of wind. The air was stale and heavy. About the farm buildings the geese lay on their bellies in the dust, their wings extended and their beaks open, panting. The horses and cattle stood under trees, swishing their tails and growing thinner every day. The vineyard was drying up.

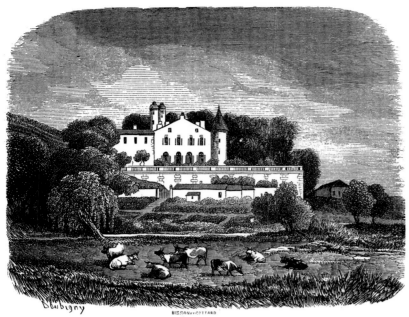

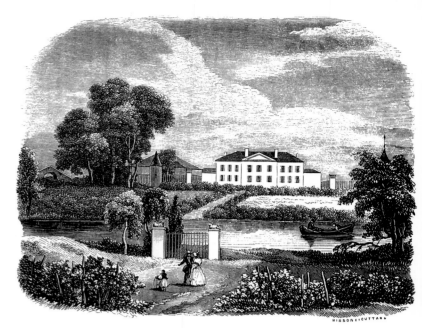

Château Lafite

Château Lagrange

Each morning when he left his cottage Rachelet looked anxiously at the sky. He well knew that the only way such weather could break was in a thunderstorm. And thunder often brought hail. So late in the season, hail would not only destroy the present crop but that of the next year also, for if the shoots were broken off there would be no bearers next spring for the new shoots to sprout from.

On July 20th there came news that several vineyards in Alsace had been battered to pieces by hailstones. (The same thing happened at much the same date in 1952.) Alsace—that was far enough away. But next day Rachelet heard on the radio of thunderstorms with hail in the Loire Valley. They were said to be moving southward. He wondered by what route they would come. It was far from certain that the bad weather would pass over Médoc. But it might.

When darkness fell the sky to the north glowed now and then with lightning. Rachelet estimated that the storm must be over Angoulême. He telephoned to a friend who lived there.

What he was told was not encouraging. Hailstones as large as sparrows' eggs had broken a number of windows before the storm passed on.

"In what direction was it traveling?" Rachelet asked.

"In your direction."

Rachelet hung up the receiver, picturing the vineyard bare as in midwinter except that the ground would be strewn with grapes and leaves. What made it still worse was that the *patron* was away on holiday and he would have to tell him about it when he returned.

There was nothing to be done except wait. The *vignerons* wandered aimlessly about the yard kicking the empty barrels which might not be wanted for two years, or stood in groups speculating pessimistically. Their cigarettes glowed in the darkness. Rachelet walked away and sat down alone under the cedar.

The lightning was growing brighter and the thunder more loud. There was no longer any reasonable chance that the storm would miss them. Rachelet wanted to pray, but he was ashamed to. He had never been much of a one for the forms of religion, and to call upon God only when he was in trouble seemed dishonest. At last he put it like this: "Lord, I am in Your hands. It is Your storm, but I am responsible for this vineyard. I only mention that the sea is very close and hail would do no damage there."

Then he resigned himself to wait. He must have dozed. When next

184

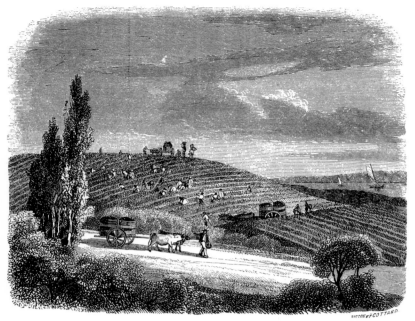

Vendanges du Médoc

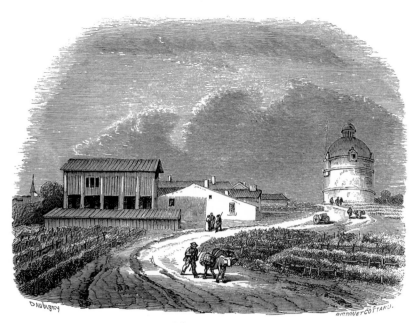

Château Latour

he became fully conscious of his surroundings he realized that there was no lightning. Had God seen the point of his argument? But there were no stars. The night was black, and heavy as sand. When he ran his fingers through his hair it crackled. Was he about to be punished? Had he offended God?

Without any warning there was a deafening explosion and a burning sword stabbed down into the heart of the vineyard. For a moment after that there was complete silence. Then it came down. It was as if the acres of crisp leaves were under heavy machine-gun fire. Scarcely knowing what he was doing, Rachelet ran out from the shelter of the cedar, his arms extended as if to protect his vines.

He stopped in his tracks. His arms dropped slowly to his sides and his head went back. He was soaked to the skin already, but nothing stung his face. It was water that was coming down, not ice—rain to fill the grapes, not hail to destroy them.

For a long time he remained at the edge of the vineyard, racking his brain for the proper words to express pious gratitude. At last he murmured: "Lord, I will drink Your health in the wine which You have saved."

Sitting at the table he now lifted his glassful to the moonlit sky. The wine was much better than it had been when he had first fulfilled his vow. After eighteen years of education in the *chai* it was nearly as good as it would ever be. Was his homage any worthier as a result? Was he himself better? He shrugged his shoulders. He felt better at the moment, but only God could judge. Dimly, half-consciously, he pictured God the Father in the image of the old *patron*, God the Son as something like the young one. He had never been obsequious to the *patron*, either the old or the young, and on certain occasions he had been downright rude. But they respected him as a good servant who worked hard for the vineyard rather than himself. He believed that God would have the same point of view. In any case, he would not be ashamed to face Him, cap in hand, when the time came.

But the time had not yet come, thank God. In fact, it was many years since he had felt so well. How was that? He tasted the wine again and remembered something else about it. While it had been in barrel it had been extremely promising and had sold well. But some years after it had been bottled it had gone off badly. Respected judges had even said that

185

it was finished. Then—no man knew why—it had picked up again and become excellent. Wines did that sometimes—so why not human beings? Had he himself really taken a turn for the better, or was it just that traveling back along the road of vintages made him *feel* better? No matter: when a wine tasted good it was good, so presumably when he felt better he was better. The idea amused him. He got up and moved farther down the table.

But with the candle in one hand and the other hand reaching out for a bottle, he suddenly remembered something and sat down without refilling his glass. The '33 had been fair, but the three previous vintages had been terrible. He recalled this clearly enough without any stimulus of taste, for these were his first vintages as *maître de chai*. He had just taken over after his father's death and he meant to carry on the tradition—but everything went wrong.

Bad weather and disease summed it up. Cold rainy days, very little sun—that wasn't his fault. But when the disease was first noticed he made a mistake. He thought it was oïdium, of which his father had talked almost as often as of the phylloxera, and he treated the vines with sulphur. Very soon he recognized his error. The *tache d'huile* was only on the lower side of the leaves. (If it had been oïdium the mark would have been on both sides.) It was the downy mildew, and it had got a grip. The little grapes turned brown, they shriveled and died. He was afraid the whole vineyard might be lost through the falling of the leaves. Copper sulphate and newly slaked lime was the cure, but in that wet weather a number of sprayings were necessary before it took effect.

As if that were not enough there followed in the next year *coulure*, a complete failure of fertilization, and *millerandage,* the halfway stage when only little seedless berries, round and small as peas, are born. The bad weather at the flowering time was surely part of the cause, but Rachelet wondered gloomily if he had pruned too short or manured wrongly.

He shrugged his shoulders. No use worrying now. Better find something else to think about. He moved a pace or two along the table and filled his glass from a bottle chosen at random.

He knew it immediately as the '29. He put the glass back on the table and stared at it. After a little while he involuntarily reached out his hand and took a mouthful. He kept it there, caressing its smooth fullness with his tongue, wondering at it. It was worth laboring from dawn to dusk a whole active lifetime to have been responsible for such a wine. And he had been chiefly responsible, for his father had died on the eve of the vintage, and of his retirement. The old man had been carried off by the apoplexy, as quickly and it seemed as painlessly as a vine dies of the disease.

Rachelet had loved and respected his father. He felt his loss deeply. The *chai* was a sad place without him. But Michel knew the only way in which he could show respect to the old man. He himself was in his prime, strong and eager to carry on the tradition. And God was good to him that year in other ways. Victor had completed his studies at the University. He had proved himself capable of great things in the outside world. But he

had chosen to return to Château La Tour-St.-Vincent and work under his father. What a year it had been with that fine young fellow at his side, learning as he himself, Michel, had learned from his own father. And for the vines it was a wonderful year, a vintage still remembered by the whole world.

He returned to contemplation of the wine. How deeply satisfactory it was to feel it in one's mouth. . . . Inconsequently his memory went flying off to an entirely different period, to his childhood.

He was about six years old. On some special occasion, with his mother and a few other women and children of the estate, he had been shown over the château by the wife of the old *patron*. She had taken from its case and handed round a beautiful ruby which had belonged to Marie Antoinette. The Marquise talked about it for some time, telling its romantic history. The queen had never had it set, for she could not make up her mind how best to use so wonderful a stone.

At the end the Marquise held out her hand to take the jewel back. . . . It could not be found. Each person protested she had passed it on to another. Consternation! The beautiful Marquise became very pale and at last sent a servant for her husband. They waited for the *patron* in the most acute embarrassment. That one of the estate people should be a thief was unthinkable. And yet—where was the jewel?

The situation was at its worst when Madame Rachelet noticed, as mothers do, something strange about her child's expression. In her agitation she shook him violently—and the ruby fell out of his mouth onto the floor.

At home he took his punishment in silence. He could not give a reason for what he had done. Yet this wine somehow reminded him of the proud and satisfying feeling of holding that precious jewel in his mouth.

Most of the châteaux of Médoc rated the 1929 as their best vintage of the past fifty years. Rachelet considered the wine he had just tasted to be quite as good as that from any other vineyard. But he believed that Château La Tour-St.-Vincent had produced an even better one within the century—the 1900. Certainly it was the best that he himself had ever experienced. His father had said the same even when the wine was young. That made it the greatest wine of a hundred years, and last time he had tasted it, it gave the impression of improving still. Appropriately, 1900 was also the most important year of his own life. It would make a fitting climax to his pilgrimage of tastes and memories.

He would drink it at once: it would be exactly right after the 1929. He got to his feet and, picking up the candle, started the ten or twelve paces to the dark end of the table where he had begun the evening and where the old wine stood.

But he had not taken more than a couple of steps before he sat down again, shaking his head. There was no need to taste the intervening vintages: many were indifferent wines. But they had been good years of living. He would not hurry tonight. He would make the most of this journey on which all real sorrow lay behind and only the cares and happiness of youth in front.

He sat now with his back to the vineyard, looking with wrinkled forehead along the line of remaining bottles, each blurred by the shadow of the one in front. The best third of his life was there. But it was curious, the harder he tried to think of incidents, the less he seemed able to remember.

He became conscious of the music. They were playing a mixture of old tunes, strung together and fitted to a modern dance. Rachelet listened intently. Quite often an air stirred something at the back of his mind. More than once he saw Victor dancing or heard him whistling as he worked. Quite often he himself was swinging his glass at a feast at vintage time. Once he was dancing with Madeleine. But before he could get everything out of the tune it had changed to another. Music went through your head and was lost. You could not hold it in your mouth and chew it until you were sure.

As Rachelet sat listening in the black shadow of the cedar, groping for memories which slipped away like a swiftly flowing river from the eager fingers of the waterweed—as he sat there feeling half happy, half uncertain, the table in front of him became flooded with silver. The moon had found a gap between the fan-shaped branches. Half a dozen bottles were illuminated as by a spotlight. And the beam gradually moved, taking in another bottle every minute.

It became possible to read the labels. When Rachelet had first tried to do this they had been in his own writing, but now they were in the large, ill-educated yet most expressive hand of his father. His father was *maître de chai*, and it had always been his custom with these bottles destined for the *bibliothèque* to write not only the date but also a note as to the bins in which the rest of the vintage was stored.

Memories came quicker now; "1928"—a year almost as good as '29. "1924 Bins 72–81"—Rachelet could see himself in a particular corner of the cellar, stacking the bottles. The crop that year was enormous—the second-largest he had known—but there had been far too much rain and the wine was thin.

But what made Rachelet smile was the manner in which the labels had been written. They showed his father's opinion of the wine. For instance, that of 1928 was written large and decorated with a scroll-like pattern. The details of a poor wine were written small and plain. One could feel that he was angry and ashamed.

What a character his father had been. People called him, Michel, a character, but he got it all from the father whom they had forgotten. He had been a hard master, treating his son more severely than any other of his assistants. He had taught him not only facts but also a principle. The good of the wine came first, human beings and their feelings second. Michel smiled, remembering the occasion when one of the *patron*'s nephews, a young *beau* from Paris, had arrived to show some friends round the *chai*. Rachelet *père* had barred his way, telling him to go first and wash his hair, which was dressed with some highly scented lotion.

There must be nothing in the *chai* which might even temporarily mar the wine or distract those whose duty was to watch over it by tasting. Women were excluded, even the Marquise, whom the *maître de chai*

188

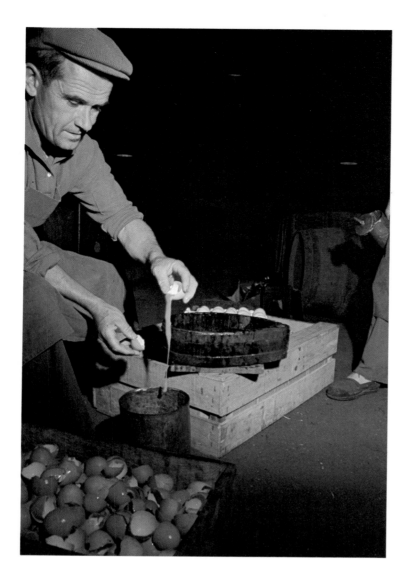

Fining is an operation for clarifying and stabilizing wine that has been practiced since Roman times. When a substance such as egg white is added to the wine in barrel, the insoluble particles coagulate and settle to the bottom, leaving the wine crystal-clear. Gelatin, isinglass, chemicals, and even fresh blood are sometimes used for fining

adored. (She knew his rule and never challenged it, saying that she took it as a compliment.) The only woman who had ever succeeded in entering the sacred gloom was Madeleine. She had once visited her husband in the *chai*—of all reasons to collect the yolks of the eggs, the whites of which had been used for fining. She came disguised in her son's clothes and carrying a sack of corks on her shoulder. Madeleine was always up to some mischief. Everybody loved her—not least her father-in-law.

How happy they were—the aristocracy of the estate. They knew how to live—to enjoy themselves and also to work. . . . The moonlight, moving obliquely across the table, just touched a bottle marked 1919. (If they had been afraid of work it might never have been filled.) One July night that year Rachelet was strolling with his wife along a vineyard path when he saw a number of moths fly overhead. He told his father, and next morning they investigated. On the leaves of one of the first vines they looked at were patches of eggs. It might have been the *altise,* but on consideration they decided it was the rare *pyrale.*

The old *patron* joined them, and turned anxiously to his *maître de chai.* Although the *pyrale* is almost unknown in Médoc, he knew it well enough by reputation. Once the eggs hatched out the caterpillars were difficult to deal with, for if alarmed they went into the ground. And how they ate! With his own eyes, he said, he had seen a vineyard of the Midi in summer which had no leaves at all.

"That is not all," Rachelet *père* burst out, as pessimistically excited as his *patron.* "The grubs turn to moths and the moths lay again. In the

autumn the young grubs go under the bark. They come out in the spring and spin their webs over the buds and eat their hearts out."

"What are we to do?" the *patron* shouted. "In Burgundy they scald the vines."

"In Burgundy they have vineyards like cottage gardens. Besides, that is in winter," Rachelet *père* shouted back. To all appearances he and the *patron* were engaged in a furious quarrel.

"Then chemicals—lead arsenate—"

"And where, *patron*, can one get lead arsenate nowadays? There is nothing to be bought this year, nothing at all."

The *patron*'s anger left him. "That is true," he said. "One can get nothing at all." And then, half to himself, he added as if it were a tragic additional point: "In Germany they call this thing the *Springwurmwickler*."

Young Rachelet burst out laughing. He had been listening, silent and worried, but the absurdly long word was too much for him.

Both men turned on him as on a common enemy.

"He discovered it, strolling in the moonlight! It is up to him to find a cure," his father said.

Rachelet was sobered immediately. He tried to think under the angry glances.

"If we could remove the eggs—" he began.

His hearers raised their eyes to heaven.

"I own, I believe, three-quarters of a million vines," the *patron* said at last. "How many leaves have they? I do not say that there are eggs on every leaf, but every leaf must be examined for eggs. And we have at most forty workmen. Is it mathematically possible for them to do what you suggest?"

Rachelet began to feel obstinate. "There are about two hundred persons available, counting women and children old enough to walk," he answered. "And we have ten days before the eggs hatch. I am not clever at mathematics, but if you give me the authority the work shall be done."

The work was done. The women left their homes and the children stayed away from school—and every infected leaf was picked and burned. A fortnight later this tremendous task was done again, just to ensure that there had been no second laying.

The crop was saved.

While Rachelet had been thinking of this incident the pool of moonlight had slipped off the side of the table, leaving the bottles once more unilluminated except by the small flame of the candle.

With the half-conscious intention of maintaining the sequence of his memories, he stretched out his hand and filled his glass.

There was something familiar in the sharp smell. He continued to breathe it, fascinated against his will, for it stung like vinegar.

At that moment there was a burst of noise. The remaining dancers were pouring out into the night behind the musicians, singing a marching song.

Rachelet brought the glass down onto the table so violently that it broke, cutting his hand. The tune was *La Madelon* and the wine the first he had drunk when he returned on leave to La Tour-St.-Vincent at Christmas, 1918.

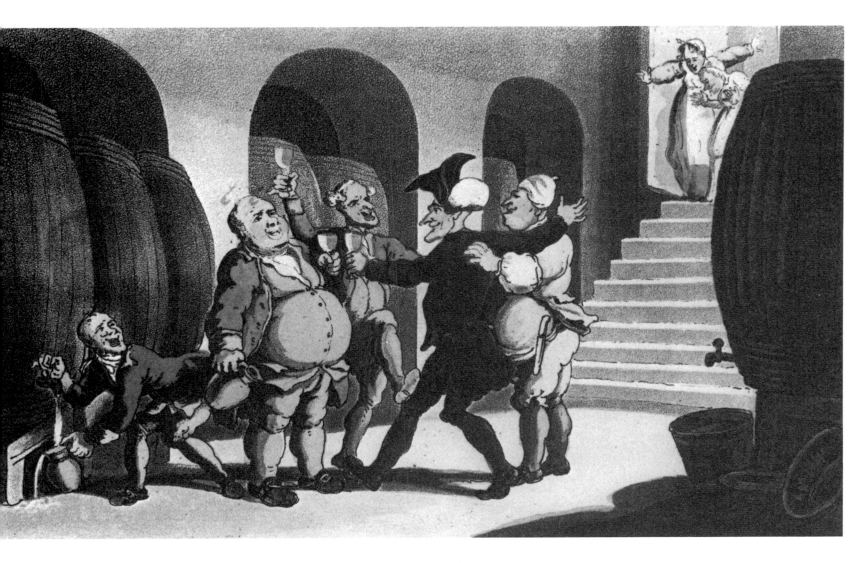

Dr. Syntax Made Free of the Cellar,
hand-colored aquatint by Thomas
Rowlandson

He had loathed the war. It was not from fear: he had taken the necessary risks philosophically. It was not from the hardship: although he had the *vigneron*'s standards of comfort—two good meals with wine and a dry bed at night—he had accepted the misery of the trenches. It was not only from missing his wife, his friends, and his vineyard. What he had most loathed about the war and what had continually horrified him was the waste.

He saw land devastated, which was bad enough. On the Marne front it was Champagne country—a district he had pretended to despise—but to see vine fences used for barbed wire, vineyards plowed up with trenches and shell holes. . . . Worse still were the bodies. They were harvested by the machine-guns and they lay swelling and fermenting into bad smells. . . . He was given a medal for bringing in wounded under fire. He was told that he was brave. But he had only done what he considered to be his duty. He had prevented a few young lives being picked before their time.

Rachelet bound up his cut hand with his handkerchief, holding one end of the knot with his teeth. Then, moving slowly but unhesitatingly, he took the candle to the end of the table. He would taste the 1900 at once. He would be missing no memories, for the years which followed belonged to it.

The bottles here were disordered, no doubt because the guests had clustered about Rachelet to say good night. He picked up another glass and began searching for the wine he longed for. He could not have said

191

how he would recognize it any more than he could have described how he would recognize a voice. But he never doubted that he would.

He tried three or four bottles which were almost as dead as water under his nose. There had been bad vintages in the intervening years, as if the ground had been exhausted by what it gave in 1900.

Sitting in the same chair where he had begun the evening, he filled his glass once more.

With the involuntary gasp of happiness with which one recognizes an old love, he became conscious that he had found what he had been searching for. His scholar nose pressed eagerly into the glass. . . . There was no doubt about it. The *bouquet* was faint but unmistakable. He felt his heart beating against his ribs.

He sat with the glass in his cupped hands, looking out over the vineyards and breathing this magic old wine. . . . Little by little the scene in front of him appeared to change. The setting moon became the rising sun which lit the dew-damp leaves but filled the corridors with shadow, so that the whole vineyard was streaked alternately with silvery green and dark purple. The larks were climbing their invisible spiral staircases, singing as they went. The grasshoppers were warming up. It was as clear as that in every detail, yet somehow everything was small, as if it were a long way off.

He saw nearly a hundred people come out from the village of estate buildings and walk in scattered groups toward the southern end of the vineyard. Most of them were young. The girls wore coal-scuttle bonnets, full skirts, and blouses with sleeves which bunched over their shoulders but left their forearms bare. Their clothes were full of color. They carried wicker baskets and chattered gaily as they went along. The men wore berets, and bright handkerchiefs round their necks. Behind the last of them came a wagon drawn by two white oxen whose flanks and long-horned heads swung rhythmically with each slow stride.

When everybody had reached the chosen part of the vineyard a man began shouting, pulling and pushing at the cheerful throng until he had got each person facing a corridor between the vines. Then they began to pick.

Eight or nine men were left over. These were the foreman, the driver of the wagon, and the six strong fellows who wore the *hottes*. Rachelet himself was one of this half-dozen. He was straight and tall, with twirled mustaches, and he carried the big wooden container as a soldier carries his pack on parade.

He walked round to the other end of the plot and stood there waiting for the pickers to reach him with their full baskets. They advanced slowly, stooping almost to the ground, snip-snipping off the bunches which grew low down on the vines, now and then straightening up to ease their backs and talk and eat a grape or two. They were in no great hurry, for they had in front of them a fortnight or more of tiring work which would become monotonous if they did not make something of a game and gossip of it.

The straggling, chattering line came toward Rachelet. He knew most of the pickers: they were the families of the estate men. But about a third

were strangers from Bordeaux and elsewhere. For the most part these had come in groups which kept together. He looked at them critically, wondering how useful they would prove. A party of willful or lazy students could cause trouble, and it might not be easy to discipline them without damage to the gay spirit of the vintage.

The first of the pickers reached him—Marie Canet. It was natural that she should be first, for being the daughter of the schoolmaster she felt herself superior and therefore talked little to her companions. The second, third, and fourth arrived almost together, with loud asides about the handsome *porteur*. Rachelet turned his back on them and they emptied their baskets into his *hotte*. He walked first in one direction and then in the other, receiving two or three kilos of grapes from each person—generally with a joke or a tap on the head with the empty basket. Only one picker had not reached the end, a girl. Rachelet waited for her impatiently, for the load on his back was heavy by now and he wanted to go and empty it into one of the *douils* on the ox wagon.

The girl was small—it seemed not much taller than the vines—which should have made it easier for her to pick the low bunches. She was evidently taking pains not to miss any grapes hidden by leaves. But she must be clumsy. In any case she was delaying the team.

"You are very slow," he said.

"I do my best," she answered.

On the tip of Rachelet's tongue was a sharp remark about the trouble caused by amateurs who did not appreciate the importance of a vintage at Château La Tour-St.-Vincent, and who got themselves taken on by overstating their qualifications. But the girl's tone made him hesitate. Her answer had been neither defiant nor humble: a quiet statement of fact. Her face was hidden by the rim of her bonnet.

"From where do you come?" he asked.

"From Bordeaux."

"This is your first vintage?"

"Yes. We must all start sometime. Soon I shall be as quick as anybody."

"Exactly"—Rachelet remembered why he had first spoken to her—"it is important not to dislocate the schedule. See, they are already starting on another row."

"In that case would it not be better to take my grapes without delay?"

Rachelet turned his back on her.

"You will have to stoop down," she said.

They were walking after the pickers when he noticed that the little handkerchief she held in her left hand was stained bright red.

"You have hurt yourself," he said.

"It is nothing."

"Let me see."

One of her fingers had a deep wound which was bleeding freely.

"How did this happen?" he asked.

"It was so stupid. I was holding a bunch. It was under the leaves. I cut—but it was not the bunch I cut. That is why I have been slow."

(Overleaf)
The Vintage of Médoc: Cuvier, or Pressing House, at Château d'Estournel, Illustrated London News, October 14, 1871

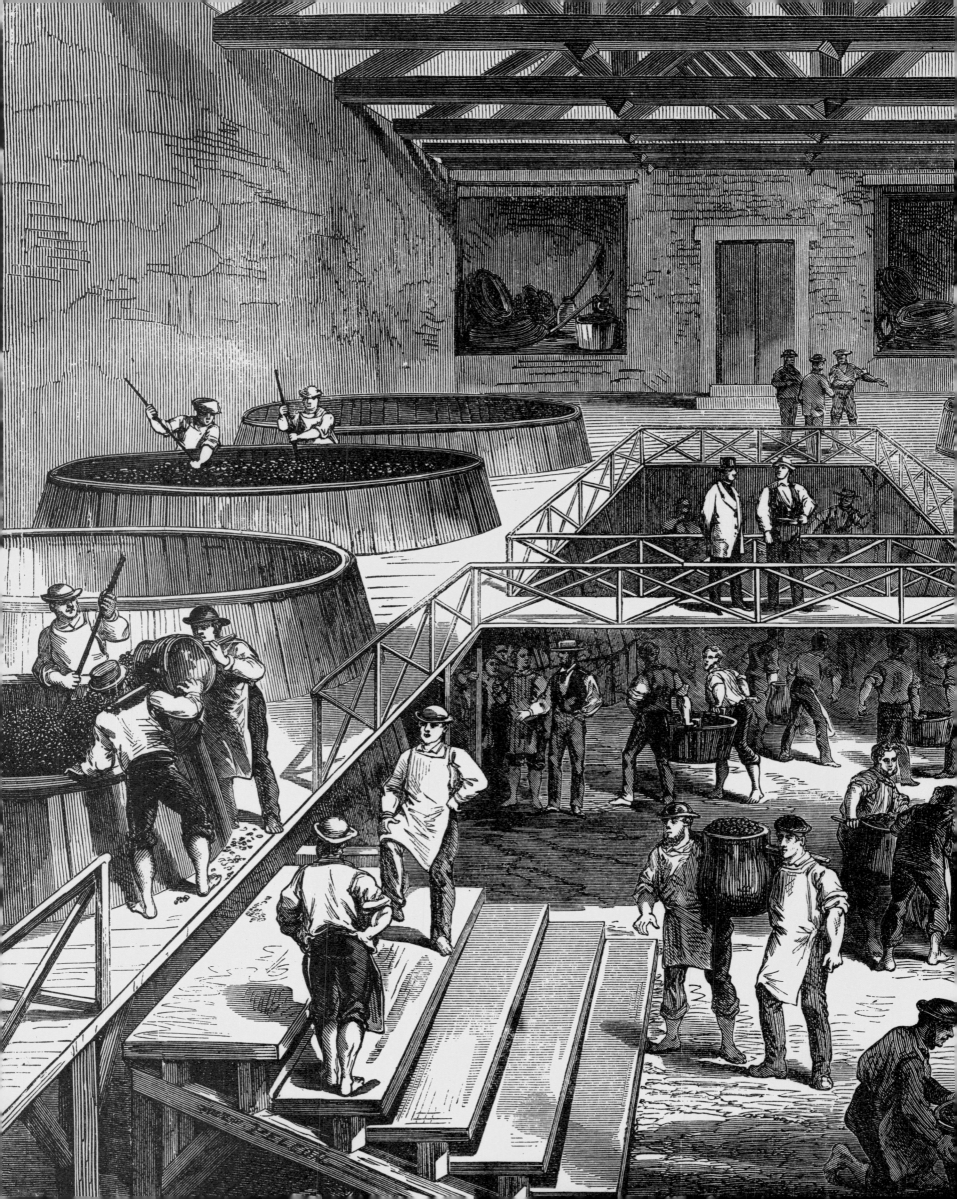

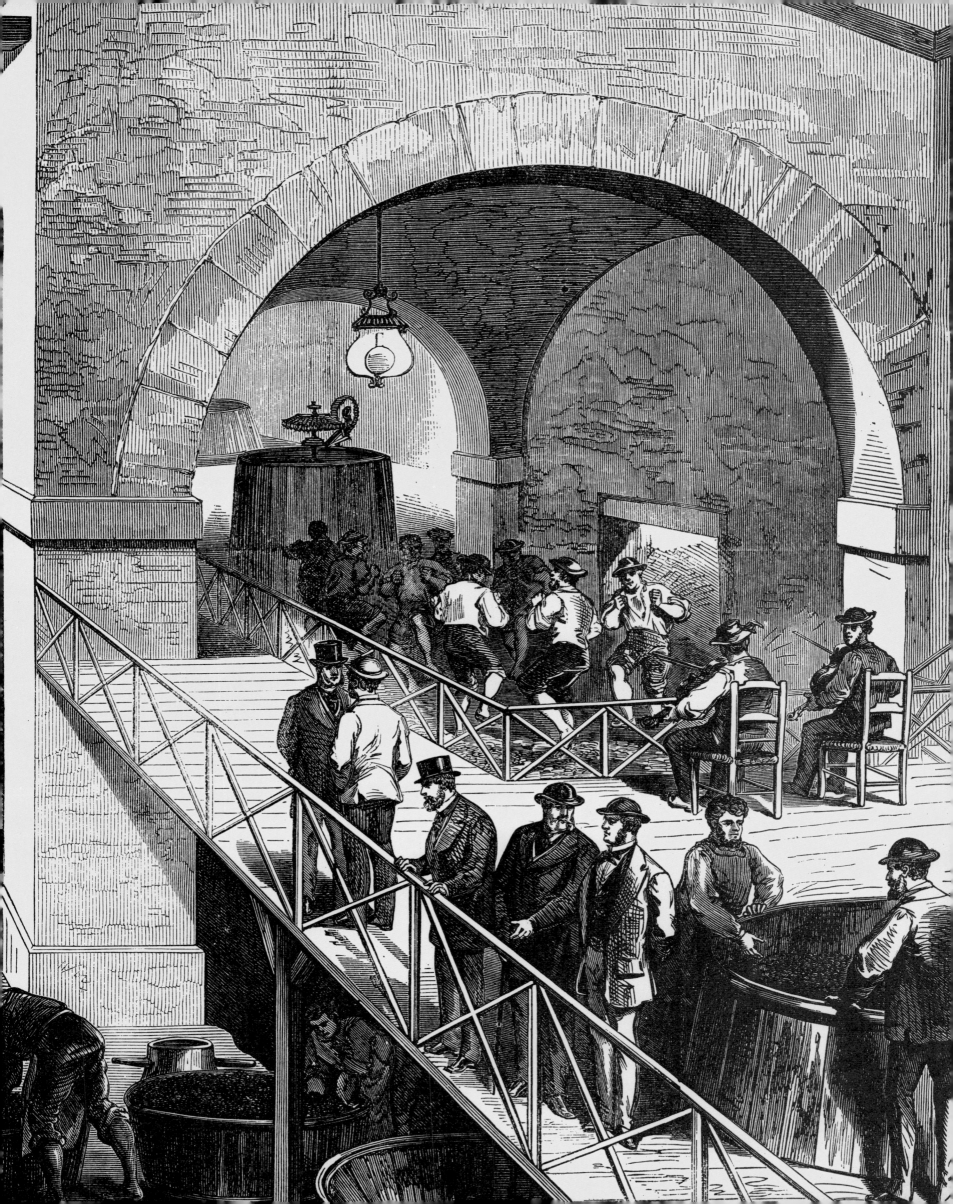

"But you did not call out? You said nothing?"

"It was so stupid."

Rachelet, who was on his knees before her, tearing his own not very clean handkerchief into strips, looked up into her face. It might have belonged to a pretty and mischievous little boy, but it was evidently very near to tears. She was biting her lip, fighting against them; but they were there, making her blue eyes glisten. Instinctively he knew that this was less from the pain than from his sympathy. He was glad—but for the sake of her pride she must not cry! He felt his heart swell. He jumped to his feet.

"It needs proper attention. Come with me, please," he said, in a businesslike voice. And as they walked together, so different in height, he went on talking to her bonnet.

"It is not serious, but it must be disinfected. I have been a soldier and you can believe I know about wounds. . . . Yes, yes, it is just two years since I finished my military service and returned to the château. I was a cavalryman. Do you love horses? We were in Algeria, and I saw some fighting, I can tell you!"

When they reached the wagon he washed her cut finger under the tap of the wine keg, then bound it up.

"Now you will rest a little," he said.

"No, I must not dislocate the schedule."

They had returned halfway toward the pickers when she asked: "Why did you not empty that thing on your back?"

Rachelet stopped and stared down into her upturned face. For the last quarter of an hour he had been bustling about with a *hotte* containing seventy pounds' weight of grapes on his shoulders—and he had not even noticed it. He burst out laughing. The girl laughed too, with the bubbling, overflowing laugh of a child.

And then they both became silent and embarrassed.

During the next few days the girl proved that she was not, as Rachelet had thought, a helpless little thing who could not be trusted even with a pair of pruning scissors. She became a quick and efficient worker. She was popular with the other pickers for her good nature and puckish humor. But she was always a little reserved—and therefore mysterious. Rachelet saw as much of her as he could. He did not mind if it caused gossip; nor, it seemed, did she. He walked with her to and from the picking plots, and they had long talks in the warm, soft evening when the work was done. Rachelet's mother, who besides running the kitchen was in general charge of the women pickers, quickly noticed what was in the air. But she could find no fault with the girl. In fact she took Madeleine—that was her name—under her special care, and learned her simple story before her son did—which perhaps prejudiced her in the girl's favor. Madeleine was the daughter of the mate of a trading vessel. They had their own house in Bordeaux and were evidently respectable. But he had been away three months on a voyage and money was running short, so she had taken this job.

After the first few days of the vintage the tempo of work considerably increased. It was evident that this would be a bumper harvest, perhaps

196

the biggest in living memory. The weather was perfect, but it could not be expected to remain so forever, and rain would wash the yeast spores from the skins of the grapes. Therefore both the picking and pressing must be speeded up. More pickers were drafted in, while the four best men were taken from the fields and added to the skilled team in the *cuvier*.

Rachelet was one of the chosen four. It was remarkable promotion for a young man who only a couple of years previously had returned to the château from his conscript service. . . . But he was sorry to leave the fields just then.

He had little time, though, for thinking about Madeleine. One after another, at short intervals, the wagons came creaking into the yard and were backed against the entrance to the *cuvier*. Each wagon carried two *douils,* huge tubs piled high with several hundredweight of grapes. These tubs had to be unloaded, emptied, and put back on the wagons without delay so that the oxen could return to the vineyards. The grapes had to be got off their stalks, pressed, and deposited in the vats before the next relay brought in another load. Under Rachelet *père* there were no newfangled apparatus at the Château La Tour-St.-Vincent. The *douils* were unloaded and reloaded by sheer strength. The grapes were handled and trodden and their juice transported in traditional style. The bunches were pitchforked onto the *table d'égrappage,* a table like a huge checkerboard in which the black squares were a latticing of hard wood and the white squares were holes. Six men, three on each side, moving with a rhythm like rowing, massaged the bunches on this sieve-table to make the grapes fall through the holes, leaving their stalks behind. The pitchforker continued to load the table and the massagers to stroke and press the bunches until the whole load was separated, stalks and grapes. Then the table was removed and the grapes were crushed underfoot, the half-naked men marching with high steps round and round, clasping each other's waists. Then the juice, the skins, the crushed flesh and the uncrushed pips (what together is called the must) were spooned with wooden shovels into *hottes* and carried up a twelve-foot ladder to be tipped over the head, with a sudden bowing action, into one of the five-thousand-liter vats where the juice of yesterday was already seething in the full frenzy of fermentation.

Two teams of seven men each were engaged in this work. They raced against each other for the fun of it and in the hope that they might win an interval to wash and rest. But at best they only had time to run to the pump and splash their faces before they heard the creak and rumble as the next wagon came into the yard.

They were all big fellows in the *cuvier*. The muscles rippled under their skin. But they looked like savages in war paint, their limbs spattered with the juice, their eyes red and their hair purple. They worked from dawn till dark. No one complained. Rachelet had never known a man to complain of hard work at vintage time. It was as if the bursting energy of the yeast cells got into their blood. And on this occasion they had a particular incentive, for it was evident that the vintage was going to be something quite out of the ordinary—not only in amount. From the first evening when the *maître de chai*, saccharometer in hand, had nodded approvingly over a sample of the juice, he had gone about like one who

guards a tremendous secret. His team, pausing for a moment in their work, studied his face after his daily sampling of the forming wine. He had always been quick to criticize a post-phylloxera vintage, but he said nothing against this. Instead he chuckled to himself and rubbed his hands. And at the end of the first week he made a solemn announcement.

"Listen well. In the future, all over the world, men who have drunk this wine that you are making will boast about it to their grandchildren."

Word of this soon reached the pickers, and they caught the fever. Every day there was a new record of loads sent in to the *cuvier*. Excitement hung over the vineyards like the dancing haze and the shrill whistle of the grasshoppers. The symphony of the vintage rose in continuous crescendo.

Then came the final day.

The field workers gathered beside the last few acres of unharvested vines before the sun had risen. As soon as they could see they began to pick. The grapes were so fat and tightly clustered that the first wagon was soon loaded. Rachelet and his fellows stood watching at the entrance of the yard—for the pickers were working only a hundred paces from the château—until they saw the oxen come to life and start slowly toward them along the dusty track. Then the men of the *cuvier* took off their shirts, rolled up their trousers and put on sacking aprons. The calmest and most provident of them swallowed another mouthful or two of the bread and cheese and onion and wine which formed their breakfast. But most of them were too high-strung to eat. This was the climax. They would complete the harvest before they slept even if they had to work by torchlight, for although the weather was still fine it was said that rain was on the way.

From ten o'clock it began to be oppressively hot, but this slowed no one. Their streaming faces were drawn and there was little talk. But when they caught each other's eyes they smiled, sharing the secret that kept them going.

They had never worked so quickly in the *cuvier*, and yet it was all they could do to keep up with the pickers who were sending loaded wagons in at shorter and shorter intervals. It went on and on until they were dizzy with the strain of it.

They finished a pressing and turned to unload the next wagon. It was not there. They waited a minute or two and then went out to the entrance of the yard to see what had gone wrong.

Most of the pickers were sitting on the ground. The porters had put down their empty *hottes* and were staring at them. The driver was in his seat on the loaded wagon, but seemed to have lost the use of hands and voice. There was nothing more for the harvesters to do. The impression one got was of a complicated piece of machinery which has run down and stopped.

Then the *maître de chai* shouted out in his loud, cracked voice: "It is good wine. Bring in the final load!"

That set everything into violent action. But it was action of a new sort. The harvesters went racing here and there, gathering wild flowers—

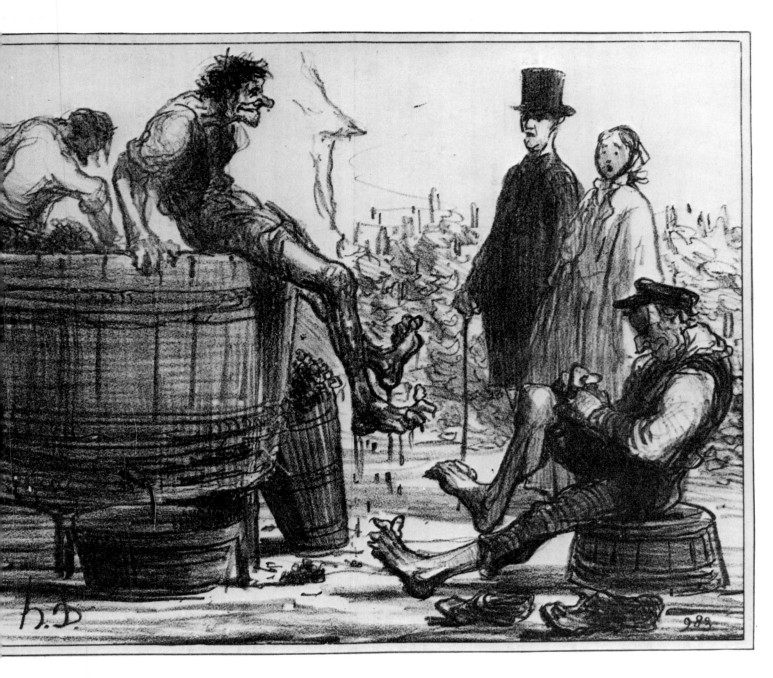

Impressions of the Grape Harvest
"What! You go in there with bare feet!" "Well, should I put on polished shoes?"
Lithograph by Honoré Daumier

thyme, sage, mallow, marjoram, yarrow, and verbena. Within a few minutes the *douils* were decorated and the oxen had garlands slung between their horns. Then the wagon was driven in.

The pickers danced on either side of it and crowded round it in the courtyard, singing and shouting. But the two white oxen, having backed the load against the entrance to the *cuvier*, stood still and mute with lowered heads and sad, reproachful eyes. One of them reached up with its tongue and managed to get a flower into its mouth.

There was a burst of laughter, but Rachelet, as often before, felt sorry for the beast. It had worked as hard as anybody and deserved some recompense instead of being made a fool of. Yet he hesitated what to do.

Madeleine stepped out of the throng, small, sun-browned and self-contained. Rachelet's heart bounded, for he had not seen her during these last hectic days. She went up to the ox, and taking off its garland fed it with the flowers one by one. It ate them with an expression that suggested that they were better than nothing, although not as good as grass. Rachelet could have hugged the girl. But he could not even speak to her then, for

199

his father was calling him into the *cuvier* to press out the last of the wine.

That night there was a feast. Following tradition, a long table was set up under the cedar tree. Rachelet could see the young people round him now, their tired faces flushed with excitement, pledging each other in young wine. He was conscious of the chatter and the laughter—then the silence as the old *patron* (a young man then) and the beautiful Marquise came out with their little son between them to thank their people and tell them that they had done well. He ordered up some bottles of the 1858, the great vintage of the childhood of Rachelet *père*, and they pledged the new wine in the old.

Afterward there was dancing in one of the buildings. It was wild. They had reached that stage of tiredness from achievement when the excited mind can keep its body dancing like a marionette as long as it does not loose the strings. Now and then, in an interval, a dancer would flop down and sit there smiling foolishly. He had let go of the strings and could not pick his tired limbs up again.

Rachelet felt superior to all the rest. He wanted to impress Madeleine with his strength. He swung her right off her feet, the mad music in his blood. She was his marionette. . . . No, she was not. When he put her down again she stood squarely, her hand on her side, and laughed up into his face. She was happy and friendly, but he was not impressing her at all. He felt suddenly awkward. He asked almost timidly if she would like some fresh air.

They went out of doors together. They walked a few paces and then stopped.

There was no moon, but there were more stars than there had ever been before. Every square meter of the dark blue velvet heaven was dancing with them. And how they danced! The vineyard which had been harvested, the poplars, the river, the low hills beyond—everything on earth lay watching in the soft warm air, trembling with wonder. And one felt rather than heard the high-pitched insect throbbing, something like the trembling note which a fine glass makes when its rim is stroked.

"Come and find a grasshopper," Rachelet said.

Remembering this so clearly, almost as if it were happening as it had happened fifty paces away and nearly fifty years ago, Rachelet smiled and shook his head. What does one want with grasshoppers when one's blood is seething like the forming wine? What he wanted, desperately, were words to express his feelings.

They wandered silently along the narrow paths. He must speak to her tonight or she would be gone in the morning. But he must put it in the right way to touch her heart. She was mysterious. He did not know her feelings, and he was afraid of her quick laugh. . . . The phrases he wanted were so slow to come!

He decided to take her to the ruined tower, a relic of the ancient days when the English owned this part of France. It was a most romantic place. They walked there slowly, and all the time he was rehearsing his declaration.

They climbed the grass knoll. She sat down on a piece of masonry. He dropped on his knees and took her hand. (He felt less awkwardly tall

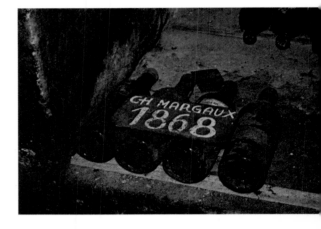

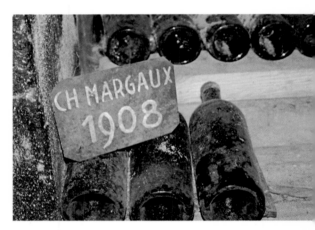

The noble wines of Bordeaux have what André Simon has called "the gift of age." These treasures, laid down in their cool cellar years ago, will probably still be great wines when they are awakened from their long slumber

when kneeling.) Immediately, before his courage failed him, he began to speak. But he had got no further than the first cautious sentences when he saw that her attention was suddenly switched elsewhere. Deeply hurt, he asked her what the matter was.

"Are cattle allowed to eat the vines after the grapes have been picked?" she asked.

"What? Cattle? Where?" He jumped to his feet, looking where she pointed.

Breaking the even pattern of the vineyard were the big black silhouettes of cows.

"*Nom d'un pipe!*" he shouted, and worse words too. "It is those damned pickers. They have gone spooning and left the gate open. Come!" He jerked her to her feet.

It was not easy to drive the cattle off without making them panic in the dark and break more vines. But it was done at last and the gate closed.

"I interrupted you," she said. "You were saying something."

"About those damned pickers?"

"About one of them," she answered. Her eyes were bright as stars.

"Oh, yes," he said—and took her in his arms. He could not start thinking up those phrases all over again.

What it came to, Rachelet decided, was that this wine of 1900 which he was still holding under his nose was the wine of his adult life. At the age of twenty-three he had been concerned both with the harvesting and the pressing of its grapes. While it was making he had first taken Madeleine into his arms, and they had drunk a glass of it for luck at their marriage in the spring. It had played its part on every important occasion— the baptism of Victor, who was born five years later, his first communion, and his coming of age, and on every one of their wedding anniversaries. Each time the wine had tasted fuller and better balanced, as Rachelet had felt himself more mature.

He could have drunk this most famous vintage of Château La Tour-St.-Vincent still more often, for the old *patron* gave him the freedom of it as a wedding present. But it had seemed to belong to special occasions, not to ordinary days. He had not had the heart to drink it after Madeleine died.

But he would drink it tonight. Everything was different tonight. Although Madeleine and Victor were not actually with him—although he was by himself—he was not the least bit lonely. And he had never felt better in his life. He smiled, nodding his head energetically.

He drank the wine he had been holding under his nose. By habit he drank it as a taster does, stroking it with his tongue and sucking it down in a thin stream. But even before he had completed this automatic action his expression changed. The peaceful, confident look—almost the smile of a young man thinking of yesterday—became in a moment the lined mask of disillusioned age.

It was not that the wine was bad. It had not turned to vinegar like that hard wartime vintage. It had been noble, and one could still distinguish the qualities of its greatness. But they had become so faint! Most

noticeable of all, the wine had grown weak. It no longer filled the mouth: it slipped almost unnoticed down the throat. It was on the way out—a great wine, but finished.

When had it started to decline? Rachelet tried to remember when he had last tasted it. . . . It was on the evening of the young *patron*'s return from the war—the second war—when he had been praised for his work and offered the house and vineyard in Anjou, but had preferred to work on another seven years. Those years had been a terrible strain. They had broken him. . . . Was he talking of the wine or of himself? It made no difference.

The wine had finished its work in life. Whenever great wines were drunk, people would be reminded of it and would talk of it, praising it perhaps even more than it deserved. But such bottles as remained would be left untouched in their bin in the museum, fading gradually into water and mud. It was the same with him. He had allowed himself to dream he was back in the days when he planned and worked with keen hope for the future. He had been wakened with a shock to find he had achieved what he had planned. He had married and begotten a fine son, he had improved the vineyard, increased the fame of Château La Tour-St.-Vincent and himself become a legend in the process. He would be talked of for a while as more remarkable than he had been. But they had put him away in his bin tonight and few people would even know when he actually died.

And what about the future of the vineyard? If he could have handed it over to Victor he would have been content. Instead Pierre Simon was *maître de chai*. He was a clever fellow, but . . . Rachelet remembered how, dozing in his chair in the evenings, he had heard so many conversations about money between Pierre and Jeanette. It was not the pay packets of the *vignerons* which made the vines bear good grapes. It was that top dressing of human sweat. Would anybody give that any more? Did young people nowadays love the vines for themselves as he and his father had done?

As Rachelet stared gloomily at the vineyard he saw something moving. A small figure emerged from among the vines and came slowly and doubtfully toward the table, drawn by the candle flame.

It was a little boy about seven years old. He was bare-footed and bare-legged, dressed only in an old shirt which was too large for him—probably the thing he slept in. With his two small hands he held against his chest an enormous bunch of grapes, and one cheek was bulging with a mouthful. He stared wonderingly at the old man, but did not seem to be afraid of him.

Rachelet believed he knew the boy by sight. He must be one of the many children of the estate. In any case he understood why he was there. How often had he himself, at that age and in this season, crept out of bed and through the window and down to the vineyard! He had liked to carry back a bunch and get into bed with it, to lie in the darkness putting one grape after another into his mouth and playing with it with his tongue until it burst against his palate. It had not been greed: he had loved grapes as his sister loved her dolls. . . . Once his father had caught him on one of these midnight excursions—but had not punished him. He had taken him

up in his arms and carried him home with gentle words. It had puzzled
him at the time. Now he saw a reason.

A strange emotion flooded through Rachelet, making him tremble
and filling his eyes with tears. But it was not sadness. It was something
else.

He refilled his glass and raised it to the fascinated child.

"We who are on the way out salute you who are on the way in," he
said softly. "There will always be good young wine coming on in the *chai*
and good young fellows who love the vines. When you are a man you
will sit here and drink the blood of those grapes. May the good God show
you what He has made me see."

He drank the wine of his life. Then, feeling contented but very tired,
he laid his head down on his forearm on the table.

From somewhere among the buildings a woman's voice began shout-
ing shrilly: "Uncle Michel, Uncle Michel! Where are you?"

A man questioned her and she shouted back: "It is Gros Michel. We
thought he had gone to bed when we went to the dance. But he is not
there. He will catch his death. He never will realize how old he is."

The child looked in the direction of the voice, then at Rachelet's
bowed head. Suddenly he became frightened and ran away.

203

THE WINES OF FRANCE

From a banquet to a picnic, there is a French wine appropriate to every occasion. A pleasant Côtes de Provence red, cooled in icy water, is delightful with an outdoor lunch

One out of every seven Frenchmen earns his livelihood directly or indirectly from wine. In France wine is considered a food, an essential part of the daily fare, and no table is set without a bottle or carafe. The present greatness of the wines of France had its genesis two hundred years ago, when the use of the cork made it possible to age wines in the bottle. Despite periodic invasions by the phylloxera, the vine pest that destroyed most of the French vineyards in the late nineteenth century, France continues to produce the largest number of the world's finest wines. Chambertin, Château Lafite, La Tâche, Château Margaux, Le Montrachet, Château d'Yquem are but a few illustrious names on a list that could easily be multiplied twenty times over. The roll of near-greats could be even longer: whole regions, such as Chablis and Champagne, produce wines of such matchless character that their would-be imitators elsewhere in the world might be wise to call their wines—pleasant as they may be—by other names.

These classic wines of France exist for reasons both obvious and obscure. Why should the grapevine give great wine when it grows in soil that is often too poor for any other crop? In the rich, fertile soil of France's Mediterranean coast from Montpellier to Perpignan the vines produce nothing more than good *vin ordinaire*. Vines seem to prefer soil pebbled with gravel and chalky with calcium, containing scant but balanced traces of several important minerals. Each layer of subsoil

205

through which the deep roots of the vine penetrate offers its own elements to the grape, ultimately to contribute bouquet and taste to the finished wine. Those minerals in the soil which foster excellence have so far defied conclusive analysis. Other factors, too, are involved. Not only the makeup of vineyard soil but the precise situation of the ground is critical—its particular tilt to the warm, nourishing rays of the sun. And beyond these elements there are others we still do not understand. Why should Chambertin have so much more depth and balance than a wine grown only a hundred yards away in the very same commune? Why is Château Petrus superior to any other Pomerol?

The fortuitous exposure of the Romanée-Conti vineyard is another example. Situated on the fabled Côte d'Or of Burgundy, the vineyard faces due east, thus catching the sun early in the day. To the west, gentle slopes shelter the vines from behind, helping to ward off the cold, moisture-laden winds from the southwest. The fact that 4 1/3 acres of Romaneé-Conti year after year yield wines so definitely superior to those of its neighbors a few strides away simply demonstrates how capricious nature can be in the favors she bestows. Throughout France the winemaker must follow her whims: in the Graves region of Bordeaux the best vineyards face southwest; in Champagne, near Reims, slopes angled to the north inexplicably yield excellent wine; in Chablis the great vineyards look south.

No matter how perfect the exposure of a vineyard, the number of hours of sunshine it will enjoy during the growing season is also a question of weather. And to a winemaker weather means many more things than just the sun. Frost-free nights during the flowering in late spring, an ideal balance of sunshine and rain through the summer and approaching harvest, none of the sudden hailstorms whose icy stones can cause catastrophic damage—these are the winemaker's dream. As often as not, the absence of one of these conditions turns the dream into a nightmare. Yet the best vineyards of France seem to make consistently fine wines, even in years when the district as a whole has done poorly. This brings us to another crucial factor, the winemaker himself. Great wine is no accident, for, given the best of natural conditions, the man who makes it must be perfectly attuned to the needs of his vines and wines. He must be able to protect the vines from bad weather and disease; he must understand how to prune the plants so that their juice will concentrate, giving the wine depth and character; he must know how to supply fertilizer in

Rising behind the village of Vosne-Romanée is the hillside of patchwork vineyards that are the greatest in Burgundy. The birthplace of the world's costliest wines, this little section of the Côte d'Or produces La Romanée, Romanée-Conti, Le Richebourg, La Grande Rue, and La Tâche

206

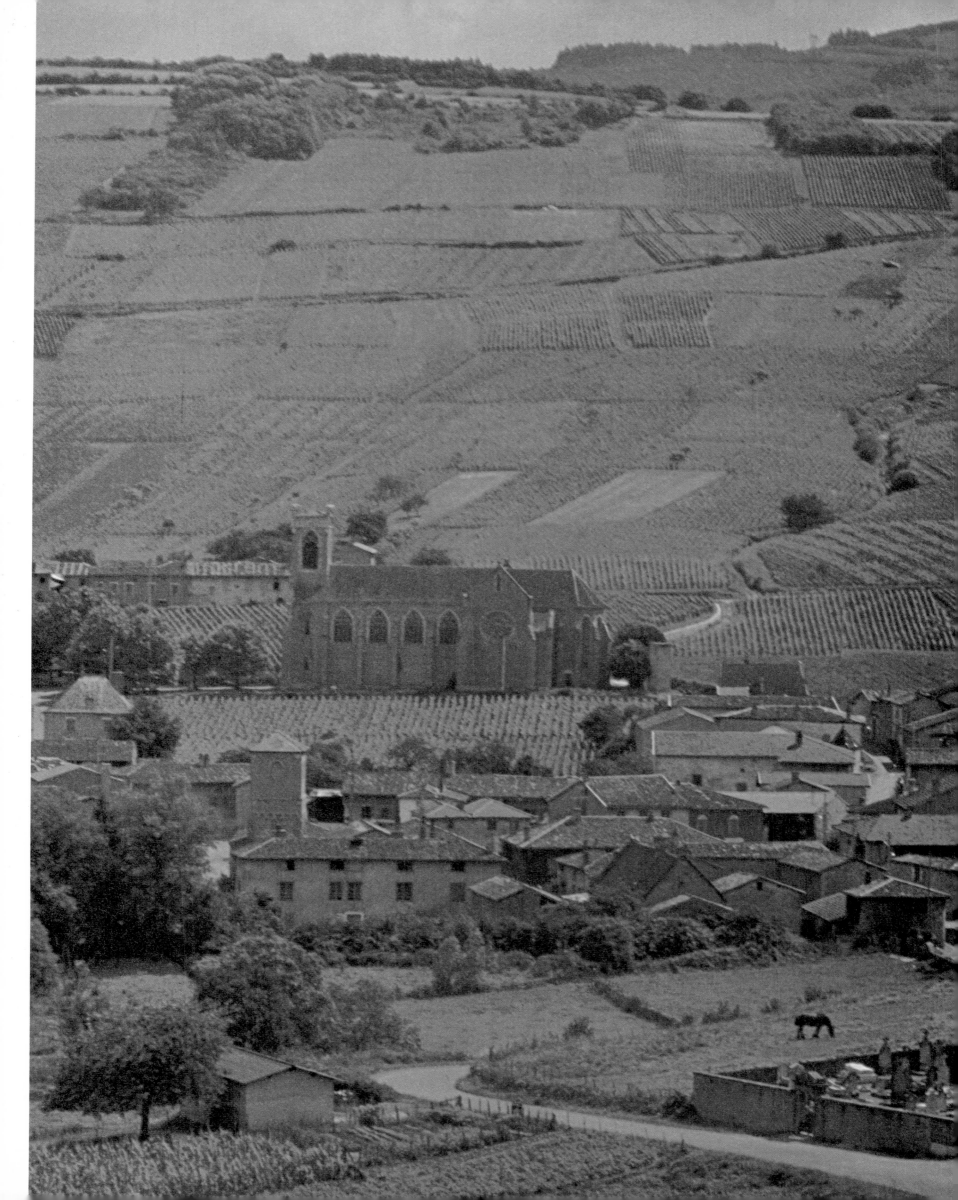

just the right amount (too much will result in more grapes but of lesser quality). And it is he who must determine the moment to begin the harvest so as to pick the grapes at their peak. Once the crop is in, he has to keep careful watch over the process of fermentation. The must (juice of the crushed grapes) cannot be allowed to overheat if the autumn weather is warm. Each step requires his minute attention, and every great winemaker has certain secrets that help to maintain his wine's high reputation.

Another reason for the premier position of French wines is the strict controls established by the growers themselves and enforced by the French government. The laws of *Appellation Contrôlée* guarantee the wine drinker that a given wine is the genuine article, meeting the standards that have been set

Science has joined forces with climate, soil, and the winemaker's skill in the development of modern wines

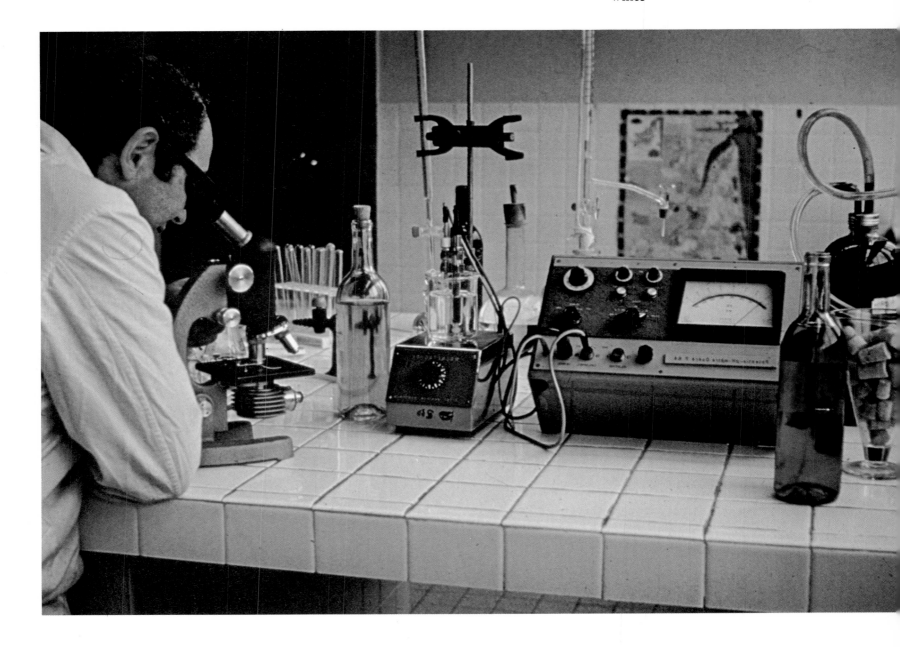

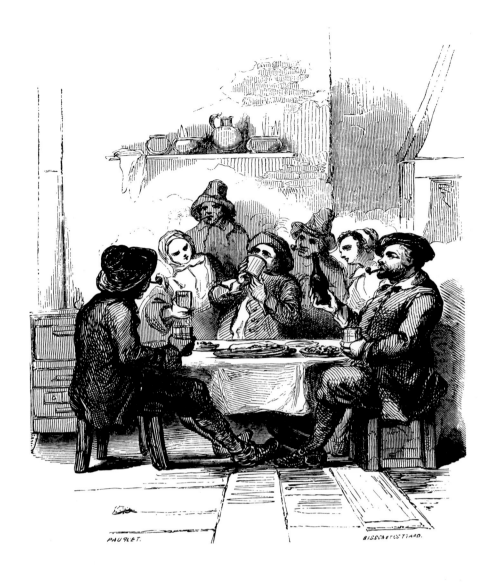

Vin ordinaire, France's everyday wine, has been enjoyed by her people for generations. The simple white, red, and rosé account for almost half of the country's wine production

for it. The words *Appellation Contrôlée* (literally "controlled name of place of origin") on a label guarantee that the birthplace of a wine is correctly stated. The regulations legally delimit each winegrowing area, name those grapes which may be planted, and define the conditions under which sugar may be added to the must to assure a stable wine. In addition, they prescribe such viticultural practices as pruning and planting, procedures of vinification (the actual process of winemaking), and even the maximum permissible yield per acre. These laws are respected both by *vignerons* (growers) and by *négociants* (shippers). Government inspectors are on the job in every district to see that the laws are obeyed.

The power of these *Appellation Contrôlée* laws was dramatically demonstrated in 1974, when inspectors in Bordeaux discovered that a broker was shipping common wine from the Midi, misrepresenting its important control papers and peddling it to various *négociants* under the desirable *Appellation* Bordeaux Rouge. The most important purchaser of this misnamed wine was the world-famous house of Cruse. Sixteen defendants were brought to trial in what became France's most sensational legal case since the Dreyfus affair. For wine drinkers everywhere, this deplorable incident had its

positive side: the rigorous legal proceedings and the penalties meted out—reported daily in the press and on radio and television—reaffirmed the French government's commitment to protecting the quality of the wines of France.

The laws are rigid on all levels, but the finer the wine, the stricter the regulations that apply to it. A regional wine such as Bordeaux Rouge, for example, carries the simplest and broadest designation for the vast assortment of red Bordeaux wines. But within the region there are districts such as Médoc, Pomerol, and Graves whose wines are subject to higher and more specific standards than the simpler regional wines. Within the Médoc district are the communes (parishes), whose standards are higher still. Like the concentric circles on a target, the place of origin contracts and grows smaller as it becomes more specific: the whole is the region of Bordeaux, the outer circles are the districts, the inner ones are the communes. The great vineyards represent the bull's-eye. For example, the commune of Margaux—population 1,800—has many small vineyards. The best is Château Margaux, a property of some 150 acres that produces each year about 20,000 cases of wine. This great and justly famous wine will bear on its label the most specific *Appellation* that it is entitled to, that of its commune, Margaux, rather than the broader *Appellation* of Bordeaux or Médoc.

Thus the key words on the label of Château Margaux are *Appellation Margaux Contrôlée.* In Burgundy this system reaches even greater refinement, since each *Grand Cru* (Great Growth) vineyard has its own legal *Appellation* and is not required to show even a commune name. A *Grand Cru* Burgundy vineyard like Clos de Vougeot, one of the thirty-odd Great Growths of Burgundy, will have on its label merely "Clos de Vougeot, Appellation Contrôlée."

Although vineyards with *Appellation Contrôlée* status are to be found in virtually all the major wine districts of France, only 10 to 15 percent of the nearly 2 billion gallons of French wine produced annually qualify for the designation. The rest is largely the *vin ordinaire* the Frenchman drinks daily or the *vins du pays,* the local country wines that travelers in France often find so agreeable. Happily, most of what is imported into the United States is *Appellation Contrôlée,* the best that France has to offer. Some wines of the rank below *Appellation Contrôlée* also reach us. These are the wines with a label bearing the letters V.D.Q.S. (*Vin Délimité de Qualité Supérieure*) that make for pleasant casual drinking. S. A.

BORDEAUX

Burgundy and Bordeaux—who can say which is the greater? Each has its devotees, whose preference would probably depend on the occasion, the food served, and even the season and time of day. Would one choose a rich red Burgundy for a Sunday brunch in May? Unlikely. But for warding off the winter chill at a dinner of roast venison on a late December day, a Richebourg or an Échezeaux would be a warmly auspicious choice. To avoid partisanship, let us consider Bordeaux and Burgundy in alphabetical order.

Besides being one of the finest wine regions of France, Bordeaux is the largest, with 200,000 acres planted in vines, more than twice as many as Burgundy. In 1973 over 60 mil-

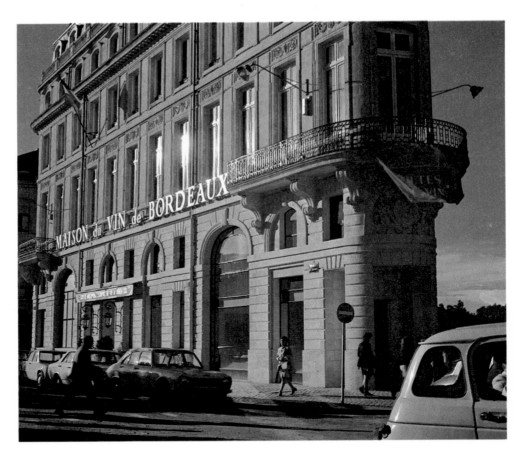

The noble old city of Bordeaux, built on the banks of the Gironde, is the port from which the region's great wines have been shipped for hundreds of years. The "House of Wine" is headquarters for the C.V.I.B. (Interprofessional Committee for the Wines of Bordeaux), which scrupulously polices wines intended for export

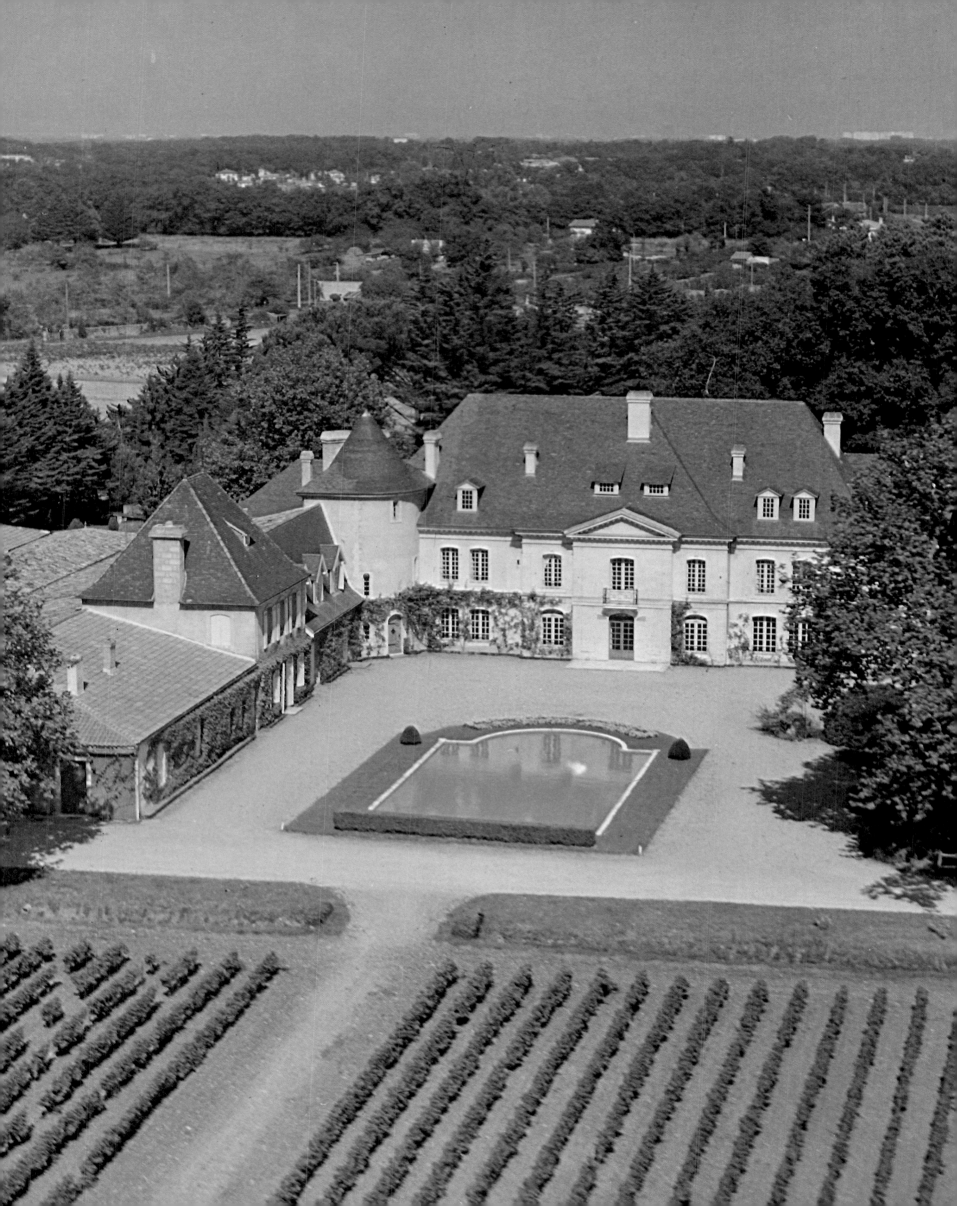

lion cases of Bordeaux wine were produced. The region lies near the Atlantic coast in southwest France and, as its name suggests, water plays an important role in its geography. The green web of vineyards borders both the Dordogne and Garonne rivers, as well as the wide estuary, called the Gironde, into which they flow before emptying into the Bay of Biscay. Of the thirty wine districts in Bordeaux, the most famous are the Médoc, Graves, Saint-Émilion, Pomerol, and Sauternes. These five districts produce the fabulous wines that serve to glorify the region as a whole, prompting connoisseurs to refer to Bordeaux as "the Queen of Wines." Many other districts produce wines that, though less well known, are honest and agreeable, and often inexpensive. Among them are the Côtes de Bourg, Canon-Fronsac, Côtes de Blaye, Montagne-Saint-Émilion, Entre-Deux-Mers, Lalande de Pomerol, and Puisséguin-Saint-Émilion.

Half the wine of Bordeaux is red, half white. The division is roughly geographical, since the reds come mainly from the northern areas and the whites from the south. An exception is Graves, which makes both red and white, with white predominating. The British have long called red Bordeaux wines "claret" (a corruption of the old French *clairet*, the name of a pale red wine first shipped to England in the twelfth century). Today the word may refer to any light-bodied red wine (it is commonly so used by vintners in Spain and California). In wine-drinking circles the name "claret" is synonymous with good red Bordeaux.

The primary grape varieties used for making red wine in Bordeaux are Cabernet Sauvignon and Merlot, with supporting roles played by Malbec, Cabernet Franc, and Petit-Verdot. In some of the vineyard districts, one of the latter three may dominate the plantings. For white wines the Sémillon and Sauvignon Blanc are most important, with Merlot Blanc and Muscadelle used to a small extent. In order to give their wines balance and harmony or to counter the overpowering influence of any single grape, most vineyards are planted in more than one variety.

The high quality of the better Bordeaux wines is due in part to the mysterious interaction of soil and climate and vine. The soil is quite poor, but its rough and rocky composition affords excellent drainage, forcing the roots of the vine to grow deep in search of the moisture and nutrients they need. Deep roots enable the vines to remain healthy and productive in times of too much or too little rain. The orientation of the

In the Graves district, Château Bouscaut, with its neatly tended vines and reflecting pool, looks like a Californian dream of a French vineyard. American-owned, it produces good château-bottled red and white wines

213

great vineyards is excellent, with long sun, from early morning to evening. The climate, mitigated by the nearby Atlantic, is moderate, though spring and fall frosts are a constant threat.

Proud of its products and eager to maintain its high standards, the wine trade of Bordeaux has rated the local wines in order of quality. Attempts to rank the many different wines go back several centuries, but perhaps the most complete is the famous 1855 classification of Médoc wines, almost as valid today as it was then. The 1855 list still has its faults; however, the major one, rating Mouton-Rothschild a Second Growth, has been corrected. In 1973 this vineyard was elevated to the top category, where most experts feel it has always belonged. In 1955, on the occasion of the one-hundredth anniversary of the Médoc classification, and in subsequent years, Alexis Lichine and other leaders in the wine industry endeavored to update it. Tradition and conservatism thwarted these efforts to create an officially recognized current classification. Time inevitably brings change. Most of the other leading districts of Bordeaux also have fixed ratings, though none is so complex or comprehensive as that of the Médoc.

That a particular wine is included in a classification is one indication of its potential quality. Another warranty of excellence on the label of a fine wine is the phrase *Mis en bouteille au château,* or "Bottled at the château." This is the assurance by the grower that the wine in the bottle was made and bottled by him, that it was not blended or tampered with by anyone else (as is sometimes the case when wine is shipped off in bulk to a merchant). Château-bottled wines guarantee authenticity and, to some extent, quality, although lesser vineyards of inconsistent or inferior worth have caught on to the marketing value of the phrase, which is in fact sometimes misleading, since in many cases the "château" is little more than a country home or a simple farmhouse. Often the most imposing building on the property is the *chai,* the long, low shed where the wine is stored in barrels until it is mature enough to bottle. *Grands châteaux,* some built hundreds of years ago, do exist, and they are the ones we see pictured most often—Margaux, Mouton, Lafite, Beychevelle, Petrus, and Haut-Brion, to name a few.

The names of the great châteaus are important, but so are those of the major Bordeaux shipping firms: Cordier, Cruse et Fils, Calvet, Barton et Guestier, William Bolter, Dourthe, Deluze, Eschenauer, Nathaniel Johnston, Kressmann, Alexis Lichine & Co., Schroder & Schÿler, Delor, Sichel et Fils.

ATLANTIC OCEAN

N
W E
S

THE
VINEYARDS
OF
BORDEAUX

Gironde

St.-Estèphe

Pauillac

St.-Julien

Dordogne

Margaux

POMEROL AND
ST.-EMILION

HAUT-MEDOC

Libourne

St.-Emilion

Bordeaux

Garonne

GRAVES

ENTRE-DEUX-MERS

SAUTERNES
AND BARSAC

Langon

FRANCE

BORDEAUX

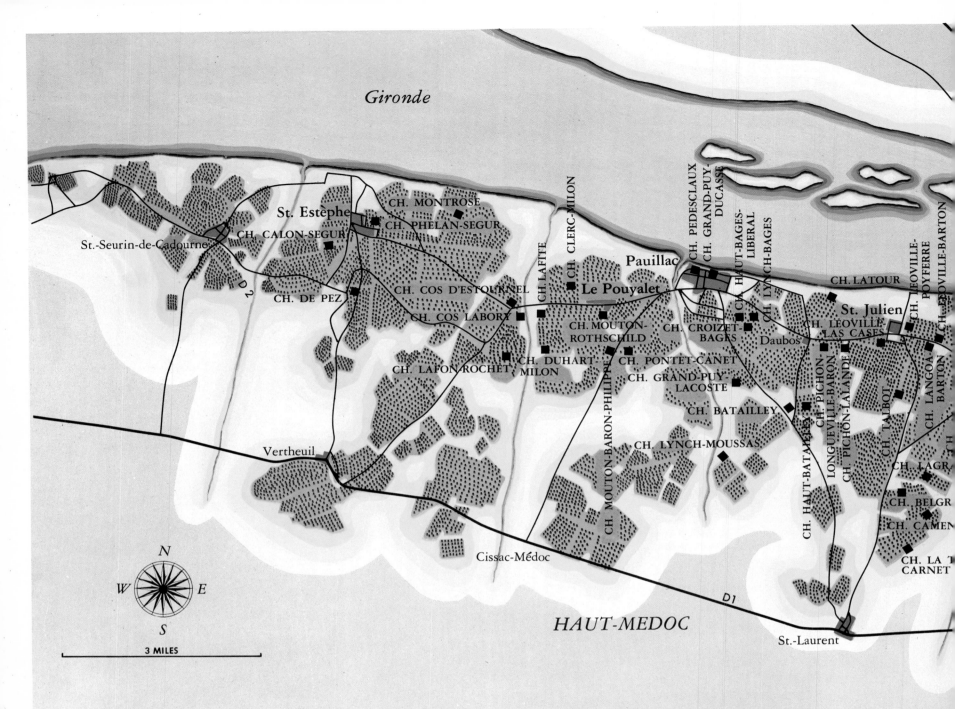

Gironde

St.-Seurin-de-Cadourne

St. Estèphe

CH. MONTROSE
CH. CALON-SEGUR
CH. PHELAN-SEGUR
CH. DE PEZ
CH. COS D'ESTOURNEL
CH. COS LABORY
CH. LAFON-ROCHET
CH. LAFITE
CH. CLERC-MILON
CH. DUHART-MILON

Pauillac
CH. PEDESCLAUX
CH. GRAND-PUY-DUCASSE
CH. HAUT-BAGES-LIBERAL
CH. LYNCH-BAGES
Le Pouyalet
CH. MOUTON-ROTHSCHILD
CH. MOUTON-BARON-PHILIPPE
CH. PONTET-CANET
CH. GRAND-PUY-LACOSTE
CH. CROIZET-BAGES
Daubos
CH. BATAILLEY
CH. LYNCH-MOUSSAS

CH. LATOUR
St. Julien
CH. LÉOVILLE-POYFERRE
CH. LÉOVILLE-BARTON
CH. LÉOVILLE-LAS CASES
CH. PICHON-LONGUEVILLE-BARON
CH. PICHON-LALANDE
CH. HAUT-BATAILLEY
CH. TALBOT
CH. LANGOA-BARTON
CH. LAGR
CH. BELGR
CH. CAMEN
CH. LA T
CARNET

Vertheuil

Cissac-Médoc

HAUT-MEDOC

St.-Laurent

D 2

D 1

N W E S

3 MILES

THE HAUT-MEDOC AND GRAVES

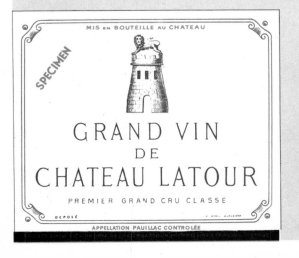

MIS EN BOUTEILLE AU CHATEAU

SPECIMEN

GRAND VIN DE CHATEAU LATOUR

PREMIER GRAND CRU CLASSE

DEPOSÉ

APPELLATION PAUILLAC CONTROLÉE

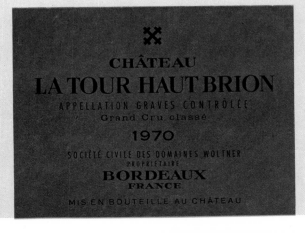

CHÂTEAU LA TOUR HAUT BRION

APPELLATION GRAVES CONTRÔLÉE
Grand Cru classé

1970

SOCIÉTÉ CIVILE DES DOMAINES WOLTNER
PROPRIÉTAIRE

BORDEAUX
FRANCE

MIS EN BOUTEILLE AU CHATEAU

Château Giscours

GRAND CRU CLASSE EN 1855

MARGAUX

1970

APPELLATION MARGAUX CONTROLEE

NICOLAS TARI, PROPRIETAIRE A LABARDE PAR MARGAUX . 33
ALC. 11°-13° · H.P.A. 114

MIS EN BOUTEILLES AU CHATEAU

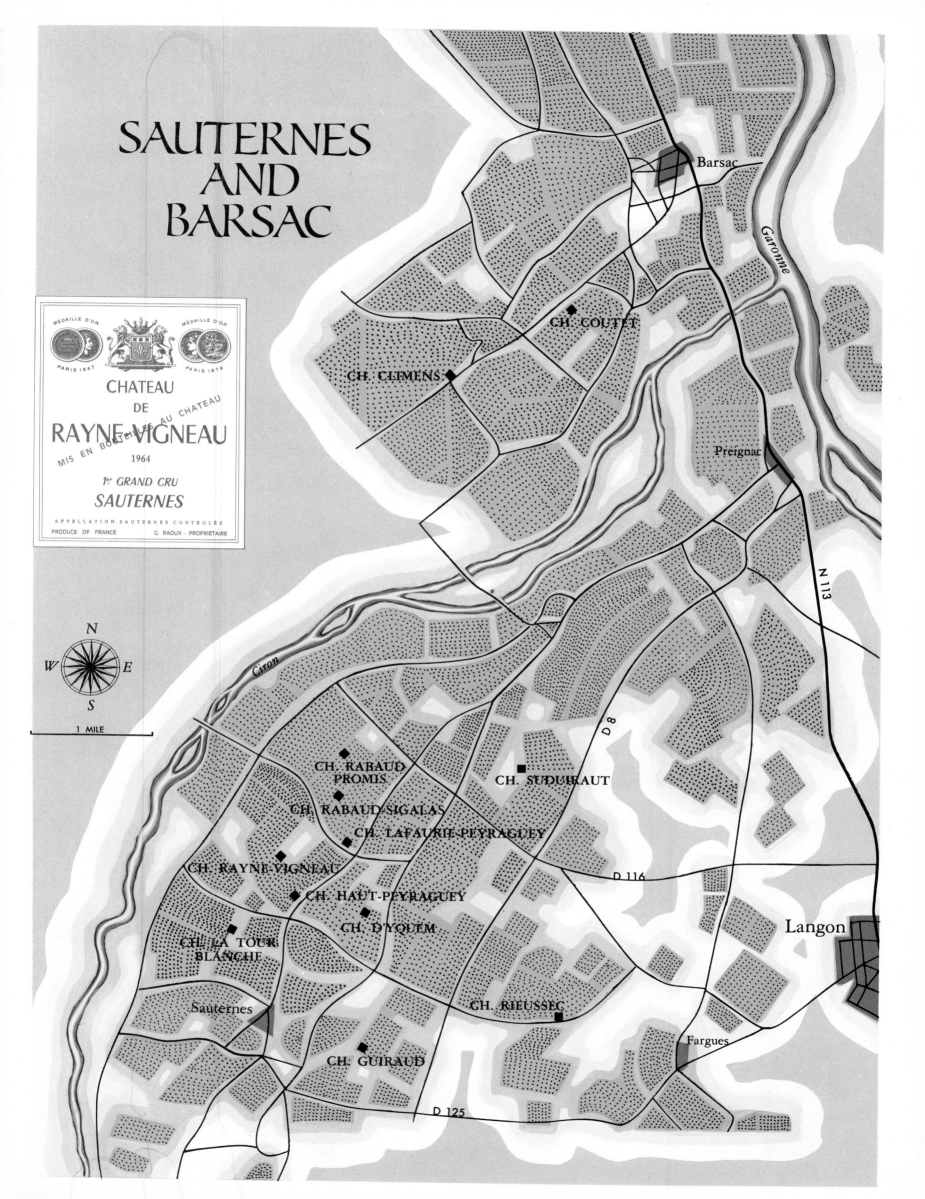

SAUTERNES AND BARSAC

CHATEAU
DE
RAYNE-VIGNEAU
MIS EN BOUTEILLES AU CHATEAU
1964

1er GRAND CRU
SAUTERNES

APPELLATION SAUTERNES CONTROLÉE
PRODUCE OF FRANCE G. RAOUX - PROPRIÉTAIRE

MÉDAILLE D'OR
PARIS 1867

MÉDAILLE D'OR
PARIS 1878

N
W E
S

1 MILE

Barsac

Garonne

Preignac

N 113

CH. COUTET

CH. CLIMENS

Ciron

D 8

CH. RABAUD PROMIS

CH. SUDUIRAUT

CH. RABAUD-SIGALAS

CH. LAFAURIE-PEYRAGUEY

CH. RAYNE-VIGNEAU

D 116

CH. HAUT-PEYRAGUEY

CH. D'YQUEM

CH. LA TOUR BLANCHE

Langon

Sauternes

CH. RIEUSSEC

Fargues

CH. GUIRAUD

D 125

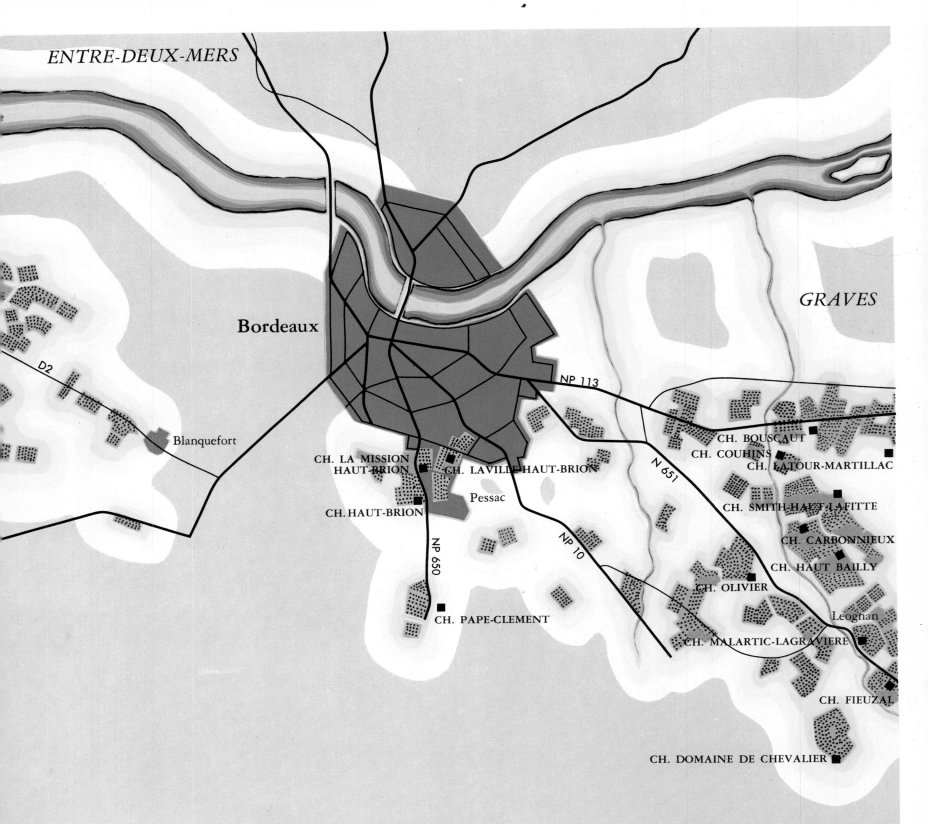

ENTRE-DEUX-MERS

GRAVES

Bordeaux

D2

Blanquefort

NP 113

N 651

CH. BOUSCAUT
CH. COUHINS
CH. LATOUR-MARTILLAC

CH. LA MISSION
HAUT-BRION

CH. LAVILLE HAUT-BRION

CH. SMITH-HAUT-LAFITTE

Pessac

CH. HAUT-BRION

CH. CARBONNIEUX

CH. HAUT BAILLY

NP 650

NP 10

CH. OLIVIER

Leoghan

CH. MALARTIC-LAGRAVIERE

CH. PAPE-CLEMENT

CH. FIEUZAL

CH. DOMAINE DE CHEVALIER

Mis en Bouteille au Château
1971
Château Bouscaut
GRAND CRU CLASSÉ
1 PT. 8 FL. OZS. ALCOHOL 12 °/- BY VOL.

APPELLATION GRAVES CONTROLEE
Domaine Wohlstetter - Sloan
Sté Civile du Château Bouscaut
PROPRIÉTAIRE
à CADAUJAC près BORDEAUX
RED BORDEAUX WINE PRODUCT OF FRANCE

SPECIMEN
MIS EN BOUTEILLES AU CHÂTEAU

CHATEAU LAFITE-ROTHSCHILD
1961
DÉPOSÉ.
APPELLATION PAUILLAC CONTRÔLÉE

CHATEAU
MALARTIC-LAGRAVIÈRE
Grand vin de Bordeaux
1967
CRU CLASSÉ DE GRAVES
APPELLATION GRAVES CONTRÔLÉE

JACQUES MARLY-RIDORET PROPRIÉTAIRE A LÉOGNAN (GIRONDE)
MISE EN BOUTEILLE AU CHATEAU

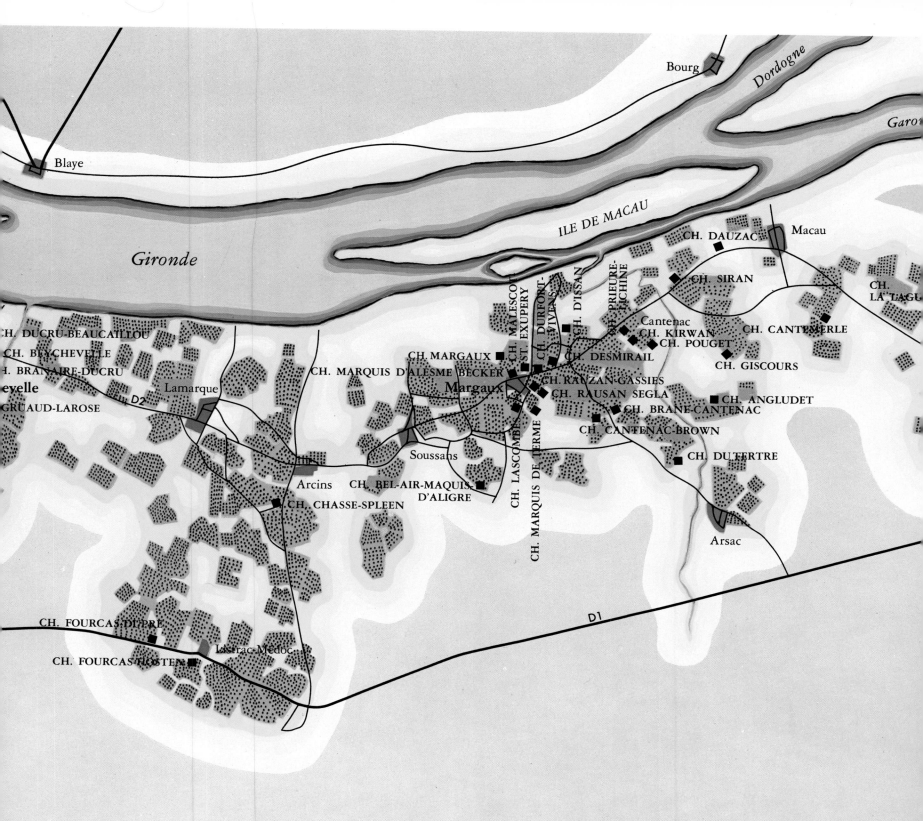

Bourg

Dordogne

Garo

Blaye

ILE DE MACAU

Gironde

Macau

CH. DAUZAC

CH. SIRAN

CH. LA TAGU

CH. DUCRU-BEAUCAILLOU

CH. BEYCHEVELLE

H. BRANAIRE-DUCRU

eyelle

GRUAUD-LAROSE

D2

Lamarque

CH. D'ISSAN

CH. MALESCOT

ST. EXUPERY

CH. DURFORT-VIVENS

CH. PRIEURE-LICHINE

CH. MARGAUX

CH. MARQUIS D'ALESME BECKER

Margaux

CH. DESMIRAIL

Cantenac

CH. KIRWAN

CH. POUGET

CH. CANTEMERLE

CH. GISCOURS

CH. RAUZAN-GASSIES

CH. RAUSAN SEGLA

CH. BRANE-CANTENAC

CH. ANGLUDET

Soussans

CH. LASCOMBE

CH. MARQUIS DE TERME

CH. CANTENAC-BROWN

Arcins

CH. BEL-AIR-MAQUIS-D'ALIGRE

CH. CHASSE-SPLEEN

CH. DU TERTRE

Arsac

D1

CH. FOURCAS-DU-PRE

CH. FOURCAS-HOSTEN

Listrac-Médoc

1967

CHATEAU DE LAMARQUE

APPELLATION HAUT-MEDOC CONTROLEE

GROMAND d'EVRY - Lamarque - Gironde

Successeurs des MARQUIS D'EVRY et des COMTES DE FUMEL

Exploitation Familiale depuis 1841

MIS EN BOUTEILLE AU CHATEAU

MÉDAILLES D'OR

EXPOSITIONS UNIVERSELLES

PARIS 1867

PARIS 1878

GRANDE MÉDAILLE MINISTÉRIELLE 1871

Château Montrose

APPELLATION SAINT-ESTÈPHE CONTROLÉE

1969

L. Charmolüe

MIS EN BOUTEILLE AU CHATEAU

PRODUCE OF FRANCE DÉPOSE

CHÂTEAU

LAVILLE HAUT BRION

APPELLATION GRAVES CONTRÔLÉE

Grand Cru classé

1970

SOCIÉTÉ CIVILE DES DOMAINES WOLTNER

PROPRIÉTAIRE

BORDEAUX

FRANCE

MIS EN BOUTEILLE AU CHATEAU

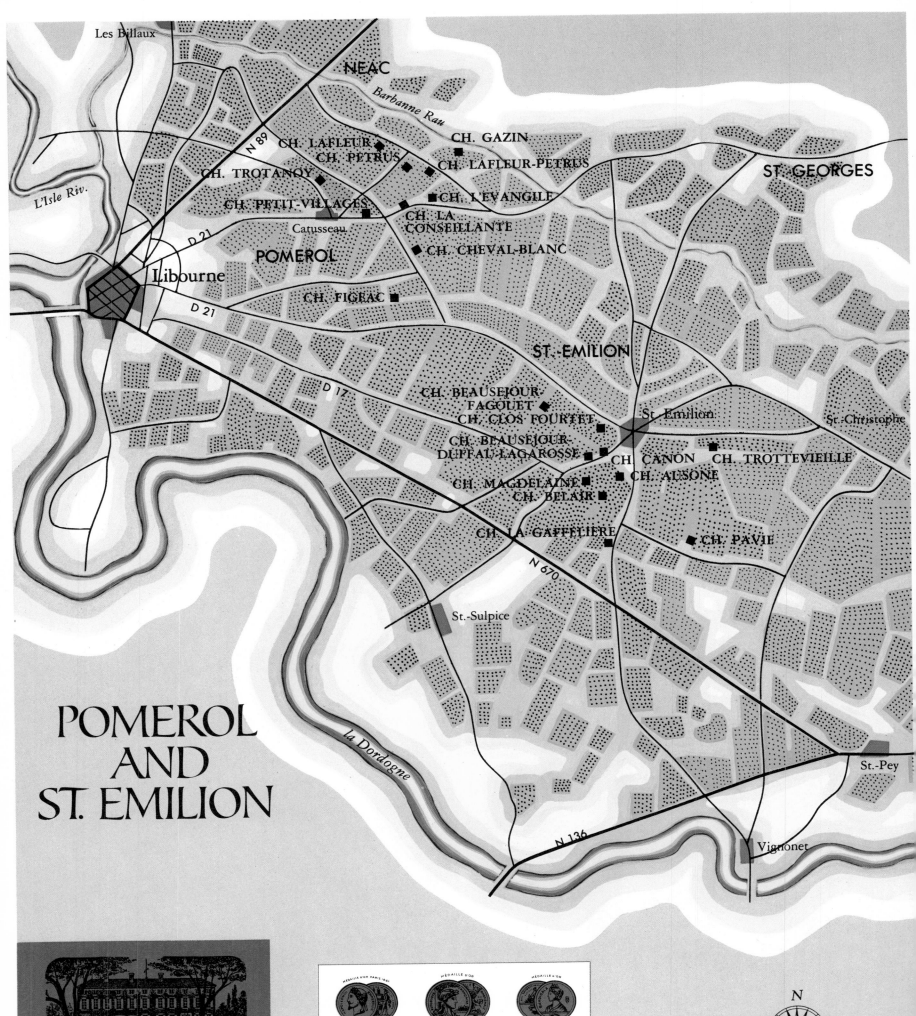

Les Billaux

NEAC

Barbanne Rau

L'Isle Riv.

N 89

CH. LAFLEUR
CH. PETRUS

CH. GAZIN

CH. LAFLEUR-PETRUS

ST. GEORGES

CH. TROTANOY

CH. PETIT-VILLAGES

CH. L'EVANGILE

D 21

Catusseau

CH. LA
CONSEILLANTE

POMEROL

CH. CHEVAL-BLANC

Libourne

D 21

CH. FIGEAC

D 17

ST.-EMILION

CH. BEAUSÉJOUR-
FAGOUET
CH. CLOS FOURTET

St.-Emilion

St.-Christophe

CH. BEAUSÉJOUR-
DUFFAU-LAGAROSSE

CH. CANON

CH. TROTTEVIEILLE

CH. MAGDELAINE
CH. BELAIR

CH. AUSONE

CH. LA GAFFELIERE

CH. PAVIE

N 670

St.-Sulpice

la Dordogne

POMEROL
AND
ST. EMILION

St.-Pey

N 136

Vignonet

CHÂTEAU ROUGET

GRAND CRU

POMEROL

APPELLATION POMEROL CONTROLÉE

1967

Marcel BERTRAND, propriétaire à Pomerol (Gironde)

MIS EN BOUTEILLES AU CHATEAU

MÉDAILLE D'OR PARIS 1867 MÉDAILLE D'OR MÉDAILLE D'OR
 PARIS 1900 BORDEAUX 1895
GROUPE DES 1ᵉʳˢ CRUS

Clos-Fourtet

PREMIER GRAND CRU CLASSÉ

Saint-Emilion

APPELLATION SAINT-ÉMILION CONTROLÉE

François LURTON
PROPRIÉTAIRE
SAINT-ÉMILION

1969

N
W E
S

1 MILE

All Bordeaux wines, white and red, have the characteristics of finesse, complexity, and amazing longevity that set them apart from the wines of any other region of France. Even so, there are innumerable variables of taste, bouquet, and character that every reputable grower takes pride in nurturing. Soil composition, sites of exposure, the predominant grape variety—all may vary from district to district and from vineyard to vineyard. One of the special delights of wine drinking is to sample a great many wines, allowing each one to reveal its special nuance. And nowhere else are these more pleasurable than among the districts, communes, and châteaus of Bordeaux.

THE MÉDOC AND THE HAUT-MÉDOC

The incomparable red wines of the Médoc and particularly of the Haut (Upper) Médoc, include some of the most famous in the world. For elegance, breed, and finesse (that is to say, fine-ness), they are unsurpassed. The tenacity of their staying power is often astonishing. Château Margaux 1899 is one of the remarkable old Médocs I enjoyed recently; it is not unusual to find the great wines from this district still good after sixty or seventy years. The celebrated communes of Margaux, Saint-Julien, Pauillac, and Saint-Estèphe are situated in the Haut-Médoc on the west bank of the Gironde. Margaux is near the southern end of the district, Saint-Estèphe is toward the north.

The best vineyards of these communes make up the First Growths of the 1855 classification, which also included Château Haut-Brion in neighboring Graves (its excellence could not be ignored). When the classification was devised, the ranking was based on the prices the wines had brought over the previous century, prices that reflected the current value of the land and, presumably, the quality of the various wines. It is indeed interesting that this list has stood the test of time as well as it has. Most experts would make only a dozen or so changes in the standing of the sixty or so vineyards represented. Perhaps more amendments would be made to upgrade deserving vineyards (Mouton-Rothschild is a case in point) than to demote those making less interesting wines. In addition to the original four Médoc top growths, many of the minor Médoc châteaus were classed in several other categories, for example, *Cru Bourgeois Supérieur* and *Cru Bourgeois.* In many cases these wines have improved steadily over the

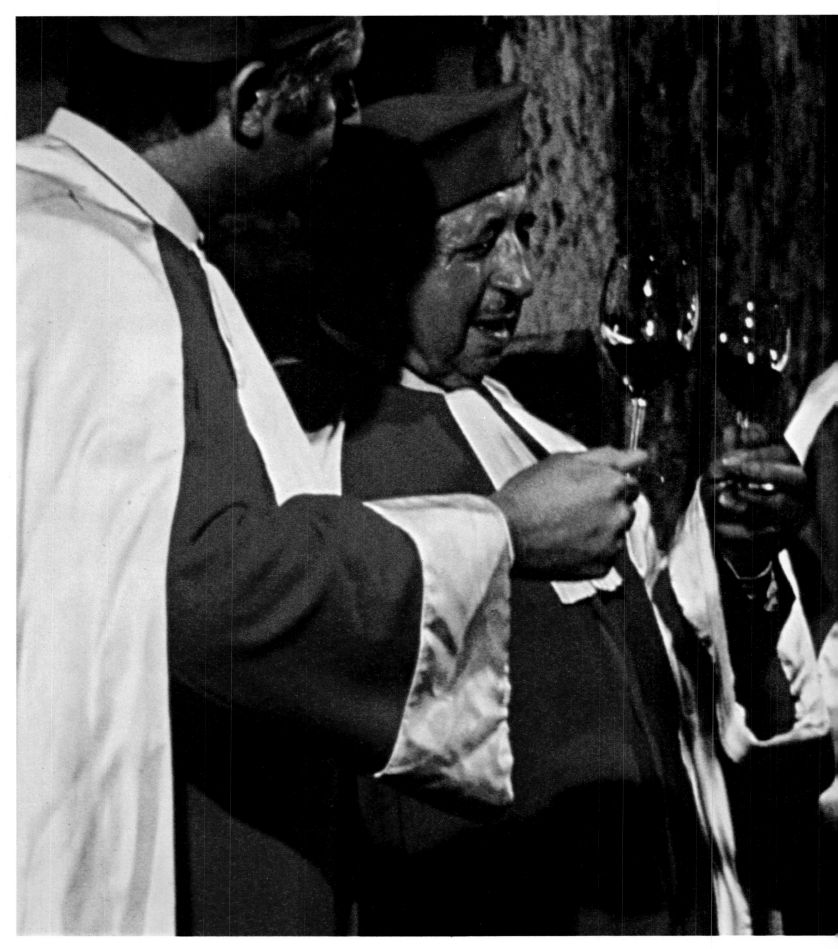

Members of the Jurade de Saint-Émilion gather
to celebrate the glories of their wines

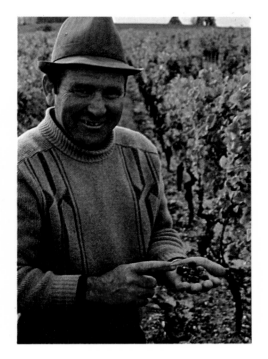

A worker at Château d'Yquem proudly exhibits a handful of late-picked grapes already shriveled and darkened by the "noble rot." This beneficial mold concentrates the fruit's sugar, and the result is a wine that is naturally sweet and rich

past century and a quarter. In the 1855 classification we are dealing with the nobility, the very best of the 6,000 vineyards of the Médoc; even the vineyard of the lowest rank can be considered a duke or an earl. To say that a Fourth Growth is only one-quarter as good as a First Growth is to miss the point. The variations in these sixty-odd wines of the 1855 classification are only a matter of degree, and very gradual degrees at that. In the array of wines in any good wineshop, châteaus officially ranked as Third or Fourth or Fifth Growths often claim prices as high as some Second Growths, and rightly so. Growers and shippers commonly refer to all the wines below the first category as Second Growths. Things seem to get a little out of hand at times, since the five wines of the top rank currently bring three times as much as the costliest Second Growth. First Growth prices reflect status as much as the intrinsic quality of the wine.

Saint-Estèphe. Some experts say that because the soil is different in the northern reaches of the Haut-Médoc, having more clay and less gravel, the wines of Saint-Estèphe tend to be firmer, higher in tannin content, and slower to mature than the other wines of the district. The wines of the leading vineyards, among them Cos d'Estournel, Montrose, Lafon-Rochet, Calon-Ségur, Cos Labory, are prized for their depth and sturdiness. They are dark, tannic wines, slow to offer up their bouquet and very long-lived. Among the up-and-coming *Crus Bourgeois* of Saint-Estèphe are Meyney, Phélan-Ségur, and de Pez, each eliciting increasing interest from wine lovers who seek good value as well as excellence.

223

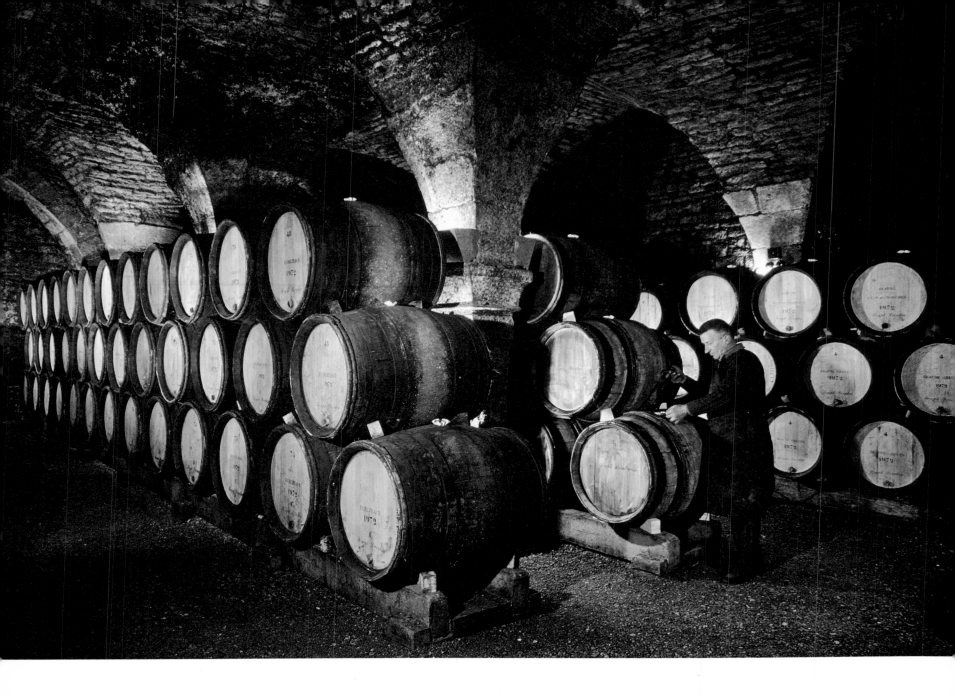

MAÎTRE DE CHAI: LATOUR

Large, elderly, stiff, remote,
He moves like a narrow-boat
 Down the long canals between
His casks in regular line.
He does not talk about wine
 In wine-talk (you know what I mean—

The mysterious jargon in use
Among those who are fond of this juice).
 Indeed, he seems almost perverse
The way he tends to compare
One year with another year
 By calling it 'Better' or 'Worse.'

His hairy fingers stroke
The close-grained staves of oak
 Where a dribbling indigo stain
Covers the round of the cask.
'Is that fermentation?' I ask.
 He grunts and tries to explain

That the seasons tug like a tide
On the raw new wine. When, outside,
 The vines are in trivial flower
It works and moves to that pull.
And again, when the grapes are full,
 It knows, he remarks, its hour.

I feel the hair on my nape
Prickle, to think of the grape
 Being mashed, fermented, and run
Into barrels, and fined, and racked—
Being ten-times-processed, in fact—
 But moving still when the sun

Moves, here, in the wood, in the dark.
No wonder his language is stark:
 When phenomena such as these
Are part of his everyday
Problems down in the chai
 He needn't make *mysteries*.

—Peter Dickinson

224

Pauillac. South of the vineyards of Saint-Estèphe lies the Médoc's most distinguished commune, Pauillac. Three of the five First Growths are planted within its boundaries: Lafite-Rothschild, Latour, and Mouton-Rothschild. These three wines are classic Bordeaux. To many they represent the ideal claret: smooth but full-bodied, with great depth and also a hint of luscious fruit, having a tremendous fragrance that develops as they mature. Perfectly balanced, the wines have a subtlety and distinction all their own. When allowed to reach the lofty peak of greatness, each is literally beyond adequate description, offering a wine-drinking experience second to none. Unfortunately, most bottles of Lafite, Mouton, and Latour are consumed too young, as their purchasers these days frequently lack the patience to wait ten, fifteen, or twenty years for the wines to mature.

Discovering the differences among the three is a happy and satisfying—if costly—pastime indeed. Lafite and Mouton are contiguous and were once part of the same vineyard. The

At Château Lafite-Rothschild the "library" of old bottles contains cobweb-encrusted relics of great vintages that go back to before 1800

owners are cousins, both barons of the Rothschild family. In a sense the wines are blood brothers, but each has an obvious individual style. Mouton's vineyards are planted almost entirely in the leading grape variety of Bordeaux, the Cabernet Sauvignon. The predominance of the Cabernet gives the Mouton wines a robust bigness and power and legendary long life. The suppleness of Lafite derives from the softness of the Merlot grape, planted to a much greater extent at Lafite than at Mouton or even Latour. Lafite's distinctive elegance and extraordinary finesse are set off by a delicate sensuousness. The word most often used to describe the wine is "beautiful."

Visiting the vineyards is a fascinating experience. The grandeur of Château Lafite, with its great long *chai* lined with row upon row of barrels filled with new wine, is impressive. At Mouton-Rothschild, Baron Philippe de Rothschild has established a wine museum filled with fabulous and fascinating objects pertaining to wine.

Latour, one of whose owners is Lord Cowdray of England, lies at the opposite end of the parish of Pauillac. Like Mouton, the vineyard is planted largely in the Cabernet Sauvignon, which gives Latour a pronounced solid and masculine character. Though the *encêpagement* or ratio, of the different grapes grown in the vineyard, is close to that of Mouton, the wines are quite different. That is part of the appeal of the great wines of the Médoc. Latour is deep-flavored, with a rich bouquet when fully mature. It was one of the favorite wines of Charles de Gaulle. Strengthened with the sturdiness of the Cabernet grape, the wine is consistent from vintage to vintage. Even in poor years, Latour is much sought after.

Though Lafite, Latour, and Mouton are certainly the most famous, many other fine vineyards lie within the confines of Pauillac. The two Second Growths, Pichon-Longueville-Baron and Pichon-Longueville, Comtesse de Lalande (often shortened to Pichon-Lalande), are elegant, well-balanced, long-lived wines, the latter somewhat lighter and fruitier, but both entirely deserving of their high reputation. Among the Fifth Growths, Lynch-Bages, Pontet-Canet, and Grand-Puy-Lacoste are extremely popular wines with prices reflecting their renown. Lynch-Bages competes with Mouton in weight and intensity. Pontet-Canet, one of the largest vineyards of Bordeaux, makes a particularly velvety wine. And at Grand-Puy-Lacoste, the most interesting gastronomic lunches in the whole region (hosted by Monsieur Dupin, the proprietor) are accompanied by its very generous, fruity wine. S. A.

THE MUSEUM AT MOUTON

There are several wine museums in Europe, all interesting and instructive. But there is none quite like the Museum at Mouton, an integral part of the great Mouton-Rothschild vineyard of Pauillac in the Gironde. It is the creation of two members of the Rothschild dynasty: Baron Philippe de Rothschild and his American-born wife, Pauline, née Potter. The Museum, an exquisite demonstration of the bond between wine and civilization, bears as its device the motto of the vineyard itself: *La qualité et la gloire.* It is formed on aesthetic rather than historical or folkloristic principles. Everything in it is beautiful, rare, perfect of its kind, illustrating the close connection between wine and the creative spirit of the artist. The Baron has emphasized that connection by commissioning some of the leading artists of our time to design the Mouton-Rothschild wine labels, and on the following pages a montage of labels by Miró, Chagall, Dali, Braque, and others serves as a background for photographs of the Rothschilds.

Denys Sutton, editor of the English art magazine *Apollo,* wrote: "It is perhaps significant that this Museum is situated in the Gironde and that the grape is the chosen theme. Inevitably much nonsense is talked about wine and its virtues, but surely it is undeniable that the ability to detect quality, so vital in the tasting of wine, holds a message applicable to the study of art. . . . spending part of one's life in a district in which *La qualité et la gloire* are sought after at all levels of society would have a tonic effect on the eye. It has certainly produced in this case a museum which will perpetuate the memory of its founders and provide endless pleasure for the visitor."

The main gallery of the Museum has been created from the original aging cellar of the winery, and upon entering it one can still detect the lingering aroma of old wine barrels. But the long room has been completely transformed by the Baroness, whose unerring taste was responsible for the arrangement of the collection; the masterly lighting was accomplished by Baron Philippe.

The collection is remarkable for its range of centuries as well as of places. It began with an inheritance of ceremonial silver vessels from the collection of the Baron's great-grandfather. It now includes a "Gilgamesh Cup," carved about 2500 B.C.; an Egyptian bas-relief from about 2400 B.C.; Greek, Roman, Egyptian, Chinese, and Middle Eastern treasures; a gold jug and gold beaker crafted in Amlach nearly three thousand years ago; five glorious sixteenth-century tapestries; and a remarkable gold, platinum, and copper modern sculpture by Richard Lippold, *The Spirit Vine.*

The Museum at Mouton is not thronged with visitors, for one must obtain permission to view its treasures. One enters it with a certain reverence; it is hardly a tourist attraction. The illustrations on the pages that follow give only a hint of what the Museum offers the sensitive wine lover.

C.F.

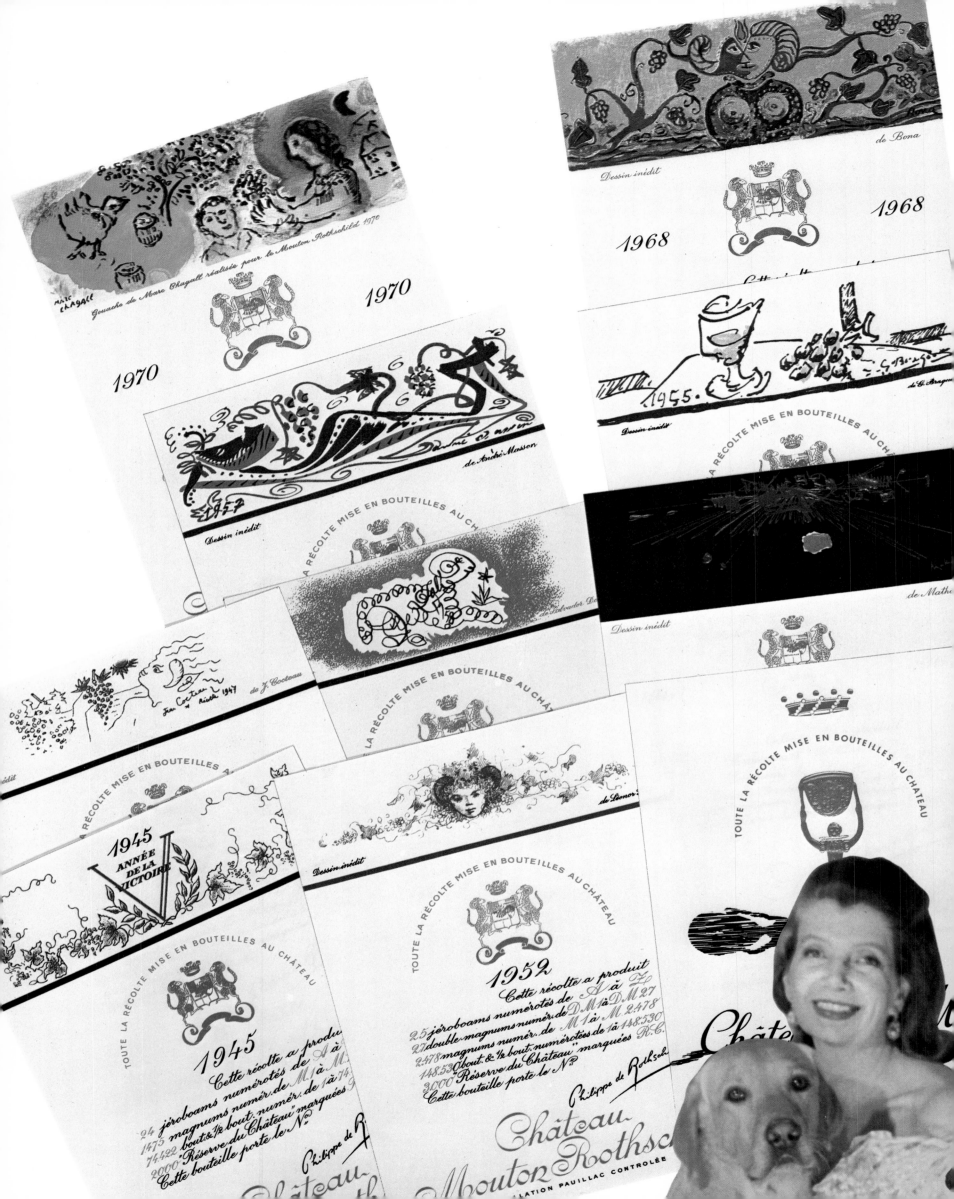

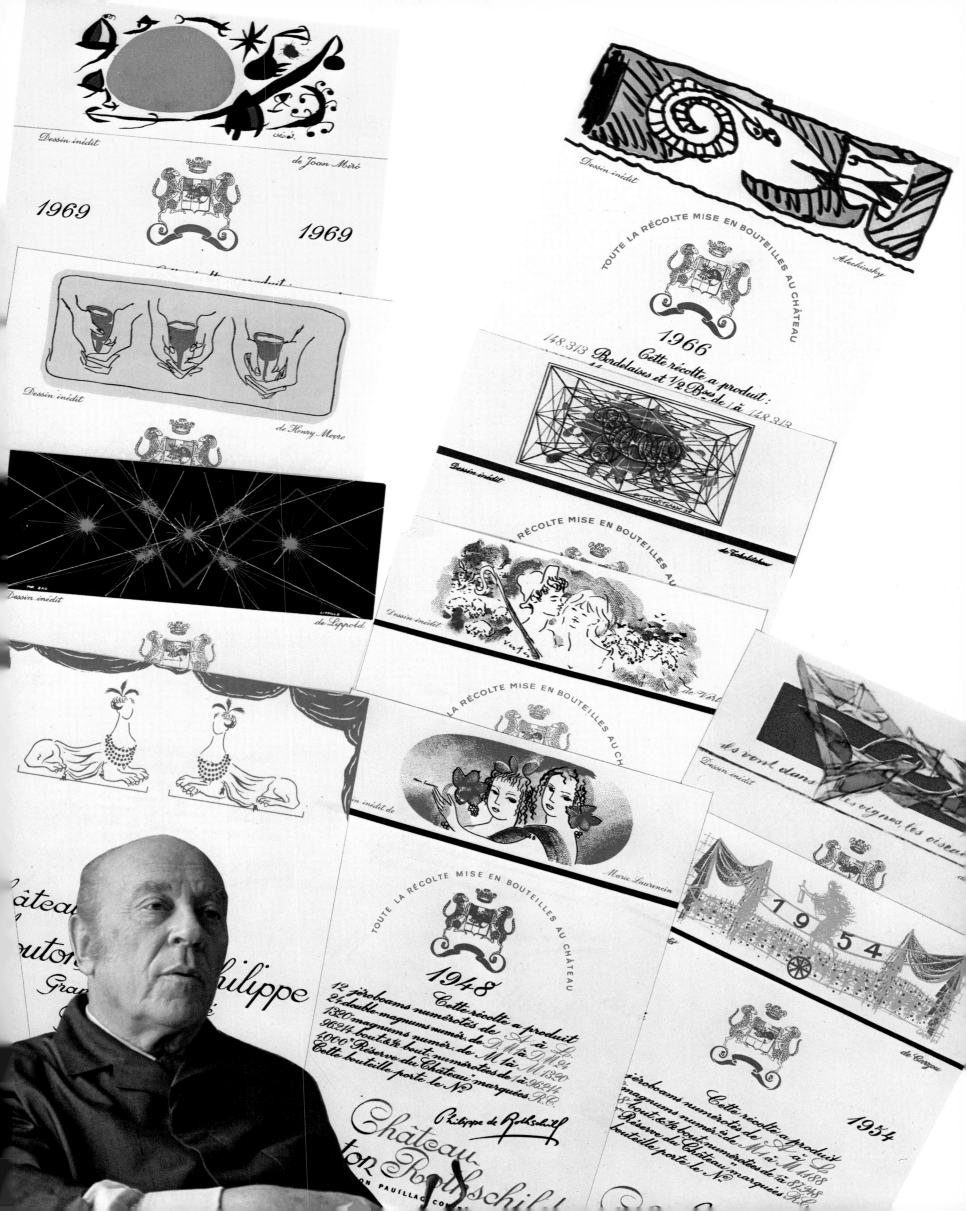

Dessin inédit de Joan Miró

1969 1969

Dessin inédit de Henry Moore

Dessin inédit de Lippold

TOUTE LA RÉCOLTE MISE EN BOUTEILLES AU CHÂTEAU

1966

Cette récolte a produit :

148.313 Bordelaises et ½ Bles de 1 à 148.313

Dessin inédit de Pichliskew

RÉCOLTE MISE EN BOUTEILLES AU

Dessin inédit de de Vert

LA RÉCOLTE MISE EN BOUTEILLES AU CH

Marie Laurencin

TOUTE LA RÉCOLTE MISE EN BOUTEILLES AU CHÂTEAU

1948

Cette récolte a produit
12 jéroboams numérotés de J à L.
24 double-magnums numér.
1390 magnums numér. de M¹ à M 1390
96924 bout.& ½ bout. numérotées de 1 à 96924
1000 Réserve du Château marquées R.C.
Cette bouteille porte le N°

Philippe de Rothschild

Château
ton Rothschild
PAUILLAC

Dessin inédit

ils vont dans
les vignes, les oiseaux

de Carzou

1954

1954

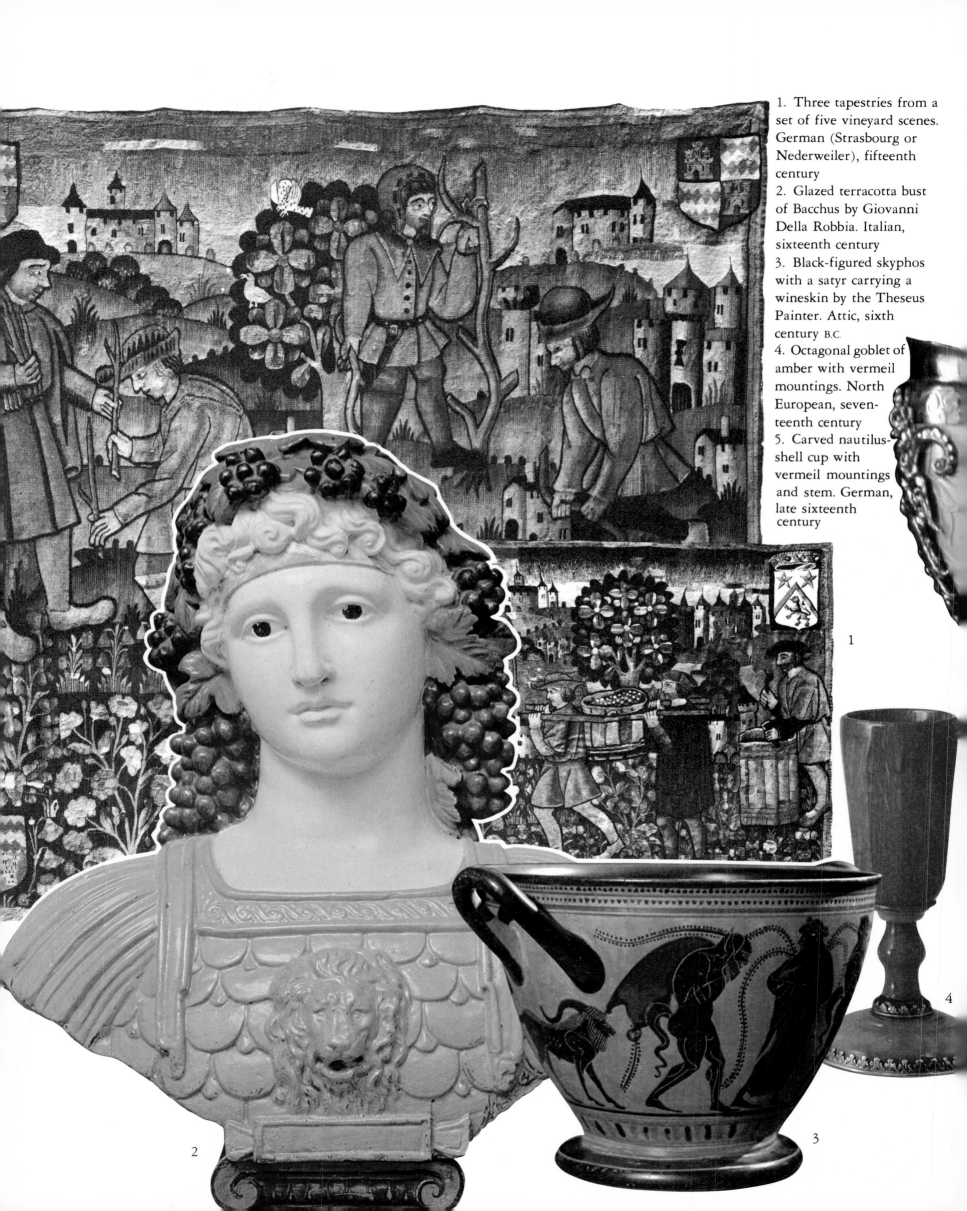

1. Three tapestries from a set of five vineyard scenes. German (Strasbourg or Nederweiler), fifteenth century

2. Glazed terracotta bust of Bacchus by Giovanni Della Robbia. Italian, sixteenth century

3. Black-figured skyphos with a satyr carrying a wineskin by the Theseus Painter. Attic, sixth century B.C.

4. Octagonal goblet of amber with vermeil mountings. North European, seventeenth century

5. Carved nautilus-shell cup with vermeil mountings and stem. German, late sixteenth century

1

2

3

4

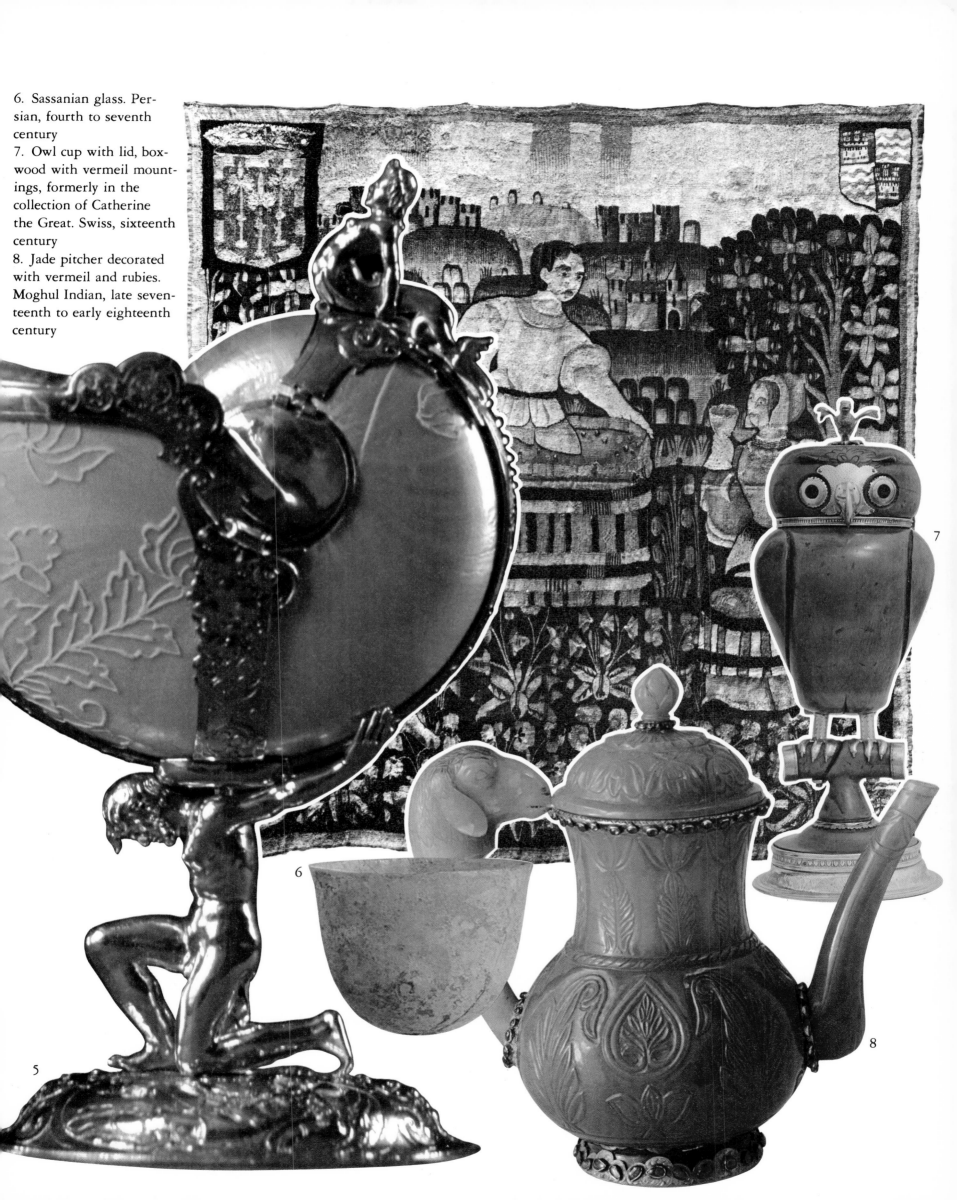

6. Sassanian glass. Persian, fourth to seventh century

7. Owl cup with lid, boxwood with vermeil mountings, formerly in the collection of Catherine the Great. Swiss, sixteenth century

8. Jade pitcher decorated with vermeil and rubies. Moghul Indian, late seventeenth to early eighteenth century

5

6

7

8

Château Margaux's classic facade, framed by the double row of trees, is well known from the label of one of the five great First Growths of the Médoc

Saint-Julien. Though Saint-Julien can claim no First Growths, the commune produces superlative wines among the châteaus of the second, third, and fourth ranks. Such vineyards as Ducru-Beaucaillou, Gruaud-Larose, the three Léovilles (Léoville-Las-Cases, Léoville-Poyferré, and Léoville-Barton), Beychevelle, Talbot, as well as a number of others, make lovely wines year after year. Lying between Pauillac and Margaux, Saint-Julien draws a bit from the style of each. Slightly fuller in body than a Margaux, the typical Saint-Julien bears more resemblance to some of the wines of Pauillac. Saint-Julien wines are relatively quick to mature and, like Margaux wines, have a rather tender quality that makes them highly desirable. Each of the Léoville wines is excellent, as is the wine from Château Talbot, one of the largest vineyards in the Médoc. Beychevelle, usually considered the most beautiful château in all Bordeaux, produces very good, very popular wine. While the name Pauillac rarely appears by itself on a label, since most of the vineyard lands belong to the important châteaus and there is little ground to cultivate for regional wine, the commune wines of Saint-Julien can be found more frequently, and generally can be counted on for excellent value.

Margaux. The noble name Margaux sometimes leads to confusion, since it applies both to a commune and to a specific vineyard. Its greatest distinction derives from Château Margaux, a First Growth whose wines are noted for their exquisite breed, velvety texture, and richly haunting bouquet. These

Claret bottles resting on their sides form a brilliant honeycomb pattern

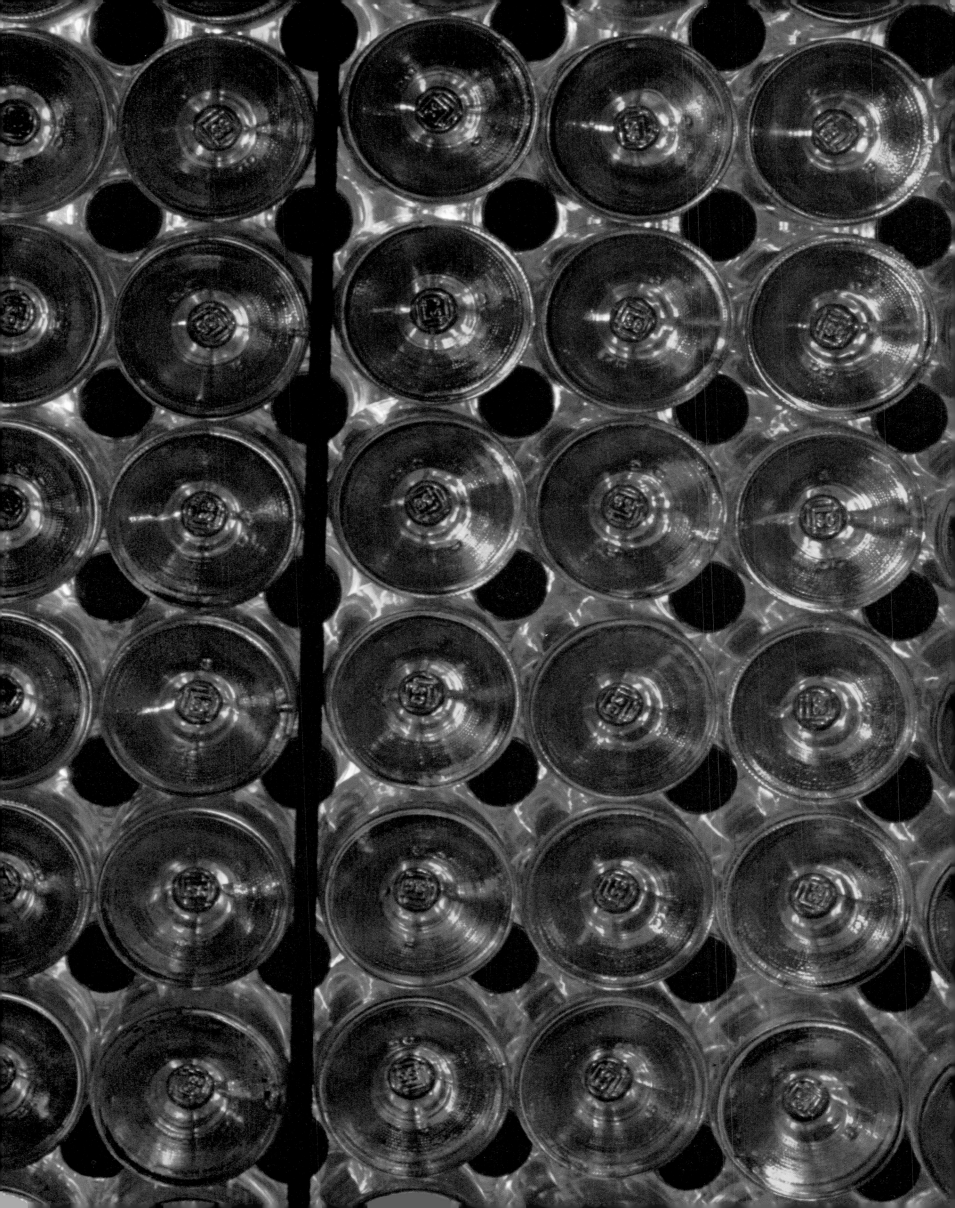

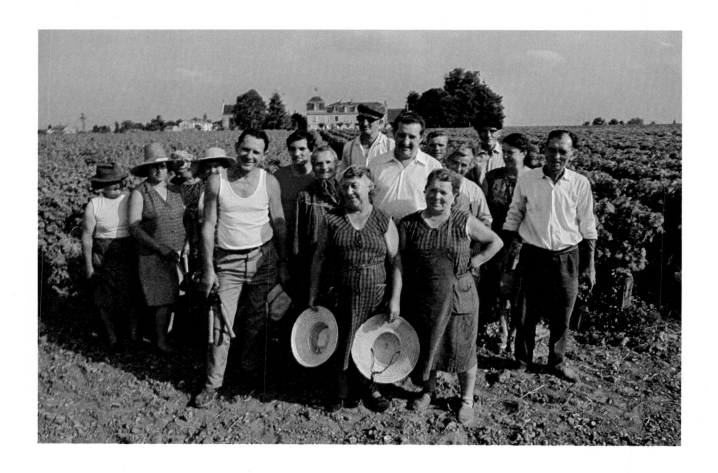

supple wines from the southernmost of the famous communes ripen early into suave and silky beauties possessing the floweriest fragrance of any wine from the Médoc. With much agreeable commune wine being rightfully sold under the name Margaux, the unwary buyer may take this to be the wine of the famous château. The considerable price difference, however, is a clue to the quality of the wines; on being tasted, they immediately show the reasons for the widely differing cost. The stately gates and the columned facade of Château Margaux are as graceful and elegant as the wine it produces. Perhaps this is partly what tempted the father of its present owner, Fernand Ginestet, to sell his other holdings in the Médoc in order to assume sole ownership of the château in 1949.

If a certain masculinity characterizes the vigorous wines of Pauillac, its complement is to be found in the feminine delicacy and suppleness of all good Margaux wines. Besides the marvelous wines of Château Margaux, several other outstanding wines from the commune command attention year after year. Among these are Châteaus Palmer, Lascombes, Brane-Cantenac, Giscours, and Rausan-Ségla. Good wines can also be had from Boyd-Cantenac, Rauzan-Gassies, Malescot-Saint-Exupéry, Prieuré-Lichine, and Kirwan, as well as other

The elegant château wines are given their start by teams of harvesters who pick the ripe grapes for the winery

234

classified Third and Fourth Growths. Château Palmer always commands prices as high as any except the First Growth châteaus of the Médoc. Lascombes and Prieuré-Lichine are the superb creations of Alexis Lichine, who sold the former vineyard in 1972 to the English brewers Bass-Charrington.

Four other neighboring communes—Cantenac, Soussans, Arsac, and Labarde—are also entitled to the designation Margaux, if their soil, as ascertained by experts, is of typical Margaux quality.

As has been noted, in 1855 a selected group of Bordeaux wine authorities were requested to rank the very finest vineyards of the Médoc in five categories. Sixty-two vineyards won this elite standing. The judges also placed Château Haut-Brion of Graves in this top group, since they could not overlook its world-famous wine. The 1855 list of honor appears below, with the 1973 inclusion of Mouton-Rothschild among the First Growths and with current production figures and my own comments on the vineyards and the wines.

1855 Official Classification of the Great Growths of the Médoc (as Amended in 1973)

Château	Commune	Estimated Current Production in Cases	Comments
FIRST GROWTHS			
Lafite	Pauillac	25,000	Elegance and finesse; relatively light, owing to a high proportion of the Merlot grape. Great.
Margaux	Margaux	20,000	Elegant, suave, and delicate wine, certainly the most feminine of all the First Growths.
Latour	Pauillac	25,000	With a high Cabernet Sauvignon content, robust, deep, and full-bodied; a noble wine needing years to mature.
Haut-Brion	Pessac	18,000	Very full and rich, even in years when lesser vineyards falter.
Mouton-Rothschild	Pauillac	25,000	Though not as delicate as Lafite, the wine has its own special depth and grandeur. Remarkable.
SECOND GROWTHS			
Rausan-Ségla	Margaux	10,000	Fine and perfumed, a light and velvety wine.
Rauzan-Gassies	Margaux	8,000	Delicate, but a bit thin; the wine is no longer considered the equal of other Second Growths.
Léoville-Las-Cases	Saint-Julien	20,000	Excellent, justly famous wine, always full of flavor. Well-balanced.

Léoville-Poyferré	Saint-Julien	20,000	A worthy rival of Las-Cases, usually the fullest of the three Léovilles.
Léoville-Barton	Saint-Julien	15,000	A solid Second Growth, with good body in great vintages.
Durfort-Vivens	Margaux	7,500	A well-made wine, but often not so good as many others of this rank. Not prominent.
Gruaud-Larose	Saint-Julien	25,000	Popular, fruity, and fast-maturing.
Lascombes	Margaux	25,000	Now has the status of one of the best of the Second Growths. Exceptional bouquet and finesse.
Brane-Cantenac	Cantenac	25,000	Big and dependable, but sometimes coarse. Not one of the leaders.
Pichon-Longueville-Baron	Pauillac	18,000	A consistent, rich, and powerful wine.
Pichon-Lalande	Pauillac	20,000	Suppler and lighter than the other Pichon.
Ducru-Beaucaillou	Saint-Julien	15,000	Now manifesting the full richness afforded by its pebbly soil.
Cos d'Estournel	Saint-Estèphe	25,000	Lighter than other wines of this commune, but still full, fine, and sturdy.
Montrose	Saint-Estèphe	25,000	Relatively hard, extremely long-lived. Popular in England.

THIRD GROWTHS

Kirwan	Margaux	10,000	Improved, but no longer of Third Growth status.
Issan	Margaux	10,000	A rich, proud, and typically delicate Margaux wine.
Lagrange	Saint-Julien	22,000	Coarse and slow maturing, not the equal of most of the other Third Growths.
Langoa-Barton	Saint-Julien	15,000	Good, typical Saint-Julien, lighter than its Léoville neighbor.
Giscours	Labarde	25,000	Delicate and improved; now rather popular.
Malescot-Saint-Exupéry	Margaux	10,000	Elegant and richly bouqueted, a sound Third Growth.
Cantenac-Brown	Cantenac	10,000	Big, strong, and improving, the wine still deserves its rank.
La Lagune	Ludon	25,000	Slow to mature, with a bit of the taste of the wines from Graves. Perhaps deserves a higher rank.
Palmer	Margaux	17,000	Elegant, good bouquet; highest-priced except for First Growths.
Desmirail	Margaux	—	No longer exists; has been absorbed by its neighbor Palmer.
Calon-Ségur	Saint-Estèphe	22,000	With Montrose, possibly the most robust and long-lived of the Saint-Estèphes.
Ferrière	Margaux	—	No longer exists; has been absorbed by its neighbor Lascombes.
Marquis d'Alesme Becker	Margaux	5,000	Not well-known; a minor wine no longer of Third Growth status.
Boyd-Cantenac	Cantenac	5,000	Light and well-made, but little-known.

FOURTH GROWTHS

Saint-Pierre	Saint-Julien	10,000	Sound, light, not overly interesting wine. Hard to find. (In 1855 called Saint Pierre Bontemps and Saint Pierre-Sevaistre.)
Talbot	Saint-Julien	30,000	Dependable, big, and fruity wine that might even deserve a higher rank.
Branaire-Ducru	Saint-Julien	15,000	An uneven wine, but one that has lately shown improvement.

Duhart-Milon	Pauillac	15,000	A wine to watch, now often as good as some Second Growths.
Pouget	Margaux	5,000	The lesser wine of Boyd-Cantenac. Not of great distinction.
La Tour-Carnet	Saint-Laurent	10,000	Obscure and unexceptional in recent years; in 1966 its return to excellence began.
Lafon-Rochet	Saint-Estèphe	15,000	Won an award as the best of the great 1970 Saint-Estèphes. Happy harmony of the long-lived hardness of Saint-Estèphe and the complexity of Pauillac, which it borders.
Beychevelle	Saint-Julien	25,000	Very elegant, popular Médoc, worthy of Second Growth rank.
Prieuré-Lichine	Cantenac	15,000	Flavorful and fast-maturing, the wine can challenge many a Third Growth.
Marquis-de-Terme	Margaux	20,000	One of the better of its class; rich and full.

FIFTH GROWTHS

Pontet-Canet	Pauillac	40,000	Largest single classified vineyard of the Médoc. Opposite Mouton-Rothschild, but the wine is a bit lighter.
Batailley	Pauillac	20,000	Good average quality, but not distinguished.
Haut-Batailley	Pauillac	10,000	Until 1942 part of the above estate. The wines are similar in characteristics.
Grand-Puy-Lacoste	Pauillac	15,000	Excellent, dependable wine deserving a higher rank.
Grand-Puy-Ducasse	Pauillac	10,000	Has less body than Grand-Puy-Lacoste. Finesse.
Lynch-Bages	Pauillac	22,000	Rich, concentrated. Often called "the poor man's Mouton-Rothschild" because of its power and depth.
Lynch-Moussas	Pauillac	10,000	Like the above château, once the property of an Irish Mayor of Bordeaux named Lynch. The wine is well known in the Low Countries but almost unheard-of in Britain and the United States. Not long-lived.
Dauzac	Labarde-Margaux	15,000	Until recently rather undistinguished, but projects a better future.
Mouton-Baron-Philippe	Pauillac	15,000	Can be considered a lighter version of the famous Mouton-Rothschild. The estates are adjacent and have the same proprietor.
du Tertre	Arsac-Margaux	15,000	Acceptable wine, without the majesty of the other classified growths.
Haut-Bages-Libéral	Pauillac	10,000	Full, powerful, and improving.
Pédesclaux	Pauillac	6,000	Obscure, far from outstanding
Belgrave	Saint-Laurent	15,000	Full, fruity, but varies from year to year.
Camensac	Saint-Laurent	12,000	Pleasant but lacking in distinction.
Cos Labory	Saint-Estèphe	7,500	Like other Saint-Estèphes, big and long-lived.
Clerc-Milon	Pauillac	8,000	Full and rich, now one of the holdings of the Mouton-Rothschild *domaine*.
Croizet-Bages	Pauillac	10,000	Good, but not outstanding.
Cantemerle	Macau	15,000	Very fine and light, with an excellent bouquet; should have a higher rating.

In the more than a century that has passed since the 1855 classification was established, the quality of the wines from some of the vineyards has fallen off and the quality of others has improved. As noted, one official change has taken place: in 1973 Mouton-Rothschild was raised from Second to First Growth status by the French Minister of Agriculture.

According to my research, the Médoc châteaus listed below in alphabetical order have shown so much merit during recent decades that they are worthy of being considered the equals of the Fifth Growths of the original 1855 classification.

Recommended Additions (as of 1975) to the Official Classification

Château	Commune	Estimated Current Production in Cases	Comments
Angludet	Margaux	10,000	Light and very supple; quite an engaging wine.
Bel-Air-Marquis-d'Aligre	Margaux	10,000	Consistently exhibits the finesse and delicacy associated with Margaux wines.
Chasse-Spleen	Moulis	20,000	Exceptional wine has been produced since the mid-1950s.
Fourcas-Dupré	Listrac	10,000	Full, long-lived.
Fourcas-Hosten	Listrac	12,000	Rich, even, and well-balanced.
Gloria	Saint-Julien	17,000	Similar in style to Léoville-Poyferré, and almost its equal.
de Pez	Saint-Estèphe	13,000	Directly opposite Calon-Ségur; the wine has the same depth and excellence.
Phélan-Ségur	Saint-Estèphe	20,000	With the richness, tannin, and depth typically associated with Saint-Estèphe.
Siran	Margaux	7,000	Much improved. Softly perfumed.

GRAVES

South and west of the city of Bordeaux lie the vineyards of Graves, producing very pleasant wines and—in the case of several, notably Haut-Brion—very great wines as well. Graves (the French word means "gravelly ground") is a gift from the Garonne River, which bears sand and gravel from the hills and deposits them here as it does in the Médoc. Originally Graves was known for its white wines, but the reds have long since come into their own, gaining the attention and acclaim they deserve. Though they do resemble certain Médocs, Graves wines tend to be sturdier, asserting themselves with an appealing forthrightness. In their attempt to achieve Haut-Brion's superb fruit, deep flavor, and lingering bouquet, some of the Graves come quite close

The dry white wines of Bordeaux are well suited to fish and seafood. Entre-Deux-Mers ("Between Two Seas") lies across the Gironde River from Graves, but its wines, less expensive, lack the quality of a good Graves

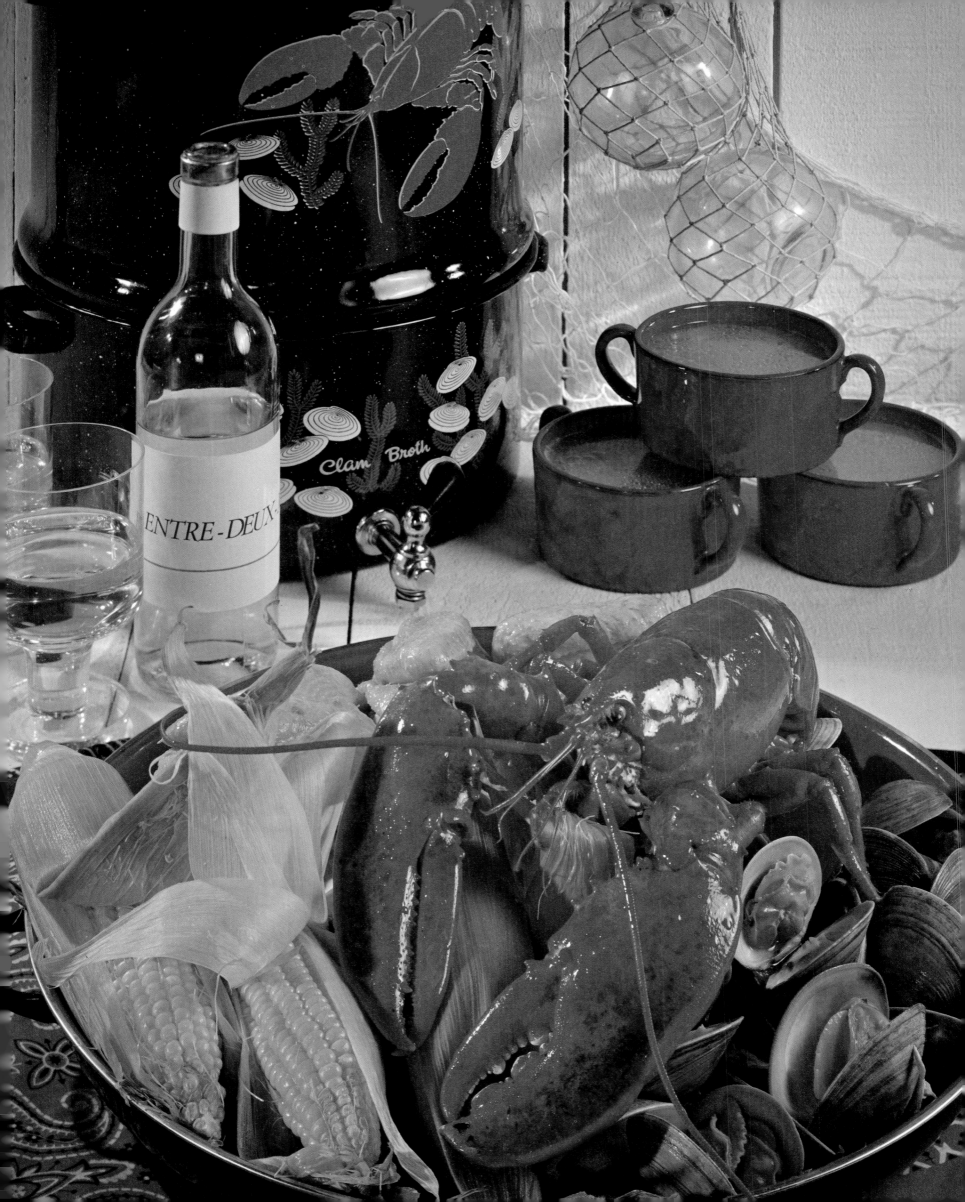

—especially La Mission Haut-Brion and Domaine de Chevalier. Other fine vineyards must be mentioned: Bouscaut, Haut-Bailly, Pape-Clément, and La Tour-Haut-Brion. The great Haut-Brion vineyard was acquired in 1935 by the American financier Clarence Dillon. La Mission Haut-Brion and La Tour-Haut-Brion belong to the Woltner family.

The white wines of Graves are somewhat less distinguished than the reds, though some châteaus with high standards produce a light, pleasantly dry white wine (often in vintages that were poor for red wines). However, a great deal of white Graves, sold simply as Graves, is rather thin, sweetish, and undistinguished. One can expect to find the best of the white Graves coming from these superior vineyards: Domaine de Chevalier, Bouscaut, Laville-Haut-Brion, Carbonnieux, and Olivier. While Haut-Brion Blanc is considered the best dry white of Bordeaux, it should be made clear that none of the whites is today in the exalted class of the reds.

The moated Château Olivier in Graves, dating from the thirteenth century, was at one time the Black Prince's hunting lodge. Its vineyards produce a well-known white and red, both *Grands Crus*

1959 Official Classification of the Great Growths of Graves

Château	Commune	Production in Cases	Comments
Haut-Brion	Pessac	18,000 red	Concentrated, earthy, handsome, and long-lived.
		1,000 white	The dry white, relatively recent, is a rarity.
La Mission Haut-Brion	Pessac	12,000 red	Second only to Haut-Brion, its neighbor across the road.
Haut-Bailly	Léognan	7,500 red	Rich, deep, slow to mature.
Domaine de Chevalier	Léognan	5,000 red	Red is considered equal to a Second Growth of the
		2,000 white	Médoc. White is dry, complex, and elegant.
Fieuzal	Léognan	5,000 red	Small production, scarcely seen outside France.
Malartic-Lagravière	Léognan	5,000 red	Not well-known in the United States and Britain.
		800 white	
Latour-Martillac	Martillac	5,000 red	A leading property, making an excellent wine.
		1,500 white	
Smith-Haut-Lafitte	Martillac	10,000 red	Long-lived, but not among the very best.
		1,500 white	
Olivier	Léognan	7,000 red	The dry white wine is featured on good wine lists
		10,000 white	in Europe and America.
Bouscaut	Cadaujac	15,000 red	Dramatically improved quality. Fine perfume.
		2,000 white	
Pape-Clément	Pessac	10,000 red	Great wine. Consistently commands a high price.
Couhins	Villenave d'Ornan	3,000 white	Pleasant, but not great.
Laville-Haut-Brion	Talence	2,500 white	Complex, dry, and altogether excellent.
Carbonnieux	Léognan	8,000 red	Good
		10,000 white	Pale, dry, good fruit; one of the best.
La Tour-Haut-Brion	Talence	1,500 red	Full, fine, but sometimes hard.

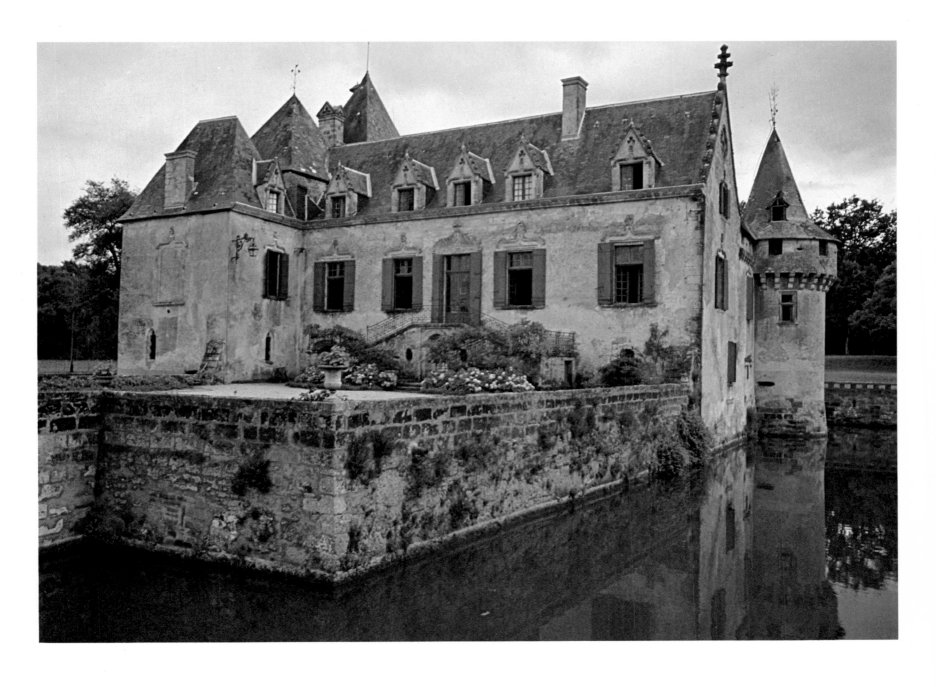

SAINT-ÉMILION

The charming ancient town of Saint-Émilion overlooks the valley of the Dordogne River. Its vineyards, the oldest of Bordeaux, spread out along the escarpment surrounding it on three sides, north, west, and south. The wines of Saint-Émilion are known for their generous nature—perhaps the most generous of all Bordeaux. Robust, warm-hearted wines, they are attractive even when drunk young. Their full and savory character has led them to be called "the Burgundies of Bordeaux" (though neither the Burgundians nor the Bordelais approve of the expression, it nevertheless contains some truth). The two greatest wines of Saint-Émilion, Cheval Blanc and Ausone, are in a class by themselves, ranking with the four top Médocs, Haut-Brion of Graves, and Petrus of Pomerol as the most remarkable wines of Bordeaux. Cheval Blanc is a true thoroughbred—its 1947 vintage is legendary. This is the wine that the shipper Jean Calvet served

241

me when, a few years ago, he kindly offered what he considered the best red wine of Bordeaux for present drinking. Cheval Blanc is a wine of tremendous power and depth, with more fragrance than is usual for a Saint-Émilion. Ausone, named for the Roman poet Ausonius, who is believed to have owned the vineyard in the fourth century, is a wine with a noble past. Its 1920 vintage is an unforgettable classic. However, since World War II the wine, though achieving a high average, has never quite attained the peaks it once reached. Experts now consider Figeac the second-finest wine of Saint-Émilion.

Because they are fruity and quick to mature, Saint-Émilions are often in youth the most attractive of the red Bordeaux. In barrel, Cheval Blanc will always outtaste Lafite or Haut-Brion, but time cancels that early lead. We must remember that the Merlot and Cabernet Franc grapes used to a great extent in Saint-Émilion produce softer vintages. Saint-Émilion regional wines are especially attractive during their younger years.

Listed below are the *Premiers Grands Crus Classés,* headed by Cheval Blanc and Ausone. Among my favorites in this exalted area are Figeac, Pavie, and Canon. The 1955 Saint-Émilion committees were wise to have the lesser vineyards drop the word *Premier,* calling themselves simply *Grands Crus*—and there are dozens of them. In this category, the ones that I particularly enjoy are Chauvin, Dassault, Grand Pontet, Pavie-Macquin, Ripeau, Tertre-Daugay, Trimoulet, and Troplong-Mondot. All are blessed with the roundness and fruit associated with all the good wines of Saint-Émilion.

The cobbled streets and tiled roofs of Saint-Émilion follow the steep slope of the old hill town. For more than 1,500 years it has been famous for its wines; the hermit cave of Saint-Émilion, as well as Roman ruins, are reminders of the town's antiquity

1955 Official Classification of the Great Growths of Saint-Émilion

Château	Production in Cases	Comments
Cheval Blanc	16,000	Saint-Emilion's best. Very full, very expensive.
Ausone	3,500	Still remarkable, but not what it once was.
Beauséjour-Dufau-Lagarrosse	3,000	Because of a very small production, rarely seen.
Beauséjour-Bécot	3,500	Seldom seen on wine lists.
Belair	10,000	Adjacent to Ausone; the wine has much of the same class.
Canon	9,000	Full, rich, and long-lived.
Clos Fourtet	8,000	Sturdy and deep, very popular in the United States.
Figeac	10,000	Deep and fruity; one of the finest Saint-Emilions.
La Gaffelière	11,000	Formerly La Gaffeliere-Naudes. Especially full-flavored.
Magdelaine	4,000	Neighbors Ausone and Belair; the wines are similar in style.
Pavie	18,000	Light-bodied, well-balanced, fine.
Trottevieille	6,000	Smooth, elegant, much finesse.

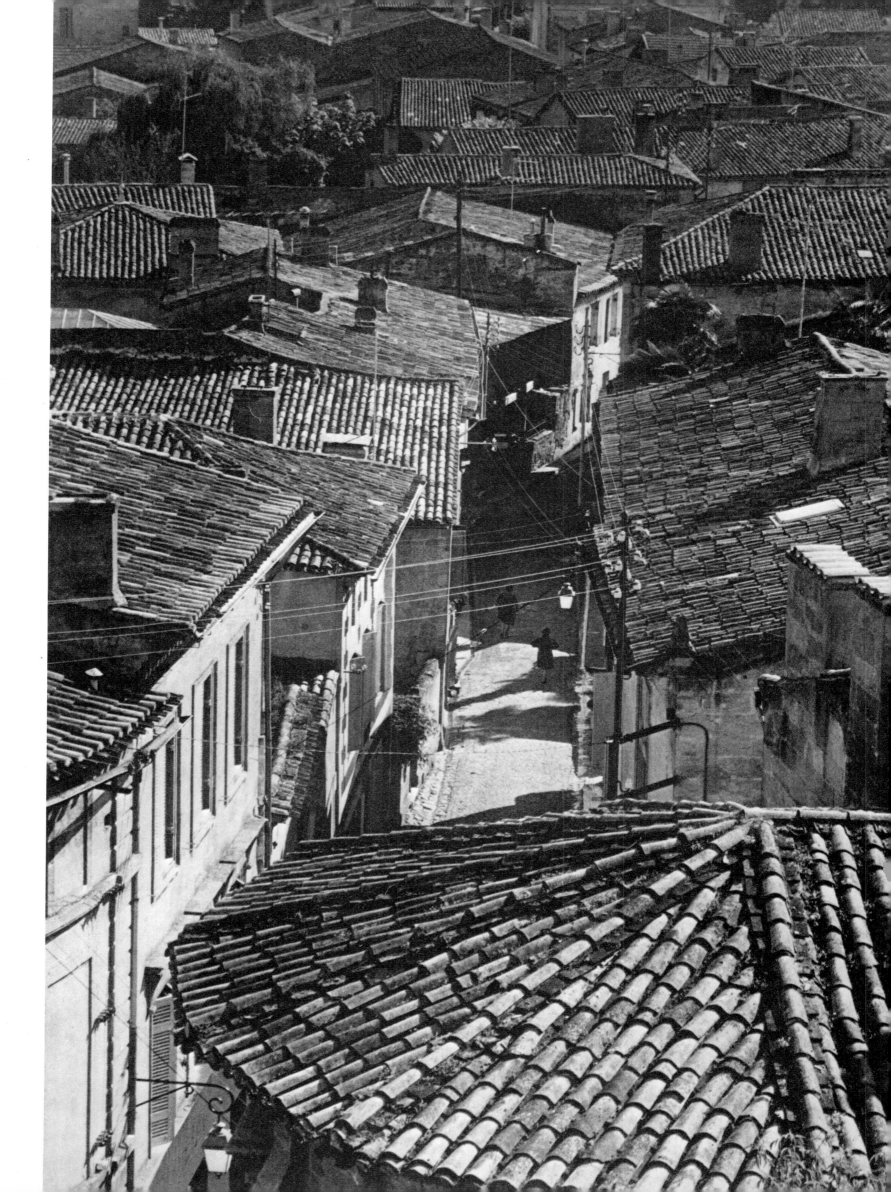

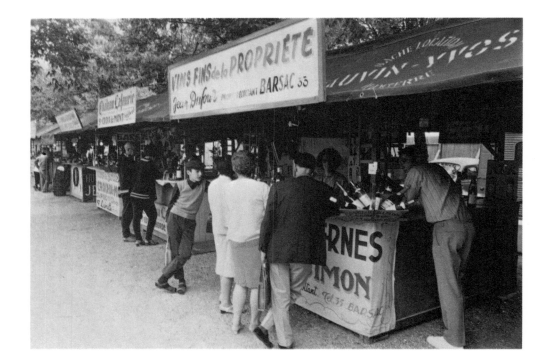

At the annual Agricultural Fair in Lesparre the sweet wines of Barsac are popular with visitors

POMEROL

Adjoining Saint-Émilion is Pomerol, the smallest district in Bordeaux. Its high plateau is dotted with the best châteaus, whose fruity Pomerol wines mature even earlier than the Saint-Émilions do. As in several of the other regions of Bordeaux, liberal use of the Merlot grape imparts softness and delicacy to the wines. (In Pomerol the Merlot makes up about three-quarters of the vineyard plantings.) Despite their early maturation, the wines have excellent staying power. Though for years they were overshadowed by the bigger, more complex wines of the Médoc, Pomerols are now accorded the respect they justly deserve. The undisputed leader of the Pomerol vineyards, Château Petrus, is considered the peer of the First Growths of the Médoc. I shall never forget my 1956 visit, with Frank Schoonmaker, to Mme. Loubat, the proprietor of Château Petrus. Mr. Schoonmaker (on behalf of Henri Soulé of Le Pavillon restaurant in New York) purchased 500 cases of her great wine from the 1952 and 1953 vintages at $35 a case. Both these wines brought $800 a case wholesale in 1973.

In poor years some Pomerols can be quite good, maintaining a remarkable continuity of gentle roundness and ripe scent. Though there is no official classification, certain wines do stand out. Following, in my own estimation, are the better Pomerols in the rank below Petrus: Gazin, La Fleur, La Fleur-Petrus, Latour-Pomerol, Nénin, Petit-Village, Rouget, Trotanoy, and Vieux-Château-Certan.

SAUTERNES AND BARSAC

Sauternes, the fifth of the districts that lend great distinction to the region of Bordeaux, produces the luscious, fruity, and dra-

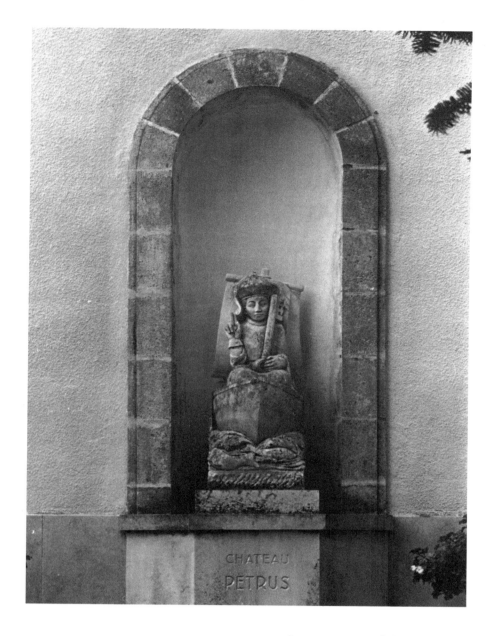

The greatest Pomerol comes from
Château Petrus, namesake of
Saint Peter, whose statue blesses
the vines

matic sweet white wine acclaimed everywhere. In a world
where both natural and concocted sweet white wines are
grown in practically every winemaking country, Sauternes is
supreme. Only the *Beerenauslese* and *Trockenbeerenauslese*
wines of Germany and the Tokay Eszencia of Hungary are true,
if essentially different, peers. Most people think of Sauternes
as an accompaniment to dessert, but the vogue in France is to
serve it icy cold with foie gras as the prelude to dinner. I first
encountered this noble pairing as a guest of Louis Vaudable at
Maxim's in 1956. Skeptical in the beginning, I soon recognized
the accord between the silky texture of the foie gras and the cold
unctuousness of the Yquem. The wine's low temperature re-
duced its sweetness; harmony prevailed.

Making Sauternes is extremely costly, and only the best
châteaus can afford to do it properly. Beginning in October, the
pickers go into the vineyards to clip, one by one, those clusters of
grapes that have been attacked by the dusty mold *Botrytis cine-
rea.* This special fungus, developing fully only in great vintages,
transforms the grapes from a state of complete ripeness to one

245

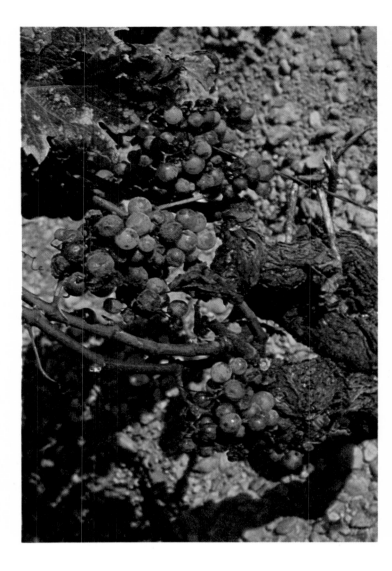

From these overripe and shriveled
grapes is made the greatest sweet
wine of France, Château d'Yquem.
The picking begins in late autumn,
and grapes are selected one by one,
with the harvesters working over
the vines repeatedly for more than
a month

The fifteenth-century Château
d'Yquem is a fortress commanding
its 200 or so acres of vineyard
from the top of a gentle slope

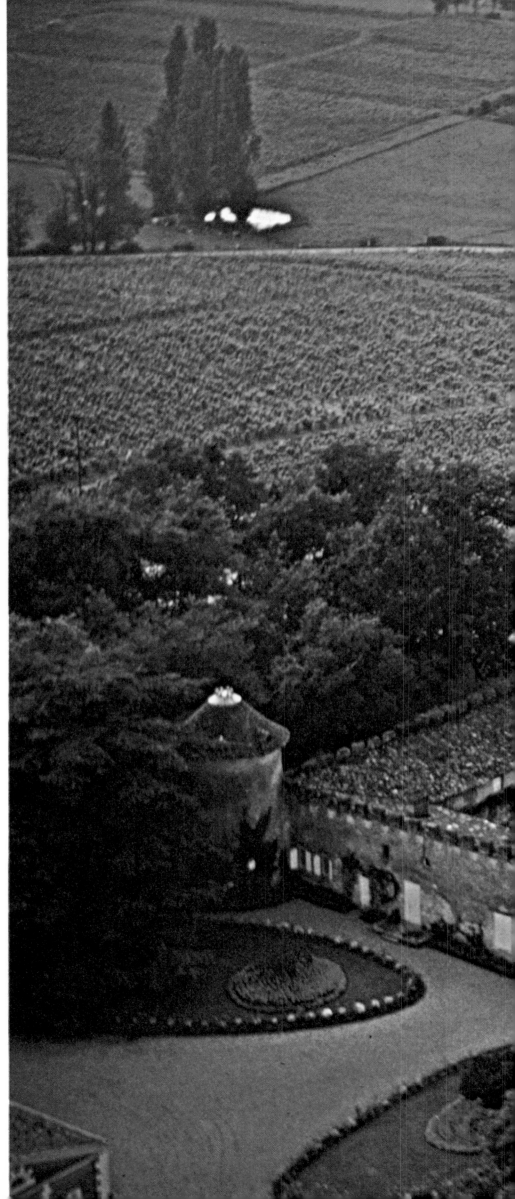

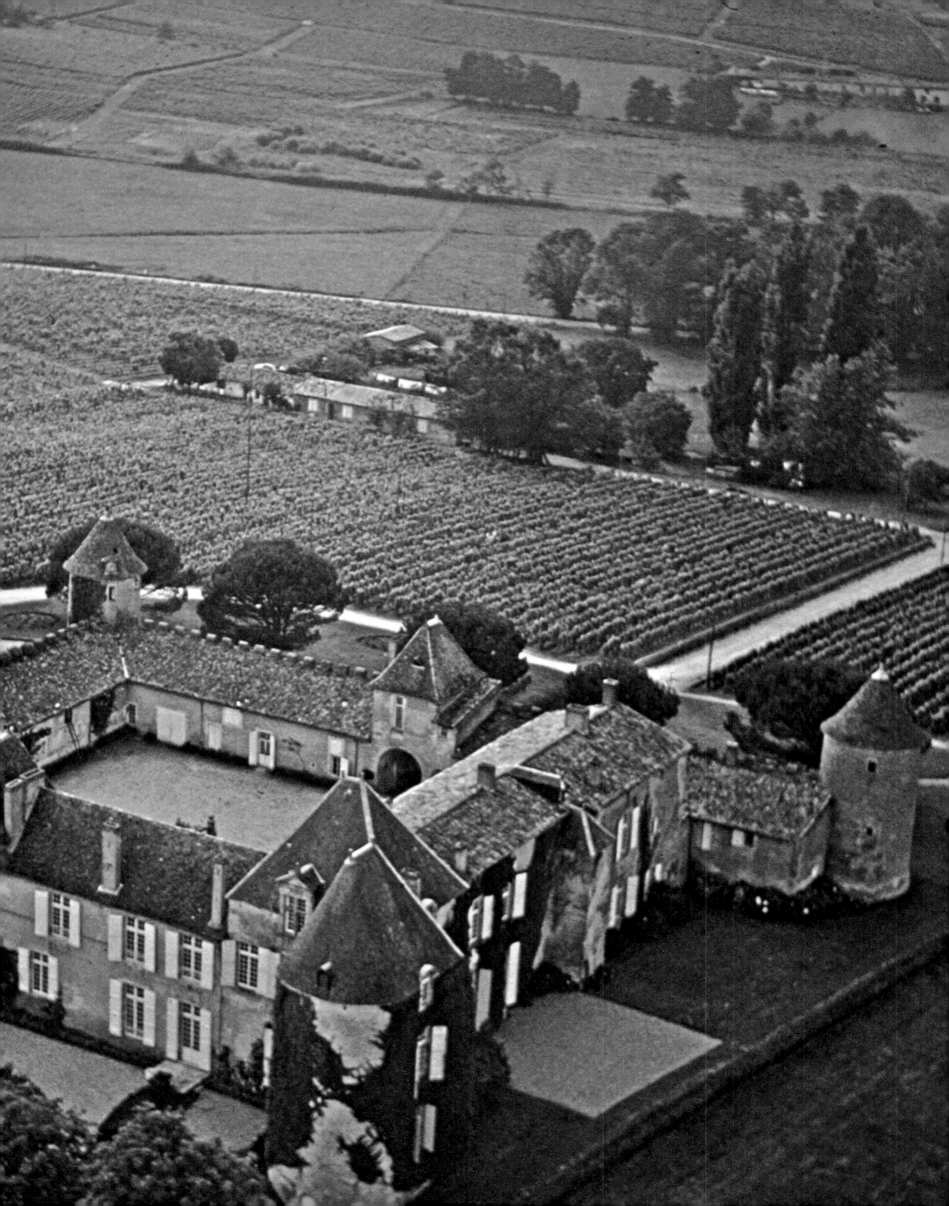

of *pourriture noble,* or "noble rot." The botrytis allows the water in the grapes to escape, leaving in its wake a rich concentration of fruit, sugar, and natural acids. The tedious method of harvesting, repeated as many as eight or nine times, weather permitting, may continue in a fine year into December, until the last grape has succumbed to the fungus and then to the field hand's knife. Since a grape contains but little juice, every one is precious. More than in any other Bordeaux wine district, the success of the wine of Sauternes depends on the weather. First, it must enable the grapes to ripen completely; second, the conditions must be right for the growth of the *Botrytis cinerea*; finally, good weather must hold through the harvest. One heavy rain, one hailstorm, one severe frost, can destroy the carefully nurtured, nobly rotting grapes. The risk is great, but somehow the gamble enhances the breed of the greatest wines. In poor years (of which there have been many in the last decade), either the vineyards produce no Sauternes worth the name or the grapes are vinified into an undistinguished dry white wine.

Tart Sémillon and fruity Sauvignon Blanc grapes are used almost exclusively in the making of a Sauternes. A tiny bit of Muscadelle may be added to balance the character of some of the wines.

There are five communes in the district which may bear the Sauternes *Appellation Contrôlée:* the town of Sauternes itself, Barsac, Bommes, Preignac, and Fargues, all represented by at least one of the classified First Growth châteaus established long ago. The Sauternes vineyards were rated in 1855, the same year that the great classification of the Médoc was completed. Interest in the finest wines of Sauternes was so great during the nineteenth century that the experts felt it necessary to create an official list of the top wines. At the head of the ranking stands Château d'Yquem. Its magnificence is not exaggerated: superb, smooth sweetness, almost creamy but never cloying, utterly luscious fruit, and a rich perfume redolent of flowers and spices. The large vineyard and impressive château, dating back to the twelfth century, have long been the property of the distinguished de Lur-Saluces family. Early in the last century, the winemakers of the Marquis de Lur-Saluces learned the art of select picking from German growers in the Rheingau. With their new knowledge came the first deliciously sweet Yquems. Only recently, at Château Rausan-Ségla in Margaux, I experienced (there is no other word for it) a bottle of 1893 Yquem. Though dark in color, the wine was a triumph of the freshness and fruit associated with the historic vineyard. Fruit

Clos Fourtet is one of the top wines of Saint-Émilion. As is customary in many fine Bordeaux wineries, the nozzles, pipes, spigots, and other winemaking tools are hung in a beautifully composed still life, the artist-craftman's pride

sugar not only brings us a flower garden of bouquet and taste but preserves the wine for many decades.

Eleven vineyards are classed below Yquem. Several, such as Coutet, Climens, Rayne-Vigneau, Suduiraut, and Haut-Peyraguey, approach the pinnacle of perfection that Yquem invariably attains. Coutet and Climens are in the commune of Barsac, the one part of the Sauternes district famous enough to be granted its own *Appellation Contrôlée*.

It is not fashionable (alas!) at present to serve Sauternes, though it once graced the tables of European monarchs at every banquet. No true wine lover should deny himself the exquisite pleasure that this rich, golden wine affords. But be forewarned not to chill it into numbness. Severe cold can mask a multitude of sins in an inferior wine, but fine Sauternes has nothing to hide, and every nuance of its majesty should be enjoyed.

The 1855 classification of the Sauternes vineyards ranked the various châteaus in three categories: First Great Growth, First Growths, and Second Growths. Listed below are the first two categories, for among the Second Growths only Filhot and Doisy-Daëne are well known.

1855 Official Classification of the Great Growths of Sauternes and Barsac

Château	Commune	Estimated Current Production in Cases	Comments
FIRST GREAT GROWTH			
Yquem	Sauternes	11,000	One of the most famous vineyards in the world. The wine, very rich and distinctly dramatic on the palate, is always expensive.
FIRST GROWTHS			
Climens	Barsac	5,000	Best of Barsac, often rivaling Yquem.
Coutet	Barsac	7,000	Fruity, excellent bouquet, much breed.
Guiraud	Sauternes	9,000	Grown near Yquem, but a lighter wine.
Haut-Peyraguey	Bommes	3,000	Very limited production, but typical and elegant.
Lafaurie-Peyraguey	Bommes	6,000	Full, golden, exceptionally sweet.
La Tour–Blanche	Bommes	10,000	The French government runs a viticultural school here. The wine is less sweet than some of the others.
Rabaud-Promis	Bommes	10,000	Part of the Sigalas property until 1952; its wine is deep and concentrated.
Rabaud-Sigalas	Bommes	4,000	Full, like Rabaud-Promis.
Rayne-Vigneau	Bommes	8,000	Very sweet, highly perfumed.
Rieussec	Fargues	10,000	Outstanding for sweetness and depth, especially in the wines of the last decade.
Suduiraut	Priegnac	11,000	Relatively large production. Flowery and fruity.

TASTE

ROALD DAHL

*Born in Wales in 1916, of Norwegian parents, Roald Dahl was a fighter pilot in the R.A.F. in World War II. Married to the actress Patricia Neal, he has two daughters. He is the author of several books of short stories, of which two (*Someone Like You *and* Kiss Kiss*) contain some miniature masterpieces of the macabre. His most recent collection,* Switch Bitch *(1974), adroitly mingles the scabrous and the horrifying. The tale that follows, an outgrowth of his knowledgeable interest in wine drinking, made its first stunning appearance in* The New Yorker. *It is the finest of the many stories that turn on the fascinating problem of vintage identification.* C. F.

There were six of us to dinner that night at Mike Schofield's house in London: Mike and his wife and daughter, my wife and I, and a man called Richard Pratt.

Richard Pratt was a famous gourmet. He was president of a small society known as the Epicures, and each month he circulated privately to its members a pamphlet on food and wines. He organized dinners where sumptuous dishes and rare wines were served. He refused to smoke for fear of harming his palate, and when discussing a wine, he had a curious, rather droll habit of referring to it as though it were a living being. "A prudent wine," he would say, "rather diffident and evasive, but quite prudent." Or, "a good-humored wine, benevolent and cheerful—slightly obscene, perhaps, but nonetheless good-humored."

I had been to dinner at Mike's twice before when Richard Pratt was there, and on each occasion Mike and his wife had gone out of their way to produce a special meal for the famous gourmet. And this one, clearly, was to be no exception. The moment we entered the dining room, I could see that the table was laid for a feast. The tall candles, the yellow roses, the quantity of shining silver, the three wineglasses to each person, and above all, the faint scent of roasting meat from the kitchen brought the first warm oozings of saliva to my mouth.

As we sat down, I remembered that on both Richard Pratt's previous visits Mike had played a little betting game with him over the claret, challenging him to name its breed and its vintage. Pratt had replied that that should not be too difficult provided it was one of the great years. Mike had then bet him a case of the wine in question that he could not do it. Pratt had accepted, and had won both times. Tonight I felt sure that the little game would be played over again, for Mike was quite willing to lose the bet in order to prove that his wine was good enough to be recognized, and Pratt, for his part, seemed to take a grave, restrained pleasure in displaying his knowledge.

The meal began with a plate of whitebait, fried very crisp in butter, and

to go with it there was a Moselle. Mike got up and poured the wine himself, and when he sat down again, I could see that he was watching Richard Pratt. He had set the bottle in front of me so that I could read the label. It said, "Geierslay Ohligsberg, 1945." He leaned over and whispered to me that Geierslay was a tiny village in the Moselle, almost unknown outside Germany. He said that this wine we were drinking was something unusual, that the output of the vineyard was so small that it was almost impossible for a stranger to get any of it. He had visited Geierslay personally the previous summer in order to obtain the few dozen bottles that they had finally allowed him to have.

"I doubt anyone else in the country has any of it at the moment," he said. I saw him glance again at Richard Pratt. "Great thing about Moselle," he continued, raising his voice, "it's the perfect wine to serve before a claret. A lot of people serve a Rhine wine instead, but that's because they don't know any better. A Rhine wine will kill a delicate claret, you know that? It's barbaric to serve a Rhine before a claret. But a Moselle—ah!—a Moselle is exactly right."

Mike Schofield was an amiable, middle-aged man. But he was a stockbroker. To be precise, he was a jobber in the stock market, and like a number of his kind, he seemed to be somewhat embarrassed, almost ashamed to find that he had made so much money with so slight a talent. In his heart he knew that he was not really much more than a bookmaker—an unctuous, infinitely respectable, secretly unscrupulous bookmaker—and he knew that his friends knew it, too. So he was seeking now to become a man of culture, to cultivate a literary and aesthetic taste, to collect paintings, music, books, and all the rest of it. His little sermon about Rhine wine and Moselle was a part of this thing, this culture that he sought.

"A charming little wine, don't you think?" he said. He was still watching Richard Pratt. I could see him give a rapid furtive glance down the table each time he dropped his head to take a mouthful of whitebait. I could almost *feel* him waiting for the moment when Pratt would take his first sip, and look up from his glass with a smile of pleasure, of astonishment, perhaps even of wonder, and then there would be a discussion and Mike would tell him about the village of Geierslay.

But Richard Pratt did not taste his wine. He was completely engrossed in conversation with Mike's eighteen-year-old daughter, Louise. He was half turned toward her, smiling at her, telling her, so far as I could gather, some story about a chef in a Paris restaurant. As he spoke, he leaned closer and closer to her, seeming in his eagerness almost to impinge upon her, and the poor girl leaned as far as she could away from him, nodding politely, rather desperately, and looking not at his face but at the topmost button of his dinner jacket.

We finished our fish, and the maid came around removing the plates. When she came to Pratt, she saw that he had not yet touched his food, so she hesitated, and Pratt noticed her. He waved her away, broke off his conversation, and quickly began to eat, popping the little crisp brown fish quickly into his mouth with rapid jabbing movements of his fork. Then, when he had finished, he reached for his glass, and in two short swallows he tipped the wine down his throat and turned immediately to resume his conversation with Louise Schofield.

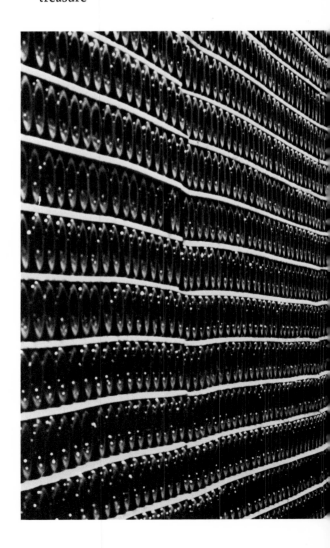

The wine vault at Château Haut-Brion is a Fort Knox of liquid treasure

Mike saw it all. I was conscious of him sitting there, very still, containing himself, looking at his guest. His round jovial face seemed to loosen slightly and to sag, but he contained himself and was still and said nothing.

Soon the maid came forward with the second course. This was a large roast of beef. She placed it on the table in front of Mike, who stood up and carved it, cutting the slices very thin, laying them gently on the plates for the maid to take around. When he had served everyone, including himself, he put down the carving knife and leaned forward with both hands on the edge of the table.

"Now," he said, speaking to all of us but looking at Richard Pratt. "Now for the claret. I must go and fetch the claret, if you'll excuse me."

"You go and fetch it, Mike?" I said. "Where is it?"

"In my study, with the cork out—breathing."

"Why the study?"

"Acquiring room temperature, of course. It's been there twenty-four hours."

"But why the study?"

"It's the best place in the house. Richard helped me choose it last time he was here."

At the sound of his name, Pratt looked around.

"That's right, isn't it?" Mike said.

"Yes," Pratt answered, nodding gravely. "That's right."

"On top of the green filing cabinet in my study," Mike said. "That's the place we chose. A good draft-free spot in a room with an even temperature. Excuse me now, will you, while I fetch it."

The thought of another wine to play with had restored his humor, and he hurried out the door, to return a minute later more slowly, walking softly, holding in both hands a wine basket in which a dark bottle lay. The label was out of sight, facing downward. "Now!" he cried as he came toward the table. "What about this one, Richard? You'll never name this one!"

Richard Pratt turned slowly and looked up at Mike; then his eyes traveled down to the bottle nestling in its small wicker basket, and he raised his eyebrows, a slight, supercilious arching of the brows, and with it a pushing outward of the wet lower lip, suddenly imperious and ugly.

"You'll never get it," Mike said. "Not in a hundred years."

"A claret?" Richard Pratt asked, condescending.

"Of course."

"I assume, then, that it's from one of the smaller vineyards?"

"Maybe it is, Richard. And then again, maybe it isn't."

"But it's a good year? One of the great years?"

"Yes, I guarantee that."

"Then it shouldn't be too difficult," Richard Pratt said, drawling his words, looking exceedingly bored. Except that, to me, there was something strange about his drawling and his boredom: between the eyes a shadow of something evil, and in his bearing an intentness that gave me a faint sense of uneasiness as I watched him.

"This one is really rather difficult," Mike said, "I won't force you to bet on this one."

"Indeed. And why not?" Again the slow arching of the brows, the cool, intent look.

"Because it's difficult."

"That's not very complimentary to me, you know."

"My dear man," Mike said, "I'll bet you with pleasure, if that's what you wish."

"It shouldn't be too hard to name it."

"You mean you want to bet?"

"I'm perfectly willing to bet," Richard Pratt said.

"All right, then, we'll have the usual. A case of the wine itself."

"You don't think I'll be able to name it, do you?"

"As a matter of fact, and with due respect, I don't," Mike said. He was making some effort to remain polite, but Pratt was not bothering overmuch to conceal his contempt for the whole proceeding. And yet, curiously, his next question seemed to betray a certain interest.

"You like to increase the bet?"

"No, Richard. A case is plenty."

"Would you like to bet fifty cases?"

"That would be silly."

Mike stood very still behind his chair at the head of the table, carefully holding the bottle in its ridiculous wicker basket. There was a trace of whiteness around his nostrils now, and his mouth was shut very tight.

Pratt was lolling back in his chair, looking up at him, the eyebrows raised, the eyes half closed, a little smile touching the corners of his lips. And again I saw, or thought I saw, something distinctly disturbing about the man's face, that shadow of intentness between the eyes, and in the eyes themselves, right in their centers where it was black, a small slow spark of shrewdness, hiding.

"So you don't want to increase the bet?"

"As far as I'm concerned, old man, I don't give a damn," Mike said. "I'll bet you anything you like."

The three women and I sat quietly, watching the two men. Mike's wife was becoming annoyed; her mouth had gone sour and I felt that at any moment she was going to interrupt. Our roast beef lay before us on our plates, slowly steaming.

"So you'll bet me anything I like?"

"That's what I told you. I'll bet you anything you damn well please, if you want to make an issue out of it."

"Even ten thousand pounds?"

"Certainly I will, if that's the way you want it." Mike was more confident now. He knew quite well that he could call any sum Pratt cared to mention.

"So you say I can name the bet?" Pratt asked again.

"That's what I said."

There was a pause while Pratt looked slowly around the table, first at me, then at the three women, each in turn. He appeared to be reminding us that we were witness to the offer.

"Mike!" Mrs. Schofield said. "Mike, why don't we stop this nonsense and eat our food. It's getting cold."

"But it isn't nonsense," Pratt told her evenly. "We're making a little bet."

I noticed the maid standing in the background holding a dish of vegetables, wondering whether to come forward with them or not.

"All right, then," Pratt said. "I'll tell you what I want you to bet."

"Come on, then," Mike said, rather reckless. "I don't give a damn what it is—you're on."

Pratt nodded, and again the little smile moved the corners of his lips, and then, quite slowly, looking at Mike all the time, he said, "I want you to bet me the hand of your daughter in marriage."

Louise Schofield gave a jump. "Hey!" she cried. "No! That's not funny! Look here, Daddy, that's not funny at all."

"No, dear," her mother said. "They're only joking."

"I'm not joking," Richard Pratt said.

"It's ridiculous," Mike said. He was off balance again now.

"You said you'd bet anything I liked."

"I meant money."

"You didn't *say* money."

"That's what I meant."

A white Burgundy is poured with a candle held beneath the bottle to show up any sediment (a rarity in a white wine)

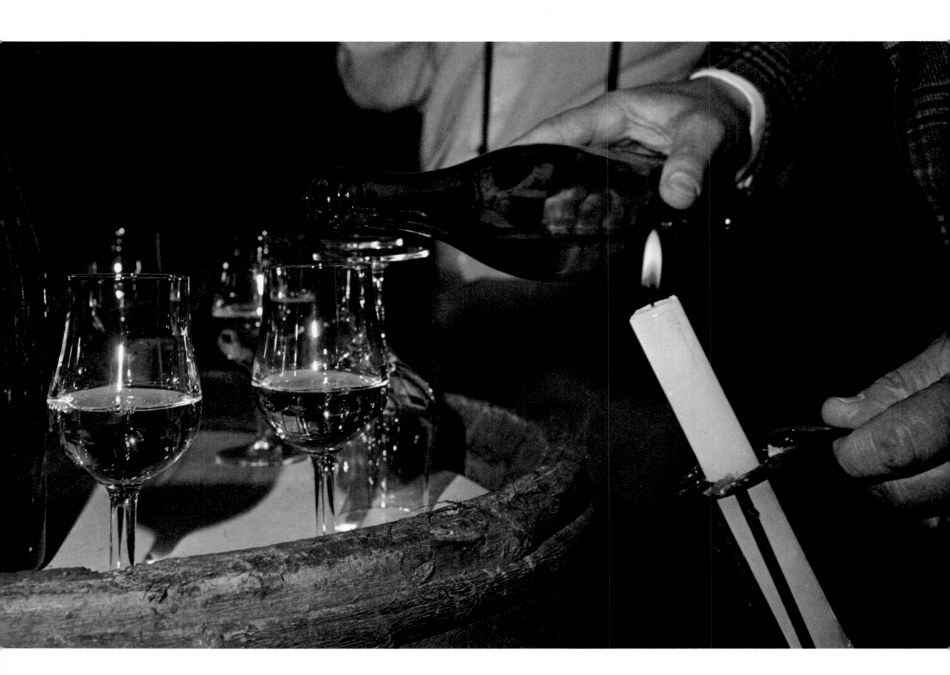

"Then it's a pity you didn't say it. But anyway, if you wish to go back on your offer, that's quite all right with me."

"It's not a question of going back on my offer, old man. It's a no-bet anyway, because you can't match the stake. You yourself don't happen to have a daughter to put up against mine in case you lose. And if you had, I wouldn't want to marry her."

"I'm glad of that, dear," his wife said.

"I'll put up anything you like," Pratt announced. "My house, for example. How about my house?"

"Which one?" Mike asked, joking now.

"The country one."

"Why not the other one as well?"

"All right then, if you wish it. Both my houses."

At that point I saw Mike pause. He took a step forward and placed the bottle in its basket gently down on the table. He moved the saltcellar to one side, then the pepper, and then he picked up his knife, studied the blade thoughtfully for a moment, and put it down again. His daughter, too, had seen him pause.

"Now, Daddy!" she cried. "Don't be *absurd!* It's *too* silly for words. I refuse to be betted on like this."

"Quite right, dear," her mother said. "Stop it at once, Mike, and sit down and eat your food."

Mike ignored her. He looked over at his daughter and he smiled, a slow, fatherly, protective smile. But in his eyes, suddenly, there glimmered a little triumph. "You know," he said, smiling as he spoke. "You know, Louise, we ought to think about this a bit."

"Now, stop it, Daddy! I refuse even to listen to you! Why, I've never heard anything so ridiculous in my life!"

"No, seriously, my dear. Just wait a moment and hear what I have to say."

"But I don't *want* to hear it."

"Louise! Please! It's like this. Richard, here, has offered us a serious bet. He is the one who wants to make it, not me. And if he loses, he will have to hand over a considerable amount of property. Now, wait a minute, my dear, don't interrupt. The point is this. *He cannot possibly win.*"

"He seems to think he can."

"Now listen to me, because I know what I'm talking about. The expert, when tasting a claret—so long as it is not one of the famous great wines like Lafite or Latour—can only get a certain way toward naming the vineyard. He can, of course, tell you the Bordeaux district from which the wine comes, whether it is from St. Émilion, Pomerol, Graves, or Médoc. But then each district has several communes, little counties, and each county has many, many small vineyards. It is impossible for a man to differentiate between them all by taste and smell alone. I don't mind telling you that this one I've got here is a wine from a small vineyard that is surrounded by many other small vineyards, and he'll never get it. It's impossible."

"You can't be sure of that," his daughter said.

"I'm telling you I can. Though I say it myself, I understand quite a bit about this wine business, you know. And anyway, heavens alive, girl, I'm your father and you don't think I'd let you in for—for something you didn't want, do you? I'm trying to make you some money."

La Félicité Parfaite, by Louis Leopold Boilly (1761–1845), hand-colored lithograph, French

The Christian Brothers Collection

256

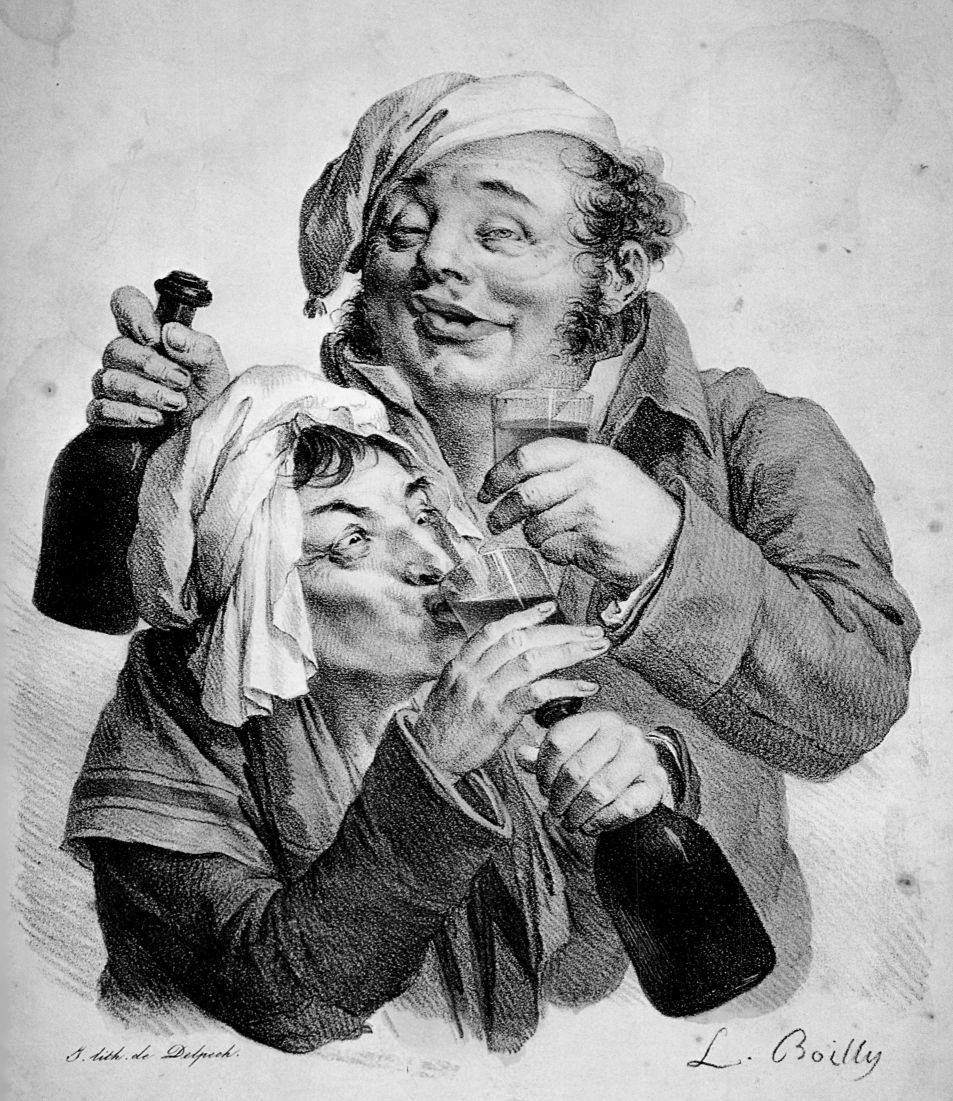

lith. de Delpech.

L. Boilly

La Félicité Parfaite.

"Mike!" his wife said sharply. "Stop it now, Mike, please!"

Again he ignored her. "If you will take this bet," he said to his daughter, "in ten minutes you will be the owner of two large houses."

"But I don't want two large houses, Daddy."

"Then sell them. Sell them back to him on the spot. I'll arrange all that for you. And then, just think of it, my dear, you'll be rich! You'll be independent for the rest of your life!"

"Oh, Daddy, I don't like it. I think it's silly."

"So do I," the mother said. She jerked her head briskly up and down as she spoke, like a hen. "You ought to be ashamed of yourself, Michael, ever suggesting such a thing! Your own daughter, too!"

Mike didn't even look at her. "Take it!" he said eagerly, staring hard at the girl. "Take it, quick! I'll guarantee you won't lose."

"But I don't like it, Daddy."

"Come on, girl. Take it!"

Mike was pushing her hard. He was leaning toward her, fixing her with two hard bright eyes, and it was not easy for the daughter to resist him.

"But what if I lose?"

"I keep telling you, you can't lose. I'll guarantee it."

"Oh, Daddy, must I?"

"I'm making you a fortune. So come on now. What do you say, Louise? All right?"

For the last time, she hesitated. Then she gave a helpless little shrug of the shoulders and said, "Oh, all right, then. Just so long as you swear there's no danger of losing."

"Good!" Mike cried. "That's fine! Then it's a bet!"

"Yes," Richard Pratt said, looking at the girl. "It's a bet."

Immediately, Mike picked up the wine, tipped the first thimbleful into his own glass, then skipped excitedly around the table filling up the others. Now everyone was watching Richard Pratt, watching his face as he reached slowly for his glass with his right hand and lifted it to his nose. The man was about fifty years old and he did not have a pleasant face. Somehow, it was all mouth—mouth and lips—the full, wet lips of the professional gourmet, the lower lip hanging downward in the center, a pendulous, permanently open taster's lip, shaped open to receive the rim of a glass or a morsel of food. Like a keyhole, I thought, watching it; his mouth is like a large wet keyhole.

Slowly he lifted the glass to his nose. The point of the nose entered the glass and moved over the surface of the wine, delicately sniffing. He swirled the wine gently around in the glass to receive the bouquet. His concentration was intense. He had closed his eyes, and now the whole top half of his body, the head and neck and chest, seemed to become a kind of huge sensitive smelling-machine, receiving, filtering, analyzing the message from the sniffing nose.

Mike, I noticed, was lounging in his chair, apparently unconcerned, but he was watching every move. Mrs. Schofield, the wife, sat prim and upright at the other end of the table, looking straight ahead, her face tight with disapproval. The daughter, Louise, had shifted her chair away a little, and sidewise, facing the gourmet, and she, like her father, was watching closely.

Where the Médoc Wine Road enters Saint-Julien, between Château Ducru-Beaucaillou and Château Branaire-Ducru, stands this 30-foot wine bottle—untypical ballyhoo for the commune's regional wine

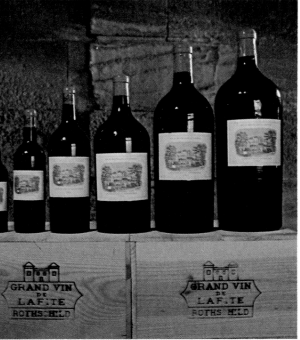

(Top) A student harvesting grapes

(Bottom) Bordeaux bottles have distinctive names and sizes: fillette (half-bottle and bottle), magnum (two bottles), Marie-Jeanne (three bottles), double magnum (four bottles), jeroboam (six bottles), imperial (eight bottles)

For at least a minute, the smelling process continued; then, without opening his eyes or moving his head, Pratt lowered the glass to his mouth and tipped in almost half the contents. He paused, his mouth full of wine, getting the first taste; then he permitted some of it to trickle down his throat and I saw his Adam's apple move as it passed by. But most of it he retained in his mouth. And now, without swallowing again, he drew in through his lips a thin breath of air which mingled with the fumes of the wine in the mouth and passed on down into his lungs. He held the breath, blew it out through his nose, and finally began to roll the wine around under the tongue, and chewed it, actually chewed it with his teeth as though it were bread.

It was a solemn, impressive performance and I must say he did it well.

"Um," he said, putting down the glass, running a pink tongue over his lips. "Um—yes. A very interesting little wine—gentle and gracious, almost feminine in the aftertaste."

There was an excess of saliva in his mouth, and as he spoke he spat an occasional bright speck of it onto the table.

"Now we can start to eliminate," he said. "You will pardon me for doing this carefully, but there is much at stake. Normally I would perhaps take a bit of a chance, leaping forward quickly and landing right in the middle of the vineyard of my choice. But I must move cautiously this time, must I not?" He looked up at Mike and he smiled, a thick-lipped, wet-lipped smile. Mike did not smile back.

"First, then, which district in Bordeaux does this wine come from? That is not too difficult to guess. It is far too light in the body to be from either St. Émilion or Graves. It is obviously a Médoc. There's no doubt about *that*.

"Now—from which commune in Médoc does it come? That also, by elimination, should not be too difficult to decide. Margaux? No. It cannot be Margaux. It has not the violent bouquet of a Margaux. Pauillac? It cannot be Pauillac, either. It is too tender, too gentle and wistful for a Pauillac. The wine of Pauillac has a character that is almost imperious in its taste. And also to me, a Pauillac contains just a little pith, a curious dusty, pithy flavor that the grape acquires from the soil of the district. No, no. This—this is a very gentle wine, demure and bashful in the first taste, emerging shyly but quite graciously in the second. A little arch, perhaps, in the second taste, and a little naughty also, teasing the tongue with a trace, just a trace, of tannin. Then, in the aftertaste, delightful—consoling and feminine, with a certain blithely generous quality that one associates only with the wines of the commune of St. Julien. Unmistakably this is a St. Julien."

He leaned back in his chair, held his hands up level with his chest, and placed the fingertips carefully together. He was becoming ridiculously pompous, but I thought that some of it was deliberate, simply to mock his host. I found myself waiting rather tensely for him to go on. The girl Louise was lighting a cigarette. Pratt heard the match strike and he turned on her, flaring suddenly with real anger. "Please!" he said. "Please don't do that! It's a disgusting habit, to smoke at table!"

She looked up at him, still holding the burning match in one hand, the big slow eyes settling on his face, resting there a moment, moving away

again, slow and contemptuous. She bent her head and blew out the match, but continued to hold the unlighted cigarette in her fingers.

"I'm sorry, my dear," Pratt said, "but I simply cannot have smoking at the table."

She didn't look at him again.

"Now, let me see—where were we?" he said. "Ah, yes. This wine is from Bordeaux, from the commune of St. Julien, in the district of Médoc. So far, so good. But now we come to the more difficult part—the name of the vineyard itself. For in St. Julien there are many vineyards, and as our host so rightly remarked earlier on, there is often not much difference between the wine of one and the wine of another. But we shall see."

He paused again, closing his eyes. "I am trying to establish the 'growth,'" he said. "If I can do that, it will be half the battle. Now, let me see. This wine is obviously not from a first-growth vineyard—nor even a second. It is not a great wine. The quality, the—the—what do you call it?—the radiance, the power, is lacking. But a third growth—that it could be. And yet I doubt it. We know it is a good year—our host has said so—and this is probably flattering it a little bit. I must be careful. I must be very careful here."

He picked up his glass and took another small sip.

"Yes," he said, sucking his lips, "I was right. It is a fourth growth. Now I am sure of it. A fourth growth from a very good year—from a great year, in fact. And that's what made it taste for a moment like a third—or even a second-growth wine. Good! That's better! Now we are closing in! What are the fourth-growth vineyards in the commune of St. Julien?"

Again he paused, took up his glass, and held the rim against that sagging, pendulous lower lip of his. Then I saw the tongue shoot out, pink and narrow, the tip of it dipping into the wine, withdrawing swiftly again—a repulsive sight. When he lowered the glass, his eyes remained closed, the face concentrated, only the lips moving, sliding over each other like two pieces of wet, spongy rubber.

"There it is again!" he cried. "Tannin in the middle taste, and the quick astringent squeeze upon the tongue. Yes, yes, of course! Now I have it! This wine comes from one of those small vineyards around Beychevelle. I remember now. The Beychevelle district, and the river and the little harbor that has silted up so the wine ships can no longer use it. Beychevelle . . . could it actually be a Beychevelle itself? No, I don't think so. Not quite. But it is somewhere very close. Château Talbot? Could it be Talbot? Yes, it could. Wait one moment."

He sipped the wine again, and out of the side of my eye I noticed Mike Schofield and how he was leaning farther and farther forward over the table, his mouth slightly open, his small eyes fixed upon Richard Pratt.

"No. I was wrong. It was not a Talbot. A Talbot comes forward to you just a little quicker than this one; the fruit is nearer to the surface. If it is a '34, which I believe it is, then it couldn't be Talbot. Well, well. Let me think. It is not a Beychevelle and it is not a Talbot, and yet—yet it is so close to both of them, so close, that the vineyard must be almost in between. Now, which could that be?"

He hesitated, and we waited, watching his face. Everyone, even Mike's wife, was watching him now. I heard the maid put down the dish of veg-

etables on the sideboard behind me, gently, so as not to disturb the silence.

"Ah!" he cried. "I have it! Yes, I think I have it!"

For the last time, he sipped the wine. Then, still holding the glass up near his mouth, he turned to Mike and he smiled, a slow, silky smile, and he said, "You know what this is? This is the little Château Branaire-Ducru."

Mike sat tight, not moving.

"And the year, 1934."

We all looked at Mike, waiting for him to turn the bottle around in its basket and show the label.

"Is that your final answer?" Mike said.

"Yes, I think so."

"Well, is it or isn't it?"

"Yes, it is."

"What was the name again?"

"Château Branaire-Ducru. Pretty little vineyard. Lovely old château. Know it quite well. Can't think why I didn't recognize it at once."

"Come on, Daddy," the girl said. "Turn it round and let's have a peek. I want my two houses."

"Just a minute," Mike said. "Wait just a minute." He was sitting very quiet, bewildered-looking, and his face was becoming puffy and pale, as though all the force was draining slowly out of him.

"Michael!" his wife called sharply from the other end of the table. "What's the matter?"

"Keep out of this, Margaret, will you please."

Richard Pratt was looking at Mike, smiling with his mouth, his eyes small and bright. Mike was not looking at anyone.

"Daddy!" the daughter cried, agonized. "But, Daddy, you don't mean to say he's guessed it right!"

"Now, stop worrying, my dear," Mike said. "There's nothing to worry about."

I think it was more to get away from his family than anything else that Mike then turned to Richard Pratt and said, "I'll tell you what, Richard. I think you and I better slip off into the next room and have a little chat?"

"I don't want a little chat," Pratt said. "All I want is to see the label on that bottle." He knew he was a winner now; he had the bearing, the quiet arrogance of a winner, and I could see that he was prepared to become thoroughly nasty if there was any trouble. "What are you waiting for?" he said to Mike. "Go on and turn it round."

Then this happened: The maid, the tiny, erect figure of the maid in her white-and-black uniform, was standing beside Richard Pratt, holding something out in her hand. "I believe these are yours, sir," she said.

Pratt glanced around, saw the pair of thin horn-rimmed spectacles that she held out to him, and for a moment he hesitated. "Are they? Perhaps they are. I don't know."

"Yes sir, they're yours." The maid was an elderly woman—nearer seventy than sixty—a faithful family retainer of many years' standing. She put the spectacles down on the table beside him.

Without thanking her, Pratt took them up and slipped them into his top pocket, behind the white handkerchief.

But the maid didn't go away. She remained standing beside and slightly

261

behind Richard Pratt, and there was something so unusual in her manner and in the way she stood there, small, motionless, and erect, that I for one found myself watching her with a sudden apprehension. Her old gray face had a frosty, determined look, the lips were compressed, the little chin was out, and the hands were clasped together tight before her. The curious cap on her head and the flash of white down the front of her uniform made her seem like some tiny, ruffled, white-breasted bird.

"You left them in Mr. Schofield's study," she said. Her voice was unnaturally, deliberately polite. "On top of the green filing cabinet in his study, sir, when you happened to go in there by yourself before dinner."

It took a few moments for the full meaning of her words to penetrate, and in the silence that followed I became aware of Mike and how he was slowly drawing himself up in his chair, and the color coming to his face, and the eyes opening wide, and the curl of the mouth, and the dangerous little patch of whiteness beginning to spread around the area of the nostrils.

"Now, Michael!" his wife said. "Keep calm now, Michael, dear! Keep calm!"

The carved panel with the motto *In Vino Veritas* comes by coincidence from Château Ducru-Beaucaillou, neighboring vineyard to the one in this story

262

BURGUNDY

Burgundy produces the most extravagantly praised wines in the world. And, by any standard, the enthusiastic compliments are justified, for the wines are of an extravagant, even flamboyant, nature. Burgundies are big wines, fat with "stuffing," heady with perfume, round and full and deep in all respects. Hugh Johnson has aptly observed, "Bordeaux appeals to the aesthete as Burgundy appeals to the sensualist." Exposed to the air, Burgundies unfold their complexities assertively, revealing a tremendous power and concentrated richness with an authority that earns them the title "King of Wines." Delicate they can be, especially in texture, and sometimes in bouquet and fruit. Some are as elegant as classic claret; many deserve to be called noble.

The rich expansiveness of the wines of Burgundy parallels the robust heartiness of the food traditionally prepared in the kitchens of the ancient duchy. The cuisine of no other French wine region is so famous as Burgundy's. From pastures to the west comes the succulent Charolais beef for making boeuf bourguignon; from farms to the east come flavorful Bresse chickens for coq au vin. Such delicacies, prepared at home or in the fine restaurants of Beaune, Saulieu, and Chagny, splendidly complement the glorious fruit of the Burgundy vines.

Burgundy proper and its neighboring vineyards stretch some 130 miles south from Dijon, a city in earlier times more famous for its wine than for its mustard. The first section is by far the most important: the Côte d'Or, whose renowned vineyards include two subdistricts, the Côte de Nuits to the north and the Côte de Beaune to the south. Below the town of Chagny lie the lesser districts of Burgundy, the Côte Chalonnaise and the Mâconnais. Finally, there are the hills of Beaujolais, home of that high-spirited and delightful young wine.

Burgundy produces less than one-third the volume of wine that Bordeaux does. The fine and famous wines of the Côte d'Or make up only 5 percent of the total. Scarce and expensive,

these superb wines can only become more so in the face of ever-increasing demand. In order to buy intelligently, one must have a thorough knowledge not only of the communes and vineyards, as in Bordeaux, but also of the individual growers' parcels of a particular vineyard, for some growers take greater pains than others in making their wines. As an example of the situation in Burgundy, let us compare Mouton-Rothschild, a vineyard of about 150 acres in Bordeaux, and the Clos de Vougeot, whose 124 acres constitute the largest vineyard along the Côte d'Or. Mouton-Rothschild is owned by one man, Philippe de Rothschild, who grows the grapes, makes the wine, and bottles it, all on the same property. Clos de Vougeot, by contrast, is owned by some sixty different growers, each of whom makes the wine in his own way and each of whom may sell it to a shipper who has his own standards for the wine he distributes under his name. Wines from a vineyard so fragmented cannot have the uniformity of character found in château-bottled Bordeaux; although the wine may bear the distinct qualities imparted by Clos de Vougeot soil, each of the various growers will have put his particular stamp, for better or worse, upon it. Unless one knows the names of the reputable growers and shippers, one may easily forfeit the enjoyment of tasting the best representative of a great wine.

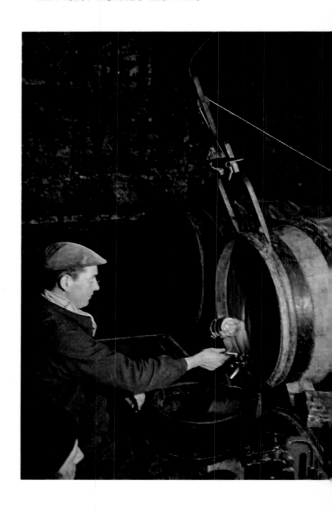

Fine Burgundies are bottled by hand, a slow method but the one that least disturbs the wine

Among the reasons for the varying quality of Burgundy wines is the fact that the environment of the vineyards differs appreciably from *climat* to *climat* (*climat* is an individual field of vines). Some *climats* have better exposure or better soil composition than others. And of course in a district where the slightest change in a vineyard's exposure to the elements can make a tremendous difference in the quality of a wine, the weather as a whole is critical. In years when conditions are severe—too hot or too cold, too wet or too dry—the resulting damage to the wines can ruin a small grower. For this reason many vineyard owners will have their plots scattered here and there within one or more communes in order, so to speak, not to have all their grapes in one basket. It is quite common for hailstorms, rainstorms, or frosts to hit one area and spare another nearby.

The *Appellation Contrôlée* laws in Burgundy are more complex than in any other region. Yet in a way they are more useful, since the laws single out the names of the very best vineyards. Each of the top thirty-one vineyards has been granted its own *Appellation*—Musigny, Clos de Vougeot, Bonnes-Mares, Chambertin, Richebourg, Le Montrachet, and

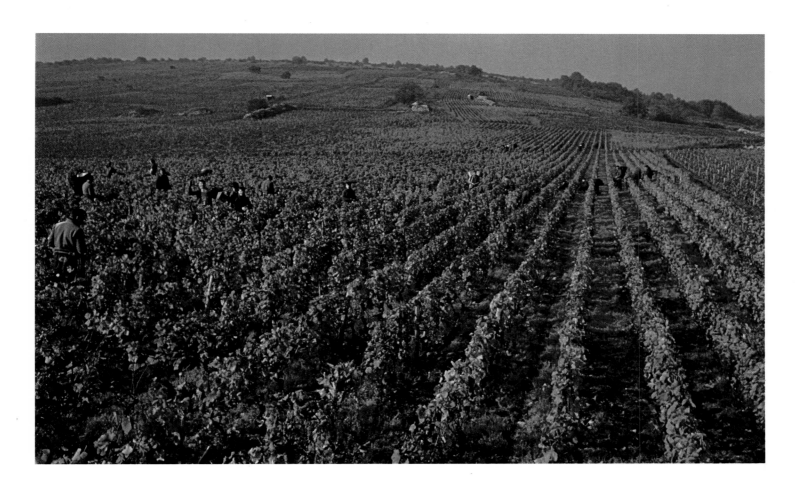

The harvest at La Tâche, a small vineyard in the Côte de Nuits that produces one of the greatest red Burgundies

so on. These *Grand Cru* vineyards need not even identify the name of the village in which they are located. In fact, many villages have appended their most illustrious vineyard's name to their own. Thus Chambolle is now Chambolle-Musigny, Gevrey is Gevrey-Chambertin, and Aloxe is Aloxe-Corton. This practice can lead to the same sort of confusion as was pointed out in connection with the name Margaux in Bordeaux: a buyer who does not know better may think he is getting the great Chambertin when he buys the village wine called Gevrey-Chambertin—which, however, may be quite good.

Wines of the second level, comparable to a classified Second or Third Growth of the Médoc, are designated as *Premier Cru*. Their legal *Appellation* consists of the commune name followed by the name of a specific vineyard. With the wine called Volnay-Caillerets, for example, Volnay is the name of the village, Caillerets the name of one of its best vineyards. When the village name appears alone with the words *Premier Cru*, it usually means that the wine comes from more than one of the *Premier Cru* vineyards.

The *Appellation Contrôlée* laws also limit the grape varieties which may be planted. For red wines, only the Pinot Noir is permitted. For whites, Pinot Chardonnay predominates, though a little Pinot Blanc is planted here and there. The maximum yield per acre is regulated as well—the better the vineyard, the smaller the crop. The maximum yield for Côte d'Or vineyards in general is 374 gallons per acre; but the

265

allotment for such *Premiers Crus* as Charmes-Chambertin is 342 gallons, and the *Grand Cru* plots such as Richebourg may yield only 321 gallons per acre. These limits ensure that quality will not suffer in the effort to increase quantity. In the face of a significant demand, vineyards may be tempted to "stretch" their wines; a grower who owns only a small portion of the Clos de Vougeot may produce no more than two dozen cases of wine, and if it is much sought after, the desire to increase the yield is understandable. Better growers have combated this problem by instituting a bottling practice similar to that common in Bordeaux. As a conscientious Bordeaux grower will château-bottle his wines to guarantee their authenticity, so a fine Burgundian winemaker will estate-bottle his vintages (châteaus are practically nonexistent in Burgundy). When the words *Mis en bouteilles à la Propriété, Mise au Domaine,* or *Mis en bouteilles au Domaine* appear on the label, they guarantee that the wine was made and bottled by the grower and is genuinely what the label represents it to be.

A phrase that appears very often on corks and labels is *Mis en bouteilles dans nos Caves,* or "Bottled in our cellars." The cellars are usually those of a shipper. If the wine is not bottled by the grower himself, he traditionally sells his wine to one of these shippers, or *négociants*—who may or may not handle the wine scrupulously. Most of the shippers in Burgundy have high standards and produce superb wines; others, unfortunately, do not. One needs to know something of their reputations in order to be able to choose intelligently. Many of the great Burgundy houses have contributed to the honor of the trade for centuries and themselves own sections of the top vineyards. One can generally be certain of getting good wines from such shippers as Joseph Drouhin, Louis Latour, and Louis Jadot. Other well-respected shippers are Bouchard Père et Fils, Remoissenet, Patriarche, Chanson, Faiveley, and Mommessin.

One of the pleasantest ways to become familiar with the wines of the Côte d'Or is to drive leisurely south from Dijon through the villages along the Route des Grands Crus (Route of the Great Growths), which is to the west, or right, of the heavily trafficked main road to Lyons. They are old towns, nestling among the rows and rows of vines that spread out around them in all directions. Most of the great vineyards slope gently upward to the west along a narrow strip often no more than a mile wide. The golden color of the vine leaves in the autumn reveals the origin of the name Côte d'Or.

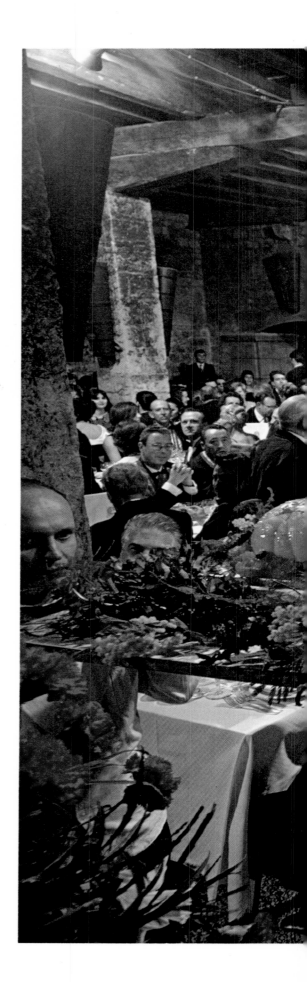

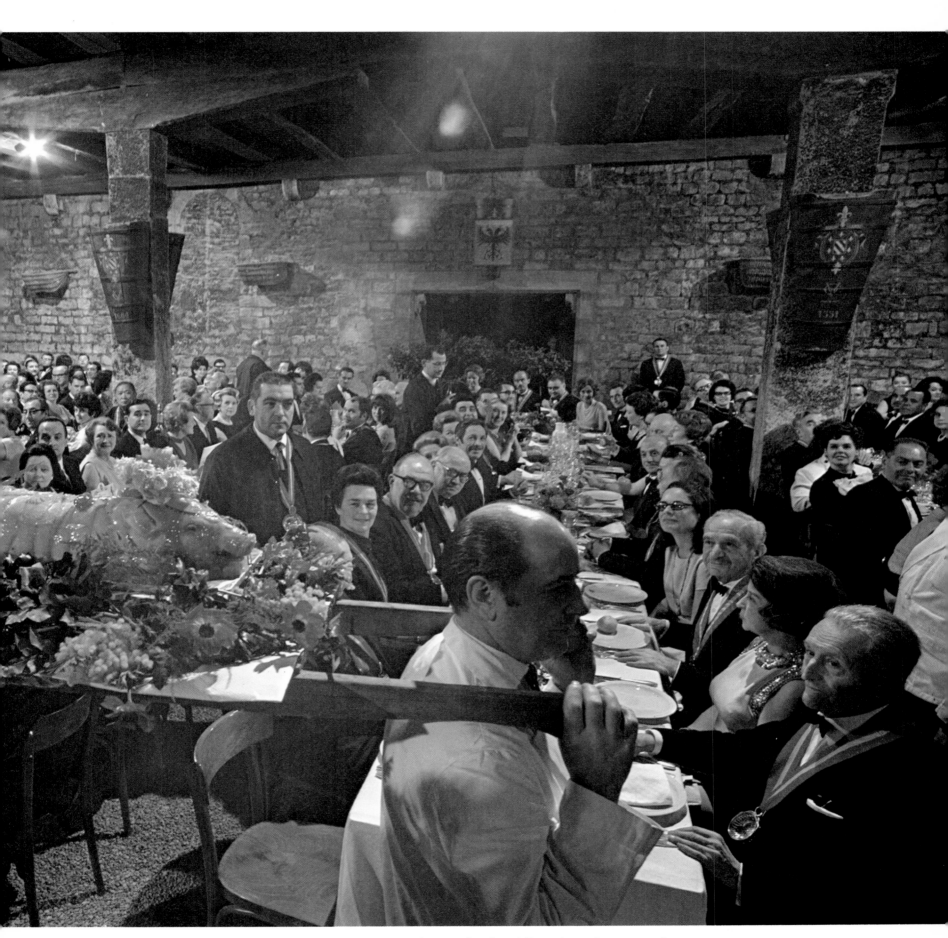

An entrée of suckling pig makes a grand entrance
in the banquet hall of the Château de Vougeot

CHÂTEAU ... NARD

Product of France
Red Table Wine

s : 1 Pt. 8 Fl. Oz.

l By Volume 13

Beaujolais=Villages

LAIS VILLAGES CONTROLÉE

Joseph Drouhin

ABLE WINE ALCOHOL BY VOLUME 12·5 PRODUCT OF FRANCE CON

LAFORET
MACON-VILLAGES

APPELLATION MACON-VILLAGES CON

MIS EN BOUTEILLES PAR JOSEPH DRO
NÉGOCIANT A BEAUNE, COTE-D'OR, AUX
DES ROIS DE FRANCE ET DES DUCS DE BOU

ntents 1 pint 8 fl. oz.

oduct of France Alcohol 11 to 14

Bur

Nuits St George
Les Cailles

APPELLATION CONTROLEE

Shipped by

Henri de Villamo...

Eleveur à Savigny-les-Be...

SOLE

Chambertin
Cuvée Héritiers Latour

APPELLATION CHAMBERTIN CONTRÔLEE

Mis en bouteilles
dans les caves du propriétaire

1970 197

POMMARD

APPELLATION POMMARD CONTROLÉE

JACQUES PARENT, PROPRIÉTAIRE A POMMARD (COTE D'OR)

ne) France

PRODUCE OF FRANCE

Shipped by

ALEXIS
HINE & C°

OCIANTS A BORD...

PRODUCE OF FRANCE

Chabl...

APPELLATION CHABLIS CONT

illes ...

...lin

U CHAPITRE DE
III° SIÈCLE PAR
NOTRE-DAME.

MEURSAULT
Appellation Contrôlée

mis en bouteille par

ANT AU CHAPITRE - BEAUNE, COTE-
OHOL BY VOLUME 12,8% CONTENTS 1 PT. 8 FL. OZS PRODUCT O

Hospices de Bea

1971

SPECIMEN

BEAUNE
Appellation Beaune Contrôlée
Cuvée Maurice-Drouhin

Chaque année, le troisième
Dimanche de Novembre,
a lieu la célèbre vente aux
enchères à la chandelle des
Grands Vins du Domaine
des Hospices, constitué tout
au long des siècles grâce à
de généreuses donations.

Ces grands vins en tonneaux
sont pris en charge par les
acquéreurs...

CORKSCREW
CAROL

Blest bright names of Burgundy,
Light the candles on my tree.

Meursault, Chablis, Chambertin,
Raise in me the Christmas man.

Raise in me love dead and gone
Pommard, Beaujolais and Beaune.

Ashes crowned, with cloth of sack on,
Let me now rejoice in Macon.

I'll rejoice and hang the holly,
Hang expense and melancholy.

Hang your bright Burgundian names
Round the tree in bottled flames.

Holy Night and nuit si jolie,
Nuits St. George and sweet Vin Volnay . . .

—Laurie Lee

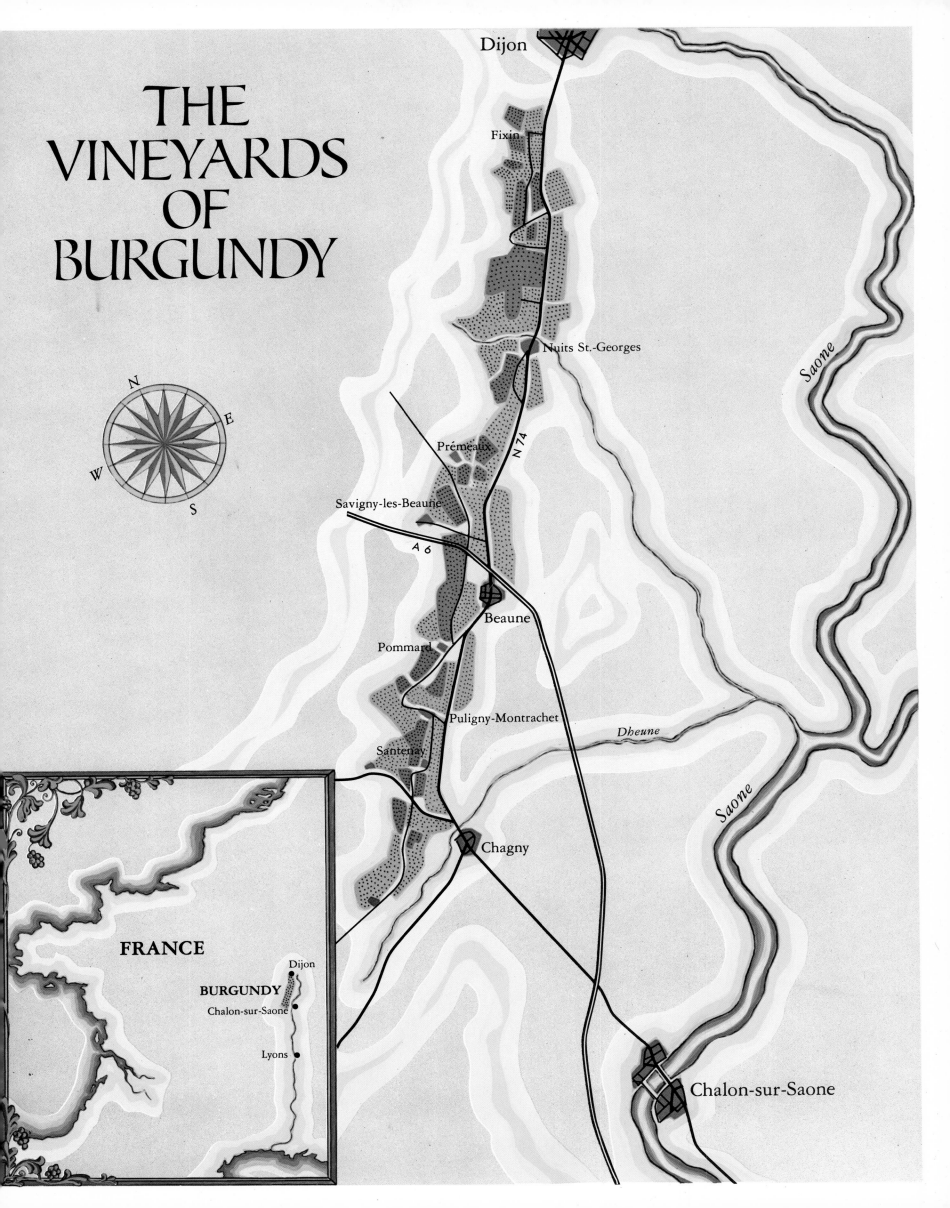

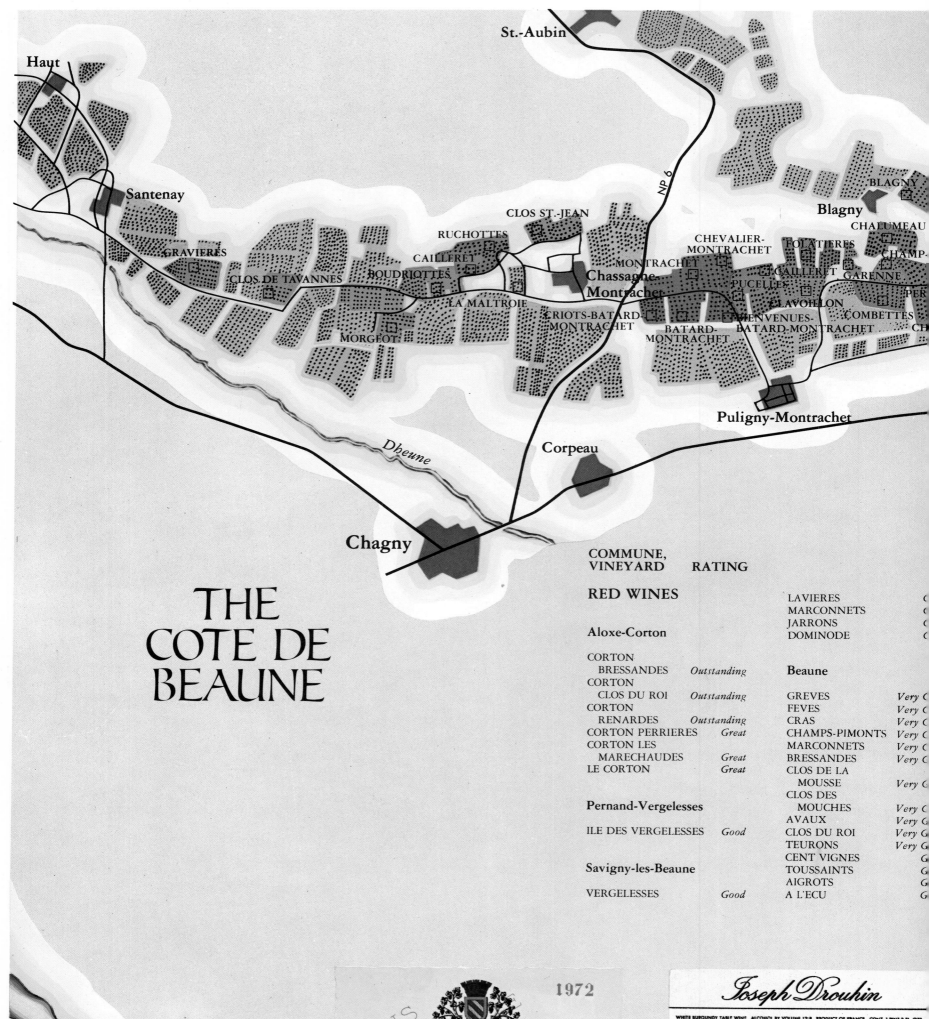

THE COTE DE BEAUNE

St.-Aubin

Haut

Santenay

GRAVIERES

CLOS DE TAVANNES

BOUDRIOTTES

LA MALTROIE

MORGEOT

RUCHOTTES

CAILLERET

CLOS ST.-JEAN

MONTRACHET

Chassagne Montrachet

CRIOTS-BATARD-MONTRACHET

BATARD-MONTRACHET

CHEVALIER-MONTRACHET

CAILLERET

PUCELLES

BIENVENUES-BATARD-MONTRACHET

CLAVOILLON

BLAGNY

Blagny

CHALUMEAU

FOLATIÈRES

CHAMP-

GARENNE

COMBETTES

Puligny-Montrachet

Dheune

Corpeau

Chagny

COMMUNE, VINEYARD	RATING
RED WINES	
Aloxe-Corton	
CORTON BRESSANDES	*Outstanding*
CORTON CLOS DU ROI	*Outstanding*
CORTON RENARDES	*Outstanding*
CORTON PERRIERES	*Great*
CORTON LES MARECHAUDES	*Great*
LE CORTON	*Great*
Pernand-Vergelesses	
ILE DES VERGELESSES	*Good*
Savigny-les-Beaune	
VERGELESSES	*Good*

	RATING
LAVIERES	O
MARCONNETS	O
JARRONS	O
DOMINODE	O
Beaune	
GREVES	*Very G*
FEVES	*Very G*
CRAS	*Very G*
CHAMPS-PIMONTS	*Very G*
MARCONNETS	*Very G*
BRESSANDES	*Very G*
CLOS DE LA MOUSSE	*Very G*
CLOS DES MOUCHES	*Very G*
AVAUX	*Very G*
CLOS DU ROI	*Very G*
TEURONS	*Very G*
CENT VIGNES	G
TOUSSAINTS	G
AIGROTS	G
A L'ECU	G

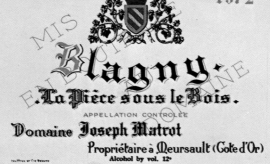

1972

Blagny

La Pièce sous le Bois

APPELLATION CONTROLÉE

Domaine Joseph Matrot

Propriétaire à Meursault (Côte d'Or)

Alcohol by vol. 12°

Joseph Drouhin

WHITE BURGUNDY TABLE WINE ALCOHOL BY VOLUME 12·8 PRODUCT OF FRANCE CONT. 1 PINT 8 FL. OZS

MEURSAULT-PERRIÈRES

APPELLATION CONTROLÉE

MIS EN BOUTEILLE PAR

JOSEPH DROUHIN

Maison fondée en 1880

NÉGOCIANT A BEAUNE, CÔTE-D'OR

AUX CELLIERS DES ROIS DE FRANCE ET DES DUCS DE BOURGOGNE

AGENT *Dreyfus, Ashby & Co* NEW YORK, N.Y.

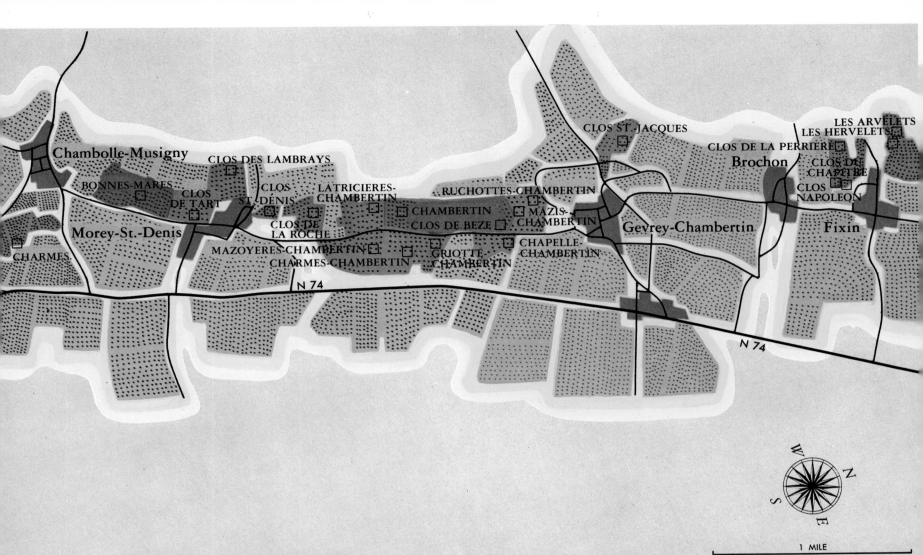

LES PRULIERS *Great*
LES PORRETS *Great*
CLOS DE THOREY *Great*
LES BOUDOTS *Great*
MURGERS *Very Good*
RICHEMONE *Very Good*

Outstanding Vineyard

Great Vineyard

Very Good Vineyard

Good Vineyard

WHITE WINES

Chambolle-Musigny

MUSIGNY BLANC *Outstanding*

Vougeot

CLOS BLANC DE
 VOUGEOT *Great*

Nuits St.-Georges

PERRIERE *Good*

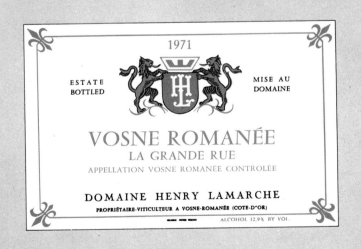

1971

ESTATE BOTTLED MISE AU DOMAINE

VOSNE ROMANÉE
LA GRANDE RUE
APPELLATION VOSNE ROMANÉE CONTROLÉE

DOMAINE HENRY LAMARCHE
PROPRIÉTAIRE-VITICULTEUR A VOSNE-ROMANÉE (COTE-D'OR)

ALCOHOL 12.9% BY VOL.

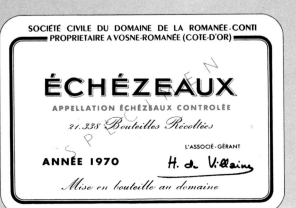

SOCIÉTÉ CIVILE DU DOMAINE DE LA ROMANÉE-CONTI
PROPRIÉTAIRE A VOSNE-ROMANÉE (COTE-D'OR)

ÉCHÉZEAUX
APPELLATION ÉCHÉZEAUX CONTROLÉE

21.338 Bouteilles Récoltées

L'ASSOCIÉ-GÉRANT

ANNÉE 1970 *H. de Villaine*

Mise en bouteille au domaine

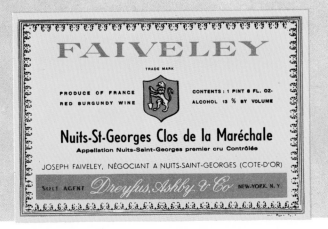

FAIVELEY
TRADE MARK

PRODUCE OF FRANCE CONTENTS : 1 PINT 8 FL. OZ.
RED BURGUNDY WINE ALCOHOL 13 % BY VOLUME

Nuits-St-Georges Clos de la Maréchale
Appellation Nuits-Saint-Georges premier cru Contrôlée

JOSEPH FAIVELEY, NÉGOCIANT A NUITS-SAINT-GEORGES (COTE-D'OR)

SOLE AGENT *Dreyfus, Ashby & Co* NEW-YORK, N.Y.

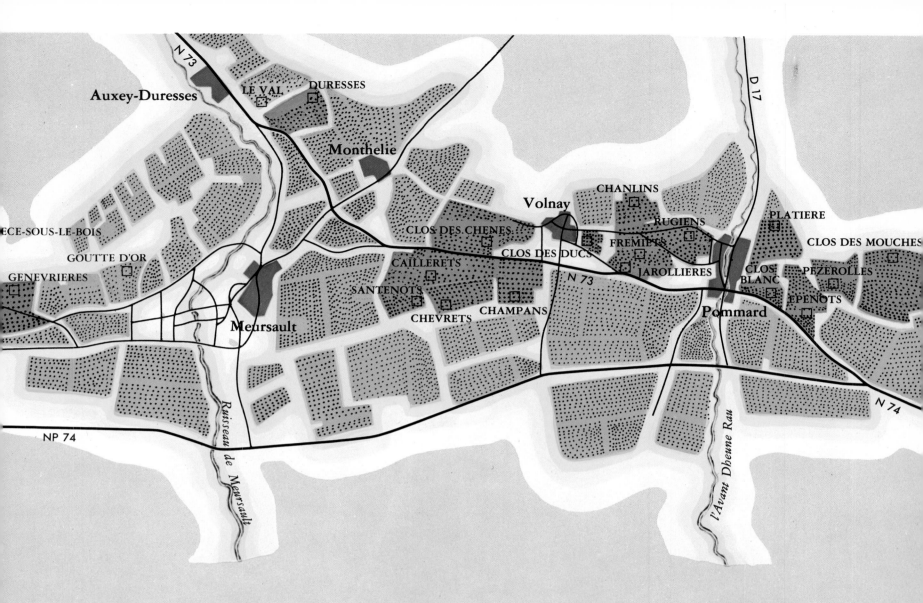

Map labels:

N 73
Auxey-Duresses
LE VAL
DURESSES
Monthelie
CHANLINS
Volnay
PLATIERE
RUGIENS
CLOS DES CHENES
FREMIETS
CLOS DES MOUCHES
ECE-SOUS-LE-BOIS
CLOS DES DUCS
JAROLLIERES
CLOS BLANC
PEZEROLLES
GOUTTE D'OR
CAILLERETS
N 73
GENEVRIERES
SANTENOTS
EPENOTS
CHEVRETS
CHAMPANS
Pommard
Meursault
D 17
NP 74
Ruisseau de Meursault
l'Avant Dheune Rau
N 74

...mard

...GIENS	Great
...NOTS	Great
...EROLLES	Very Good
...S BLANC	Very Good
...NLINS	Very Good
...TIERE	Very Good
...OLLIERES	Very Good

...nay

...S DES DUCS	Great
...LLERETS	Great
...MPANS	Great
...MIETS	Very Good
...VRETS	Very Good
...TENOTS	Very Good
...S DES	
...HENES	Very Good

...ey

...ESSES	Very Good
...AL	Good

Chassagne-Montrachet

BOUDRIOTTES	Very Good
CLOS ST.-JEAN	Very Good
MALTROIE	Good
MORGEOT	Very Good

Santenay

GRAVIÈRES	Very Good
CLOS DE	
TAVANNES	Very Good

WHITE WINES

Aloxe-Corton

CORTON-	
CHARLEMAGNE	Outstanding

Beaune

CLOS DES	
MOUCHES	Very Good

Meursault

PERRIERES	Great
GENEVRIERES	Great
CHARMES	Great
LA PIECE-SOUS-	
LE-BOIS	Very Good
BLAGNY	Very Good
SANTENOTS	Very Good
GOUTTE D'OR	Good

Puligny-Montrachet

MONTRACHET	Outstanding
CHEVALIER-	
MONTRACHET	Outstanding
BATARD-	
MONTRACHET	Outstanding
BIENVENUES-BATARD-	
MONTRACHET	Outstanding
COMBETTES	Great
CHALUMEAUX	Great
FOLATIERES	Great
CLAVOILLON	Very Good

PUCELLES	Great
CAILLERET	Great
CHAMP-CANET	Very Good
GARENNE	Very Good

Chassagne-Montrachet

MONTRACHET	Outstanding
BATARD-	
MONTRACHET	Outstanding
CRIOTS-BATARD-	
MONTRACHET	Outstanding
RUCHOTTES	Great
MORGEOT	Very Good

Outstanding Vineyard

Great Vineyard

Very Good Vineyard

Good Vineyard

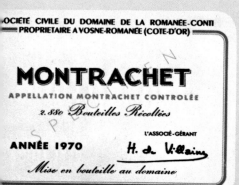

SOCIÉTÉ CIVILE DU DOMAINE DE LA ROMANÉE-CONTI
PROPRIETAIRE A VOSNE-ROMANÉE (CÔTE-D'OR)

MONTRACHET
APPELLATION MONTRACHET CONTROLÉE
2.880 Bouteilles Récoltées
L'ASSOCÉ-GÉRANT
ANNÉE 1970
H. de Villaine
Mise en bouteille au domaine

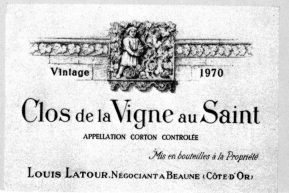

Vintage 1970
Clos de la Vigne au Saint
APPELLATION CORTON CONTROLÉE
Mis en bouteilles à la Propriété
LOUIS LATOUR, NÉGOCIANT A BEAUNE (CÔTE-D'OR)

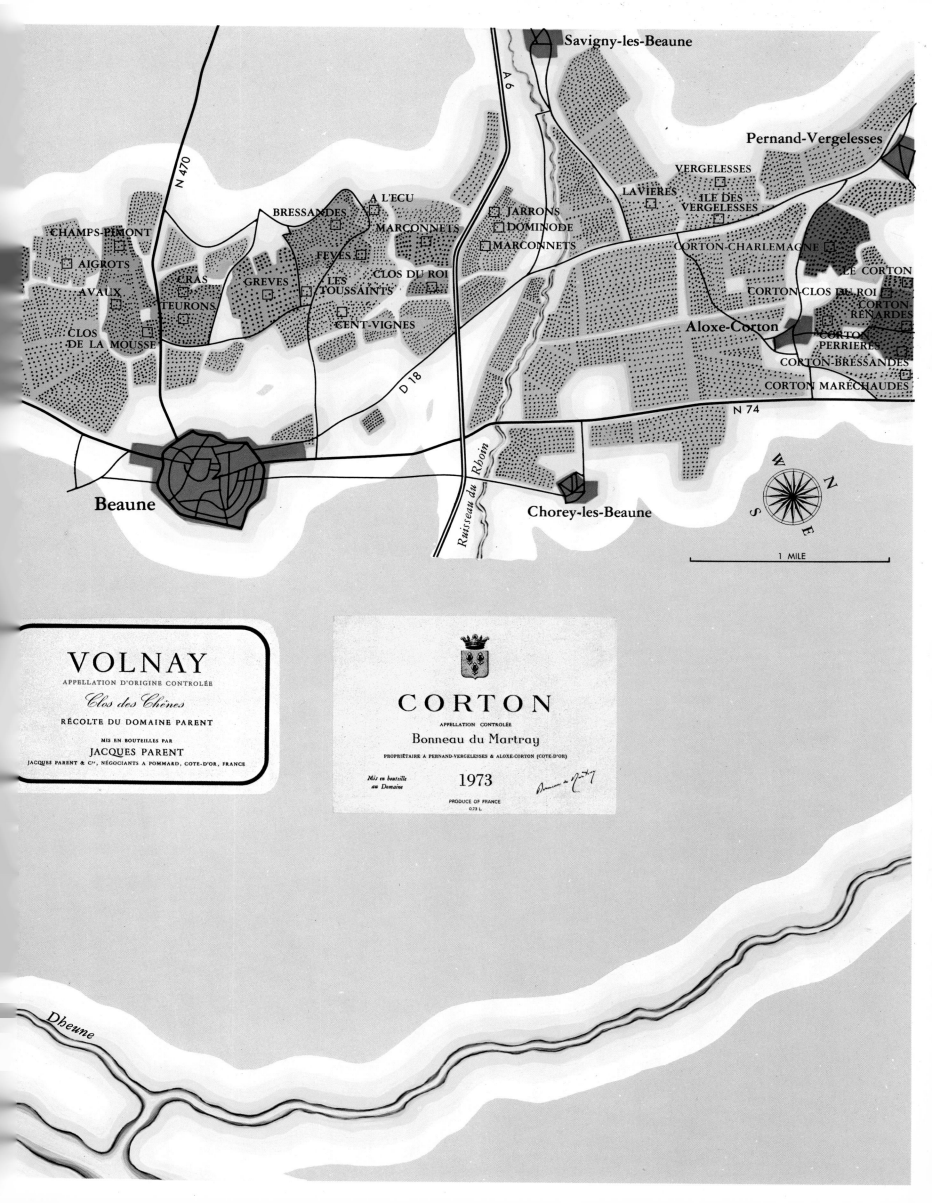

Savigny-les-Beaune

Pernand-Vergelesses

VERGELESSES

LAVIÈRES

ILE DES
VERGELESSES

BRESSANDES

A L'ECU

JARRONS

DOMINODE

MARCONNETS

CHAMPS-PIMONT

MARCONNETS

CORTON-CHARLEMAGNE

AIGROTS

FEVES

LE CORTON

CRAS

GREVES

CLOS DU ROI

CORTON-CLOS DU ROI

AVAUX

LES
TOUSSAINTS

CORTON-
RENARDES

TEURONS

Aloxe-Corton

CLOS
DE LA MOUSSE

CENT-VIGNES

CORTON-
PERRIERES

CORTON-BRESSANDES

CORTON MARÉCHAUDES

N 74

Beaune

Chorey-les-Beaune

N 470

A 6

D 18

Ruisseau du Rhoin

1 MILE

N
W
S
E

Dheune

VOLNAY

APPELLATION D'ORIGINE CONTROLÉE

Clos des Chênes

RÉCOLTE DU DOMAINE PARENT

MIS EN BOUTEILLES PAR

JACQUES PARENT

JACQUES PARENT & Cᴵᵉ, NÉGOCIANTS A POMMARD, COTE-D'OR, FRANCE

CORTON

APPELLATION CONTROLÉE

Bonneau du Martray

PROPRIÉTAIRE A PERNAND-VERGELESSES & ALOXE-CORTON (COTE-D'OR)

Mis en bouteille
au Domaine

1973

PRODUCE OF FRANCE

0.73 L.

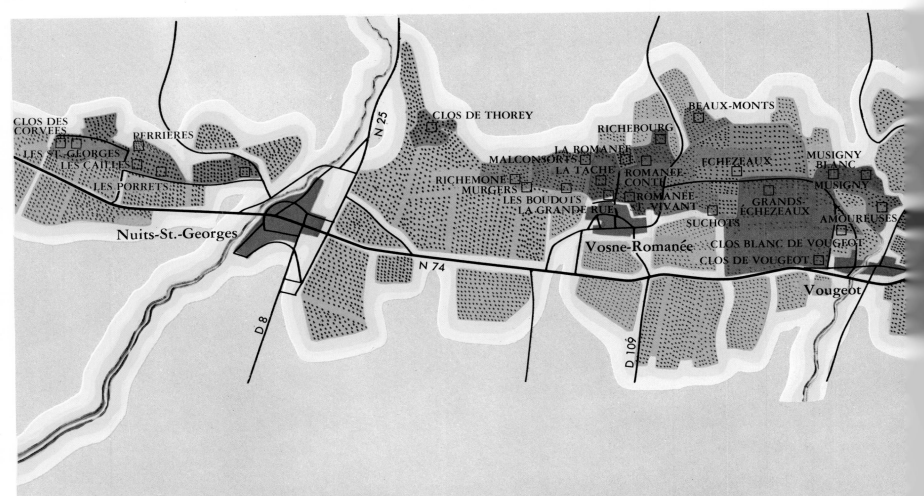

THE COTE DE NUITS

COMMUNE, VINEYARD	RATING

RED WINES

Fixin

LES HERVELETS	*Very Good*
CLOS DU CHAPITRE	*Very Good*
CLOS DE LA PERRIERE	*Very Good*
ARVELETS	*Very Good*
CLOS NAPOLEON	*Very Good*

Gevrey-Chambertin

CHAMBERTIN	*Outstanding*
CLOS DE BEZE	*Outstanding*
LATRICIERES-CHAMBERTIN	*Great*
MAZIS-CHAMBERTIN	*Great*
CHARMES-CHAMBERTIN	*Great*
MAZOYERES-CHAMBERTIN	*Great*
GRIOTTE-CHAMBERTIN	*Great*

RUCHOTTES-CHAMBERTIN	*Great*
CHAPELLE-CHAMBERTIN	*Great*
CLOS ST.-JACQUES	*Great*

Morey-St.-Denis

BONNES MARES	*Outstanding*
CLOS DE LA ROCHE	*Great*
CLOS DE TART	*Very Good*
CLOS ST.-DENIS	*Very Good*
CLOS DES LAMBRAYS	*Very Good*

Chambolle-Musigny

MUSIGNY	*Outstanding*
BONNES MARES	*Outstanding*
AMOUREUSES	*Great*
CHARMES	*Very Good*

Vougeot

CLOS DE VOUGEOT	*Outstanding*

Flagey-Echezeaux

GRANDS-ECHEZEAUX	*Outstanding*
ECHEZEAUX	*Very Good*

Vosne-Romanée

ROMANEE-CONTI	*Outstanding*
LA TACHE	*Outstanding*
ROMANEE-ST.-VIVANT	*Outstanding*
RICHEBOURG	*Outstanding*
LA GRANDE RUE	*Outstanding*
LA ROMANEE	*Great*
MALCONSORTS	*Great*
SUCHOTS	*Great*
BEAUX-MONTS	*Great*

Nuits St.-Georges

LES ST.-GEORGES	*Great*
LES CAILLES	*Great*
CLOS DES CORVEES	*Great*
LES VAUCRAINS	*Great*

CHAMBERTIN CLOS DE BÈZE

APPELLATION CONTRÔLÉE

Domaine Armand Rousseau Père et Fils

GEVREY-CHAMBERTIN (CÔTE D'OR)

MISE AU DOMAINE Product of France

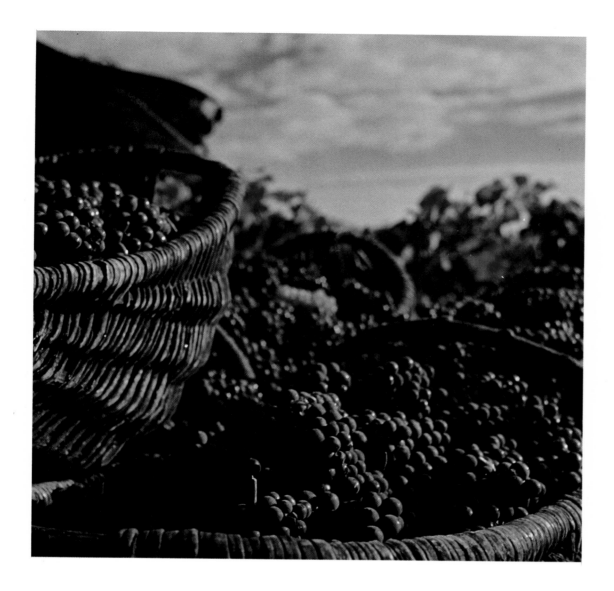

THE CÔTE DE NUITS

The Pinot Noir is the great grape of Burgundy and Champagne, producing all the best red Burgundies and two-thirds of the champagne

The vineyards outside the city of Dijon, called the Côte de Dijon, once had a local renown for a variety of high-quality wines, but today are known best for their pale rosé, Marsannay. Made from the Pinot Noir grape, it is a particularly fresh and delightful pink wine.

Fixin, the first village on the Côte de Nuits, heralds the great Burgundies grown beyond its borders to the south. Fixins have much of the strength and power that characterize the truly fabled wines of the northern half of the Côte d'Or. Since they are far less well known than they deserve to be, the wines of Fixin can be excellent values. Several of the *Premier Cru* wines are comparable in quality to the fine vintages of Fixin's neighbor Gevrey-Chambertin. Among these notable Fixins are Clos de la Perrière, Clos Napoléon, Les Hervelets, and Clos du Chapitre.

The pride of Gevrey-Chambertin is the great wine Chambertin, which has been called the headiest of all Burgundies. It is celebrated both for its deep red color, or robe, and for its powerful nose. (The word "bouquet" cannot adequately de-

275

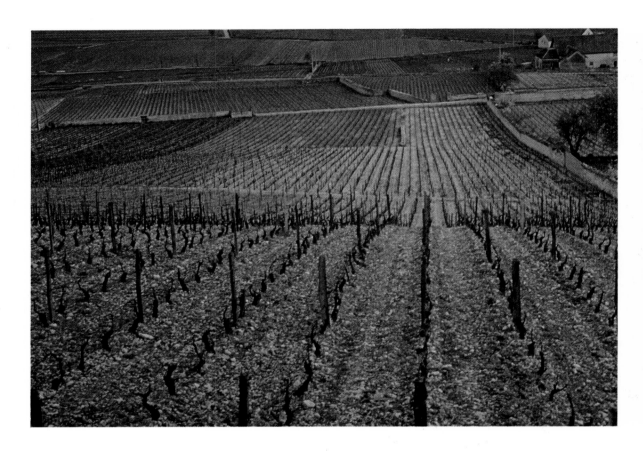

Each year between December and April the vines are pruned. In spring, after the sap has risen in the dormant vines, a new cycle begins. Beneath the sheltering leaves tiny berries grow into bright green grapes that will assume their mature color in August

scribe its grandeur.) Chambertin has a regal history. Napoleon was among the wine's great admirers: he is said to have carried Chambertin with him wherever he went, even during his campaign into Russia. The adjoining vineyard, Chambertin–Clos de Bèze, is equally magnificent; many experts insist that it is almost impossible to distinguish between the two wines. The seven other Gevrey *Grands Crus* may use the name Chambertin only in combination with their own vineyard names. Certainly fine wines in themselves, they are not to be slighted: Chapelle-Chambertin, Charmes-Chambertin, Latricières-Chambertin, Ruchottes-Chambertin, Mazis-Chambertin, Mazoyères-Chambertin, and Griotte-Chambertin. The village *Appellation* of Gevrey-Chambertin has several outstanding *Premier Cru* vineyards, among them Clos Saint-Jacques, Varoilles, Cazetiers, and Aux Combottes.

The next village down the vineyard road, the Route des Grands Crus, is Morey-Saint-Denis. Though not quite as famous as its neighbors, Morey nevertheless counts four *Grands Crus*: Clos de la Roche, Clos de Tart (one of the few Burgundy vineyards with a single owner, in this case the Mommessin family), Clos Saint-Denis, and Bonnes-Mares (the last-mentioned lying mostly in Chambolle-Musigny, the commune to the south). Another vineyard, the Clos des Lambrays, is con-

276

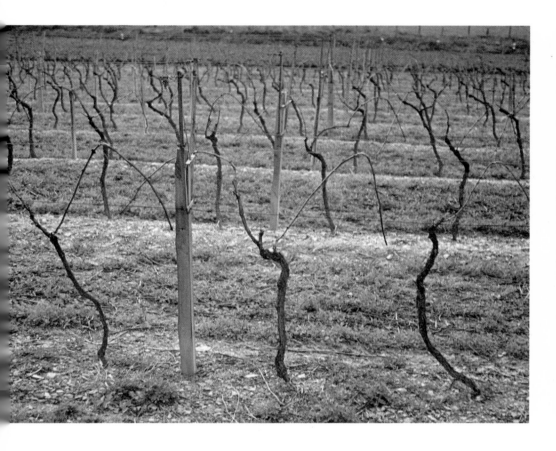
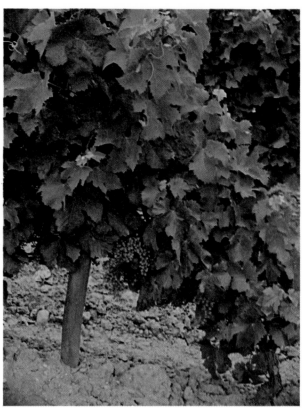

sidered by many to equal the four top ones. All produce sturdy, full-bodied Burgundies, quick to mature and very long-lived. A number of quite fine *Premier Cru* wines, usually labeled simply Morey-Saint-Denis, grow here as well.

Chambolle-Musigny, besides claiming thirty-four of the thirty-eight acres of the important Bonnes-Mares vineyard, is the home of the superb Musigny, a wine of velvet smoothness, delicate but luscious fruit, and perfectly balanced body. The average quality of the wines of Chambolle is very high. They are considered the most feminine of Burgundy wines, and two of the best vineyards are aptly named Les Amoureuses and Les Charmes. Both possess the flowery fragrance that makes the finest wines of Chambolle-Musigny so attractive.

The fame of Vougeot derives from the great Clos de Vougeot, one of the few Burgundy vineyards containing a château of any importance. Built in the sixteenth century by Cistercian monks, the château is today the setting for the great dinners of the Confrérie des Chevaliers du Tastevin, a famous Burgundy wine society. Its members gather throughout the year in the great hall of the Vougeot château to taste the fine wines of the Côte d'Or, hailing them with song and ceremony. At its best, Clos de Vougeot is a glorious wine. But, as we have seen, its quality can vary, since more than sixty growers own

277

the vineyards within its boundaries. A very fine and rare white wine called Clos Blanc de Vougeot is produced from one small part of the vineyard. Wines with only the *Appellation* Vougeot are seldom seen.

Flagey-Échezeaux, Vougeot's neighbor to the south, boasts the two *Grands Crus* Échezeaux and Grands-Échezeaux. Their labels rarely mention the village name. In fact these two wines are more commonly associated with Vosne-Romanée, the more famous commune across the road. All the vineyards of Flagey-Échezeaux are entitled to sell their wines with the *Appellation* Vosne-Romanée, and most of them do.

Romanée-Conti, the most expensive wine in Burgundy, perhaps in the world, comes from the commune of Vosne-Romanée. The other *Grand Cru* vineyards of this commune are hardly lesser lights in an extraordinary group of wines: La Tâche, La Romanée, Romanée-Saint-Vivant, Richebourg, Grands Échezeaux, and Échezeaux. Their consistent excellence is no small tribute to the men who insist upon maintaining the highest standards of quality, Louis Gros, Charles Noëllat, and the owners of the Domaine de la Romanée-Conti, M. de Villaine and M. Leroy. The wines of the Domaine are in a class by themselves. Silken in texture, they have exceptional breed, impeccable grace, and expansive fragrance—a perfume so heady that at times it fairly fills a room. The Romanée-Conti vineyard was, after the legendary harvest of 1945, among the last to replant its vines on American root stocks to remedy the damage wrought by the phylloxera. It is said that the wines made before the grafted vines were set out surpassed even the excellent vintages of today. The 1942 Romanée-Conti, which I know well, certainly supports this view. It is an astonishing and unforgettable wine. Many other extremely good wines are made in Vosne-Romanée in addition to the supreme ones. High moments of pleasurable drinking will be provided by La Grande Rue, Les Malconsorts, and Les Suchots, to name but three.

Nuits-Saint-Georges is the last village on the Côte de Nuits. Although it has no *Grand Cru* vineyards, Nuits produces many wines of generally high quality and can claim several *Premiers Crus*. Les Saint-Georges is perhaps the best-known vineyard. Others are Les Porrets, Les Vaucrains, Les Pruliers, all producing strong, full-bodied wines more closely resembling Gevrey-Chambertins than the wines of neighboring communes. From the nearby village of Prémeaux come pleasant wines also entitled to the *Appellation* Nuits-Saint-Georges.

The buying and selling of new wines is a serious business. The color, the smell, the taste—and the price—must all be considered against a background of experience and expertise

(Overleaf)
The Cadets de Bourgogne, a prankish glee club whose forte is drinking songs, amuse their fellow members of the Chevaliers du Tastevin. Their maxim: "Wine is good for women—when men drink it."

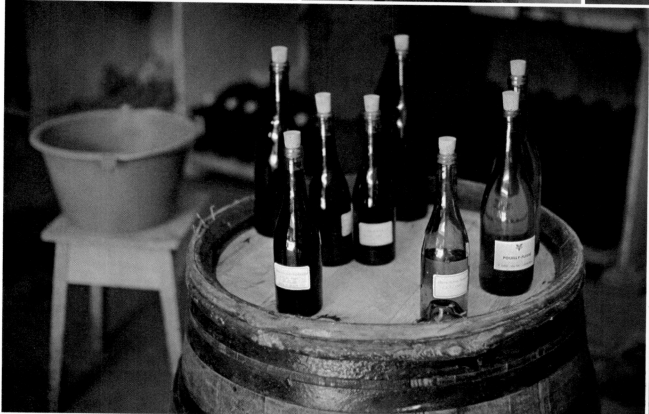

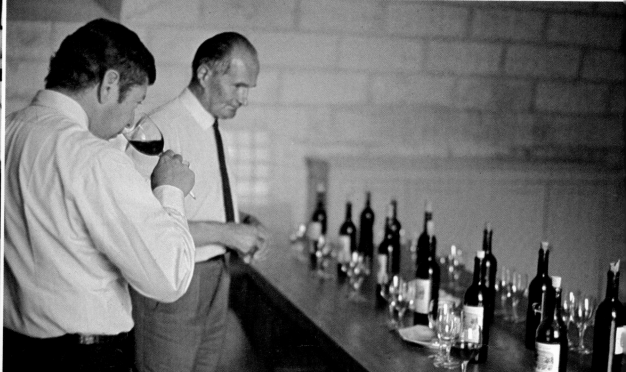

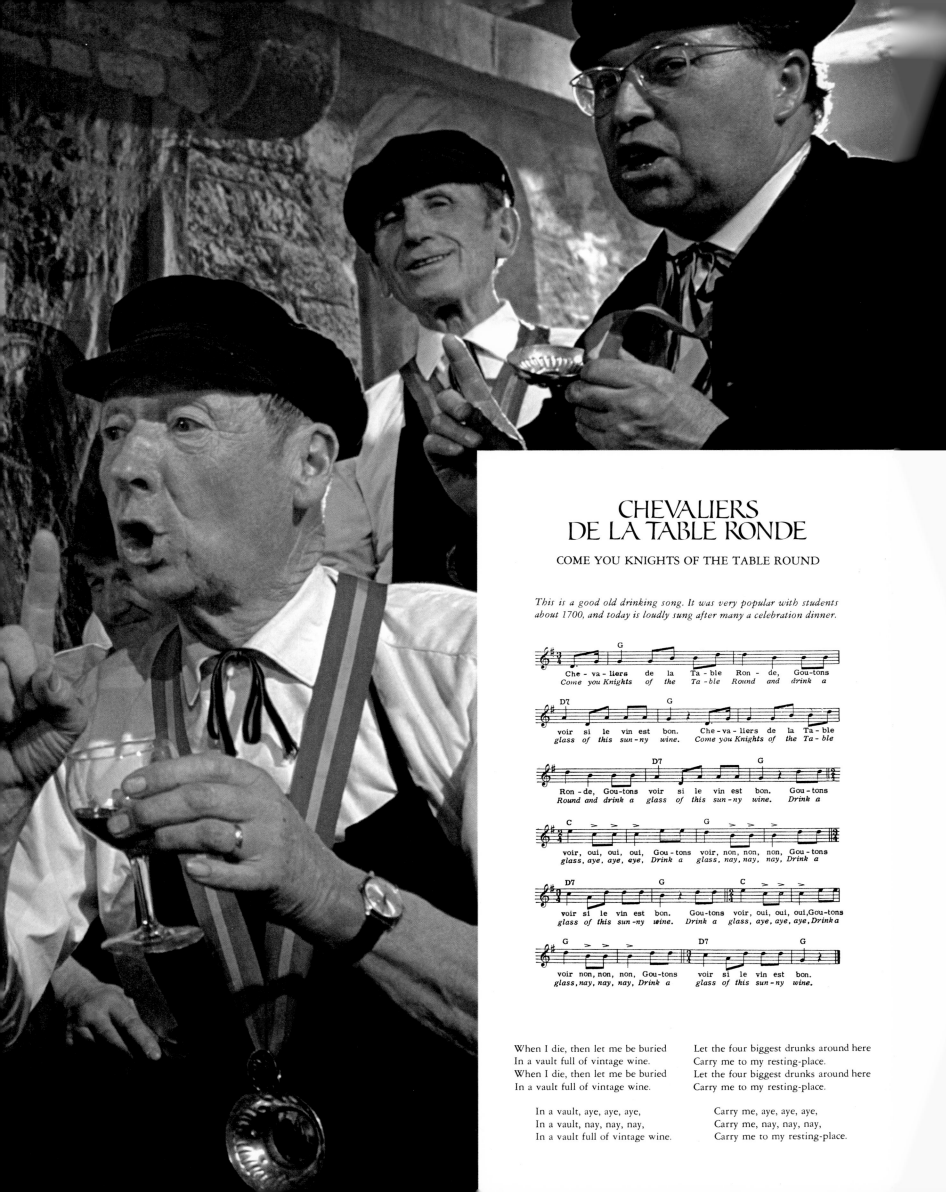

CHEVALIERS DE LA TABLE RONDE

COME YOU KNIGHTS OF THE TABLE ROUND

This is a good old drinking song. It was very popular with students about 1700, and today is loudly sung after many a celebration dinner.

Che - va - liers de la Ta - ble Ron - de, Gou-tons
Come you Knights of the Ta - ble Round and drink a

voir si le vin est bon. Che - va - liers de la Ta - ble
glass of this sun - ny wine. Come you Knights of the Ta - ble

Ron - de, Gou-tons voir si le vin est bon. Gou - tons
Round and drink a glass of this sun - ny wine. Drink a

voir, oui, oui, oui, Gou-tons voir, non, non, non, Gou - tons
glass, aye, aye, aye, Drink a glass, nay, nay, nay, Drink a

voir si le vin est bon. Gou-tons voir, oui, oui, oui, Gou-tons
glass of this sun-ny wine. Drink a glass, aye, aye, aye, Drink a

voir non, non, non, Gou-tons voir si le vin est bon.
glass, nay, nay, nay, Drink a glass of this sun-ny wine.

When I die, then let me be buried
In a vault full of vintage wine.
When I die, then let me be buried
In a vault full of vintage wine.

 In a vault, aye, aye, aye,
 In a vault, nay, nay, nay,
 In a vault full of vintage wine.

Let the four biggest drunks around here
Carry me to my resting-place.
Let the four biggest drunks around here
Carry me to my resting-place.

 Carry me, aye, aye, aye,
 Carry me, nay, nay, nay,
 Carry me to my resting-place.

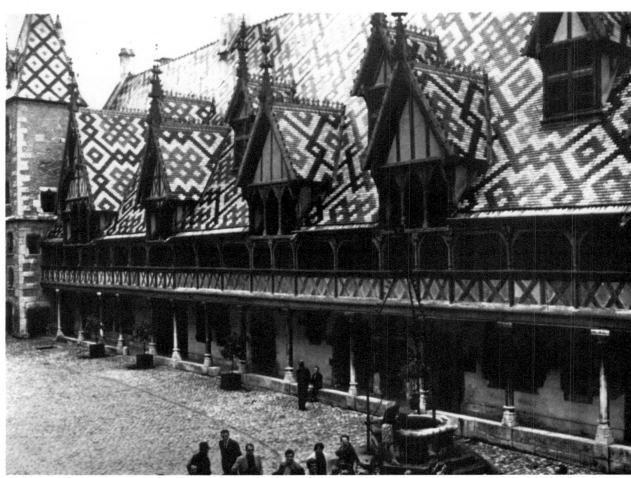

The Hospices de Beaune, a charity hospital founded in 1443 by Nicolas Rollin, Chancellor to the Duke of Burgundy, and his wife, Guigone de Salins, owns some of the best local vineyards. In this court, the November auction of its wines establishes price levels for the year's new Burgundies

THE CÔTE DE BEAUNE

Unlike the Côte de Nuits, which is famous for its reds, the Côte de Beaune is best known for its white wines. However, the Côte de Beaune vineyards also produce a great deal of fine red wine, more than three-quarters of their total output of about a million cases. The first important commune is Aloxe-Corton, whose *Grand Cru* vineyard, Corton, makes the best red wine of the Côte de Beaune. Corton is every bit as vigorous and proud as its sturdy brothers to the north. The excellent shipper Louis Latour owns a large part of the vineyard, bottling his wines at Château Grancey, a lovely property which has long been the pride of the Latour family. Although they are *Premiers Crus*, such vineyards as Corton-Clos-du-Roi, Corton-Maréchaudes, and Corton-Bressandes make wines so admirable that they are permitted to use Corton as a prefix to their own names. Aloxe-Corton has another *Grand Cru*, Corton-Charlemagne, producing magnificent white wines rich in flavor and bouquet. a sizable part of this vineyard is owned by the Latour and

Jadot shipping firms. Corton-Charlemagne takes its illustrious name from the great emperor, who in the eighth century owned vineyards somewhere in the vicinity.

Pernand-Vergelesses is a small village adjoining Aloxe. A few sections of the great Corton and Corton-Charlemagne vineyards lie within its boundaries. Wines sold as Pernand-Vergelesses, particularly those from the Île des Vergelesses, offer high quality and excellent value.

Savigny-les-Beaune is the next commune along the southward vineyard road. Many of its vineyards make very creditable red wines, among them the three *Premiers Crus* called Les Marconnets, Dominode, and Vergelesses. Savigny red wines, typical of the Côte de Beaune reds, are lighter and suppler than those from farther south.

Southeast of Savigny is Beaune, the unofficial capital of the Côte de Beaune and the center of the Burgundy wine trade. Dozens of wine merchants have their headquarters there, buying and distributing wines from all parts of the region. At the heart of this ancient walled city stands the Hospices de Beaune, a venerable charity hospital founded in the fifteenth century by the Chancellor to the Duke of Burgundy, Nicolas Rollin. He and his wife endowed it with several important vineyards in the surrounding area. Donors great and small have contributed vineyards to the hospital ever since. Each fall the wines of the Hospices plots are auctioned off, the proceeds going to support its work. The sale is held on

The medieval auction "by the candle" means that the winning bid must be called before the third and last taper gutters out

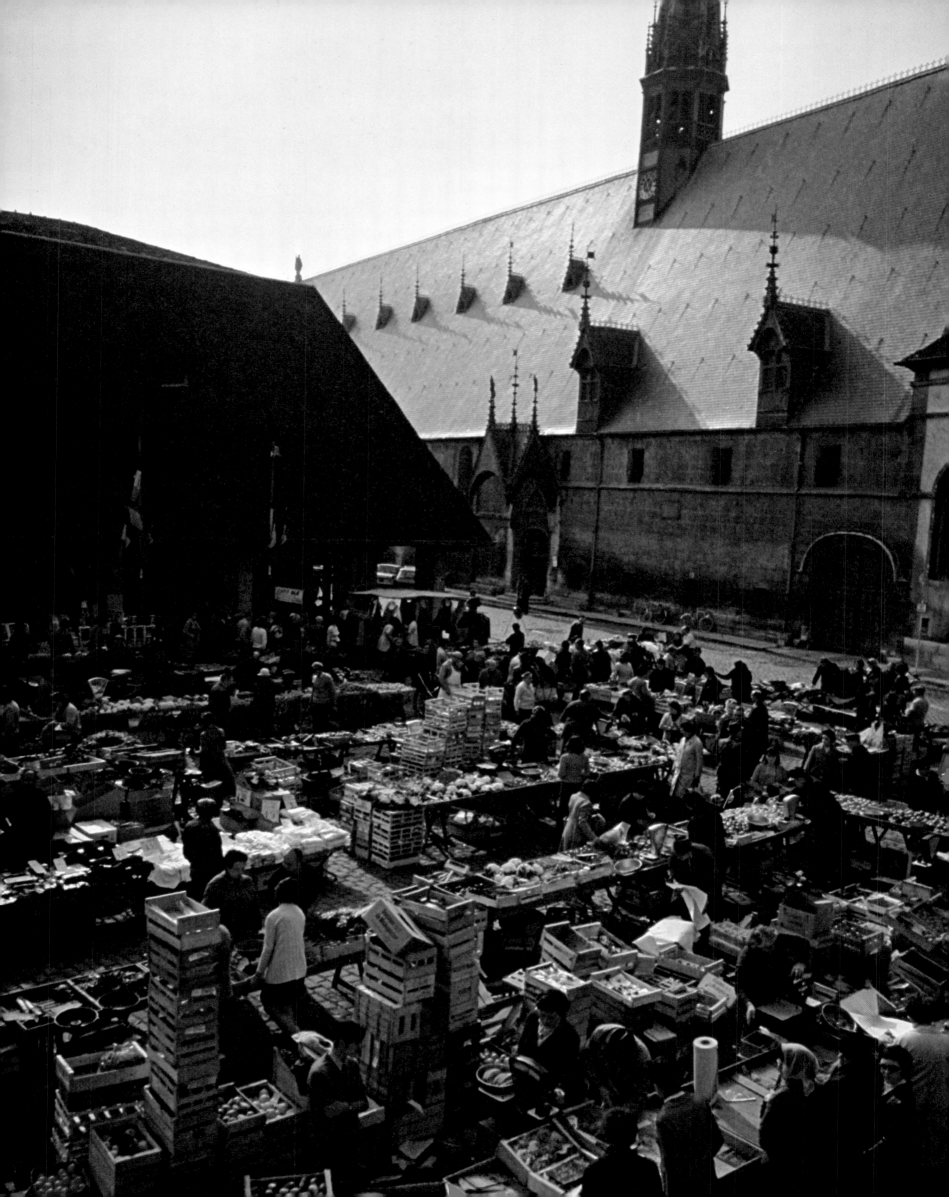

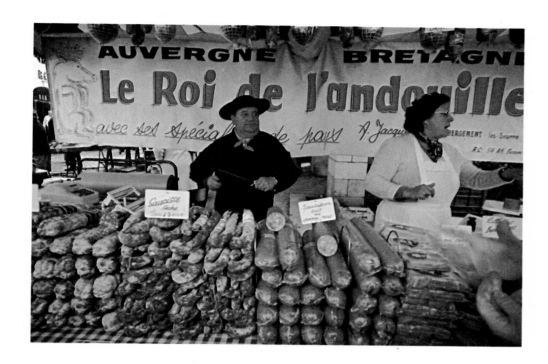

the third Sunday of November in either the Beaune market hall or the courtyard of the Hospices. A colorful and picturesque event, the auction is conducted with much ceremony. Among the traditional procedures is the medieval custom of lighting three successive candles to limit the period of bidding; the bid heard last before the third flame flickers out is the one that wins the wine. Most of the Hospices wines are truly fine, representing the best of the Côte de Beaune. The individual lots, or *cuvées*, bear the name of the vineyard and the name of the donor who originally gave the land to the Hospices: Meursault-Genevrières, Cuvée Philippe-le-Bon, for example. Since the auction is a prestigious affair, the wines predictably bring higher than average prices; however, the bids can be a good indication of the general price level for all the year's new Burgundies.

Beaune itself produces as much wine, both red and white, as any other commune on the Côte d'Or. Many are good; some of the *Premier Cru* wines are very good. Among the leading Beaune vineyards are Grèves, Fèves, and Clos des Mouches.

Below Beaune lies Pommard, well known for its delicious long-lived red wines. The names of the better Pommard vineyards are important, since some of the wine sold as Pommard may have been stretched or tampered with to meet the demand. Authentic Pommard has a distinctive *goût de terroir,* or "taste of earth." Two of the best vineyards, Les Rugiens and Les Épenots, are known for this rich earthiness. Two other fine

Saturday is market day in the old city of Beaune, "the capital of Burgundian wines." Cellars beneath the streets and the square store the wines of the district, while above ground the foods of the countryside are offered for sale

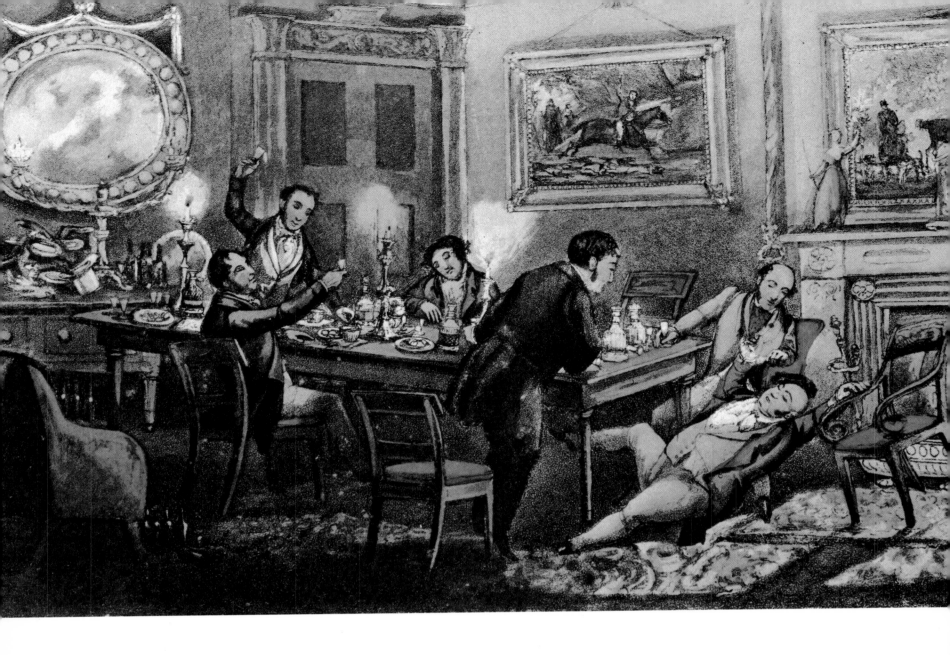

BALLADE
BEAUNE

There are merits in whisky and stout;
Of rum I am no deprecator;
And gin is a blessing, no doubt,
To those who live near the Equator;
In Russia, with vodka they cater
For warmth in that boreal zone;
But Burgundy's cleaner and straighter,
Bring me a bottle of Beaune!

Champagne one is better without,
While Schnapps as a drink's a third-rater;
Liqueurs cause laryngeal drought,
A thirst like Vesuvius' crater:
Of Malmsey and Sack I lack data,
They may have a charm of their own,
But (if I'm to be a debater)
Bring me a bottle of Beaune!

Port is productive of gout,
And brandy makes many a prater;
Think of (with feelings devout)
The hooch that is made from the 'tater;
So let us thank the Creator
Who ripens the grapes by the Rhône,
For Burgundy's never a traitor,
Bring me a bottle of Beaune!

Prince, I'll attend to you later,
Or give you a call on the 'phone,
I'm busy at present . . .
 'Hi! Waiter!
Bring me a bottle of Beaune!'

—H. S. Mackintosh

286

Pommards are sold at the Hospices de Beaune auction: Cuvée Billardet and Cuvée Dames de la Charité.

The reds of Volnay might be called the most gracious wines of the Côte d'Or. They have great delicacy and charm, appealing fruitiness, and softness. Volnays are not usually as long-lived as other red Burgundies. Several excellent vineyards are ranked as *Premiers Crus:* Caillerets, Champans, Clos des Ducs, and Clos des Chênes. Volnay joins Meursault, justly famous for soft and luscious white wines. Both villages produce red and white wines, but the whites of Volnay are sold as Meursault and the reds of Meursault are sold as Volnay.

The green-gold wines of Meursault are much sought after for their full, dry flavor and elusive bouquet. To some it seems that almonds or violets haunt Meursault's gentle fragrance. The most renowned wines come from the vineyards of Genevrières, Perrières, Charmes, and La Goutte d'Or. Many good wines from nearby Blagny are sold under the Meursault name.

The reds of Auxey-Duresses and Monthélie, two hamlets to the west of Meursault, are agreeable wines but are overshadowed by the other reds of the Côte de Beaune. Auxey-Duresses also produces a light and delicious white wine, often reasonably priced because it is little known. Auxey-Duresses Blanc can be a real discovery for lovers of white Burgundy.

The celebrated name Montrachet lends distinction not to just one but to two communes, Chassagne-Montrachet and Puligny-Montrachet. The famous vineyard of Le Montrachet lies roughly halfway between the two villages. It produces indisputably the finest dry white wine in the world. Generations of wine drinkers have been awed by Montrachet's exquisite breed and finesse. The most lavish—yet hardly excessive—praise has been heaped upon the wine. The essence of a truly noble bottle, richly concentrated in every respect, Montrachet combines full, long-lived flavor with enthralling bouquet on a magnificent golden ground. Such growers as the Marquis de Laguiche, Baron Thénard, and the Domaine de la Romanée-Conti take special pride in their excellent examples of the great wine. Four other vineyards rank as Great Growths: Bâtard-Montrachet, Chevalier-Montrachet, Criots-Bâtard-Montrachet, and Bienvenues-Bâtard-Montrachet. These wines, too, possess many of the same superlative qualities, doing honor to Le Montrachet itself.

The *Premier Cru* wines of Chassagne and Puligny seem similar, but each has its particular character. Puligny perhaps has the better reputation because of its superior vineyards,

including Les Pucelles and Clos du Cailleret. In addition, Chevalier-Montrachet and Bienvenues-Bâtard-Montrachet lie in Puligny. Fuller-bodied than Chassagne wines, Pulignys are quite dry and elegantly complex. However, Chassagne-Montrachets are not to be slighted. They are lighter, a bit fresher, and therefore not so long-lived as some of the grander white Burgundies. The commune produces red wines too. Though not as well known as the whites, they are nonetheless generous and pleasantly robust wines. Slow to mature, red Chassagnes are ready to be enjoyed sooner than most of the other red wines of the Côte de Beaune. (A typical red wine from this part of Burgundy needs five years to mature.)

Santenay is the last village on the Côte de Beaune. Its pleasant light red wines also develop slowly and show an appealing fruitiness in good years. Reasonable prices have made them increasingly popular. Clos de Tavannes and Grevières are the best-known vineyards.

SOUTHERN BURGUNDY

Côte Chalonnaise and Mâconnais. South of Chagny are the districts of southern Burgundy: the Chalonnais, Mâconnais, and Beaujolais. The Côte Chalonnaise is distinguished by two red wines, Givry and Mercurey, both resembling some of the lighter reds of the Côte de Beaune. They are solid, sturdy wines, best enjoyed young. The villages of Rully, Mercurey, and Montagny make dryish light white wines not often seen in this country.

The white wine from Pouilly-Fuissé has become one of the most sought-after wines of France. Sometimes showing a hint of the fullness of the great white Burgundies, these wines never fail to charm. Only wines from the villages of Solutré-Pouilly, Fuissé, Chaintré, and Vergisson are permitted this *Appellation*. The nearby hamlets of Loché and Vinzelles may call their similar but less elegant wines Pouilly-Loché and Pouilly-Vinzelles. Saint-Véran, just beyond the limits of the Pouilly-Fuissé district, makes another good and less expensive light white wine.

The red wines of Mâcon are little more than *vin ordinaire*, though perfectly adequate, if honestly made, for everyday drinking. They are usually not so attractive as Beaujolais, and not so expensive either. The white Mâcon wines are superior to the reds but less interesting than the Pouilly-Fuissés. A genuine Mâcon Villages Blanc offers a particularly pleasing

Le Vin, hand-colored lithograph
by L. Scherer, Paris, c. 1850

French wine value, as do the Pinot Chardonnays from Lugny and Clissé.

Beaujolais. Fruity and lighthearted, Beaujolais is one of the best-loved wines in the world. Even its sound, "BO-zho-lay," is romantic and musical. It is a zesty, joyous wine to be enjoyed any time, anywhere. When confronted with an interminable wine list or a dizzying array of bottles, many people will simply choose their trusty friend Beaujolais.

The district extends from below the town of Mâcon to just north of Lyons. Beaujolais is pleasant, fertile country, wider and more dramatic than northern Burgundy. Beneath rock-crowned hills sheltering old villages lies some of the prettiest vineyard land in France. The best wines grow in the northern half of the district.

Except for a few of the better-known *Crus,* Beaujolais is not a wine to drink slowly or thoughtfully. Much of it, in fact, is never even bottled but is sent off in barrels to the restaurants and bistros of Paris and Lyons that specialize in serving the "new Beaujolais" (Beaujolais nouveau) in carafes to accompany the good, simple food that is its perfect complement. Parisians drink it in such copious quantities that Beaujolais nouveau is known as "the wine of Paris." Though in Paris,

289

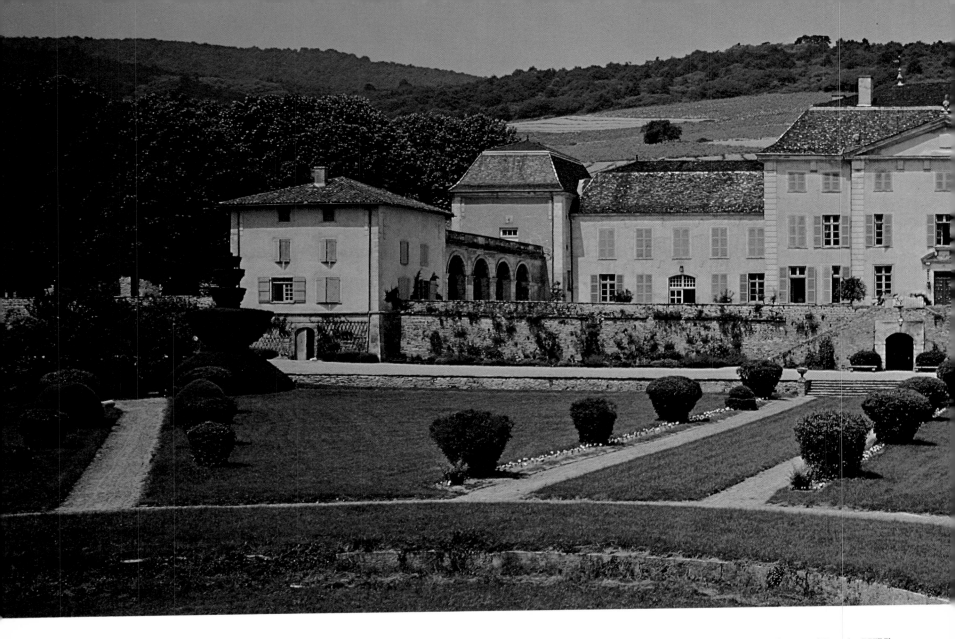

and elsewhere, the popularity of Beaujolais is consistent, the quality of the wine is not. As with every other French wine, there are good and bad years in the rolling vineyards of Beaujolais. Only in a fine vintage will the wine be fresh and uncomplicated—delightful in all respects.

The Gamay grape gives Beaujolais its youthful exuberance. It produces huge crops, and in an especially plentiful year the vats in the cooperatives throughout the region are overflowing. Beaujolais is one of the few French wine districts in which the Gamay makes something more than *vin ordinaire.* The grape has long been banished from the famous vineyards of the Côte d'Or, where the nobler Pinot Noir reigns, and it has never been grown in the vineyards of Bordeaux.

The most general *Appellation* for the wine is simply Beaujolais. To promote a consistent product, the regulations provide that this wine may be blended from the Gamay grapes grown in any of the fifty-nine communes of the district. It is the lightest (usually 11 percent alcohol) and most inexpensive of all Beaujolais wines. Beaujolais Supérieur is nearly identical; its alcoholic content must be a little higher and the yield per acre slightly lower.

Beaujolais-Villages names an even finer wine, defined by

Built by a nephew of Louis XIV's confessor, Château de La Chaize is a beautifully preserved example of seventeenth-century French architecture. Its vineyards make one of the best Beaujolais

290

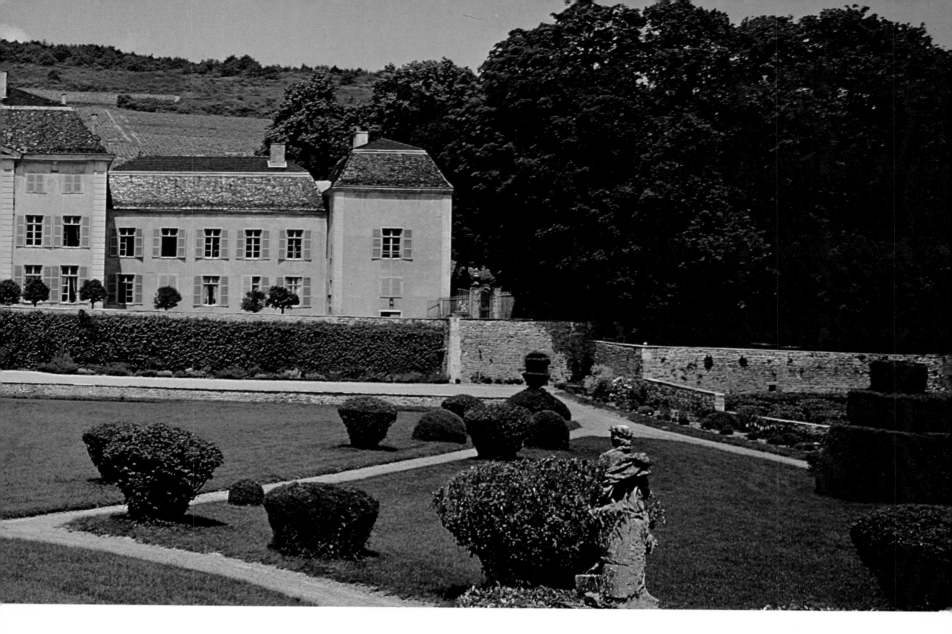

still higher standards. Thirty-five communes with better than average vineyards are granted the right to the *Appellation*. They may also use their own names on the labels of their wine, but most prefer the well-known designation Beaujolais-Villages. The wines have more character and style, and probably a more honest pedigree, than some of the cheaper Beaujolais seen on the market.

Nine other villages or vineyard areas make the best wines of Beaujolais, the individual *Crus* Moulin-à-Vent, Brouilly, Côte de Brouilly, Fleurie, Saint-Amour, Juliénas, Chiroubles, Morgon, and Chénas. Each is entitled to its own *Appellation*. These nine excellent *Crus* have more depth, greater strength, and more staying power than any of the other Beaujolais wines. Each one has its followers, but two or three always make the region's best wine. Moulin-à-Vent, a longer-lived wine than most, recalls some of the light reds of the Côte d'Or when it is mature. Morgon, too, benefits from a few years in bottle. The firmest of the Beaujolais at birth, it mellows to become attractive and full. Fleurie is another of the wines with fine body. Perhaps the most typical Beaujolais, it is not so long-lived. Brouilly is fresher and fruitier than any of these. With its especially pleasant and flowery bouquet, my favorite is the

Brouilly produced at La Chaize, the beautiful Louis XIV château that has for centuries been the property of the family of the Marquise de Roussy de Sales. The Brouilly vineyards ring those of another *Appellation*, Côte de Brouilly, whose vines grow on the slopes of the imposing Mont de Brouilly. Juliénas and Chénas are among the sturdier Beaujolais wines, the former being fuller and quicker to mature. Chénas boasts a longer life. Chiroubles, the softest Beaujolais, is quite popular in France but probably the least-known *Cru* found in the United States. The northernmost village of the nine, Saint-Amour, makes excellent, distinctive Beaujolais, both red and white.

CHABLIS

The small district of Chablis lies to the northwest of Burgundy proper. The unique character of the wine has eluded numerous imitators around the world, for none can match its steely elegance. The vineyards stretch for about ten miles around the rugged, calcium-rich slopes above the Serein River. The hardiness of the Pinot Chardonnay grape in this sometimes inhospitable climate accounts for much of the great strength and distinction of Chablis. The best wines, *Grand Cru* Chablis, are crisp, dry as flint, almost breathtaking. They have great depth and breed, combined with gentle fruit and a delicate bouquet. Even their color, green-gold, adds to the effect of mossy coolness so appealing on a warm day. Since the *Grand Cru* wines account for only 5 percent of the total production, they are understandably expensive. The *Grand Cru* vineyards are Les Blanchots, Bougros, Les Clos, Grenouilles, Les Preuses, Valmur, and Vaudésir. The mystery that makes these wines so superior to the other fine Chablis is hardly better understood than the enigmatic difference that distinguishes a Richebourg from a simple Vosne-Romanée. One fact is certain: the great vineyards all share the same south-oriented strip of vineyard slope. The second-rank wines, called *Premiers Crus,* are a bit less fine, though still remarkable. Montée de Tonnerre, Fourchaume, Les Forêts, Mont de Milieu, and Vaulorent are some of the best *Premiers Crus.* Wines with only the *Appellation* Chablis rarely approach the two top ranks in complexity and balance. Petit Chablis, a wine from the outskirts of the region, seems pleasant enough when drunk young but is a thin wine of no distinction in off years.

THE RHONE VALLEY

The Rhône Valley vineyards that the French call the Côtes du Rhône begin just below Lyons, about thirty miles from the southern end of Beaujolais. This part of France, producing tremendous quantities of red, white, and rosé wines, is the gateway to the sunny south of Provence and the Riviera. Even along the upper stretches of the Côtes du Rhône, the climate is too hot and too dry for growing the grape varieties that give the fine wines of Bordeaux, Burgundy, and Champagne. Instead, such strains as the Syrah and the Grenache are planted. Although these wines are considered inferior to many others, several of the wines they produce on the banks of the fast-flowing Rhône are of the highest quality. Such full-bodied wines as Châteauneuf-du-Pape, Côte Rôtie, and Hermitage are dark, heavy reds that can live for decades.

The finest stretch of vineyard along the Côtes du Rhône is the Côte Rôtie ("Roasted Slope"), whose vines, facing southeast above the river, all but cook under a great orange sun in the hottest days of summer. The sun-baked grapes give Côte Rôtie wines a strong constitution, heavy with tannin and alcohol. Nearby lie the vineyards of Condrieu, producing a pungent, sharp-edged, dry white wine. Just south of Condrieu are the vineyards of Château Grillet, producing the best-known and most expensive white wine of the Rhône. Many of the 400 cases produced annually are sold to La Pyramide, the incomparable restaurant located in the town of Vienne, a few miles from the Grillet vineyard.

The superb Hermitage wine grows near Vienne on sheer rock facing due south. The name may apply to either red or white wines; the reds account for the bulk of the production. George Saintsbury, awed by its vigor, strength, and longevity, called Hermitage Rouge "the manliest of wines." White Hermi-

tage is full-bodied, dry, and earthy. The vineyards surrounding the Hermitage slope are permitted to call their wines Crozes-Hermitage. Though similar in style, these wines do not achieve the bouquet and distinction of true Hermitage, which commands a much higher price than its poorer relations.

Farther down the Rhône lie the vineyards of Saint-Joseph, Cornas, and Saint-Péray. Their wines, while lighter versions of Hermitage, are often quite good. They age extremely well.

Some fifty miles below the cluster of Saint-Joseph, Cornas, and Saint-Péray lie the world-famous vineyards of Châteauneuf-du-Pape. The wine takes its name from the now ruined castle that served as the summer home of the Avignon popes in the fourteenth century. A vast production, as many as a million cases in some years, has made Châteauneuf-du-Pape one of France's best-known wines abroad. Often stronger than other Rhône reds, it is a round, sturdy wine of dependable quality. The *Appellation Contrôlée* laws require that the wines of Châteauneuf-du-Pape have the highest minimum alcohol content of all French wines—12.5 percent. In past years Châteauneuf-du-Pape was known to mature slowly and to have a long life. Recently some of the vineyards have begun making the wine in a more modern style, producing vintages that mature more quickly but do not last so long. While these can be pleasant and agreeable, they lack the complexity and depth of wines made in the traditional fashion. An honest bottle of old-style Châteauneuf-du-Pape needs five to ten years to mature.

(Left) The distinctive pink color of vin rosé is achieved by drawing the wine off the red grapeskins after only two or three days, before the color deepens

(Right) A robust red wine from the Côtes du Rhône stands up well to barbecued meats

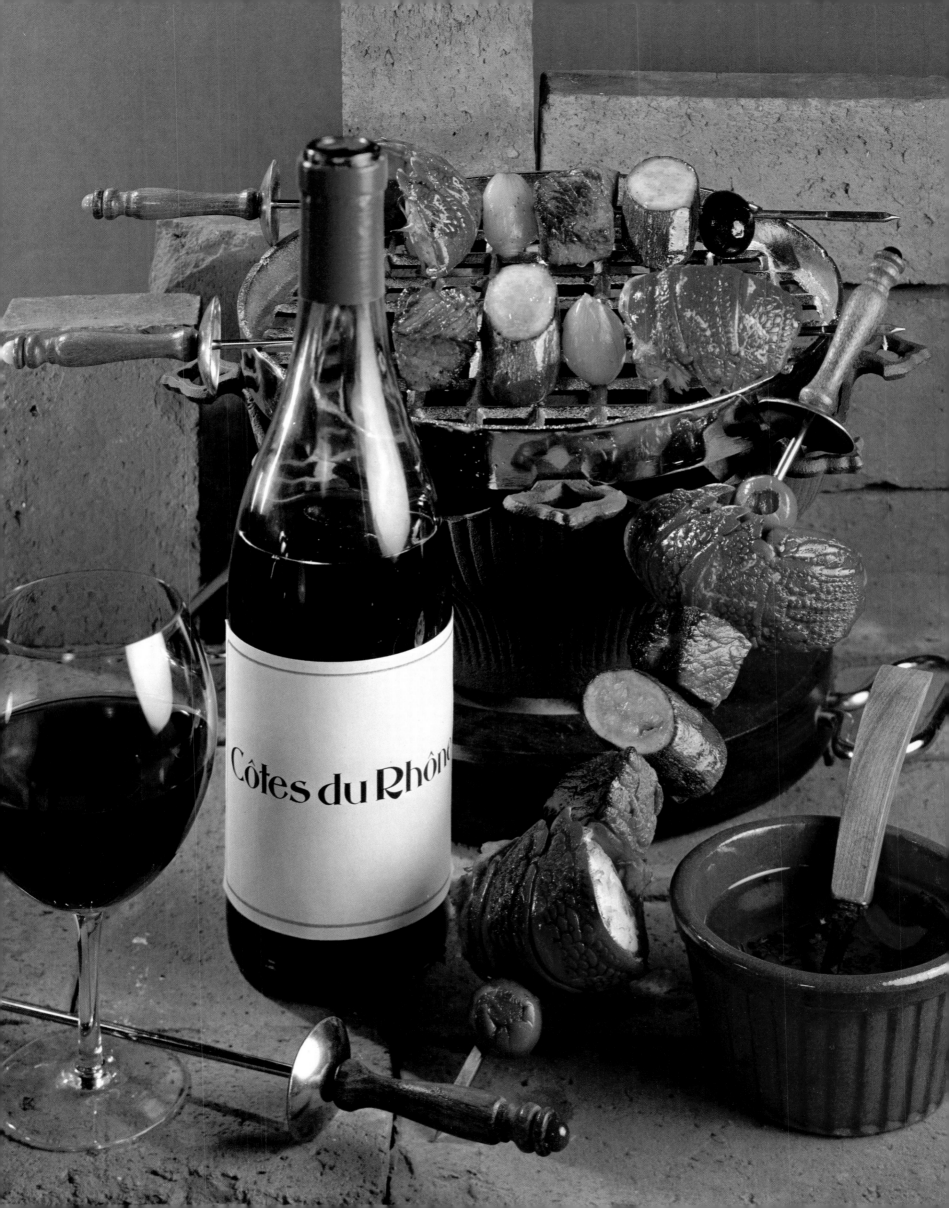

Wine bottles swathed in tissue paper wait to be packed in cases

The great red wines of Châteauneuf-du-Pape, Hermitage, and Côte-Rôtie are responsible for the fame of the vineyards of the Rhône Valley. Though the regional wine called Côtes du Rhône cannot compare to the valley's best, it offers a pleasant introduction to the dark-red wines of the Rhône. Nearly all the wine entitled to the rather broad Côtes du Rhône *Appellation* is red. The delimited area is vast and the production standards for the wine are minimal, so the annual production often exceeds 5 million cases. Côtes du Rhône regional wines share the lovely fruitiness of other Rhônes, but most are softer and shorter-lived than the classic wines of the area. Made to be drunk young, they can be excellent values. Many Beaujolais wines have become more expensive and Côtes du Rhônes offer a good low-cost alternative. One of the best I have enjoyed comes from La Vieille Ferme, a fine property in the Vaucluse hills east of the river.

One of the world's finest vins rosés grows in the Rhône Valley around the quaint town of Tavel, across the river from Avignon. The robust Grenache grape planted in the arid, rocky soil of the Tavel vineyards gives the wine its remarkable quality. Most pink wines should be consumed as young as possible, but a good Tavel needs about three years in bottle to be at its best. Lirac, a town just north of Tavel, also produces a fine rosé, one that is less costly than the popular Tavel.

THE
LOIRE
VALLEY

The vineyards of the Loire Valley are strung along one of the prettiest rivers in France. Some of the charming Loire towns, such as Sancerre, sit high above the river's banks; others, such as Pouilly, nestle in one of its serpentine bends. On its travels to the Atlantic, the Loire winds past many fanciful châteaus built by kings and princes centuries ago—Chambord, Chenonceaux, Azay-le-Rideau, Cheverny, and Amboise. Two of France's most exuberant writers roamed this castle-dotted countryside—Rabelais of Chinon and Balzac, born in Tours. Through such creations as Gargantua and Pantagruel and the peripatetic friar of many a droll tale, they touted not only the wines of the Loire but any wine, so long as it was plentiful.

The Loire is the longest river in France. Rising southwest of Lyons in the mountains of the Massif Central, the river flows more than 650 miles, first northwest and then, a hundred miles or so below Paris, west. Generous quantities of wine, mostly white and rosé, are made all along its vine-clad banks. However, much of the wine is too low in alcohol (under 11 percent) to withstand the rigors of travel. To sample the complete variety of Loire wines, the wine lover must journey to the delightful vineyards in the valley itself. There it is soon discovered that the wines are the most pleasant and engaging *vins du pays* in all France, especially when they are enjoyed in one of the many fine local restaurants, accompanied by some of the light *spécialités de la campagne* and pungent cheese. One town, Sancerre, is as famous for its goat cheese (*chèvre*) as for its wine. Little spheres, pyramids, and cylinders of the chalk-white cheese are sold in markets and restaurants everywhere along the Loire. Though cheese is traditionally served with a full-bodied red wine, the *chèvres* of the Loire seem a perfect complement to the valley's many white wines.

Sancerre and Pouilly-Fumé are two of the most famous

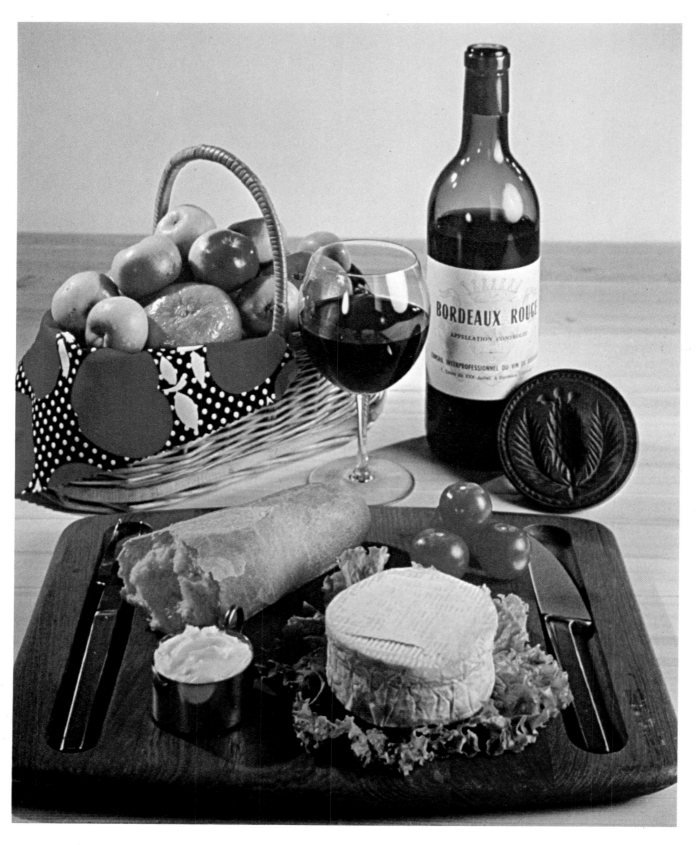

wines of the Loire Valley. The vineyards lie on opposite sides of the river above the town of Nevers, not far from Burgundy. Sancerre is a fresh dry white wine of considerable character (more than most Loire wines have, except perhaps its neighbor Pouilly-Fumé) with marvelous fruit and an enticing, spicy bouquet. Sancerre was a great favorite of Ernest Hemingway's. He wrote of icing down cases of it in the back of his car to drink "crackling cold" on his way south from Paris to Spain. The best Sancerre comes from the communes of Chavignol, Bué, and

The wine man's rule "Buy on water, sell on cheese" is based on the fact that wine is enhanced by a good cheese. A loaf of bread, a piece of cheese, an apple, and a glass of red wine make the perfect repast

298

Amigny, whose names occasionally appear somewhere on the label. Some consider Sancerre rosé, made from the Pinot Noir grape, the best pink wine of France—even better than Tavel.

Across the river is the town of Pouilly-sur-Loire, home of the popular Pouilly-Fumé wine. A richly fruited, well-rounded, but quite dry wine, Pouilly-Fumé is made, like Sancerre, from the Sauvignon Blanc grape, known in this part of the valley as the Blanc-Fumé, or "Smoky White." The origin of this name is something of a mystery. Whether it arose because of the autumn mist that drifts above the vineyards at harvest time or because of the dusty bloom that develops on the ripened grapes, no one can say for sure. The name Pouilly-Fumé is a combination of the town's and the grape's names. Pouilly makes another wine from a different grape, the Chasselas, a variety widely used in Switzerland. Pleasant, but lacking the distinction of Pouilly-Fumé, this wine has the *Appellation* Pouilly-sur-Loire. Pouilly wines, especially Pouilly-Fumé, can easily be confused with the white wine of southern Burgundy, Pouilly-Fuissé. More common in the United States than some of the Loire wines, Pouilly-Fuissé is a richer, fuller, and softer wine.

Downstream from Pouilly-sur-Loire is Tours, capital of the Loire wine country. Foremost of the wines of the Touraine, as the environs of Tours are called, is Vouvray. A soft white wine that is most often dry but sometimes sweet and sometimes sparkling, Vouvray is made from the Chenin Blanc grape. It is fresh and delicious, a pleasing wine to drink as an aperitif. Attesting to its popularity, the cry of "Ouvrez le Vouvray!" still resounds through Paris in the spring. In favorable years, when the grapes have ripened more fully than usual, lovely sweet Vouvrays are made. These sweet wines from great vintages can be very rich and long-lived indeed. Only recently, when visiting the Vouvray cellars of Marc Brédif, I was astounded by the youth and vigor of his 1921.

After bottling, some Vouvrays may generate carbon dioxide, becoming slightly sparkling—what the French call *pétillant.* As with champagne, the sugar in the wine starts to ferment in the bottle, resulting in barely perceptible little bubbles. Other Vouvrays actually have sugar added to make the wines fully sparkling, or *mousseux.* All these versions of Vouvray find their way to America, but the still table wine, both dry and sweet, makes up most of our imports.

The Touraine also produces a great deal of rosé wine, as well as the only reds of distinction from the Loire—Chinon and Bourgueil. Most of the rosés, made from any of a number of

grape varieties, including the Cabernet Franc, Gamay, Pinot Noir, and Pinot Gris, are rather light and do not travel well. The vineyards of Chinon and Bourgueil (and Saint-Nicolas de Bourgueil, whose wines are especially fruity and quick to mature) are planted entirely in Cabernet Franc, a red-wine grape of Bordeaux. These light red wines are similar to good Beaujolais, but often have more depth and style. Bourgueil is slightly heavier than Chinon and will improve after several years in bottle.

Saumur is a picturesque little town between Tours and Angers, the capital of the Anjou district. Saumur is best known for its white wines, generally soft and dry, but it also produces a good deal of sparkling wine sold as Saumur Mousseux. The rosés of Saumur are very light and very pale but quite refreshing and agreeable. The red wines, mostly from Champigny and labeled Saumur-Champigny, are seldom seen outside France.

Saumur lies near the edge of the region of Anjou, producer of much white and rosé wine, plus some red. The best Anjous come from the Côteaux du Layon, the Côteaux de la Loire, and the Côteaux de Saumur. The whites of the Côteaux du Layon are especially delightful, similar in style to some of the good Rhine and Moselle wines of Germany. Many of the lesser Côteaux du Layon wines have a soft, dryish texture, bordering on sweetness, that makes them ideal for summertime drinking. The greatest, sweetest wines from exceptional vintages are rich and delicious, some elegant enough to rival the better Sauternes and Barsacs. Throughout Anjou, the leading grape variety is the Chenin Blanc, so widely used that it is known as the "Pineau de la Loire." Another Anjou wine, typically not so sweet as some from the Côteaux du Layon, is Savennières. Its honeysuckle bouquet and light but complex taste make it one of my favorites.

From the vineyards near the mouth of the Loire comes what may be the most popular of all the valley's wines: Muscadet. Its fame, though worldwide, is fairly recent. Fifty years ago Muscadet was simply a good *vin du pays* that rarely left the region. Now many happy wine drinkers have come to enjoy its charms, especially as a complement to all sorts of seafood. The largest Muscadet-producing area is Sèvre-et-Maine, southeast of Nantes, the ancient capital of the province of Brittany. The Côteaux de la Loire grows a much smaller amount. The wine is made from a grape known as the Muscadet, correctly a Burgundian variety, Melon, that produces undistinguished wine elsewhere. Gros Plant, a fresh, light white wine from nearby that is cheaper than Muscadet, is becoming increasingly popular. S.A.

Rembrandt's *Self-Portrait with Saskia*, c. 1636

TO THEA AT THE YEAR'S END – WITH A BOTTLE OF GEWÜRZTRAMINER

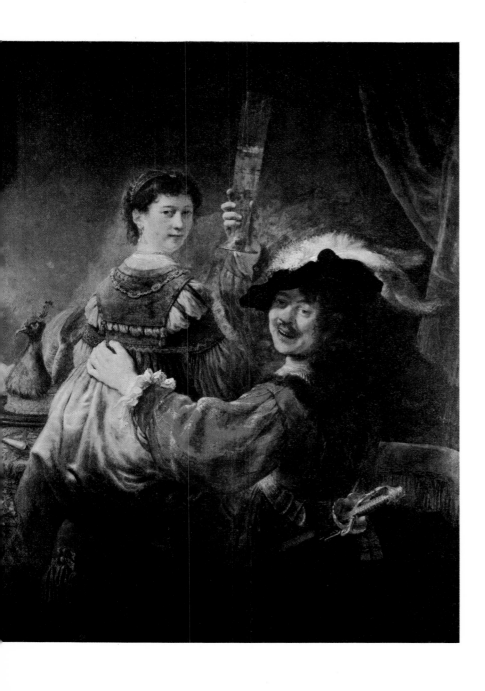

I have no fancy to define
 Love's fullness by what went before;
I think the day we crossed the line
Was when we drank the sea-cooled wine
 Upon a sun-warmed shore.

The sun in sudden strength that day
 Inflamed the air, but could not reach
The steel-sharp sea of middle May
That brimmed with cold the breathless bay
 Below the sun-drowned beach.

The sun's heat laid its heavy hand
 On unaccustomed skins as we
Went tip-toe down the tilted strand
And set our bottle on the sand
 To cool it in the sea:

And watched as, where the sea-surge spent
 The last of its quiescent strength,
Stone-cold and circumambient,
The intermittent water went
 Along its polished length.

The bottle took the water's cold
 But did not let its wetness pass;
Glinting and green the water rolled
Against the wine's unmoving gold
 Behind its walls of glass.

We cooled it to our just conceit
 And drank. The cold aroma came
Almost intolerably sweet
To palates which the salt and heat
 Had flayed as with a flame.

We swam and sunned as well as drank,
 And found all heaven in a word;
But, dearest Thea, to be frank,
I think we had the wine to thank
 For most of what occurred.

And now the winter is to waste,
 I bring a bottle like the first;
And this in turn can be replaced,
As long as we have tongues to taste,
 And God shall give us thirst,

Lest with the year our love decline,
 Or like the summer lose its fire,
Before the sun resurgent shine
To warm the sea that cooled the wine
 That kindled our desire.

—P. M. Hubbard

ALSACE

All French vineyard regions tend to please the eye, but Alsace, on the northeastern border with Germany, may be the prettiest of all. The vines grow tall on the green slopes of the Vosges foothills, which rise about twenty-five miles west of the French bank of the Rhine. Many Alsatian villages still have a medieval look about them. Riquewihr, with its cobbled streets and Gothic courtyards, is one of the most enchanting wine villages in France. Kaysersberg, with a limpid stream lacing the town, is just as lovely. These villages, along with several others, such as Ammerschwihr, Bergheim, and Guebwiller, produce the white wines that are distinctively Alsatian.

Not surprisingly, the wines of Alsace are similar to those from the nearby Rhine and Moselle vineyards of Germany. The grape varieties are the same: Riesling, Sylvaner, and Traminer grow in the best plots on both sides of the Rhine. Alsatian wines, however, do not show the German tendency toward sweetness; they are strong, dry, and clean, higher in alcohol and fuller-bodied. The control of Alsatian wines is exercised by a regional organization independent of the French government; it determines which wines are permitted to use the *Appellation d'Origine Contrôlée Vins d'Alsace,* and which grape varieties may be used in their production. Alsatian wines are identified by the names of the grapes from which they are made. As in Germany, the Riesling is the foremost variety. Alsatian Rieslings are dry and full of fruit, with only a trace of sweetness. Somewhat lighter and less elegant is the Sylvaner. Fresh and attractive, Alsatian Sylvaner is the wine I serve on my terrace when warm weather begins. The Traminer grape gives the richest, fruitiest, most dramatic wines of Alsace. The best are called Gewürztraminer. The word *gewürz* means "spicy" in German, and indeed the wine is spicy and flavorful, with a concentrated bouquet. It makes an excellent accompaniment to

A 90-mile Wine Road curves through the vine-clad hills of Alsace, past picturesque villages and fields where the scent of flowers blends with the fragrance of grapes

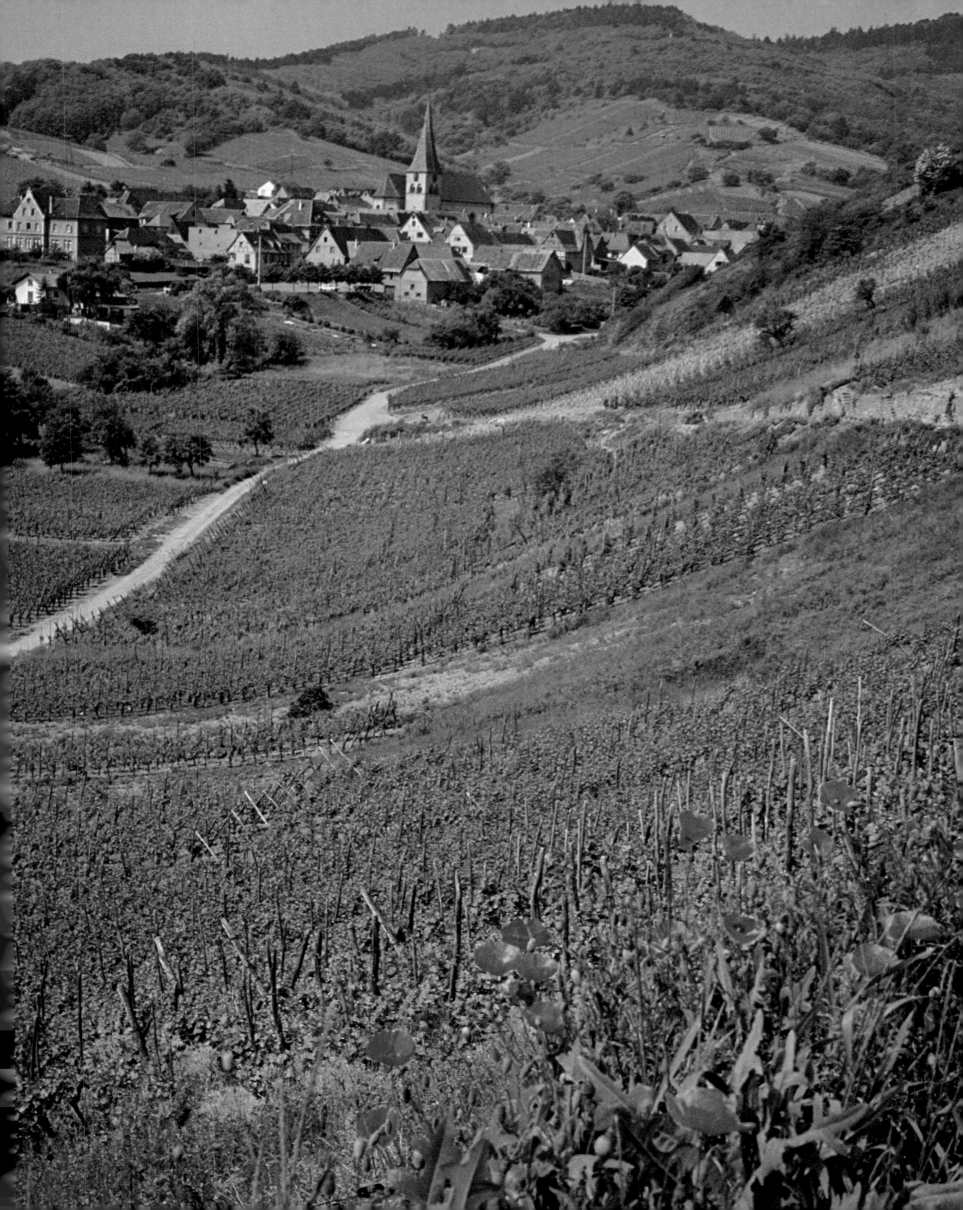

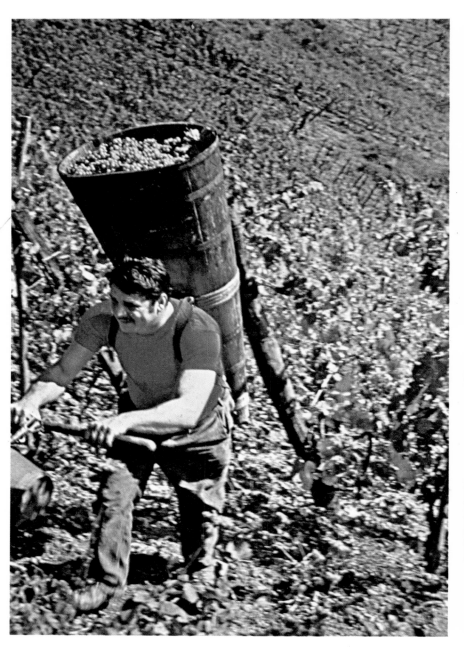

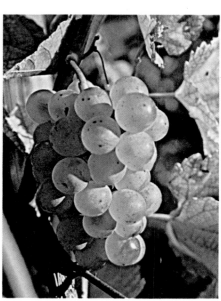

the rich, pungent food of Alsace—such specialties as foie gras and choucroute (pork sausages cooked with sauerkraut and wine).

A few other grape varieties are used in Alsace for white wines, and the Pinot Noir yields a pleasant rosé. The Muscat grape, grown the world over for sweet wines, in Alsace gives a crisp, dry, and fruity wine.

Alsatian wines often represent superior values—excellent quality at a reasonable price—because of the tremendous quantities produced, usually more than 10 million cases annually. Most of the wines of Alsace found abroad are exported by large shippers who buy grapes and vinify the grapes themselves. Some of the first-rate firms are Hügel, Trimbach, Jules Muller, Beyer, Preiss-Henny, and Dopff.

Alsatian wines, unlike other French wines, are known by their grape variety rather than their place of origin. The spicy Gewürztraminer and the elegant Riesling are the two most popular white wines of the region

CHAMPAGNE

Vintners in the United States, Chile, Russia, and countless other countries make a sparkling wine they call "champagne." But strictly speaking, Champagne is the name of a region lying about a hundred miles east and north of Paris—and, more important for our purposes, the name of the wine produced there. Of all the French geographic wine names seized upon by winemakers around the world, "champagne" is the one most often and most eagerly appropriated. Properly, the word should be used to describe only the wine grown, nurtured, and bottled by the world-famous wine houses in that part of France. However, owing perhaps to complacency and legal negligence, the Champagne winegrowers have never protected their bubbly birthright. As a result, champagne has become a general term for sparkling wine.

Champagne—true French champagne grown on the chalky hillsides south of the old cathedral city of Reims and on the hilly country overlooking the Marne River Valley—symbolizes joy and celebration. I simply cannot imagine that either of my daughters would be married without a fête featuring a champagne toast. Lively and effervescent, champagne brings a gaiety and merriment to the world such as no other wine can inspire. The sound of a popping cork, the sight of sparkling bubbles spiraling through golden liquid, transforms a happy occasion into an ebullient one.

Like so many other French wines, champagne traces its origin to the days when the Church was a major landholder, with many monasteries owning vineyards and making wines. One monastery, the Abbey of Hautvillers in the heart of the province of Champagne, had an important winemaking establishment headed by the Benedictine monk Dom Pérignon. Being blind, the good friar had a highly developed sense of taste. It is he who is credited with discovering the artful blend of wines that

gives champagne its distinctive flavor and with developing the process that creates the famous bubbles. The story is told that when he first sipped his new drink he called to his brother monks, "Come quickly, I am tasting stars!" Each year Hautvillers holds a wine festival to honor him.

No compromise with quality is permitted in the production of champagne. Only three grape varieties may go into the wine. They are the Pinot Noir, the great red-wine grape of Burgundy; the Pinot Chardonnay, responsible for the finest white Burgundies; and the Pinot Meunier, a black grape, used to a lesser extent. If the Pinot Chardonnay is used exclusively, the grower may call his wine *blanc de blancs,* a phrase which simply means a white wine made from white grapes. *Blanc de blancs* champagne is particularly light and delicate. However, more than 90 percent of French champagnes are a blend of the Pinot Chardonnay and the Pinot Noir, the latter imparting depth and body to the wine. The Pinot Noir grapes are vinified with the juice separated from the skins so that none of their dark color tints the wine.

Like Bordeaux and Burgundy, Champagne is composed of different districts, each with its own characteristics. The slopes of the large Montagne de Reims section are planted exclusively in Pinot Noir. The grapes from this area yield wines of firmness and great fragrance, with enough acidity to encourage long life. Another district, the Vallée de la Marne, is also planted solely in Pinot Noir. It produces wines that are rounder and richer in flavor than those from the Montagne de Reims. The last but not the least important winegrowing area is the Côte des Blancs, planted, appropriately enough, in the light-colored Pinot Chardonnay, which contributes notable finesse to the finished wine.

Within these three districts are the various villages that have been officially rated according to the quality of the wines they produce. The most famous communes are Verzenay, Mailly, Bouzy, Ambonnay, Ay, Avize, and Cramant. These towns hold the top, or 100 percent, rating, and the greatest of vintage champagnes contain a high proportion of the superior wine from these villages.

Looking at a map of France, it is easy to see that the Champagne vineyards are the northernmost of all the French wine regions. Thus their weather is often the harshest and most changeable of any vineyard weather in the country. In years when the climate is relatively warm and mild, fine vintage wine can be made. In less favorable years Champagne houses blend the production of great years, average years, and poorer

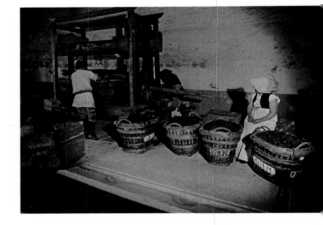

(Above) At the yearly Champagne festival an old winepress and costumes from another era speak of the past. The harvest baskets, brimming with dark Pinot Noir grapes, have been typical of the Champagne region for generations

(Right) Champagne should be served chilled in tall, flute-shaped or tulip-shaped glasses to preserve the precious bubbles. Pouring with white gloves is not *de rigueur* but adds a princely flourish to the service of a kingly wine

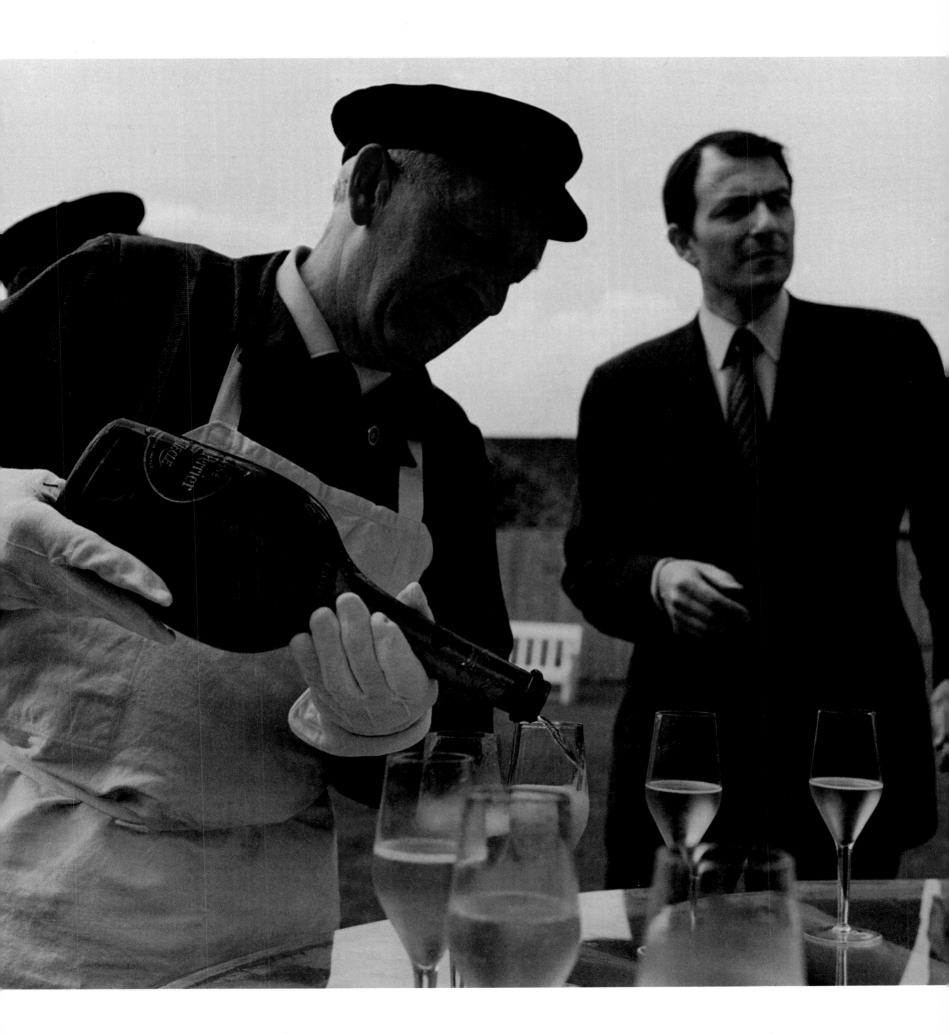

years into a nonvintage wine. To assure that nonvintage champagne retains its standing as a superb wine, no grower is permitted to sell more than 80 percent of his grapes of a successful year for the production of vintage wine. The other 20 percent is used to improve the quality of nonvintage champagne.

Since most champagne is a nonvintage blend, the consumer must rely on the integrity of the various firms. The brand or name of the champagne house is therefore more significant than the vineyard or district. Indeed, vineyard or district names seldom appear on champagne labels. The world-renowned champagne firms have become synonymous with excellence and reliability. Rather than a complete classification such as that provided above for Bordeaux and Burgundy, it is therefore useful for the student of wines who is interested in champagne to have the names of the firms that have represented the highest quality over the past century: Ayala, Bollinger, Charles Heidsieck, Clicquot, Deutz and Geldermann, Dom Ruinart, Heidsieck Monopole, Krug, Lanson, Laurent Perrier, Louis Roederer, Mercier, Moët & Chandon, Mumm, Perrier Jouët, Pol Roger, Pommery and Greno, Piper Heidsieck, Salon, and Taittinger.

We must remember that until Dom Pérignon entrapped the first bubbles in a bottle of champagne, the district made only still table wines. Some nonsparkling wines are still made there. Champagne Nature is a favorite in the restaurants of Paris but cannot be legally exported for fear that someone in a neighboring country might carbonate it, selling the newly sparkling wine as champagne. Champagne Nature is a delicate, very light, dry white wine rather like Chablis. Champagne also produces a small quantity of still red wine, resembling the lightest red Burgundies.

How is champagne made? After the first fermentation, which turns the grape juice into wine, sugar and yeast are added to the newborn champagne, causing a secondary fermentation. Promptly the wine is bottled and corked. Carbon dioxide, the natural by-product of the second fermentation, is trapped in the bottle and merges with the wine. When the bottle is eventually opened, the CO_2 gas escapes through the wine, causing the rush of foam and the sparkle of pearly bubbles. Not only carbon dioxide but sediment is formed during the second fermentation, sediment that cannot be left in the bottle to cloud the wine. To concentrate this sediment for easy removal, the bottles of champagne are placed neck down in riddling racks and are shaken and turned by hand each day for many months until all the deposit rests next to the cork. At this point the cham-

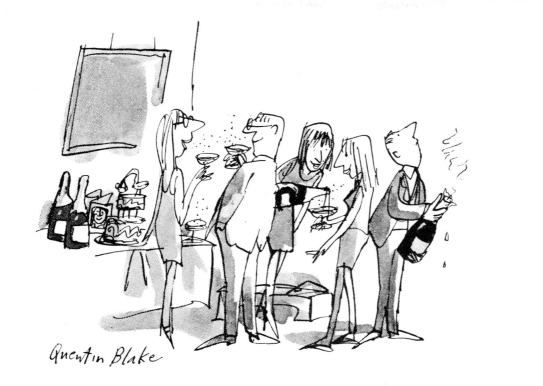

Quentin Blake

pagne is too dry and too astringent for pleasant drinking. Thus the winemakers' problem is to remove the sediment and to add sufficient sweetness to make the wine palatable. The solution is a quick and efficient process requiring much skill. A dextrous disgorger dips the neck of each bottle into an icy brine just long enough to freeze the inch or so of wine surrounding the sediment. He then removes the old cork, and the pressure of the gas forces out the plug of frozen sediment and wine. In a matter of seconds, before the bottle is recorked, a *dosage* of sugar syrup combined with wine or a little brandy is added to fill the bottle. The amount of sugar added (the *dosage*) determines the degree of sweetness of the wine. The driest French champagne, called brut, contains from 1 to 1.5 percent sugar; "extra-dry" contains up to 3 percent; "dry," or *sec,* means that 4 percent or more sugar has been added to the wine, making it sweet despite its name. Such very sweet champagne is seldom seen today, but in years past it was quite popular, especially with the czars of imperial Russia.

Champagne reaches its peak about four years after the vintage and remains on a plateau of excellence for another six. Any champagne more than ten years old must be approached warily unless it has had ideal storage conditions. When too old, the wine will lose its bubbles, turning flat and brown.

Sparkling wines are produced in other parts of France. These are called simply *vins mousseux,* from the French word for effervescent, and they are not entitled to be called champagne. Some of them can be quite good, and they are always less costly than true champagne. I rather like the dry sparkling wine from the Haute-Savoie. The fruity *mousseux* of the Loire Valley can be delightful, as can some of the better examples from both Burgundy and Bordeaux. In the eastern part of the Rhône Valley the very attractive Clairette de Die, a sweet sparkling wine, is produced in considerable quantity.

LESSER-KNOWN FRENCH WINES

To enjoy French *vins du pays* we need no longer visit the regions that produce them. More and more these country wines are seen in wineshops and on wine lists everywhere, particularly in the United States. Such wines as Cahors, Corbières, Fitou, Bergerac, and Crépy now appear here with increasing frequency. Frenchmen have always appreciated these so-called "little" wines. Most are of V.D.Q.S. status, but in recent years a number of the better ones have been granted the *Appellation Contrôlée* in recognition of their improved quality.

Among the most interesting of these wines are those produced in the Jura Mountains, which lie midway between Burgundy and Switzerland. The old Geneva-to-Paris road runs right through this gently rolling country of green hills and meadows. Large quantities of wine were once made here, but since the phylloxera struck, destroying most of the vineyards, production has been significantly smaller. Jura wines come in many colors. Red, white, and pink wines are produced, but so are "yellow" and "gray" ones. The yellow wines, or *vins jaunes,* are of course white wines, yet they have a much richer color and flavor than most other whites. Deep, nectarlike, they resemble light Spanish sherries. The likeness is not just coincidence. The two wines undergo a similar aging process. Unlike most other wines, which age in new or thoroughly scrubbed barrels, *vins jaunes* mature in old casks whose insides retain vestiges of a yeast that grows on the top of the resting wine. This is the same microorganism —the Spanish call it *flor*—that contributes flavor to Fino sherries. Most *vins jaunes* have the *Appellation* Arbois, the name of the chief town of the département of Jura. But the best and most famous is labeled with the name of a small village to the south of Arbois, Château-Chalon. The Château-Chalon name is a little confusing, since the wine is not the product of a single property.

310

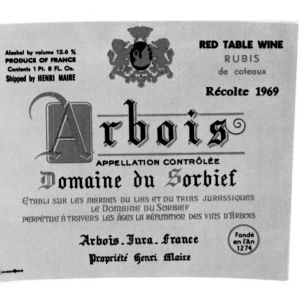

All *vins jaunes,* Château-Chalon included, are bottled in squarish, stumpy flagons called *clavelins.*

Red wines and the best true whites from the Jura are made at Arbois, but some very good white wines come from the southernmost part of the region called l'Étoile. The fine Rosé d'Arbois is one of the most delightful pink wines to be found in all France. The lesser, extremely pale rosés are referred to as *vin gris*—"gray wine."

Southeast of the Jura, south of Geneva, lies the département of Haute-Savoie, famous for skiing and for lake resorts such as Annecy and Chamonix. Savoie wines are almost exclusively white and are very similar to those of nearby Switzerland. Light, soft, and dry, their fresh, clean quality seems to capture the spirit of a rushing mountain stream. Two Savoie wines have the *Appellation Contrôlée.* Seyssel, from the town of that name on the Rhône River, is made in two versions: one sparkling, one still. Both are remarkably enjoyable, but Seyssel Mousseux is more popular abroad, especially as a low-cost substitute for champagne. The other *Appellation Contrôlée* wine is Crépy, a crisp white made from the Chasselas grape. Indeed, Crépy seems more Swiss than French.

Bordeaux dominates any consideration of the wines of southwest France, but that part of the country produces several interesting lesser wines, until recently little known abroad. One of them, Cahors, has long been considered the finest of the V.D.Q.S. wines; its quality officially recognized at last, Cahors received its own *Appellation Contrôlée* in 1971. A sturdy, nearly hard wine, Cahors is slow to mature and very long-lived. So strong was its backbone of tannin, so deep its crimson hue, that for years it was known as "black wine"—*vin noir.* Demand for Cahors has increased since its elevation to *Appellation Contrôlée* status.

The pale gold wines of Jurançon have a long and distinguished history, but few people outside the region know them well. The wines were a great favorite of King Henry IV of France, born in the city of Pau on the edge of the Jurançon district. The sweet, unusually spicy wines that he enjoyed are somewhat rare today but are well worth seeking out. Not so good is the indifferent dry white made throughout Jurançon.

East of Bordeaux is the little town of Bergerac, home of the great-nosed Cyrano. The many wines made here suffer, perhaps unfairly, by comparison with the illustrious vintages of their neighbor to the west. Some of the reds, sold as Bergerac and Montravel, are quite pleasant. A sweet white, Monbazil-

lac, is made from the Sauternes grape varieties, Sémillon, Sauvignon, and Muscadelle. The grapes, left late on the vines to develop the noble rot, are vinified in the same manner as Sauternes. Much Monbazillac is produced, over a million cases annually, but the wine rarely approaches the subtlety of Sauternes itself.

The Côtes de Provence produces considerably more wine than many of the other French wine districts, often in excess of 150 million gallons a year. Early to mature, somewhat coarse and heady, Provence wines should be consumed with eager gusto, not careful contemplation. The fresh and lively rosés are especially attractive. The best of these come from Bandol and Cassis, two little seaport towns east of Marseilles. Light and dry Provence whites are ideal for quaffing with the bouillabaisse prepared in kitchens all along the Mediterranean coast. Whether red, white, or rosé, most wines of Provence are best drunk young. Some of the reds grown around Aix and Palette improve with a few years of bottle age.

Even more fruitful than Provence is the Midi, the largest wine-producing area of France. Curving along the Mediterranean west of the Rhône River, the Midi is responsible for the vast bulk of *vin ordinaire* drunk daily by the French. Since it often has as little as 10 percent alcohol, *vin ordinaire* can be consumed copiously. A great deal of the cheap heavy red wine made here is blended with wines from other parts of the country.

An Outside Dinner After the Hunt,
hand-colored etching, English,
c. 1830

The Christian Brothers Collection

312

The hot southern sun creates a climate unsuitable for making the greatest wine, but a few interesting wines are worth exporting.

The Corbières district lies inland from the Mediterranean, between the ancient towns of Perpignan and Carcassonne. A virile red wine, sometimes of excellent quality, Corbières has now been granted the *Appellation Contrôlée*. A reasonable price makes it all the more attractive. Nearby grows Minervois, which, like Corbières, is similar to the red wines of the Côtes du Rhône. White and rosé wines, too, are made in each district, but neither is so good as the red.

Another full-bodied red from the south is Fitou, grown just below the town of Narbonne. Often a very good value for pleasant everyday drinking, it also has an *Appellation Contrôlée*.

The Mediterranean coast produces a number of unique sweet wines. France's only natural fortified wines, by law they must have at least 15 percent alcohol. As dessert wines, most of them enjoy a good reputation and a considerable market. Among the best are Grand Roussillon, Banyuls, and Muscat de Frontignan. Muscat, Grenache, and Malvoisie grapes, all of which thrive in the Mediterranean climate, are widely planted. Muscat de Frontignan, made from a variety of the Muscat grape, is powerful and golden, perhaps the very best of these fortified wines. Other very sweet, heavy dessert wines come from Roussillon, the southernmost winegrowing region of continental France. Best-known is Banyuls, grown around the picturesque fishing villages of Banyuls and Collioure. This rusty red wine recalls Tawny Port. Most plentiful is Muscat de Rivesaltes.

Corsica's steeply terraced vineyards have recently become an important source of inexpensive wine for the French mainland, especially since Algeria no longer ships her low-cost wines to France. The best Corsican wine is Patrimonio Rosé, which now has the right of *Appellation Contrôlée*. Vineyards around the town of Ajaccio produce good red and white wines. The V.D.Q.S. vineyards of Sartène are responsible for a robust red wine; the red from Balagne on the northern coast is much lighter. The Cape Corse peninsula produces both dessert wines and a fortified aperitif. S.A.

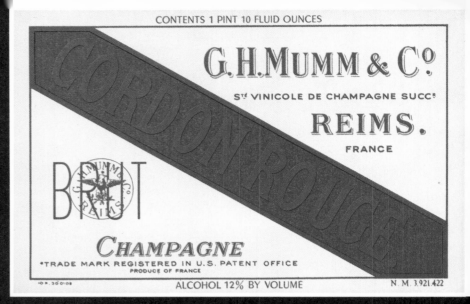

A *NÉGOCIANT'S* SELECTION

Alsatian wines bear the broad *Appellation Alsace Contrôlée*, and the name of the grape from which they are made—in this case Gewürztraminer. Often the *négotiant's* name is more prominent than the grape's—an indication of the importance of the blender and bottler in determining the wine's quality.

A CHÂTEAU-BOTTLED BORDEAUX

This wine's excellence is signified by the name of the property (Haut-Brion), controlled district name (Graves), vintage date (1966), and, as a further guarantee of authenticity, *Mis en bouteilles au château*. In addition, *Premier Grand Cru Classé* indicates the wine's place in that select first rank of classified Bordeaux wines.

HOW TO READ A FRENCH WINE LABEL

A BANNER BRUT

French champagne is so famous that its labels need not say *Appellation Contrôlée*. Cordon Rouge is the brand name (or *grande marque*) for the brut champagne of Mumm, one of the great champagne producers whose names have become synonymous with quality. This is a nonvintage blend of wines from two or more years.

A *GRAND CRU* FROM BURGUNDY

Musigny and some other great vineyards are so renowned that each has its own *Appellation;* the label need not include *Grand Cru* or the village name, Chambolle-Musigny, given here as the grower's address. Further indications of greatness are *Cuvée Vieilles Vignes* ("Selections from Old Vines") and the numbered bottle. *Mis en bouteilles au domaine* signifies estate-bottling.

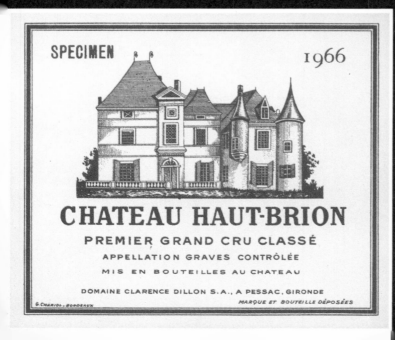

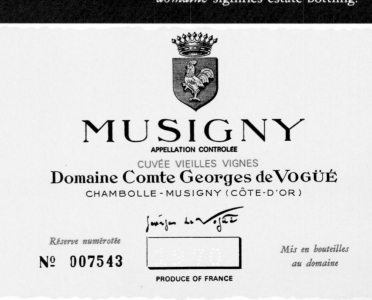

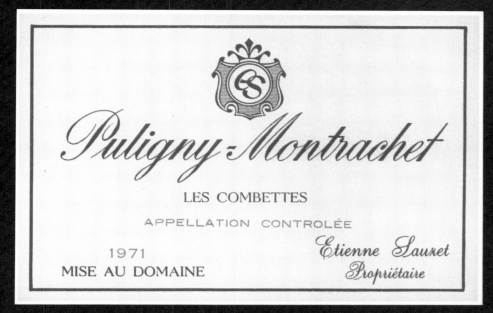

A *PREMIER CRU* FROM BURGUNDY

In the classic tradition of Burgundy, this wine bears the name of the village, Puligny-Montrachet, and of one of its *Premier Cru* vineyards, Les Combettes. *Appellation Contrôlée* refers to the village. *Mise au domaine* is widely used in Burgundy to indicate estate-bottling.

A BORDEAUX REGIONAL WINE

Don't confuse this with château-bottled claret. *Appellation Bordeaux Contrôlée* means that the wine may come from anywhere in Bordeaux. *Dans nos chais* ("in our cellars")—not the same as *au château*—means that this is a blend from several vineyards, created for consistency and value. Mouton-Cadet is made by the respected Baron Philippe de Rothschild, who makes the magnificent château wine Mouton-Rothschild.

A V.D.Q.S. WINE FROM THE LOIRE

The name combines the grape (Gros Plant) with the area (Nantes). The key words are *Vin Délimité de Qualité Superieure*, the designation granted regional wines, better than *vins ordinaires* but not as good as those with the *Appellation Contrôlée*.

A TOP BEAUJOLAIS

Brouilly is one of the nine Growths (*Crus*) in Beaujolais. Since this wine was grown, made, and bottled on an estate properly called a château, the label may say *Mise en bouteille au château*. ("Estate bottled" is the Burgundy designation.) The neckband proclaims the wine's vintage and awards.

THE GROWTH OF MARIE LOUISE

JOHN LE CARRÉ

The best-selling creator of Tinker, Tailor, Soldier, Spy, The Looking-Glass War, The Spy Who Came In From the Cold, *and other chiller-thrillers here appears in a somewhat less familiar guise. The effluence of wine, the delicate reek of the flesh, and the thin humors of academia are mingled in this sly tale of a bottle that served perfectly as a bridge between the intellect and the body. Do not overlook the provocative wine pun concealed in the title.*
　　　　　　　　　　　　　　　　　　　　　　　　　　　　C. F.

I was not, in my youth, fortunate with women.

The point needs little elaboration. They found me either cold and wary, or over-attentive to their wishes. They cast me, I had the impression, midway between Cardinal Richelieu and an Italian head waiter. From time to time, because of this curious fusion of withdrawal and what the smart ones call empathy, I was challenged as a homosexual. The charge was false; my wishes were frank and uncomplicated: I longed for women, all women, and rejoiced in their embraces. Unfortunately, despite good looks, a fair wit, and a reasonably charitable nature, I had little occasion to rejoice. In my childhood, women scolded me a great deal, and I learned quickly to obey them. It still came hard to me, in later years, to play a more masterful role. The psychiatrists may have their sport with me: my predicament was simple. I wanted women and won them seldom. It was a predicament in which (as I have since learned from my contemporaries) I was not alone.

My needs were never more pressing, or more painfully frustrated, than in the little Provençal town of Étrouille-sur-mer, in the year 1954. The date is relevant: for the people of Étrouille-sur-mer, 1954 is the *annus mirabilis*. In the preceding year, the small and normally unrewarding vineyards on the southern slopes, which hitherto had produced only a thin and disagreeable *rouge*—in its poorest years it was more like a blushing *rosé*—known throughout Provence as *le pipi d'Étrouille,* yielded providentially and with only the smallest encouragement from the dispirited inhabitants, a truly remarkable growth. The grapes, until then pallid and limp affairs, were bursting and erect; the vines, known everywhere for their frail and inhibited appearance, for once held their rich burden sturdily. Étrouille-sur-mer, barren for a decade, had borne Bacchus a child of delight. As for her inhabitants, filled to the brim with the new wine, they were as proud as if he had slept with every one of them; their skins swelled and colored like the skin of their grapes; their eyes sparkled like the light in their vats; and none was more positively affected than my

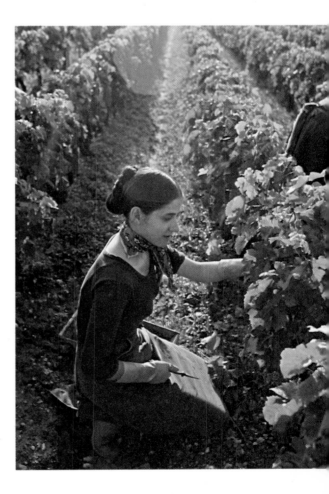

In the golden days of late summer young people who help with the vintage observe the joyous harvest traditions of centuries

own Marie-Louise, employee and principal attraction at the Auberge de la Domaine where I myself, as a student awaiting admission to Oxford, had accepted service—need I say it?—as a waiter.

I will not say I loved her; I desired her. I wanted her with a physical pain known only to those who are accustomed to failure; I was her servant. Whatever strategy I had learned at the hands of the English girls in the meager neighborhood where I grew up was as useless as a toy pistol before her sexual armory. At night I lay awake, constructing fine phrases, devising opportunities, hotly dreaming of her rich hips and thighs, her plump lips and dancing breasts; I stripped her, kissed, caressed, penetrated, and amazed her, all in my imagination; but by day I was as cumbersome, and as ineffectual, and as inwardly agonized as on my first day of puberty. I watched her as I cleared away the empty glasses she had so provokingly replenished; I watched her as she lowered her black-fringed eyes at the brown peasants from the vineyards; I watched them lust for her blandly with their clean, outdoor, uninhibited gaze; and I hated her, as the jealous do, for the small favors she occasionally granted me. A kiss, a dance, a squeeze of the hand, even a consoling, playful pat upon the backside: what were these but sweetmeats handed to the children while the adults glutted themselves on stronger fare? Even the carafe of new wine, the bowl of apples, which she occasionally left in my room, the small keepsakes she brought me from the town when she rode with the peasants to the *coopérative,* were nothing but salt in the wound. Now and then, I had no doubt, a certain maternal affection overcame her for the impoverished English boy who skulked so incongruously at the edge of their carefree lives; but I did not want a mother, I wanted a mistress, and to my aching, envious heart, these moments of generosity were no more than the *coup de chapeau* of a wanton girl to the life she had left behind. In all Étrouille, I was convinced, I was the one man who had not enjoyed her charms. How she tantalized me! I remember still how at night, late at night, when we had swept away the last debris, counted the money, set the chairs upon the tables, and sprinkled the wet sawdust on the wooden floor, she would even take my hand, and lead me upstairs, softly past her parents' door, would sit on the bed with a small and wistful sigh and—still without relinquishing my hand—shake her head so that the long ears of black hair fluttered like silk curtains over her retreating face.

"*Poor* one," she would say, "*poor* one, you want me so much," as if lust were a condition to be pitied in a person so far removed from the easy, primitive way of life. And then jump up, angry with me, toss her head, riffle through my books and papers.

"It is interesting?" she would ask in English. "It interests you?" I could speak French to anyone but her. "Tell me please about the world of the mind." I forget what answer I gave, but inwardly I knew but one. "Marie-Louise, Marie-Louise," my heart cried, "the mind has no meaning if it is not implanted in the flesh!"

I was even sorry for her then, sorry for the emptiness that awaited her, when her ripe body was past its year, her vintage beyond the caprice of man's enjoyment. And lifting my glass to her departing footsteps, I drank from the carafe she had brought me, drank until I fell asleep, drank the rich fruit of last year's miraculous vintage, promising myself that one day, when the turbulence of Marie-Louise's youth had worn itself out, and

the *pipi d'Étrouille* was once more equal to its pathetic reputation, I would return, rich and wise and forgiving, to care for the twilight of her life, though she had scorned the dawn of mine.

It had a curious flavor, that great wine, even when it was new; it is with me still as I write. I knew nothing of wine in the general way; the cult bored me. Neither then nor now could I be relied upon to detect a great year from an indifferent one. But the wine of Étrouille, harvested in 1953 and first enjoyed (prematurely) in 1954, is like the one tune in the memory of a deaf man. It was constructed like the act of love itself. At first taste, it promised and withheld itself; it lay trembling upon the tongue, begging the reassurance of a kindly palate; this granted, it gently opened, responding to the new, internal intimacy, and suddenly the ecstasy was upon you: a strange but brilliant odor filled the nostrils, infused the palate; the liquid swelled and broke upon the senses; and thus, at last, but slowly, it sank little by little into the perfect languor of a protracted afterglow. I did not by any means wholly enjoy it, for we are not always generous to those who stir us from our apathy, or lull us away from our desires; but I could no more forget it than my first conquest in the field of love. They named it *la Cuvée Marie-Louise* after the girl they had all enjoyed; the outside world saw little of it. Only a few bottles, they say, found their way to the tables of the connoisseur; the lion's share remained in Étrouille, and was quickly consumed by greedy natives before it even had time to mature.

I left Étrouille in March, a few hundred francs the richer; I had nowhere particular to go. My tutors would accept me, but not immediately. But I could not endure the thought of living in Marie-Louise's presence a second time while the valley woke to the fertilities of spring. I took one job with the Post Office in St. Albans, and another with a large store in Watford. Sometimes I wrote to Marie-Louise; sometimes she wrote to me. Once she sent me a rather pathetic parcel. It was my birthday, I suppose, for she was always sentimental about birthdays. There had not been a peasant in Étrouille whose birthday she had not remembered with a free bottle of *la Cuvée*. She sent me a tin of home-made pastries—they were salted things which she made herself and served free to regular customers—but they had crumbled during the journey and all that was left was a sort of cheesy shrapnel which I fed to the swans at Bushey. A week after Christmas I received a terse note from the Customs advising me that two bottles of "dutiable wine" had been sent to me from Étrouille-sur-Mer. But like the biscuits they had arrived broken. I wrote and thanked her all the same, but her letter was returned to me by her mother. Marie-Louise had vanished.

She had waited for me for over a year, her mother said, and surely that was long enough for any girl? She had eloped with a schoolmaster, her mother said, an *assistant* of no fortune or prospects, a *Lyonnais* quite incapable of making her happy. Her father was furious, her mother said, and would have no part of it; the *assistant* was a prig, he had declared, a religious fool, and worst of all a nondrinker; he came from a family of notorious teetotalers. The child, in his frank opinion, had thrown herself away. She could come back any time but not with her damned *assistant*. Let her get the Englishman if she wanted something exotic. At least the

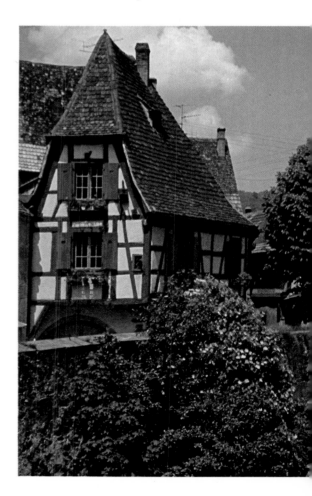

The towns and villages of great old wine regions have acquired a special charm; the gabled houses of Riquewihr, Kaysersberg, and Colmar in Alsace date from the sixteenth century

318

Englishman drank. . . . Her mother finally was extremely apologetic, but, she said, I must understand that young girls these days cannot wait forever; Marie-Louise, though she had never broken faith with me, was of an age where she needed a man; she had always dreamed of marrying a schoolmaster, an academic, she was a passionate reader and at school she had taken the first place; though she had the instincts of a woman, her first ambition had always been in the spiritual direction

I could bear no more. I tore the letter in pieces and withdrew, a broken man, to the bachelor seclusion of an Oxford college. I worked like a madman. The harder the memory of Marie-Louise oppressed me, the more furiously I fought it away with ruthless disciplines of intellectual abstrusion. Only once did I allow myself the pleasures of the body, and the result was a disaster. Under heavy pressure from my colleagues, I agreed to attend some wretched celebratory dinner. Our master of ceremonies, charged with arranging the menu, served a particularly foul *rouge*, overpriced at twenty-two shillings, too thin to be taken for anything but a *rosé*, and distributed under the title of Merveille d'Étrouille. Even my colleagues found it undrinkable. The master of ceremonies, who was an idiot, refused to apologize. He had consulted written authorities, he explained, which spoke of the Étrouille crops with the deepest respect; in nineteen fifty-three the southern vineyards of Étrouille had produced a wine. . . . Later, having railed him, they threw him in the pond, and having given them every assistance I returned to my studies.

I suppose, nevertheless, that I owe my success in the examination to my poor Marie-Louise. The thought of her in the arms of her mean and cheerless academic drove me again and again to my desk. It was no longer the *Cuvée Marie-Louise* which lulled me into a giddy sleep, it was the ashen dullness of Kantian dialectic, the critique of pure reason, the observation of minds in flight from the flesh. Yet at heart I was not deceived by these stern philosophies. I had no taste for the disembodied mind; the abstractions of German philosophic verbalism were like a musical score that would never be played. I took high honors and was offered a fellowship. Thus, though the academic life drew me inevitably, I entered its gates as a prisoner, but not as a penitent. At least Marie-Louise, I thought, had she but known, would have been proud of me. I was not proud of myself.

The academic reputation of the provincial French University of Félon was in those days, heaven knows, not exactly high. Félon is a fortress town not far from Avignon; behind its redoubtable walls, five hundred years ago, a band of monks elected to subsidize their living by imparting secular knowledge to the sons of merchants. Neither the standard of instruction nor the pace of everyday life, it is often said, has been much altered by the intervening centuries. But academics, like the rest of the world, find their stars in strange places, and it was in Félon, for all its somnolence, that they found du Chêne. All of a sudden, in the tiny world to which I now belonged, du Chêne was the arbiter of intellectual fashion. It is not much, I know, but the fact remains: from Uppsala to Berkeley, there was not a Germanist who ventured into print on the subject of the nineteenth-century thinkers without reckoning with the judgment of du Chêne. The merest hint of fantasy, the smallest leap into unfounded speculation, and

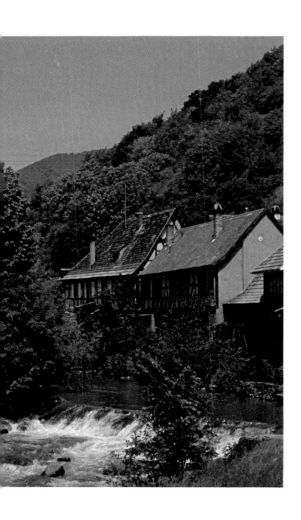

in a dozen learned journals his pen struck like a whip. For du Chêne was not merely our star, he was our abbot, and the scourge of all untidy thinking; and it was in Félon, of all places, that he had made his home. It was with uncommon pride, therefore, that I accepted his invitation to address the Faculty. Not only had du Chêne been gracious enough on a number of occasions to give favorable notice to my work: the University of Félon was famous for its hospitality.

Du Chêne and I shared, I liked to think, a mutual regard. He had written warmly of my reappraisal of Schiller's interpretation of the naive; I had been much excited by his observations on the inductive nature of Kant's logic. But his invitation, extended in the name of his colleagues, overwhelmed me with its generosity. *"Your diligence,"* I read, *"your perseverance in the noble search for spiritual and intellectual enlightenment"* It was a citation. I replied the same morning: I would be proud, I said, to address the Faculty, and delighted to attend a dinner afterward in my honor. The same afternoon I made a special journey to Low's in Hatton Garden. I bought an eighteenth-century bonbon dish for the Professor's wife; the Professor should know that I did not take his invitation lightly. Du Chêne, to my delight, was to meet me at the station. I know precisely how I expected him to look: massive and oak-like, a Jung-like aristocrat, as rigorous and austere as his writings. I imagined a generous man, but stern, who strode firmly but not (since he admired me) uncharitably across the earth: I dressed him in a suit of dark gray, clean but rubbed shiny at the elbows by the rich teak of an ancient roll-top desk; and I fancied a large and cumbersome motorcar parked in a privileged place, and a loyal driver waiting at the wheel. So that when the freckled clerk in the English blazer approached me at the barrier, a grubby Bon Marché carrier bag dangling from his left hand, I assumed that du Chêne had been detained for reasons of state, and had sent his acolyte instead.

"Du Chêne," he said, hissing like Kaa, while his upper lip rose in a sneer, as if names were a subject he had yet to write about, and with the contempt they deserved. I did not realize at first that he was introducing himself. I thought he was making an apology on behalf of an absent master, and that du Chêne was the subject of an unfinished sentence. But he had taken my hand in his by then, and was feeling the flesh with disapproval. We had a couple of hours to kill, he explained, before my lecture; had I eaten on the train or would I care for a sandwich?

My spirits were at a low ebb by the time my lecture began. I had gone to some lengths, in my paper, to pay tribute to my great patron, and by the time I got on to the rostrum I was beginning to feel I had rather overdone it. It had occurred to me, as I listened to his unbroken monologue in the dingy bar where we drank our coffee, that du Chêne's ideas were not ideas at all, but attitudes of scorn conveyed by a sharp but barren mind; I had thought of him as breaking new ground, but now that I had listened to him, I knew that he was merely retracing old paths, and beating down the bushes to either side. I tried to remember what he had praised in my own work, and I realized for the first time that he had only sided with me where I had questioned the work of others; and as I watched him, perched on that bar stool and fluttering his hands about like any second-year undergraduate laying down the law in the bar of the Union, I wondered

how on earth I had been taken in by him, and how his colleagues—who were now to form the nucleus of my audience—could tolerate the dictatorship of such a shallow, bitter, and ungenerous intellect. I was soon to know the answer.

Du Chêne himself had decided to introduce me.

We would all be familiar, he said, with the rich contribution which our guest had made to his chosen field of study. Du Chêne himself had had occasion to be grateful for several stimulating suggestions. He referred in particular to my paper on the Schillerian distinction between naive and sentimental. Personally—the upper lip trembled—du Chêne was inclined to question whether Schiller was a philosopher at all. The word *Dichter* in German covered a multitude of confusions; he had noticed, in his recent readings, that the *literati* tended to speak of Schiller as a philosopher, while the philosophers spoke of him as a poet

It was while he was making this tired joke that I woke to the reaction of the audience. It was one of unmixed loathing. They followed him as racegoers might follow an unpopular winner, longing for him to fall, yet knowing there was little hope. Some had lowered their heads and were staring miserably at their hands; some had turned their eyes glumly to the high dusty windows, but God was hidden behind a black and stormy sky that day and they had no comfort there. A few—they were the younger men whose nerve perhaps was stronger, and whose aspirations had not yet died—these few stared at him with passion burning in their Gallic gaze, each one a Cassius to this precocious, usurping Emperor; and I knew they hated me also as his protégé.

Du Chêne must have been nearly done, for he was talking now of my own person. We all looked forward, he said, to the privilege of a closer acquaintance at the Faculty dinner tonight; it was not often that they had the pleasure of receiving a *gentleman of Oxford* in their midst. Speaking for himself, du Chêne said, he had a warm affection for Oxford: he had spent a term at St. Peter's Hall while still a student. *In vino veritas,* he had learned, was the Oxford motto; it was a nice thought, for those of us who enjoyed the pleasures of the table (the upper lip made it clear that he was not among them) that today an Oxford man was supplying the truth, and that Félon was supplying the wine.

I spoke appallingly. I departed from my text, I skipped, at random, long pages of eulogy of du Chêne, and the whole fabric of my thesis collapsed. I extemporized, and could not find the words; I made awful jokes and no one laughed; I apologized and no one pitied me. I spoke of the great French institutions of learning, of hands clasped across the Channel; but all I felt was the smoldering hostility of an alienated audience. And all the while, through the mist, du Chêne's gleaming eyes watched me like prison lights from which there was no shade and no refuge.

I think that in a way they actually quite liked me. Du Chêne, after all, had raised me. Du Chêne, after all, had brought them here to listen to me; they expected a destructive robot of du Chêne's own school. Instead, they had watched me fail, and fail royally. The apprentice had disgraced his master; the day was not wholly the enemy's. When it was over, they shook my hand quite kindly. An older man—I had seen him earlier appealing to God—actually patted my arm. He had gained *much* from my lecture,

he said; it had been a very *human* lecture. Humanity these days—here a small glance in the direction of du Chêne—was often in rather short supply at Felon, particularly among the *young,* he said; there was such a premium on youth these days. But tonight, he added with a parting smile, tonight they would do justice to my humanity. "We bring our wives," he explained, quoting John Gay to me. "They unbend the mind," he said. "They unbend the mind." He was an anglicist, I learned later, with a gift for apt quotation.

They had taken a private dining room at the inn where I was staying. The french windows gave on to a courtyard planted with trees. The branches had been trained over a pergola, and the lamps shone downward through the leaves. I was reminded, a little sadly, of Étrouille.

Alone in the dining room, I waited for my hosts to arrive. Du Chêne had gone home to collect his wife, and I knew at once that I would be facing him down the length of the table, for while every other place was set with a cluster of wineglasses, du Chêne's was provided only with a tumbler, a clouded, drab-looking tooth mug which I am sure the *maître d'hôtel* had chosen personally as his emblem of contempt. I remained there sadly, listening for the first car to arrive. A waiter had entered, quite a young man, a student perhaps, filling in time before beginning his studies. He smiled at me pleasantly, and offered me an aperitif. I was enjoying my stay? I was enjoying it very much, I replied; I was overcome with hospitality, I was enchanted by the town; and I might have added, if I had not heard a car drawing up in the courtyard, I might very well have told him that I envied his estate, and wished to heaven I had never renounced it in favor of the hollow triumphs of an academic discipline.

I composed myself suitably, waiting for the door to open. It is a silly game one plays at such moments of nervousness. The hand before, or the hand behind? Should one be turned expectantly to the doorway, or allow oneself to be discovered unawares? It was the du Chênes; I actually caught a few words as he settled with the taxi-driver; a month ago, he was saying, the fare had been four francs sixty; now it was four francs eighty. The driver answered wearily: they were held up at the lights, the meter was controlled by a combination of time and distance; he could not be responsible for the meter. I heard the rustle of crinoline and a light, feminine step, and I saw in my mind's eye the pinched, sallow wife he would have, the mother-of-pearl handbag and the poor raincoat covering the black *crêpe,* and I was in the act of thanking God that I had not parted with the silver bonbon basket as Marie-Louise walked in on the arm of du Chêne, her black hair brushed over her lovely shoulders, and her eyes turned down, so that I knew that she expected me.

Du Chêne was introducing us; I touched her hand, reaching toward her tentatively, a blind man reaching for the brushstrokes of a canvas. She gripped me as if I would save her from drowning.

"Pierre has spoken constantly of you, monsieur," she murmured, "I do not understand all, but I admire you immensely."

"Our work goes far over her head," du Chêne remarked indifferently. "But for some reason she has always been interested in your writing. Your style is very simple." He turned his back on her in order to present to me another guest, who mercifully had just entered. Soon they were arriving in

A glass of well-made wine, clear, brilliant, the product of man's and nature's cooperation, is the perfect vehicle for celebration

numbers, their faces bright with gastronomic anticipation. Rich smells preceded them from the hallway; they greeted me with pleasure, recognizing, I am sure, the light of humanity and the dash of color which now redeemed my features. Somewhere I heard music playing, though Marie-Louise has since assured me there was none. But a man who is on the edge of paradise hears his own sounds, and no one, not even Marie-Louise, has the right to dispute them.

We were eighteen at table; Marie-Louise sat on my left. She sat very demurely, talking most of the time to the elderly anglicist, unbending his mind and almost unhinging mine, for her foot was resting against my ankle, and our hands had intertwined beneath the immaculate table-cloth. She was more beautiful than ever, but more assured. I read her afresh, and I read her accurately, with an eye sharpened by love and a mind improved by years of agonized reflection. She was lost, but not forfeit; disappointed but not despairing; she had made a mistake and had seen where it could lead, and she proposed to rectify it at the earliest opportunity. Her very body was a body in waiting; I was certain she had quickly determined not to waste it on du Chêne. She had had a lover—several—and some no doubt (it was in the air) were at this very table, but the lovers were to cover the mistake she had made six years ago, and now she faced a clear sea and meant to sail her own course. There was no flirtation between us; the pact was concluded with that first handshake. Our relationship was resumed where it had left off, but it was informed with the wisdom of the intervening years. We were lovers before the act, and the act—as our secret caresses now declared—would be taken care of at the earliest possible opportunity.

There are clichés about the arts of love and the art of cooking which I have never subscribed to. The French delight in them less than we suppose, but they are victims of their reputation. There are those, without a doubt, who could recite to this day the list of superb dishes that were put before us. And Marie-Louise, in any event, is in a special position to do so, since it was she, my deputed hostess, who had ordered them. We ate, and talked and drank, each with greater liberality as the evening proceeded. I have never been so entertaining. I made jokes, and the jokes were funny; I regaled them with small gossip from my arid Common Room, and they laughed out loud, rejoicing in my frankness. I even chose a moment to criticize my own lecture of that afternoon. I had thought about it too much, I said; I had been overawed by the honor of the occasion; but they would hear no wrong of me, shouted me down, lifting their glasses to me and assuring me that every word I spoke had been a jewel of wisdom. Opposite me, at the far end of the table, already out of focus, du Chêne sipped darkly at his tooth mug, forgotten or ignored.

Who spoke first of producing a special wine? Marie-Louise assures me to this day that it was the old anglicist on her left, but if that is so, then Marie-Louise implanted the notion in his mind. The movement began with a conference from which I was excluded; a muddle of excited murmurs at the center of the table, a short dispute followed by universal agreement, and the waiter, the young waiter, was summoned and addressed in terms near to reverence. The bottles should be decanted, they said; they should be uncorked now and allowed to breathe; no, they should

be uncorked later. The dispute broke out again afresh, and this time it was Marie-Louise who quelled it. This wine, she said simply, should be drunk directly from the bottle and uncorked only at the last minute. The waiter returned with a colleague. The bottles they carried were wrapped in linen napkins. Silence descended on the company. Only du Chêne, sensing an irregularity, his rimless spectacles glittering unpleasantly in the candlelight, chose to speak.

"What ritual, may I ask, is being observed tonight?"

Not a head turned. It was the anglicist who finally replied.

"We are making a bridge," he explained (I think he was holding Marie-Louise's other hand, for I felt a surge of warmth for him that was like an electric reaction), "between the naive and the sentimental. Between the intellect and the body."

"More like a river," du Chêne retorted sullenly, regarding the little row of white-clad bottles which stood like virgins before their first communion, but the day was undoubtedly the old professor's and had been from the beginning.

"And since your guest," the professor continued, "*our* guest, has taught us that life is not only to be contemplated but enjoyed, we propose to ask him"—here he glanced at Marie-Louise as if she were at least party to the notion—"to ask our guest to sample a wine we have chosen in his honor, and to give us the advantage of his valued academic judgment."

I protested, but only feebly. I was no connoisseur, I said, but again they shouted me down. All my reserve had left me. I am no musician, but if they had put a grand piano before me that night, I could have played them a Beethoven sonata with the confidence of a master.

The young waiter's hand trembled a little as he poured. He had put a new glass before me of the classic, balloon shape, and the whole table watched in silent rapture as the red wine spread like a stain over the broad base.

The glass had not reached my lips before I heard the raucous chatter of the peasants in the *bistro* below my bedroom; I smelled the wet, sweet scent of the vine leaves on the southern slope of the valley and heard the cracked, irreverent chime of the little chapel summoning the heathen Gauls to worship some other God but Bacchus; I saw Marie-Louise lean back a little in her chair, as she had lain so vainly on my little bed. At last I drank. The liquid swelled on my tongue; its aroma infused my nostrils, turned my head

For a moment, I feared I had lost altogether the power of speech: for not even the great *cuvée* could wash away the lump in my throat, or keep back the tears which crowded my heated eyes. My first words, I think, were inaudible to all but those closest to me:

"It is the finest of all French wines . . . I had thought it was lost to us forever . . . a wine as rare and as rich as happiness itself . . . of multiple and mysterious tastes, a wine of the mind and of the body . . . it was found once only"—my voice gathered strength—"for those of us at this table, it will not be found again in our lifetime . . . a gift of God to a barren valley . . ." I named it, but not at once, for I had du Chêne in mind. Even in that moment of ecstasy, with Marie-Louise's little hand resting coolly on my thigh, cunning was my ally. The year was fifty-three, I said; the wine was first enjoyed (prematurely) in fifty-four; the valley was remote and even

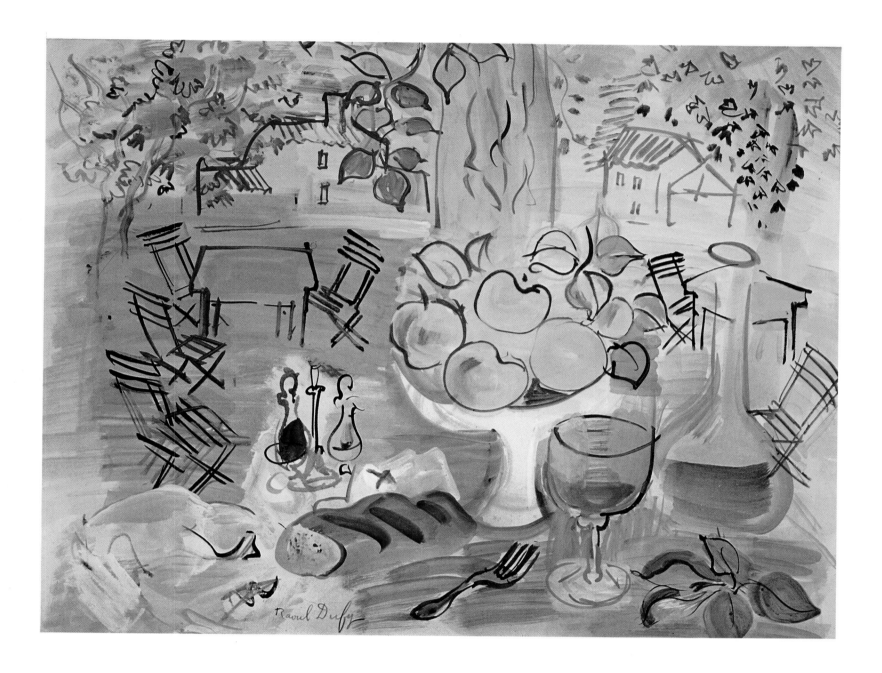

Still Life, watercolor by
Raoul Dufy, 1941

despised by those who thought they had experienced the best Provence could yield. . . . They were applauding, but I barely heard them. Someone was clapping me on the back, someone else was embracing me, but I saw only Marie-Louise and the sweet tears running down her cheeks

Du Chêne had made it a rule to retire at eleven. He liked to rise early, he explained in a metallic voice, in order to arrange his correspondence. I thanked him for his generosity. No, I said; I would make my own way to the station; he had done enough for me already. The anglicist promised to bring Marie-Louise home—she was, after all, the hostess and obliged to remain—and when du Chêne had left she gave him a little kiss which he seemed to understand.

We took the midnight train to Étrouille, changing at Avignon. I have altered the name, for we do not care for visitors in the valley. There are a few dozen bottles left in the cellar of the Auberge de la Domaine, and we like to use them sparingly. The bonbon dish sits resplendent on our dining table; Marie-Louise fills it from time to time with savory pastries of her own manufacture. The quality of the *Cuvée Marie-Louise* has, if anything, improved; not even its most ardent admirers had dared to expect such a maturity in the flavor. The afterglow is particularly rewarding.

325

COGNAC, ARMAGNAC, AND EAUX-DE-VIE

One of the great joys of wine is their distillation into brandy. No people on earth create such fabulous brandies as the French. Cognac, Armagnac, marc, all descend directly from the bounty of France's vineyards. Their close relative eau-de-vie ("water of life") springs from the fruit of her orchards and berry patches.

Brandy is a natural by-product of wine, made nearly everywhere that wine is made. Its most common, and coarsest, French form is marc—a rough and vigorous spirit distilled from the purplish gray mush of skins, pips, and liquid left in the press after the wine is squeezed out. The two best-known marcs are those from Burgundy and Champagne. Marc de Bourgogne is full, heavy, and not always subtle. Some of the great vineyards of the Côte d'Or make their own individual brandies: Marc de Musigny, Marc de Chambertin, etc. The finest of this sort that I have ever enjoyed is the Marquis d'Angerville's Marc de

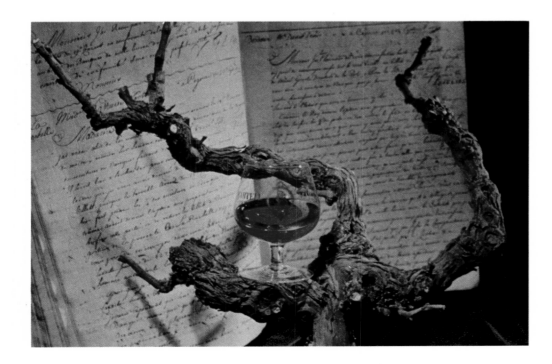

(Left) Book, vinestock, cognac—all have been ennobled by age

(Opposite page)
(Top) Cognac owes its distinction in large part to aging in barrels of Limousin oak, which impart a special character to its flavor and bouquet

(Left) Raw cognac comes from the copper pot still as a white brandy, 70 percent alcohol. Aging in oak will darken and mellow it

(Right) Skilled blenders of cognac determine by smelling, rather than tasting, when the desired balance is reached

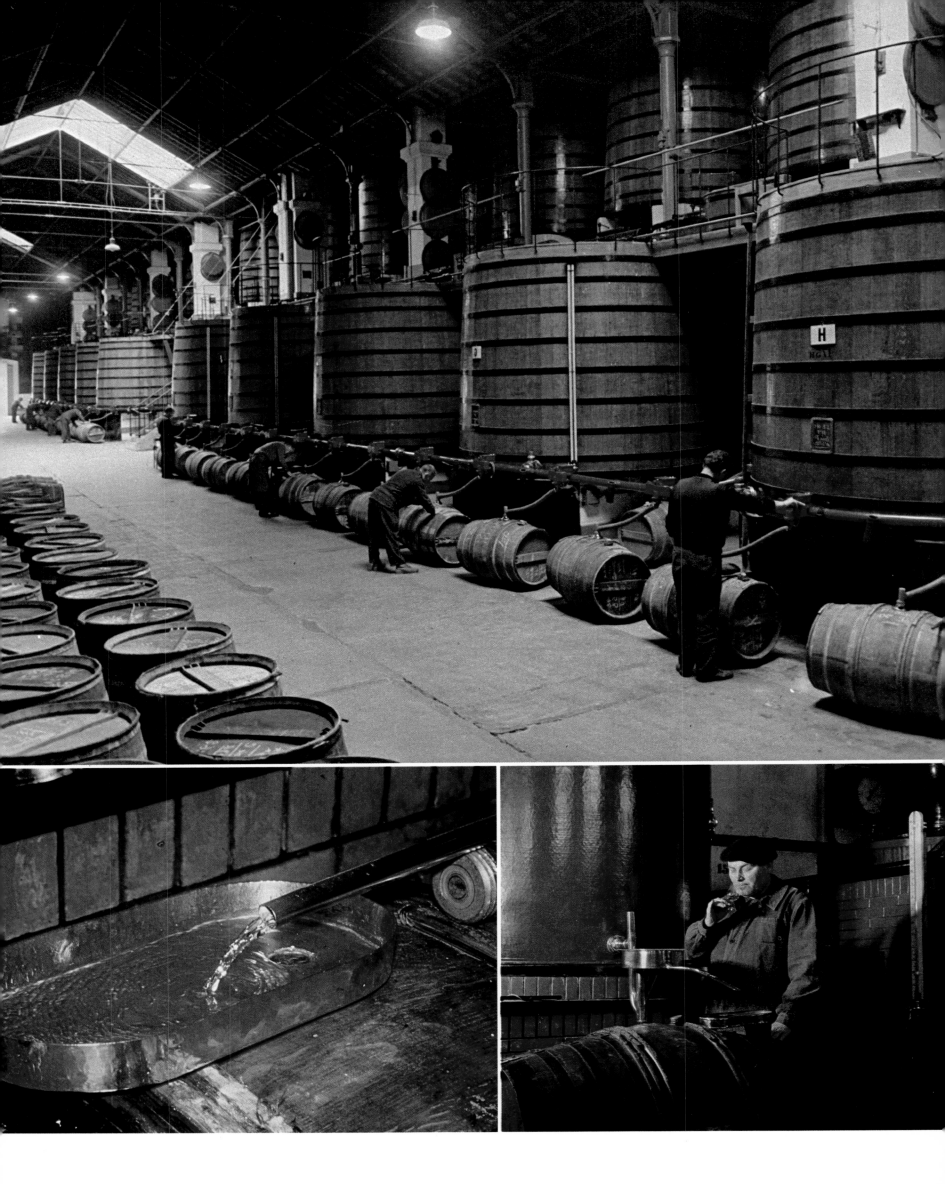

Volnay, a venerable old spirit equaling the finesse of most cognacs. Lighter and grapier than the marcs of Burgundy are the more elegant and refined Marcs de Champagne. For all their aristocratic style, they retain a large measure of the country warmth and exuberance that every good marc should have.

The vivacity and spirit characteristic of marc is relegated to the background in cognac, the greatest of all the extraordinary essences the French evoke from wine. Unlike marc, cognac is made from wine itself, wine as strictly controlled as those made in France for drinking, not distilling. Wine that is to be cognac may be produced only within a delimited area of the Charente region in western France, north of Bordeaux. The district, centered in the town called Cognac, subdivides into six areas. The most important is Grande Champagne, named for its chalky soil, similar to that in Champagne. Grande Champagne marks the heart of Cognac, with the five other sections spreading out around it in roughly concentric circles: Petite Champagne, Borderies, Fins Bois, Bons Bois, and Bois Ordinaires. Each circle of vineyards produces a brandy of a different quality. Grande Champagne gives the most remarkable cognac, Bois Ordinaires the least distinguished.

The major grape variety planted in all these regions is the Ugni Blanc, or Saint-Émilion (it bears no relation to the district of that name in Bordeaux). Folle Blanche and Colombard are grown to a much lesser extent. Though in other parts of France and in California these grapes make pleasant wine, what they yield in Cognac is tart and harsh, hardly fit to accompany food. But distilled twice in the copper, kettle-like stills dating back to the days of the alchemists of medieval Europe (and even earlier in the Middle East) their yield becomes an elixir fit to crown dinners of the finest fare.

Making cognac is a long and laborious process. The first slow distillation produces a whitish liquid called *brouillis*. The *brouillis* is then redistilled into *la bonne chauffe,* a colorless spirit of 70 percent alcohol. This is raw cognac, even more ferocious than the wine of which it was born. It is then barreled in weathered casks of white Limousin oak, seasoned wood that imparts further flavor and a certain amount of amber color to the young brandy.

The number of years that cognac spends in wood depends on its original quality. The better the cognac, the longer it needs to mature—the finest will improve in cask up to forty years. Once it is rich and mellow, cognac stored in wood begins to lose some

(c) Punc

"I've got a cousin at Chartreuse you know—the damn fools are selling their stuff!"

of its character; to avoid this decline it is transferred to glass containers, where no further change takes place. Spirits neither improve nor deteriorate in bottle. Thus the only date of any real importance for a fine cognac is the number of years it has aged in wood. This information is seldom given, even on a great bottle of brandy. If a label reads 1904, who can say how many years the cognac was left in wood before bottling? Cognac firms traditionally use stars and letters to indicate a spirit's age, but at best their meaning is imprecise. Most houses make "three-" or "five-star" and V.S.O.P. (Very Superior Old Pale). By French law, these cognacs need be aged in wood no more than five years. Clearly, the reputations of the various cognac shippers now become important. The best firms, some of which are listed below, use combinations of letters to designate older and better cognac: V.V.S.O.P. (Very, Very Superior Old Pale), V.S.E.P. (Very Superior Extra Pale), and X.O. (Extra Old), to cite a few.

The different styles of cognac sold by each shipper are careful blends of the brandies from the six sections of the production area. The best Grande Champagne or Grande Fine Champagne, comes solely from Champagne. At least fifteen years of barrel aging go into the making of this superbly smooth brandy, with a distinction that sets it far above the rest. Other very fine cognacs are a blend of brandies from the top three regions. Fine Champagne, one of the most familiar, is Grande Champagne combined with some Petite Champagne. Many houses add brandy from the Borderies to give additional body. Blending cognac is a refined art. The great firms jealously guard their sources and their secrets. The higher their standards, the better the brandy, of whatever grade. Among the fine cognac producers are Hennessy, Hine, Martell, Rémy-Martin, Courvoisier, Otard, Delamain, Bisquit, Monnet, Denis-Mounié, Gaston de Lagrange, and Ragnaud.

If any other French brandy can challenge the supremacy of cognac, it is Armagnac, made in and around the Gers départe-ment in southwest France near the Pyrenees. This part of the country, once known as Gascony, was the home of that most famous and lusty of musketeers, d'Artagnan. Armagnac is excellent brandy, lighter in body than cognac but with more flavor and fragrance. Often described as a much earthier spirit, Armagnac can equal cognac in nearly every quality save finesse. Yet silken smoothness gives good Armagnac an elegance all its own.

The best Armagnac comes from the plain in the north of the district called Bas-Armagnac. Many of the grape varieties

planted there and in the other parts of the strictly delimited region are the same ones grown in Cognac: Folle Blanche, Colombard, Saint-Émilion, and others. Armagnac wine, like that of Cognac, is thin and undistinguished, with a distinctive taste of the sandy earth about it. This *goût de terroir* survives the flame and steam of distillation to contribute much to the special flavor of Armagnac. Another important reason for the brandy's generous style is the black Gascon oak in which it is aged. In black oak barrels the brandy matures sooner than in the white oak casks common in Cognac. An eight-year-old Armagnac is smoother than an eight-year-old cognac. With long aging in wood, Armagnac can become truly superb.

Armagnac is not dominated by large firms, like those in Cognac. The trade is conducted on a much smaller scale. Some individual farmers even make and sell their brandies direct. Always marketed in the round, squat bottles peculiar to the region, good Armagnacs seen in this country include Larressingle, Sempe, and those from the Marquis de Montesquiou, a descendant of d'Artagnan, and the Marquis de Caussade.

The distance between brandies made from grapes and brandies made from other fruit is not great, especially if the path leads first to Calvados, the finest apple brandy in the world. Calvados looks and tastes more like cognac, marc, or Armagnac than any other eau-de-vie. It is distilled from fermented cider made in the part of Normandy called Calvados; the best comes from a small region known as the Vallée d'Auge. The fiery brandy, rendered deep mahogany by years of aging in wooden casks, wondrously recalls the freshness of the Norman apples that are its soul.

Alsace supplies the great white eaux-de-vie of France. Unlike Calvados or the other brown brandies, which are aged in wood, spirits distilled from Alsatian fruit mature in glass or crockery. Never having touched the staves of a charred oak barrel, they remain crystal clear—hence the name *alcools blancs*, or "white spirits." Every variety of fruit grown on the pretty Alsatian hills finds its way into some sort of eau-de-vie, each one taking the name of the fruit from which it is made. The pits of tiny cherries make kirsch; raspberries give framboise; plump pears yield an excellent spirit called poire. Yellow plums make mirabelle, blue plums, quetsch. Wild strawberries and even holly berries are distilled into particularly exotic brandies. All these *alcools blancs* are extraordinarily powerful: the first sip leaves one breathless. Chilled to near-freezing, they are unforgettable, fragrant facets of the joys of wine.

label
de qualité
Nº OL 239
Marque déposée

la
vieille prune
Brand

Réserve
de la Maison
Louis Roque
à Souillac

Eau de vie de Prune
French Prune Brandy

Product of France — 84 proof — Contents 4/5 quart

OTHER
WINES
OF
THE
WORLD

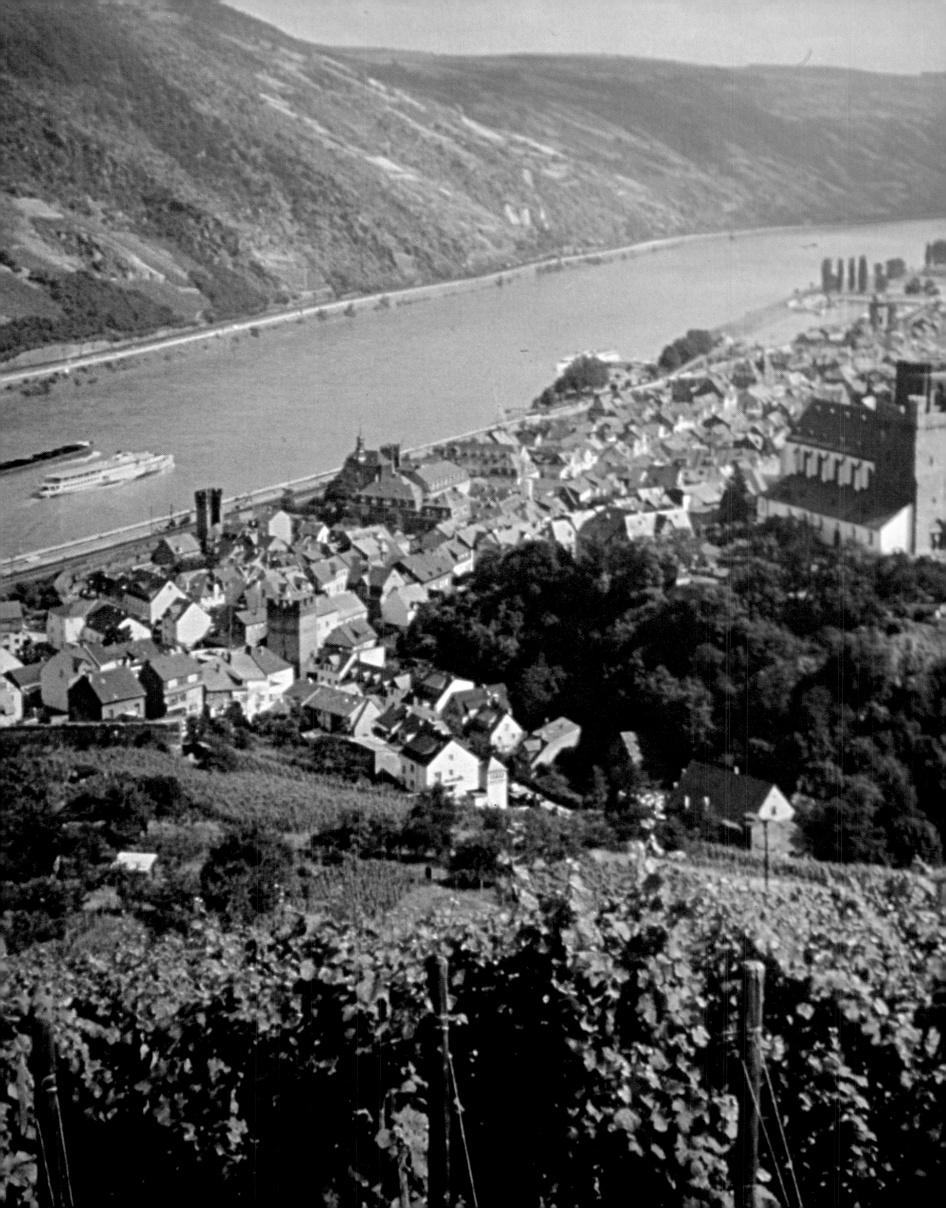

THE WINES OF GERMANY

If, as has been suggested, adversity builds character in wines as well as in people, nowhere on earth does adversity play a larger part than in molding the magnificent breed of the white wines in Germany. The best wines from the Rheingau and the Moselle grow in conditions so rude that a plant less noble than the Riesling vine would either desist or pull up its roots and move elsewhere. Germany's greatest vineyards, being among the northernmost on the globe, subject their grapevines to a harrowing succession of physical hardships—cold winters, spring frosts, sunless summers. Yet, given a fighting chance, the Riesling responds to the challenge with the greatest variety of fine white wines grown anywhere in the world. Nature does bestow on the winemakers of Germany the blessing of a long period of warm, gently sunny weather toward the end of summer. During these temperate weeks a pleasant combination of coolness, warmth, sun, and rain allows the grape varieties to ripen slowly, attaining all their marvelous complexity. German winegrowers watch the weather with the same pragmatic passion with which the *vignerons* of Burgundy study the lay of their land or the château owners of Bordeaux fret over their vineyards' drainage.

What the concerned winemaker seeks—and what the capricious climate almost seems to strive to prevent—is the delicate balance of sugar and acid in the wine that makes the best of it both dulcet and fresh. With acidity alone, the wine snaps sharp and bitter on the tongue; with sweetness alone, the wine lies flat and listless. The golden harmony is struck somewhere in between. And since German wines are relatively low in alcohol (8.5 to 12 percent) the balance of the other constituents becomes even more crucial. No fine German white will ever please merely because it is big, alcoholic, and powerful, as

A village on the Rhine, with vineyards climbing the hill behind it, is typical of one of the world's great wine-producing areas

333

might a French red from the Rhône. There simply is not that much alcohol in the background of a good bottle of German wine. Only on such a neutral ground can the wine's sugars, acids, and scents achieve the state of astonishing breed and subtlety in which nuance rules and bravura is banished.

Unlike a commanding red Burgundy, or even a less assertive claret, good German wine demands that its charm be quietly discovered and graciously considered. If at first blush the wines seem light and simple, in time they reward with a range of tastes and bouquets as wide as those offered by any of their more immediately accessible and impressive cousins. The adversity that may be in part responsible for the outstanding quality of the best German whites must perhaps be charged with making them also just a little bit shy.

One vine, the Riesling, must be accorded the honor of giving us the finest of German wines. Though its grapes are small and not very juicy, the wines they yield are some of the most wonderful in the world. Today plantings of the Riesling are concentrated in the famous regions of the Rheingau and the Mosel-Saar-Ruwer and in a few of the best vineyards in some of the other winegrowing regions, notably the Rheinhessen, the Nahe, and the Rheinpfalz (the Palatinate). Also common is the Sylvaner, which is known, too, in Alsace and parts of California. Its wine is less rich and flavorful than the Riesling's. A bottle of average-quality German wine with no grape name on its label is sure to contain wine made mostly from the Sylvaner or from the Müller-Thurgau. A cross of the Riesling and the Sylvaner, the Müller-Thurgau is widely planted in many vineyards of the Rheinhessen and the Palatinate. Müller-Thurgau vines are early-ripening and their wine shows little of the brilliance of the Riesling parent. The Gewürztraminer, like the Sylvaner, is widely known abroad for the fresh and intriguing wine it gives in Alsace.

From the cold Alpine lakes on the Swiss border to the hills south of Bonn, the vineyards of Germany follow the river Rhine and its tributaries. The true gold of the Rhine sparkles not in its once pure waters but in the vineyards along its banks. Many of these wine districts take their names from the river— the Rheingau, Rheinhessen, Rheinpfalz, Mittelrhein.

The German wine law of 1971 defines much of the present wine terminology. The German vineyards are officially divided into eleven districts: Ahr, Mittelrhein, Mosel-Saar-Ruwer, Rheingau, Hessiche Bergstrasse, Nahe, Rheinhessen, Rheinpfalz, Franken, Württemberg, and Baden. All produce both

Between January and March —frequently in the snow—the initial stages of work on the vines for the new wine crop are carried out

mediocre and good wines, but only selected sections of the Rheingau, Mosel-Saar-Ruwer, Nahe, Rheinhessen, and Rheinpfalz regions grow that special 5 percent of Germany's wines prized by connoisseurs.

Ahr and Mittelrhein, being so far north, are noteworthy for producing wine at all. Baden, Bergstrasse, Württemberg, and Franken give large quantities of good everyday wine and small amounts of exceptional wines as well. The growers in the less-favored districts have responded to their countrymen's demands for their present wines (national consumption is now about 30 bottles per person annually, and much of this wine is imported) by reshaping the vineyard land and banding together into larger and more powerful cooperatives. Steep hills have been smoothed and huge new wine facilities have been erected —all to make the sound, everyday wine so popular with Germans throughout the country. This *Tafelwein* (Table Wine), as it is called, is seldom found outside Germany.

The 1971 wine law not only named the large winegrowing regions but also defined their various subdivisions. Each of the eleven major wine regions is called a *Gebiet*. In descending order of size, the subdivisions are: the *Bereich* (district), the *Grosslage* (group of vineyards), and the *Einzellage* (small single site). It is the *Einzellagen* that produce the fabulous wines and have the famous names.

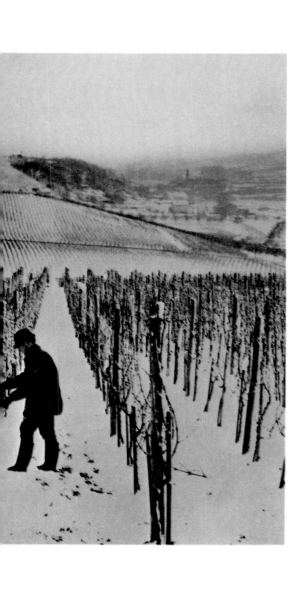

In general, the more limited the area of a wine's origin, the better the wine. Thus a wine in a green sloping-shouldered bottle whose label says little more than "Mosel-Saar-Ruwer" will be a light and undistinguished wine grown anywhere within that large *Gebiet*. A wine whose label also says "Bereich Saar-Ruwer" must come from that smaller and more defined section of vineyards and should be a bit more interesting. Further, if the label also includes "Grosslage Scharzberg," we know that the wine grew along the Saar River itself, where the Scharzberg vineyards are situated. When the name Ockfen is given (it would appear in the form "Ockfener") the wine must have been grown on the 200 acres of vineyards associated with that well-known Saar town. Finally, "Ockfener Bockstein" on a label indicates that the wine is from the fine Bockstein vineyard plot on the east side of the village of Ockfen. The great German wines from such small vineyards associated with a town have a specificity similar to that of a wine from one of the little vineyards of the Côte d'Or in France—Vosne-Romanée or La Grande Rue, for example.

A great wine from the Moselle or the Rheingau does not

necessarily state the name of the grape from which it was made —in most cases the Riesling. But a lesser wine or one from another region usually includes the grape name along with its geographic designation—for example, "Bernkasteler Riesling" or "Niersteiner Gutes Domtal Sylvaner."

Long a seemingly obscure field, German wines have been brought into the present by the admirable 1971 wine law. It was an ambitious task, and the law, in consolidating vineyard names and in setting exact standards for the various quality levels of wine, has to a great degree succeeded. No wine may claim a designation of high quality merely because it comes from a famous vineyard. It must pass a regular series of tests conducted by regional panels of experts before it may bear one of the great vineyards' names.

The wine law promulgated in 1971 laid down three basic levels of quality for German wines. *Tafelwein,* as already noted, is the ordinary, everyday beverage making up most of the production. *Qualitätswein* (Quality Wine) is the next grade. It must come from recognized grape varieties, be grown in one of the eleven official regions, and have, before fermentation, a minimum level of natural sugar. The third category, *Qualitätswein mit Prädikat* (Quality Wine with Special Attributes) represents the top wines; to these no sugar can be added, and thus they can be produced only in years when nature yields up fully ripened grapes.

The "Special Attributes" are indicated by five German terms that may seem difficult but tell us precisely the grade of wine that is in the bottle we are buying. The most general of these terms is *Kabinett* (spelled only thus); it denotes the lightest and driest of the top-quality wines. *Spätlese* is the next higher distinction. The word means "late picking"; a wine so labeled is made from grapes left on the vine until ripened. A *Spätlese* wine is sweeter and richer than a *Kabinett.* The third designation, *Auslese,* means "select picking." To make an *Auslese* wine, the vintner picks over his grapes and selects only the perfect and fully ripe bunches. In very successful vintages, *Ausleses* are made from grapes on which the "noble rot" (*Botrytis cinerea;* in German, *Edelfäule*) has appeared. Such a wine is sweeter and more interesting still, and proportionately more expensive. *Beerenauslese* is a step up from *Auslese.* Only overripe grapes are picked, singly, to go into one of the very sweet and complex wines labeled *Beerenauslese,* which are not unlike fine French Sauternes.

The fifth designation—*Trockenbeerenauslese*—appears

Jungfrau Becher, marriage cup, silvergilt and silver, German, seventeenth century

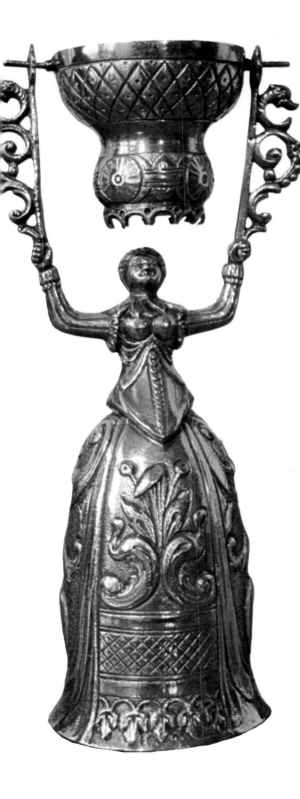

only on wines from great vintages, when the grapes matured well and the *Edelfäule* descended upon them. The same mold that by concentrating the sugars makes a great Sauternes so luscious is responsible for the remarkable German elixir known as *Trockenbeerenauslese* wine, which is made from grapes so ripe that they resemble raisins or dry berries—*Trockenbeeren.* Each of these single fruits must be separated from its less lucky brothers, hence the name, which means "dry berry select picking." These wines are rare and are priced accordingly. The grapes that make *Trockenbeerenauslese* wine may often remain on the vines into November and December, when the weather may turn bad, threatening to destroy all the precious, "nobly rotting" fruit. Since they involve no small risk, *Trockenbeerenauslese* wines are produced mainly by the great estates or holdings, but more and more they are being made at good cooperatives as well. They are indeed something special, the highest expression of a skillful and patient artistry that understandably fills the winemaker with pride—and the taster's mouth with a joy so concentrated that it lingers for many minutes.

Sometimes, as the grower waits through the fall for his grapes to get riper, in hopes of making perhaps half a barrel of a *Trockenbeerenauslese,* his plans are thwarted by an unexpected frost. Working quickly, he will harvest the grapes while the water in them is still frozen and gently press out the concentrated liquid, which remains rich in sugar and flavor. From this syrup he makes *Eiswein,* a rarity but never so good as *Trockenbeerenauslese* itself.

As has been indicated, the Germans are chary with the distinctions that honor their great wines, those born in a fine plot and named with one of the five special designations mentioned above. Merely to claim to be an *Auslese* or a *Spätlese* or indeed just a *Qualitätswein* is not enough. The wine and its producer must prove themselves in a laboratory and before a government control panel. Only after passing a chemical analysis and obtaining the tasting panel's approval, signified by a registration number, which must appear on the label, can a wine of this caliber be sold.

The scheme was meant to be democratic, and certainly it is. But the laws inadvertently point up that the truly aristocratic German white wines still are raised in a few select stretches of vineyard sprinkled across the country. It is to the Rheingau, the Mosel-Saar-Ruwer, the Nahe, and the two short strips of the Rheinhessen and the Palatinate that we must now look.

THE RHEINGAU

One of the greatest white-wine regions of the world is on the slopes of the Taunus Mountains, a low range above the Rhine in central Germany, north and east of Mainz. The river here turns from its northward course, flowing west for some twenty miles at the base of one of the most famous hillsides on earth. The Rheingau vineyards climb the hills on the north bank and thus have an ideal southern exposure. Even the rays of the sun reflected from the river below help to ripen the grapes. Assmannshausen and Lorch on the west and Hochheim on the east mark the limits of the district, the greatest wines growing in the central section, from Rüdesheim to Eltville.

Some 5,000 acres of the stretch are covered with vines, fully 70 percent of them Riesling. The heart of the Rheingau is nearly all planted in that grape. So much a part of the district is the Riesling that in other parts of the world the grape is often known by the name of one of the famous Rheingau towns—Johannisberg. The Swiss call the Riesling simply Johannisberger; the winemakers of California know it as the Johannisberg Riesling.

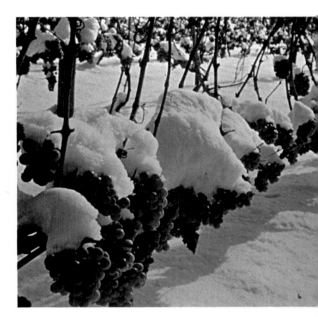

The wines yielded by this grape on these precious plots run the full range from light regional bottlings to such glorious *Qualitätsweine mit Prädikaten* as *Auslese* and *Trockenbeerenauslese.* The average quality of the wines is remarkably high. Grown in the humid and sunny climate above the river, the Riesling is a typically flowery wine with more depth and power than it develops along the Moselle. Though they are superficially light and pleasing, no wine man would ever call the best wines of the district soft or delicate. When mature they show a certain complexity that sets a fine Rheingau apart from all its lesser relations.

The village at the western edge of the Rheingau, at the turn where the river resumes its northward route, is known, curiously enough, for its red wines. This is Assmannshausen, whose vineyards grow the Pinot Noir of Burgundy. Though scarcely great, it is perhaps the most famous red in all Germany. More red wine is being produced today in some of the replanted districts of the south, but the reds remain only 15 percent of Germany's total production. East of Assmannshausen the white-wine vineyards commence in earnest with the towns of Rüdesheim and Geisenheim. Bottles labeled "Rüdesheimer Riesling" are often seen, but much better is the wine whose label bears both the town name and the name of one of the better individual vineyards that wind around the hill to the

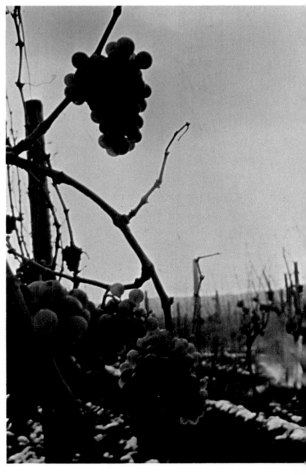

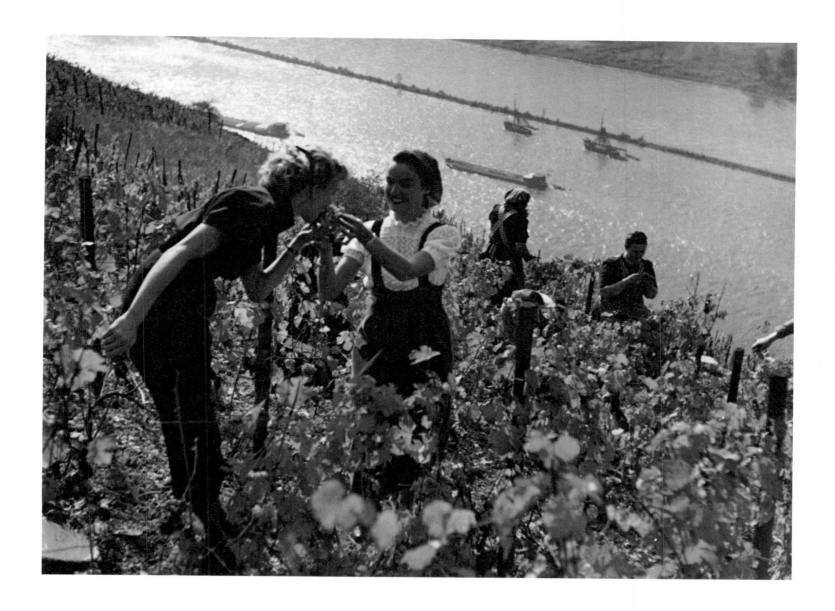

The vintage at Assmannshausen on the Rhine, where the best-known red wine of Germany is made

Only in Germany is Eiswein made. In late November or December overripe grapes sometimes freeze on the vine. Picked early in the morning, they are crushed immediately to make a sweet rich wine—one of nature's accidents turned to good advantage

To protect their vines from frost, growers often build fires between the rows of vines

west of the village. Among the best are Berg Roseneck, Berg Rottland, Berg Schlossberg, Bischofsberg, and Klosterberg. In Geisenheim the Klaus and Kilzberg vineyards make good wine, but the town is better known as the home of Germany's greatest wine school, the Lehr- und Forschungsanstalt, one of the most respected centers of the study of viticulture in the world.

Continuing east, Johannisberg and Winkel come next. Vogelsang and Hölle in Johannisberg, Jesuitengarten and Hasensprung in Winkel are very good wines, but each town is more famous for a private estate making especially remarkable wines: the Johannisberg hill is crowned with Schloss Johannisberg, and on the slopes above Winkel stands Schloss Vollrads.

Schloss Johannisberg commands the Rhine's north bank from the crest of its green ranks of Riesling vines. The great block of a castle and its vineyards belong to the Metternich family. In 1816 the property was given to the master diplomat Klemens von Metternich by the Emperor of Austria in recognition of his services to the empire at the Congress of Vienna.

The wines, among the most expensive from the Rheingau, are graded by a system of color-coded labels and capsules (the metal-foil seals over the corks and necks) that is at least as confusing as it is helpful. More often than not the national standardized designations established by the wine law of 1971 are exact enough.

The different grades of wine from Schloss Vollrads, only a mile distant, are also distinguished by a color coding of the labels and capsules. The best are among the richest and most elegant of the great Rheingaus. The property, with its castle and pretty five-story tower, has been the home of the counts Matuschka-Greiffenclau since the fourteenth century.

In Oestrich, the Doosberg and Lenchen vineyards are well known, as is Schönhell in neighboring Hallgarten, near the top of the Rheingau slope. The next village is Hattenheim. Its best wines come from the famous Steinberg vineyard, part of the vineyard holdings that are known as the Hessian State Domain. Surrounded by the woods behind the Steinberg vines is the wonderful Kloster Eberbach, once, like the Clos de Vougeot, the pride of wine-loving Cistercian monks. (In fact both vineyards were founded by Abbot Bernard of Clairvaux.) Though for 600 years great Rheingau wine came to life here, the centuries-old presses now stand dry and dusty. Steinberger wine is made in the government's modern winery. Generally the best wines in the district are those grown on the riverfront, away from the towns. Yet between Hattenheim and Erbach runs the Markobrunn vineyard, whose wine can often challenge any for miles around. Just behind it lies the other great Erbach vineyard, the Siegelsberg.

Eltville, with its Schloss Eltz bottlings, and Kiedrich make a wide range of good wines, but it falls to Rauenthal to give the other truly great wines of the Rheingau. The small village sits atop the Rauenthalerberg, several miles back from Eltville. It is on the edge of the hill southwest of Rauenthal that the greatest wine grows—in Baiken, Gehrn, and Langenstück. Rauenthal is particularly known for its *Auslese* wines. The Germans themselves regard them as perhaps the best that the Rheingau can offer, and their prices always reflect the demand. In good years the wines have a deep spiciness.

Hochheim (the town whose name gave the designation Hock to Rheingau wines in general) lies to the east of the heart of the Rheingau, by the Main River. The wines tend to be heavier and earthier than those from the other important villages. Domdechaney, Kirchenstück, Stein, and Hölle make the best.

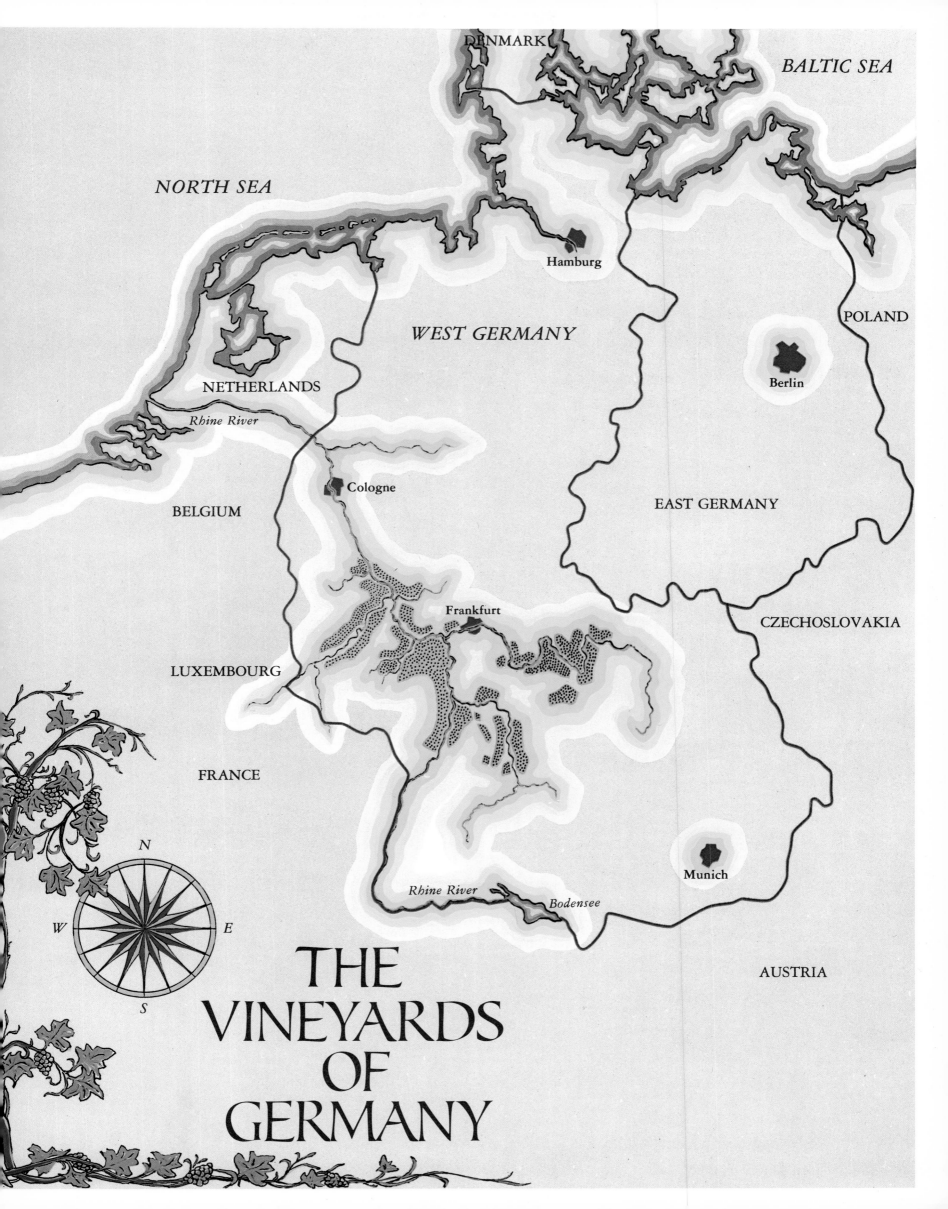

BALTIC SEA

DENMARK

NORTH SEA

Hamburg

WEST GERMANY

POLAND

NETHERLANDS

Rhine River

Berlin

Cologne

BELGIUM

EAST GERMANY

CZECHOSLOVAKIA

Frankfurt

LUXEMBOURG

FRANCE

N

W E

S

Rhine River

Bodensee

Munich

AUSTRIA

THE VINEYARDS OF GERMANY

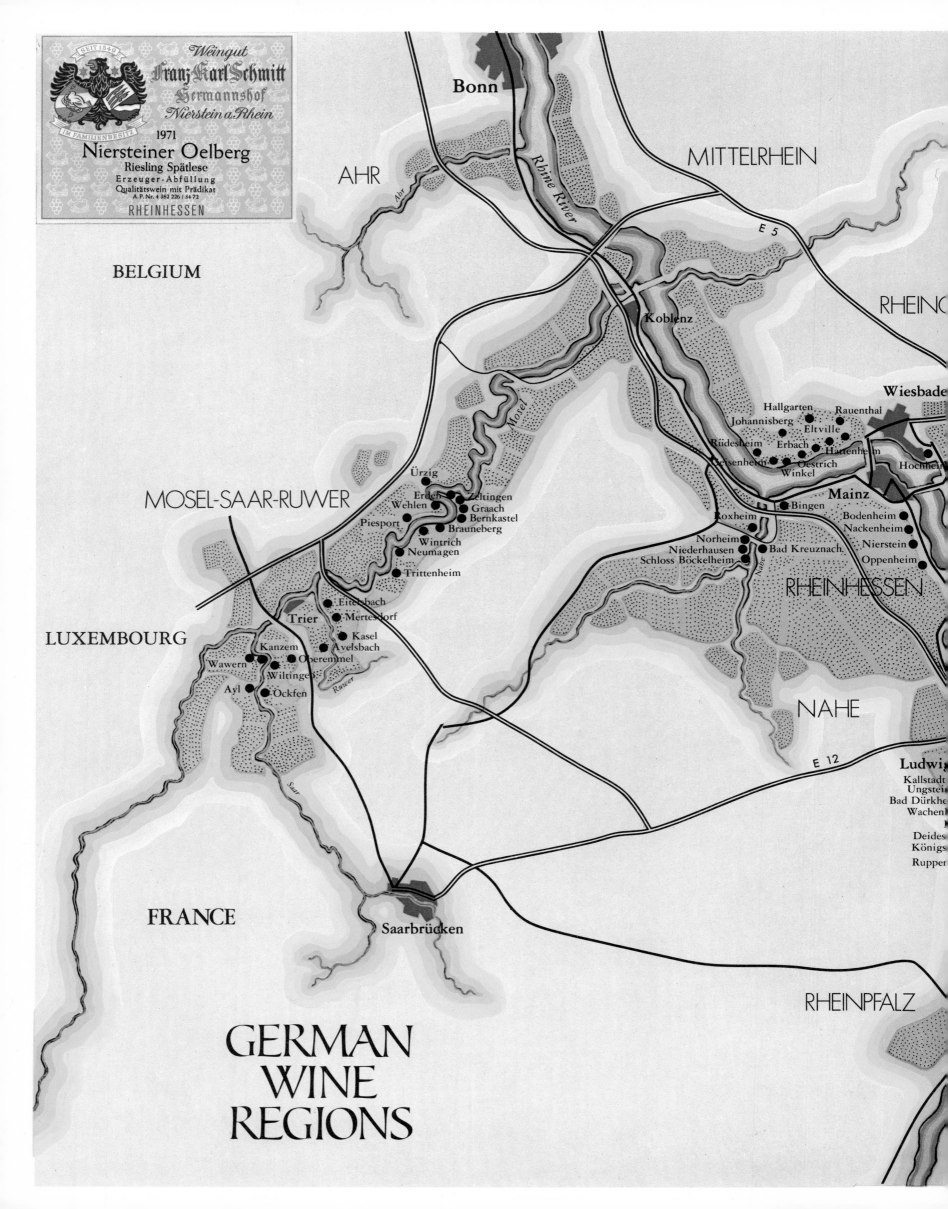

BELGIUM

AHR

MITTELRHEIN

Bonn

Ahr

Rhine River

Koblenz

RHEIN

Mosel

Wiesbade

MOSEL-SAAR-RUWER

Hallgarten Rauenthal
Johannisberg Eltville
Rüdesheim Erbach Hattenhe
Geisenheim Oestrich Hochheim
Winkel

Ürzig

Erden Zeltingen
Wehlen Graach
Piesport Bernkastel
Brauneberg
Wintrich
Neumagen

Trittenheim

Mainz

Bingen

Roxheim

Norheim
Niederhausen Bad Kreuznach
Schloss Böckelheim

Nahe

Bodenheim
Nackenheim
Nierstein
Oppenheim

RHEINHESSEN

Eitelsbach
Mertesdorf
Trier
Kasel
LUXEMBOURG Kanzem Avelsbach
Wawern Oberemmel
Wiltingen
Ayl Ockfen

Ruwer

NAHE

E 12

Ludwi

Kallstadt
Ungstein
Bad Dürkhe
Wachen

Deides
Königs

Rupper

Saar

FRANCE

Saarbrücken

RHEINPFALZ

GERMAN
WINE
REGIONS

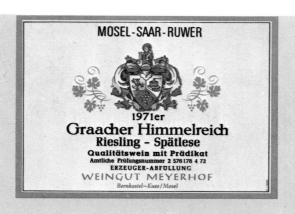

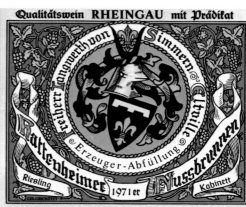

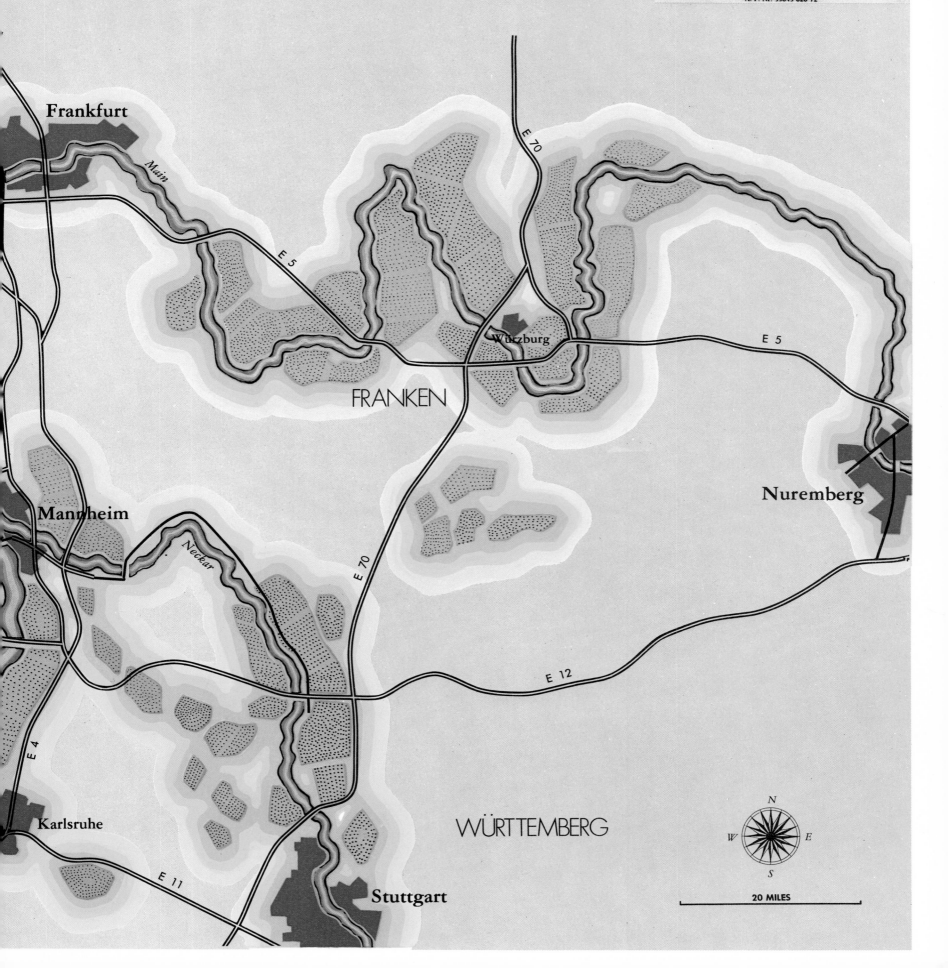

Frankfurt

Main

E 70

E 5

E 5

Würzburg

FRANKEN

Nuremberg

Mannheim

Neckar

E 70

E 12

Karlsruhe

WÜRTTEMBERG

N
W E
S

E 4

E 11

Stuttgart

20 MILES

MOSEL-SAAR-RUWER

Born in France, widening in Luxembourg, the Moselle River (Mosel is the German form) flows through Germany from above Trier to Koblenz, where it joins the Rhine. A straight line between the two towns would be scarcely seventy-five miles long. As if the river sensed the work it had to do, the Moselle meanders gently for many more miles than that, through one of the prettiest of Europe's many pretty valleys— and past some of her most important vineyards. Once inside Germany, the Moselle flows but a few miles before meeting with the river Saar. Then scarcely has the Moselle run past the town of Trier than it is joined by the little stream called the Ruwer. The great vineyards of these three valleys join to form the *Gebiet* Mosel-Saar-Ruwer, and this is the name that appears on wine labels. The wines are the most delicate, complex white wines in the world.

Along the Moselle proper, the chosen stretch is the section called by Germans the Mittel-Mosel. From its vineyards come the truly wonderful Moselle wines. This part of the valley runs from Trittenheim some forty miles to Traben-Trarbach; the great towns are Piesport, Brauneberg, Bernkastel, Wehlen, Graach, and Zeltingen. In a bad year the wines are tart and disappointingly thin; even in a good one they have little alcohol (rarely more than 10 percent). But they are possessed of such flowery, spicy, and at the same time steely elegance that at their best not even the majestic Rheingaus can compare with them.

The good Mosel-Saar-Ruwer wines, like most other German wines, are named for the town and vineyard from which they come. Trittenheim has its Apotheke and Altärchen, Neumagen its Rosengärtchen and Laudamusberg, and Dhron its Hofberger. The Moselle passes these good vineyards as it flows nearly due north, making its way to Piesport and the first great Moselle wines. In Piesport it carves a slow, gigantic bend. On the north bank behind the quaint town are the great vineyards—Goldtröpfchen, Falkenberg, Treppchen, and Günterslay. The secret of all the finest Moselles is the interaction of the aristocratic Riesling with the gray slaty soil that covers the steep hills. In Piesport the result is a wine even more delicate than some of the other fine Moselles, one with remarkable fragrance and class.

The Ohligsberg wine from Wintrich is good, but the next truly great Moselles grow in Brauneberg. The best vineyards

Cochem, one of the toylike wine villages of the Moselle, is dominated by its feudal castle on a vine-covered hill

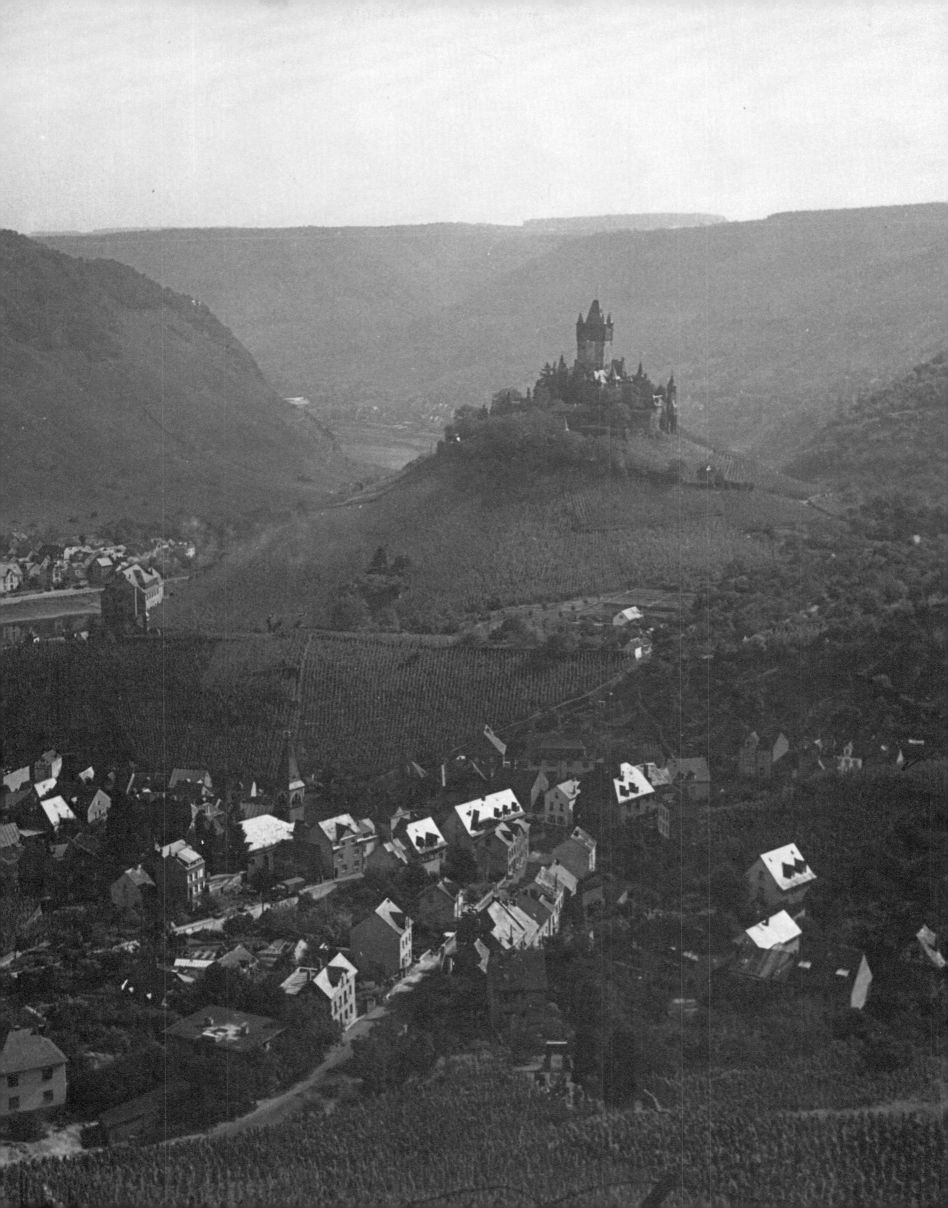

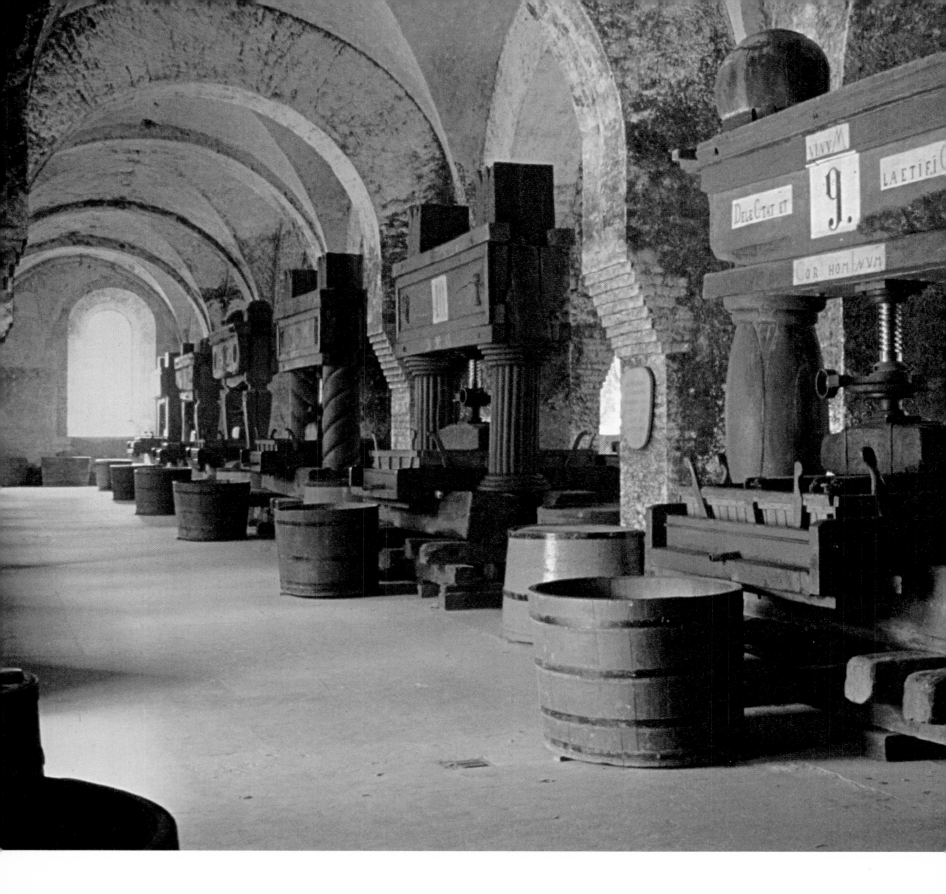

In the twelfth-century Gothic monastery
Kloster Eberbach, the ancient winepresses,
said to have been the model for Gutenberg's
printing press, were in use until recently

A venerable cellar master puts his wine to
the test

are Juffer, Hasenläufer, and Juffer-Sonnenuhr. The choice plots face south so that the vines catch the maximum sunshine. The wines can be very sweet, and when sweet wine was the preference, some hundred years ago, the wines of Brauneberg ranked highest of all the Moselles.

From the Juffer vineyard in Brauneberg to the town of Bernkastel, most famous on the Moselle, is only a few miles. Amid the rows of Riesling vines that tower like a wall above Bernkastel is the Doktor vineyard, perhaps the most renowned in Germany. The nearly vertical acres of vine are angled away from the river, facing due south. Some wine drinkers fancy that they detect in Doktor wine the smoke from Bernkastel's little chimneys. Others receive from this expensive wine an impression, at once sweet and piquant, of bouquets of flowers wrapped in palest gold. Besides Doktor (the wine was once credited with healing properties), Bernkastel boasts the Lay, Graben, Bratenhöfchen, and Schlossberg vineyards, which continue along the great wall of vines as it curves north of the village and crosses the boundary into Graach. Here the best wines are Himmelreich and Domprobst.

The miraculous vertical vineyards continue on to the best plots in the towns of Wehlen and Zeltingen. The preoccupation with sunshine has led to the prevalence of sundials (*Sonnenuhren*) along the river, and certainly the best-known of these is the one that gives its name to the great wine of Wehlen. If any vineyard can challenge Bernkasteler Doktor as king of the Moselle wines it is Wehlener Sonnenuhr. Indeed nowadays many experts agree that Wehlener Sonnenuhr is a better wine than the famous Doktor. At Zeltingen, as the Moselle reaches a long turn, the wall lowers, but not before producing some exceptionally fine and full-bodied wines: Schlossberg, Sonnenuhr, Himmelreich, and Deutschherrenberg. Then follow Ürzig and the Würzgarten ("spice garden") vineyard, where a sharp, penetrating wine that bears out its name is grown. Treppchen and Prälat in the town of Erden are two of the last great vineyards of the middle Moselle. The great district comes to an end with the "bare-bottom" (Nacktarsch) wine of Kröv (its label depicts a bare-bottomed boy being spanked) and the only-average wines from Traben-Trarbach, although the river continues on past many more vineyards of Zell, which grow the undistinguished "black cat" (Schwarze Katz) wines.

The river Saar meets the Moselle at the tiny village of

Konz, west of Trier. The countryside is so peaceful and beautiful, and its wines so ingenuous, that to imagine the raging industrial furnaces of the Saar Basin, just upstream, is difficult indeed. Only the polluted river serves as a reminder. As on the Moselle, the Riesling vines and the slate soil join forces against the cold in the struggle for sunshine. The vines here rarely win, but when victory is theirs they are worthy of any laurels. The Saars and Ruwers triumph in the hottest years, when the wines wrap their steeliness and strength in a clover-honey cloak.

Wiltingen is the best-known town in the Saar, with the best-known vineyard, the Scharzhofberg. Its 30 acres give a wonderful wine which proudly bears only the vineyard's name. The town's name is nowhere to be seen on the label. Several owners, the most famed being Egon Müller, divide the vineyard; all make wines of tremendous distinction. Among the other vineyards in Wiltingen the better ones are Gottesfuss, Braune Kupp, and Klosterberg.

The Hütte, Altenberg, and Karlsberg vineyards are the pride of Oberemmel, the town just behind the Scharzhofberg vineyard. On the other side of Wiltingen stands the town of Kanzem, with the Sonnenberg and Altenberg vineyards at the top of its wine list. Farther upstream sits the pretty village called Ockfen, where the famous Bockstein vineyard spreads back into the valley behind the few scattered houses. The wine is so light that one can only wonder how it can offer such a range of complex and elegant tastes.

The third valley growing Mosel-Saar-Ruwer wines is that of the Ruwer, a stream so minor that it seems remarkable that it should give its name to a wine district capable of producing some of Germany's best wines. The little brook joins the Moselle at the town of Ruwer, but it is a few miles upstream that the great enological events occur. The town of Kasel makes pleasant, very pale wines that represent the average Saar. Eitelsbach and Mertesdorf are better known because each is the home of a truly fine estate where great wine is grown. In Eitelsbach is the Karthäuserhofberg, whose wines bear only a colorful label strip pasted across the neck of the tall green bottle. This is certainly the smallest German label, but it carries the longest wine name: Eitelsbacher Karthäuserhofberger. The one estate name covers the wines from several specific vineyards. The quality of each wine is very high, the suave blend of floweriness and metallic austerity that is the incredible accomplishment of the best wines from the Mosel-Saar-Ruwer *Gebiet.* Across the

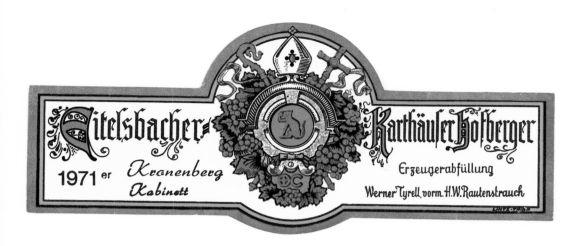

A small label with a very long name

stream is the Maximin-Grünhaus vineyard in Mertesdorf. As in the case of the Karthäuserhofberg, the name applies to the wine from several vineyards within the estate's 120 acres, and each vineyard name is given as part of the playfully rococo label. Maximin-Grünhaus wine from great years (a qualification that must always apply in these northern areas) is white wine of the highest class.

THE RHEINHESSEN

The Rheinhessen, or Hesse, as it is often known in English, is a vast rectangle of rolling, fertile farmland whose vineyards grow quantities of soft light wines—except on one small section of the eastern slopes, which falls away toward the Rhine and produces some of the finest wine in Germany. The Rhine borders the district not only on the east but on the north: the Rheinhessen fills the great curve of the river. To the south lie the vineyards of the Palatinate, to the west those of the Nahe Valley, and across the Rhine to the north rise the stately hills of the Rheingau.

The Sylvaner and the Müller-Thurgau account for most of the average-quality wines that grow in the many widely scattered vineyards along the central section of Hesse, from Dalsheim, Alzey, and Wörrstadt to Elsheim and Ingelheim. For many years these anonymous bulk wines found an outlet under the well-known name of Liebfraumilch. The 1971 German wine regulations have limited the use of that name to *Qualitätswein* from the Rheinhessen, Rheingau, Rheinpfalz, and Nahe, but it is still a catchall that may be used by wines from any number of mediocre vineyards. It originated with the wine from the little vineyard behind the Liebfrauenkirche in Worms, at the southern end of the Rheinhessen. Liebfraumilch (or Liebfrauenmilch, "the milk of the Blessed Virgin") was never a great wine, and its present popularity is out of line with the wine's merit. Some Liebfraumilchs are quite good because talented blenders can create pleasant and consistent products. I have tasted note-

worthy examples from Sichel, Deinhard, Langenbach, and Kendermann.

Not all the wine of the Rheinhessen, fortunately, is of the uncertain quality of the innumerable Liebfraumilchs. Down the Rhine, some thirty miles from the original Liebfraumilch vineyard in Worms, are the handful of towns about which grow the truly first-rate vines of the district. The great vineyards, planted partly in the Riesling grape, rise up from the "Rheinfront" as the river flows by in a crescent from Oppenheim to Nackenheim. Between these two towns stands Nierstein, home of the finest of all Rheinhessen wines, considered by Germans themselves to be the country's most famous wine town.

In a plentiful year, more than half a million gallons of wine may earn the right to the name Niersteiner, surely the Rhine's most general village name, as Bernkastel is along the Moselle. To obtain a topflight Niersteiner, it is important therefore to make sure that the name of a specific vineyard also appears on the bottle. When the plot named on the label is a good one and the vine is the Riesling (or even in a few special cases the Sylvaner), the wine will be noble indeed, with much fruit and finesse. The greatest names are Hipping, Rehbach, Orbel, Rosenberg, and Glock, but Kranzberg, Pettenthal, Zehnmorgen, and Oelberg also give remarkably good wine in a successful vintage. The town of Nierstein deserves to be better known outside Germany: once a bottle of its elegant wine is opened, the lucky taster will not soon forget the name.

The Nierstein vineyards curve around the village from south to north, where the vines continue into neighboring Nackenheim. Nackenheimer wines are almost as good as the Niersteiners, and their bouquet may be even finer. Rothenberg and Engelsberg are the best individual vineyards. The town of Bodenheim is a few miles north of Nackenheim; there the best wines are Burgweg and Hoch.

South of Nierstein, almost next door, is the village of Oppenheim, with about 500 acres of vineyards. Here the Riesling begins to be crowded out by the Sylvaner and the Müller-Thurgau. The *Einzellagen* called Kreuz and Sackträger make noteworthy wines, yet none is quite so fine as the best from Nierstein. Schlossberg, Daubhaus, and Zuckerberg are also good.

The wines from the short stretch of the riverbank from Oppenheim to Nackenheim have no equal in the Rheinhessen, but before the Rhine loses touch with the Hessian vineyards, it passes one more town whose vineyards have long been famous. This is Bingen, facing Rüdesheim in the Rheingau, at

the confluence of the Rhine and the Nahe. The most important vineyards are those on the Scharlachberg, the "scarlet hill," which has the same red earth as Nackenheim, and is as well known as any vineyard in Rheinhessen. The wines are less distinguished and full than the Oppenheimers but nonetheless they are fine and flowery, rich and earthy. Besides the Scharlachberg, Rosengarten and Kapellenberg grow the best Bingener wines.

THE NAHE

The town of Bingen in the Rheinhessen guards the mouth of the river Nahe where it meets the Rhine. In this lower part of the Nahe Valley, the wines often resemble those of the Rheingau, without achieving the level of excellence common to the great growths of Germany's most famous vineyard land.

Upstream from Bingen lie the vineyards that give the best Nahe wines. These begin just below Bad Kreuznach—an old spa that is the center of the Nahewein trade—where the best sites are Narrenkappe and Brückes. Above Kreuznach the vineyards give way to a clump of forested hills and the river is forced to curve sharply by the rocks that mount behind the town of Bad Münster. The most famous section of this rise is the spectacular Rotenfels escarpment, a 600-foot cliff of reddish-orange rock thrust up from the bank of the Nahe. Vines cling to a narrow path at the base of the Rotenfels, and with the southern exposure and the warmth retained in the stones, they make a spicy, profound wine called Rotenfelser Bastei. Beyond the track of Bastei vines begin the Norheim *Einzellagen,* giving good but rather hard-to-find wines. Dellchen and Kafels are the best names.

Niederhausen and Schloss Böckelheim, the next two towns up the river, have the greatest vineyards of the river valley. Here the wines resemble some of the good Saars and Ruwers; indeed, neither the Saar nor the Ruwer is very far away. Both of the fine plots are on the Kupferberg ("copper mountain") midway between the two towns: on the Niederhausen side, Hermannshöhle is the famous site; in Schloss Böckelheim, the Kupfergrube ("copper mine") vineyard is even more renowned. Next to the Kupfergrube are the admirable cellars of the State Domain in Hesse, where some of the best white wine in all Germany comes to life. The well-known Schloss Böckelheim name has long been given to all the regional wine made in this part of the Nahe. One can be sure that the wine in question

is a fine one from the town itself if the label also includes a specific vineyard name, such as Kupfergrube, Königsfels, Felsenberg, Heimberg, In den Felsen.

THE RHEINPFALZ (THE PALATINATE)

The Rheinpfalz is Germany's largest winegrowing region, vines being planted from the border with northern Alsace to Worms, where the vineyards meet the farms of southern Rheinhessen. In a plentiful year nearly 40,000 acres under vine yield almost 20 million gallons of wine. Most of the wine is harsh, with a distinct taste of the soil, passable only if quaffed icy cold on the flower-decked terrace of an old inn at one of the many charming towns that grace the countryside. The Pfalz is the sunniest and driest of the German vineyard regions. The important centers lie protected from less friendly weather by the Haardt Mountains—the German continuation of the French Vosges, the hills that shelter the vineyards of Alsace.

Several grape varieties flourish along the vineyard road known as the Weinstrasse. Sylvaner, Müller-Thurgau, Elbling, Traminer, Tokay, and Muscat go into the bulk of ordinary Pfälzerweine—most of it not even fit for bottling, let alone for export. These common, coarse wines had enormous popularity as far back as the time of the Holy Roman Empire; then, as now, the Pfalz provided copious quantities of undistinguished wine. The name Pfalz is a corruption of *Palast,* the German word for palace (deriving from the fact that the Roman imperial residence was built on the *palatium,* or Palatine Hill). The name Palatinate came from the title "count palatine" awarded to the high officials of the Empire who governed such regions as the Rheinpfalz.

The Pfalz is the only important German wine region not on a major river. The vineyards lie in a wide band some ten to twenty miles back from the Rhine. Only one tiny section west of Speyer and Mannheim produces wine of top quality: a serene trail of vineyards called the Mittelhaardt, running from Neustadt north to Dackenheim. All their wines are better than the average Palatinate wine, and one patch of the Mittelhaardt grows wines that outclass any others from the district. The core of the Mittelhaardt—from Ruppertsberg to Kallstadt—produces white wines that are among the best in Germany. In the finest vineyards the Riesling assumes an importance never achieved in the other parts of the Palatinate; it makes a full-bodied wine with a rich taste of the soil and a heady bouquet.

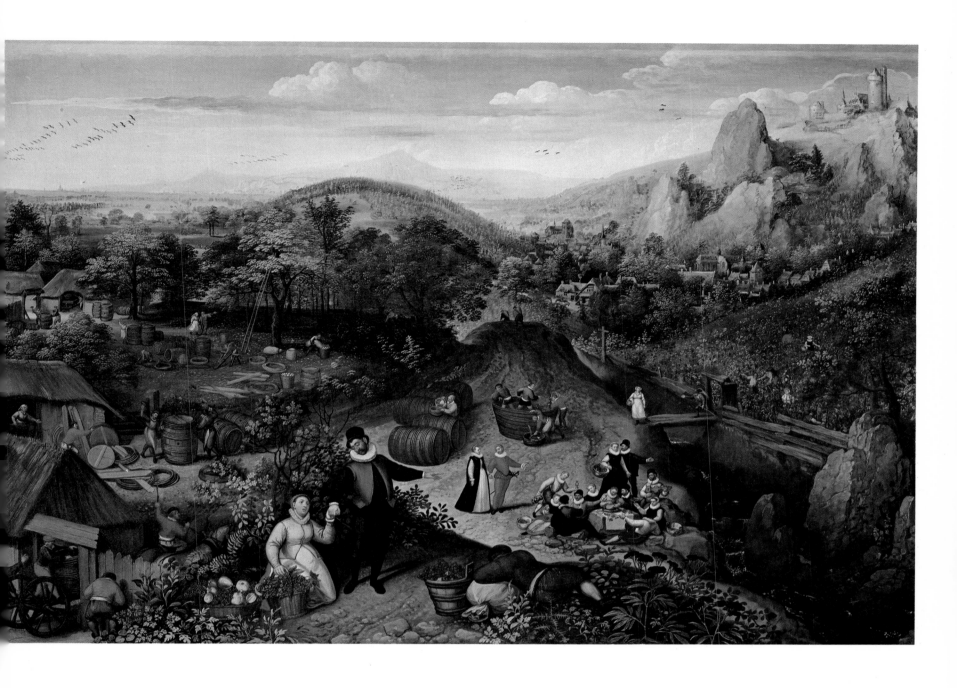

Autumn Landscape: Vintaging,
by Lucas van Valckenborch,
Flemish, 1585

Ruppertsberg wines are mostly Sylvaner and thus slightly less fine than the wines from the towns where the Riesling grows. Gaisböhl, Spiess, Hoheburg, and Nussbein are the best individual vineyards. The wines may be higher in alcohol than many of the other fine German whites, but they are nevertheless well-balanced and rich.

Less than a mile from Ruppertsberg is Deidesheim, where Hohenmorgen, Herrgottsacker, Grainhübel, Kieselberg, Langenmorgen, Leinhöhle, Kalkofen, and Mäushöhle are the plots with the highest reputations. Many of the Deidesheim vineyards are owned by the three great wine men of Pfalz (known as "the three Bs"): Bassermann-Jordan, von Buhl, Bürklin-Wolf. In no other section of German vineyards is there a comparable trio making most of the great wine. The town itself would probably be famous for its colorful rural beauty even if its wines were not among the most distinguished in the Pfalz. The best Deidesheimers are invariably Riesling. Since this grape is the

353

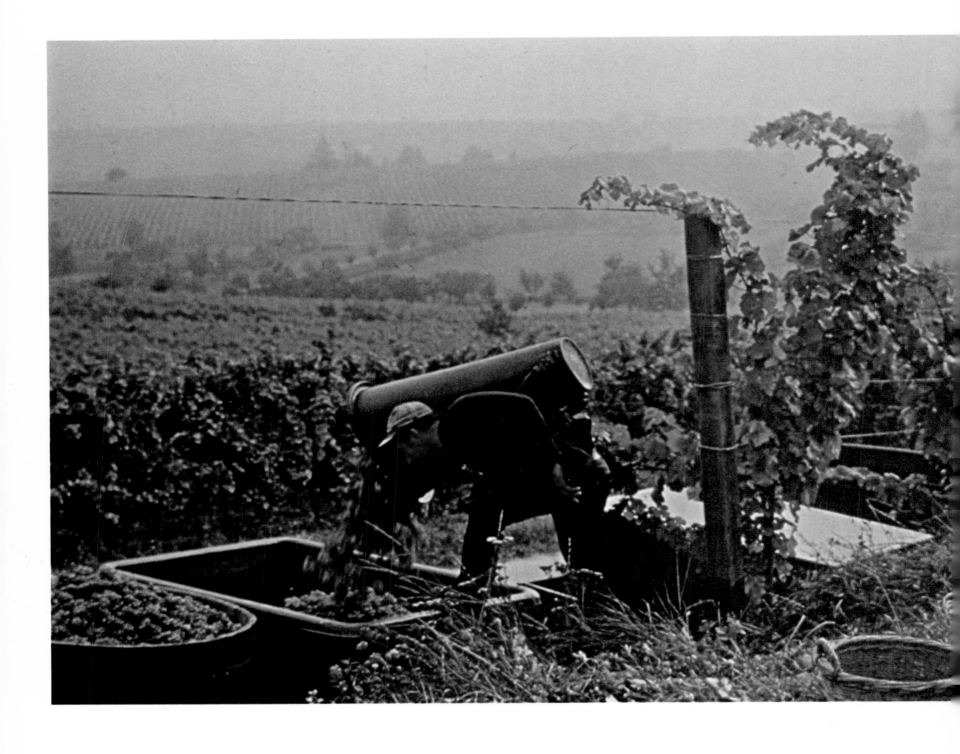

exception rather than the rule in the Palatinate, wines made from the Riesling include its name on the label. Deidesheim wines range from dry to very sweet, and no matter where in that range they fall, they have remarkable class and distinction.

The Weinstrasse runs north out of Deidesheim, bisecting the notable Herrgottsacker vineyard. The Weinstrasse is the main, and nearly the only, street in the tiny village of Forst. A bulge of black basalt helps the Forst soil retain the warmth of the sun, one of the reasons that Forst wines are some of the sweetest in all Germany. They are especially elegant, and the most famous names are known around the world: Kirchenstück, Jesuitengarten, Ungeheuer, Freundstück, and Pechstein.

Wachenheim's 850 acres of vineyard adjoin those of Forst on the north. The Wachenheim wines are every bit as grand

Franconia, in the upper valley of the Main, harvests its grapes late: Sylvaner, one of the region's leading varieties, being gathered on a hazy autumn morning

Wine monument near Würzburg

354

as the best from its neighbor to the south but are a bit lighter and less rich. Gerümpel is the finest of the Wachenheimers; Rechbächel, Böhlig, Goldbächel are also good.

Bad Dürkheim, the next town north on the vineyard road, has more vineyards than any other wine commune in Germany. Unlike the smaller villages in this prime section of the Pfalz, Dürkheim plays a double role, as wine center and as health resort. At least as many people make a visit to one of the several spas to take the waters as to sample the wines. And unlike its winemaking neighbors, Dürkheim grows quite a substantial quantity of red wine along with the ever-present white. The red, a product of the grape called the Portugieser, is of fair quality; most of the white is a little better. A small fraction of the white wines should be included with the best from Wachenheim and Forst: these are the Riesling wines from the Herrenmorgen, Hochbenn, and Rittergarten vineyards.

Beyond Dürkheim lie Ungstein, Kallstadt, Harxheim, and Dackenheim, where the quality of the wines begins to fall off. Soon the choice Mittelhaardt is passed and the great wine land gives way to orchards and common vineyards that produce uninteresting wines.

OTHER GERMAN WINE REGIONS

The Ahr Valley, not many miles south of Bonn, produces much of Germany's limited volume of red wine. In hot and sunny years, which are rare here, wine from the Pinot Noir is enthusiastically touted by many Germans as equal to or, in some cases, better than any red wine. Red Ahr wines may be good and pleasing, but they are no match for the great red wines of Burgundy, Bordeaux, or California. Ahrweiler, Neuenahr, and Walporzheim are the villages whose names are most often seen on Ahr wine labels.

North and south of the Ahr the vineyards along the Rhine are in the region known as the Mittelrhein. The wines from these picturesque banks of the river are rarely exported; they are downed happily enough by the thousands of tourists who throng this section of the river valley to cruise the fast-flowing water and take in the sights—the legendary Lorelei rock and the romantic castles.

Franconian wines grow around Würzburg, upstream from Frankfurt on the Main River. The wines, which come in squat flasks called *Bocksbeutels* rather than the "flute" bottles that are traditional for German wines, have their own style; they

are noticeably drier and do not have much to do with the Riesling grape. The best wines come from the Sylvaner, and in great years (like 1971) are among Germany's finest. As a whole, Franconian wines are often called "Stein Wines," but the name properly applies only to the wines from the famous Stein vineyard overlooking Würzburg. Besides the Würzburg vineyards, those around Escherndorf, Iphofen, Randersacker, and Rödelsee are well known and give wines of a quality above the Franconian average. Some top producers also make the great *Qualitätswein mit Prädikat* wines.

Between Franken and the Rhine is Bergstrasse, a tiny district of only secondary importance. The vineyards of Baden, stretching 150 miles south of Bergstrasse all the way to the Rhine where it borders Switzerland, dot the narrow band of rolling hills that mark the transition from the Black Forest to the wide river plain. Baden's best wines grow on the slopes of an extinct volcano, the Kaiserstuhl, northwest of Freiburg. The people of Baden are enthusiastic wine drinkers, consuming all of their local product. Their vineyards are some of the best-planned and -managed in the world, their wineries among the most modern. Robert Mondavi, the noted winemaker from California's Napa Valley, was impressed by the facilities he saw during a recent visit to the great Baden cooperative at Breisach. And what is more important, at such fine up-to-date cooperatives the Germans are producing excellent inexpensive wine. The beautiful vineyards of the Bodensee *Bereich* around Lake Constance form part of the Baden region, too. These produce the lovely *Seeweine* ("lake wines"), which often include a rosé called Weissherbst, pressed from the red Pinot Noir grapes growing along the lake shore.

Württemberg is the name of the wine district in the Neckar River Valley east of Baden; Stuttgart is the wine center. More red wine than white is produced, also some rosé.

GREAT GERMAN WHITE-WINE VINEYARDS

Before the wine law of 1971 became effective, the various German winegrowing districts counted more than 30,000 individually named vineyards. The law has grouped many of the smaller plots together, reducing the total number of vineyard names to about 3,000. Of this still large number, relatively few consistently produce the finest German white wines—these are the 140-odd vineyards listed below, arranged by region and

town. The top vineyards are rated *great* (incomparable, like the First Growths of Bordeaux or the *Grands Crus* of Burgundy), *very good* (always regal, elegant, with finesse and breed), *good* (still remarkable, far above average). S.A.

The Great Vineyards of the Rheingau

Town	Vineyard	Rating
Rüdesheim	Berg Roseneck	very good
	Berg Rottland	very good
	Berg Schlossberg	very good
	Bischofsberg	good
	Klosterberg	good
Geisenheim	Klaus	very good
	Kilzberg	good
Johannisberg	Schloss Johannisberg	great
	Vogelsang	very good
	Hölle	very good
	Klaus	very good
Winkel	Schloss Vollrads	great
	Hasensprung	very good
	Jesuitengarten	good
Hallgarten	Schönhell	very good
	Hendelberg	good
	Jungfer	good
Oestrich	Lenchen	good
	Doosberg	good
Hattenheim	Steinberg	great
	Mannberg	very good
	Wisselbrunnen	very good
	Nussbrunnen	very good
	Schützenhaus	good
Erbach	Markobrunn	great
	Siegelsberg	very good
	Steinmorgen	good
Rauenthal	Baiken	great
	Gehrn	great
	Langenstück	very good
	Rothenberg	good
Hochheim	Kirchenstück	good
	Domdechaney	good
	Stein	good
	Hölle	good

The Great Vineyards of Mosel-Saar-Ruwer

MOSEL

Town	Vineyard	Rating
Trittenheim	Apotheke	very good
	Altärchen	good
Neumagen	Rosengärtchen	good
	Laudamusberg	good
Piesport	Goldtröpfchen	very good
	Gunterslay	good
	Treppchen	good
	Falkenberg	good
Wintrich	Grosserherrgott	good
	Ohligsberg	very good
Brauneberg	Hasenläufer	very good
	Juffer	very good
	Juffer-Sonnenuhr	good
Bernkastel	Doktor	great
	Graben	great
	Lay	very good
	Bratenhöfchen	very good
	Schlossberg	very good
	Rosenberg	good
Graach	Himmelreich	very good
	Domprobst	good
Wehlen	Sonnenuhr	great
	Nonnenberg	good
	Klosterberg	good
Zeltingen	Sonnenuhr	very good
	Schlossberg	very good
	Himmelreich	very good
Urzig	Würzgarten	very good
Erden	Treppchen	very good
	Prälat	good

SAAR

Town	Vineyard	Rating
Wawern	Goldberg	good
	Herrenberg	good

Kanzem	Sonnenberg	good
	Altenberg	good
Wiltingen	Scharzhofberg	great
	Gottesfuss	very good
	Klosterberg	good
	Braune Kupp	good
Ayl	Herrenberger	very good
Ockfen	Bockstein	great
	Herrenberg	very good
	Geisberg	good
Oberemmel	Hütte	good

RUWER

Mertesdorf	Maximin Grünhaus	great
Eitelsbach	Karthäuserhofberg	great
Kasel	Nies'chen	very good
	Hitzlay	good
Avelsbach	Herrenberg	good
	Altenberg	good
	Hammerstein	good

The Great Vineyards of the Rheinhessen

Town	Vineyard	Rating
Oppenheim	Sackträger	very good
	Kreuz	good
	Schlossberg	good
Nierstein	Orbel	great
	Hipping	great
	Ölberg	great
	Glock	very good
	Rehbach	very good
	Zehnmorgen	very good
	Kranzberg	very good
	Rosenberg	good
Nackenheim	Rothenberg	very good
	Engelsberg	good
Bodenheim	Hoch	good
	Burgweg	good
Bingen	Scharlachberg	very good
	Rosengarten	good
	Kapellenberg	good

NAHE

Bad Kreuznach	Narrenkappe	very good
	Brückes	very good
	Kronenberg	good
Norheim	Kafels	good
	Dellchen	good
Roxheim	Birkenberg	good
	Höllenpfad	good
Niederhausen	Hermannshöhle	great
	Rosenheck	very good
	Klamm	good
Schloss Böckelheim	Kupfergrube	great
	Felsenberg	very good
	Königsberg	very good
	Mühlberg	good

The Great Vineyards of the Rheinpfalz (The Palatinate)

Town	Vineyard	Rating
Königsbach	Idig	very good
	Reiterpfad	good
Ruppertsberg	Gaisböhl	very good
	Spiess	good
	Hoheburg	good
Deidesheim	Herrgottsacker	great
	Grainhübel	great
	Kieselberg	very good
	Leinhöhle	very good
	Hohenmorgen	very good
	Kalkhofen	good
	Mäushöhle	good
Forst	Kirchenstück	great
	Jesuitengarten	great
	Freundstück	very good
	Ungeheuer	very good
	Pechstein	good
	Elster	good
Wachenheim	Gerümpel	great
	Rechbächel	very good
	Böhlig	good
	Goldbächel	good
Bad Dürkheim	Hochbenn	very good
	Michelsberg	good
	Fuchsmantel	good
Ungstein	Herrenberg	good
	Michelsberg	good
Kallstadt	Horn	good
	Kronenberg	good
	Steinacker	good

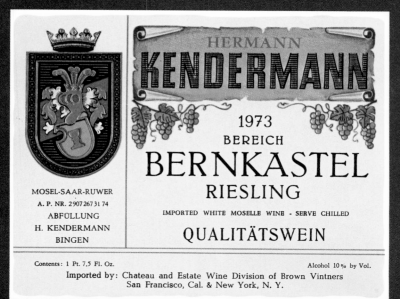

HOW TO READ A GERMAN WINE LABEL

A REGIONAL MOSELLE

Bernkastel is now also the appellation for the middle section of vineyards (*Bereich*) in the Mosel-Saar-Ruwer. To avoid confusion with the famous town, wines from this section must be labeled "Bereich Bernkastel." This wine is made from the Riesling. *Qualitätswein* is the legal designation for second-rank wines in any of the official wine regions. The certified test number (*amtliche Prüfungsnummer*) is awarded only when a Quality Wine fulfills all the requirements before bottling.

A TYPICAL TOPFLIGHT MOSELLE

Town and vineyard are named. The suffix "-er" indicates that the wine comes from the town, not the *Bereich*. This wine from the famous Doctor vineyard was made on the estate (*Weingut*) of Dr. Thanisch's widow. *Qualitätswein mit Prädikat* is the term for first-rank wines. Here the special attribute is *Spätlese*. *Erzeuger-Abfüllung* is the legal phrase for estate bottling. V.D.P.V. *Verband Deutscher Prädikatwein Versteigerer* means that this wine was made by a member of an association of top-quality wine producers.

A NEW RHEINGAU REGIONAL

Erntebringer is the section (*Grosslage*) at the heart of the Rheingau slope that includes Geisenheim and Johannisberg. "Grosslage Erntebringer" could come from anywhere in this area, but "Johannisberger" tells us that the wine was grown in the vineyards associated with that town. This *Qualitätswein* carries the requisite registration number.

A GREAT RHEINGAU ESTATE WINE

Schloss Johannisberg is the home of many great Rheingau wines. *Spätlese* is the special attribute of this *Qualitätswein mit Prädikat*. The proprietor, Prince Paul von Metternich-Winneburg, has his own color system for grading wines. *Grunlack* ("green label") is always used for *Spätlese* wines. *Erzeuger-Abfullung* indicates château (*Schloss*)-bottled wine.

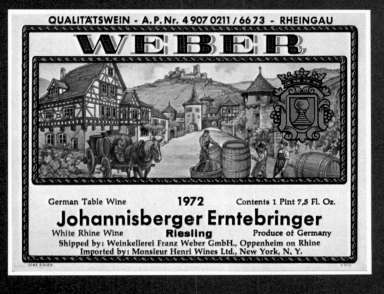

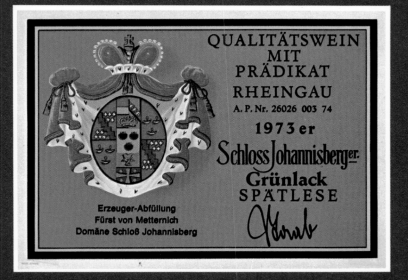

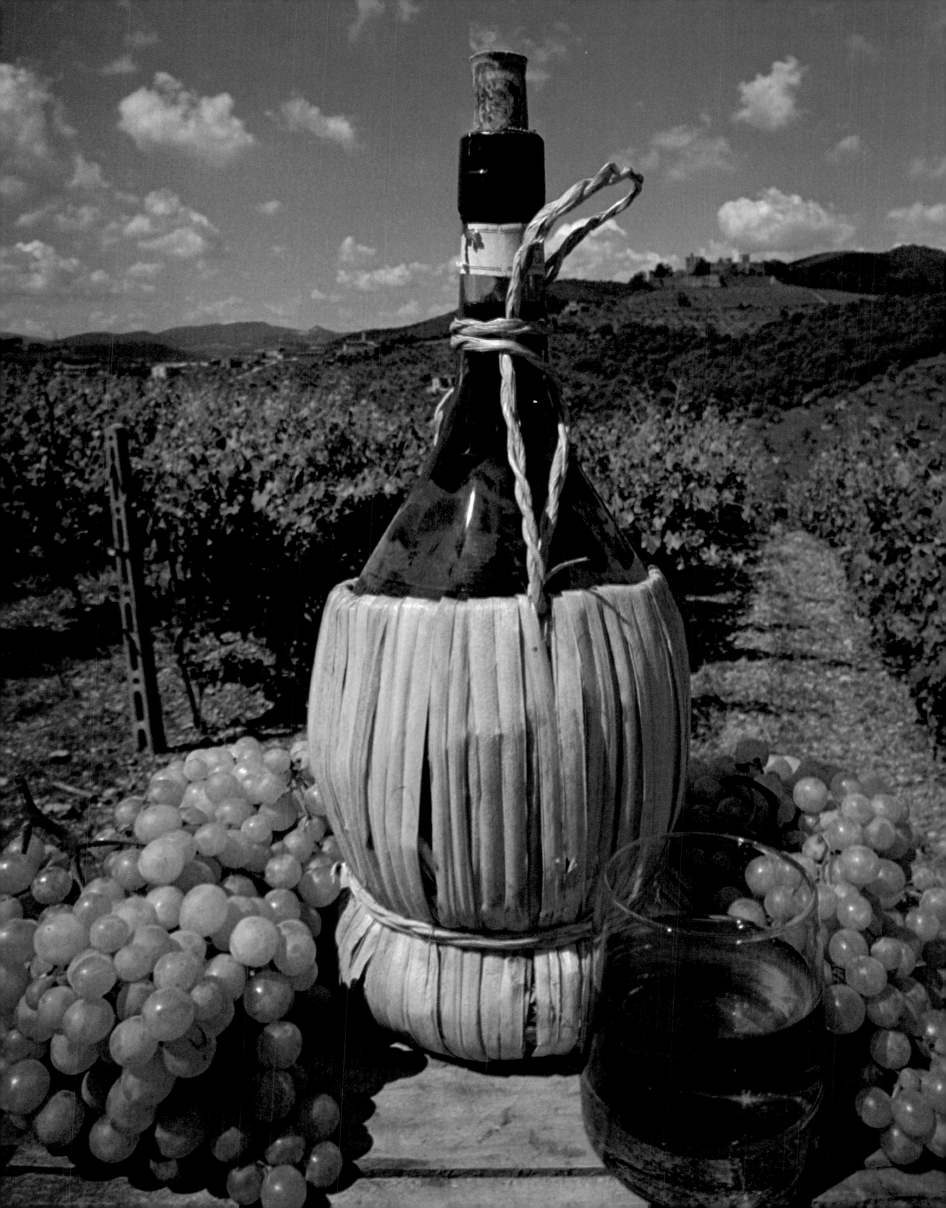

THE WINES OF ITALY

At times all that seems to bind Italy together is the concrete threads of *autostrade* that weave across the peninsula from the Alps to the Strait of Messina. Each region of Italy goes its own way: the south distrusts the north, the north disdains the south. Even the supple Italian language cannot always be considered common ground.

But one joy that all Italy shares is wine. If united on no other count, Italians make up the greatest body of winemakers and wine drinkers in the world. They produce almost 2 billion gallons of wine every year, consuming most of it themselves. The typical Italian adult downs more than 200 bottles of wine annually. Some 60 percent of all the farms in Italy have their own vineyards, a total of at least 2 million in the entire country. Intensive grape cultivation covers 3 million acres of the Italian terrain. Half again that number of acres are devoted to still more wine grapes in so-termed "promiscuous cultivation," where the vines are mixed in among olive and fruit trees, rows of flowers, files of grain. Given the slightest chance, the grapevine seems to twine its way everywhere.

Like the nation itself, the wines of Italy are anything but unified. Only within each province does any sense of unity exist. And a corollary of this is that the character of the province bears an unmistakable resemblance to the wines it produces. Piedmont, birthplace of many of modern Italy's statesmen, makes wines that are refined, dignified, even austere. Wines from the Veneto are engaging, friendly, not particularly serious—like many a carefree Venetian. The capricious, colorful Neapolitans seem to be reflected in their exuberant wines.

The government has, to be sure, made a grand effort to delimit growing regions and to set standards of quality for the best wines. The laws of 1963 have helped to impose some

A sturdy young Chianti in its straw-wrapped *fiasco* epitomizes Italian wine. The fortress-castle of Brolio in the background is one of the great wine estates of the world

361

semblance of order on the vast disarray of Italian wines, and these specifications promise much for the future of Italian wines. The notable wines of Italy are isolated summits (not peaks) rising from a sea of everyday wines. Like some vinous archipelago, they resist systemization. Each island stands alone, many yet undiscovered.

These relatively outstanding wines are named in several ways. Many good Italian wines (and the better ones, likely to be found abroad, are our primary concern) take the name of the town or region in which they were first produced; thus Barolo is so called after the town and district of that name, while Chianti is named for the small mountain range in the heart of Tuscany on whose slopes it grows. Other wine names, such as Merlot Trentino, derive from a grape plus a town or district. Still other names, like "Lacrima Christi," are the product of fantasy or are allusions to historical anecdote. Wines named for a specific vineyard within a wine community, comparable with a château in Bordeaux, a *Cru* in Burgundy, or an *Einzellage* in Germany, are rare.

No matter what its name or origin, an Italian wine exported to the United States is likely to carry the words *Denominazione di Origine Controllata* on the label. The phrase, literally "Controlled Denomination of Origin," is usually abbreviated, even in Italy, to D.O.C. The concept is a rough equivalent of the French *Appellation Contrôlée*. Now in force for over a decade, the statutes specify three levels of control. First is the plain Denomination of Origin (seldom seen on bottles in the United States), indicating that the wine was produced from particular grapes grown in a delimited area and that the wine has the required alcohol content, age, and character. The quality and vinification methods of these wines are not as strictly controlled as those of the higher grades. For the wines of the second rank, the D.O.C., the yield per ton of grapes must be less, natural alcohol content must be higher, and aging must be longer.

When these basics are established, a national committee reviews the recommendations, either granting or refusing the right to a D.O.C. The third and top grade of wines set forth in the law are those with controlled and guaranteed denomination of origin; these wines, made in accordance with the strictest standards, represent the best of the controlled wines, and their labels must include aging and bottling information not required of the second rank, the D.O.C. wines.

The laws are both as strict and as detailed as those of France, but their enforcement can hardly be called as zealous.

A smiling sun and plump grapes carved on a barrelhead of Ruffino Chianti hint at the delights within

As a result, hundreds of wines from everywhere in Italy—deserving and undeserving, great and small—have sought and won the D.O.C. Although still new, and far from perfect, the laws have nevertheless done much to delimit special wine areas, roughly along the lines used in other Common Market countries. This assurance to the consumer of some sort of guide to origin and quality has made a wider variety of Italian wines popular abroad.

IMPORTANT RED WINES

The best wines of Italy are red, and the name of at least one is known around the world. Chianti, as has been noted, grows on the Tuscan hills south of Florence and north of Siena. The wine has had an extraordinarily long past: it was first called by its present name in the year 790, and the League of Chianti established its first wine controls in 1248. In one form or another, Chianti must have been a wine that gave pleasure to such great figures as Giotto, Donatello, and Michelangelo, when, in pre-Renaissance and Renaissance times, they traveled and worked in the province of Tuscany. Only in the last century, however, were standards formalized for making the wine that has since become so popular. San Giovese, Canaiolo, and a small proportion of white Malvasia and white Trebbiano grapes (the last a versatile wine grape known in France and California as the Ugni Blanc) go into the wine. About 1860, Baron Bettino Ricasoli listed the percentages of the grapes that should be included in the wine and the best methods for cultivating them. Ricasoli's descendants today make one of the finest Chiantis in the district. Ricasoli Chianti and the good wines of the other important houses are for the most part Chianti Classico, that is, Chianti made from grapes grown in the Classico zone, the heart of the district, which contains six other zones. Chianti Classico always bears the local association's seal, a black cockerel (the *gallo nero*). This classic Chianti (to be distinguished from the sprightly "Italian Beaujolais" that comes in gay straw-wrapped *fiaschi*) is a noble red wine which sometimes demands extra aging both in the cask and in its brown Bordeaux-style bottles. A deep, rich Riserva Classico (one that has been aged) from a successful vintage and an honorable producer will live for years. When mature, it will provide an unequaled Italian wine experience.

A crucial part of the making of Chianti that is meant to be drunk young is the process called *il governo*. During the vintage, cellar masters set aside a small reserve of grapes to dry somewhat, then crush and ferment them slightly. The potent purple

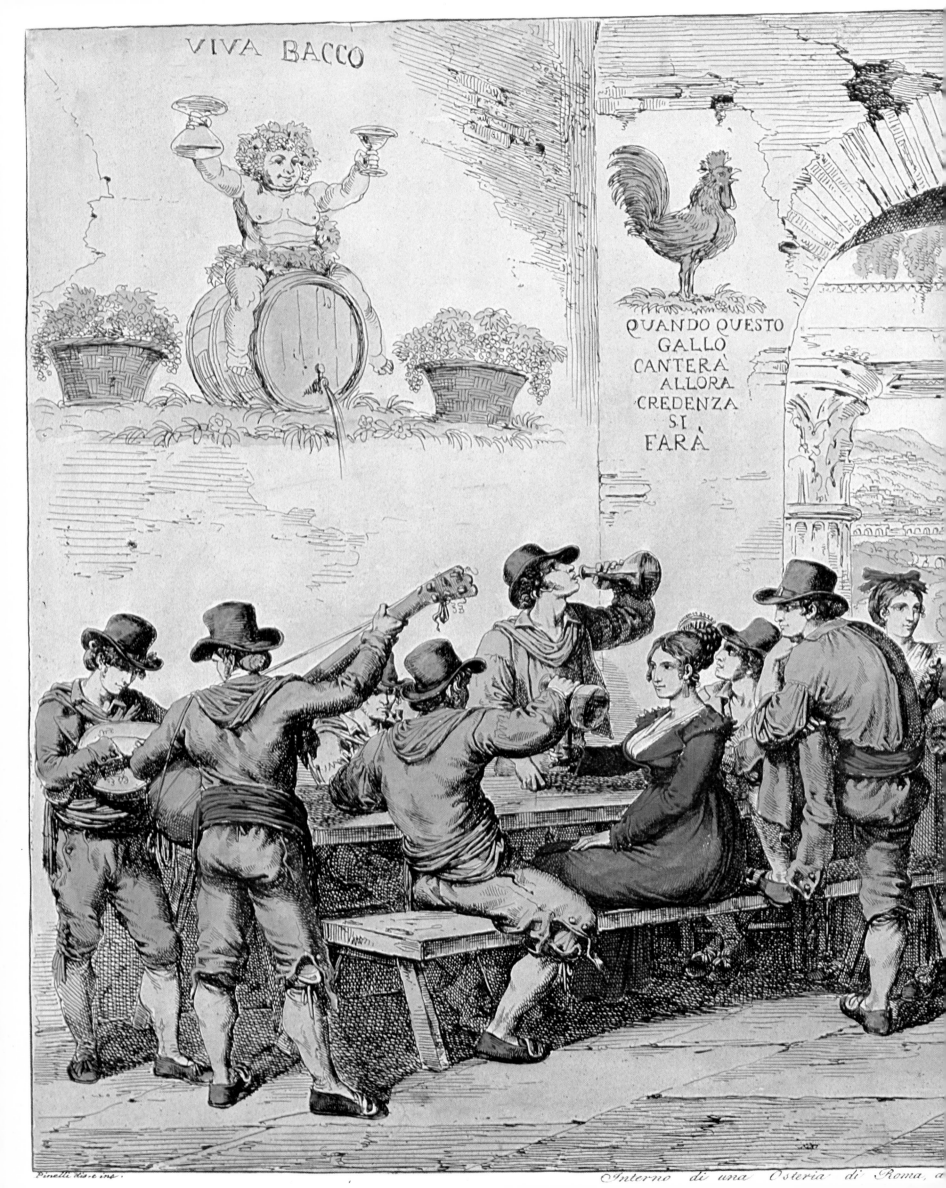

VIVA BACCO

QUANDO QUESTO
GALLO
CANTERÀ
ALLORA
CREDENZA
SI
FARÀ

Interno di una Osteria di Roma,

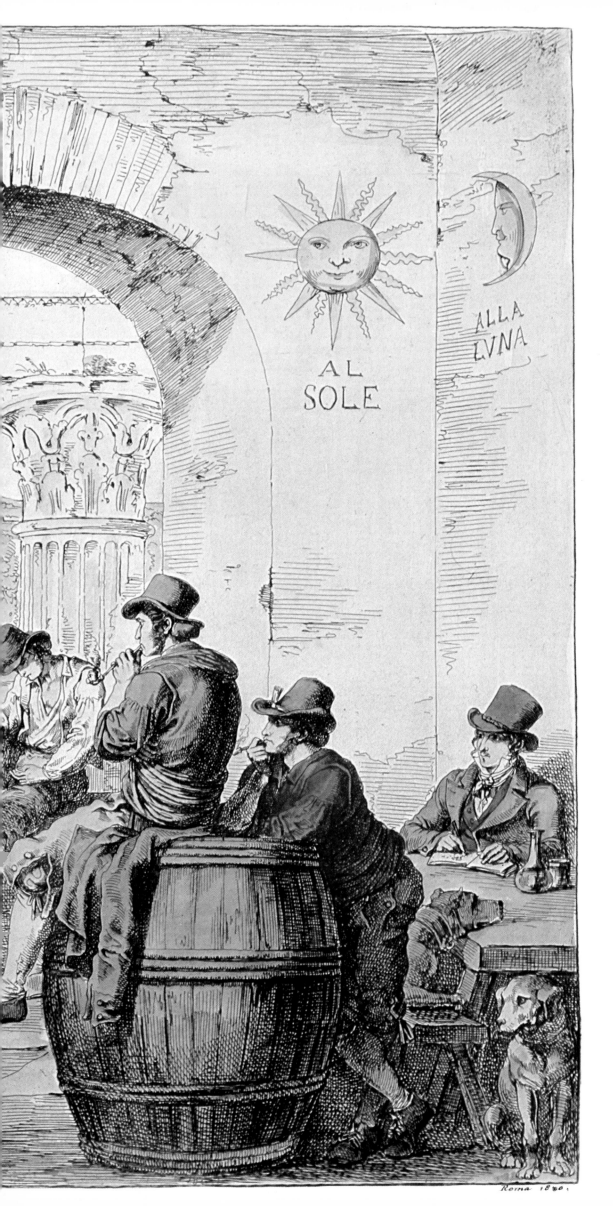

Interior of an Inn on a Hillside near Rome, hand-colored etching by Bartolomeo Pinelli, Italian, 1820

365

must that results is added to the regular wine already resting in barrel. The rich admixture intensifies the flavor of the Chianti and, by encouraging a secondary fermentation, gives it a faint prickle.

One wine of Italy that can be even better than a fine Chianti Riserva is Barolo, grown in a very small area of the Piedmont about thirty miles south of Turin. Barolo is a big, heavy, alcoholic wine, rather like one of the best reds from the Rhône Valley in France. It is made from the great red wine grape of Italy, the Nebbiolo, which, as its name suggests, gives its finest wines in those areas where early morning fog (*nebbia*) often shrouds the vines at vintage time. Such is the case in the dales of Barolo. Like a good Chianti Riserva, the wine must be given enough time to lose its youthful harshness. Mature Barolos, with a prominent orange cast after a decade in bottle, have a long-lasting taste and a remarkable bouquet reminiscent of violets and fresh-turned earth. An old-fashioned Barolo, decanted off its considerable sediment, and enjoyed with rich Piedmontese food, faces little serious competition as one of the greatest of Italian wines.

Within a few miles of the town of Barolo is the little village of Barbaresco, whose vineyards make another excellent wine from the Nebbiolo grape. Barbaresco is somewhat lighter, faster-maturing, and less robust than Barolo. It is also shorter-lived. Many Italians consider Barbaresco a feminine version of Barolo.

Barbaresco and Barolo have three close relatives from northern Piedmont which should be included in any listing of remarkable Italian wines. Gattinara, Spanna, and Ghemme grow on the slopes of the little hills between the town of Novara and the shore of Lake Maggiore. The Nebbiolo produces all these wines, but Gattinara is the best, on occasion even superior to Barolo. Famous since pre-Renaissance times, Gattinara is among the most elegant of Italy's red wines. Slow to mature, with more finesse than Barolo and a light raspberry bouquet, Gattinara can live for decades. The same region also gives us Boca, Fara, and Sizzano—red wines all far above the Italian average.

The north of Italy produces lighter red wines, too, notably around Verona, where the fragrant, fruity Valpolicella and the light-colored Bardolino are well known. The noble Nebbiolo plays no part in these wines. Rather, they are made from a blend of three lesser grape varieties: Corvina, Molinara, and Rondinella. Like many Italian reds, Valpolicella and its rather similar

Ischia, sister island of Capri, produces a light dry white wine—perfect for drinking at its colorful summer festival

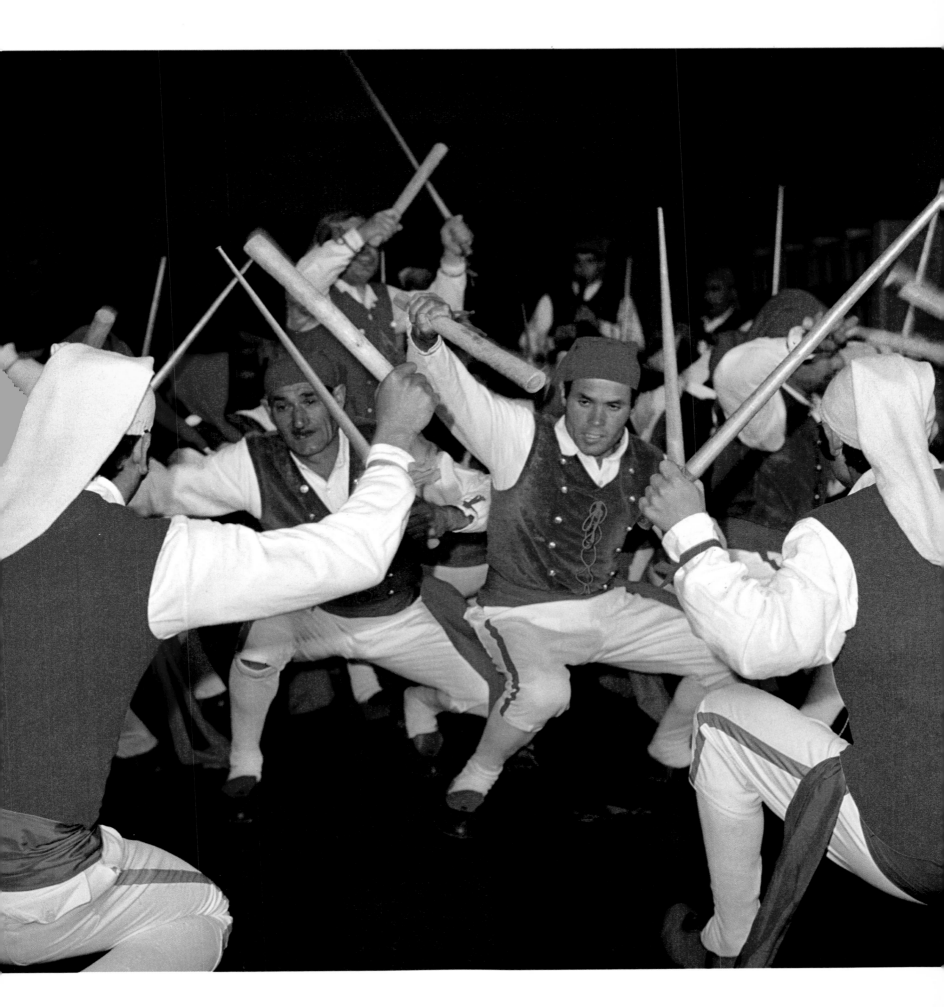

neighbor, Valpantena, are made in two styles—one for drinking young, the other for a few years of bottle aging. The other good Verona wine, Bardolino, grows on the eastern slopes above Lake Garda. Scarcely more than a very dark rosé, Bardolino should be drunk within a few years of the vintage, when it is still fresh and cherry-colored. Facing the Bardolino vineyards across the quiet waters of the lake rise the hills that grow one of Italy's best rosés—Chiaretto. The wine is a light ruby color, a few shades lighter than Bardolino. Chiaretto del Garda, from vineyards closer to the lake, must also be enjoyed young and is even more pleasant. Nearby is made the special and costly Amarone wine. Produced from dried grapes, it is concentrated and rich—lovely after dinner.

Barolo, Valpolicella, Chiaretto, and the rest of the wines described above (except Chianti) grow in the center of northern Italy. Closer to the Alps a few scattered valleys and hillsides make noteworthy wines. In the French-speaking Val d'Aosta, spreading out along the road to the Mont Blanc tunnel, grow the wines Donnaz and Carema, both smooth and vaguely Alpine. Carema is fuller-bodied than Donnaz. To the east, Valtellina wines from Lombard vineyards in the Alps near the Swiss border have been made on the steep mountain slopes at least since the fifth century. The best are Grumello, Inferno, Sassella, and Valgella, all from the Nebbiolo grape. Deep garnet, slow to develop, good to lay down, the wines certainly deserve a wider fame. Production is small because viticulture is arduous in the steep vineyards. Workers must pick through the vines three or four times, selecting only the ripest grapes each time around. Despite the tremendous labor involved, Valtellina wines represent some of the best red-wine values in Italy.

Other good wines from the Italian Alps grow in the upper portions of the valley of the Adige River. This region is the southern Tyrol, once part of the Austrian Empire, and the wines show the distinct influence of the Germanic lands of the mountains and beyond. Even today, Alto Adige wines are especially popular in Switzerland, Austria, and Germany. Lago di Caldaro (or Kaltersee, as it is sometimes styled on labels) is a gentle, round wine with an aftertaste of almonds. Like other Adige wines, it is made from a good grape variety, the Schiave, trained on trellises above the ground. Meranese is pleasant enough, but still better is Santa Maddalena, a fresh, soft, and perfumed wine grown on a mountaintop near the town of Bolzano. It is rather like a full-bodied Bardolino.

Farther down the Adige Valley the terrain becomes less

Wine Merchant in the Suburbs of Rome, hand-colored lithograph by Victor Adam after a drawing by Carle Vernet, French, nineteenth century Christian Brothers Collection

mountainous and the wines lose some of their Germanic character. These wines, the Trentinos, have more body but less bouquet than those from higher up in the Alps. Cabernet, Lagrein, Merlot, and Pinot Noir grapes make the enjoyable Trentino wines.

OTHER RED WINES

The red wines of central and southern Italy generally arouse less interest than do the fine reds of the north and Chianti. Other Tuscan wines simply are not in Chianti's class, except for the glorious and expensive Brunello di Montalcino. In Umbria, south of Perugia, there grows the pleasant Torgiano (from "Torre di Giano," the "tower of Janus" that stood near these vineyards in medieval times); its name reminds us that the ancient Roman deity with two faces was the guardian of the vine.

Rosso Piceno and Rosse Cornero come from the Marches along the Adriatic coast. Both are a lovely ruby red, becoming smooth with a little bottle aging—welcome improvements on the rather bleak red-wine situation in this part of Italy.

Campania boasts several famous white and light-red wines from the coast and the islands near Naples, but the finest and the fullest of the red Campanian wines are those from farther inland. Taurasi and Aglianico del Vulture, made from the Aglianico grape, can be very dark and powerful. Both must be aged for many years before they are truly ready to savor, showing all of their considerable bouquet. Gragnano, too, is a good wine from Campania.

Calabria, the toe of Italy's boot, makes only one interesting red wine, Cirò. Since the wine has a high alcohol content, 15 percent or more, a well-made Cirò can live for decades without losing its charm to any extent.

Sardinia and Sicily make much dessert wine and a smaller quantity of good red table wine. The family of wines made from the Cannonau grape are the best reds of Sardinia: strong, dark, generous, and tannic. Among these are Capo Ferrato, Jerzu, Oliena, and Pedru Rubia. Marsala overshadows all the other modest wines of Sicily, but Fara, Etna, and Corvo are good enough to claim a little of the limelight.

WHITE WINES

If any Italian white wine comes close to being as famous as the red Chianti, it is Soave. Certainly not a great wine, even by Italian standards, Soave pleases because it is simple, plain, clean, flinty, and fresh—predictable. The wine is blended from

Garganega, Trebbiano, and even a little of the Italian Riesling grape, all grown on pergolas and trellises north of the tiny village of Soave, in the Veneto, east of Verona. Nearly all Soave comes to life in one of the giant factories of the large producers located there, and this helps assure the uniform quality of the wine. Soave, like other light Italian whites, must be drunk young, within four years of the vintage. Longevity is not one of the qualities of this very agreeable wine, but fortunately the many Soaves that leave Italy in their pretty tall green bottles are so popular that few remain in a wine merchant's cellar.

The north of Italy makes half a dozen other white wines, which are overshadowed by Soave's fame. Cortese, the best white wine from the Piedmont, can be lovely and elegant, with a greenish tinge complementing its freshness. Near the Valpolicella region around Lake Garda are the vineyards of Lugana, planted in the Trebbiano grape. Lugana is tart and delicate when very young, warmer and amber-colored with a few years of age. Alto Adige and Trentino growers make several good whites. The area is the home of the Gewürztraminer grape, originally cultivated around the town of Tramin, or Termeno, as the Italians call it. Traminer Aromatico Trentino, like its more famous German and Alsatian cousins, sparkles pale golden in the glass, dry and spicy on the palate. Riesling, Pinot Blanc, plus one or two other well-known wine grapes are planted on the dramatic hillsides of the Alto Adige. Most produce a coarser wine here than in other parts of Europe.

In the Marches near the Adriatic lies the Castelli di Jesi region, a name unfamiliar by itself but one that no wine drinker fails to recognize when it is combined with the name of the grape grown there—Verdicchio. Verdicchio dei Castelli di Jesi is very like Soave, to be drunk young and fresh. Exported in a slender bottle, usually in the form of a fish, amphora, or vase, Verdicchio, with its rosiny aftertaste, has become one of the most popular white Italian wines sold abroad.

On the other side of the Apennines in central Italy, Orvieto is made, either dry *(secco)* or sweetish *(abbocato)*. The grape vines responsible for the well-known wine grow haphazardly on the city's hillsides, even within sight of the remarkable facade of Orvieto's cathedral. A better example of the enthusiastic Italian "promiscuous cultivation" it would be hard to find. Abbocato Orvieto is not a cloying, sugary dessert wine. The touch of sweetness is slight, and has made many converts even among those who claim to abhor sweet table wines. Est! Est!! Est!!!, grown west of Orvieto, is light and just barely sweet.

Far better than Est! Est!! Est!!! is the Torgiano Bianco from Perugia. Better still is the impressive Vernaccia di San Gimignano from Tuscany, a wine reminiscent of some of the great French white Rhônes.

The hills south of Rome produce Frascati, a dry golden wine very popular in the capital, though no Roman today would praise it as highly as Horace did the famed Falernian of ancient Rome. The island of Elba off the coast makes a very tart and acid wine called Procanico, much stronger than the wines many tourists drink on the islands of Capri and Ischia in the Bay of Naples. Naples itself is better known for the wines of Vesuvius, notably Lacrima Christi. It is a pleasant, soft golden wine, made more famous than it should be by its intriguing name. Only wines from the delimited area of the mountain vineyards can bear the words "del Vesuvio."

Sardinia's white wines are heavy and robust. Vernaccia resembles sherry; Nuragus is somewhat better to drink with food. Sicily counts several good whites: the wine from the slopes of Mount Etna, the Val di Lupo, and Corvo. As is usual in Italy, these names apply to both red and white wines.

DESSERT AND SPARKLING WINES

Sicily's Marsala was the last of the four great fortified wines of Europe to see the bottom of a wineglass. Its relatives—Madeira, sherry, and port—are Marsala's seniors by many years. The strong, famous version of Marsala was popularized around 1760, almost by accident, when John Woodhouse, an English wine merchant, shipped some of his light table wines from the town on the western coast of Sicily. Before the barrels left the island the inventive wine man added a dose of distilled wine to each cask to brace the Marsala for the voyage to London. The once uninteresting table wine took well to the strengthening, and within a few years the making of fortified Marsala was firmly established on the island. Several sorts of Marsala are made today. Some are sweet and rich, ideal for drinking with or after desserts; others are a bit drier and make fine aperitifs. One Marsala, called *vergini*, is fortified but not sweetened, and resembles sherry.

The Muscat grape, in Italy known as the Moscato, makes a number of strong dessert wines in several parts of the country. Cagliari comes from Sardinia; Pantelleria from an island off the coast of Sicily. The Lipari Islands, also off Sicily, make an excellent dessert wine from the Malvasia grape. Moscato di Siracusa grows near Syracuse on Sicily. The list could go on

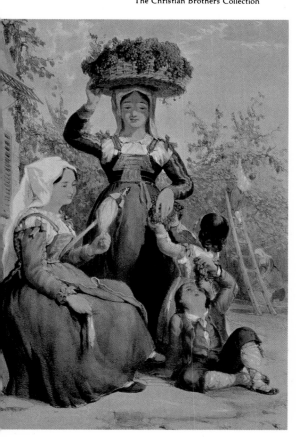

Vintage of the Abruzzi, hand-colored lithograph by Thomas Allom, English, nineteenth century

The Christian Brothers Collection

371

and on. Most of the wines resemble the sweet natural wines from the Mediterranean vineyards of the French coast near the Spanish border.

One pale, sweetish Muscat wine, the Moscato Canelli, is made around the village of Canelli in the Piedmont, near Asti. Not well known as a still wine, this Moscato gains worldwide fame when it is turned into the most popular of all Italian sparkling wines, Asti Spumante. Many people find Asti Spumante disconcertingly sweet. Certainly it has little of the elegance of French champagne, but no one can deny the lift it gives to a dessert of rich Italian confections. Italy produces another wine more like champagne. Called Gran Spumante or Spumante Brut, it is made by the classic *méthode champenoise* from a blend of Pinot-grape wines.

Following is a list of Italian wines with their regions, a brief comment, and my rating. S.A.

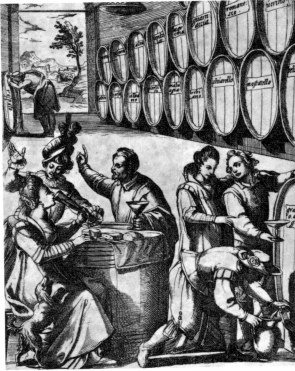

View of a Roman Wine Cellar, by Nicolaes van Aelst, Rome, early seventeenth century
The Christian Brothers Collection

ITALIAN TABLE WINES

RED WINES

Wine	District	Comments	Rating
Aglianico	South-central Italy between Bari and Naples	Full, pronounced character, long-lived.	good
Amarone	Veneto, near Verona	Dark, full, complex.	great
Barbaresco	Piedmont, near Alba (south of Turin)	Light, well-balanced, enjoyable.	very good
Barbera	Piedmont, especially east of Turin	Common and inexpensive; named for the Barbera grape.	acceptable
Barbera d'Alba	Piedmont, around Alba	Smooth, flavorful, good value.	good
Barbera d'Asti	Piedmont, around Asti	Excellent; deep character.	very good
Bardolino	Southeastern shore of Lake Garda, near Verona	Very light in color and taste, to be drunk young.	good
Barolo	Southern Piedmont	Fine wine, powerful and subtle.	great
Brunello di Montalcino	Tuscany, south of Siena	Scarce, elegant, rewarding	great
Chianti	Tuscany	Agreeable, undistinguished, easy to drink.	good
Chianti Classico	Tuscany, between Siena and Florence	Good all-round wine, fruity and dry.	very good
Chianti Riserva	Tuscany, between Siena and Florence	One of the best; finesse and long life.	great
Gattinara	North Piedmont, near Lake Maggiore	Slow to mature, rich and complex.	great
Ghemme	North Piedmont, near Lake Maggiore	Long-lived, soft, very pleasant.	very good

372

Wine	District	Comments	Rating
Gragnano	South of Naples, near Sorrento	Almost a Beaujolais; fruity, sweetish.	good
Grignolino	Piedmont	Attractive and pleasant; grape does well in California.	good
Grumello	East of Lake Como, near Swiss border	Sturdy; dry, deep crimson.	very good
Inferno	East of Lake Como, near Swiss border	Rich, full-bodied, austere.	very good
Lago di Caldaro	Near Bolzano in Tyrol	Fragrant, light, fresh.	good
Lambrusco	Near Bologna	Slightly sparkling, fruity, sweetish.	acceptable
Nebbiolo d'Alba	Piedmont, around Alba	Agreeable, like a lighter Barolo.	good
Santa Maddalena	North of Bolzano in Tyrol	Clean, charming, tart.	good
Sassella	East of Lake Como, near Swiss border	Firm, deep-colored; ages well	very good
Spanna	North Piedmont, near Lake Maggiore	Closely related to Gattinara and sometimes even better; grown just outside the delimited zone for Gattinara.	great
Torgiano	Central Italy, near Perugia	Robust, rich, full.	good
Valgella	East of Lake Como, near Swiss border	Lighter than some of its neighbors.	very good
Valpolicella	Just north of Verona	Quality varies; best are velvety and light.	good

WHITE WINES

Wine	District	Comments	Rating
Capri	Island in the Bay of Naples	Pale and very dry.	good
Cortese	Piedmont	Agreeable and light.	very good
Est! Est!! Est!!!	At Montefiascone, north of Rome	Common and undistinguished.	acceptable
Etna	On the slopes of the Sicilian volcano	Dry, almost spicy.	good
Frascati	Hills outside Rome	Popular, but little more.	acceptable
Ischia	Island of Ischia, in the Bay of Naples	Refreshing, pale, dry.	good
Lacrima Christi	Mt. Vesuvius, near Naples	Soft, sweetish, golden.	very good
Lugana	Southern shore of Lake Garda	Not well known, but good.	good
Orvieto	Umbria, north of Rome	Sweet version is best.	good
Riesling	Alto Adige	Lighter than its German cousins.	good
Soave	Just east of Verona	Attractive, agreeable, light and dry.	very good
Termeno	Tyrol	Fragrant and spicy; Gewürztraminer grape.	good
Valtellina Bianco	East of Lake Como, near Swiss border	Refreshing, light, tart.	good
Verdicchio	Near Adriatic coast in central Italy	Distinctive, very dry.	good
Verdiso	North of Venice	Fine; unusual bouquet and texture.	good

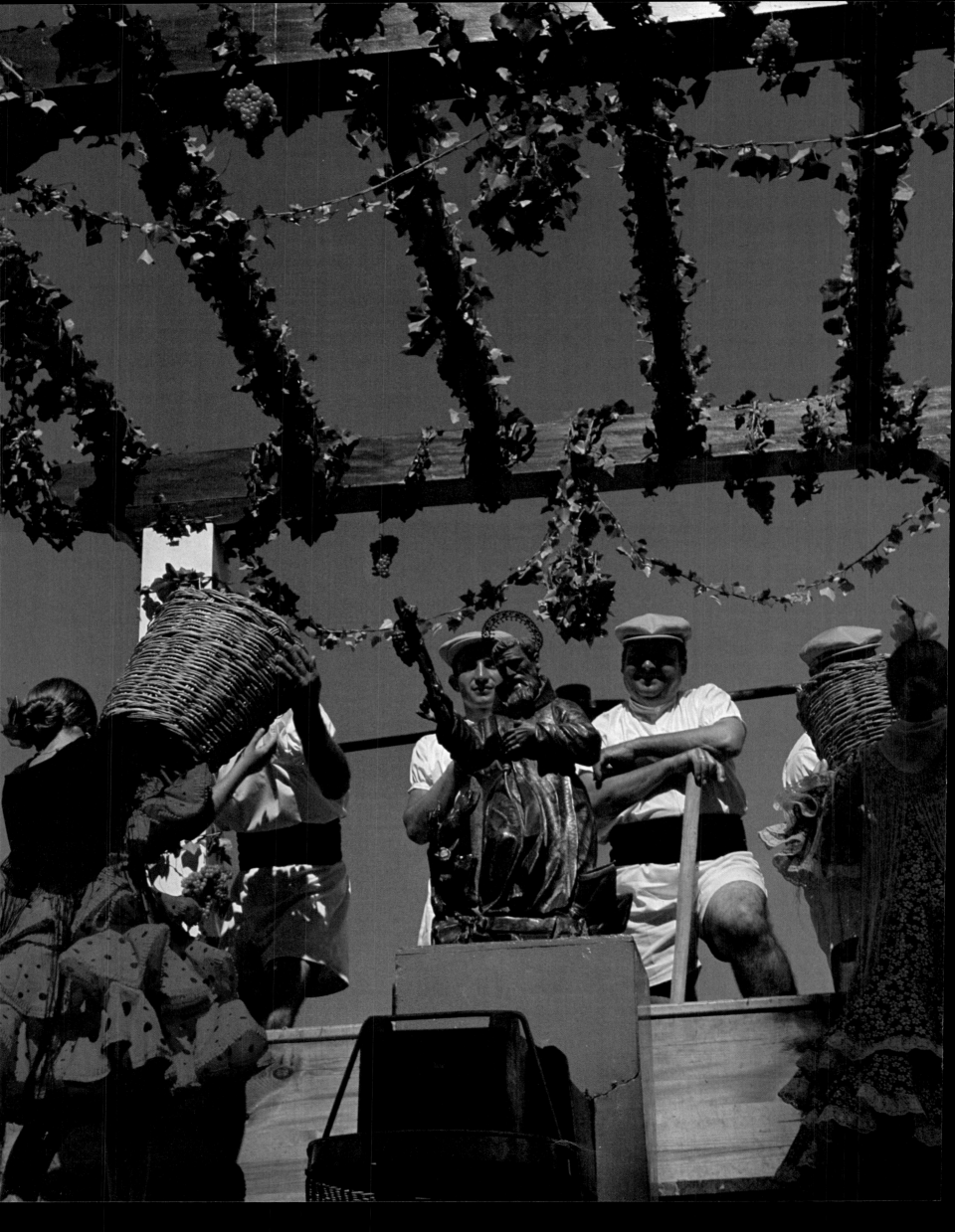

THE WINES OF SPAIN

The reputation of wines from Europe's Mediterranean countries seems to suffer from a variety of half-truths and misconceptions. Even in the face of our new wine consciousness the old clichés persist: Greece is retsina and nothing else; Yugoslavia makes wines, to be sure, but they are either undrinkable or unpronounceable; southern France can make only *vins ordinaires;* Italy will always be Italy—straw-covered bottles of mediocre red wine that everyone loves so long as it is cheap.

And then we come to Spain. Spanish wines would probably be damned with a combination of these prejudices (save perhaps the resin-flavored one) were it not for two exceptions, the wines of Jerez and the wines of Rioja.

Sherries are without a doubt the greatest wines of Spain, and the best of them rank with the finest wines of any country in the world. For their part, red Rioja wines can be exceedingly fine, even if they cannot be reckoned among the world's greatest. What lies between these two—sherry growing in the extreme southern part of Spain and Rioja coming from the far north—is the most extensive vineyard acreage within the borders of any one country anywhere. Italy and France each make more wine, but Spain claims more vineyard because the Spanish take into account all the vines interspersed in the mixed cultivation so prevalent across the Iberian Peninsula.

Much of the hundreds of millions of gallons of wine made annually on this record acreage deserves to be dismissed without comment (which would have to be unflattering). In fact the bulk of Spain's production, the red *vino corriente,* or common wine, is seldom worthy of being bottled, and is usually sold in carafe. But from Andalusia to Catalonia some good and honest table wines are made that rank with the simple, inexpensive country wines of other European nations.

At the *Feria* in Jerez each September the new vintage is blessed. The beautiful local girls in Andalusian costumes carry baskets of grapes to a treading press installed next to the church

RIOJA WINES

The finest Spanish table wines grow in a rocky, desolate area along the banks of the river Ebro. Haro, the drowsy Rioja wine capital, seems dwarfed by the *bodegas* on its outskirts. It is at Haro that the Rio Oja joins the Rio Ebro. No more than a stony stream, the Rio Oja has given its name to the district as a whole.

Rioja is a controlled wine. Only certain grape varieties may be planted within the legally defined boundaries of the district. All of them are Spanish varieties except the Garnacha, the Grenache of the Rhône Valley in France. Producers intending to bottle Rioja wines must have a volume and stock of wines large enough to meet minimum government standards. This curious rule was designed to make supervision and control easier, not to exclude small vintners from the profitable Rioja wine trade, and in practice small but top-quality *bodegas* are allowed to call their wine Rioja. Wine controls along the Ebro cannot be compared to the strict laws governing the production of sherry, still less to the statutes controlling the wines of France.

If the Spanish in Rioja have been less assiduous in lawmaking than their neighbors to the north, they have learned much from the winemakers of France. When the phylloxera struck the Bordeaux vineyards in the mid-nineteenth century, many French winegrowers left their land, moving south across the Pyrenees to the vineyards of Rioja. Winegrowing had long been practiced there, but the talented French *vignerons* found much that they could improve upon. Once crude and careless, the techniques of vinification and aging were refined and standardized. Rioja wines prospered even after the French *vignerons* returned to Bordeaux. The phylloxera came to the Spanish vineyards, too, but the vines were replanted, and the advances brought by the French continued. A viticultural station established at Haro after the turn of the century has been the center for a vigorous campaign of improvement and protection of Rioja wines.

Rioja is often compared to Bordeaux. Similarities do exist—both wines are deep, tannic, long-lived, and elegant—but the differences are just as great, if not greater. Were I to single out the way Riojas differ most from Bordeaux red wines, I should name barrel aging, especially as it reflects the Spanish attitude toward wine aging in general. Red Bordeaux ages in wood for two to three years, then in glass bottles until it is

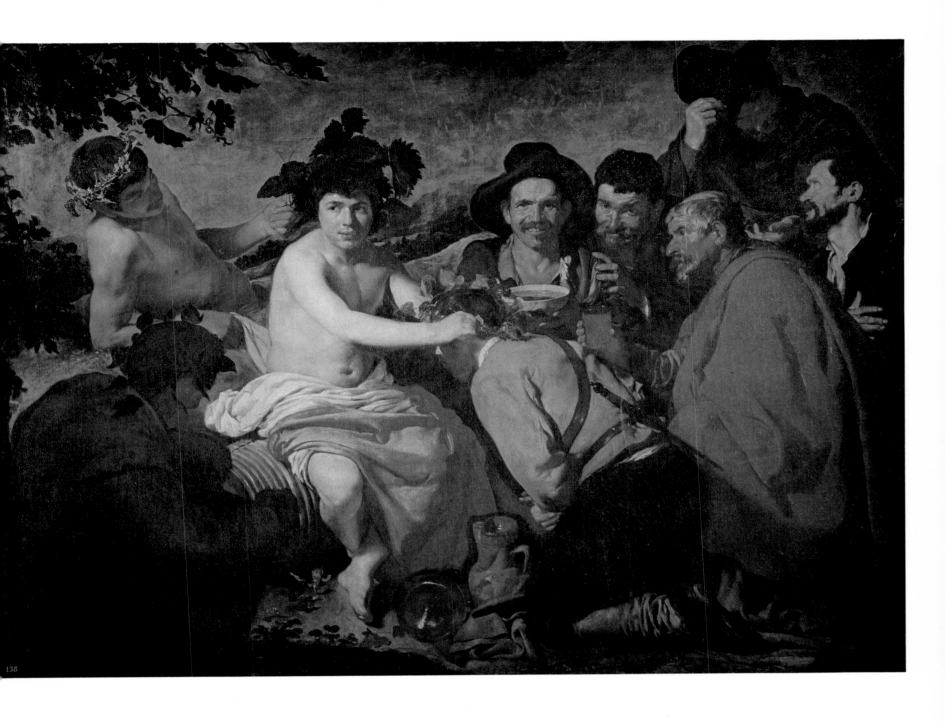

Los Borrachos (The Drinkers),
Diego Velázquez, c. 1629

ready to drink. By contrast, red Riojas may spend seven, eight, or even a dozen years in wooden barrels before bottling. The Spanish favor aging the wine in wood rather than in glass. As a result, Riojas take on a tawny color and absorb much of the vanilla scent of the oak. Once bottled, Riojas remain more static than Bordeaux wines. They do not soften and develop bouquet to nearly the same extent. Although much of the tannin—the acid that enables red wines to live in the bottle for many years—is lost during the years in barrel, enough remains so that the wine can enjoy a very long life. Riojas of ten, fifteen, or twenty years are common. They are not invariably great wines, but they offer a smooth, fragrant, memorable wine experience. To that extent, they may well be compared to the clarets of Bordeaux.

There is no real counterpart of the Bordeaux château wine

377

property in Rioja. About two dozen *bodegas* make nearly all the wine. Some of the important ones are La Rioja Alta, Viní-cola del Norte, Bodegas Bilbainas, Riojanas, Federico Pater-nina, Marqués de Murrieta, and Marqués de Riscal. Most of these and the other major firms own vineyards in which they grow their own grapes, although they also buy grapes from many of the smaller producers.

Wine labels usually bear the brand name or some special distinction added by the bottler to the basic Rioja appellation. A number of the best bottles are wrapped in a light wire mesh. This covering is more than a decoration: to a wine trade that reveres age almost for its own sake, the wire mesh is valuable as a means to prevent tampering with the dates printed on the labels. Riojas are finding a larger, more important, and more demanding audience outside Spain.

SHERRY

The corner of Andalusia that is sherry country lies south of Seville and borders on the Atlantic. At its center is the town that gives the wine its name, Jerez de la Frontera, around which vineyards extend for more than a dozen miles in every direction. Fifteen miles to the west, on the banks of the Gua-dalquivir River, is Sanlúcar de Barrameda, the second city of sherry. Jerez itself is an ancient town founded three thousand years ago by the Phoenicians. Greeks, Romans, Vandals, and Moors have ruled it at one time or another. In the look of the place today the excesses of late Moorish architecture merge with the whitewashed simplicity of the squat stucco houses common in this part of Spain. The startling brilliance of the buildings is heightened by the almost eerie light reflected up from the chalky white ground of the finest vineyards, for in Jerez as in Champagne the key to the light, subtle, remarkable wines is white chalk. In the French earth, the chalk crumbles, but in Spain it forms a hard, brilliant crust on top of the ground. In the summer this calcite plate reflects the strong rays of the hot Spanish sun up toward the ripening fruit. At times the eye-stunning white light nearly bakes the grapes. Just as important, the unbroken crust of chalk helps keep pre-cious moisture in the soil, down near the vines' deep roots. The water that these roots draw into the vines is mixed with the minerals of the chalk, and these give the grapes a distinct character. The special soils containing high proportions of chalk are called *albarizas*. Without them, sherry would have none of its world-famous finesse; it would be but another of the

(Top) Men wearing specially cleated boots tread out the sherry grapes in a large wooden trough

(Bottom) Making sherry casks at Gonzalez Byass. Unfinished barrels are soaked in water, then placed upside down over a pile of burning wood shavings. The heat makes the wet staves supple enough to be drawn together and hooped

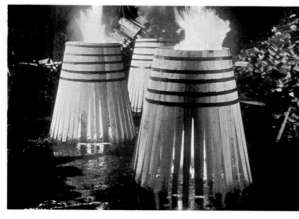

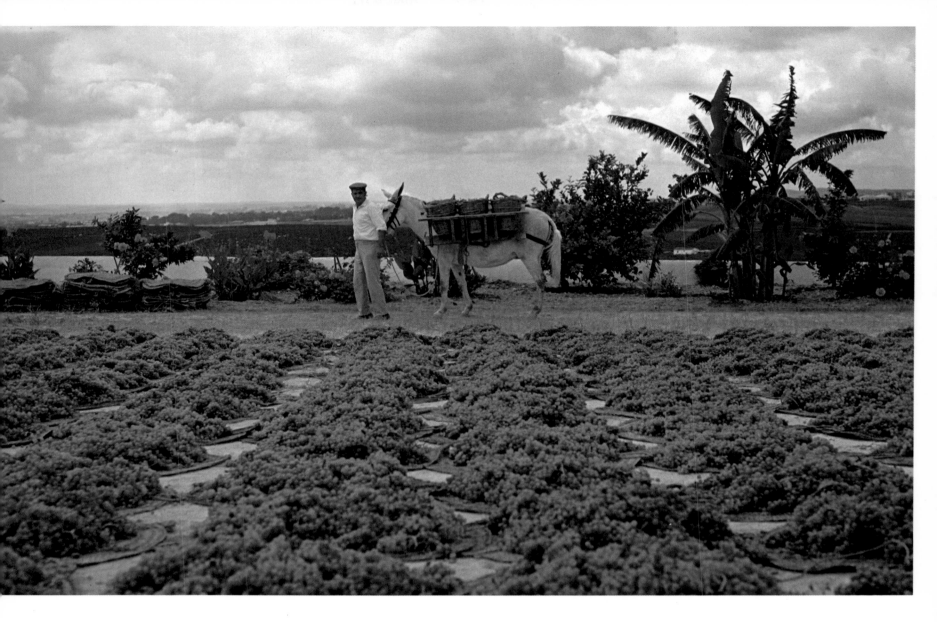

Palomino grapes on round grass
mats, drying in the Andalusian sun

strong, alcoholic, fortified beverages found all around the
Mediterranean.

Not all the ground inside the circle of vineyards around
Jerez shares the blessing of the chalk. The secondary soils
are clay (*barro*) and sand (*arena*). Vines growing in such soil
can never hope to give truly great sherries. The *barro* and
arena wines are, however, useful and necessary for blending.

One type of soil—that of chalk zones—monopolizes any
discussion of good Jerez ground. One grape—the Palomino—
dominates any discussion of the best sherry vines. The Palo-
mino is *the* grape of Jerez, accounting for more than 80 per-
cent of all wine grown there. It thrives in the intense heat: in
the glare of the harvest sun the ripe Palominos hang in long,
fat, pale-brown bunches. Not only does the Palomino create
superb wine; it makes excellent eating as well. This double
bounty for the citizen of Jerez is hardly pleasing to the owners
of the vineyards; there is a running battle to ward off grape
snatchers.

Once harvested, the Palominos and the other sherry wine
grapes are laid on round grass mats to dry slightly in the sun.
This step, evaporating some of the water from the very ripe
clusters, results, after pressing, in an alcoholic and stable
wine, the sort of raw material demanded by the lengthy, rigor-

379

ous blending and aging process that sherry undergoes. In the press house, men wearing boots with cleats pounded diagonally into the soles "tread out" the grapes piled in the wooden trough. When the last juice, or *mosto*, is squeezed from the resulting pulp, either by a traditional straw press or by a modern mechanical one, and stored in 150-gallon butts, the sherry begins to ferment. For the first few days the wine seethes violently. Then the fermentation quiets down, continuing for several weeks. In December or January the wine is racked, that is, it is carefully poured off the sediment in the bottom of the cask and transferred to a clean cask (in effect, a large-scale decanting). At this point not even the most experienced winemaker in the sherry wineries, or *bodegas*, as they are called, can say what sort of sherry the new wine will be. It is in the fresh barrels that the mysterious process begins whereby the different styles—the Fino ("fine") and the Oloroso ("fragrant")—of the wine develop.

The mysterious agent at work here is a yeastlike fungus, *Mycoderma vini*, which grows on the surface of the wine. The casks or butts are filled only to a point below the bung, so that air can come into contact with the wine, encouraging the yeast to grow. Thus sherry is one of the few wines for whose proper production air is an absolute necessity and not an absolute detriment. The Spanish term for this special yeast is *flor* ("flower"); for all its poetic name, the growth more resembles the whitish scum that forms on stagnant water. The *flor* is thickest on wines destined for the Fino label, and develops a thinner film on the wines that will be of the Oloroso type. As it flourishes on top of the wine, the *flor* subtly flavors the sherry beneath it.

When the *flor* has done its work, the fungus dies and the film sinks to the bottom of the sherry butt. The wine can then be racked again, graded for quality, and fortified with a dose of brandy distilled from the inferior grades of sherry. Finos take on only a small amount of brandy, Olorosos a little more. Newly fortified, the different types of sherry that have resulted from the uneven action of the yeast age for a year or more in sections of the *bodegas* called *criaderas* ("nurseries"). Once the wines reach what might be termed their adolescence, they are fit to mingle with their older relations as part of the *solera* system, the ingenious method of blending developed by the winemakers of Jerez. The Palomino grape and the *albariza* soil are crucial for the wine before it reaches the *bodegas*, where nature continues her capricious hold on the sherry through

MANNERS AND CVSTOMS OF Yᵉ ENGLYSHE·IN·1849· Nᵒ.

Yᵉ WYNE·AVLTS·AT Yᵉ·DOCKS SHOWYNGE A PARTYE TASTYNGE·

the little-understood action of the *flor.* But it is in the blending of the *solera* that nature yields to the hand of man.

The *solera* as a whole is a rank of four or five casks perched one on top of another. The word, derived from the Latin *solum* (floor), refers to the bottom barrel of wine, the one on the floor, from which the mature sherry is drawn. The uppermost barrel holds the youngest wines, those straight from the *criaderas.* The one below it contains older wine, the next lower one a blend of wine that is older still. In the bottom barrel is the oldest and most mature wine, the wine that will find its way into a shipper's blend. As the cellar master draws off some of this wine from the bottom cask, the butt is refilled with some of the younger wine from the barrel above. This cask likewise is refreshed with sherry from the one above it, and so forth. When the top barrel needs refilling, the replacement wine comes from the *criaderas.* The magic of the *solera* is that it produces a very consistent wine. The first and oldest wine in the floor-level cask is refilled from the next oldest cask, and it defines the style of all the wines that will emerge from a particular *solera.* Throughout the life of a *solera,* no cask is ever completely emptied. Enough wine must remain at each level to keep the taste constant. Certainly little if any of the original wine remains in the bottom barrel after years of refilling, but the wine in that barrel carries on the family line, with the power to mold the character of the younger sherry that is periodically blended with it.

The *solera* system precludes the classification of sherry wine by vintage years, but dates are sometimes to be seen on fine sherries. Such dates as 1850, 1879, 1906 indicate when the first wine went into the bottom barrel, and sherry bearing a *solera* date should come exclusively from that one series of casks. The *solera* date is a very far cry from the vintage date, for, as we have seen, after a hundred or more years virtually none of the wine from the year indicated would be found in the cask or bottle. But the *solera* date has its own significance: an old *solera* sherry will have more complexity and finesse than any recent blend could ever hope to muster.

Dated solera sherries are the exception rather than the rule in the *bodegas* of Jerez. Most of the production of a sherry firm is wine chosen from several of its stacks of barrels, then blended into one of the many sorts of sherry the firm offers. Among the important houses are Diez Hermanos, Williams & Humbert, Harvey, Pedro Domecq, Wisdom & Warter, Duff Gordon, Gonzalez Byass, Sandeman, Terry, Garvey, Cano,

and Rivero. Each of these concerns makes a selection of sherries ranging from very dry to very sweet.

As has been said, sherries develop into two main types—Fino and Oloroso. The driest sherries are those called Fino. They are generally considered to be the best and the most elegant. They grow only in the white chalk soil, show the maximum growth of the *flor*, and need but a little brandy for fortifying. Finos are the liveliest and freshest of all sherries, bone-dry and intriguingly non-grapy. The Jerezanos, who know Fino at its best, buy the wine in half bottles, chill it, and finish it when it is first opened; to recork and drink the wine another day would be to miss much of the Fino's freshness. No serious wine expert could complete his list of the great wines of the world without including the Fino of Jerez.

A Fino reared not in Jerez but in Sanlúcar de Barrameda is called a Manzanilla. Though the soils, grapes, and production of the two centers do not differ substantially, a Manzanilla is a Manzanilla and never a Fino *tout pur*. Sanlúcar de Barrameda is a seacoast town. Ocean breezes blowing through the vineyards and the *bodegas* give Manzanillas their special bitter aftertaste. Manzanillas are usually the palest and driest of all sherries, even drier than the Finos from Jerez itself. But though the wine in a bottle labeled "Manzanilla" is almost certain to be dry, sweeter versions of the wine can be found.

Amontillado comes darker, stronger, and richer than either Manzanilla or Fino. When the magical *flor* growing on the surface of the young sherry turns brown, cellar masters know that this wine is destined to become an Amontillado.

The Olorosos are the sherries with the most body and substance. Quite the opposite of the delicate, racy Fino, the Oloroso has a distinct fatness and pungent power that linger long on the palate. Sherries destined to be Olorosos are those least affected by the *flor*. They retain much of the natural warmth and richness of the Palomino grape as it grows in the hot climate of southern Spain. A century ago, before the light Fino sherries became popular, Olorosos dominated the sherry market. They are not so common today, except in their sweetened form.

Sweetened Olorosos are developed into the dark Amoroso and Cream Sherries. Vintners add very strong, very sweet wine made from the Pedro Ximénez grape to make both Amorosos and Cream Sherries, using an especially dark wine to color the Amoroso.

SPANISH COUNTRY WINES

Sherry has a not-too-distant cousin in the wine of Montilla and Los Moriles. Grown just southeast of Córdoba in southern Spain, these wines often made their way to Jerez to become "sherry," but Montilla–Los Moriles now has its own appellation and sells its wine under its own name. The best are light, dry, elegant Fino wines (usually not fortified because of their naturally high alcohol content), quite like sherry itself, with excellent character and breeding. The chalky soils, the Palomino grapes, the *flor*, and the *solera* system all contribute, as they do in Jerez, to the high quality of the wine.

The region of Catalonia produces many different sorts of wine, good and bad. Dessert and fortified wines are some of the most famous, though they are seldom found outside Spain. Tarragona is probably the best-known; it was once made in conscious imitation of port. Tarragona has gone the way of another sweet Spanish wine, Malaga. Malaga, from the Costa del Sol, enjoyed a wide popularity in England a century ago under the name "Mountain." Today's wine enthusiasts have little taste for such rich, sweet, but inelegant wine. Among the heavy, sweet dessert wines, only port, Madeira, and a few others that have real finesse still flourish.

Priorato, Alella, and Panadés are Catalan table wines worth mentioning. Their names generally apply to both red and white wines. The reds are much more vigorous and earthy than Rioja wines, though their strength is not always one that softens after a few extra years in bottle. These Catalan wines, indeed most of the red country wines of Spain, tend to fade after only a few years in bottle. They should be drunk young, when they are at their heady, assertive best. In the case of Panadés, the white wine is superior to the red.

The plains of central Spain mostly supply the anonymous *corriente* wines, of which only a few are noteworthy. Toro and Rueda, growing in the vineyards of the northwest, near the Portuguese border, can be pleasantly long-lived and tannic, like Riojas, but without their delicacy. Some Spaniards claim the Toro wine got its name because it is as strong as a bull. In Castille, one remarkable vineyard and winery, Vega Sicilia, makes some of the best table wines in Spain. Exclusively red, and named for the grape varieties from which they are made, Vega Sicilia wines deserve to be better known in other parts of Spain, and abroad as well.

A colorful Spanish meal—gazpacho and paella with golden sherry and red Rioja—contrasts with the dull grayish-brown landscape

© Arnold Newman

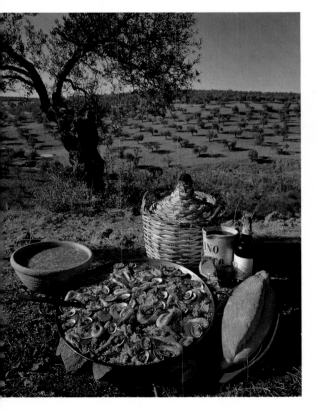

383

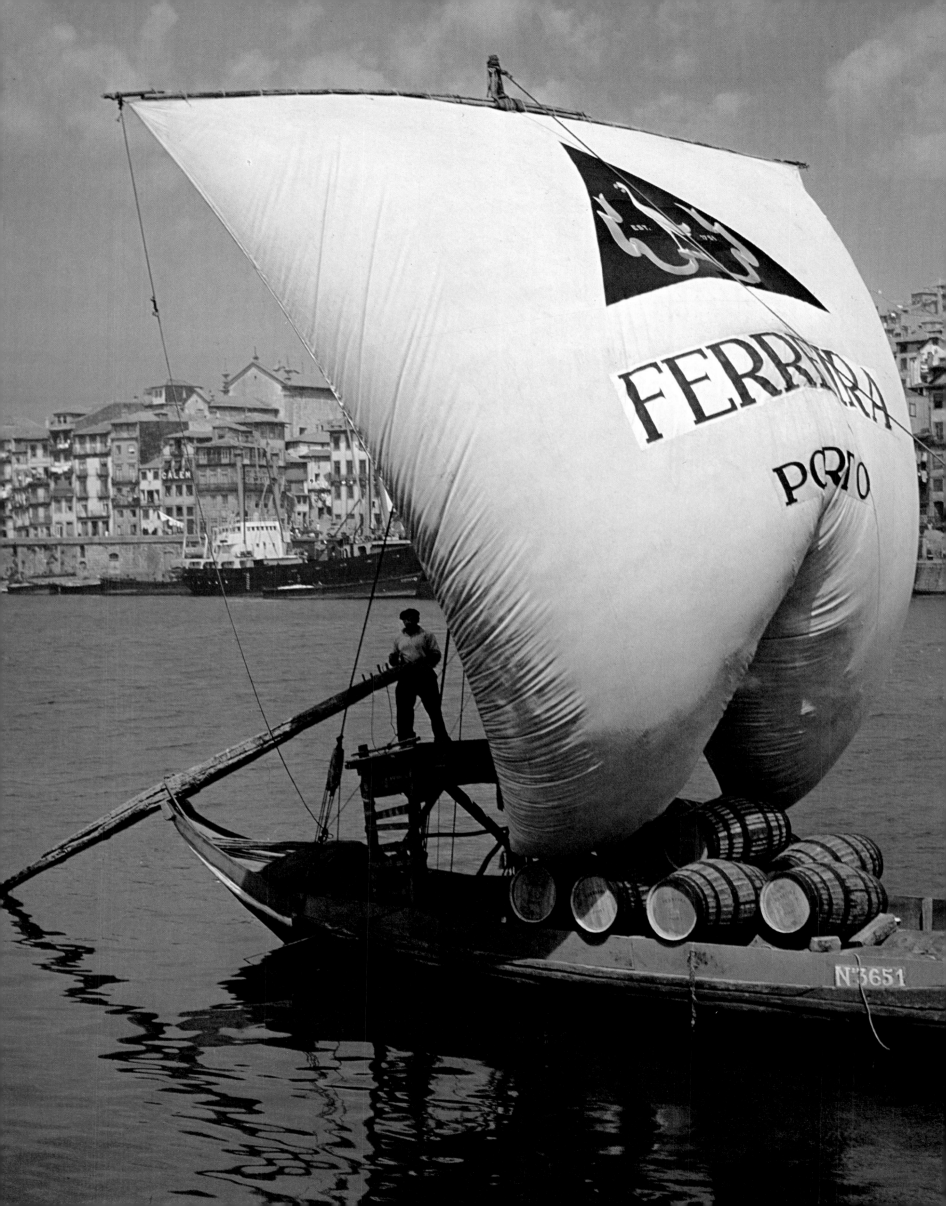

THE WINES OF PORTUGAL

For many generations of English-speaking wine drinkers, Portugal meant port, the incomparable dessert wine grown on the terraced rock slopes of the river Douro in the wild northeast of the country. For many of today's young wine drinkers, Portugal means not port but another wine from farther down the Douro: the vastly popular Mateus Rosé. While the various styles of port remain the finest and most famous wines of Portugal, the light, fresh, easy-to-enjoy table wines epitomized by Mateus and Vinhos Verdes are now exported in greater quantities than port ever was.

Whether one chooses the noble port or the simple, satisfying table wine, the contents of the bottle are governed by the regulations of the exemplary Portuguese wine laws. There are two official organizations legally empowered to work with the wine trade. Each is called a *gremio*. The *gremio* in Oporto is concerned with port, the one in Lisbon with all other wines. The *gremios'* control of the Portuguese wines begins at the individual vineyards. The winegrowing regions have been demarcated into seven areas by law: the Douro (where port comes from), Vinhos Verdes, and Dão in the north; Colares, Bucelas, Carcavelos, and Moscatel de Setúbal in the environs of Lisbon. Wine made in any of these controlled regions must have government approval to leave the vineyard on its way to a shipper, then must be subjected to tasting and laboratory tests, and finally must be registered as part of a firm's inventory—all before the wine may be bottled and sealed with the wine's demarcated name. The day-to-day technicalities of this surveillance are the responsibility of the federations of local winegrowers within each of the seven districts. The Portuguese laws are more stringent than their enforcement, but regulations have done a great deal on the local and national level to improve the quality of the wines and to protect their names

A *barco rabelo,* the narrow sailboat of the Douro River, carries casks of new port to the warehouses of the shippers near Oporto for blending and aging

from misuse. There have been no known cases of false labeling in Portugal.

TABLE WINES

In the northwest corner of the country is the demarcated region for Vinhos Verdes. These "green wines"—green because the grapes are picked young and the wines drunk young—have a slight natural sparkle owing to the secondary fermentation in the bottle. This characteristic is especially appealing in the white Vinhos Verdes. The red Verde wines seem somewhat less pleasing than the whites: when fresh and young they are tart and prickly rather than light and flowery like a French Beaujolais.

Drink Vinhos Verdes young. The appeal of the wines is in their vivacity and youthful ebullience. Hardly refined or great wines, they are not meant for laying down. Keeping them too long is in fact detrimental, since a typical Vinho Verde can live only a few years. Ideally, they should be enjoyed in the spring sun of Portugal just a few months after the vintage.

Their very short life span makes Vinhos Verdes unlikely candidates for massive exportation. Another wine from northern Portugal, Dão, needs bottle aging and thus is exported in greater quantities than the green wines. While the important Vinhos Verdes are white wines, the best Dãos are reds (though white ones can be very good). Dão country is a patchwork of granite hills and pine forest whose viticulture includes both vines planted in conventional rows and vines jumbled amid other low-growing plants. These red wines are a blend of a number of different grape varieties. They are strong and rather high in alcohol, resembling the Rhône wines of France or some of the bigger Riojas from Spain. With time, red Dãos develop a good bouquet, but with more than ten years of bottle age they tend to fade.

Several interesting wines are produced within a thirty-mile radius of Lisbon: Colares, Bucelas, Carcavelos, and Moscatel de Setúbal. Colares is probably the best Portuguese red wine, unmistakably full and spicy. It has a definite tang of the sea, since the Atlantic lashes at the rocky shore below many of the vineyards. Colares has a long and famous history in Portugal and in England, but the future of the wine does not look bright. For one thing, resort developments have crowded out many of the vines. Moreover, the replanting and maintenance of the vineyards themselves present real problems.

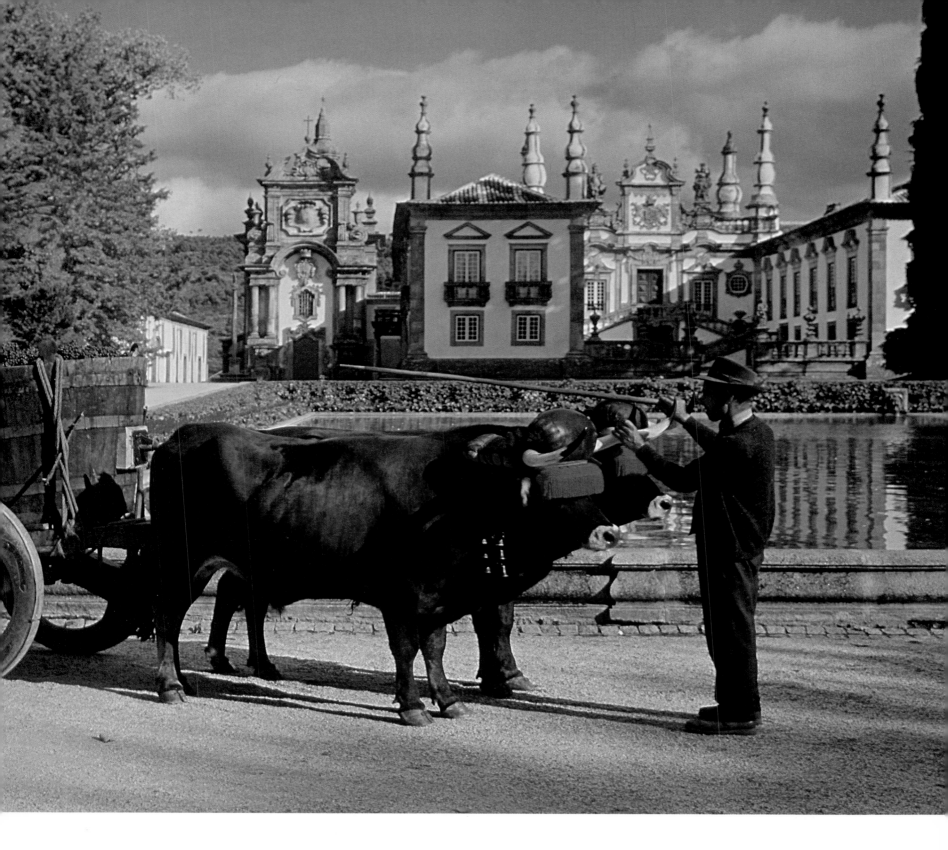

The Douro, famous for port, also produces a well-known table wine—Mateus Rosé—at Vila Real

Both the Bucelas and the Carcavelos vineyards are threatened by the steady growth of Lisbon. Today little of either wine is made. Bucelas is a light, dry white wine, completely unlike the sweet fortified wine of the same name that was a favorite in England 150 years ago. In its present form, Bucelas is a wine for early drinking. Bottle aging only harms it. Carcavelos remains the fortified and sweet wine that was popular in England even before Bucelas. The Portuguese drink the rich, topaz-colored wine both before and after meals.

Across the Tagus River from Lisbon are the vineyards that produce the remarkably scented Muscat wine called Moscatel de Setúbal. There are two distinct vineyard districts, with

differing climates, but the grapes grown in both are often blended into one wine. Setúbal, pleasantly amber-colored, is known for its wide range of aftertastes. During the vinification, brandy is added to keep the wine sweet, then fresh muscat grape skins are steeped in the wine to impart more flavor. With enough age, the wine is quite good.

PORT

The contrast between the fine Georgian dining rooms in which port is often served and the part of Portugal in which it is grown could not be greater. Few vineyard regions of the world are as desolate and unwelcoming as the banks of the upper Douro. Long ago the landscape showed only hills of granite rock. Ages have crumbled it into schist, and hardy plants, the vine among them, have helped create a thin layer of arable soil. As it is, the vineyards are terraced up the steep slopes of the hills, the poor earth held back by retaining walls fashioned from the omnipresent granite. Several vines grow here. Touriga, Mourisco, and Bastardo make up the bulk of the plantings. In addition, a family of vines called Tintas is grown because their grapes give extra color to the wines.

Vintage time along the upper Douro presents one of the few chances for celebration in the bleak lives of the Portuguese *vignerons*. Their brief merriment is certainly deserved, for the work of picking the grapes and making the wine is back-breaking. High in the hills harvesters heap the fruit in tall wicker baskets, carrying them on their backs down the ranks of steep steps to the houses and sheds where the treading begins. When the grapes are dumped into the great stone troughs called *lagares,* five or six men jump in, link arms, and commence to crush the fruit. This colorful method for bringing a wine into the world is fast disappearing. Mechanical crushers can now do the work quicker and cheaper than the local men. But when the grapes are crushed and the fermentation has begun, the method of making port has changed little over the centuries. As the seething must achieves the proper degree of alcohol, the new wine is run off into barrels containing enough brandy to stop the fermentation. Any unfermented sugar remains in the wine, making port sweet.

This raw wine, newly fortified, rests in the stores of the *quintas,* or estates (a *quinta* may be either a large property owned by one of the major port firms or a tiny farm with only a few buildings), until spring, when it travels to Oporto and the

At a small, remote *quinta* in the Douro Valley a team of treaders has been crushing grapes. At day's end they wash their red-stained legs and feet

warehouses of the port shippers. For years this trip down the Douro was made by boats called *rabelos.* Only these long, graceful craft with beautiful high sails could negotiate the rocks and the rapids encountered on the journey to the ocean. Today the wine more often moves by rail or road. The end of the journey is in fact not the town of Oporto, the prosperous port on the Atlantic from which port wine took its name, but a suburb, Vila Nova de Gaia, just across the Douro. In Vila Nova de Gaia are the large cellars and warehouses, called lodges, where expert winemakers blend and age the wines to suit the style of the individual firms. There are five basic types of port: Vintage, Crusted, Tawny, Ruby, and White.

Vintage Port, the best of them, is made, as the name suggests, from grapes grown in one specific year. The wine is a blend of different wines from different *quintas,* but it is all wine from one year, that indicated on the bottle. Once blended in the fashion of its particular house, the port spends two years in wooden casks. Curiously, many Vintage Ports are bottled not in Portugal but in London, long the most important city outside Portugal in the port wine trade. Once in glass, the vintage wines begin a lengthy period of slow maturation, traditionally twenty years. The wine throws a considerable deposit as it develops. Unlike other wines', port's sediment does not fall to the bottom of the bottle but clings to its sides. This is the veil-like "crust" which must be carefully considered when the wine is to be drunk. Decanting, an absolute necessity, must be deftly carried out to ensure that none of the crust breaks and clouds the wine. Once decanted, the port should be consumed at one sitting. Like any other fine old wine, Vintage Port will not keep after prolonged exposure to the air.

Crusted Port is like Vintage Port—elegant, deep, rich—except that it is a blend of wine from several vintages. Crusted Port, whose name refers to its characteristic sediment, matures in glass bottles, as does Vintage Port. Though its age cannot be exactly calculated, Crusted Port is a very fine wine.

Tawny Port matures in casks, not in bottles. The interaction of wood, wine, and air softens its taste and removes its purple robe. Tawny is lighter than Vintage Port, and it does not need to be handled with so much reverential care.

Ruby Port is common port: forthrightly red, rich, and sweet. Though offering none of the finesse or range of a Vintage, Crusted, or even a Tawny, Ruby Port is a pleasant enough drink at a much lower price. S.A.

389

AN AGED WINE

GEORGE MEREDITH

George Meredith (1828–1909) is little read today and less admired. Now, however, that the Victorians are all being sympathetically reexamined, the mannered author of The Egoist *and the fine poet of* Modern Love *may soon have his turn. As for this famous passage, drawn from* The Egoist, *one is of two minds about the great Dr. Middleton, father of the book's heroine. Is he cast in the heroic mold of Dr. Johnson—or is he a windy bore? In either case, he offers some splendiferous language to describe port, the wine we have just been reading about in Sam Aaron's more businesslike phrases.* *C. F.*

Sir Willoughby advanced, appearing in a cordial mood.

"I need not ask you whether you are better," he said to Clara, . . . and raised a key to the level of Dr. Middleton's breast, remarking: "I am going down to my inner cellar."

"An inner cellar!" exclaimed the doctor.

"Sacred from the butler. It is interdicted to Stoneman. Shall I offer myself as guide to you? My cellars are worth a visit."

"Cellars are not catacombs. They are, if rightly constructed, rightly considered, cloisters, where the bottle meditates on joys to bestow, not on dust misused! Have you anything great?"

"A wine aged ninety."

"Is it associated with your pedigree that you pronounce the age with such assurance?"

"My grandfather inherited it."

"Your grandfather, Sir Willoughby, had meritorious offspring, not to speak of generous progenitors. What would have happened had it fallen into the female line! I shall be glad to accompany you. Port? Hermitage?"

"Port."

"Ah! We are in England!"

"There will just be time," said Sir Willoughby, inducing Dr. Middleton to step out.

A chirrup was in the reverend doctor's tone: "Hocks, too, have compassed age. I have tasted senior Hocks. Their flavors are as a brook of many voices; they have depth also. Senatorial Port! we say. We cannot say that of any other wine. Port is deep-sea deep. It is in its flavor deep; mark the difference. It is like a classic tragedy, organic in conception. An ancient Her-

390

mitage has the light of the antique; the merit that it can grow to an extreme old age; a merit. Neither of Hermitage nor of Hock can you say that it is the blood of those long years, retaining the strength of youth with the wisdom of age. To port for that! Port is our noblest legacy! Observe, I do not compare the wines; I distinguish the qualities. Let them live together for our enrichment; they are not rivals like the Idaean Three. Were they rivals, a fourth would challenge them. Burgundy has great genius. It does wonders within its period; it does all except to keep up in the race; it is short-lived. An aged Burgundy runs with a beardless Port. I cherish the fancy that Port speaks the sentences of wisdom, Burgundy sings the inspired Ode. Or put it, that Port is the Homeric hexameter, Burgundy the Pindaric dithyramb. What do you say?"

"The comparison is excellent, sir."

"The distinction, you would remark. Pindar astounds. But his elder brings us the more sustaining cup. One is a fountain of prodigious ascent. One is the unsounded purple sea of marching billows."

"A very fine distinction."

"I conceive you to be now commending the similes. They pertain to the time of the first critics of those poets. Touch the Greeks, and you can nothing new; all has been said: *Graiis . . . praeter, laudem nullius avaris.* Genius dedicated to Fame is immortal. We, sir, dedicate genius to the cloacaline floods. We do not address the unforgetting gods, but the popular stomach."

Sir Willoughby was patient. He was about as accordantly coupled with Dr. Middleton in discourse as a drum duetting with a bass-viol; and when he struck in he received correction from the pedagogue instrument. If he thumped affirmative or negative, he was wrong. However, he knew scholars to be an unmannered species; and the doctor's learnedness would be a subject to dilate on.

In the cellar, it was the turn for the drum. Dr. Middleton was tongue-tied there. Sir Willoughby gave the history of his wine in heads of chapters; whence it came to the family originally, and how it had come down to him in the quantity to be seen. "Curiously, my grandfather, who inherited it, was a water-drinker. My father died early."

"Indeed! Dear me!" the doctor ejaculated in astonishment and condolence. The former glanced at the contrariety of man, the latter embraced his melancholy destiny.

He was impressed with respect for the family. This cool vaulted cellar, and the central square block, or enceinte, where the thick darkness was not penetrated by the intruding lamp, but rather took it as an eye, bore witness to forethoughtful practical solidity in the man who had built the house on such foundations. A house having a great wine stored below lives in our imaginations as a joyful house, fast and splendidly rooted in the soil. And imagination has a place for the heir of the house. His grandfather a water-drinker, his father dying early, present circumstances to us arguing predestination to an illustrious heirship and career. Dr. Middleton's musings were colored by the friendly vision of glasses of the great wine; his mind was festive; it pleased him and he chose to indulge in his whimsical, robustious, grandiose-airy style of thinking; from which the festive mind will sometimes take a certain print that we cannot obliterate imme-

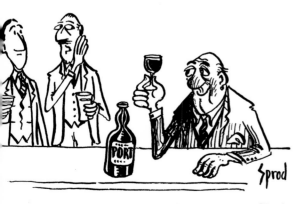

"It's his oldest ally."

diately. Expectation is grateful, you know; in the mood of gratitude we are waxen. And he was a self-humoring gentleman.

He liked Sir Willoughby's tone in ordering the servant at his heels to take up "those two bottles": it prescribed, without overdoing it, a proper amount of caution, and it named an agreeable number.

Watching the man's hand keenly, he said: "But here is the misfortune of a thing super-excellent: not more than one in twenty will do it justice."

Sir Willoughby replied: "Very true, sir; and I think we may pass over the nineteen."

"Women, for example; and most men."

"This wine would be a sealed book to them."

"I believe it would. It would be a grievous waste."

"Vernon is a claret man; and so is Horace De Craye. They are both below the mark of this wine. They will join the ladies. Perhaps you and I, sir, might remain together."

"With the utmost good-will on my part."

"I am anxious for your verdict, sir."

"You shall have it, sir, and not out of harmony with the chorus preceding me, I can predict. Cool, not frigid." Dr. Middleton summed the attributes of the cellar on quitting it. "North side and south. No musty damp. A pure air. Everything requisite. One might lie down one's self and keep sweet here."

Of all our venerable British of the two Isles professing a suckling attachment to an ancient port wine, lawyer, doctor, squire, rosy admiral, city merchant, the classic scholar is he whose blood is most nuptial to the webbed bottle. The reason must be, that he is full of the old poets. He has their spirit to sing with, and the best that Time has done on earth to feed it. He may also perceive a resemblance in the wine to the studious mind, which is the obverse of our mortality, and throws off acids and crusty particles in the piling of the years, until it is fulgent by clarity. Port hymns to his conservatism. It is magical: at one sip he is off swimming in the purple flood of the ever-youthful antique.

By comparison, then, the enjoyment of others is brutish; they have not the soul for it; but he is worthy of the wine, as are poets of Beauty. In truth, these should be severally apportioned to them, scholar and poet, as his own good thing. Let it be so.

Meanwhile Dr. Middleton sipped.

After the departure of the ladies, Sir Willoughby had practiced a studied curtness upon Vernon and Horace.

"You drink claret," he remarked to them, passing it round. "Port, I think, Doctor Middleton? The wine before you may serve for a preface. We shall have *your* wine in five minutes."

The claret jug empty, Sir Willoughby offered to send for more. De Craye was languid over the question. Vernon rose from the table.

"We have a bottle of Doctor Middleton's port coming in," Willoughby said to him.

"Mine, you call it?" cried the doctor.

"It's a royal wine, that won't suffer sharing," said Vernon.

"We'll be with you, if you go into the billiard-room, Vernon."

"I shall hurry my drinking of good wine for no man," said the doctor.

"Horace?"

"I'm beneath it, ephemeral, Willoughby. I am going to the ladies."

Vernon and De Craye retired upon the arrival of the wine; and Dr. Middleton sipped. He sipped and looked at the owner of it.

"Some thirty dozen?" he said.

"Fifty."

The doctor nodded humbly.

"I shall remember, sir," his host addressed him, "whenever I have the honor of entertaining you, I am cellarer of that wine."

The reverend doctor set down his glass. "You have, sir, in some sense, an enviable post. It is a responsible one, if that be a blessing. On you it devolves to retard the day of the last dozen."

"Your opinion of the wine is favorable, sir?"

"I will say this—shallow souls run to rhapsody—I will say that I am consoled for not having lived ninety years back, or at any period but the present, by this one glass of your ancestral wine."

"I am careful of it," Sir Willoughby said, modestly; "still its natural destination is to those who can appreciate it. You do, sir."

"Still my good friend, still! It is a charge; it is a possession, but part in trusteeship. Though we cannot declare it an entailed estate, our consciences are in some sort pledged that it shall be a succession not too considerably diminished."

"You will not object to drink it, sir, to the health of your grandchildren. And may you live to toast them in it on their marriage day!"

"You color the idea of a prolonged existence in seductive hues. Ha! It is a wine for Tithonus. This wine would speed him to the rosy morning—aha!"

"I will undertake to sit you through it up to morning," said Sir Willoughby, innocent of the Bacchic nuptiality of the allusion.

Dr. Middleton eyed the decanter. There is a grief in gladness, for a premonition of our mortal state. The amount of wine in the decanter did not promise to sustain the starry roof of night and greet the dawn. "Old wine, my friend, denies us the full bottle!"

"Another bottle is to follow."

"No!"

"It is ordered."

"I protest."

"It is uncorked."

"I entreat."

"It is decanted."

"I submit. But, mark, it must be honest partnership. You are my worthy host, sir, on that stipulation. Note the superiority of wine over Venus! I may say, the magnanimity of wine; our jealousy turns on him that will not share! But the corks, Willoughby. The corks excite my amazement."

"The corking is examined at regular intervals. I remember the occurrence in my father's time. I have seen to it once."

"It must be perilous as an operation for tracheotomy, which I should assume it to resemble in surgical skill and firmness of hand, not to mention the imminent gasp of the patient."

A fresh decanter was placed before the doctor.

He said: "I have but a girl to give!" He was melted.

MADEIRA

For those of us with a sense of history (and who has not some emotional attachment to past glories?) a glass of gleaming, tawny Madeira is an eloquent reminder of times gone by. It can conjure up a vision of great wine-laden sailing ships on the long voyage from Africa to Boston, or of an elegant Georgian drawing room with polished floors and stately highboys.

Madeira is the wine that was drunk throughout colonial America, on Boston's Beacon Hill, in mansions on the James River, in the homes of Southern planters. It was the most acceptable wine that might be offered guests as an aperitif, through the meal, and after the meal. It was an all-purpose wine, and a decanter of it always stood on the buffet. Madeira also presided in the kitchen, where it was used in many dishes, especially those indigenous favorites turtle soup and terrapin stew, in which the Madeira was as indispensable as the turtle itself.

A tantalizing question is why this special wine, produced only on a semitropical island off the northwest coast of Africa, exotic in flavor and sometimes powerfully sweet, should have dominated the wine-drinking habits of Americans for two centuries.

The compelling reason was money. Madeira was a bargain. Shipping and importing in colonial days were controlled by the British Crown, and by royal decree all European products imported to the colonies had to be shipped by way of England and carried in English merchant ships. The wines of Madeira were a notable exception. American sailing vessels out of Boston, New York, Baltimore, and Savannah all found the pleasant island of Madeira a refreshing stop en route to Europe and Africa, and on their return trips they would bring goodly supplies of the wines.

Most likely the first Madeira wines were simple red table wines. But such wines did not travel well. By the early eighteenth century, some ingenious shipper of Madeira hit upon the idea of adding a good jolt of brandy to each cask to give the wine the strength to withstand a long overseas trip.

Soon it became apparent that Madeira wines turned out best when they went on long voyages into tropical regions. The mixture of brandy and wine seemed to blend together more smoothly and the resulting drink had a mellow quality most pleasing to the palate. For a time, fine Madeiras were

Against the blue of Funchal Bay, an array of Madeiras, bottled for export to the United States

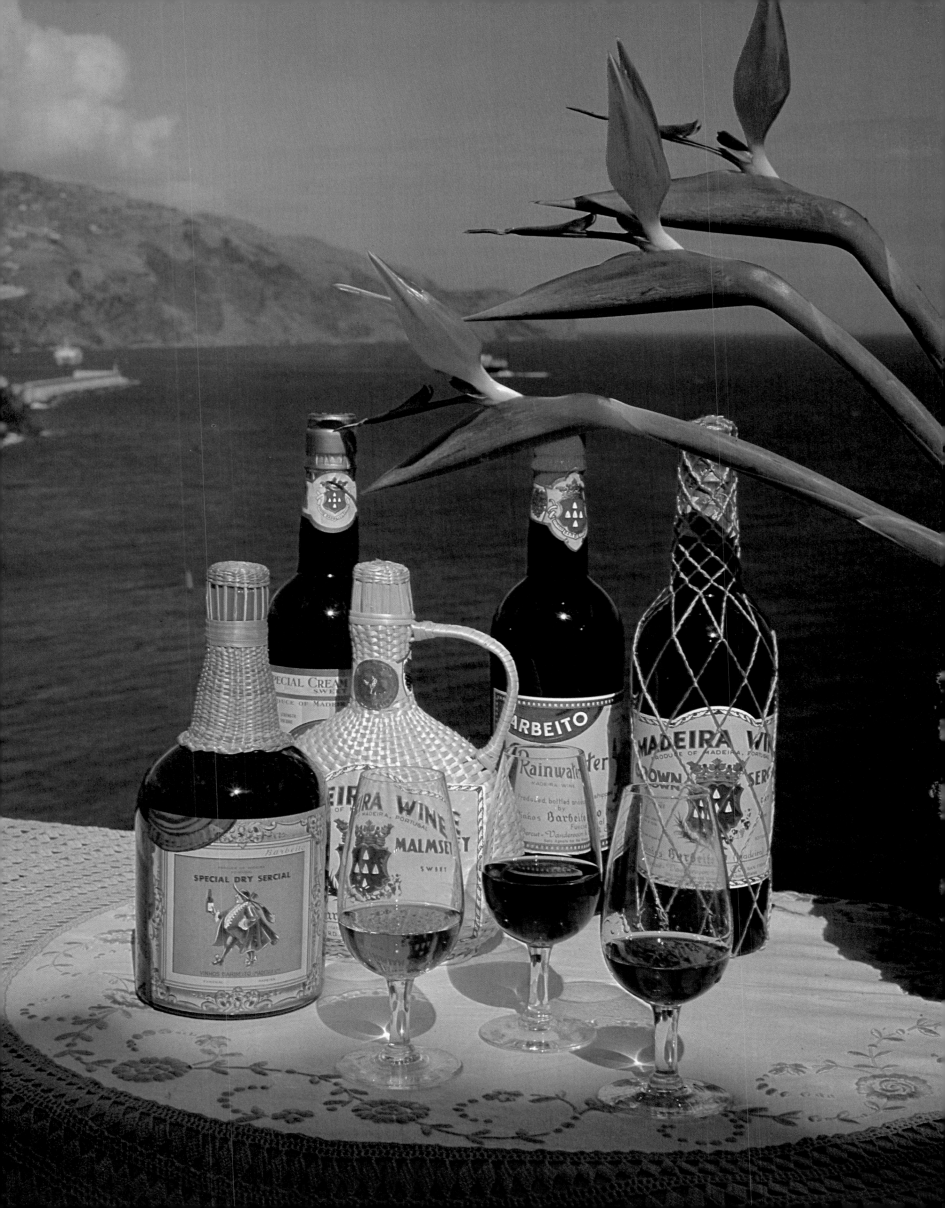

deliberately shipped on ocean trips to China or India and back again to mature the wines. But a less costly and less precarious method was needed, and in order to duplicate the effects of a voyage in a hot climate, some Madeira shippers took to exposing casks of their wines to the sun, letting them mellow for weeks or even months. By 1800 many of the leading wine merchants of Madeira had built *estufas*—special rooms in which the wines could be brought to a high temperature slowly and then slowly cooled.

At the same time Americans were experimenting with their favorite wine. At least one importer, subscribing to the theory that the rolling and rocking of the ships improved the wine, suspended his casks of Madeira in the entry to his offices. Each customer was expected to give the cask a push as he came in. Presumably the better the business the more the Madeira rocked and mellowed.

In Savannah, a wine merchant and great connoisseur, one William Hebersham, became famous for his Rainwater Madeira. It was light and very dry—an elegant aperitif. There has been much argument about the origin of the term "Rainwater." It may have come from the American practice of storing casks in housetop cisterns.

When Repeal came in 1933, the new generation knew nothing of the charms of Madeira or, for that matter, of any other wines. Madeira wines were only a faint memory of a leisurely past. Today, at last, we seem to be recapturing some of the gracious living of our past, and we are rediscovering Madeira.

What of the Madeiras we drink today? Are they the equals of the wine of the past century? Have there been changes?

If there are changes, I feel sure they are for the better. There were, we know, great Madeiras a century and a century and a half ago. There are great Madeiras today, and more predictably so. The modern shippers have the advantage of many years of experimenting to perfect the product. When brandy was first added to the wine, it was done in a haphazard fashion. Today's shipper knows just how much brandy to add, just when to add it, and how long to age the wine to get the right results.

Madeiras still come in every type, from dry to sweet, from golden to brown, from light to rich. But today they are known by grape variety; the name of the grape on the bottle tells us what to expect when we pull the cork.

"They certainly seemed to like that Madeira Cake."

First, there is Sercial. This is a light, dry wine suitable for an aperitif, for the soup course, and, as many Madeira lovers will tell you, for drinking straight through the meal. Dry as it is, the taste is only slightly acid. It is smooth and tender on the tongue, with a refreshing aftertaste. Sercial is the palest in color—a light gold, but the term "pale" is misleading, for it has brightness, or sheen. The Sercial grape is related to the Riesling of Alsace and Germany, but on the semitropical island of Madeira it takes on new characteristics. Grown high on the terraced hillsides, it holds a hint of tangy mountain air.

Next is Verdelho, not so dry as Sercial, but definitely not sweet. There is a little less tang, a little more softness, and a warm amber color. Verdelho, too, can be the constant companion, the drink with hors d'oeuvres, with soup, with a bit of sweet. This grape is related to the Pedro Ximénez of Spain, but, like the Sercial grape, when grown on this island it develops a special quality.

Bual, the third type of Madeira, is a medium-sweet wine with a richer, deeper amber color. Wine authorities have often waxed eloquent on the subject of Bual. It is admired for its delicate balance, its pungent bouquet. It is full-bodied without being overpowering.

Malmsey, the richest Madeira, carries a name that goes back farther than the history of the island. The first Malmsey probably came from the island of Cyprus. It was a sweet, heavy wine much in demand in the fourteenth and fifteenth centuries. When Portuguese settlers arrived on Madeira, they planted the Malvoisie grape, from which Malmsey is made. This has always been an expensive and scarce wine.

©Punch

The wine is rich and round, with a heady perfume and a deep brown color. It is sweet, yes, but the sweetness is backed by firm authority, by a quality of depth. Malmsey fans will not drink their wine with a rich dessert; they maintain that the subtleties of the wine are submerged by competing flavors. For them, the only suitable accompaniments are nuts or simple biscuits.

All wines, of course, hold in each sip the essence of the land from which they come: its soil, its contours, its sunlight, and its rain. But visitors to Madeira insist that its wines capture even more: the varied moods of the island and its people. Like them, Madeira has a gaiety and warmth—but dignity and a certain reserve too. S.A.

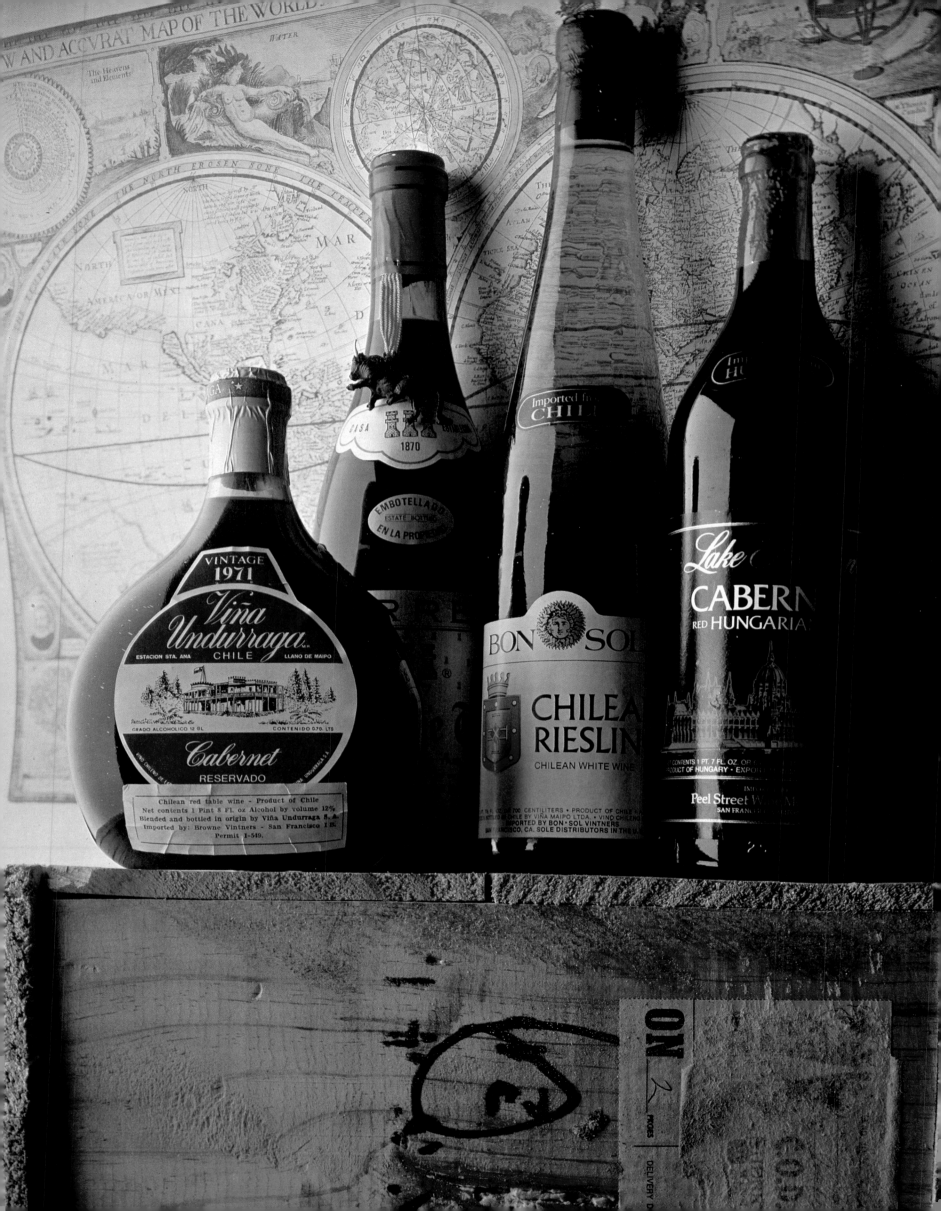

AUSTRIA

Vienna's fabled gaiety would not be complete without wine. Luckily for the Viennese, they have never had to go far to find it. Good light wines grow close by the capital, at Nussdorf and Grinzing. The best time to drink these and the many other Austrian wines is in spring and summer, when the *Heurige,* or new wine, is ready.

Just as Beaujolais nouveau, though the occasion for much festivity in Lyons and Paris, is scarcely considered France's greatest wine, the *heurigen* wines are not Austria's best. The finest Austrian wines grow not far from Vienna. Gumpoldskirchner and Vöslauer are the two most widely known. At its best, Gumpoldskirchner is a pleasantly fruity and sweetish wine reminiscent of a simple German white; the Vöslauer is a light red wine made from several grape varieties, including the local strain of the Pinot Noir. But, as in Germany, white wines seem to be more successful, and for most people the Vöslauer is something of an acquired taste.

Some forty miles west of Vienna is the picturesque Wachau district, where the vines grow along the banks of the Danube. The wines here are delicate and almost flowery, a bit less sharp than others from Austria; a dry wine exported in some quantity is called Wachauer Schluck. The important villages, the ones whose names frequently appear on wine labels, are Krems, Dürnstein, Retz, and Loiben.

Riesling, Veltliner, Rotgipfler, Muscat Ottonel, Müller-Thurgau, and Traminer are the most widely planted grapes in Austria, and their names often appear on Austrian wine labels. Other terms appearing on labels are more or less familiar from German wine bottles—*Spätlese* and *Auslese,* indicating wines made from late-picked grapes. Almost without exception the Austrian wines carrying these designations will be a little less rich and complex than their German counterparts, yet they are lovely, fresh, clean, and completely engaging.

LUXEMBOURG

Where the winding Moselle, on its way from France to the great wine lands of Germany, touches Luxembourg's eastern border, the little Grand Duchy is blessed with a narrow strip of vineyards. Luxembourg white wines are less like the V.D.Q.S. Moselle wines of France or the famed Moselles of Germany than they are like the light, crisp wines of Alsace.

The Riesling, Riesling-Sylvaner, Auxerrois, and Elbling are the most common vines growing along the 25-mile stretch of river, but only the Riesling, Traminer, Rülander, and Auxerrois grapes are permitted by the government to be used for quality wines. After tasting tests by trained officials, quality wines are further classified. These official tests determine the classification that may appear on the bottle label; the name of the grape variety and of the town of origin are also given.

Luxembourg's best wines are certified by the government for authenticity and quality with the Marque Nationale label on the neck of the bottle. Wines bearing this small label have been stringently tested and bottled under government control, and the few that are seen abroad are of this group. Belgium is the largest importer of Luxembourg's wines, but a small quantity goes to Germany and the Netherlands. These refreshing wines are best drunk cool (48–50 degrees) and not older than three years.

SWITZERLAND

The thought of Switzerland conjures up many things, but wine is not usually one of them. Yet in Switzerland, as in most European countries, wine is an

Produce of Switzerland — White Swiss Table Wine
Alcohol by volume 11%, Contents 1 Pint 8 Fl. oz.
Imported by: Crosse & Blackwell Vintage Cellars,
Div. of The Nestlé Company, Inc., New York, N.Y.

important part of the daily diet. Indeed, to meet the growing demand, the Swiss buy such great quantities from their neighbors that they are the world's biggest importers of wine.

Many Swiss wines, including Neuchâtel—the best-known wine of Switzerland—have a slight sparkle, or *pétillance,* caused by a second fermentation that takes place after the wine is in the bottle. The Swiss often refer to this nuance of sprightliness as a "star" in the wine because the rising bubbles, as they form, create starlike rays in the bottom of the glass. The vineyards on the northern shore of Lake Neuchâtel, facing southeast, produce the starry white Neuchâtel. It is a frequent accompaniment of the popular cheese fondue. A red wine made in the same region is called Cortaillod, after the little village on the northern shore of the lake.

The best Swiss wines come from the slopes on the northern shore of Lake Geneva in the canton of Vaud, where the terraced vineyards enjoy favorable southern exposure. The Vaud vineyards divide into three districts: Lavaux, east of Lausanne; La Côte, west of the pretty town; and Chablais, a narrow strip extending southeast from the eastern tip of Lake Geneva. Dézaley

The wines of the world are true ambassadors of good will,
each bearing a message of pleasure from its native land

From the Seagram Company Ltd. Collection

and Saint-Saphorin are two of the best white wines from Lavaux, and these names are often seen on Swiss wine labels; good Dézaley wine is made at the vineyards owned by the city of Lausanne. But none of the Vaud wines —indeed none from Switzerland—can be termed great. Most are simple, refreshingly tart, and clean. They are unfailingly pleasant but it does not require much thought to fathom their charms. The Chablais wines—not to be confused with French Chablis—are similar to the other Vaudois wines but are higher in alcohol.

Farther up the valley of the Rhône, the Valais produces a number of good wines, including the rare bitter "glacier wine." It is transported when young from the valley vineyards to sheds far up in Alpine villages. There in the cold climate fermentation is slow and the resulting wine has a high alcohol content, and a harsh taste.

Among the best white Valais wines is Fendant, named for the grape variety from which it is made. Dôle, light and sometimes a bit acid, is the best red wine the Swiss have to offer in any quantity. And Malvoisie is the sweet dessert wine of this canton. If the Valais vineyards do not succeed in making exceptional wines, they rarely fail to please the eye. The incomparable Alps rise in the background as the layers of terraced vines ascend the slopes facing the sun—certainly one of the most beautiful vineyard vistas anywhere on earth.

CZECHO-SLOVAKIA

Since the Czech people drink more wine than they can produce, hardly any wine from their country is seen abroad. In fact Czechoslovakia has to import wine, mostly from Hungary and Rumania, to meet the domestic demand.

The native wines reflect Czechoslovakia's position in Central Europe: winemaking traditions in the various parts of the country seem to be those carried across the arbitrary national borders from the better-known neighboring wine lands. In Bohemia, north of Prague, the wines have a distinctly German character. In the sections of Moravia bordering on Austria the wines resemble those of that country. East of Bratislava the local wines take on a Hungarian flavor. Finally, there is a little piece of hilly land in the south, on the Hungarian border just across the frontier from the Tokay district, where a good Czechoslovakian Tokay is made that is virtually indistinguishable from the original.

The Bohemian wine district is centered in the town of Melnik. There the grapes are the best German varieties: Sylvaner, Riesling, and Traminer. Though the climate is similar to that of the German Rhineland, the wines are not nearly so rich and fine. White wine predominates, with some reds well made from the Pinot Noir (here called the Burgunder), Portugieser, and Saint-Laurent—all grapes widely used for red wine in Germany.

In Moravia, as in Austria across the border, the small production is nearly all white wine. Slovakia, with the largest number of vineyards in the country, also makes mostly white wines.

HUNGARY

The one wine of Eastern Europe that stands out as its greatest is Hungary's Tokay, or Tokaji. Hungary also makes a host of lesser wines that can be very satisfying and are reasonably priced. They are the best of the wines that come from behind the Iron Curtain.

Half of all Hungarian vineyards lie in the great central plain, the Alföld, which spreads across most of the middle and southern sections of the country. Many of these vineyards grow the Kadarka grape, the most typical red-wine grape in this part of the world. The wine it makes on the great plain is undistinguished, but in another part of Hungary, as we shall see, the results are remarkable. White and dessert wines, too, are made in great quantities, but these are of little interest.

Better white wines come from the shores of Lake Balaton, especially from the district on the north shore. As their country has no seacoast, Balaton, nicknamed "the Hungarian Sea," is especially prized by the Hungarians, who have ringed it with holiday resorts and villas. The combination of southern exposure, decayed volcanic soil, and a climate favorably tempered by the lake water makes the north shore a natural vineyard. The Olasz Rizling (Italian Riesling) gives lovely wine here, light, tart, and fresh. The best of this wine comes from Csopak. The wines made from four Hungarian grapes are the real pride of Balaton, and their labels carry the grape names: the Szürke-barát (Gray Friar), Kéknyelü, Ezerjo, and Furmint make strong, honey-scented, exceptionally aromatic wines that complement the rich and pungent food of Hungary. Badacsonyi Kéknyelü, a greenish-yellow, light flowery wine, is one of the finest. New plantings of Müller-Thurgau in this part of the country have yielded many promising new wines.

Two relatively small vineyards in northwest Hungary also grow fine wine. Somló makes wine from the Riesling and, more especially, the Furmint, grown on 1,000 acres on the slopes of an old volcano surmounted by a castle. At one time the vines were tended by the nuns of a convent founded by Saint Stephen. Depending on its exposure, a Somló vineyard will produce from the same grape a light, pungent table wine or a rich dessert wine. In Sopron, on the Austrian border, red wine grows. The Kékfrankos, a Gamay grape, yields a light and fruity wine best drunk young, almost a Hungarian Beaujolais. Some vintners use the Gamay to make a rich and full-bodied wine, at its best after four to five years of bottle aging.

By far the most famous name in

Hungarian wine is Egri Bikavér. Grown northeast of Budapest, this "bull's blood" wine comes from the vineyards around the handsome baroque town of Eger. It is dark and rich, requiring much bottle aging to show its best qualities. Egri Bikavér has been famous since the sixteenth century, when it is reputed to have so fortified a group of Hungarian heroes that they turned back the Turkish hordes and saved the town of Eger.

Tokay, the queen of Hungarian viniculture, is not only the greatest wine of Eastern Europe but one of the world's greatest. The only authentic Tokay comes from the vineyards of twenty-nine little villages in the delimited district of Tokaj-Hegyalja in the Carpathian foothills of northeast Hungary. The region is dry and drear, the soil volcanic, and since 1908 no wine made outside the district has been admitted to the delimited area. Once the treasure of princes and czars, Tokay is made today under the strict supervision of the Hungarian government.

The name "Tokaji" never appears alone on a label of the authentic wine. It is always either Tokaji Aszu, Tokaji Szamorodni, or, rarest of all, Tokaji Eszencia. Aszu is roughly the equivalent of the German *Auslese,* or "select picking." Tokaji Szamorodni is a table wine made by pressing normally ripe and overripe grapes together, usually in a poor year not good enough to produce an Aszu. The vintage year is important for this wine, since it would be an indication of how sweet or how dry it is. Tokaji Eszencia, the essence of the dried berries (poetically called "the soul of Tokay"), is so rare that it is no longer marketed but is used instead to sweeten Aszus of poorer years.

BULGARIA

Wine has become a big modern industry in Bulgaria, where, under purposeful governmental control, the old traditions of winemaking have been updated. Much wine grows on the vast flat plantations near the Black Sea and the Danube, with machines doing most of the work, including the harvesting. Exports play an important part in the economy of Bulgarian wine: the country is the sixth-largest exporter of wine in the world. The Soviet Union is by far the largest customer, purchasing nearly three-quarters of Bulgaria's production. West Germany is its biggest non-Communist market.

A widely grown local grape variety, the Dimiat, accounts for most of the white wine. In the eastern part of the country, from the Danube south, this vine makes rather pleasant dry wines. These are often blended with various Muscat- or Riesling-type wines. Small amounts of Chardonnay are grown; they make a light, flavorful wine similar to some Chardonnays from California and southern Burgundy.

Red wine comes largely from the Gamza, but the wine this grape produces is probably the least good of the Bulgarian reds. Better is the dark, slow-to-mature Mavrud (Mavroud), which grows throughout most of the vineyards in the southern part of the country. Cabernet Sauvignon is planted in Bulgaria but does not fulfill its potential for excellence; the wine has few of the characteristics that distinguish it in other vineyards, even those of its close neighbors. Bulgaria's Cabernet is often a bit sweet; perhaps this is to the Russian taste.

YUGOSLAVIA

The best wines of Yugoslavia have been known to West Europeans for at least nine centuries. The Crusaders and then merchant traders traversed this rugged countryside on their way from Italy to Greece and the Near East. The wine from one small plot was so well liked by these medieval travelers that they named the vineyard "Jerusalem." The wine that was honored with the name of the Holy City grows in Ljutomer, which is still regarded as

The famed Jerusalem vineyard in Ljutomer

the home of the best wines in the country.

Ljutomer lies in the important vineyard region of Slovenia, northeast of Zagreb. The best grape varieties are Merlot, Cabernet Sauvignon (which makes my favorite red wine—astonishingly low-priced considering its excellence), Pinot Blanc, Traminer, Sipon, Sauvignon, and Italian Riesling, from which the best white wine comes. Light and pleasantly full, the Rajnski Rizling is not unlike many of the better wines from Austria, and can be a wonderful value. The Ranina Radgona estate near the town of Radgona produces the sweet white wine called Tigrovo Mleko ("tiger's milk"), a name rivaling in interest another of the district, Ritoznojcan ("the sweat from Rita's back"). Croatia grows wines near Trieste and in Istria, but they do not seem so good as those from the north. Istrian Cabernet is one of the Yugoslavian wines most widely sold in this country.

From the Republic of Hercegovina in central Yugoslavia comes the flavorful white wine called Žilavka. Long popular in Central Europe, Žilavka has been well received recently in this country.

Much wine comes from the Dalmatian coast, where, in contrast to the practice in the important interior vineyards, small individual growers still tend most of the vines. The old town of Split, with its ruins of the palace of Diocletian, is a center for red wines.

Dubrovnik, now an internationally popular resort, produces both red and white wines. The myriad islands off the coast make especially interesting and distinctive wines, seldom seen abroad. However, Plavac, a dry red wine from Hvar, and Opolo, a rosé from Dalmatia, are to be found in the United States. Prošek is a deep, rich, dessert-type wine that is really too strong to go with any sort of food and is best enjoyed by itself. Less sweet are Dingač and Postup. One of the most intriguing Dalmatian wines, at least in name, is the brownish, bitter Grk.

Grown in the southeast of the country, Serbian wines account for a large proportion of the Yugoslav total, yet they lack the personality that makes many other Yugoslav wines so good. A sparkling wine of fine quality from the Fruška Gora ("fresh hills") is sold widely in this country.

RUMANIA

Winemaking in Rumania dates from the centuries when the country was a province of the Roman Empire. Recently, interest in wine has increased: several of the old vineyard regions have been expanded, and annual production now exceeds 100 million gallons, or about one-third the United States production. State farms and cooperative cellars are at the heart of the reorganized growth of the Rumanian wine industry. Government interest in and management of the wine crop are stronger here than in any other East European country.

The most famous Rumanian wine is Cotnari 5; it is a wonderfully sweet natural dessert wine made in Moldavia, in the north of the country. Modern vineyard and winemaking techniques have not diminished its quality, and the government seems intent on maintaining the high standards of this wine, formerly known as "the Pearl of Moldavia," which has been made at least since Roman days.

The climate of the Rumanian vine-

yards is largely Mediterranean and thus not ideal for making light, subtle table wines. The vineyards of Transylvania have cooler weather and make better white wines.

Just north of Bucharest is the recently expanded vineyard area called Dealul-Mare. Well-known French red-wine grapes such as the Cabernet Sauvignon, Pinot Noir, and Merlot have been planted here. More than any other of the country's vineyards, Dealul-Mare shows the imprint of socialist management: the wines are made in great factories, not unlike those that turn out the mass-produced wines of the Central Valley of California and the Midi of France, and an experimental station and technical school for training winemakers are maintained. Despite the fine quality of the vinestocks, the wines are not at all exceptional. The hot summers and mass-production methods have hindered the development of character.

TURKEY

The Muslim prohibition of the use of alcoholic beverages notwithstanding, Turkey and the other Islamic countries of the eastern Mediterranean and North Africa make considerable quantities of wine. It is thought that the first vineyard was planted somewhere between the Caspian and the Black Sea nearly 10,000 years ago, and Turkey has always been one of the largest grape-growing countries, though most of her grapes were consumed as fruit. By the end of the last century, vintners throughout Turkey were actively fermenting, promoting, and exporting wine. The most important customers were the nations of Western Europe, whose own vineyards had been laid waste by the phylloxera scourge.

With World War I, European importation of Turkish wine came to a virtual halt, and it has remained minimal ever since. Less wine is made in Turkey today than sixty years ago, even though the vineyard area is still

WHITE TABLE WINE PRODUCT OF TURKEY

SUNGURLU Aral

VINTAGE 1970

NET CONTENTS :
1 PT. 6 FL. OZ.
ALCOHOL 11%
BY VOL.

PRODUCED AND
BOTTLED BY
ZEKİ ARAL
ANKARA, TURKEY

IMPORTED BY MONSIEUR HENRI WINES LTD. NEW YORK. N.Y.

every bit as large. A tremendous number of acres are under vine—only half a dozen nations of the world can count more—but less than 5 percent of the production goes into wine; the famed raisins and table grapes account for the remainder. Nearly all the wine is rough, coarse, and meant to be drunk young. But the Hasandede and Kalecik reds from around Ankara will improve after several years of bottle aging.

SOVIET UNION

Since World War II, wine production in the Soviet Union has increased until now its output is the fifth-largest in the world. Before the Revolution nearly all wine was made on the large estates of the nobility; Russia's relatively small production of wines, most of them sweet or sparkling, was supplemented by cases and cases of wine from France.

For the first fifteen years following the Revolution, the Soviet Union's vineyards and wineries were largely neglected. Then in the 1930s the government began the first of several attempts to increase the production both of table grapes and of wine. Wine is officially considered to serve the best interests of the people; by expanding vineyard acreage and winery capacity, the government plainly hopes to check the ever-increasing consumption of spirits.

The USSR's vineyards trail across

her southern borders, from Rumania in the west to the rising mountains of Iran and Afghanistan in the east. By far the most important of them lie along the north shore of the Black Sea and on the wide land bridge between the Black and the Caspian Sea. Even with the moderating influence of the water, winter temperatures can drop to 40 degrees below zero in some vineyards. To protect the vines from the cold, they are removed from their stakes in the fall and covered by an insulating blanket of earth. In the spring, before the vines send out new growth, the process is reversed. Machines perform this and other tasks that once occupied thousands of laborers.

The Crimea may well be the Soviet Union's finest wine region. At the beginning of the last century, the czars formally established vineyards there under the direction of French experts. Massandra, the most famous of the Romanovs' Crimean vineyards, has given its name to the peninsula's wine collective. Various wines are grown there; the best is a rich fortified dessert wine resembling Madeira.

Across the Sea of Azov from the Crimea lies the city of Rostov. On the banks of the lower Don River behind Rostov grow many local grape varieties producing a number of forgettable red and white wines, as well as the popular sparkling white wine called Donski that is one of Russia's best-known wines. The Russians are great champagne enthusiasts, preferring the sweeter types. Nearly 10 million cases are made annually, and the government is proud of the increasing volume. In fact, a champagne bearing the old Nazdorovya label is one of the few Russian wines available in the United States. Made on an estate once the property of a prince, Nazdorovya is a dulcet, fairly expensive wine.

Moldavia, formerly part of Rumania, and the southern Ukraine form the Soviet Union's largest wine district. Under the direction of the Technical

Wine Institute in Odessa, less desirable hybrid vines have been replaced with such vinestocks as Cabernet Sauvignon and Riesling. The wines they give here bear some resemblance to their nearby cousins from Eastern Europe, but most are made in the distinctively Russian sweet style. Many of the drier white wines are aged for many years in wood, so that they acquire a curious dark and heavy taste. More impressive than any of the wines are the miles of cavernous aging tunnels under the Russian soil. The vineyards of Georgia, Azerbaijan, and Armenia are some of Russia's oldest. Armenia calls itself the fatherland of the vine, and indeed the slopes of the Caucasus are generally thought to be one of the parts of the world where vines were first cultivated. With names such as Mzvane, Ghurdjurni, and Yasman-salik, these are the least European of Russia's wines. Few find their way abroad.

GREECE

Greek wines have been fabled for millennia, since long before Odysseus drugged Polyphemus with Maronean wine and outwitted Circe's potion made with Pramnian. But Greece has fallen behind the other Mediterranean countries, who long ago learned wine-growing from its seafarers and colonists.

Given the hot, generally dry climate, vines thrive throughout most of Greece. Of the 130 million gallons of wine produced annually, about one-third comes from the Peloponnesus, where several of the largest wine companies, among them Achaia-Clauss and Andrew Cambas, are situated. Attica (the region around Athens) yields considerably smaller quantities, but both areas make both red and white wines. The northern parts of Greece make mostly red wines, as does the island of Crete. The Aegean islands produce a variety of wines, and several of them, including Rhodes and Samos, specialize in whites.

At least half of all the wine is treated with various pine resins. Retsina, the white resinated wine, and Kokineli, the rosé, are an acquired taste. It is thought that the turpentine flavor was a by-product of the resins originally added either to prevent spoiling or to camouflage the taste of the goatskin containers. The wine continues to be made in the same manner because the Greek people have grown to like the biting flavor, which goes well with Greek fare.

Some of the good unresinated table wines are Navoussa, a Macedonian red, the white Savatiano from near Athens, and the semidry white Demestica from the Peloponnesus. One of the best Greek wines is the interesting strong sweet red wine Mavrodaphne.

ISRAEL

Evidence of the antiquity of viniculture in the Holy Land is found in the Bible itself. In the Book of Numbers (chapter 13) the story is told of the scouts sent by Moses to spy out the land of Canaan as a possible home for the wandering Israelites. It was "the time of the first-ripe grapes," and Joshua and Caleb brought back a cluster of grapes so

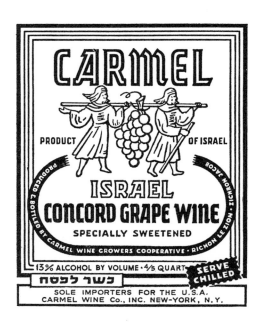

large that it had to be borne upon a pole between the two men.

Today this giant cluster of grapes, the symbol of the Carmel Wine Growers' Cooperative, appears on many wine labels from Israel. The Cooperative's wineries, at Zichron Yaacov south of Haifa and Richon-le-Zion near Tel Aviv, produce 80 percent of Israel's wine. Their vineyards and cellars were founded in 1882 with grape strains brought from France by Baron Edmond de Rothschild as part of his agricultural settlements activities. Wine was being grown in ever-increasing quantities on the new plantations when the plague of phylloxera struck, in the 1890s. Only by following the French example and replanting with vines grafted onto American roots did the Palestine vineyards survive.

Now Carmel makes many different wines. Most of these are available in the United States, which, with Canada, purchases the largest part of Israel's wine exports. The *Vitis vinifera* is the basis of Israel's winemaking. However, a little labrusca is grown for export; from it is made Carmel's popular Concord. The Carmel Richon Sacramental is also a sweet wine, but it has no labrusca flavor. Among the dry reds, the Cabernet Sauvignon, though it has little varietal character, is full of pleasing vinosity. The Carmel

Kadman is big, rich, fortified with brandy, rather like a good Malmsey. Not to be overlooked is the medium-dry white Sauvignon Blanc, rather like a simple Graves. The Hock might be compared to the Rheingau wines.

The skill of many Israeli vintners can no doubt be attributed to the Israel Wine Institute of Rehovot, founded in 1957. It has worked, in cooperation with the government, for the improvement of Israel's wines and vineyards through scientific research and rigorous quality control.

NORTH AFRICA

From the oasis of Marrakesh to the ruins of Carthage, vines grow across the narrow coastal strip of North Africa—in Morocco, Algeria, and Tunisia. Grape culture continues in plantations in northern Libya, but scarcely any wine is made there. In neighboring Egypt, viniculture again assumes importance, but not nearly to the extent that it does in Morocco or Algeria.

The modern vineyards of Algeria owe their origins to the French colonials who planted them in the last century. Until Algerian independence, in 1962, the French were the dominating force in the Algerian wine economy. They controlled the vineyards in Algeria and imported huge quantities of the wine through Marseilles. Some years ago, much Algerian wine was said to have found its way not only into the *vins ordinaires* of the Midi but into the "Burgundy" of several wine houses in Beaune. All this is changed now. For political reasons, few wines from Algeria go to France today. The great customer of the re-organized Algerian wine trade is the Soviet Union, where the wine is consumed as it comes or is blended with some of the local Crimean vintages.

Algerian wines are big and strong. The majority are suitable only for blending, but many better wines grow

at a distance from the flat plantations, in vineyards on the hillside slopes. Among the best wines are those from the Haut-Dahra, Mascara, Côtes de Zaccar, Tlemcen, Médéa, and Miliana.

In Morocco, winegrowing on a large scale dates from the years following World War II, although table grapes had been grown for centuries—before there were vineyards in Europe. The wines used to resemble the mediocre product of Algeria, but strides have been made in improving the vineyards and the wines. Some of the red wines can be very good. The two best-known (and best) Moroccan vineyards are located near the capital of Rabat. These are Sidi Larbi to the south and Dar Bel Hamri to the east. Many of the wines lack acidity and freshness, owing to the hot climate. For this reason the whites, which require the freshness of acidity, are much less acceptable than the reds.

Tunisian winemakers have maintained closer ties to their French forebears than have the Algerian *vignerons*. Private owners still control both large and small vineyards, but the wine is now made in giant cooperatives run by the government. Enologists and technicians trained in France do much to supervise and improve the quality of Tunisian wines. The best ones grow near Cap Bon and on the coastal stretch between Tunis and Bizerte.

UNION OF SOUTH AFRICA

Since 1655, when Jan van Riebeeck of the Dutch East India Company first planted vines at the Cape, grape growing has been a favored part of South African agriculture. Along with Chile and Australia, the Union currently produces the best wines of the Southern Hemisphere.

The South African vineyards divide into two areas. Ordinary bulk

wines come from the grapes grown in the Little Karoo district, beyond the mountains that separate the Cape region from the rest of the country. Better wines are produced in the small triangle of vineyards lying above the Cape of Good Hope. Here grow the finest red and white table wines of the Union, but very little of the fortified and dessert wine common in the other South African vineyards.

Standing behind the winemakers in all parts of the country is the giant cooperative association known as the K.W.V. The Ko-operatieve Winjbouwers Vereniging is in control of the largest part of the wine made in South Africa. Its wineries in Paarl are among the best-equipped in the world.

Small, privately owned estates abound, too. Some of the famous and picturesque ones located in the Cape table-wine district are Twee Jongegezellen, Schoongezicht, Nederburg, Château Alphen, and Bellingham. These names are often seen on wine bottles found abroad.

Good South African table wine is light and fruity, not necessarily big and long-lived. Hermitage, Gamay, and several hybrid vines make the best red wines; Cabernet Sauvignon is grown also. A local variety, the Steen grape, gives the freshest white wines, especially when vinified dry. Some true Riesling grows in the vineyards of the private estates. Proprietary names for wines rather than varietal ones seem to be most common, and they appear in English and in Afrikaans. Not a great deal of South African wine is seen in the United States; more is found in England. Perhaps the best-known wine from South Africa is sherry. Using the Spanish *flor* and *solera* systems, the sherry makers produce what is probably the best wine of its type made outside Jerez. As South African vintners are fond of pointing out, their vineyards lie at the same latitude (albeit south of the Equator) as those in the sherry country of Spain.

CHILE

Among the wines of the world, those from Chile are often singled out as remarkable values. Good red, white, and rosé table wines priced to compete with similar ones from California flow into the United States and other countries throughout the Americas in increasing quantities every year.

With the guidance of French experts, Chilean winemakers have long since learned how to make the best wine from their fine vineyard land. Much *vin ordinaire* is made from the País or "national" grape, a heavy-bearing variety of Spanish origin, but truly good vintages are produced from the great European wine grapes: Cabernet Sauvignon, Sémillon, and Riesling. In the best vineyards these can grow on ungrafted rootstocks, since Chile is one of the few places that has not suffered the vine-killing disaster of phylloxera.

Central Chile grows the best wine. The Maipo River Valley, near Santiago, is the home of several well-known vineyards and wineries. Some of these, making wine that is sold in the United States, are Concha y Toro, Undurraga, San Pedro, Santa Rita, Santa Paula, Macul, and Santa Cecilia. As in California, each winery makes many different wines.

Riesling is the Chilean wine most people outside the country know well. Good examples, while they may not have all the fruit and finesse of a fine Moselle or Rhine, are tart, full, and refreshingly dry. A Chilean Riesling is usually drier than a German or California wine from the same grapes. The other white vinifera grape that thrives in the cool river valleys is the Sémillon. Its wines are often as good as the ones from our own California vineyards, but not quite so costly.

Red wines, too, often achieve excellence. Since the Chileans know the value of well-aged red wine, they specifically grade the vintages destined

for export according to the number of years the wine has been in cask or bottle. The best is the *gran vino,* guaranteed to be at least six years old. This is a helpful distinction for red wines, but beware of it for whites, most of which, if they are indeed six years old, will have lost their freshness and appeal. Chilean Cabernet Sauvignon generally has a fine bouquet (thanks to long bottle aging) and a light but well-formed body. Other classic Bordeaux grapes, the Merlot and Malbec, grow in Chile, too, and are blended with the noble Cabernet Sauvignon. The result is a South American equivalent of a simple and uncomplicated wine from the Médoc or Saint-Émilion. My tasting notes indicate that the Cabernet Sauvignon of Chile, since it is so moderately priced, is one of the best red-wine values produced anywhere.

ARGENTINA

The place to drink Argentine wines is Argentina. Enormous quantities of wine are made—more than 600 million gallons annually. Only France, Italy, and Spain produce more. Schooled in an enthusiastic Italian, Spanish, and French wine-drinking heritage, the Argentines know they have a good product, and they consume most of it themselves. The typical Argentine adult drinks 160 bottles of wine a year.

Nearly all the wines that the average citizen drinks are the big, fruity, robust reds grown in the west of the country on the vast plantations of the flat plains that give way to the towering Andes. The provinces of Mendoza, San Juan, Salta, Rioja, and Rio Negro are in the midst of a virtual green sea of vines stretching across the fertile landscape as far as the eye can see. In Mendoza especially, wineries produce gallon after gallon of inexpensive wine of average quality, fermented in gigantic tanks and aged in cavernous catacombs. In this modern, mechanized atmosphere, it would be

unreasonable to expect wine of memorable excellence. The red wine comes mostly from the good vinifera strain named Malbec, but it is often blended with the less distinguished Criollas, a variety spread throughout Central and South America by the first Spanish colonials and related to the Chilean País.

A small percentage of Argentina's production is first-rate premium wines, prized by local connoisseurs. Made from Cabernet Sauvignon, Merlot, Riesling, Pinot Noir, and Pinot Blanc grapes, the wines are destined to gain wide popularity. Names of reliable producers of top-quality wines include Arizu, Greco Hermanos, Orfila, Trapiche, Andean Vineyards, Furlotti, Brochel, and Lopez (whose Château Vieux is one of the most expensive). Champagnes of remarkable finesse are made by M. Chandon (owned by Moët-Hennessy, the great French champagne and cognac concern) and Pasqual Toso of Mendoza.

AUSTRALIA

The important vineyards of Australia dot the map in an arc that starts from a short section of the Hunter River Valley in New South Wales and extends down through the state of Victoria, passing to the north of Melbourne, then up through South Australia to the region around Adelaide.

Pioneers and adventurers planted Australia's first vineyards in the Hunter River Valley more than 150 years ago. Many vintners followed them; then as the decades passed, more vines were planted in Victoria and South Australia. It is in South Australia today that the heart of the country's wine industry lies.

The Hunter River Valley was not only the first Australian vineyard; for many years it was also the most famous. Several large firms continue to make wine there: Penfold's and Lindeman (two of the biggest) are joined by McWilliam, Pokolbin, Tulloch, Tyrell, and Lake on the list of the Hunter

companies with both vineyards and wineries. Among the northernmost of Australia's vineyards and comparable to the southern vineyards of Europe, those of the Hunter River Valley give wines that are often big and robust. A good red wine is made from the Hermitage grape of the Rhône Valley in France, known in Australia as the Shiraz. Australian labeling being somewhat confusing, we find as well a claret-type wine called Hermitage made by a number of vintners but not necessarily from the Shiraz grape. Again, the fine Sémillon grape of Bordeaux also reaches a high level of excellence but the wine is called "Hunter River Riesling."

Fortified wines are, as ever, the pride of the Murrumbidgee Flats (the Riverina) in central New South Wales, but the area now produces good table wine too. Not far away, in neighboring Victoria, good fortified wines are made around Corowa. The best table wines of Victoria come from the large single property at Tahbilk (with its handsome old buildings all on one estate) and the section called Great Western (no relation to the Great Western of upper New York State), both within 100 miles of Melbourne. The Wynn and Seppelt firms are the most important in Victoria, and their wines are available throughout the United States and England. Brown Brothers produces fine table wine in the Rutherglen region near Corowa.

The many vineyards of South Australia stretch from Coonawarra in the south (where excellent red wine is made) to Clare and Watervale, only 75 miles north of Adelaide. Some of the best wines grow even closer to Adelaide, in a district called the Barossa Valley. Many of the original winemakers were Germans, so it is not surprising that the best wine from Barossa is still the Riesling, or Rhine Riesling as it is called. The wineries of Hardy's, Gramp's, Hamilton's, Kaiser-Stuhl, and Buring's all make Rieslings which I enjoy because of

their refreshing dryness. Among red wines, they stress the Cabernet Sauvignon. Another important winery with a variety of good wines is Yalumba.

South of Adelaide lies the Southern Vales vineyard. Reynella and Tintara (owned by Hardy) and several cooperatives make most of the wine in this district. A good deal of it is used for such proprietary blends as Hardy's St. Thomas Burgundy, but wines with varietal and geographical names are increasingly popular.

Though the Australian vineyards are south of the equator, they are at the same relative latitude as the better wine-growing areas of California. I strongly believe that in another generation some of the best wines of the globe will be produced in these two areas.

NEW ZEALAND

Winemaking in New Zealand has not reached the level of development that it has in Australia. The weather in many of the vineyard areas of North Island is too humid. Harvest rains often spoil the vintage. Although technology is available, wine still suffers because it is a beverage nearly unknown to most New Zealanders. Today the farmers grow mostly the Palomino grape, which is used for the incomparable fortified wines of Jerez in Spain but in New Zealand yields only a tart and acid light white wine. French-American hybrids (notably the Baco Noir) and a South African one called Pinotage (Pinot Noir crossed with Hermitage) are also grown, but their wine is certainly not great. Cabernet Sauvignon will thrive in New Zealand, and it is from this noble grape that the best red wines will come. The hybrid Müller-Thurgau now planted in some of the Rhine and much of southern Germany makes the best white wine in New Zealand.

Auckland and its environs account for more than two-thirds of all the vineyards of the country. Many of the winemakers there are immigrants from

Yugoslavia. Important growers include Corbans, Western Vineyards, Montana, Penfold's, and the New Zealand branch of Gilbey's of London. In Hawke's Bay and Gisborne on the other side of the island are McWilliam's Wines (a branch of the Australian company), Te Mata, Vidal's Glenvale, and Mission. Cook's is a new and promising vineyard and winery. Few New Zealand wines are exported beyond the South Pacific area. One of the few considered to be of high enough quality to merit a place in the world market is an excellent Cabernet Sauvignon from McWilliam's.

JAPAN

Wine is the latest Western commodity to be eagerly adopted by the Japanese. Famous French bottles sell with the same ease in Tokyo as they do in Paris, London, and New York. But overall, wine represents—as in the United States—a small fraction of the total alcohol consumption. Sake and beer far outrank it in popularity. Although their own wine production is rapidly expanding, the Japanese still drink more imported than domestic wine.

Nearly all Japanese wine grows northwest of Tokyo in a section of the Yamanashi Prefecture known as the "fruit bowl" of Japan. There, near Mount Fuji, the rainfall is not so heavy as in other parts of Honshu and, with less chance of disease caused by excessive moisture, the grapevines thrive. The grapes grow on wire trellises positioned some five feet above the ground. A mature vine forms a canopy of fruit and leaves that is pruned and harvested from below.

The important grape is a reddish native variety, the Koshu. In the newly planted or experimental plots such European vines as Cabernet Sauvignon and Sémillon are grown. Throughout the country, grapes that give white wines predominate, since these wines are much more popular than the reds. Perhaps this preference is due to familiarity with sake, which is colorless.

Japanese winemakers (like others around the world) at first based their wines on European models. They now feel able to make distinctly "Japanese" wines intended to please their own tastes and not those of foreigners. At present no Japanese wine is particularly complex, though all seem well made. The wines tend to be light. All, including the champagnes, should be drunk young. Several large companies have most of the market: Sunraku-Ocean (the Mercian brand), Mann's Wine (makers of champagnes as well as still wines and a division of the Kikkoman Group), and Suntory.

PEOPLE'S REPUBLIC OF CHINA

The vine motif twines through the dynasties of ancient China, but grapes and grape wine have never been an important part of Chinese culture.

Grape growing came to China nearly four thousand years ago from Central Asia, which was also the source whence viticulture came to Europe. China's minute production of grape wines was once used exclusively for the pleasure of emperors and nobles. Outside court circles, wine drinkers knew only the commonplace "wines" fermented from rice or millet. Traditionally in China the term applied to all fermented still beverages, whether derived from grains, fruits, or grapes, is *chiu* (also romanized as *jyou*), which is generally translated as "wine." Even today, most Chinese wine is made from grain, little from grapes.

In the last three decades Chinese planners have sparked new interest in Western-style wines, and vineyards have been expanded in many provinces. The fiery liquors distilled from sorghum or cereals—the famous *mao tai* among them—are popular, but grape wines are gaining in acceptance. These wines

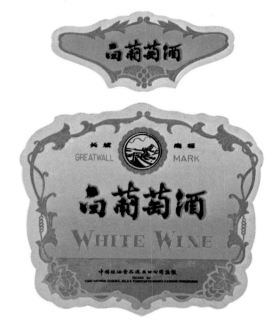

and spirits are rivaled by rice wine, beer, and tea.

China now exports a trickle of wines to countries around the world, including the United States. All the wines are produced under the supervision of the China National Cereals, Oils, and Foodstuffs Import and Export Corporation, and are brought here by importers in the United States. The wines I have tasted have more than a trace of sweetness. A rich, heavy, and aromatic red is pleasant if drunk as port or dessert wine but does not complement most Western meals. The "Great Wall" brand white wine, a deep gold color, is also rather sweet. For those who want authentic Chinese wine with Chinese food, I would suggest the "Great Wall" white, especially as an accompaniment to exotically seasoned or spicy dishes.

For the moment at least, the appeal of the Chinese wines available outside the mainland is curiosity, and Chinese wines have intrigued many people. European growers have been prompted to create wines with Oriental-sounding names. One Portuguese firm makes "Tien-Sho," and the French house of Sichel blends "Wan-Fu" from white Bordeaux wines. Both are popular in Chinese restaurants in Europe and the United States. S.A.

THE BIBULOUS BUSINESS OF A MATTER OF TASTE

DOROTHY SAYERS

Dorothy Leigh Sayers (1893-1957), born in Oxford, was one of the first women to win a degree from Oxford (Somerville College, 1915), where she took first honors in medieval literature. Her work, whether in the field of the detective story, of poetry, of translation (Dante's Inferno *and* Purgatorio*), or of Anglican drama and apologetics, bears the marks of a deeply cultivated mind. Her famous sleuth, Lord Peter Wimsey, is an elegant synthesis of Sherlock Holmes, D'Artagnan, and Oscar Wilde with—in this case—a touch of Alexis Lichine. The little tale that follows is generously conceived, for it offers us not one Wimsey but three, all making a claim to connoisseurship. It poses somewhat the same problem as Roald Dahl's "Taste": Can a palate be forged?*

C. F.

"Halte-là! . . . Attention! . . . F—e!"

The young man in the gray suit pushed his way through the protesting porters and leaped nimbly for the footboard of the guard's van as the Paris–Evreux express steamed out of the Invalides. The guard, with an eye to a tip, fielded him adroitly from among the detaining hands.

"It is happy for monsieur that he is so agile," he remarked. "Monsieur is in a hurry?"

"Somewhat. Thank you. I can get through by the corridor?"

"But certainly. The *premières* are two coaches away, beyond the luggage-van."

The young man rewarded his rescuer, and made his way forward mopping his face. As he passed the piled-up luggage, something caught his eye, and he stopped to investigate. It was a suitcase, nearly new, of expensive-looking leather, labeled conspicuously:

LORD PETER WIMSEY,
Hôtel Saumon d'Or,
Verneuil-sur-Eure.

and bore witness to its itinerary thus:

LONDON—PARIS
(Waterloo) (Gare St. Lazare)
via Southampton-Havre.
PARIS—VERNEUIL
(Ch. de Fer de l'Ouest)

The young man whistled, and sat down on a trunk to think it out.

Somewhere there had been a leakage, and they were on his trail. Nor did they care who knew it. There were hundreds of people in London and Paris who would know the name of Wimsey, not counting the police of both countries. In addition to belonging to one of the oldest ducal families in England, Lord Peter had made himself conspicuous by his meddling with crime detection. A label like this was a gratuitous advertisement.

But the amazing thing was that the pursuers were not troubling to hide themselves from the pursued. That argued very great confidence. That he should have got into the guard's van was, of course, an accident, but, even so, he might have seen it on the platform, or anywhere.

An accident? It occurred to him—not for the first time, but definitely now, and without doubt—that it was indeed an accident for them that he was here. The series of maddening delays that had held him up between London and the Invalides presented itself to him with an air of prearrangement. The preposterous accusation, for instance, of the woman who had accosted him in Piccadilly, and the slow process of extricating himself at Marlborough Street. It was easy to hold a man up on some trumped-up charge till an important plan had matured. Then there was the lavatory door at Waterloo, which had so ludicrously locked itself upon him. Being athletic, he had climbed over the partition, to find the attendant mysteriously absent. And, in Paris, was it by chance that he had had a deaf taxi-driver, who mistook the direction "Quai d'Orléans" for "Gare de Lyon," and drove a mile and a half in the wrong direction before the shouts of his fare attracted his attention? They were clever, the pursuers, and circumspect. They had accurate information; they would delay him, but without taking any overt step; they knew that if only they could keep time on their side they needed no other ally.

Did they know he was on the train? If not, he still kept the advantage, for they would travel in a false security, thinking him to be left, raging and helpless, in the Invalides. He decided to make a cautious reconnaissance.

The first step was to change his gray suit for another of inconspicuous navy-blue cloth, which he had in his small black bag. This he did in the privacy of the toilet, substituting for his gray soft hat a large traveling-cap, which pulled well down over his eyes.

There was little difficulty in locating the man he was in search of. He found him seated in the inner corner of a first-class compartment, facing the engine, so that the watcher could approach unseen from behind. On the rack was a handsome dressing-case, with the initials P.D.B.W. The

young man was familiar with Wimsey's narrow, beaky face, flat yellow hair, and insolent dropped eyelids. He smiled a little grimly.

"He is confident," he thought, "and has regrettably made the mistake of underrating the enemy. Good! This is where I retire into a *seconde* and keep my eyes open. The next act of this melodrama will take place, I fancy, at Dreux."

It is a rule on the Chemin de Fer de l'Ouest that all Paris–Evreux trains, whether of Grande Vitesse or what Lord Peter Wimsey preferred to call Grande Paresse, shall halt for an interminable period at Dreux. The young man (now in navy blue) watched his quarry safely into the refreshment room, and slipped unobtrusively out of the station. In a quarter of an hour he was back—this time in a heavy motoring-coat, helmet, and goggles, at the wheel of a powerful hired Peugeot. Coming quietly onto the platform, he took up his station behind the wall of the *lampisterie,* whence he could keep an eye on the train and the buffet door. After fifteen minutes his patience was rewarded by the sight of his man again boarding the express, dressing-case in hand. The porters slammed the doors, crying: "Next stop Verneuil!" The engine panted and groaned; the long train of gray-green carriages clanked slowly away. The motorist drew a breath of satisfaction, and, hurrying past the barrier, started up the car. He knew that he had a good eighty miles an hour under his bonnet, and there is no speed limit in France.

Mon Souci, the seat of that eccentric and eremitical genius the Comte de Rueil, is situated three kilometers from Verneuil. It is a sorrowful and decayed château, desolate at the termination of its neglected avenue of pines. The mournful state of a nobility without an allegiance surrounds it. The stone nymphs droop greenly over their dry and moldering fountains. An occasional peasant creaks with a single wagon-load of wood along the ill-forested glades. It has the atmosphere of sunset at all hours of the day. The woodwork is dry and gaping for lack of paint. Through the jalousies one sees the prim *salon,* with its beautiful and faded furniture. Even the last of its ill-dressed, ill-favored women has withered away from Mon Souci, with her inbred, exaggerated features and her long white gloves. But at the rear of the château a chimney smokes incessantly. It is the furnace of the laboratory, the only living and modern thing among the old and dying; the only place tended and loved, petted and spoiled, heir to the long solicitude which counts of a more light-hearted day had given to stable and kennel, portrait gallery and ballroom. And below, in the cool cellar, lie row upon row the dusty bottles, each an enchanted glass coffin in which the Sleeping Beauty of the vine grows ever more ravishing in sleep.

As the Peugeot came to a standstill in the courtyard, the driver observed with considerable surprise that he was not the count's only visitor. An immense super-Renault, like a *merveilleuse* of the Directoire, all bonnet and no body, had been drawn so ostentatiously across the entrance as to embarrass the approach of any newcomer. Its glittering panels were embellished with a coat of arms, and the count's elderly servant was at that moment staggering beneath the weight of two large and elaborate

suitcases, bearing in silver letters that could be read a mile away the legend: "LORD PETER WIMSEY."

The Peugeot driver gazed with astonishment at this display, and grinned sardonically. "Lord Peter seems rather ubiquitous in this country," he observed to himself. Then, taking pen and paper from his bag, he busied himself with a little letter-writing. By the time that the suitcases had been carried in, and the Renault had purred its smooth way to the outbuildings, the document was complete and enclosed in an envelope addressed to the Comte de Rueil. "The hoist with his own petard touch," said the young man, and, stepping up to the door, presented the envelope to the manservant.

"I am the bearer of a letter of introduction to monsieur le comte," he said. "Will you have the obligingness to present it to him? My name is Bredon—Death Bredon."

The man bowed, and begged him to enter.

"If monsieur will have the goodness to seat himself in the hall for a few moments. Monsieur le comte is engaged with another gentleman, but I will lose no time in making monsieur's arrival known."

The young man sat down and waited. The windows of the hall looked out upon the entrance, and it was not long before the château's sleep was disturbed by the hooting of yet another motor-horn. A station taxicab came noisily up the avenue. The man from the first-class carriage and the luggage labeled P.D.B.W. were deposited upon the doorstep. Lord Peter Wimsey dismissed the driver and rang the bell.

"Now," said Mr. Bredon, "the fun is going to begin." He effaced himself as far as possible in the shadow of a tall *armoire normande*.

"Good evening," said the newcomer to the manservant, in admirable French, "I am Lord Peter Wimsey. I arrive upon the invitation of monsieur le comte de Rueil. Monsieur le comte is at liberty?"

"Milord Peter Wimsey? Pardon, monsieur, but I do not understand. Milord de Wimsey is already arrived and is with monsieur le comte at this moment."

"You surprise me," said the other, with complete imperturbability, "for certainly no one but myself has any right to that name. It seems as though some person more ingenious than honest has had the bright idea of impersonating me."

The servant was clearly at a loss.

"Perhaps," he suggested, "monsieur can show his *papiers d'identité*."

"Although it is somewhat unusual to produce one's credentials on the doorstep when paying a private visit," replied his lordship, with unaltered good humor, "I have not the slightest objection. Here is my passport, here is a *permis de séjour* granted to me in Paris, here my visiting card, and here a quantity of correspondence addressed to me at the Hôtel Meurice, Paris, at my flat in Piccadilly, London, at the Marlborough Club, London, and at my brother's house at King's Denver. Is that sufficiently in order?"

The servant perused the documents carefully, appearing particularly impressed by the *permis de séjour*.

"It appears there is some mistake," he murmured dubiously; "if monsieur will follow me, I will acquaint monsieur le comte."

They disappeared through the folding doors at the back of the hall, and Bredon was left alone.

"and below, in the cool cellar, lie row upon row the dusty bottles" Château Lafite's cellar

411

"Quite a little boom in Richmonds today," he observed, "each of us more unscrupulous than the last. The occasion obviously calls for a refined subtlety of method."

After what he judged to be a hectic ten minutes in the count's library, the servant reappeared, searching for him.

"Monsieur le comte's compliments, and would monsieur step this way?"

Bredon entered the room with a jaunty step. He had created for himself the mastery of this situation. The count, a thin, elderly man, his fingers deeply stained with chemicals, sat, with a perturbed expression, at his desk. In two armchairs sat the two Wimseys. Bredon noted that, while the Wimsey he had seen in the train (whom he mentally named Peter I) retained his unruffled smile, Peter II (he of the Renault) had the flushed an indignant air of an Englishman affronted. The two men were superficially alike—both fair, lean, and long-nosed, with the nondescript, inelastic face which predominates in any assembly of well-bred Anglo-Saxons.

"Mr. Bredon," said the count, "I am charmed to have the pleasure of making your acquaintance, and regret that I must at once call upon you for a service as singular as it is important. You have presented to me a letter of introduction from your cousin, Lord Peter Wimsey. Will you now be good enough to inform me which of these gentlemen he is?"

Bredon let his glance pass slowly from the one claimant to the other, meditating what answer would best serve his own ends. One, at any rate, of the men in this room was a formidable intellect, trained in the detection of imposture.

"Well?" said Peter II. "Are you going to acknowledge me, Bredon?"

Peter I extracted a cigarette from a silver case. "Your confederate does not seem very well up in his part," he remarked, with a quiet smile at Peter II.

"Monsieur le comte," said Bredon, "I regret extremely that I cannot assist you in the matter. My acquaintance with my cousin, like your own, has been made and maintained entirely through correspondence on a subject of common interest. My profession," he added, "has made me unpopular with my family."

There was a very slight sigh of relief somewhere. The false Wimsey—whichever he was—had gained a respite. Bredon smiled.

"An excellent move, Mr. Bredon," said Peter I, "but it will hardly explain—Allow me." He took the letter from the count's hesitating hand. "It will hardly explain the fact that the ink of this letter of recommendation, dated three weeks ago, is even now scarcely dry—though I congratulate you on the very plausible imitation of my handwriting."

"If *you* can forge my handwriting," said Peter II, "so can this Mr. Bredon." He read the letter aloud over his double's shoulder.

"'Monsieur le comte—I have the honor to present to you my friend and cousin, Mr. Death Bredon, who, I understand, is to be traveling in your part of France next month. He is very anxious to view your interesting library. Although a journalist by profession, he really knows something about books.' I am delighted to learn for the first time that I have such a cousin. An interviewer's trick, I fancy, monsieur le comte. Fleet Street

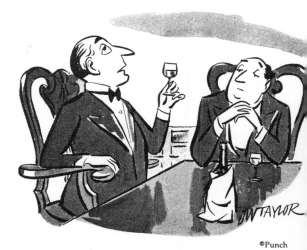

". . . and trodden, I should say, by Jacques Dupont fils."

412

appears well informed about our family names. Possibly it is equally well informed about the object of my visit to Mon Souci?"

"If," said Bredon boldly, "you refer to the acquisition of the de Rueil formula for poison gas for the British Government, I can answer for my own knowledge, though possibly the rest of Fleet Street is less completely enlightened." He weighed his words carefully now, warned by his slip. The sharp eyes and detective ability of Peter I alarmed him far more than the caustic tongue of Peter II.

The count uttered an exclamation of dismay.

"Gentlemen," he said, "one thing is obvious—that there has been somewhere a disastrous leakage of information. Which of you is the Lord Peter Wimsey to whom I should entrust the formula I do not know. Both of you are supplied with papers of identity; both appear completely instructed in this matter; both of your handwritings correspond with the letters I have previously received from Lord Peter, and both of you have offered me the sum agreed upon in Bank of England notes. In addition, this third gentleman arrives endowed with an equal facility in handwritings, an introductory letter surrounded by most suspicious circumstances, and a degree of acquaintance with this whole matter which alarms me. I can see but one solution. All of you must remain here at the château while I send to England for some elucidation of this mystery. To the genuine Lord Peter I offer my apologies, and assure him that I will endeavor to make his stay as agreeable as possible. Will this satisfy you? It will? I am delighted to hear it. My servants will show you to your bedrooms, and dinner will be at half-past seven."

"It is delightful to think," said Mr. Bredon, as he fingered his glass and passed it before his nostrils with the air of a connoisseur, "that whichever of these gentlemen has the right to the name which he assumes is assured tonight of a truly Olympian satisfaction." His impudence had returned to him, and he challenged the company with an air. "Your cellars, monsieur le comte, are as well known among men endowed with a palate as your talents among men of science. No eloquence could say more."

The two Lord Peters murmured assent.

"I am the more pleased by your commendation," said the count, "that it suggests to me a little test which, with your kind cooperation, will, I think, assist us very much in determining which of you gentlemen is Lord Peter Wimsey and which his talented impersonator. Is it not matter of common notoriety that Lord Peter has a palate for wine almost unequaled in Europe?"

"You flatter me, monsieur le comte," said Peter II modestly.

"I wouldn't like to say unequaled," said Peter I, chiming in like a well-trained duet; "let's call it fair to middling. Less liable to misconstruction and all that."

"Your lordship does yourself an injustice," said Bredon, addressing both men with impartial deference. "The bet which you won from Mr. Frederick Arbuthnot at the Egotists' Club, when he challenged you to name the vintage years of seventeen wines blindfold, received its due prominence in the *Evening Wire.*"

"I was in extra form that night," said Peter I.

"A fluke," laughed Peter II.

"The test I propose, gentlemen, is on similar lines," pursued the count, "though somewhat less strenuous. There are six courses ordered for dinner tonight. With each we will drink a different wine, which my butler shall bring in with the label concealed. You shall each in turn give me your opinion upon the vintage. By this means we shall perhaps arrive at something, since the most brilliant forger—of whom I gather I have at least two at my table tonight—can scarcely forge a palate for wine. If too hazardous a mixture of wines should produce a temporary incommodity in the morning, you will, I feel sure, suffer it gladly for this once in the cause of truth."

The two Wimseys bowed.

In vino veritas," said Mr. Bredon, with a laugh. He at least was well seasoned, and foresaw opportunities for himself.

"Accident, and my butler, having placed you at my right hand, monsieur," went on the count, addressing Peter I, "I will ask you to begin by pronouncing, as accurately as may be, upon the wine which you have just drunk."

"That is scarcely a searching ordeal," said the other, with a smile. "I can say definitely that it is a very pleasant and well-matured Chablis Moutonne; and, since ten years is an excellent age for a Chablis—a real Chablis —I should vote for 1916, which was perhaps the best of the war vintages in that district."

"Have you anything to add to that opinion, monsieur?" inquired the count, deferentially, of Peter II.

"I wouldn't like to be dogmatic to a year or so," said that gentlemen critically, "but if I must commit myself, don't you know, I should say 1915—decidedly 1915."

The count bowed, and turned to Bredon.

"Perhaps you, too, monsieur, would be interested to give an opinion," he suggested, with the exquisite courtesy always shown to the plain man in the society of experts.

"I'd rather not set a standard which I might not be able to live up to," replied Bredon, a little maliciously. "I know that it is 1915, for I happened to see the label."

Peter II looked a little disconcerted.

"We will arrange matters better in future," said the count. "Pardon me." He stepped apart for a few moments' conference with the butler, who presently advanced to remove the oysters and bring in the soup.

The next candidate for attention arrived swathed to the lip in damask.

"It is your turn to speak first, monsieur," said the count to Peter II. "Permit me to offer you an olive to cleanse the palate. No haste, I beg. Even for the most excellent political ends, good wine must not be used with disrespect."

The rebuke was not unnecessary, for, after a preliminary sip, Peter II had taken a deep draught of the heady white richness. Under Peter I's quizzical eye he wilted quite visibly.

"It is—it is Sauternes," he began, and stopped. Then, gathering encouragement from Bredon's smile, he said, with more aplomb, "Château Yquem, 1911—ah! the queen of white wines, sir, as what's-his-name says." He drained his glass defiantly.

The count's face was a study as he slowly detached his fascinated gaze from Peter II to fix it on Peter I.

"If I had to be impersonated by somebody," murmured the latter gently, "it would have been more flattering to have had it undertaken by a person to whom all white wines were *not* alike. Well, now, sir, this admirable vintage is, of course, a Montrachet of—let me see"—he rolled the wine delicately upon his tongue—"of 1911. And a very attractive wine it is, though, with all due deference to yourself, monsieur le comte, I feel that it is perhaps slightly too sweet to occupy its present place in the menu. True, with this excellent *consommé marmite,* a sweetish wine is not altogether out of place, but, in my own humble opinion, it would have shown to better advantage with the *confitures.*"

"There, now," said Bredon innocently, "it just shows how one may be misled. Had not I had the advantage of Lord Peter's expert opinion—for certainly nobody who could mistake Montrachet for Sauternes has any claim to the name of Wimsey—I should have pronounced this to be, not the Montrachet-Aîné, but the Chevalier-Montrachet of the same year, which is a trifle sweeter. But no doubt, as your lordship says, drinking it with the soup has caused it to appear sweeter to me than it actually is."

The count looked sharply at him, but made no comment.

"Have another olive," said Peter I kindly. "You can't judge wine if your mind is on other flavors."

"Thanks frightfully," said Bredon. "And that reminds me—" He launched into a rather pointless story about olives, which lasted out the soup and bridged the interval to the entrance of an exquisitely cooked sole.

The count's eye followed the pale amber wine rather thoughtfully as it trilled into the glasses. Bredon raised his in the approved manner to his nostrils, and his face flushed a little. With the first sip he turned excitedly to his host.

"Good God, sir—" he began.

The lifted hand cautioned him to silence.

Peter I sipped, inhaled, sipped again, and his brows clouded. Peter II had by this time apparently abandoned his pretensions. He drank thirstily, with a beaming smile and a lessening hold upon reality.

"Eh bien, monsieur?" inquired the count gently.

"This," said Peter I, "is certainly hock, and the noblest hock I have ever tasted, but I must admit that for the moment I cannot precisely place it."

"No?" said Bredon. His voice was like bean-honey now, sweet and harsh together. "Nor the other gentleman? And yet I fancy I could place it within a couple of miles, though it is a wine I had hardly looked to find in a French cellar at this time. It is Hock, as your lordship says, and at that it is Johannisberger. Not the plebeian cousin, but the *echter* Schloss Johannisberger from the castle vineyard itself. Your lordship must have missed it (to your great loss) during the war years. My father laid some down the year before he died, but it appears that the ducal cellars at Denver were less well furnished."

"I must set about remedying the omission," said the remaining Peter, with determination.

The *poulet* was served to the accompaniment of an argument over the

"That's what I call a palate. He can identify the château, the year, and the pesticides."

©Punch

Lafitte, his lordship placing it at 1878, Bredon maintaining it to be a relic of the glorious 'seventy-fives, slightly overmatured, but both agreeing as to its great age and noble pedigree.

As to the Clos-Vougeot, on the other hand, there was complete agreement; after a tentative suggestion of 1915, it was pronounced finally by Peter I to belong to the equally admirable though slightly lighter 1911 crop. The *pré-salé* was removed amid general applause, and the dessert was brought in.

"Is it necessary," asked Peter I, with a slight smile in the direction of Peter II—now happily murmuring, "Damn good wine, damn good dinner, damn good show"—"is it necessary to prolong this farce any further?"

"Your lordship will not, surely, refuse to proceed with the discussion?" cried the count.

"The point is sufficiently made, I fancy."

"But no one will surely ever refuse to discuss wine," said Bredon, "least of all your lordship, who is so great an authority."

"Not on this," said the other. "Frankly, it is a wine I do not care about. It is sweet and coarse, qualities that would damn any wine in the eyes— the mouth, rather—of a connoisseur. Did your excellent father have this laid down also, Mr. Bredon?"

Bredon shook his head.

"No," he said, "no. Genuine Imperial Tokay is beyond the opportunities of Grub Street, I fear. Though I agree with you that it is horribly over-rated—with all due deference to yourself, monsieur le comte."

"In that case," said the count, "we will pass at once to the liqueur. I admit that I had thought of puzzling these gentlemen with the local product, but, since one competitor seems to have scratched, it shall be brandy—the only fitting close to a good wine list."

In a slightly embarrassing silence the huge, round-bellied balloon glasses were set upon the table, and the few precious drops poured gently into each and set lightly swinging to release the bouquet.

"This," said Peter I, charmed again into amiability, "is, indeed, a wonderful old French brandy. Half a century old, I suppose."

"Your lordship's praise lacks warmth," replied Bredon. "This is *the* brandy—the brandy of brandies—the superb—the incomparable—the true Napoleon. It should be honored like the emperor it is."

He rose to his feet, his napkin in his hand.

"Sir," said the count, turning to him, "I have on my right a most admirable judge of wine, but you are unique." He motioned to Pierre, who solemnly brought forward the empty bottles, unswathed now, from the humble Chablis to the stately Napoleon with the imperial seal blown in the glass. "Every time you have been correct as to growth and year. There cannot be six men in the world with such a palate as yours, and I thought that but one of them was an Englishman. Will you not favor us, this time, with your real name?"

"It doesn't matter what his name is," said Peter I. He rose. "Put up your hands, all of you. Count, the formula!"

Bredon's hands came up with a jerk, still clutching the napkin. The white folds spurted flame as his shot struck the other's revolver cleanly

between trigger and barrel, exploding the charge, to the extreme detriment of the glass chandelier. Peter I stood shaking his paralyzed hand and cursing.

Bredon kept him covered while he cocked a wary eye at Peter II, who, his rosy visions scattered by the report, seemed struggling back to aggressiveness.

"Since the entertainment appears to be taking a lively turn," observed Bredon, "perhaps you would be so good, count, as to search these gentlemen for further firearms. Thank you. Now, why should we not all sit down again and pass the bottle round?"

"You—*you* are—" growled Peter I.

"Oh, my name is Bredon all right," said the young man cheerfully. "I loathe aliases. Like another fellow's clothes, you know—never seem quite to fit. Peter Death Bredon Wimsey—a bit lengthy and all that, but handy when taken in installments. I've got a passport and all those things, too, but I didn't offer them, as their reputation here seems a little blown upon, so to speak. As regards the formula, I think I'd better give you my personal cheque for it—all sorts of people seem able to go about flourishing Bank of England notes. Personally, I think all this secret diplomacy work is a mistake, but that's the War Office's pigeon. I suppose we all brought similar credentials. Yes, I thought so. Some bright person seems to have sold himself very successfully in two places at once. But you two must have been having a lively time, each thinking the other was me."

"My lord," said the count heavily, "these two men are, or were, Englishmen, I suppose. I do not care to know what governments have purchased their treachery. But where they stand, I, alas! stand too. To our venal and corrupt Republic I, as a Royalist, acknowledge no allegiance. But it is in my heart that I have agreed to sell my country to England because of my poverty. Go back to your War Office and say I will not give you the formula. If war should come between our countries—which may God avert!—I will be found on the side of France. That, my lord, is my last word."

Wimsey bowed.

"Sir," said he, "it appears that my mission has, after all, failed. I am glad of it. This trafficking in destruction is a dirty kind of business after all. Let us shut the door upon these two, who are neither flesh nor fowl, and finish the brandy in the library."

WINE AND FOOD AFFINITIES

JAMES BEARD

One of the great pleasures in planning a meal is choosing wines and foods that balance each other. You can start with a beautiful menu and then select the proper wines to accompany it, giving the food star billing, or you can design the meal around one or two choice bottles. To go with two bottles of 1899 Château Latour, I once did a menu in which the food provided a modest background for the wine rather than playing an equal role. Either approach takes skill and a high degree of personal taste.

There are time-ravaged rules about wine and food, of course, which many wine lovers still feel are inviolable, but we have reached an age where individuality and informality are winning out over the old conventions. We are more adventurous about our eating and drinking than we used to be, and this attitude is shared by increasing numbers of young people. Rules about wine are really pretty simple if they are applied with common sense. The basic maxim goes: a white wine before a red wine, a light wine before a full wine, a dry wine before a sweet wine, and a young wine before an old wine. Well, I think any person with a sense of balance in eating and drinking would naturally arrive at these ideas. If it's true that you try to build your menu to a climax, course by course, why wouldn't you choose the wines in an ascending order to set it off? It's logical.

Just as some foods and wines make perfect marriages—good raw oysters and fine dry Chablis or Muscadet are made for each other—some, such as spicy goulash and a flowery Moselle, are considered incompatible. Try a fine Alsatian wine with pork, and as for ham, champagne complements it in a magnificent fashion. I remember a huge tasting of hams and champagnes at the old Ritz in New York, sponsored by the Wine and Food Society. The perfume of the various hams and the brilliance of the champagnes made it a memorable occasion.

Some people don't drink wine with asparagus or artichokes, and others feel that carrots ruin the taste of wine. I've never found much basis for this, or at least I've combined wine with all three vegetables many a time and discerned no significant loss of flavor.

In some instances the antagonism between wine and food is indisputable—which is true in the case of salads heavy with vinegar. So if you are having wine with salad try making the dressing with a little cognac, or with a bit of the wine you are drinking, instead of vinegar. No one can

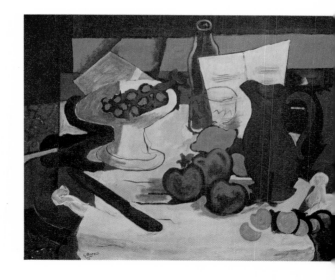

Still Life, Georges Braque, 1926

418

deny that the taste of good olive oil, fresh herbs, and a little chopped shallot or garlic will enhance a salad without benefit of vinegar.

Some egg dishes do not seem agreeable with wine—eggs Benedict, for instance. However, a cheese omelet takes a red wine gracefully. The same is so of a cheese soufflé, which I have had served as a main course with red wine. I've also had it as a first course with white wine and as a first course with a very light, slightly chilled Beaujolais. Every one of these combinations was congenial.

Some people think that salmon and wine are not complementary, but this depends on the preparation. The great André Simon once said that drinking beer was often preferable to drinking wine with salmon, particularly if the fish was oily and served in a rich way. I have found that fine sturdy whites are extremely pleasant with many salmon dishes.

Just as there are many don't's about wines, there are also many do's, such as drinking white wine with white meat and red wine with red meat. However, exceptions abound, and roast chicken or veal can be quite as delicious with a good red wine as with a white—for instance, a Côtes-du-Rhône or a light Bordeaux does as well as a Pouilly-Fuissé. It depends entirely on your preference, the time of year, the place, and the way in which you prepare the dish. Fish or meats which are simply grilled go better with light wines that are slightly dry, whereas heavily sauced dishes will be far more attractive to the palate if they're served with bigger, fatter wines. Generally, the sturdier the dish the sturdier the wine that accompanies it.

Cheese has always been considered the perfect companion for fine red wines, and it's customary to save some of the best wine to serve with cheese as a separate course. But there are certain cheeses—goat cheeses, for example—that go well with white wine, and in summer many light cheeses can be served with a chilled white wine very successfully.

Still Life, Willem Claesz. Heda, 1648

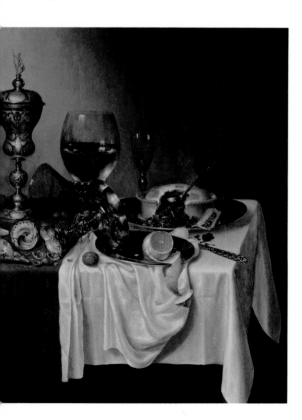

If you are having a regional dish, you will often find that it is best eaten with a wine of the region represented. A choucroute garnie from Alsace is delicious with a Gewürztraminer or a Riesling. In some cases, though, you may want to drink the same wine as was used in the dish. This is true of a coq au vin, traditionally made with a Chambertin, and it is true of dishes such as boeuf à la bourguignonne.

One way to broaden your knowledge of wines is to serve two different ones with a main course instead of serving two bottles of the same wine. With a leg of lamb, for example, your first bottle might be a Médoc and your second a more full-bodied Pomerol or Saint-Émilion, or even the same château wine but a different vintage. Wild duck could be accompanied first by a Pommard, let us say, and then by a Nuits-Saint-Georges. You might even go so far as trying a white wine and then a red wine with a roast chicken or roast of veal, to see which you like better. This is an experience you would want to share with three or four guests, rather than confining it to two people, who would of necessity have to drink half bottles, unless they were hearty winebibbers.

There may be situations when good beer or spirits are in order rather than wine. When eating caviar, you'll discover that chilled vodka is going to give you much more pleasure than any wine. You may also like vodka with smoked salmon.

419

It's worth noting that the seasons have a definite influence on which wine you drink. The late Pierre Hiély (of the famous restaurant Hiély in Avignon) had one of the finest collections of Rhône wines in France, yet he frowned on the drinking of Châteauneuf-du-Pape, Côte Rôtie, or Hermitage in summer and thought people were much better off with white wines. Considering the hot climate in Avignon in July and August, this makes great sense. Unless it's a chilled Beaujolais or a chilled Côtes-du-Rhône, red wines in summer can be heavy and oppressive. On the other hand, white wines and fruity rosés do extremely well in hot weather. I am not one to preach that rosés go with everything, but if they are good and fresh and very, very young, they can be quite rewarding. With picnics and summer buffets I think one should have both light reds and whites, chilled, and let people choose for themselves. It's an interesting way to cater to people's palates.

There are times when wines taste wonderful just for themselves alone. In summer a chilled bottle of Alsatian wine or a beautiful Moselle or a very well chilled Sauternes can be a delicious afternoon drink. Chilled glasses are essential. I also like to share a chilled bottle of Beaujolais on such occasions.

When it comes to choosing wines, people are often afraid to follow their own instincts because of what other people might think. Have no fear. Mrs. Grundy died with the last generation, and we must follow our own palates in this age. So be yourself in your wine drinking and, most of all, enjoy it.

Not too many years ago, housewives used what were called "cooking wines"—sherry, port, and Madeira with salt added to inhibit the cook from drinking them up. Needless to say, these cooking wines were a pretty terrible commodity. At the other extreme we have the old adage, "The better the wine, the better the dish." I think very few of us would make coq au Chambertin with fine old Chambertin: we would use a good substitute that was also a highly drinkable wine. The wine you use in cooking does not have to be a great wine. After all, it is used for flavor and not for anything else.

Besides the reds and whites, fortified wines, notably Madeira, are widely used in cooking. For most dishes one should choose a Madeira on the dry side. This wine from the tiny island in the Atlantic has long been a classic ingredient in cookery because of its extraordinarily wonderful flavor. It is used to make one of the great brown sauces. In addition to soups and main dishes, it is often used in vegetable dishes, and from time to time in desserts. Port, which ranges from dry to sweet, is commonly used in cookery, too, and here again one must be careful not to choose one that is overpoweringly sweet for such delicate dishes as those made with veal or chicken. The third wine in this group is sherry, used in everything from soups, through fish, meat, and sauces, to desserts. Once more, the sweetness varies. One uses dry sherry with soups and meats and works up to the rich, nutty sherries for desserts and sauces, primarily dessert sauces. One of the most delicious simple desserts in the world is a sherry jelly with whipped cream.

Another useful wine to have around is vermouth, which can serve with

(Top) *Snack for Two,* Jean Dubuffet, 1944

(Bottom) *Portrait,* René Magritte, 1935

420

great success in recipes that call for white wine. It is a blessing for the cook who needs only a touch of wine and doesn't want to open a whole bottle. In a martini-drinking family it's wiser to use up the vermouth quickly anyway, since it deteriorates once the bottle is opened.

A frequent fault of amateur cooks is that they believe they add zest to a dish if they use more wine than is called for in the recipe. Not at all. The balance of flavor has been carefully worked out in the recipe, and too much wine can ruin it.

When using wine in cooking, add it to the dish at a point that allows time for it to heat to boiling, permitting the alcohol to cook away. Otherwise it can leave a rather unpleasant flavor. Many people don't realize this, and they just add a "slug" of wine at the last minute to "improve" a dish.

Don't add wine indiscriminately where a recipe doesn't call for it. However, if you think that the addition of a little Madeira or a little sherry or a touch of red wine might make a difference to your finished dish, don't be afraid to try it out. This is the fun of cooking, but I suggest that you make the dish strictly according to the recipe the first time around.

Marinades that call for red or white wine or brandy and seasonings are seldom completely used up in preparing a dish. Therefore you'll have some left over, and if you're smart you'll store the surplus marinade in a jar. Seal it tight and keep it in the refrigerator until the next time you're making a marinated dish. It will mature and be even better the second time, serving more or less as a "mother" for succeeding marinades. This is also true when making fish court bouillon with wine. After you've cooked your fish and taken out some of the broth for your sauce, cook down the remaining broth until it's quite concentrated in flavor. Bottle it, refrigerate it, and keep it to add to fish sauces or to use as a base for another court bouillon. Both marinades and broths can be frozen successfully.

The following chart indicates some of the traditional pairings of wine and food. In most cases alternatives are offered that should lead you toward some creative experiments of your own.

Food	Suggested Wines or Spirits
Caviar	Brut champagne, vodka, Zubrowka.
Hors d'oeuvres such as crudités, olives, almonds, deviled eggs, smoked salmon	Dry aperitifs such as Fino or Amontillado sherry, Sercial or Rainwater Madeira, Lillet Blonde, Montilla, Manzanilla.
Meat pâtés and foie gras	Sometimes in France foie gras is accompanied by Sauternes very chilled (which reduces the sweetness). Interesting alternatives are cooled Beaujolais, a light red Bordeaux, Zinfandel, and Gamay, all of which admirably suit a meat pâté. If a full-bodied dry white is to be served with the following course, it would also be satisfactory here.
Consommé	Dry sherry or Madeira.
Fish soups, chowders	A light crisp white, such as Soave, Alsatian or California Riesling, Muscadet, Manzanilla, or Montilla.

Cream soups	Same as for the preceding, though a heavier white wine from the Loire is preferable.
Cold meats and other light fare for a summer picnic or buffet	Light dry wine such as Moselle, vin rosé, slightly chilled Beaujolais, Valpolicella, or Spanish Rioja.
Eggs, cheese, or stuffed omelet	Light red such as Zinfandel or a regional Médoc; perhaps a Tavel or a Grenache Rosé.
Cheese dishes, such as quiche Lorraine, fondues	Crisp dry white such as Alsatian Riesling or Swiss Neuchâtel.
Pasta	With seafood sauce—Soave or Verdicchio; with meat sauce—Chianti Riserva.
Shellfish	Chablis, white Graves, Muscadet, California or New York Riesling.
Fish, poached or grilled	Same as for the preceding; also Pouilly-Fuissé, Rheingau, Moselle.
Fish in heavy sauce or seafood ragout	Any full white Burgundy such as Meursault; a full-flavored Rheingau such as Rüdesheimer; California Pinot Chardonnay.
Chicken or turkey	A full-bodied white (as for the preceding), or a light red Bordeaux, Beaujolais, Bardolino, or Cabernet Sauvignon.
Ham and pork	Neither really complements great wine. Fruity white or sparkling wines are pleasant (champagne with ham).
Veal, sweetbreads, brains, tripe, etc.	Full-bodied white Burgundy, light red Bordeaux, California Cabernet Sauvignon, Côtes-du-Rhône, Beaujolais (Moulin-à-Vent).
Lamb	The classic choice is château-bottled Bordeaux (or California Cabernet Sauvignon).
Beef, light game such as quail or pheasant	Fuller-bodied red Bordeaux (such as Saint-Émilion), California Pinot Noir, Côtes de Beaune red, Chianti Classico, hearty Rhône.
Light stews (veal, lamb, or chicken)	Medium light wines such as Beaujolais, Zinfandel, Côtes-du-Rhône, Barbera, Volnay.
Heavier stews, cooked with wine	Châteauneuf-du-Pape, Hermitage, Côte de Nuits, Burgundy, Barolo, California Pinot Noir.
Heavier game such as venison, wild duck, goose, or hare	Full-bodied red—one of the bigger Burgundies or Rhône wines.
Salad	None, unless lemon or cognac is substituted for vinegar.
Cheese	The finest Bordeaux, Burgundies, Rhônes, vintage California Cabernet, Pinot Noir. Also fine old ports. All wines are flattered by cheese—the bigger the wine, the better the mating.
Desserts, fruits, pastries	Château d'Yquem and German *Trockenbeerenauslese,* because of their sweet, flowery qualities, represent perfection, but try also the richest, sweetest examples you can find from Sauternes, the Loire, the Rhine and Moselle; Tokay, Madeira, champagne.
Walnuts, special cheeses such as Stilton or Cheddar	Port, Madeira (Malmsey or Bual).

COOKING WITH WINE

I've chosen nine of my favorite wine recipes, dishes that I've used over and over and over and that are more or less classics in their way. I look upon recipes as classics according to the person who cooks or arranges them. We may have a classic from Escoffier, but Julia Child or Marcella Hazan may give it a different accent, and it then becomes a classic according to Julia Child or Marcella Hazan.

Well, these are classics according to James Beard, and I like them and I hope you will.

CHICKEN IN PORT
One of the most popular cuts of meat for entertaining in this country has been chicken breasts. They've been done in dozens of ways. They've been frightfully overcooked; they've been neglected and pulled out of a pot much too late before being served to guests. But I think if you try them with the delicious addition of a fine port you'll find a difference in chicken breasts— providing you don't overcook them. They're quick, easy, and distinguished, and can be served to any guest. Marsala or Madeira can be substituted for the port, if you prefer. However, I think the port belongs in this dish.

3 whole chicken breasts
Salt and pepper
Flour
Butter
Olive oil
3/4 cup shallots, finely chopped
1/2 cup duxelles (very finely chopped fresh mushrooms wrung dry in a damp kitchen towel)
1 ham steak, 1/2" thick
2 1/2 cups dry port wine
1 cup heavy cream
1 1/2 teaspoons beurre manié (butter and flour kneaded together in equal proportions)

Bone the chicken breasts and cut them in half, or ask your butcher to do it for you. Season with salt and pepper and dust with flour. In a heavy skillet brown the breasts quickly over high heat in 2 tablespoons butter and 2 tablespoons oil, then remove to a warmed platter. Reduce heat, slowly sauté shallots and mushrooms in the skillet, adding more butter if needed. While shallots and mushrooms are cooking, cut ham steak in half. Slice half the steak into very thin julienne strips. Cut the other half of the steak into cubes or, using small cookie cutters, into decorative shapes. When shallots are soft, add julienne ham strips and sauté quickly until ham is just warmed through. Lay chicken breasts on the vegetable-and-ham bed, add the port, cover, and simmer 10 to 15 minutes or until chicken is done. Do not overcook. While chicken is simmering, sauté the decorative ham pieces (or cubes) in a separate pan.

Remove the chicken to the warm platter, add the cream to the skillet, raise heat to high, and reduce sauce by half. Add the beurre manié, bit by bit, to thicken slightly. Taste for salt and pepper.

Arrange chicken breasts on a mound of buttered noodles or fettuccine and top with the sauteed ham pieces. Pass sauce separately. Serve with a green salad and a fine red wine. Serves six.

ESCALOPES DE VEAU
(Veal Scaloppine)
This is international in its popularity. The classic Italian way is to prepare the veal with dry Marsala. There are recipes from Spain using dry sherry, and from Portugal using Tawny Port, and from other countries using either white or red wine.

My particular favorite is done with white wine—a rather brisk one—tarragon, and very thin slices of lemon for garniture. It is quick—it's expensive nowadays, but it's greatly satisfying. A rice or pasta is an attractive accom-paniment, or just good French bread, a very good white wine, and, perhaps, shredded zucchini tossed in butter, or a green salad.

1 pound veal scaloppine
Flour
3 tablespoons olive oil
6 tablespoons butter
Salt
Freshly ground pepper
2 tablespoons fresh tarragon (1 1/2 teaspoons if dried)
1 to 1 1/2 cups dry white wine
Additional butter as needed
Chopped parsley
1 lemon, thinly sliced and seeded

Have the veal scaloppine pounded extremely thin. Place 1/2 to 2/3 cup flour on a sheet of wax paper. One by one, dip the scaloppine into the flour, and shake off any excess. Heat the oil and butter in a large heavy skillet over medium-high heat, and when butter sizzles, brown the scaloppine on one side. When nicely browned, turn them, and if they're thin enough they will cook through in 1 to 1 1/2 minutes. If you cannot fit all of them into the skillet at one time, cook them in relays, adding more butter if needed, and removing those that are cooked to a warmed platter.

After all the scaloppine have been cooked, keep them warm while you prepare the sauce. Pour off any excess fat remaining in the skillet and add 1 cup of the white wine (you may need 1 1/2 cups; that is for you to judge); add the tarragon, salt and freshly ground pepper to taste, and bring to a boil. Simmer for about 5 minutes, scraping up any crusty brown bits that cling to the pan. Remove from heat, and swirl in 1 or 2 pats of butter to blend into the sauce. Pour sauce over scaloppine, garnish with the chopped parsley and lemon slices, and serve at once. Serves four to six.

COQ AU VIN ROUGE
Coq au vin is a dish that is all too often ruined by overcooking and a stupid

423

sauce. *It is really nothing but a fine chicken sautéed with red wine and good flavorings. In many parts of France the sauce is thickened with fresh blood from the chicken (or other blood available from the butcher shop). Otherwise it may be thickened with beurre manié. It's a dish that takes only a short time, and it's an impressive dish. I like to serve it with boiled potatoes or with noodles and oftentimes a good fresh vegetable as a separate course. A point about coq au vin: it may be prepared in the same way with a good white wine, and in that case I would choose a white Burgundy, I think, in preference to any of the other white wines, because it has more body and gives more flavor—although the Alsatians are very fond of preparing it with a Riesling. It's a matter of personal taste.*

3 1/2- to 4- pound chicken
Flour
Salt and pepper
Butter
Olive oil
1/4 cup cognac
1/2 medium onion
1 garlic clove
1 bay leaf
1 tablespoon fresh thyme (1 teaspoon
 if dried)
3 cups red wine
1/4 pound salt pork, cut in 1/2" cubes
12 small white onions
1 teaspoon sugar
12 mushroom caps
1/4 cup fresh chicken blood, if available

Quarter chicken and pat dry. Place flour, salt, pepper in a bag, add chicken and shake till it is evenly and lightly coated. Brown the chicken in 2 tablespoons butter and 2 tablespoons olive oil. Flame with cognac. When flame subsides, add the onion half, garlic clove, bay leaf, thyme, and 2 1/2 cups warmed red wine. Bring to the boiling point, reduce heat, and simmer 30 to 45 minutes, or until chicken tests done. Do not overcook, and remember, white meat cooks faster than dark (re-move breast pieces to a warmed platter after 20 or 25 minutes).

While chicken is cooking, brown salt pork in 2 tablespoons butter, then remove to absorbent paper. Peel onions, add to pan, and brown, adding a little sugar to aid browning if necessary. Add 1/2 cup red wine and the mushrooms, and simmer 5 to 10 minutes, or until mushrooms are cooked through.

Remove remaining chicken to the warmed platter. Strain and reduce sauce by half over high heat. Taste for seasoning. Add salt and pepper if necessary. Thicken slightly by stirring in a little fresh blood or a little flour mixed with red wine.

Arrange mushrooms, salt pork, and onions around chicken pieces. Pass sauce separately. Serve with boiled potatoes and accompany with red wine. Serves four.

COUNTRY PÂTÉ

All of us like a pâté or terrine of our own preparation served for luncheon or with an aperitif. It makes a satis-fying, flavorsome, and piquant addition to any meal.

This one is a simple country pâté that is easy to prepare and will keep very well for a number of days if you store it in the refrigerator, tightly covered. It features a good deal of cognac, but if you want to you can sub-stitute sherry or port.

2 pounds lean pork
1 pound fresh side pork with fat,
 diced small
2 pounds ground veal
1 tablespoon fresh basil (1 teaspoon
 if dried)
1 1/4 tablespoons salt
1 teaspoon freshly ground black pepper
1/2 teaspoon Spice Parisienne*
1 pound pork liver
6 cloves garlic
2 eggs
1/3 cup cognac
Salt pork slices (to line the baking dish)
2 to 3 strips bacon

Cut half the lean pork into 1/2-inch dice and grind the rest; mix with the diced pork fat, ground veal, basil, salt, pepper, and spice. Divide the pork liver in half, and whirl one half in the blender with the garlic and the eggs, the other half with the cognac, adding a trifle more cognac if the mixture doesn't completely cover the blender blades.

Mix all together thoroughly with your hands or with a heavy wooden spatula. Line a 2 1/2- or 3-quart round earthenware baking dish with the slices of salt pork. Mound the mixture in it, top with bacon strips, and bake in a 350-degree oven, uncovered, 1 1/2 to 2 hours, or until the fat runs clear. Cool and chill. Serves twelve.

*Spice Parisienne is marketed by several companies. It can be prepared at home by mixing 1/2 cup ground white pepper, 2 tablespoons ground cloves, and 1 tablespoon ground nut-meg. Store in tightly covered jar.

BRAISED SALMON IN RED WINE

This is one of the unusual times when red wine is used for cooking a fish. It would be interesting to serve a slightly chilled bottle of Beaujolais or Cali-fornia Zinfandel instead of the tradi-tional white wine with this dish. Tiny boiled new potatoes and perhaps a cheese course with a sturdier red wine and fresh fruit would round out the dinner.

6 to 8 pounds salmon, cleaned
2 medium onions, thinly sliced
2 stalks celery, cut in strips
1 carrot, cut in thin strips
3 sprigs parsley
1 leek, cleaned and cut in strips
10 tablespoons butter
Salt
1 quart (or more) red wine
1 teaspoon thyme
1 bay leaf
18 small white onions
1 pound mushrooms

424

Place sliced onions, celery, carrot, parsley, and leek in the bottom of a large fish cooker or braising pan with 5 tablespoons of the butter. Cover and let cook over medium heat until the vegetables are soft. Salt the salmon inside and out, and place it on this bed of vegetables. Add red wine to half the depth of the fish in the pan, and put in the thyme and bay leaf. Bring just to a boil. Cover the fish with a piece of cooking parchment, and place it in the oven at 425 degrees, allowing 10 minutes per inch of its maximum thickness. (For a piece of salmon 2 1/2 inches thick, regardless of weight, 25 minutes of cooking time would be required.) Meanwhile, in another pan, brown the small onions in 3 tablespoons of butter, cover, and let them cook through. In a skillet, sauté the mushrooms lightly in the remaining butter, and season to taste.

Baste the fish in the oven from time to time. When it is cooked, arrange it on a hot platter and surround it with the onions and mushrooms. Strain the sauce, and if you wish it thickened, add beurre manié (see page 423). Taste the sauce for seasoning, and serve it separately. Serves eight.

PIÈCE DE BOEUF À LA BOURGUIGNONNE
(Beef Burgundian Style)
Boeuf à la Bourguignonne, or beef bourguignon, is all too common in restaurants and homes because it has had the reputation for years of being one of those dishes that can hold—and, lo and behold, when a dish is held it usually becomes pretty stringy, pretty indifferent, and totally flavorless. I have not broken with tradition in making this into a "Pièce de Boeuf à la Bourguignonne," because the dish has been prepared that way for many years; it has been notoriously overlooked in this country, where, instead of one large cut, little chunks of beef have been tortured with overcooking and overflavoring. This, I think, you'll

find an extraordinarily good version: with a good red wine for the sauce and either boiled potatoes or rice, it's a delicious dish. Also, the next day it's extremely good cold, cut in thin slices.

2 cups beef stock
1 slice lemon
3 carrots, cut in julienne strips
1 rib celery, cut in thirds
1 large onion stuck with 2 cloves
1 tablespoon fresh thyme (1 teaspoon if dried)
18 mushrooms (stems and caps separated)
1 bottle full-bodied red Burgundy
1 4- to 5-pound rump of beef
1/4 pound salt pork, cut in 1/2" cubes
2 tablespoons butter
18 small white onions
Flour
Salt and pepper

In a large, heavy braising pan, combine the beef stock with lemon slice, carrots, celery, onion stuck with cloves, thyme, mushroom stems, and one half of the wine. Simmer together 1/2 hour. Meanwhile, either brown the beef evenly under a broiler, turning two or three times, or flour it and brown it in 2 tablespoons oil and 2 tablespoons butter, over high heat, turning till evenly browned on all sides. Add beef to braising pan, cover, and simmer 2 to 3 hours (or till interior temperature on a meat thermometer reaches 165 degrees), turning three or four times. Do not overcook.

In a skillet brown the salt pork in butter. Remove and drain on paper toweling. Brown the onions in the fat remaining in the skillet. Reduce heat, add a little wine, cover, and steam. Remove onions and drain. Add mushroom caps to skillet and steam till barely cooked through. Cover and remove from heat. Remove cooked beef to warmed platter. Strain liquid, return to pan, and over high heat reduce by half. Thicken slightly with flour mixed with red wine. Remove mushrooms from skillet and deglaze skillet with remainder of red wine. Add skillet

juices to stock. Taste for seasoning and add salt and pepper if necessary.

Slice beef; garnish platter with the mushroom caps, onions, and salt pork, also boiled potatoes if desired. Pass sauce separately. Serve with red wine. Serves six.

WINE JELLY
I well remember dinners when I was a child that featured a shimmering, flavorful wine jelly, usually molded in a ring, the center filled with wine-flavored whipped cream and garnished with chopped pistachio nuts. It was an event and most satisfactory. You can combine the wines mentioned or you can make the jelly of a fine sherry or port without adding red wine to it. It's a light, lovely dessert and very decorative no matter how you do it. I like to serve this wine jelly with very crisp homemade cookies, perhaps sugar cookies or tuiles. It's a perfect ending to a rich meal.

2 envelopes unflavored gelatin
1/2 cup cold water
3 cups red wine ⎫ or 3 1/2 cups nutty
1/2 cup Madeira ⎭ sherry or port
1/2 cup strained orange juice
1/3 cup sugar
Wine-flavored whipped cream
 1 cup heavy cream
 3 1/2 tablespoons sherry, port, or Madeira
 2 1/2 tablespoons superfine sugar
2 tablespoons blanched pistachio nuts, coarsely chopped

Soften gelatin in cold water. In a saucepan (stainless-steel, enamelware, or flameproof ceramic) heat together, without boiling, all the wine (or wines) and the orange juice. Dissolve the sugar in the heated liquids. Taste for sweetness. Add softened gelatin, stirring to dissolve. Let the mixture cool to room temperature. Pour into a 1 1/2-quart ring mold and chill until set.

Whip the cream in a chilled bowl. When it begins to thicken, gradually add the wine and sugar, and continue

to whip until cream is stiff. Unmold gelatin ring onto a chilled serving platter and fill the center with the wine-flavored whipped cream. Sprinkle the cream with the chopped pistachio nuts. Serves six to eight.

ZABAGLIONE

Zabaglione, or sabayon as the French call it, is, I would say, an international classic. It can be beaten up quickly and served for a great dessert by itself, with some crisp wafers or tiny sugar cookies. It can be heaped over cake, or over fruit. Or when it has been beaten up to a froth it can be removed from the heat and beaten over ice until it's cold and then combined with whipped cream for a frozen dessert. It's really a magnificent dessert any way you look at it.

Warm

8 egg yolks (large eggs)
2/3 cup sugar
1 tablespoon grated lemon zest (the yellow part of the rind)
1 cup Marsala, cognac, port, or sweet sherry

In a 3-quart heatproof bowl, beat egg yolks very well and combine with sugar, lemon zest, and liquor. Set bowl over large pan of simmering water and continue beating until mixture is puffy. Serve in small cups or glasses; accompany with crisp wafers or sugar cookies. Serves six.

Cold

Warm zabaglione
1/2 envelope gelatin dissolved in 2 tablespoons water
3 tablespoons Grand Marnier
1 pint heavy cream, whipped

Place bowl of hot zabaglione in a bowl of ice, add softened gelatin and Grand Marnier, and beat until mixture is cold. Fold in whipped cream and spoon into individual dishes or a mold. Freeze several hours before serving. Serves eight.

PEARS IN RED WINE

A simple but really quite elegant dessert, I think. Most people don't take the pains to test the pears to see if they have been cooked until they are perfectly tender. Sometimes you get hard, rather indifferent pears in the market, and these are not particularly recommended. In this recipe, good firm pears are cooked long enough to give them a rich, finished quality and long enough to allow the red wine of your choice to imbue the fruit with its own distinguished and distinctive flavor.

2 1/2 cups red wine
1 1/2 cups sugar
1 lemon slice
2 cloves
6 firm, slightly underripe pears, peeled, halved, and cored

In a large, flat-bottomed pan, combine the red wine, sugar, lemon slice, and cloves. Over high heat, bring to the boiling point, stirring occasionally to dissolve the sugar completely. Reduce heat; add the pears and simmer till tender, turning occasionally. Remove pears with slotted spoon. Strain liquid into sauce bowl. Serve pears hot or cold. Pass sauce separately. Serves 6.

Around the Fish, Paul Klee, 1926

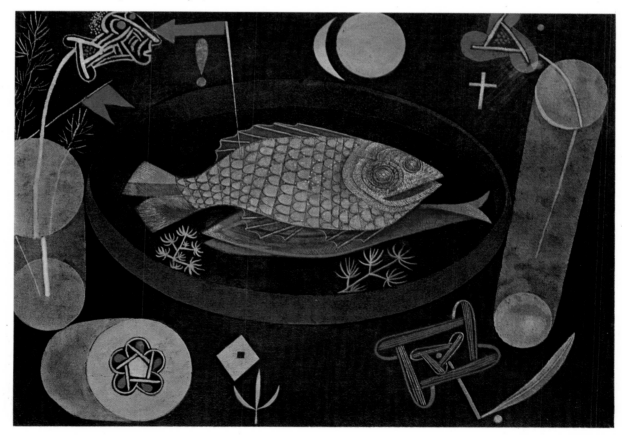

A
WINE
LOVER'S
GUIDE

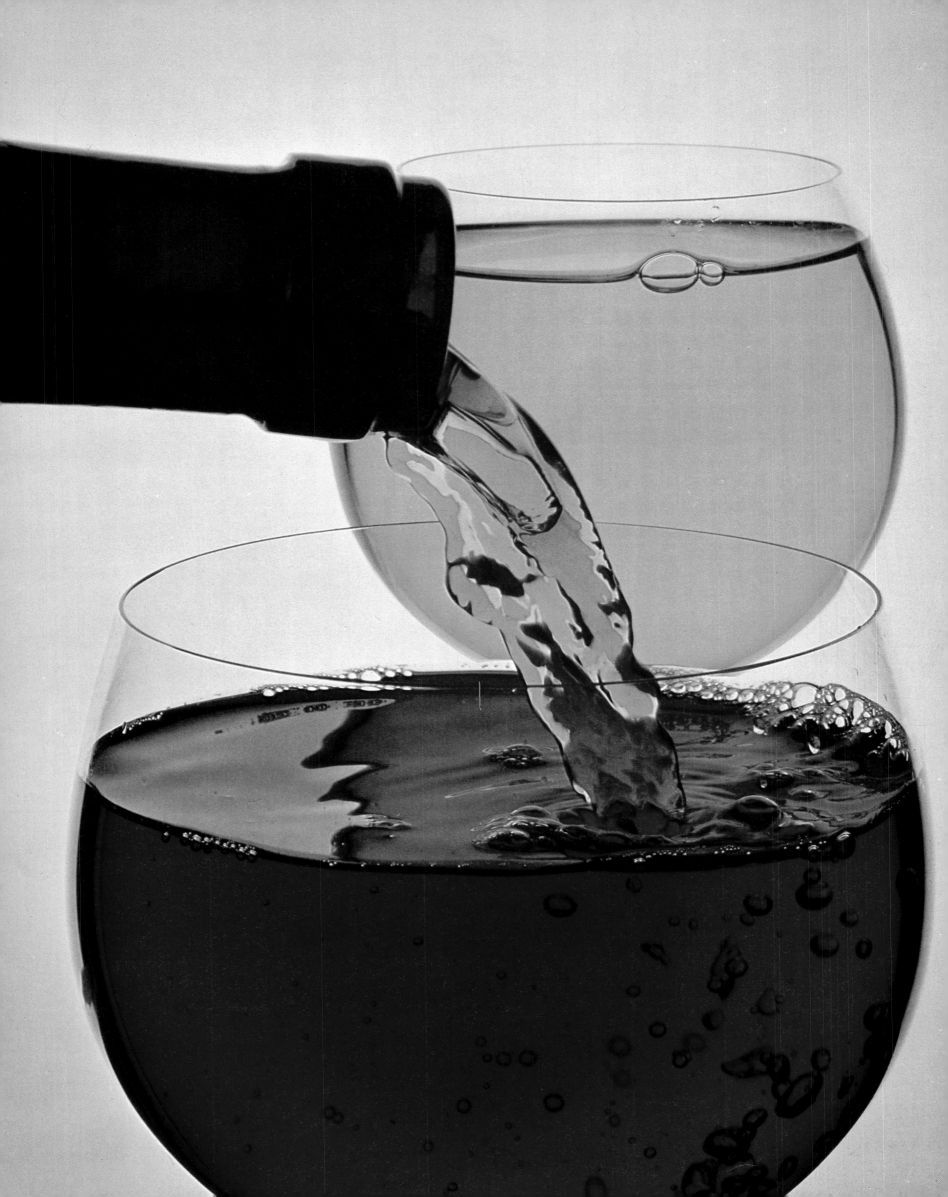

HOW TO SERVE WINE

The enjoyment of wine does not call for elaborate equipment. The only necessities are a corkscrew and wineglasses. As for the etiquette of serving, a few commonsense guidelines will suffice.

The variety of corkscrews and other devices for extracting a cork from a bottle can be bewildering, but if the following requirements are met, the tool will work well: the bore, or "worm," of a good corkscrew should be at least 2 1/4 inches long; otherwise it will not penetrate far enough into the long corks that seal fine wines. The metal should be fashioned in a true open spiral with smooth, rounded edges. Corkscrews with sharp-edged worms can literally tear up a cork—and still fail to remove it. A corkscrew's leverage should also be considered. Some people prefer the simple T-bar instrument, which offers no mechanical advantage. Loosening a stubborn cork with one of these corkscrews may require all your might. A better device from this standpoint is the double-action one: the top handle screws the bore into the cork, and turning the bottom handle smoothly pulls out even the most obstinate cork. Another good corkscrew, available almost everywhere, has two side arms that rise as the bore spirals into the cork; when these two arms, or levers, are pushed back down against the neck of the bottle, the cork is eased out. A waiter's corkscrew has excellent leverage and folds conveniently into the pocket or handbag for picnicking or traveling.

Before using any corkscrew, remove the protective foil (known as the capsule) around the top of the bottle to well below the lip, since contact with the metal may spoil the taste of the wine. If there is any mold or deposit on the top of the cork and the lip, after extracting the cork wipe the lip of the bottle with a clean napkin or paper towel.

After the bottle is opened, the next thing to consider is the wineglass. Expensive, elegant crystal may be beautiful, but it is not essential. A stemmed clear glass sets off a wine's clarity and color most effectively. The roundness of the bowl enhances the play of light, and the stem makes it possible to hold the goblet without warming the wine or smudging the glass. The colored glasses once in vogue masked the cloudiness of imperfectly clarified wines—a good reason for avoiding them.

Wineglasses come in all shapes and sizes. Many are traditionally paired with a particular wine—for example, the ones with small, clear, rounded bowls supported by tapered colored stems used for German wines. Several styles that are very popular actually interfere with the enjoyment of the wine they are intended for. A case in point is the saucer-shaped champagne glass: its broad, shallow bowl quickly dissipates the delightful bubbles that the winemaker has taken such pains to produce. A slender flute-shaped glass, one that conserves the effervescence, is best for serving champagne.

A simple and ample goblet of clear glass is suitable for any wine. Probably the ideal all-purpose glass is the graceful "tulip" shape, with bowl curved gently inward at the rim so that it concentrates and retains the wine's bouquet. Generous capacity—eight to ten ounces at least—is essential, because a glass should never be more than one-third filled. The extra space permits swirling the wine about, releasing bouquet and flavor just before it is sipped.

When more than one wine is served, glasses of different sizes may be used. If you are offering both red and white wines, reserve the larger glass for the red, or in the case of two reds, for the older, bigger wine. If you are serving two whites, the older, bigger one is also served in the larger glass.

One other important item is a decanter. Aside from being an attractive appurtenance that will enhance your table, a decanter has a practical advantage. When you pour wine into a decanter you eliminate the chance of finding unpleasant sediment in a glass. While sediment in the bottle is a natural, normally harmless deposit, an indication that the wine has aged properly, no one wants to drink it. (Young wines or wines that have been stabilized so that they will keep longer once they are opened do not throw sediment.)

Decanting is not a difficult procedure. Allow the bottle to stand upright until the sediment has settled to the bottom. This may take as long as a day, certainly not less than three hours. Decant in a good light, one that allows you to see the wine moving inside the bottle. A lighted candle placed behind the neck has been the tradition, but an electric lamp will do just as well. Handling the bottle carefully so as not to disturb the deposit, pour the wine slowly and continuously into the decanter until you see the first bit of sediment in the bottle's neck. Then stop pouring at once. If you have poured slowly and steadily, the sediment will not appear until the very end of the process, and you will lose only about an ounce of wine.

Decanting offers another advantage: aerating the wine as it is poured. The beneficial aeration that occurs in the process of decanting is actually an accelerated form of letting a wine "breathe." Except for the frailest of old vintages, every wine improves if it is given some time to air. Having been cooped up in a bottle for any number of years, a wine needs the opportunity to open up, to bloom, before it can reveal its fullest flavor and bouquet. Red wines, even when not decanted, are

From the Seagram Company Ltd. Collection

opened for a while before serving. Great red and white wines should be given more of a chance to breathe than common ones, but breathing should not be carried to the extreme, lest fragrance and flavor dissipate before the wine is poured. It is certainly better to serve a wine that has not been given enough exposure to the air than one that has stood open too long. Once served, a wine can always breathe for a moment in the glass. For a mature wine, decanting may take the place of permitting it to breathe before it is served. In the case of young wines that have not fully matured, this exposure to the air mellows them somewhat. Fully aged or very old wines should be decanted immediately before drinking. If they are exposed to the air for more than a few minutes, their bouquet and flavor may begin to fade and quickly disappear. It is customary when the wine is decanted to stand the bottle next to the decanter so that your guests may see it if they wish.

The basic rule in regard to temperature is simple: serve white wines chilled and red wines at room tem-perature. However, there is a little more to it in some instances. In the first place, what is "room temperature"? It is the temperature of the room in which the wine will be served, ideally about 68 degrees. In Europe it might be closer to 65 degrees, in the United States to 72 degrees. In any case, a red wine brought up from a 55-degree cellar needs an hour or so to come up to the temperature of the dining room, a temperature that shows the quali-ties of the wine to better advantage than does the cellar's. Some red wines, especially those that have been stored in a warm place, are pleasanter if served slightly cool. Fifteen or twenty minutes in the refrigerator for your Beaujolais or light Spanish red is all that is necessary.

White wines should be cold, but not too cold. Severe chilling can mask the defects in an inferior wine, but a fine white wine numbed to near freez-ing is robbed of its flavor. Half an hour in a bucket of ice cubes and water or 2 1/2 hours in the refrigerator will properly chill almost any white wine.
S.A.

HOW TO BUILD A LIBRARY OF WINES

The term "wine cellar" brings to mind some dark, cool, well-stocked cave in the nether regions of a great and opu-lent house. Of these actual cellars quite a few still exist, impressive in the size and quality of wine collections stored in them, not to mention the investment they represent.

In this day and age, storing wine at home seems as reasonable and agreeable as ever, but "cellar" is no longer the right word. More and more people are building what might better be called "libraries" of wine. Even the smallest apartment can accommodate a modest but select collection of wines, and for people with multiple homes—an apartment in the city, a weekend cottage in the country, and perhaps a *pied-à-terre* abroad—establishing a small but carefully stocked wine li-brary in each makes a great deal of sense. People who know and enjoy wine want to have it on hand to share with friends at a moment's notice or simply when the urge seizes them to enjoy a particular favorite.

Having your own collection of wines, replenished and enlarged as knowledge increases and new dis-coveries are made, can be a continuing source of gratification. For the wine lover, the labels on the bottles have a special romance, and as the names roll over the tongue they evoke the delight of anticipation—Haut-Brion, Montrachet, Schloss Vollrads, Lafite-Rothschild—names rich in history,

"There's no time to get them up to room temperature, but we could lower the thermostat."

© Punch

tradition, grandeur. Sharing this heritage is part of the intelligent appreciation of wine, clearly one of the civilized pleasures of life.

Aside from the aesthetic and emotional satisfactions, there are practical advantages in building a wine library. One, already mentioned, is the convenience of enjoying a bottle whenever the impulse strikes, or when friends drop by unannounced. In your own home you may leisurely make a choice to suit your mood and menu.

Many people feel uncomfortable serving wine because they are afraid of making a mistake or appearing unsophisticated. Never fear. Most wine shibboleths are nonsense. You can ignore them with propriety and proceed with assurance in cultivating your own tastes and preferences. Following are my suggestions for acquiring a well-rounded library of wines, consisting of about fifty bottles that represent the leading winegrowing regions of the world. At 1975 prices, the initial cost would be approximately $250.

Red Bordeaux: '66, '67, '69, '70, '71. Six bottles. Look for fine recognizable districts such as Médoc and Saint-Émilion. More specific and therefore generally better are château-bottled clarets. If the First Growths are too costly, try some relatively reasonable alternatives: Bouscaut (Graves), Figeac (Saint-Emilión), Vieux-Château-Certan (Pomerol), Lynch-Bages (Pauillac).

White Bordeaux: '67, '69, '70, '71. Three bottles. Choose Sauternes and Barsac as sweet dessert wines and Graves as a moderately dry white wine.

Beaujolais: '73, '74. Two bottles. Here is one of the good country wines of France, the younger the better. Look for the *Grand Cru* village wines such as Brouilly and Fleurie.

Red Burgundy: '69, '71, '72. Six bottles. Ask your wine merchant to give you estate-bottlings. The famed vineyards may be too high-priced, so look for such good values as Côte de Beaune-Villages, Pinot Noir, and Chassagne-Montrachet Rouge.

White Burgundy: '71, '72. Four bottles. These are the dry white glories of France. Select among the better villages such as Chassagne- or Puligny-Montrachet, Meursault, Chablis, and Pouilly-Fuissé. Here, too, look for estate-bottlings.

Rhine and Moselle: '71, '73. Six bottles. Some of the greatest white wines of the world are produced here. Pick '71s for rich and long-lived classics and '73s for quick-maturing, lighter wines. Popular Liebfraumilch is not to be relied upon unless bottled by a reputable shipper. You will be rewarded by asking for the hard-to-pronounce but wonderful wines that bear the names of a town and a vineyard—such wines as Niersteiner Orbel, Rauenthaler Baiken, and Zeltinger Himmelreich.

Country Wines of Europe: Recent vintages. Eight bottles. These wines are fun: delightful and often not expensive, providing a real tasting adventure. Choose among Muscadet, Sancerre, Vouvray, and Pouilly-Fumé from the Loire; Riesling and Gewürztraminer from Alsace; Châteauneuf-du-Pape and Hermitage Rouge from the Rhône (these will need bottle aging); Rioja red and white from Spain; the red Chianti, Valpolicella, and Valtellina wines and white Soave from Italy; Gumpoldskirchner from Austria; Neuchâtel from Switzerland; Vinhos Verdes and Dãos from Portugal. All are easily obtainable.

California Red Wine: Recent vintages. Six bottles. Do not overlook the beautiful red wines of northern California. The best bear the grape names Cabernet Sauvignon, Pinot Noir, and Gamay. Fine wineries abound, and their better wines improve with bottle aging.

American White Wine: Very recent vintages. Six bottles. Excellent examples of dry white wine are grown in northern California and New York State. The best bear the grape name Pinot Chardonnay; other grape names are Riesling, Semillon, Traminer, and Sauvignon Blanc.

Vins Rosés: The most recent vintage. Two bottles. This versatile pink wine adjusts to almost any menu. California rosés are excellent, or choose a moderately priced French one from Tavel, Provence, the Rhône, Bordeaux, or Anjou.

Champagne: Four bottles. The most glamorous of festive drinks is always good to have on hand for anniversaries and birthdays, when it is a must. Select the excellent French non-vintage brut rather than the very expensive vintage, or try one of the good American champagnes.

Once you have acquired your stock of wines, where will you store them? Actually the question presents no great problem. Any relatively quiet spot in your house or apartment is suitable for a wine rack or shelves, so long as it is free of vibrations and away from direct sunlight. Nor should it be situated near heating or cooling units, where temperature fluctuations can be sharp enough to damage the wines. The ideal "cellar" temperature is between 55 and 60 degrees, but any constant reading below 75 degrees will not hurt wines kept for a reasonable period of time. Remember that wine kept at 70 degrees matures faster than wine stored at 55 degrees.

Wines can be stored in any type of arrangement that suits your fancy. You can keep the finest wines in their commercial cartons, or cases, or on home-crafted shelves. Compartments to hold the bottles can be rectangular, octagonal, oval, or diamond-shaped—nearly any form will do.

The most important consideration in storing wines is that the bottles rest on their sides, tilted slightly, neck down, to keep the corks moist. If a cork dries out and contracts, letting air into the bottle, the wine oxidizes, and eventually spoils completely. Fortified wines such as sherry can stand upright with out suffering appreciable harm. S.A.

HOW TO CREATE YOUR OWN CELLAR BOOK

The advantages of a cellar book are many. You have a record of your wine purchases and of your current inventory. You are reminded which wines pleased you and which to avoid in the future. You can tell which wines are ready to drink now and which will be ready later. You have notes on how a wine of a given vintage (of which you bought a case) is coming along as you try a bottle periodically. You learn how to plan your future purchases intelligently.

To make and keep your own wine record, proceed as follows:

1. Copy or duplicate the record page shown here. Make as many sheets as you have individual wines, plus extras for future purchases. Allow one page for each wine.

2. Punch holes in the record pages and insert them into a 3-ring loose-leaf binder, dividing them with the index tabs obtainable at stationery stores.

3. You can index your entries as you see fit—alphabetically by name, by year of purchase, by general category, or by country of origin.

THE ENTRIES

At the head of the page:

Wine. Enter all important information on the label: vineyard name, grape variety, special designations, etc.

Vintage. You may have the same wine from two vintages, one outstanding, the other mediocre. You will soon learn to differentiate between vintages. If no vintage, mark NV.

Grower or Shipper. Some bottles bear the name of the grower, such as Comte de Vogüé's Musigny or Robert Mondavi's Cabernet Sauvignon. Others

Wine_____ Vintage_____

Grower or Shipper_____ Quantity_____

Purchase date_____ Merchant_____ Cost_____

DATE		COMMENTS	GUESTS

show the name of the shipper (who buys from the grower)—Joseph Drouhin's Chablis or Sichel's "Blue Nun" Liebfraumilch. This information can be important when you come to evaluate the wine.

Quantity. As the years and bottles go by, one is likely to forget whether the original purchase was five bottles or five cases. If you note the original quantity at the head of the sheet, as you record each bottle used it will be easy to ascertain your inventory by means of simple subtraction.

Purchase Date. This date is useful especially for nonvintage wines, to prevent holding a wine too long. (This is a good place to note the optimum number of years for keeping a wine, if you have that information.)

Merchant. Important in the event you want to reorder, commend for excellence, or complain because a wine did not live up to expectations; useful for ascertaining your best sources. As for gift bottles, they usually carry the dealer's name.

Cost. Obviously valuable for reference when repeating a purchase, or for budget information. Presumably the value of your fine wines will increase with the years.

At the head of the columns:

Date. The date on which the wine was tasted.

Quantity. The number of bottles consumed on the particular occasion.

Comments. State your impressions of the wine. Refer to "Wine Words: A Little Lexicon of Tasting Terms" for suggestions, but in describing the wine don't hesitate to use your own terminology, which may have even greater meaning for you.

Guests. The names of those who shared the wine will serve to recall the occasion to your mind even after the passage of years. You will also be reminded as to the wines you served, so that you can repeat a favorite or avoid serving the same wine to the same person again. C.F. and S.A.

HOW TO ORDER WINE IN A RESTAURANT

At home, we can collect the wines we like and serve them in accordance with our own taste. Dining out, we must trust the restaurateur, and restaurateurs who take pride in improving an excellent meal with a bottle of good wine, fairly priced, sometimes seem difficult to find.

To be financially successful is a normal concern of restaurants, and the patron, whether a connoisseur or a casual wine drinker, should not expect to find wines offered at the prices that prevail in a discount store. We pay the restaurant not only for the beverage but for preparing and printing the wine list, assembling and storing the bottles, hiring and training the waiters, buying and washing the glasses. Some small restaurants—usually because they lack a liquor license—permit diners to bring their own wine, charging only for service; this corkage tariff is customarily $2 to $5 per bottle, varying with the elegance of the establishment. Even restaurants famous for their wine lists may welcome a very special bottle brought from your own cellar for a special occasion.

"Bringing your own" is an exception to the general rules governing the consumption of wine in restaurants. Much more frequently we encounter a list of wines chosen by the proprietor. A good restaurateur offers a reasonable range of wines at sensible prices. An intelligently assembled list groups wines together in logical cate-

gories. A *carte des vins* at a *relais* outside the French city of Beaune may present first an impressive roll of red Burgundies, then of white Burgundies, then of red Bordeaux. A wine list in a San Francisco restaurant may start off with bottles from the Napa Valley, leaving French wines to the end. Even if a list does not feature local wines, its selections should be arranged by country, region, color, and perhaps vintage.

Wine prices may vary from restaurant to restaurant as greatly as the prices of the food served. Underneath a French inn offering exalted haute cuisine there may be a fabulous cellar of great wines from great vintages—1945 château-bottled Bordeaux, 1961 *Grand Cru* Burgundies, a 1954 German *Auslese*. Such wines are never inexpensive. Yet the sharp-eyed wine lover can often spy a bargain on the labyrinthine list of one of these inns: a good wine advantageously purchased years ago may still be offered at a cost near its original price.

A great temple of gastronomy presents its patrons with a beautifully printed and bound book of wines; an everyday eating place makes do with a less elaborate version. In the United States a modest list typically contains a selection of a dozen or so imported regional wines (Saint-Émilion, Chablis, Bernkasteler Riesling) and about half that number of well-known generic wines from California. Common additions might be a Bordeaux château wine, a German Liebfraumilch, a Portuguese rosé, often at ridiculously high prices.

Whether you feel slightly intimidated when confronted by a lengthy list of wines in a fine restaurant or are disappointed by the small number of overpriced wines offered in a less luxurious establishment, the advice is the same: fear not. In the latter situation, order a glass or carafe of the house wine—perhaps a pleasant jug wine from California, Italy, or the south of France. In the former, seek assistance from your

waiter or the special wine waiter, the sommelier. By no means should you be intimidated by him! At a reputable establishment the sommelier can be counted on to give you good wine at good value: he stands willingly at your side to help select the wine as well as to pour it. The heavy key worn around his neck may not open an actual cellar door, but the fact that he wears it indicates that he can unlock the pleasures of the list he presents.

The wine list is offered the host by the proprietor, maître d'hôtel, captain, sommelier, or waiter when the menus are distributed. In some restaurants the wines are simply listed as a part of the menu. Take time to peruse the choices, perhaps to find a wine you have enjoyed in the past, always one that will complement your meal. (James Beard's remarks about wine and food, found elsewhere in this book, suggest some classic as well as innovative pairings.) Share the fun of selecting the wine with any of your guests who are interested. Summon the waiter or sommelier when you have any questions. He will enjoy the chance to advise.

Nearly all sommeliers show you the bottle you have chosen before opening it. This is the first gesture of proper service, a point of etiquette that sometimes seems superfluous. However, seeing the bottle that the waiter plans to broach gives you a chance to verify that the label coincides with the description in the wine list, to check the vintage (if there is one), to note the shipper or grower (especially in the case of Burgundy wines). When you are satisfied that it is the wine you ordered, instruct the waiter to open the bottle and proceed to the pleasure of tasting.

A red that need not breathe much or a white that is already chilled can be sampled immediately. A red that requires a few minutes of exposure to the air should rest a bit. A white wine still at room temperature should cool in a bucket of ice. When the wine is ready, the host is offered the first taste. The ritual is meant neither to intimi-

date nor to test connoisseurship; its purpose is to determine if the wine is drinkable. If the wine seems spoiled or "off," ask the maître d'hôtel or sommelier to confirm or dispel your suspicions, and with him work out an acceptable solution. Never reject a wine capriciously simply because it is disappointing; a wine is returned only if there is something wrong with it.

After the tasting ceremony, the waiter usually places the wine's cork on the table. You may sniff, read (part of the wine's pedigree may be branded thereon), or disregard it.

A few other hints. The staff should refill your glasses—thus they sell more wine—but do not hesitate to do it yourself if no help is at hand. Make sure that the wine is poured before the arrival of the course it is to accompany; waiting for a bottle while a meal turns cold can spoil any dinner. If the sommelier sagely suggested and graciously served a wine you enjoyed, it seems only right to tip him well. (The average tip is $1 per bottle.) Besides, you may need his kind offices again. S.A.

WINE WORDS: A LITTLE LEXICON OF TASTING TERMS

Professional winetasters, author-connoisseurs, and plain ordinary wine drinkers have over the generations tried valiantly to develop a vocabulary useful in describing the color, taste, smell, feel, and general condition of a glass of wine—in a word, to express the ineffable. Such terms, though helpful, cannot—any more than the qualitative

vocabulary used by music critics to describe the mystery of sounds—be precise. Listed here are a few frequently encountered terms, along with their generally accepted meanings. But these definitions are not sworn to on oath.

ACIDITY. Tasting **astringent;** sharp, pricking the tongue. Wine must have a certain amount of natural sourness; otherwise it is bland and characterless. But too much makes it **tart.** A wine that is acid is different from a wine that has gone **sour.**

AFTERTASTE. The impression left on the palate after the wine has been sipped. A good wine that leaves a lingering impression is sometimes said to "have a tail."

AROMA. The almost immediately recognizable scent of fruit or flower in a young wine. When the wine matures, aroma is superseded by the more complex **bouquet.**

ASTRINGENT. Pleasantly crisp and **dry** (when the tannin is in correct proportion); puckery (when the tannin is too pronounced, as in some young wines).

BAKED. Describes the warm, even hot, earthy smell characteristic of red wines in the course of whose production there has been too much exposure to the sun. Can be detected in some wines from such areas as Provence (and other Mediterranean regions), the Rhône, and California.

BALANCE. Harmony of all the elements—acids, esters, tannin, fruit, alcohol—whose sum is wine. A wine with balance has neither marked deficiencies nor overpronounced characteristics; it is fully representative of its type and class.

BIG. Applied to a wine endowed with an unusual degree of flavor and **body** and high in alcohol content. Unless it also has **balance,** a big wine may prove **coarse** and unattractive.

BODY. The substance, weight, consistency, or materiality of a wine. It is not a concomitant of high alcohol content, though it depends on the pres-

ence of alcohol and other substances in adequate quantity. Body can be felt by the whole mouth; one can almost bite a full-bodied wine. A full-bodied wine is perfect only when body is in balance with other qualities (**fruit** for example).

BOTTLE SMELL. Occasionally, immediately upon being opened, a bottle will emit a discernible odor (sulphurous in whites, musty in reds), which vanishes quickly. If it remains in the glass after inhalation, the bottle is probably a poor one.

BOUQUET. The fragrance (associated with finer and older wines) the appreciation of which is one of the great pleasures of wine drinking. This widely varied message to the nose results predominantly from esters that develop from the slow oxidation of the wine's elements. Bouquet, being complex, invites more careful analysis than the much simpler **aroma.**

BREED. When the grape, the soil, and the vintner's skill are in perfect equilibrium, the resulting wine is said to have breed.

BRILLIANT. Having the absolute clarity of a well-made wine.

BRUT. Literally "raw," "unworked"; applied to French champagne and other sparkling wines it means that the wine is unchanged by added sweetening. It is the term describing the driest champagne.

CLEAN. Describes wine free of any "off" taste or smell.

COARSE. Rough-textured and heavy; lacking **finesse.**

COMMON. Ordinary; with no faults but no claim to distinction.

CORKY. Having a musty odor, the consequence of a defective or diseased cork. Since the odds are 5,000 to 1 against finding a truly corky bottle, many of the instances of corkiness noted by would-be connoisseurs must be labeled as "overdetection."

CRÉMANT. Literally "creaming"; slightly sparkling—less than **mousseux,** more than **pétillant.**

DRY. The opposite of "sweet" as applied to wines; a dry wine is one in which little or no residual natural sugar is left after fermentation.

DULL. Flat. A dull wine, though not undrinkable, will not improve.

ELEGANT. Delicate and well-made but not **big**; definitive in its charm but not aggressive. A descriptive term often applied to light wines and those not destined for long life.

FAT. Full-bodied; usually associated with a high glycerine content.

FINESSE. Encompasses delicacy, character, **breed.** An indefinable distinction analogous to that attributed to certain human beings. A wine possessing many admirable qualities may still lack finesse.

FINISH. What remains in the senses, but mainly on the palate, after you swallow. "Finish" characterizes many mass-produced wines, especially those of California. The finish of a great claret, though firm and decisive, may be evanescent.

FLINTY. Describes the mineral or gun-flint taste that certain dry white wines, especially Chablis, have. A reminder of the vineyard's distinctive soil, flintiness can be most attractive.

FOXY. Having the special wild, grapy aroma and taste of eastern American wines made from the *Vitis labrusca.* Some like it, some don't.

FRESH. Expresses the engaging quality of young or even infant wines. Freshness is found especially in whites and rosés and many Beaujolais wines.

FRUIT. The taste and smell, not necessarily of the original grape, but sometimes of other fruit, indicating the retention of the original grape sugar. Generally a term of approbation, but an attribute of certain wines only—not, for example, of a fine, extra-dry Chablis.

GENEROUS. Applied to a full-bodied, hearty, warming wine such as a red from the Rhône or Burgundy with more than 12 percent alcohol.

GOÛT DE TERROIR. Literally, "taste of earth." The earthy smell and taste of certain wines made from grapes grown in heavy, alluvial soil.

GREEN. Harsh, hyperacid, lacking in softness and mellowness. Usually, though not always, applied to immature wines.

HARD. Austere, unbending. Many wines are distinctly hard in their youth but come around beautifully with the passage of time. Hardness is not necessarily a fault, and may indicate longevity.

HEAVY. Too full-bodied, overendowed with alcohol perhaps; just short of **coarse.** The second glass does not tempt.

LIGHT. Describes a wine that, under American law, contains less than 14 percent of alcohol by volume. The opposite of **heavy** or full-bodied. To be fine, a light wine must be blessed with charm and elegance.

MADERIZED. Term applied to a white wine past its prime that has begun to oxidize, developing a brownish tint and a flavor—unbecoming in a white wine—reminiscent of Madeira.

MOUSSEUX. Literally "frothy," "foamy," "effervescent." The term is applied to all French sparkling wines, regardless of the fermentation process, with the exception of champagne, which stands alone.

MUSTY. Having a stale odor and taste (usually the result of less than impeccable cleanliness in cork or cask).

NOSE. An example of the figure of speech known as metonymy, the term covers fragrance, **aroma, bouquet** —the qualities that can be discerned by the olfactory organ.

OEIL DE PERDRIX. Literally, "eye of the partridge"; color or **robe** characteristic of certain tawny pink or rosé sparkling wines from Champagne or Burgundy.

PELURE D'OIGNON. Literally, "onionskin"; a light russet hue sometimes taken on by certain older rosés or **maderized** white wines.

PÉTILLANT. Literally "crackling," "sparkling," "fizzing." In wine parlance it means lightly sparkling.

PIQUANT. Agreeably acid. Applied usually to young **dry** whites.

PRECOCIOUS. Early-maturing.

QUEUE DE PAON. Literally "peacock's tail." A French phrase describing the peculiar power of sensory expansion on the palate possessed by some complex wines.

ROBE. The color of the wine; its chromatic clothing. The term is usually reserved for fine wines.

ROBUST. Sturdy and full-bodied. One is more apt to speak of a robust Burgundy than a robust claret, but a simple Italian country wine may be robust—if little more.

ROUND. Harmonious, satisfying to the mouth, full; the opposite of **thin.** Usually applied to a mature and well-balanced wine.

SEC. Literally "dry"; in general it is applied to a still wine with only moderate retention of natural sugar after fermentation. Applied to champagne, however, it indicates a sugar content of 3 to 5 percent by volume— fairly sweet as compared with champagne **brut,** which contains less than 1.5 percent sugar by volume.

SÈVE. Literally "sap"; figuratively "vitality." An important term, difficult to define exactly. A wine with *sève* has vigor, élan, the capacity to mature because of its inherent life, and it has the **body** and flavor to satisfy the palate.

SOUND. A basic term: clean, decently balanced, having no abnormalities. A sound wine is not necessarily a distinguished wine.

SOUR. Having the taste and smell of vinegar. Acetic acid is the villain; throw the wine out! Remember that in wine terminology "sour" and "sweet" are not opposed; "dry" and "sweet" are.

TANNIC. Tasting of tannic acid; **astringent.** (To identify the taste of tannin, drink a little oversteeped tea.) Typical of a young wine with a long life ahead.

TART. Having a certain excess of the grape's natural acids, but perfectly drinkable.

THIN. Meager, lacking in **body;** age will not improve a thin wine.

VELVETY. Mellow, smooth, rich, soft yet not **dull;** the opposite of rough.

VINOSITY. The degree of balance of flavor, **body,** and **bouquet**—of the characteristics of a good wine.

WOODY. Tasting of wood; an unhappy legacy of the cask.

C.F. and S.A.

A SELECTED BIBLIOGRAPHY

Adams, Leon D. *The Wines of America.* Boston: Houghton Mifflin, 1973.
A historical survey of winegrowing and winemaking in North America, from the beginnings to the present boom. Emphasis on unusual localities.

Allen, Herbert Warner. *Sherry and Port.* London: Constable & Co., 1952.
A Contemplation of Wine. London: Michael Joseph, 1951.
A History of Wine. London: Faber and Faber, 1961.
The Romance of Wine. London: Ernest Benn Ltd., 1931.

Amerine, Maynard A., and Joslyn, Maynard A. *Table Wines.* Berkeley and Los Angeles: University of California Press, 1970.

Balzer, Robert Lawrence. *The Pleasures of Wine.* Foreword by André Simon. Indianapolis and New York: Bobbs-Merrill Co., 1964. Informal, enthusiastic account, by a respected gourmet and wine man, of various wine tours, mainly in California. A most pleasant book.

Berry, Charles Walter. *Viniana.* New York: Alfred A. Knopf, 1930.
A Miscellany of Wine. London: Constable & Co., 1932.
In Search of Wine. London: Constable & Co., 1935.

Bespaloff, Alexis. *Signet Book of Wine.* New York: New American Library, 1971.
A Guide to Inexpensive Wines. New York: Simon and Schuster, 1973.

Unhappily, books like this one are going to become more and more necessary.
Bordeaux et ses vins. Twelfth edition. Bordeaux: Claude Feret et Fils, 1969.

Churchill, Creighton. *Great Wine Rivers.* New York: Macmillan, 1971.
A Notebook for the Wines of France. New York: Alfred A. Knopf, 1961.

Croft-Cooke, Rupert. *Port.* London: Putnam, 1957.
Madeira. London: Putnam, 1962.
Sherry. London: Putnam, 1955.

Dallas, Philip. *The Great Wines of Italy.* Garden City: Doubleday, 1974.
This book offers a broad panorama of the delights of Italian wine-bibbing and puts into high relief the best wines and the names of their makers.

Fisher, M.F.K. *The Story of Wine in California.* Photographs by Max Yavho. Berkeley and Los Angeles: University of California Press, 1962.
Much knowledge couched in quiet, well-bred prose, and complemented by photographs, some in color, that are inspiring or businesslike, as may be required.

Frumkin, Lionel. *The Science and Technique of Wine.* Cambridge, England: Patrick Stephens, 1974.
A fairly technical book on the wine-making process; a must for those in the trade, also useful for the home winemaker and the dedicated wine lover.

Gold, Alec (Editor). *Wines and Spirits of the World.* Coulsdon, Surrey: Virtue & Co., 1972.
Large factual compendium, the many contributors being all members of the wine and spirit trade. Uneven but informative.

Gould, Francis Lewis. *My Life with Wine.* St. Helena, California: 1972.
Unpretentious, friendly reminiscences by a veteran connoisseur, for many years responsible

for *Bottles and Bins,* the wine quarterly of Charles Krug Winery. Charming introduction by the great M.F.K. Fisher.

Grossman, Harold J. *Guide to Wines, Spirits, and Beers.* New York: Scribner, 1955.

Gunyon, R.E.H. *Wines of Central and Southeastern Europe.* New York: Hippocrene Books, 1971.

Hallgarten, S.F. *Rhineland-Wineland.* London: Elek Books, 1955.
Alsace and Its Wine Gardens. London: Elek Books, 1957.

Hannum, Hurst, and Blumberg, Robert S. *The Fine Wines of California.* Garden City: Doubleday, 1971.
Honest evaluation of over four hundred premium California wines, together with other useful information. Main virtue is its independent tone.

Healy, Maurice. *Stay Me with Flagons.* London: Michael Joseph, 1941.

Hyams, Edward. *Dionysus: A Social History of the Wine Vine.* London: Macmillan, 1965.
Good historical account, well illustrated.

Johnson, Hugh. *Wine.* With line drawings by Owen Wood. New York: Simon and Schuster, 1967. Revised edition 1975.
Thorough, informative, world-embracing, the work of a distinguished English authority; the organization is not by productive areas but by broad wine types: red, white, aperitifs, after-dinner. Good maps and pleasing color photographs.
World Atlas of Wine. New York: Simon and Schuster, 1971.
The first detailed mapping of the vineyards of the world.

Langenbach, Alfred. *German Wines and Vines.* London: Vista Books, 1962.

Lexique de la vigne et du vin. Paris: Office International du Vin, 1963.
A standard reference dictionary in several modern languages giving good, concise meanings for wine and winemaking terms.

Lichine, Alexis. *Encyclopedia of Wines and Spirits.* New, completely revised edition. New York: Alfred A. Knopf, 1974.
An invaluable reference work, now totally revised to reflect recent developments.
Wines of France. New York: Alfred A. Knopf, revised edition, 1972.
A thorough and very pleasant book, written by one of wine's true masters.

Massee, William E. *Guide to Wines of America.* New York: Dutton, 1974.
Wine Handbook. Garden City: Doubleday, 1961.

Penning-Rowsell, Edmund. *The Wines of Bordeaux.* New York: Stein and Day, 1970.

Postgate, Raymond. *The Plain Man's Guide to Wine.* London: Michael Joseph, 1951; revised edition, 1967.

Poupon, Pierre, and Forgeot, Pierre. *Les Vins de Bourgogne.* Paris: Presses Universitaires de France, 1964.
Almost 200 pages of solid, factual information about Burgundy.

Rainbird, George. *Sherry and the Wines of Spain.* London: Michael Joseph, 1966.

Ray, Cyril. *Cognac.* New York: Stein and Day, 1973.
A complete account by a first-order authority.
Lafite. New York: Stein and Day, 1969.

Saintsbury, George. *Notes on a Cellar Book.* London: Macmillan, 1920.
A crusty old Tory's small, cantankerous personal record, whose outmodedness is one of its attractions.

Schoonmaker, Frank. *Encyclopedia of Wine.* New, completely revised edition. New York: Hastings House, 1973.
One of the great total-view reference works, by an acknowledged master who can also write.
Wines of Germany. New York: Hastings House, 1956.

Seltman, Charles Theodore. *Wine in the Ancient World.* London: Routledge & Paul, 1957.

Shand, P. Morton. *A Book of French Wines.* Revised edition. New York: Alfred A. Knopf, 1960.

Simon, André L. *A Dictionary of Wines.* London: Jenkins, 1958.
History of Champagne. London: Ebury Press, 1962.
The Commonsense of Wine. London and Cleveland: World, 1966.
The International Wine and Food Society's Encyclopedia of Wines. New York: Quadrangle, 1973.
Geographic directory (312 pages) of the world's wines and vineyards. In-depth book of reference, the master's last work. 64-page map section.
Wines of the World. New York: McGraw-Hill Book Co., 1967.
A mammoth affair (719 pages) covering the world's wines by major regions. The great Andre himself handles France, North Africa, South Africa, Australia, New Zealand, and, in collaboration, Germany. Many other distinguished contributors. Much historical information, lovely color photographs.

Wagner, Philip M. *American Wines and Winemaking.* New York: Alfred A. Knopf, 1933.
A Wine Grower's Guide. New York: Alfred A. Knopf, 1945.

Waugh, Alec. *In Praise of Wine.* London: Cassell, 1959.
Wines and Spirits. New York: Time-Life Books, revised edition, 1974.

Waugh, Harry. *Diary of a Wine Taster.* New York: Quadrangle, 1972.

Younger, William. *Gods, Man and Wine.* London and Cleveland: Wine and Food Society with World Publishing Co., 1966.
Perhaps the fullest and most scholarly historical account in English; unfortunately, out of print.

Yoxall, H. W. *The Wines of Burgundy.* New York: Stein and Day, 1970.
C.F. and S.A.

A CHART OF RECENT VINTAGE YEARS

The vintage chart is a helpful guide for those wise enough to know when to ignore it. To follow such a chart slavishly, buying nothing but the very greatest of vintage years, means paying the highest prices for the top-rated years and overlooking wines produced in good average years that can be acquired at relatively modest cost. One must put a vintage chart in perspective in order to be able to interpret and grasp its implications. Since some highly touted years may prove not to hold up with the passage of time, constant reevaluation is called for.

This guide was compiled in 1975, and its recommendations should be considered in terms of that year; for example, wines suggested for "present drinking" in 1975 would be good to drink only until 1978 or 1979.

In the case of the highly publicized vintages there is still a sorry tendency to consume them before their time. This is especially true of the best red wines of Bordeaux, which, in general, age better and live longer than the wines of Burgundy, the Rhône, the Rhine, and the Moselle. To consume a great wine before its prime is rather like hanging a painting before the artist has had time to finish it.

It is helpful to bear in mind that climate and weather, though they are the factors that determine which vintages will be outstanding, are not as important as soil in forming a wine's character. Thus a Latour or an Haut-Brion of an off year like 1968 (from the point of view of weather) will often prove to be more of a thoroughbred, thanks to the exceptional quality of the soil in question, than a lesser Bordeaux of a great year such as 1970. Wines can be as complex and illusory as humans: there is good in every bad year and bad in every good.

The ratings listed below, which run from 0 to 20 (a vintage given 17 or more is a great one indeed) are offered in the spirit of the British army maxim attributed to Winston Churchill: "Rules are made for the obedience of fools and the guidance of wise men."

438

RED BORDEAUX

Year		Rating
1974	A wonderfully dry and sunny summer gave promise of a very special year. September rains dampened these hopes, but they could not completely spoil the wines. In each of the famous districts, the wines have good color and will mature well, resembling the lovely '62s and '67s.	17
1973	Record-breaking harvest—the largest in thirty years. Because of abundance, wines relatively light, early maturing, not destined to be long-lived. Wines from the famed châteaus exhibit softness, elegance, and good fruit, with a life expectancy of about 10 years.	16
1972	Opening prices broke all records, quality was called high, but the wines have not lived up to early expectations. Insufficient fruit emphasizes the relatively dry, tannic quality on the palate. The austere Cabernet Sauvignon grape thrived, while the softer Merlot did not; hence the Médoc, where Cabernet flourishes, produced better wines than did Saint-Émilion and Pomerol.	15
1971	Overlooked because of universal praise showered on the '70s, the '71s may ultimately prove their equal; in many instances they will outlive the '70s. Body, power, and fullness are recognizable features. Low yields meant concentrated flavor. Will mature slowly and gracefully.	19
1970	Shares with '45 and '61 the honor of being among the very best vintages since World War II. Considering the excellence, quantity produced was surprisingly large. Fully developed Merlot grapes added soft and round elegance. Holds promise of long life.	20
1969	Highly praised immediately after the harvest, the '69s are simply not in the league with the '61s, '66s, and '70s. Nevertheless, a most acceptable year, producing excellent, slow-maturing wines, particularly in the Médoc and Graves, with slightly lower quality in Pomerol and Saint-Émilion. The crop was half the normal size.	16
1968	Wines below average in general, but among the better vineyards some are very attractive, and attractively priced. Latour and Haut-Brion, noted for their quality in off years, are especially good values.	12
1967	Bounteous crop; wines show good fruit and balance. Excellent for present drinking and until at least '78.	17
1966	Glorious wines of exceptional bouquet, with superb balance and style. A bit lighter in body than the '61s, but still sufficiently tannic to provide happy drinking until 1995. Worth laying down.	19
1965	Has passed its peak; should be ignored.	2

1964 Charming, fruity wines reaching their apex in Saint-Émilion, Pomerol, and Graves. Unfortunately, rain hit during mid-harvest in the Médoc, drenching about half the vineyards. One must choose carefully here. While awaiting the glories of '66 and '70, the '64s, which can be drunk now, offer much pleasure, and will until 1980. **16**

1963 A very spotty year, owing to spells of bad weather. Forget about Saint-Émilion and Pomerol. Some good wines were produced in the Médoc, but most have passed their prime. **9**

1962 Overlooked at first, the outstanding qualities of the firm, well-balanced, soft '62s are beginning to be recognized. Good fruit and fine bouquet have developed beautifully. If you can obtain them, you will find them excellent for drinking during the next few years. **16**

1961 In the classic tradition of the '45s: low yield, hence well-nourished grapes. Rich concentration, exceptional color, body, and bouquet. Remarkable longevity—some of the wines will be vibrant well into the next century. **20**

Older Clarets. The '60s were better than average, but they have not lasted. 1959 was highly acclaimed as "the year of the century"; many of these wines are just at their peak, though some of the lesser vineyards have begun to decline. The '57s continue to be rather hard and disappointing. The '55s are still perfection if properly stored and provide exceptional tasting experience. Fine '53s are still to be found, but I suggest that you try a bottle before investing in a case. Superb '52s from Saint-Émilion and the Médoc are available. The '50s received little attention, but wines from the top vineyards can be remarkable. '49s from the best châteaus are now glorious. Many '48s are still enjoyable and represent good values, particularly Médocs and Pomerols. If they have been lovingly cared for, '47s offer memorable drinking. The unsurpassed '45s are still dramatically great. Among the older claret vintages that have retained their excellence and character are '37, '34, '29, '28, '24, '23, '21, and '18. If properly cared for and decanted, they can provide extraordinary moments. Anything older than 1918 is uncertain.

WHITE BORDEAUX

1974 Good average year for both Sauternes and Graves. **16**

1973 Fruit and balance poor in Sauternes. **11**
Graves are somewhat better but not outstanding. **14**

1972 Though striking a fine balance of fruit and acidity, the Graves are a bit light and thin. Here again, Sauternes did not get its full quota of October sunshine and the wines are disappointing. **16** / **13**

1971 Graves well-balanced, possessing depth and an appealing style, fresh bouquet and flavor. **18**
In Sauternes, beautiful fruit and perfect balance have given us rich and elegant wine. Equals the great '62. **19**

1970 A bounteous vintage in Graves, producing very fine wines, medium-dry with charming fruit. Excellent, concentrated richness in Sauternes means wines of velvet smoothness, luscious fruit, and long life. **18** / **17**

1969 Graves excellent in their early years but now beginning to show age. **14**
Rather poor overall quality in Sauternes, but d'Yquem stands supreme. **10–16**

1968 No wines of distinction. **10**

1967 Good, well-made, attractive Graves. **16**
Sauternes outstanding, rich and deep, long-lived. **19**

Older White Bordeaux. Sauternes and Barsac reached glorious heights in 1962, with '61 and '59 not far behind, if not equal. The wines of these vintages will last for many years to come. Sweet wines from the best châteaus can still be enjoyed in these classic vintages: '55, '53, '49, '45, '37, '34, '21, '18, '14, and '08. The dry whites of Graves are too old if they bear a date before 1969.

RED BURGUNDY

1974 Like Bordeaux, Burgundy looked forward to a splendid vintage, but the cool, wet weather of September resulted in wines that were good, not great. Average quantity, much less than in the record year of 1973. **11–17**

1973 A record crop, as in Bordeaux, with wines of medium quality. Many of the lesser wines are thin and watery. Careful consideration is required to select the best wines from the good vineyards. These will mature rather quickly and can be enjoyed fairly young. **8–17**

1972 Very firm wines of strong character, depth, and balance. Not so harsh as originally thought, but the abundance of tannin means the wines will live long. Slow-maturing, worth waiting for. Many excellent smaller wines. **18**

1971 Possibly the best red Burgundies since 1929. Very complete wines, possessing all the richness, power, and depth for which the wines of Burgundy are renowned. Sufficient fruit to give them a gentle roundness as well. Will last for twenty years. **20**

439

1970 Well-balanced, stylish wines produced in great quantity. Superb for drinking now and over the next few years. — 15

1969 An extraordinary year, with wines rich in tannin needing many years to develop. Unfortunately, many of the great wines have already been consumed, since this was a very small vintage. Fine for drinking from the late 1970s on. — 19

1968 The worst Burgundy vintage in two decades. — 8

1967 Though some good examples can be found, most '67 Burgundies proved too light and pale, vanishing quickly on the palate. — 12

1966 A very good year, with fruity, elegant wines, especially fine as to bouquet. They are not long-lived and some may be over the hill, but the better wines are at their peak now. — 17

1965 Forget about this one.

1964 Many of the best wines have matured slowly and well and are close to their prime. Though originally touted as remarkable, some of the wines have already lost their fruit and attractiveness. Careful choice is necessary. — 14–18

1963 Poor. — 9

1962 The well-made wines from superior vineyards are extremely pleasing to drink now; the others, lacking fruit and depth, are disappointing. — 16

1961 Superb wines of great longevity. Now just coming around and will be great for another dozen years—until 1987. Few remain, owing to the very small harvest. — 19

Older Burgundies. As a rule, red Burgundy does not last more than a decade, though time and time again the top vineyards are the exceptions that prove the rule. The '59s were uniformly superb, but most are old and tired. A few fine '52s and '49s can still provide dramatic drinking.

WHITE BURGUNDY

1974 Light and simple wines, on the average, but with some very fine ones produced at the famous vineyards. — 15

1973 Last-minute rains produced a bountiful crop but filled the grapes with water. The resulting wines are fruity, supple, and graceful but very light, and should be consumed young. — 15–17

1972 Cooler weather made most Chablis excessively acid. Select carefully. — 10–15

1971 The whites from the Côte d'Or, farther south, will be elegant until 1980. Though rich and nectarlike, the wines are not long-lived. Should be enjoyed now. — 17

1970 Graceful and fruity, these wines have developed quickly and are ideal for drinking now. Fine balance of fruit, alcohol, and acidity. — 18

1969 As with the reds, greatness was achieved here. Quite rich wines, possibly the best white Burgundy in several decades, but very limited quantity. — 19

Older White Burgundies. The life expectancy of white Burgundy is not great, so it is best not to get involved with anything older than 1969, though the remarkable wines of 1961 if from the top vineyards are still enjoyable.

BEAUJOLAIS

Vintage years do not mean much if the label reads simply "Beaujolais" or "Beaujolais Villages." These light, fruity wines should be consumed when their charm is greatest—in their youth, usually within two years of the vintage. But the nine *Grand Cru* Beaujolais, such as Fleurie and Brouilly, may ripen beautifully in three to six years after bottling. Many of these are well worth waiting for. Since lesser Beaujolais do not live long, avoid anything older than 1971.

1974 A very large crop of pleasant, fruity wines. As always, the wines from the nine *Crus* made the best Beaujolais. — 17

1973 A huge crop, which produced thin wines in some cases, though the *Grands Crus* made the most of their hilltop situations and produced typically fruity, delightful Beaujolais to be enjoyed within the next three years. — 13–17

1972 A very disappointing vintage for Beaujolais fans. Though there were some superb exceptions in Brouilly and Moulin-à-Vent, most wines were lacking in fruit, the heartthrob of Beaujolais. — 12–16

1971 A most unusual year in Beaujolais, with wines high in tannin and long on depth. They taste amazingly like the lighter reds of the Côte d'Or. Classic, long-lived Beaujolais. — 18

CÔTES-DU-RHÔNE

1974 Sizable production of average-quality wines. Choose carefully. — 11–16

1973 A record-breaking crop, of which 20 percent is truly excellent. For the rest, excessive production diluted quality. — 12–17

1972 Excellent wines, generous in body, depth, and character. Big and long-lived. — 19

1971 Limited quantity and uneven quality because of rain during the harvest. A few good wines, but select with care. — 14–17

1970 A hot, dry summer and fine weather during the harvest gave uniformly excellent wines. Good quantity; round, strong character. — 19

1969 Fine wines throughout the Rhône Valley; not a large production, but good flavor and bouquet. — 18

1968 Fared much better than the rest of France 14
during this year. Some very agreeable wines.

1967 Reds are very attractive for present drinking. 16
Whites and rosés were disappointing; most 12
are now too old.

1966 Superb, especially Hermitage and Châ- 18
teauneuf-du-Pape, both with fine balance and
longevity. Very charming wines.
The whites of the region were also excellent. 17
The rosés are too old. 12

Older Côtes-du-Rhône. Some red wines of the
Côtes-du-Rhône have great longevity. The
wines of '62 are fine for drinking now. The
remarkable '61s, the best postwar vintage on
the Rhône, are wines of beautiful balance and
charming fruit. Excellent now and for years
to come. You would indeed be fortunate to
come upon '57, '53, '49, or '45—dramatically
great wines. They will have thrown much
sediment and should be decanted carefully.

LOIRE VALLEY

1974 Good wines generally, but no great peaks. 15
1973 Typically fresh and charming wines through- 18
out the valley, to be drunk with pleasure
while still young.

1972 The grapes did not ripen properly in most 13–16
areas, and the resulting wines were thin and
rather acid. Muscadet, where the nearby
Atlantic Ocean moderated the otherwise
cool season, was the exception, giving lovely
wines.

1971 Small production but full, well-ripened wines 18
of delectable fragrance. Longer-lived than
most recent Loire vintages, they will provide
pleasant drinking until 1981 or 1982.

1970 Certainly one of the best vintages in two 19
decades. Stylish wines with appealing bou-
quet and dryness, attractive for drinking now.

Older Vintages. For the most part, the charm of
Loire wines is their youthful freshness and
fruit. There are exceptions, however, among
the very sweet wines of Anjou and Vouvray,
some of which in great vintages can be very
long-lived indeed. The reds of Chinon and
Bourgueil improve after a few years in bottle.

RHIEN AND MOSELLE

1974 Rain during the harvest along the Rhine and 15
the Moselle prevented both estates and co-
operatives from producing the better grades
of wine: little *Auslese* will be seen. Average
quantity of light, quick-to-mature wines.

1973 As in France, nature was bounteous, making 17
probably the largest vintage ever harvested
in Germany. Elegant, light, and of fine fruit-
iness, the wines will be enjoyable at least
through 1978.

1972 Essentially light, pleasant wines for con- 14
suming early. Not for laying down.

1971 An exceedingly great year, in the same ex- 20
alted class as '53, '45, and '37. Much rich
Spätlese and *Auslese* was produced, all
possessed of beautiful balance and lon-
gevity. Here are wines that can be enjoyed
through 1985 as complexity develops in the
bottle.

1970 Light, typical wines produced in large quan- 16
tity. The better ones, to the surprise of many,
will still be delightful even at the end of the
1970s.

1969 Pleasant enough until 1973, but now too old. 12

1968 Fine body and style and an adequate balance 12–15
between sugar and acidity, but few great
rich wines were produced.

1967 Good balance and depth; many superb 18
Auslese wines that will be very long-lived.

1966 High average quality, some wines with 15
great finesse. Not for laying down after 1975.

Older German White Wines. Surprisingly, the
best *Auslese* wines of '53 and '59 are still
superb and will delight us until 1985. Wines
older than '53 should be ignored.

CHAMPAGNE

Vintages are declared in Champagne only
when the harvest results in particularly ex-
cellent wines. Most champagne, however, is
a blend of the wines of several years and
thus cannot bear a vintage date. The great
vintages ready to drink now are '71, '70, '69,
'66, '64, '61, and (if stored properly) '59, '55,
and '52. Shippers in Champagne claim that
1973 holds great promise for the future.

ALSACE

1974 Normal quantity, good quality, better than 17
the '73s. The best should be given some
bottle aging.

1973 High yield of light, fruity, agreeable, typic- 17
ally Alsatian wines.

1972 Less fruit and more acidity than 1973. Re- 14
freshing.

1971 As in Germany, its neighbor across the 19
Rhine, a truly outstanding vintage. Wines
are extremely rich, full, and fruity.

1970 Record-breaking crop of light and early-ma-
turing wines. 15

Older Vintages. Save for a few rare exceptions,
wine from Alsace older than 1970 should be
avoided.

ITALY

Until recently, there was little control of the
vintage dates appearing on bottles of Italian
wine. In 1963 the Italian government created

441

the *Denominazione di Origine Controllata,* the Italian counterpart of the French *Appellation Contrôlée.* Stricter standards, more precise language, and tasting tests, all administered by local wine committees, now enable us to rely on the vintage dates appearing on Italian wine labels. It must be remembered that most Italian wines are quick-maturing, informal, meant to be drunk young—in many instances the younger the better. As a general rule I recommend looking for a very recent vintage date, indicating an age of not over three years, on such wines as Bardolino, Soave, Valpolicella, Verdicchio, Chiaretto, and all wines grown south of Rome.

The better red wines, as in France and California, profit from barrel and bottle aging. Maturation particularly benefits wines made from Nebbiolo grapes grown in Piedmont and Lombardy: Barolo, Barbaresco, Gattinara, Ghemme, and the Valtellina wines Sassella, Inferno, and Grumello. A few years in bottle also improve the finer Chiantis, wines from the heart of Tuscany. The better Chiantis are identified by such adjectives as "Riserva" and "Classico." Avoid the attractive straw-covered bottles. These wines are not the finer grades of Chianti; they have not been aged. Among the recent red-wine vintages to look for are 1973, 1971, 1970, 1967, 1966, 1964, 1962, and 1961.

SPAIN

For the most part, Spain's Mediterranean climate makes vintage years unimportant. The exception is one small corner of the country near the French border: the Rioja region, about 150 miles southwest of Bordeaux. Here a temperate climate prevails, varying widely from year to year, so that vintage dates take on real meaning. But, unfortunately, Rioja growers revere age for its own sake, and some of the Riservas spend too many years in barrel, losing freshness. Many wise producers now bottle closer to the vintage date, and this trend bodes well for the future of Rioja wines. Outstanding recent vintages are 1961, 1962, 1964, 1966, 1969, 1971, and 1973. Despite tales of legendary high-priced wines, it is hazardous to venture into years earlier than 1961. As for the rest of the table wines of Spain, the most recent vintage is to be preferred.

PORTUGAL

With the important exception of Vintage Port, the Portuguese solve the tricky vintage problem by dating few of their wines. Vinhos Verdes, Roses, Dãos, and Colares are wines to quaff informally, for pleasure is to be found in their young charm.

As for Vintage Port, the year on the label is all-important. The wines mature slowly indeed, never revealing their excellence until at least a decade has passed. If you are lucky enough to find them, the following vintages can be enjoyed now and many years hence: 1960, 1958, 1955, 1950, 1948, 1945. Port for laying down should be chosen from 1973, 1970, 1966, and 1963.

CALIFORNIA

From Repeal up until about 1954 California vintners boasted, "In Europe there are good and bad vintages, in California only good ones," and vintage dating was scorned as unnecessary and unimportant. Now, however, wiser wine men have learned that there is no fine table wine district anywhere in the world that is not subject to variable weather patterns affecting the quality of the wine. Today we can compare a great Napa Cabernet Sauvignon from 1973 with the same wine from 1972, a year of distinctly inferior quality.

If you have ever tasted a fine ten-year-old Cabernet Sauvignon, you will realize that the better California wines develop in bottle the way a Château Margaux or a Château Haut-Brion does. One of the wisest wine investments is a 1973 Napa or Sonoma Cabernet acquired young, while the cost is low. Let it rest in your cellar for several years, to be drunk only when it has aged properly. By that time the same wine will command triple the price—if available at all.

Unlike Europe, California does not experience really disastrous vintages. Nevertheless, some years are better than others. Among the better recent years are 1973, 1971, 1970, 1969, 1968, and 1966.

NEW YORK STATE

It is difficult to discuss vintages in New York unless we are sure that everything in the bottle was grown within the confines of the state. Such smaller vineyards as Bully Hill, Benmarl, Vinifera Vineyards, and a few of the large producers make 100 percent New York wine. For these the following vintage ratings hold true: 1973, 1971, and 1967 were excellent years for both red and white wines, thanks to especially good weather in the late summer and fall. 1972 made better white than red wines; 1970 finer reds than white.

S.A.

442

INDEX

Page numbers preceded by an asterisk indicate illustrations.

447

ACKNOWLEDGMENTS

From its inception this book has benefited in ways small and large from the encouragement and support of many friends and associates. To them we express our warm appreciation of their part in helping us bring *The Joys of Wine* to completion.

In this space it would not be possible to acknowledge our indebtedness to all those who have furthered our effort. But in gratitude for their liberality with their time and talent we should like to specify our obligation to the following:

To the experts who are our colleagues in New York City: Richard Blum of Julius Wile Sons; Barry Bassin and Joseph Morelli of Dreyfus, Ashby, Inc.; Joseph Baum; Mario Daniele of C. Daniele & Co.; Margaret Dorsen of Schieffelin & Co.; Maurice Feinberg of Monsieur Henri Wines, Ltd.; Paul Kovi of the Four Seasons Restaurant; George Lang of the George Lang Corporation; Alexis Lichine; Richard Newman and George Manderioli of Austin, Nichols; M. J. Rossant; Peter M. F. Sichel of H. Sichel Sons; Frank Schoonmaker; Abdallah Simon of the Château and Estate Wine Division of Browne Vintners; Byron G. Tosi of the Jos. Garneau Co.; Jack Yogman of Joseph E. Seagram & Sons, Inc.

To these dedicated men of the California wine industry: Dr. Maynard Amerine, for many years on the faculty of the University of California at Davis; Gerald Asher of the Monterey Bay Company; Alfred Fromm of Fromm & Sichel; Ernst Mittelberger of the Wine Museum of San Francisco; Robert Mondavi of the Robert Mondavi Winery; Dr. Kirby Moulton of the Agricultural Extension Service of the University of California; Arthur Palombo of Browne Vintners; Dr. Richard Peterson of the Monterey Vineyard.

To the many friends, old and new, scattered among the vineyards and wine companies of the Golden State: James Beckman of Guild Wineries; Jack Davies of Schramsberg Champagne Cellars; Louis M. Foppiano of Foppiano Vineyards; Michael Galick of Château Montelena; Ernest and Julio Gallo and Howard E. Williams of E. & J. Gallo Winery; Philip Gaspar of the Buena Vista Winery; Ben Hecht of Korbel; Hans Kornell of the Hans Kornell Champagne Cellars; Fred A. Lico of San Martin Vineyards; Jack Loffmark of the Simi Winery; R. B. Macumber of Sterling Vineyards; Robert Magnani of Grand Cru Vineyards; Louis P. Martini of Louis M. Martini; John P. McClelland of Almadén Vineyards; Frederick McCrea of the Stony Hill Vineyard; Terrence McInnes of the Wine Institute, San Francisco; Douglas Richards of Weibel Champagne Vineyards; August Sebastiani of Sebastiani Vineyards; Robert Sessions of Hanzell Vineyards; Helen Silberberg of the Cresta Blanca Winery; D. Lee Squyres of Mirassou; Rodney Strong and Peter Friedman of Sonoma Vineyards; André Tchelistcheff, long associated with Beaulieu Vineyards; Barry P. Tobin of United Vintners; Robert Travers of Mayacamas Vineyards; Louis Trinchero of the Sutter Home Winery; and a special tribute to Burgess Meredith, at whose California home we have tasted and talked about many great and delightful wines.

To these dependable sources of information about the other wines of the United States: J. Myron Bay of Mogen David; Lester Gruber; Dr. Konstantin Frank of Vinifera Vineyards; Mark Miller and Philip Powers of Benmarl Vineyards; Walter Taylor of Bully Hill Vineyards; Jocelyn and Philip Wagner of Boordy Vineyards.

To the family of our close associates in the French wine trade: Martin Bamford of Gilbey's; William Bolter; Robert J. Drouhin of Joseph Drouhin; Yves Fourault of Eschenauer et Cie; Robert Haas of Robert Haas Selections; Nathaniel Johnston of Nathaniel Johnston & Fils; Count A. de Lur-Saluces of Château d'Yquem; Henri Martin of Château Gloria; Allan Meltzer and Howard Sloan of Château Bouscaut; Baron Philippe de Rothschild and Philippe Cottin of Château Mouton-Rothschild; Marquis de Roussy de Sales of Château de La Chaize; Guy Schÿler of Alfred Schÿler Fils & Co.; Henri de Villaine of the Domaine de la Romanée-Conti; Seymour Weller and Jean Delmas of Château Haut-Brion.

To these good friends from around the globe who made valuable corrections and suggestions: Michel Dreyfus, founder of Dreyfus, Ashby; R. W. Finlayson, Toronto; G. S. Hargrave of Thomas Hardy & Sons, Ltd., Australia; Hugh Johnson; Hans Kendermann and Margrit Goebels of Herman Kendermann, Bingen, Germany; Dmitri Tchelistcheff of Bodegas de Santo Tomás, Mexico; H. Gregory Thomas; Harry Waugh; Frederick Wildman, Jr., of Frederick Wildman Sons, Inc.

To the skilled associates who typed and retyped countless drafts of the manuscript: Betty Kirsh and Sylvia Leven.

To the tireless and talented assistants: Barbara Ensrud and Marcelle Clements.

To the ever-smiling researcher, organizer, and liaison between authors and publisher, John Laird.

To the understanding associates at Sherry–Lehmann, Inc.: Michael Aaron and David Reilly.
C.F. and S.A.

PICTURE CREDITS

The text of this book was set in Garamond Number 3, a modern recutting of a book face created by Claude Garamond in Paris in the sixteenth century. The type was set by Carson/Berkowitz, Broomall, Pennsylvania, and Radnor Graphic Arts, Radnor, Pennsylvania. The headings were set in an original typeface made from an alphabet designed by the contemporary American calligrapher and typographer Arthur Baker. They were photocomposed by Type Men, Inc., New York.

The book was printed and its two-color black double-dot reproductions were made by Case-Hoyt, Rochester, New York, under the personal supervision of Anson Hosley. The four-color separations were supplied by National Colorgraphics, New York. The paper is 100-pound Patina, manufactured by S. D. Warren Co., New York, and supplied by the Lindenmeyr Paper Corporation, New York.